Photographing Nature in Action

Arnold Wilson

CROWOOD

First published in 2013 by
The Crowood Press Ltd
Ramsbury, Marlborough
Wiltshire SN8 2HR

www.crowood.com

British Library Cataloguing-in-Publication Data
A catalogue record for this book is available from the
British Library.

ISBN 978 1 84797 553 9

ACKNOWLEDGEMENTS

The production of a book is a combined effort
involving many professional people, not just the
Crowood team, but their various suppliers, each
playing a vital role. – thank you all very much.

Nearer to home, I am greatly indebted to my
good friend Dr Mike Kelly who sorted out several
computer problems and helped with the cropping and
sequencing of the images. Thank you, Mike.

My sincere thanks also to Julie Richardson who
produced the excellent digital illustrations in the
section on Colour in Chapter 3.

Finally, a very special thank you to my wife Margaret
who encouraged and supported me throughout the
project, converting my untidy much altered script into
a beautifully presented manuscript, correcting a few
errors en route. I would not have attempted to write
the book without your support and encouragement.
Thank you very much, Margaret.

Frontispiece: Puffin on Farne Island, Northumberland.
Exposure 1/125 sec f8. ISO 100

Typeset by Servis Filmsetting Ltd, Stockport, Cheshire
Printed and bound in Singapore by Craft Print International

CONTENTS

Introduction

In this book for photographers of the natural world, I have concentrated on producing stimulating images of plants and animals in action. With a background in biology I have long been interested in photographing the natural world, including those microscopic plants and animals invisible to the unaided human eye.

At first sight restlessness and movement in the plant kingdom appear to be rather rare or almost non-existent. However, closer examination reveals that somewhere in their life cycle all plants have a motile phase, if they are to thrive and colonize new ground. Movement takes place when the male pollen is shed and transferred to the female ovary, or more obviously when fruits and seeds are dispersed away from the parent plant. Plant growth can also be considered a form of movement, as seen in a tree root system where the slow but powerful movement is sufficient to collapse a well-established stone wall.

Animals are restless in their search for food or a mate, reproducing and feeding their young, and where possible, colonizing new territories. We will analyse and explore the photography of animal movement in water, land and in the air.

We begin by looking across the range of cameras – compact, bridge and compact system cameras and the single lens reflex (SLR) camera. Some of the images in the book were captured on film but the majority were taken with modern digital cameras, including a compact Canon PowerShot G series bridge camera and a Sony alpha digital SLR camera.

In the micro-world many organisms living in both fresh water and marine environments exhibit interesting methods of movement, which are readily observed in close-up and particularly under the microscope. As many of the animals and plants photographed in later chapters are quite small (e.g. tiny barnacles, butterflies, moths, spiders and red campion capsules) we will concentrate on equipment which is particularly useful in close-up work.

The mere mention of close-up and macro photography is sufficient to frighten off many photographers, thinking that their digital compact camera is a non-starter for serious close-up work, while SLR owners assume close-up work requires lots of extra, expensive equipment and techniques which are too complicated for the average photographer to cope with. They would be wrong on both counts!

Over the years I have developed techniques to enable me to photograph particular moments, such as sycamore fruits spinning to the ground, while at a much higher magnification and using electronic flash I have captured tiny barnacles feeding. On a larger scale, but presenting other difficulties, to capture butterflies, moths, damsel flies and bumble bees in flight I have designed and built a flight tunnel which I use with very high-speed flash.

The photographs are accompanied by information about the natural history and biology of the organisms; this should add immeasurably to a greater appreciation of the photographs, and help you to work out how you wish to take your own photographs.

For each photograph details of the set-up, lighting, background, lens aperture, shutter speed and ISO setting have been provided, often with descriptions of conditions on the day, to give you a full appreciation of how they were taken.

This book was written for lovers of the natural world who are keen to capture the wonders they notice, both for their own pleasure and for that of others.

◄ Smooth newt. Exposure flash f11 50mm macro lens. ISO 100

Chapter 1

TYPES OF CAMERA

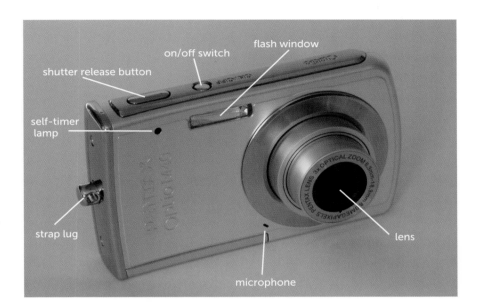

The literally hundreds of different makes and models of cameras available can fortunately be subdivided into four basic groups: point-and-shoot compacts, bridge cameras, compact systems cameras (CSCs) and single lens reflex cameras (SLRs). Each group is analyzed below, giving their basic characteristics, their advantages and disadvantages and how well suited they are to the types of photographs considered in this book.

DIGITAL POINT-AND-SHOOT COMPACTS

Although these cameras are often thought of as the simplest of the four groups, they do include highly complex electronics and could almost be thought of as miniature computers. The level of sophistication can be confusing for the first time buyer. The example discussed here is the Pentax Optio M40, a typical point-and-shoot digital compact camera, which produces very acceptable holiday and family photographs.

◄ Fig. 1.0
Eagle owl. Flash 500mm lens f8 ISO 100

Camera Front

The lens

The lens is obviously the key component in any camera, collecting light from the scene being photographed and focusing it on the image sensor at the back of the camera. Lenses are complex, computer-designed, multi-element units made of glass or plastic, with most elements being symmetrical and spheric (part of a sphere).

The focal length of the lens is the distance between the lens and the image sensor when the lens is focused on distant objects (theoretically at infinity) and is marked on the rim of the lens.

Most digital compacts have a zoom lens, enabling you to produce a larger image from the same distance. The range of zoom focal lengths is also marked around the rim of the lens, with the

Pentax Optio having a zoom range from 6.3mm to 18.9 resulting in a 3× magnification. (The 35mm equivalent is 36mm to 108mm).

As there is no control of the lens aperture (f numbers) on a point-and-shoot compact, this topic will be covered in the section on bridge cameras.

Autofocus (AF) assist

In dim light this feature produces a red beam of light that helps the camera to focus on the subject, but it is not available on all compact cameras.

▼ Fig. 1.2
The shot of the squirrel was taken from the back door using the Pentax Optio M40 point-and-shoot digital compact camera. The Programme setting was used and the lens was fully extended. Programme 3× zoom. ISO 100

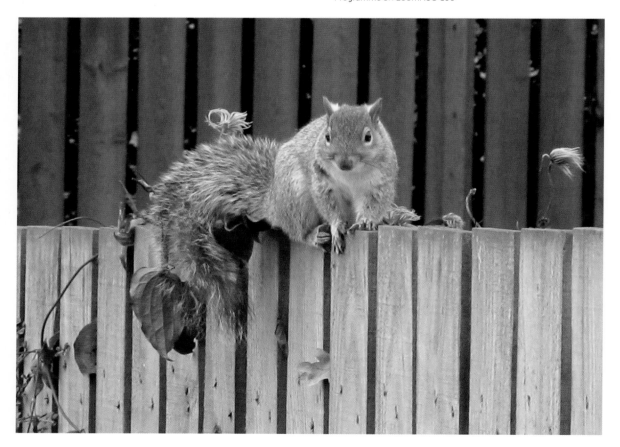

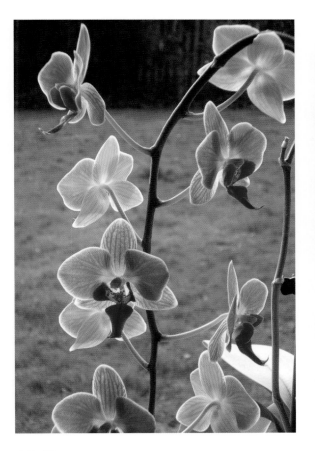

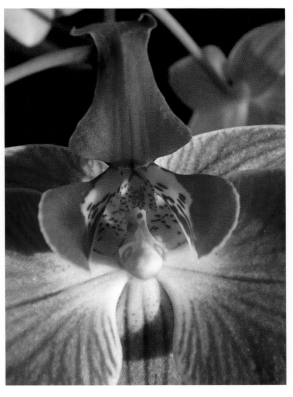

▲ Fig. 1. 4
Close-up of an orchid flower with the lens on the macro setting.
Tripod-mounted camera for stability. Programme macro setting.
ISO 100

▲ Fig. 1.3
A potted orchid sitting on the kitchen window sill and backlit by the
late afternoon sun. Handheld and set to Programme. ISO 100

Flash window

The built-in flash unit has a fairly weak output (GN
around 11 at ISO 100) being controlled by a button
at the back of the camera. The flash guide number
(GN) is an indication of the strength of the flash,
where, for example, GN 11 indicates that if the lens
aperture is set at f2 the flash will produce a well-
exposed image at distances up to 11÷2=5.5m (18ft).

Optical viewfinder

An optical viewfinder is found on one or two digital
compact cameras (notably Canon) and is useful for
viewing the image in bright sunlight when the LCD
screen image is difficult to see.

Self-timer lamp

When the self-timer is in operation, the picture
is taken either ten seconds or two seconds after
the shutter release button has been pressed. The
self-timer lamp will blink red during the countdown,
and on the Pentax M40 it is located next to the flash
window.

Microphone

The microphone is positioned behind a tiny hole
towards the bottom left of the lens.

Zoom control lever

The shutter release button is often surrounded by a spring lever, which operates the zoom lens, although on some cameras the zoom control is a separate rocker switch located in a convenient position elsewhere on the body. In the Pentax M40 it is on the back of the camera next to the LED screen. The digital zoom (4×), giving even greater magnification, is accessed from the same lever, but as it only selects the centre of an increasingly large image the quality is bound to suffer, so it is preferable not to use this unless no other option is available.

Camera Top Plate
Power switch

This switch turns the camera on and off.

Shutter-release button

This operates the shutter, allowing a measured amount of light to fall on the image sensor. Shutters are electronically controlled, with speeds ranging typically from 10sec to 1/1500sec (4sec to 1/2000sec in the Pentax M40). The advantage of this type of shutter (a between-the-lens leaf-blade shutter) is that flash can be used at all speeds. Half-pressing the button activates the autofocus mechanism and the light meter, in anticipation of making an exposure. This greatly shortens the shutter delay time, making it easier to obtain sharp, in-focus photographs of sporting activities and other fast-moving events.

Camera Back
Liquid crystal display (LCD) screen

The largest component on the camera back is the LCD screen. It consists of between 65,000 and more than 230,000 pixels (150,000 in the Pentax M40), and being live, it shows the image you are about to photograph. In playback mode the captured image is also displayed on the screen together with the shooting details. Screen sizes range from a modest 5cm (2in) to the larger 7.6cm (3in). As with television screens the screen size is measured diagonally across the screen.

on/off switch shutter release button

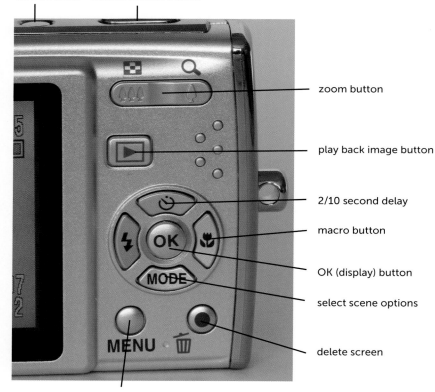

zoom button

play back image button

2/10 second delay

macro button

OK (display) button

select scene options

delete screen

recording/setting information

◀ Fig. 1.5
The business end of the camera showing some of the main settings.

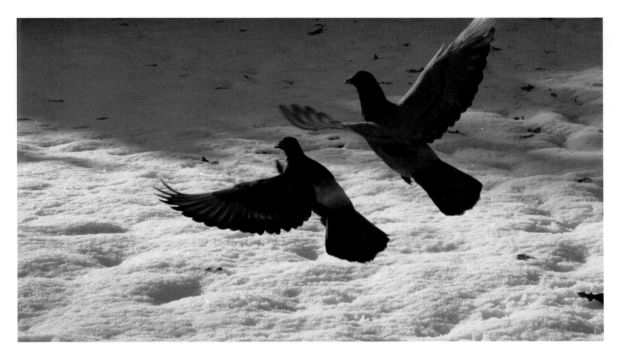

▲ Fig. 1.6
The shot of the pigeons was taken from the back door using the little Pentax point-and-shoot compact. Selecting the Sports setting produced a shorter shutter speed, sufficient to almost freeze the wing movements. Sports setting. ISO 400

Four-switch button

The most obvious feature on the back (apart from the LCD screen) is a fairly large button containing four switches. One side-switch often controls the flash unit (On, Off, Auto) while another sets the close-up option. A third often selects a single-shot exposure, multiple shots in rapid succession, and a time-delay setting. In playback mode these switches have different functions.

Function button (Func Set)

The function button is in the centre of the large button and usually provides information on a wide range of settings including ISO, white balance, drive, flash compensation, metering, compression and image size. Each is on a default setting, but can be altered as required, and other options – scenes (SCN) are arranged round the top of a rotatable knob on most digital compacts. On the Pentax M40 the

button marked Mode brings up fifteen small draw-ings (such as scenes), any of which can be selected using the two side buttons.

Auto and Programme settings

The first two settings, Auto and Programme, are extremely useful to anyone new to compact cameras, with the Auto setting selecting everything for you. This includes the lens aperture, shutter speed, focus, ISO setting and white balance. Most people use this setting regularly and are quite happy with the results.

The Programme setting is mainly automatic but also includes landscape and close-up settings, auto or manual focus and full control of the ISO level. These are the settings on the Pentax M40 compact, but they do vary a little from camera to camera.

Also included are Portrait, Sport, Pets, Kids and Face Recognition options, automatically selecting for each setting the appropriate lens aperture, shutter speed, ISO setting and overall colour where appro-priate (such as adjusting for natural skin tone on

the portrait setting). Pressing the OK button on the Pentax will confirm the settings selected, rather like the central Func Set on many other cameras.

Menu button (recording mode)

On the Pentax M40 the Menu button allows you to select many of the recording parameters including number of recorded pixels, quality (three levels), focus area (three settings) and sensitivity (auto or any ISO setting), white balance (auto and five settings) and image quality level (three settings).

Recording a video clip

The recording menu suggests that 640 pixels, at 30 frames per second (fps) produces the best quality images. Automatic white balance (AWB) is standard and the flash is switched off. Using the Pentax M40 and pressing the Mode button brings up the fifteen picture options. Click onto the image of a professional-looking movie camera and save it by pressing the OK button. Set the zoom lens appropriate to the composition of the image (only the digital zoom can be used during filming) and press the shutter release button. Press it again to stop the filming.

Playback mode

On the Pentax M40 switching from record to playback by pressing the triangular-marked button brings up the images on the LCD screen, while activating the zoom lever or rocker switch enlarges them, allowing closer inspection for overall quality. Pressing the central button shows the shooting parameters on the screen, including the ISO setting, exposure and film size, plus a histogram indicating whether the image has been correctly exposed.

To view and playback videos, locate the beginning by using the two side buttons (marked Flash and Close-up on the Pentax M40) and press the top button (showing the shutter time delay icon). Stop the moving image by pressing the bottom button (marked Mode).

To erase an image it is always necessary to press two buttons, with the dustbin button providing a choice of Erase or Cancel, while pressing the function or OK button completes the procedure.

CAMERA BASE

Located in the camera base of the Pentax M40 compact camera is a lithium-ion (Li-ion) battery which, as cameras are becoming smaller and require more power, have replaced the original rechargeable AA nickel metal hydride (Ni MH) batteries which took up too much space. Battery capacity is sufficient to power around 200 images, depending on how often the flash and the LCD screen are used.

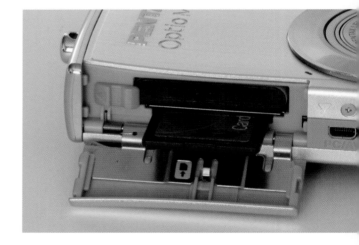

▲ Fig. 1.7
The camera base with the battery compartment open, showing the Li-ion battery and the SD card.

Secure Digital (SD) memory card

This small but vitally important card, located next to the battery, holds all the images you have taken with your camera. It replaces the storage element of film and can be used an almost infinite number of times. SD cards are available in different capacities ranging from 2GB (gigabytes) to 32GB. The memory card receives its electronic images from the image sensor via the drive engine (buffer). The image sensor is

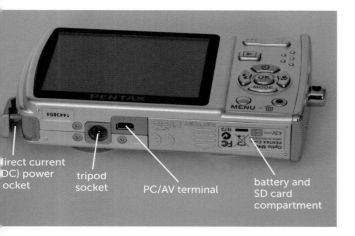

direct current
DC) power
ocket

tripod
socket

PC/AV terminal

battery and
SD card
compartment

▲ Fig. 1.8
The camera base showing three sockets and the closed memory
card and battery compartment.

located at the inside back of the camera, where
the film is located in a film camera. The number of
mega-pixels in the camera's specification indicates
how many million pixels (light receptor units) are
located on the image sensor.

Three sockets

Along the base of the Pentax M40 are three
important sockets.

The first is a tiny PC/AV socket which, via the
appropriate cable, connects the camera to a com-
puter (default setting), or by selecting Pickbridge it
will link to a compatible printer. The same socket
is also used to connect the camera to a television
using the AV cable supplied.

The second is a tripod socket with a universal
thread, allowing any tripod head or ball and socket to
be screwed into it.

Finally, at the end of the camera base is a neatly
protected DC socket, which via a mains transformer
will provide the camera with a low voltage (around
4 volts) direct current. This unit is not supplied with
the camera.

Making a Start

Perhaps surprisingly the information provided above
has covered only a tiny fraction of the informa-
tion provided in the 187-page Pentax Optio M40
Operating manual. To get started, often the best way
is to let the camera look after everything. Simply
switch on the camera, line up the image on the
LCD screen and press the shutter button. You can
then move on to the Programme setting which is
still quite straightforward but gives more choice in
the settings, such as the ISO level, flash control and
possibly a choice of scenes depending on the model
of camera.

THE BRIDGE CAMERA

The typical point-and-shoot digital compact camera
accounts for about 70 per cent of the digital camera
market. However, there is a more technically and
optically advanced group of cameras which help to
fill the gap between the compact and the compact
systems cameras and the much larger digital single-
lens reflex cameras. These are known as the bridge
cameras, such as the Nikon P100, Canon S1000,
Panasonic FZ and the Canon G12. As bridge cameras
are generally larger than compacts they have a
greater surface area with space for more and larger
dials and knobs. This allows useful information to be
accessed both quickly and easily.

The Canon PowerShot G10 (now replaced by G15)
will be covered here, based on my own experience
over some time, including topics such as lens aper-
tures (f numbers), memory cards and image sensors,
which apply to all cameras.

Camera Top

The top of the camera shows obvious differences
from the digital compact discussed earlier.

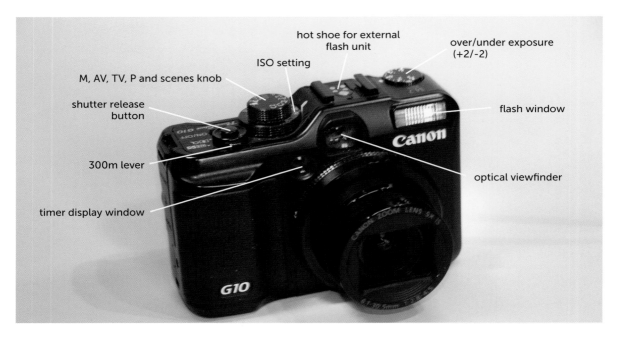

▲ Fig. 1.9
The Canon camera top and front showing the main controls and settings.

Auto settings

Near to the centre is a large dial containing several letters including AUTO, P, Tv, Av and M. These letters are used on all Canon cameras, while the rest of the world seems to follow the more universal lettering system of AUTO PASM. As mentioned earlier, the AUTO setting is used by many people who want a simple point-and-shoot system, allowing the camera to look after almost everything. More useful is the programme (P) mode, where the ISO setting, flash output and exposure adjustment are controlled by the photographer, while the camera takes care of the focusing and exposure.

Aperture and Shutter Priority

Important additions are the priority settings. For aperture priority (A), you select the aperture (and therefore the depth of field), leaving the camera's exposure meter to determine the shutter speed. This is very useful in landscape photography and

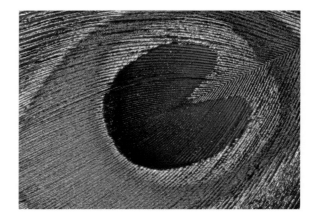

▲ Fig. 1.10
This shot was taken on the wide-angle default setting in the macro mode. The lens was approximately one centimetre above the peacock eye feather producing an image measuring 4×3cm 1/8 sec f8 macro setting. ISO 80

close-up work, where control of the depth of field is important, and in macro work where the lens can be stopped down to f22.

In shutter priority (S) you select the shutter speed, leaving the camera's metering system to come up with the correct aperture and exposure. Shutter priority is useful when photographing moving subjects such as people, cars, birds or animals.

In the manual mode (M) you select the aperture and the shutter speed independently of each other; this is mainly used by very experienced photographers.

Selecting the special scenes (SCN) setting on the dials reveals a list of twenty different scenarios, with the camera's electronics computing the most appropriate settings, as described earlier in this chapter.

Hot shoe significance

The flash hot shoe, quite rare in digital compact cameras, allows a much more powerful flash unit to be attached and controlled by the camera in addition to the built-in flash.

ISO settings

Finally, at the right side is the ISO dial, permitting a quick and easy change of ISO setting without having to scroll through the screen menu. I find this an extremely useful feature when, for example, the exposure for a particular shot is too long for a handheld camera, but by flicking the dial to a higher ISO number, the shutter speed can be halved or even quartered, reducing the exposure from, say, an unusable 1/15 sec to a more useful 1/30 or 1/60 sec.

The Lens

Non-interchangeable lenses

Bridge cameras are more expensive than their digital compact counterparts (but cheaper than SLRs) although the zoom lens is not interchangeable. Zoom lenses range from a modest 3× right up to a jaw-dropping 36× in the Nikon P500. In the end it comes down to personal preference: for some photographers these cameras are too bulky for day-to-day use, particularly when on holiday, while for others they are ideal.

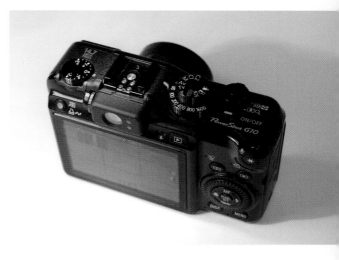

▲ Fig. 1.11
The back of the camera is dominated by a large LCD screen with a range of control knobs and buttons at the far end. Above the screen is the eye-piece for the optical viewfinder. The functions of the buttons to the right are fairly obvious and almost universal, with the exception of the grooved wheel surrounding the 4-switch buttons, which sets the lens aperture.

The larger LCD screen on bridge cameras makes it easier to see and to compose the image, although most have a very efficient eye-level viewfinder, making some of these cameras resemble small SLRs. A few professional photographers use a bridge camera such as the Canon G12 as a back-up for their digital SLRs.

Lens aperture and f numbers

Around the rim of the lens in addition to the zoom range is a second group of figures (ignore the number 1 which is not relevant to the present discussion) representing the 'speed' of the lens (the maximum amount of light the lens will transmit at the extremes of the zoom range). Referred to as the f number of the lens aperture, a small number (for example f2.8) will allow a lot of light through, whereas a large number (such as f22) transmits only a tiny amount of light. For example, lens settings of f1.4 and f2.8 are referred to as 'fast' lenses transmitting a lot of light, while f16 and f22 are 'slow' lenses transmitting very little light.

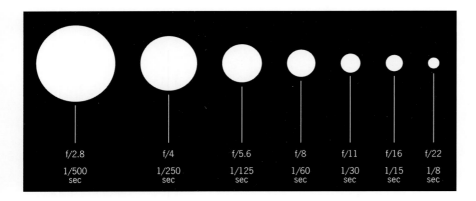

◀ Fig. 1.12
As the lens aperture decreases the f number increases, with each increase in f number halving the amount of light passing through the lens. The f number and shutter speed below produces exactly the same exposure, right across the diagram, so that 1/500sec at f2.8 is the same exposure as 1/8sec at f22.

THE F NUMBER

The f number of the lens is calculated by dividing the diameter of the lens aperture into the focal length of the lens. For example, a standard 50mm focal length lens with a lens diameter of 28mm will have an f number of 50÷28 =1.8.

The lens aperture is controlled by the iris diaphragm which is similar in function to the iris of the human eye. It controls the size of the aperture (pupil) according to the strength of the light entering the eye.

Depth of field

Stopping down the lens (making the lens aperture smaller) increases the depth of field – that is, how much of the photograph is acceptably sharp in front of and behind the point of focus; this is approximately one third of the distance in front of the point of focus and two thirds beyond the point of focus. Depth of field is particularly important in landscape photography where most photographers prefer everything from nearby to infinity to be in sharp focus, and in close-up work where the depth of field is extremely small, often measured in millimetres. The downside is that longer exposures are required, hence the popularity of tripods in landscape and close-up photography.

Memory Cards

An item which is common to all digital cameras, from the humblest point-and-shoot compact to the

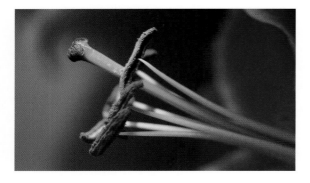

▲ Fig. 1.13
When working close, the depth of field is very shallow. In this image of the lily flower the macro lens was wide open (f2.8) resulting in a shallow depth of field, but highlighting the stamen heads and the stigma at the expense of the petals. 1/250sec f2.8. ISO 100

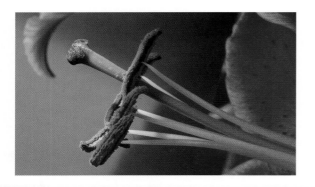

◀ Fig. 1.14
With the lens stopped down to f22 everything including complete stamens, the pistil and the petals of the lily are in sharp focus. 1/4sec f22. ISO 100

mighty digital SLR camera, is the memory card for storage of images. After the photograph has been taken the electronic information from the image sensor is transferred via the camera's buffer into the memory card. There are several sizes and shapes of memory cards available including compact flash (CF), secure digital (SD), IBM Microdrive and the memory stick (MS) card. Higher speed cards work more swiftly, allowing a greater number of pictures to be taken quickly, with less time lag between pressing the shutter button and the information being processed to the memory card (write and re-write speeds).

The SD card is now the most common type of memory card used in cameras today. The exceptions are some of the top of the range SLRs such as Canon and Nikon which use the compact flash (CF) card and the Sony alpha SLRs which stick to the MS card, although there is the option to use CF cards. However, many of the DSLR cameras, particularly the entrance level and mid-priced cameras are now using the ubiquitous SD card.

SDHC cards, although physically the same size as SD cards, are designed differently internally and can only be used with SDHC compatible cameras. There are four main types from Class 2 (C2), C4, C6 and C10, with the latter being the fastest and most expensive.

The development of Transferjet gives a glimpse of the future. Basically it is a wireless technology, developed by Sony, that allows you to transfer images from Transferjet enabled cameras to Transferjet enabled PC, TVs and even other cameras. It does not mean the end of the memory card because a Transferjet Memory Stick is required as an integral part of the process – however, it could mean the end of cables and card readers.

Image Sensor

The lens, diaphragm and shutter have all developed fairly slowly over many years, whereas the image sensor and its associated electronic circuitry has witnessed explosive research and development since the first digital SLR camera, containing a mere 1.3 megapixels, became commercially available in 1991, at the eye-watering price of £15,000.

The majority of DSLR cameras use a CCD (charge-coupled device) or a CMOS (complementary metal oxide semiconductor) image sensor. A typical compact digital camera might well have a 1/2.5in sensor (these imperial units date back to an early system used in the vidicon tubes of TV cameras). Suffice to say, a 1/2.5in sensor measures 5.8 × 4.3mm – smaller than a child's little fingernail. Yet this tiny rectangular sensor can incorporate up to a staggering 15+ million minute pixels (PICture ELements)

SENSOR SIZES

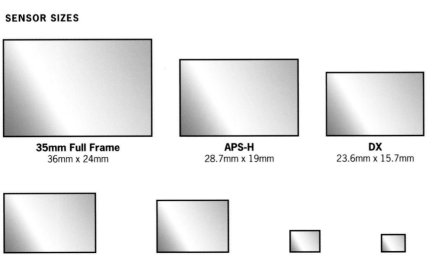

35mm Full Frame
36mm x 24mm

APS-H
28.7mm x 19mm

DX
23.6mm x 15.7mm

APS-C
22.2mm x 14.8mm

Four Thirds Micro
17.3mm x 13mm

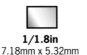

1/1.8in
7.18mm x 5.32mm

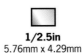

1/2.5in
5.76mm x 4.29mm

◀ **Fig. 1.15**
The image sensor in digital cameras varies in size from the tiny 1/2.5in (5.8×4.3mm) sensor in most digital compacts to the 35mm full frame (36×24mm) sensor in the top quality professional SLR cameras.

▲ Fig. 1.16
The most common type of colour filter arrangement in an image sensor is the Bayer pattern mosaic, where there are twice as many green pixels as there are red and blue.

arranged in a regular mosaic, each one responding to light and generating a tiny electrical charge. Many top of the range DSLRs feature sensors carrying 25+ million pixels, while 645 SLRs boast up to a whopping 40 million pixels.

Much of the quality of the DSLR camera can be attributed to the area of the image sensor, which comes in sizes ranging from 17.3 × 13mm (Micro Four-Thirds system: Olympus and Panasonic), to 22.2 × 14.8mm (APS-C, Canon) to 28.7 × 19mm (APS-H, Canon), to full frame 36 × 24mm (Nikon, Canon).

Image Sensor Design

Looking in more detail at the image sensor, each pixel is covered with a red, green or blue filter (the same three colours which make up the colour TV picture), with twice as many greens to correspond to the human eye's greater sensitivity to green light. The electronic information produced by the sensor is handled by the camera's buffer before being passed on to the memory card.

Image Sensor Sensitivity (ISO settings)

The sensitivity of the image sensor (and film) to light is referred to as its 'speed' or ISO (International Standards Organization) rating. At a low setting (ISO 80) the sensor has reduced sensitivity to light but produces very clear, detailed images, whereas high ISO settings tend to have the opposite effect. Doubling the ISO number doubles the sensor's sensitivity to light – equivalent to one stop on the camera lens or doubling the shutter speed.

A high ISO setting often introduces some noise (non-signal impulses), resulting in general blotchiness and lack of detail. This also shows up as tiny multicoloured speckles, particularly in areas of dark tone. Over the years the ISO speed has increased quite dramatically, with 6,400 and above being quite common. However there is a significant difference in noise levels between that produced by the tiny image sensors on many compact cameras (where any speed above ISO 400–800 is not usually recommended) and the large APS-C and whole frame sensors where useable settings up to ISO 3,200–6,400 are not uncommon. At the extreme ISO 102,400 setting photographs can be taken in almost pitch darkness.

JPEG AND RAW CHARACTERISTICS

To keep the image data (that is, the film size) reasonably small, allowing more images to be stored on the memory card, the information can be compressed by the camera's processor, resulting in a JPEG (Joint Photographic Expert's Group) file. The camera's processor removes areas of similar colour and detail in the image, thereby reducing the file size to a JPEG. JPEGs come in varying degrees of compression, with the least compressed producing the highest quality images. When you select the JPEG setting, the camera will automatically start making a series of adjustments including sharpness, contrast and colour saturation so that the images are ready to be printed with a minimum or no editing.

RAW files, as the name suggests, are completely unmanipulated, having none of the adjustments that are applied to JPEG files. All professionals shoot RAW because RAW files contain a vast amount of information (up to 8× more than some JPEG files), allowing the photographer to manage many characteristics including exposure control, colour balance, saturation contrast, highlight and shadow detail and full control of the white balance (Kelvin temperature). Therefore, the final results can be very impressive indeed.

If you are undecided between shooting JPEGs or RAW many cameras allow you to shoot both simultaneously.

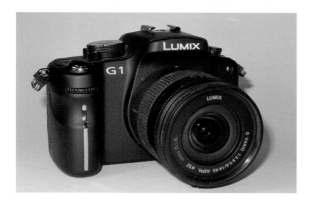

▲ Fig. 1.17
The most obvious feature of the Panasonic Lumix and most CSC cameras is the compactness of the body and lens, and the flat top normally occupied by the pentaprism in SLR cameras. It is also quite light but does have a decent handgrip making it very convenient to use.

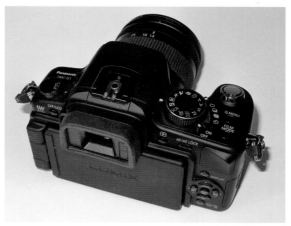

▲ Fig. 1.18
The camera top has the usual array of self-explanatory knobs and buttons with the eye-piece of the electronic viewfinder (EVF) a prominent feature. When the eye is brought up to the viewfinder it transfers the LCD screen image to the viewfinder. The hinged LCD screen is useful when taking high angle and ground level photographs.

COMPACT SYSTEM CAMERAS (CSCS)

These cameras were developed to appeal to photographers who wanted to upgrade from a compact camera but were not too happy with the bulk and weight of a typical SLR camera. They share much of the potential of an SLR but have smaller lighter bodies and smaller interchangeable lenses.

They differ from typical SLRs, having no reflex mirror or pentaprism, and not having a reflex mirror allows the bodies to be narrow from back to front. As the lenses do not have to cover a full frame image sensor, more compact lenses have been developed – the micro four-thirds lens fitting of Panasonic and Olympus being fairly typical, and other manufacturers such as Nikon, Sony, Ricoh, Samsung and Pentax have all developed compact interchangeable-lenses cameras, each with its own lens fitting.

Characteristics
Autofocus
Without using a mirror, autofocus is achieved using a contrast-detect system which, as the name suggests, works well when the image being photographed is quite contrasty. However, the system is quite different and probably not as effective as the advanced phase auto-focus system on DSLRs.

Viewfinder
Having dispensed with the reflex mirror and bulky pentaprism, compact system cameras have either a separate optical viewfinder or an electronic view-finder (EVF). Many photographers still prefer the traditional mirror/pentaprism system, although I am happy with the EVF on my Panasonic G1 camera.

Frames-per-second (fps) shooting rate
Because these cameras lack a moving mirror system, they are better able to photograph fast-moving subjects by shooting up to 10 fps which gives a much better chance of capturing that often elusive image of the fast moving deer or moment of touch-down of a water bird.

Lens crop factor
As compact system cameras have interchangeable lenses we meet for the first time the term 'crop factor'.

Why is the term '35mm equivalent' usually used when referring to these lenses? The edge-perforated 35mm film has been the bed-rock of image capture for more than eighty years and is deeply embedded in a photographer's psyche. This film, exactly 35mm wide, was originally used only in the movie industry, but in 1924 Ernst Leitz, a German optician built the

first compact camera, the Leica, designed to use 35mm film. In the mid 1930s the German manufacturer Ihagee produced the first single-lens reflex (SLR) camera, again using 35mm film and producing negatives or transparencies measuring 36 × 24mm. This frame size, now referred to as 'full frame', has therefore a very long history with all lenses designed to cover the 35mm format. Today high quality and expensive cameras from Nikon, Canon and Sony use full frame image sensors.

If you attach a standard lens of any focal length to an SLR with a smaller than full frame sensor (for example, 17.3 × 13mm in the Panasonic G1, which is half a length and width of a full frame), then you will only be seeing the central portion of the full frame image – the image having been cropped by the sensor. To produce that size of cropped image on a full frame camera (film or digital) you would have to use a more powerful lens. In the Panasonic G1 example the lens would have to be twice as powerful, so that a 100mm lens would require a 200mm lens on a full frame 35mm camera, that is, a crop factor of 2×. Apart from one or two full frame SLRs, the normal crop factor on most DSLRs, based on the size of the image sensor, is around 1.5× or 1.6× – the 35mm equivalent.

Depth of Field

Although the lenses on compact system cameras are much smaller and lighter than their 35mm equivalents, the downside is that the lens apertures tend to be around f3.5–5.6 resulting in a rather deep depth of field. This is not usually a problem for most landscape photographers but it is not ideal in, for example, portraiture, where a shallow depth of field would allow the background to go 'soft' and well out of focus, enhancing the final image. The depth of field problem is exacerbated by the very short focal length (14mm on several CSCs) of the lens at the wide-angle setting.

▶ Fig. 1.19
With the lens removed, it becomes vulnerable to dust particles. Virtually all these cameras have dust prevention devices built in. Note the array of electrical contacts around the lens flange.

COMPARING CSCS WITH SLRS

As compact system cameras represent a relatively new area in camera development, the following comparison between CSCs and typical SLR cameras, based on the specification of over twenty cameras across the range, should prove useful to anyone considering a change of camera.

Basics
There are seven different lens mounts, for example, with only Olympus and Panasonic being interchangeable. The size of the image sensor varies greatly from very small 1/2.5 in, 5.8 × 4.3mm (for example, Sony) up to the quite large four-thirds 17.3 × 13mm (such as Olympus and Panasonic), and yet the number of pixels only ranges from 10 to 15 megabytes (MB). Similarly top ISO speeds do not vary much, with most ranging from 3,200 to 6,400 and only three cameras having top ISO settings of 12,800 or above. All CSCs have live view LCD screens – some fixed and others articulated – and most list an optional viewfinder with the exception of Samsung and Panasonic which sport the latest development in electronic viewfinders (EVF).

Shooting modes and scenes, flash and memory cards
All the cameras have manual and auto focusing, while several have aperture and shutter priority. The number of pre-set scenes varies from 5 (Nikon) up to 21 (Panasonic). Most of the compact system cameras have flash either built in or available as an optional extra. Rather surprisingly, all the cameras use the now ubiquitous SD (or SDHC) memory card, with Sony offering both SD and MS.

Anti-dust and image stability
Dust on the image sensor has always been a problem with interchangeable lens cameras. In SLR cameras the sensor is to some degree protected by the mirror, but in mirror-less compact system cameras there is no protection, with the sensor being visible and exposed as soon as the lens is removed. It is no surprise then, that virtually all the cameras have built-in anti-dust mechanisms.

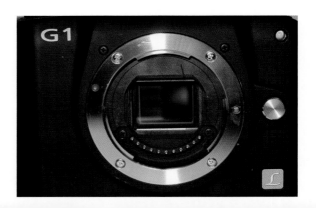

Image stability can be a problem when using the long end of a zoom lens or when photographing in poor light when a rather long shutter speed may be required. Fortunately approximately half the cameras have image stability, which is worth around 2 EV units.

Movie functions and burst rates

Not having a mirror, these cameras are well suited to shooting video, often rivalling DSLRs for final image quality. All the cameras except one of the Ricoh models are equipped to take high definition video images, which reflects the current trend for making short film sequences.

Burst rates vary considerably from camera to camera, from a 2 fps in a Samsung model up to 10 fps in one of the Sony cameras.

Size and weight

Among the main advantages of the CSCs is their small size and light weight compared to a typical DSLR camera. One of the smallest is the Nikon J1 measuring 106 × 61 × 29.8mm (width, height and depth) and weighing just 277g (body only), while the largest is the Panasonic GH2 at 124 × 89.6 × 75.8mm weighing 370g (body only).

A top of the range DSLR such as the Nikon D33s measures 159 × 157 × 87mm and weighs a hefty 1240g whereas a mid-range SLR is considerably smaller and weighs around 600 grams which is still more than double the weight of a typical compact systems camera.

Summing up

As mentioned earlier, the compact systems camera is a relatively new venture in camera lens design, with the emphasis on lightness and compactness, compared with a typical digital SLR camera. Overall build quality is very good, with the image sharpness being extremely high particularly in cameras using one of the larger image sensors. Only a few of the basic functions have been considered here, but there are lots more in the camera menus, which compare favourably with mid-range DSLR cameras.

At the moment the range of lenses for CSCs is fairly limited, but new ones are slowly being developed. Unfortunately, due partly to the fairly large number of lens fittings required and the rather limited sales of the individual models, independent lens manufacturers such as Sigma, Tamron and Tokina are only just beginning to produce any lenses for these cameras.

From my own experience with the Panasonic Lumix G1 it provides considerable sturdiness, range of functions and pin-sharp images at A3 size and above. Many professional photographers are now using compact system cameras as a regular back-up for their main DSLRs and seem to be quite happy with the results..

▲ Fig. 1.20

The Sony alpha is a fairly typical SLR camera containing most of the features you would expect in this type of camera. I used Minolta film cameras for many years so I was delighted when Sony bought out Minolta and continued to use the same lens and body flange, including all the electrical connections.

DIGITAL SINGLE LENS REFLEX (DSLR) CAMERAS

After considering compact, bridge and compact system cameras we have now reached the final group – the single lens reflex (SLR) camera, which is the camera of choice for all professional and many enthusiastic amateurs.

The single lens camera can be traced right back to the early 1800s when the camera lens was used to compose and focus the image on a ground glass screen at the back of the camera. This was then replaced by a photographic plate and the exposure made.

Today the single lens of the SLR camera still provides the light to form and focus the image (via an optical viewfinder) while light on a photoelectric cell eventually produces the exposure required. The term reflex refers to light through the lens being 'turned backwards', reflected upwards from a 45 degree inclined mirror. The light then passes through a heavy glass pentaprism and into the eyepiece of the camera's viewfinder.

As mentioned in the previous section on compact system cameras, the reflex mirror and the

heavy pentaprism have been replaced by a much lighter and more compact electronic viewfinder (EVF), and many photographers are wondering whether the very successful and long life of the SLR might be coming to an end. However, the DSLR still reigns supreme.

The single lens translucent (SLT) camera

At this point we need to consider the Sony Alpha 55, 33, 35 and the latest A77, in which the 45 degree mirror of a typical SLR has been replaced by a semi-translucent mirror resulting in what is now referred to as a single lens translucent (SLT) camera.

The translucent mirror allows around 70 per cent of the light from the camera lens to pass through it onto the image sensor, while 30 per cent is reflected up onto the phase auto-focus sensor (there is no pentaprism). The information is then transmitted to an electronic viewfinder (EVF). These are still being improved but at the moment the level of detail and resolution are still below that of a top quality optical viewfinder. However the fixed mirror allows a much higher frames-per-second rate, while the lack of a pentaprism slightly reduces the bulk and weight of the camera body.

Almost fifty years ago (1964) Canon introduced the Pelix, using a fixed pellicle (skin) semi-translucent mirror. To compensate for the reduced light (a loss of around 60 per cent) reflected from the mirror, the 'speed' of the standard 50mm lens was increased from the standard f1.8 to f1.2. An obvious advantage (as in the current Sony) was that at the moment of exposure the image was clearly visible in the viewfinder. However despite the slightly faster lens the viewfinder image, via a standard penta-prism, was not particularly bright. (The electronic digital revolution was still many years away and the electronic viewfinder was not even a twinkle in the camera designer's eye.) Production of the Canon Pellix cameras ceased around 1970.

COMPARING SLRS WITH CSCS

The information below compares professional and advanced amateur SLR cameras with some of the compact system cameras (CSC).

Size, weight and longevity
Professional DSLR cameras are much bulkier (up to 3x) than a typical CSC camera, and up to 4x heavier. They are very well put together, extremely robust, being well able to cope with the rigours of the everyday life of a professional photographer. Reliability is very important to these photographers and the top of the range cameras are very trustworthy.

Lenses and lens mounts
One of the advantages of compact system cameras is that their lenses are much smaller and lighter than those of a typical DSLR camera, this being one of the great selling points.

In DSLR cameras each manufacturer uses a different fitting to attach the lens to the camera body. Fortunately the Canon, Pentax and Nikon cameras have lens fittings which they used in their 35mm film cameras, allowing many excellent lenses from the past to be used on their current DSLR cameras. Sony felt no need to develop a new lens mount, as several years ago it bought out Minolta and continues to use the Minolta fitting (renamed the Sony lens mount). However, most of the Minolta lenses can be used successfully on the current Sony cameras.

Special lens fittings for Olympus cameras
The odd one out is Olympus which developed a new lens mount known as the four-thirds, used on a fairly extensive range of new lenses. The independent lens makers such as Sigma, Tamron

▼ Fig. 1.21
Most people thought the arrival of the Sony single lens translucent (SLT) camera was a first. However Canon marketed a fixed pellicle camera, the Pellix, in 1964 but without the advantages of electronic amplification available today, and despite increasing the standard lens aperture from f1.8 to f1.2 the viewfinder image was still not very bright. Airborne dust could be a problem as dust prevention devices had not been invented. Production ceased around 1970.

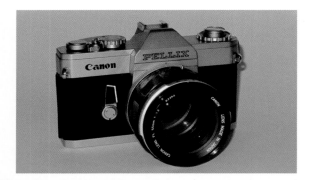

and Tokina manufacture a large range of lenses, but with mounts for only Nikon, Canon and Sony, that is, for the three best selling brands of DSLR camera.

Zoom lenses are extremely popular although many purists still prefer the quality of the fixed-focal-length (monofocal) lens, despite the extra weight of a bag full of quality optics. For high-quality close-up work there is nothing to beat a fixed focal length macro lens – virtually all the close-up images in this book were taken with a 50, 80 or 90mm macro lens.

Crop factor

One of the great advantages of the full frame sensor is that almost any lens with the correct lens mount produced over the years, or any current lens can be used to produce a full frame image without having to take into account the crop factor (see earlier in this chapter). Digital SLR cameras using the APS-C size sensor (23.6 × 15.6mm) or the four-thirds (18 × 13.5mm) have crop factors of 1.5× and 2.0× respectively.

ISO capabilities

The top of the range DSLRs have maximum ISO settings ranging from 1800 to 25,600 with at least one model from each of the main manufacturers boasting a staggering 102,400. The larger image sensors can cope well with high ISO settings before 'noise' becomes a problem, and these high settings can be very useful in low light conditions such as photographing badgers at dusk or capturing the action in a live theatre or disco. Some professional cameras using the highest settings can shoot scenes in almost pitch darkness and still produce a useable image.

Image stabilization

Also known as anti-shake or vibration control, around 60 per cent of compact system cameras and most SLRs have this facility. It can be built into the image sensor (Sony, Pentax, Olympus) and will therefore work with any lens, or it can be lens-based which is said to be slightly more effective (Nikon, Canon). The stabilized lenses are, not surprisingly, more expensive than the non-stabilized ones.

Image-stability technology usually gives the photographer a two-stop advantage, equivalent to lengthening the shutter speed from, say, 1/30thsec to 1/8thsec without any evidence of camera shake in the final image.

Burst rates: frames per second (fps)

High burst rates allow the professional photographer to shoot at 5–10 fps, while a basic DSLR camera can typically offer 3–5 fps. It is worth noting that the Sony translucent mirror cameras with a fixed mirror can shoot at 12 fps, which is likely to increase as the technology develops. A high burst rate should be backed up by a good buffer memory, where the images are processed prior to being transferred to the memory card. This is extremely useful for wildlife and sports photographers.

Anti-dust mechanisms

While digital compact cameras with non-interchangeable lenses do not suffer from dust problems on the sensor, with DSLR cameras and compact system cameras, once you remove the lens, atmospheric dust particles can become a problem. Also, the mirror flapping up and down with each exposure continually stirs up dust in the camera body. In film cameras a new piece of film is used for each exposure, whereas the fixed-image sensor has to withstand hundreds or even thousands of potentially dusty exposures. Most cameras have a built-in dust-removal system which cleans the sensor, often by incorporating an anti-static coating on the sensor's filter, coupled to vibration of the sensor. The old method of using a blower often tends to stir up existing dust particles and is not recommended.

Additional DSLR features

The list of features available on various cameras is impressive and includes:

- multi-stage heightened dynamic range (HRD);
- dynamic range optimizer;
- eye-start autofocus;
- wireless flash capability;
- digital filters to add black and white, sepia and 'soft' effects;
- RAW and JPEG processing within the camera (control of various parameters);
- C1, C2 and C3 custom shooting modes, each of which allows you to register specific settings that can be recalled at the touch of a button;
- and up to 10× magnification for accurate manual focusing – ideal for close-up still-life work.
- Other features include:
- HD movie mode with up to 60 fps with exposure as short as 1/4000sec;
- selected crop modes;
- sweep panoramas;
- and full control of the white balance (Kelvin scale).

Obviously not all of these features are available on every camera, making it well worth checking to see whether the features you require are included on the camera's shortlist.

Summing up

The DSLR camera is indeed an extremely sophisticated piece of optical and electronic equipment with many of the working features of a mini computer. It is only by having high volume world-wide sales that prices have been kept at a fairly acceptable level.

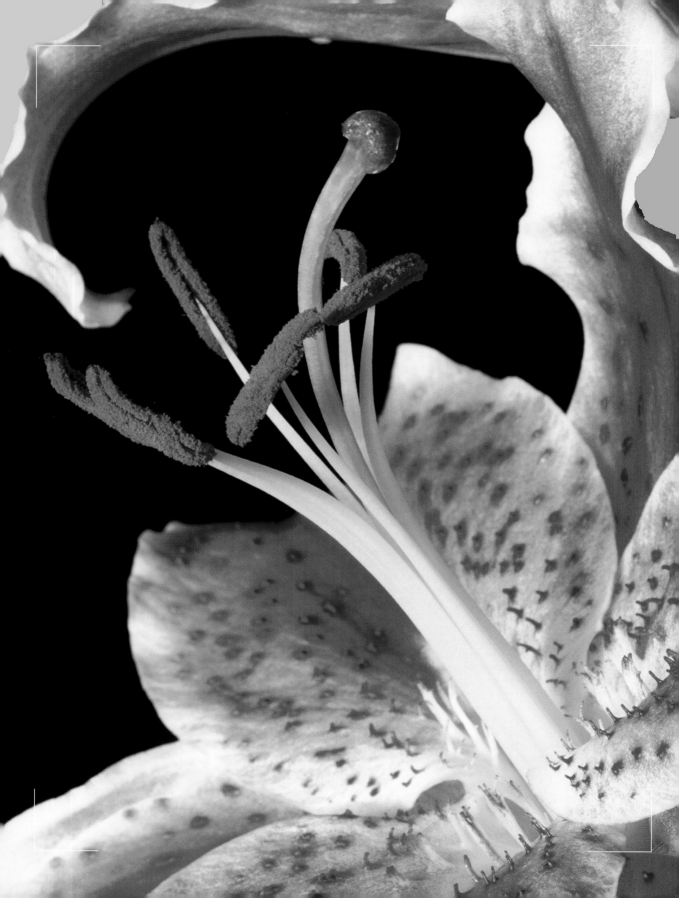

Chapter 2
Equipment and Methods

In this chapter we will be considering the range of accessories available to photograph the natural world, concentrating on equipment which is particularly useful in close-up work.

CLOSE-UP WORK

With a Digital Compact Camera

The Canon PowerShot G10 compact camera, like many digital compacts, will focus down to around 30cm (12in) without altering any of the settings, resulting in a coverage of approximately A3 – 40×30cm (16×12in). Using the macro setting (a flower-shaped icon) the lens will focus right down to approximately 1cm giving a coverage of 3.9×3cm (1.53×1.2in), about the size of a large postage stamp. However this only works when the lens is on the default wide-angle setting.

Using the zoom in the macro mode and at its maximum optical extension (5× magnification) results in a coverage of 9×7cm (3.5×2.7in) – about the size of a credit card, but at a useful working distance of 30cm (12in).

The Pentax M40 point-and-shoot compact camera also has two macro settings, which will deliver good quality close-ups right down to around 1cm from the subject.

▲ Fig. 2.1
This shot of the small tulip was taken on the Canon G10 compact camera using the full optical zoom (5x) setting in the macro mode. The working distance was 30cm producing an image approximately the size of a credit card. Tripod-mounted camera. 1/6 f8. ISO 80

◀ Fig. 2.0
Tiger lily. 2+ close-up lens 1/4sec f11. ISO 80

▲ Fig. 2.3
A selection of close-up lenses – usually single elements, but the better quality ones are two-element achromatic doublets.

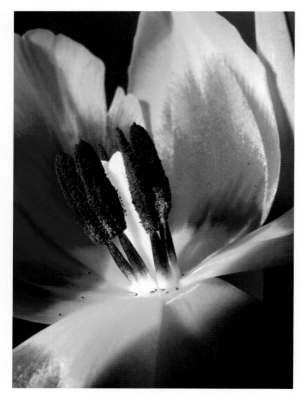

▲ Fig. 2.2
Using the wide-angle default setting in the macro mode the camera would focus down to approximately 1cm resulting in an image about the size of a large Christmas postage stamp. But due to the close proximity of the lens barrel to the stamens and petals, effective lighting using an LED torch proved rather difficult resulting in the dark shadow at the bottom right side of the image. Tripod-mounted camera. 1/4 f8. ISO 80

With a Digital SLR Camera

Close-up lenses are the first step in getting closer to your subject and still keeping it in focus These lenses come in strengths of +1, +2, +3 etc dioptres (a dioptre is the reciprocal of the focal length in metres); these measures are basically the same as +1, +2D etc spectacle lenses used for reading.

The majority of these close-up lenses are uncorrected single-element lenses which produce reasonably satisfactory results when the camera lens is stopped right down so that only the central portion of the close-up lens is being used. Manufacturers including Nikon, Sigma and Canon supply two-element achromatic doublets as close-up lenses for their standard and zoom lenses, and these are well worth considering.

Second-hand close-up lenses are readily avail-able at classic camera fairs where one can be bought for little more than the price of a sandwich and a coffee.

As they are threaded and screw directly onto the front of the camera lens, they are extremely easy to use. If your close-up lens is not the same diameter as the camera lens (and it rarely is!) all is not lost, as stepping rings are readily available which either step-up to take your oversize close-up lens (such as 49–55) or step-down to accommodate a rather smaller close-up lens (49–46) but with the possibility of some vignetting around the edges of the image.

With a Standard Prime Lens

A standard prime lens from, for example, an old SLR film camera, can be reversed onto the camera lens, allowing great close-ups to be taken. As a general rule the shorter the focal length of the extra lens, the closer you can get to your subject. The magnifica-tion is calculated by dividing the focal length of the prime lens by that of the lens reversed onto it. For example, a 28mm wide-angle lens reversed onto a standard 50mm camera lens will produce a magnification of 50÷28=1.8× life-size.

▲ Fig. 2.4
An old Olympus 50mm f1.8 lens used as a close-up lens and reversed onto a 75–300mm telephoto lens set at 100mm resulting in 100÷50 = 2× magnification.

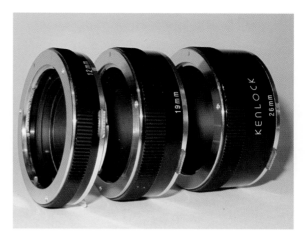

▲ Fig. 2.5
Using extension tubes (singly or in any combination) is an excellent way of getting closer to the subject while still keeping it in sharp focus.

Homemade male-to-male adapter ring

To attach the reversed lens to the camera lens will require a male-to-male coupling ring with a male filter thread on both sides. You can make one by removing the glass from the two filters (preferably the same diameter) and gluing them together face-to-face.

GETTING CLOSER USING THE STANDARD LENS

Extension Tubes and Bellows Units

Using an extension tube is a very simple way of moving the camera lens further away from the image sensor and closer to the subject being photographed, while keeping the subject in sharp focus.

An extension tube consists of a length of metal tubing with the camera body flange at one end and the lens flange at the other end. It usually comes in a set of three (for example, 12mm, 20mm, 36mm) and can be used either separately or in any combination. The most expensive units are coupled for the exposure and automatic focusing. The three tubes used together can achieve a 1:1 magnification, or greater.

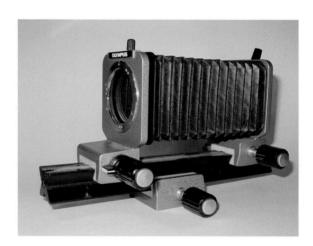

▲ Fig. 2.6
A bellows unit is another way of getting closer to the subject. Some have electrical connections between the lens and the camera body, but the less expensive ones do not.

A bellows is a flexible, variable length extension unit with end flanges for the camera body and the lens. It sits on a rack and pinion base providing smooth focusing from around 10mm to 200mm, depending on the model. The less expensive units have no linkage between the lens and the camera body, while those manufactured by Novoflex include automatic diaphragm operation and open aperture metering but they are expensive.

Although extension tubes and bellows units are extremely useful accessories, there are a couple of disadvantages. Due to the increased distance between the lens and camera body neither unit will allow the lens to focus at infinity. The other drawback is the problem of light.

The Problem of Light

As the lens is moved further away from the camera body the light level reaching the image sensor is greatly reduced, based on the inverse-square law of illumination. This states that when the distance between the lens and the camera sensor is doubled the level of illumination is not halved as might be expected, but squared – that is, one quarter. Similarly with 4× extension the light level at the image sensor will fall to 1/16 of its original value and would require stronger lighting, a longer exposure, flash lighting if subject movement were involved, or an increase in the ISO setting.

The following table shows the exposure increase for close-up work. Beyond 1/5× life-size the exposure increases dramatically with 10× magnification requiring a massive increase of 121.00×. This would be equivalent to opening up the lens aperture from f16 to f1.4, or increasing the exposure from ⅟₂₅ to ½sec.

EXPOSURE INCREASE FOR CLOSE-UP WORK

Magnification × Life-Size	Exposure Increase
1/20×	1.10×
1/5×	1.44×
1/2×	2.25×
life-size	4.00×
2×	9.00×
4×	25.00×
10×	121.00×

Effective Lens f Numbers in Close-Up Work

Another way of thinking about the fall-off in light level during close-up work is to consider the changes in the effective f numbers. The f numbers on a lens are correct only when the lens is focused at infinity, and as the lens is moved further away from the image sensor in close-up work, the level of illumination decreases in accordance with the Inverse Square Law, discussed above.

These longer than normal distances can be allowed for by applying the following simple formula:

Effective f number =
Marked f number × (Magnification +1).

Thus in close-up work where the magnification might be, for example, 3× a marked (or set) f number of f8 becomes an effective or functional f number of 8× (3+1) =32.

This illustrates quite clearly why such high light levels are necessary when photographing living material in close-up.

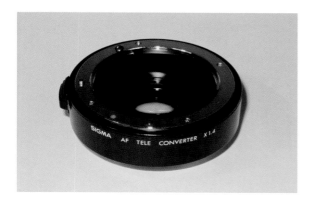

▲ Fig. 2.7
A 1.4x teleconverter is a fairly inexpensive way of converting, for example, a 200mm lens into a 280mm lens but at a loss of one f stop of light in the process.

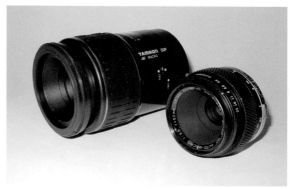

▲ Fig. 2.8
Two macro lenses which have produced excellent results over many years are the 50mm f3.5 Olympus Zuike and the 90mm f2.8 Tamron. Both have the outer lens element sunk deep into the lens barrel reducing the need for a lens hood.

Teleconverters in Close-Up Work

A teleconverter is an extension tube containing several lenses, and fits between the lens and the camera body. It increases the focal length of the lens without affecting the close-focusing distance, or the ability of the lens to focus at infinity. They come in 1.4x and 2x strengths, with the former resulting in a lens aperture loss of one stop, and the latter in a loss of two stops – converting, for example, an f11 lens setting to f22. Using a 2x teleconverter to convert a 210mm telephoto lens into a 420mm lens is obviously significantly cheaper than buying a 420mm lens. Electrical connections between the lens and camera body are maintained by the converter. These converters are very popular with both amateur and professional photographers.

Macro Lenses

Having tried extension tubes, reversed lenses and the rest, many photographers who are keen to produce 'better' close-up photographs often feel that the only way forward is to buy an expensive macro lens. A key feature of all macro lenses is that they will focus from infinity right down to life-size without the intervention of tubes, close-up lenses or any other attachments. Another important quality is that at life size the images are bitingly sharp.

▼ Fig. 2.9
Flowering cherry leaves in late spring, photographed using the 120mm f4 Pentax macro lens. 1/60 f16. ISO 100

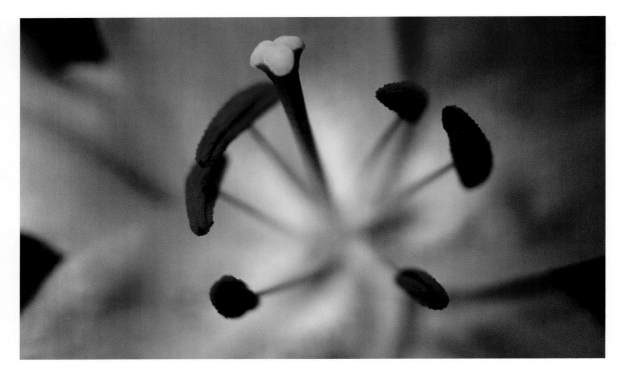

▲ Fig. 2.10
A lily flower photographed using a 90mm macro lens set at f2.8,
producing a very shallow depth of field. 1/250 f2.8. ISO 100

Photographers often buy a 50mm macro lens
instead of the standard 50mm lens. For many years
I used a 50mm f3.5 Olympus macro lens, and
although it only focused down to half life-size, I
was never disappointed with the results. A 90mm
f2.8 Tamron macro lens is now almost permanently
attached to my Sony digital SLR camera.

SLR manufacturers including Nikon, Canon and
Sony and the independents Sigma and Tamron
produce all macro lenses ranging from 45mm to
200mm focal lengths but they are all pricey (usually
around three times more expensive) compared to
the non-macro equivalent. The Canon MP-E 65mm
f2.8 macro lens can focus straight down to a stag-
gering 5× life-size, which is quite an achievement, if
you can afford it.

Depth of Field

The part of the area in front of and directly behind
the subject being focused on, which is acceptably
sharp when examined from the normal viewing
distance, is the depth of field. Spatially the generally
accepted division is one-third in front and two-
thirds behind the subject, with the overall depth of
field varying greatly with the distance of the subject
from the camera and the lens aperture. A typical
landscape photograph could have a depth of field
spanning hundreds of metres, whereas in a portrait
the photographer might reduce the sharp zone to
less than half a metre and throw the background out
of focus.

At macro level the depth of field becomes very
shallow indeed. Using a 50mm macro lens at f4 and
focused at 25cm (10in) it is a mere 9.5mm (0.37in).
If the lens is then focused really close to produce
5× magnification, the depth of field is reduced to
a microscopic 0.07mm (0.03in) and even when
stopped down to f16 it is still only 0.23mm (0.01in).
Critical focusing is therefore essential.

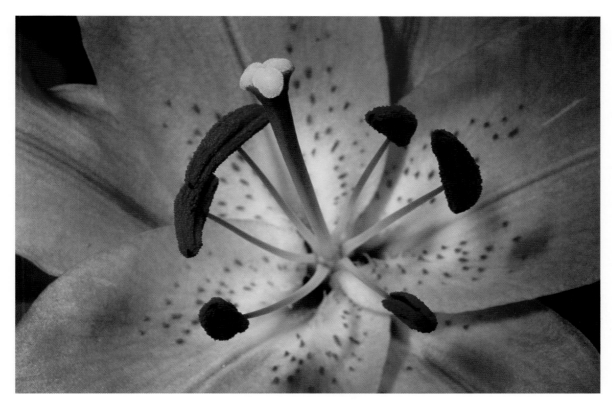

▲ Fig. 2.11
The same set-up with the lens stopped down to f22 bringing the petals, stamens and pistil into sharp focus. In both images the camera was focused on the stigma at the top of the pistil. 1/4 f22. ISO 100

Stopping down the lens aperture (that is, increasing the f number) will extend the depth of field until a point is reached when diffraction of light through the lens will begin to degrade the image.

THE ULTIMATE IN EXTREME CLOSE-UPS

If you want to produce a highly magnified image of a water flea, details of a butterfly's antenna, or a cluster of finely sculptured pollen grains, the ultimate magnifier is the compound microscope. With it any competent photographer can take photographs not only of static material, but also of living, moving creatures. To the casual observer, the microscope probably looks quite complicated, but basically it is nothing more than a powerful magnifier with illumination and a focusing system built in.

Total Magnifying Power

The final magnification is the product of the magnifying powers of the objective lens and the eyepiece lens. The former is the main magnifier and is available from 2.5× to 100×, while the eyepiece, which is much simpler optically, is available in three popular magnifications: 5×, 10×, and 16×.

For nature photographers the lower magnifications, such as 2.5× to 40× objectives and 5× and 10× eyepieces, are most useful, giving final magnifications ranging from 12.5× to 400×.

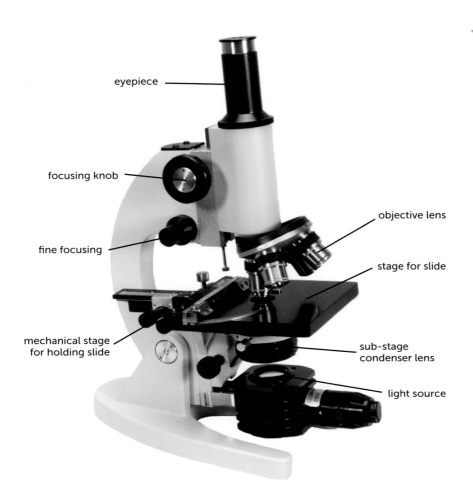

eyepiece

focusing knob

fine focusing

mechanical stage
for holding slide

objective lens

stage for slide

sub-stage
condenser lens

light source

◀ Fig. 2.12
Fig. 2.12
The Westbury SP14
microscope includes
everything required to
produce high quality images
of microscopically small
creatures and plants, at
magnifications ranging from
10× to 1250×.

Methods of Lighting

On many microscopes the illumination is provided
by daylight reflected from an adjustable substage
mirror up through the optics into the eye. If daylight
is too weak or unavailable, an LED lamp can be
used as a separate unit or built into the base of the
microscope, the latter making the mirror redundant.
A further refinement is a substage condenser lens
(Abbe condenser) to concentrate the light onto
the specimen. Finally, a substage iris diaphragm
remotely controls the aperture of the objective lens
(and hence the depth of field) and the overall light
intensity.

In comparison to cameras and lenses, micro-
scopes are not expensive. Anyone seriously inter-
ested in photomicrography can invest in a useful
microscope with three objectives, two eyepieces, an
Abbe condenser and built-in illumination.

Inexpensive, Lightweight, Handheld Microscope

The Trekker T35 is a handheld microscope suf-
ficiently small to fit into the palm of your hand. It
has an objective lens (3.5× magnification) and a
10× eyepiece giving a fixed overall magnification of
35×. There is a small LED lamp underneath and a
spacious stage on top to accommodate the subject
being examined. It can easily be attached to any

SLR body using a pair of simple adapter rings, and produces remarkably good results. The Trekker T35 is available from GX Optical.

PHOTOGRAPHY THROUGH A MICROSCOPE

Taking photographs through a microscope is quite easy using an SLR camera, and the only additional equipment required is a simple tube and a T2 adapter to link the camera body (minus the lens) to the microscope. Some microscope heads have an extra vertical tube specifically for photographic work, enabling you to use the microscope in the normal way and switch to the camera to take photographs.

Lighting
Supported by flash
Although any form of tungsten, halogen or LED lighting can be used, the illumination will not be sufficient to arrest the movement of living organisms. My technique is to use the built-in lighting to examine and focus the material, but use flash to make the exposure. You can do this by positioning a small half-silvered mirror (resembles smoked glass) at 45 degrees, just above the light source with the flash unit next to it pointing horizontally. Much of the flash output is lost through and around the mirror but sufficient is reflected up into the microscope to produce well-exposed images and freeze the movement of living organisms.

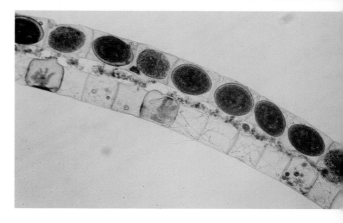

▲ Fig. 2.14
Spirogyra is a filamentous green alga common in ponds and resembling green cotton wool. The image shows the reproductive process where the contents of the cells from one filament have moved through a short canal to fuse with the cell contents of the adjacent filament. The zygospores produced eventually grow into new filaments. ⅟₁₅ magnification 30×. ISO 100

Top lighting for a different effect
Flash units can also be positioned just above the stage to provide low-angle incident lighting but, as the sub-stage iris diaphragm is not in use, the objective lens will be working fully 'open' with a very shallow depth of field. If your camera has TTL flash metering, exposure problems will be minimal. The photomicrography of pond-life is discussed in Chapter 4, 'Restless in Water'.

Photography through a Microscope using a Compact Point-and-Shoot Camera
Although most enthusiasts, photographing microscopic animals and plants through a microscope will use a digital SLR camera, the basic compact camera has not been forgotten. Brunel Microscopes market their Unilink and Linkarm adapters which will link most compact cameras to the microscope eye-tube. Details and technical support are available from Brunel Microscopes (*see* Appendix).

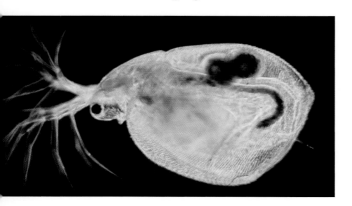

◀ Fig. 2.13
The tiny pinhead-sized water flea Daphnia can be found in ponds but is also very common in cattle drinking troughs. In this living specimen note the large eye just below the branched antennae, the two developing eggs and the long curved digestive tract. Flash magnification 30×. ISO 50

TELEPHOTO LENSES FOR BIRDS-IN-FLIGHT PHOTOGRAPHY

Bird flight photography calls for a quite different type of optic – the long range telephoto lens (from the Greek *tele* – far off, and *phös/phötos* – light). A telephoto lens (also referred to as a long lens or zoom lens) with a suggested range of around 70–300mm or the slightly more compact 100–200mm focal length is recommended. Bear in mind that unless you are using a full frame SLR camera, you will have a crop factor of around 1.5× or 2×, giving the 100–200mm lens a 35mm equivalent of 150–300mm or 200–400mm zoom range.

▲ Fig. 2.15
A zoom lens with a range of 70–300mm focal length and an aperture of f4–f55.6 has proved extremely useful when photographing birds in flight as well as actively moving small mammals such as squirrels and dogs. The apertures are modest and so is the price.

Independent lens manufacturers such as Sigma and Tamron market 70–300mm telephoto lenses with modest apertures of f4.0 to f5.6 but at a reasonable price. A little more expensive, both Nikon and Canon also manufacture 70–300mm f4.5–f5.6. For a 'faster' lens, which would be useful in dull weather to help freeze the birds in full flight (by using a shorter shutter speed) Sigma and Tamron produce 70–200mm f2.8 lenses at a reasonable price, whereas at Nikon and Canon the equivalent lenses are more expensive. It is well worth noting that these f2.8 lenses maintain this aperture throughout their zoom range, which is why the glass elements are so large and heavy and the lenses so expensive.

ACHIEVING RIGIDITY AND STABILITY

Vibration and instability are the two villains of any photography, but especially in close-ups where the slightest movement of the camera or subject during the exposure can result in a blurred image. Even the vibration caused by a free-standing electric fan heater or passing traffic can soften the image, which is one reason why electron microscopes are often housed in deep vibration-free basements. If you have ever seen photographs of the huge camera rigs and gantries used by Oxford Scientific Films or the BBC Natural History unit in Bristol, you will appreciate just how important rigidity is in the quest for super-sharp images.

Camera Supports

To view the LCD screen on the back of the camera we tend to hold the camera at almost arm's length. This unstable cantilever-like position can result in camera shake, particularly at the telephoto end of the zoom range, and fortunately, manufacturers are beginning to incorporate image stability technology into their camera bodies or lenses. Self-help measures such as a beanbag placed on the car roof, a wound-down car window or on a wall, or a small camera-clamp table tripod, or a bendy-legged Gorillapod are all worth having as part of your gear.

Monopods and Tripods

Monopods give extra stability to a handheld camera when photographing birds in flight or animals on the move (see Chapter 8). For serious photographic work it is worth investing in a tripod. It is useful to have two tripods. One of mine is a large heavy Benbo, which can stand in 30cm (12in) of water without damaging the sliding legs. This can also be used on the kitchen floor when doing indoor close-up work. The other is a smaller lighter Velbon for more distant outdoor work. Both are made of steel

▲ Fig. 2.16
My main camera support workhorse is a large Benbo (bent-bolt) tripod in which the black legs slide outside the polished main legs. This allows it to be used in water up to 30cm (12in) deep without any leakage or damage.

and are therefore quite heavy, but this gives them plenty of inertia, helping to keep the camera steady. Lightweight carbon fibre or aluminium tripods are useful when you have to cover long distances on foot, but steel is best as a basis for camera stability. Hanging a camera bag or a bag of pebbles or stones from underneath the tripod centre column adds extra stability to the tripod and camera.

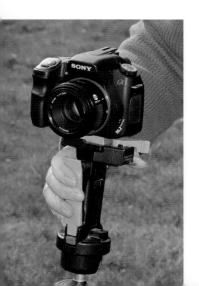

◀ Fig. 2.17
In the grip action ball head, squeezing the hand grip loosens the ball and socket allowing repositioning of the camera. As the tension in the ball and socket can be adjusted, any size or weight of camera can be accommodated.

A ball and socket head is more compact and more useful than a pan-and-tilt unit. If you have to hand-hold the camera, try to ensure the exposure is no longer than the reciprocal of the focal length of the lens (that is, 1÷focal length). For example, if your lens has a 6× zoom, at full zoom (approximately 300mm) the exposure should be no longer than 1/300.

Shutter-Release Systems

All digital cameras other than point-and-shoot compacts have a socket to take a plug and lead, allowing the shutter to be released at the press of a button. The leads are available in various lengths and all have a two-stage release button (focus and shutter release). The more sophisticated units are wireless and infra-red triggered, while some include a time lapse facility, allowing you to take, for example, a series of photographs, at set intervals, of an opening flower or a changing landscape.

DEALING WITH THE LIGHT

Lens Hoods

Lens hoods are essential for keeping out unwanted light. Only the light forming the image on the image sensor at the back of the camera should be allowed through the lens. Extra peripheral light, if not absorbed by the interior of the blackened lens barrel, can result in lens flare, causing softening or complete wash-out of the image.

Ideally a lens hood aperture should have the same proportions as the image sensor (that is, rectangular). The most efficient lens hood is a bellows, which can be adjusted to accommodate different focal lengths of lenses. Many experienced amateurs and most professional photographers use this type of lens hood, as do all professional movie makers. The once popular rectangular and square lens hoods used on film cameras (35mm and 6×6cm models) seem to have disappeared from the market place.

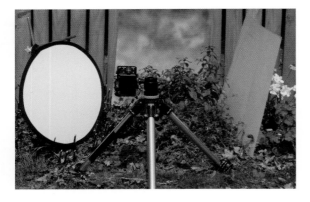

▲ Fig. 2.18
A white reflector was used to lighten the dark side of the fuchsia flowers, while the board on the right was merely a windbreak. The eye-catching fence was concealed by a background board.

For most photographers a round, often flex-ible lens hood attached to the lens has to suffice. The deeper the lens hood the more effective it is, but caution is called for when using a wide-angle lens or the wide-angle setting on a telephoto lens. Some wide-angle lenses include a petal lens hood, where the four corners have been cut away to allow light to reach the corners of the image and prevent vignetting.

Fortunately in most digital compact cameras the lenses are well sunken into the lens barrel, reducing the need for a separate lens hood.

Reflectors and Diffusers

Reflectors are used to reflect light (daylight or artificial) into dark shadowy areas. A plain white surface is a fairly weak reflector delivering very soft diffused lighting, while at the other extreme a mirror is a powerful reflector bouncing back all the light falling on it.

You can collect small reflectors from odd sources, including lids from Chinese takeaway containers (white and silver), circular cake baseboards (crinkled silver and gold), and bathroom cabinet mirrors. All are ideal for close-up work. You can, of course, buy pro-fessionally made white, silver and gold reflectors from Lastolite – a useful one is 50cm (20in) in diameter which collapses to a very portable 15cm (6in).

Diffusers are placed between the light source and the subject to soften the light falling on the subject. In close-up work, when the sunlight is bright and harsh a piece of translucent plastic sheet can be held between the sun and the subject to soften the light and reduce the contrast. Flash lighting can produce hard-edged shadows, and a handkerchief tied over the flash head will soften the light considerably while also absorbing at least one stop (half the light) in the process.

A popular method of softening flash lighting is to use a flash brolly or a soft box, accessories which are widely used by portrait photographers. A very useful diffuser for natural history photography is a small, lightweight, white fabric umbrella which can easily be packed away and taken into the countryside or onto the seashore.

Filters

A filter placed in front of the camera lens will alter the light passing through it. Filters should be looked after with the same care you give to your lenses.

Although much can now be done as part of the post-image editing, many photographers still prefer to sort out any colour issues before making the exposure. A polarizing filter will cut out surface reflections and increase the colour saturation of grass and blue sky, while an amber warm-up filter (81A and 81C) will brighten up a cold scene. You can use a neutral-density graduated filter to darken an overlit sky, and an ultraviolet (UV) filter at high

▼ Fig. 2.19
A selection of filters including coloured, graduated coloured and neutral density, polarizer, warming up and ultra-violet. Although much can be altered using the computer, many photographers still prefer to sort out their colour issues prior to making the exposure.

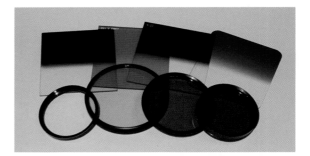

altitude to reduce the ultraviolet light so prevalent in mountainous regions.

Digital compact cameras are not designed to take filters, but it is quite easy to hold a filter in front of the lens, as they are quite large (particularly square Cokins). On SLR cameras circular filters screw into the lens barrel.

Lighting Equipment

The problem of lighting for close-up work is that you cannot get sufficient of it. The main reason is the inverse-square law of illumination, which states that as the lens is moved further away from the sensor surface (as in close-up work), the intensity of the illumination decreases, not in direct proportion to the distance but to the square of the distance. The main types of illumination used in close-up work are daylight, filament lamps, halogen spotlights, light emitting diodes (LEDs) and electronic flash.

Tungsten filament lamps are too hot and too yellow (too low a Kelvin temperature) and are being phased out (a green issue), whereas halogen spotlights are focused, bright and cheap to buy.

LED Reading Lamps and Hand-Torches

LED lighting has a colour temperature similar to daylight and emits virtually no heat. An anglepoise-type lamp containing 55 LEDs is particularly useful, and for close-up static subjects a pair of LED hand-torches supported on laboratory stands and clamps can be set up in exactly the best positions.

Flash Lighting

If you want to photograph fish or frogs moving about in an aquarium, or tiny seeds being flung out of a red campion capsule, flash lighting is the best way to produce sufficient light to obtain really sharp images.

Physically small flashguns can be positioned really close to the subject because they remain quite cold, while their high output allows the use of small lens apertures with a welcome increase in the depth of field. The very short flash duration of at

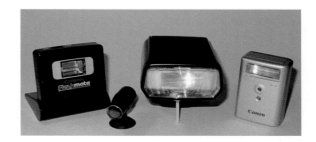

▲ Fig. 2.20
Three small flash units useful for close-up work, which can be used with digital compact point-and-shoot cameras. The Cobra Flashmate (left) is a supplementary flash, triggered by the camera's flash. No flash metering – the light level is controlled by moving the flashgun nearer or further away from the subject. The Canon HF-DC1 (right) is more advanced, has three power settings and is triggered by the camera's flash; the small left of centre unit is simply a flash slave trigger which can be connected, using a PC cord, to any flash unit and is triggered by another flash. Finally, the central flashgun is a conventional unit (GN 22 at ISO 100) which, when camera mounted or used remotely with a TTL cord, will produce accurate flash exposures.

least 1/1,000sec is sufficient to freeze the movement of most small creatures while the daylight colour temperature is a welcome bonus.

Several small but quite powerful flash guns can be linked to the camera through TTL (Through The Lens) leads, with the camera's flash metering system determining the exposures, although they can be bracketed when dealing with tricky subjects. Without TTL leads, the flash can be triggered using a simple PC lead and switch, although exposure determination would require a series of test exposures, but this is not a problem as we have immediate access to the images via the camera's LCD screen. Some flash guns can now be fired wirelessly, with full TTL metering, allowing one or more units to be placed in the best possible positions, without the intrusion of flash leads around the set-up.

The only disadvantage of using flash is that you cannot predict with any certainty the final result of the lighting arrangement. Handheld LED torches can be used to find the best lighting set-up, later replacing them with the flash guns. When working in a tight space, a ring-flash attached to the lens barrel can be useful, providing shadowless, if somewhat flat, lighting.

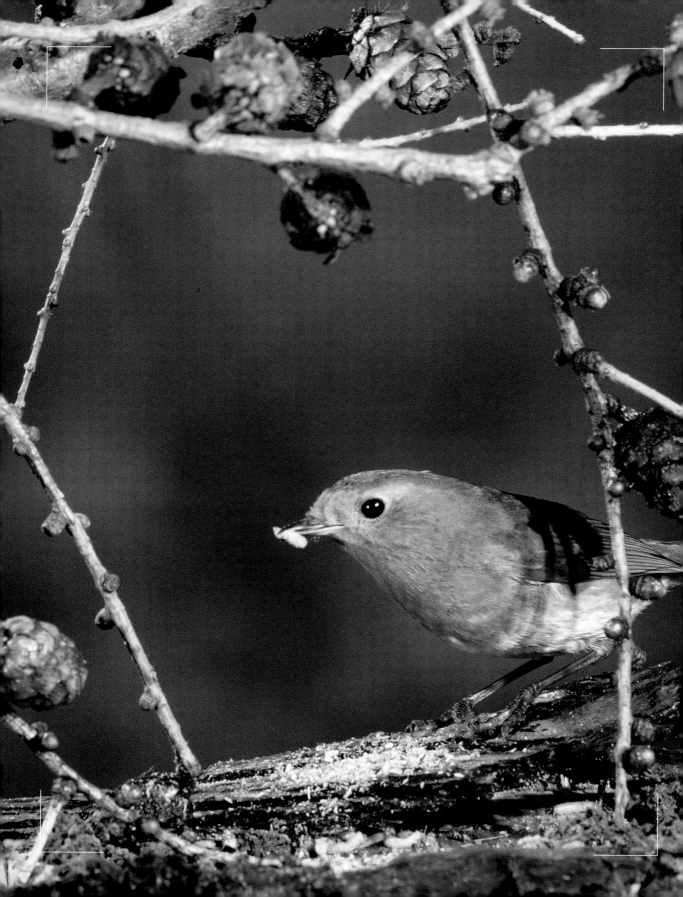

Chapter 3
Composition

▲ Fig. 3.1
These shots were taken to show the effect of different focal lengths on the perspective. For each shot the camera was moved to keep the daffodils the same size and position in the frame. (a) 28mm (b) 50mm – normal perspective and (c) 300mm 1/125sec f11. ISO 100

Most people can recognize a good or pleasing photograph without being able to say precisely what makes it good or pleasing. It may be because of the subject in the photograph or, less tangibly, because the composition is satisfying. For some, composition is instinctive and second nature, but for others

◄ Fig. 3.0
Well-framed robin with grub. Multiple flash f11. ISO 100

it has to be explained and thought about before the concept becomes understood.

Composition refers to the way we arrange the various elements of the subject to form a satisfactory whole. Obviously we cannot arrange the various elements in a landscape in the same way as we arrange the pieces on a chessboard. However, it is possible to change the position of the camera, holding it near ground level when the foreground will be enhanced at the expense of the middle distance, or using a high camera angle brings the middle distance to the fore. The greatest change to the relative positions of the various elements in a landscape however can be produced by moving the

camera to the left or the right of its original position, allowing objects in the foreground (and to a lesser degree in the middle distance) to be repositioned in respect to the background, which can easily alter the overall composition.

Another method of altering the composition is to change the focal length of the lens. A zoom lens set at around 50–60mm focal length will produce an image very similar to that seen by the human eye. Setting the lens at its wide-angle position will significantly widen the angle of view, pushing distant objects far away from their natural position, while using a long focal length lens will compress everything from nearby objects to the distant horizon, again radically altering the overall feeling and composition.

Although the above discussion applies specifically to outdoor work, the points mentioned are relevant to close-up work. Fortunately you have much more control over the arrangement of the material and the lighting, making good composition easier to achieve in many cases. The final image might be dramatic, moody, pastoral or even jarring, but if you are content with the arrangement and treatment of the various elements, then for you the composition is satisfactory. Composition can be a very personal concept, but for your work to be appreciated by a wider audience then to some degree you should compose the image within guidelines that are universally accepted.

Analyse the paintings of Rembrandt, Turner and Monet, or the photographs of Karsh, Cartier-Bresson and Lichfield, or the wildlife images of Stephen Dalton, John Shaw and Andy Rouse, and you will discover that they have all been very carefully composed, often along well-established lines, which will be discussed later. The 'rules' of composition are not meant to be a straight jacket suppressing your own creativity, but a guide as you develop your own personal style. A successful picture is a combination of technical skill that can be mastered and your aesthetic awareness that puts your own individual stamp on the image.

ELEMENTS OF COMPOSITION

Picture Shape and Boundaries

Generally speaking, the horizontal or landscape format is, as the name suggests, appropriate for many landscapes or any picture intended to convey peace and tranquillity, whereas the vertical or portrait format suggests imposing subjects such as

◀ Fig. 3.2
The zebra butterfly, *Heliconius melpomona* against a non-obtrusive blue background and well-placed in the frame; a quiet peaceful image. Multiple flash f22. ISO 64

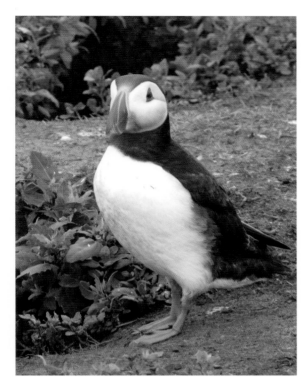

▲ Fig. 3.3
A puffin standing upright fits well into the portrait format. Using a horizontal frame would result in lots of wasted space on either side of the subject. 1/60 f8.0. ISO 200

▼ Fig. 3.4
The water dragon, *Iguana iguana*, fits well into a horizontal format with space to the left side for the reptile to look into. Flash f16. ISO 64

high buildings or tall natural objects like a section of coniferous woodland. Close-ups of tall plants or a vertical cliff face and sitting animals such as squirrels, meerkats or puffins look quite effective in the portrait format, whereas animals moving across the field of view will fit the horizontal format much better (see Chapter 5). These suggestions can of course be discarded when the subject calls for a more radical approach.

The Golden Ratio

This is also referred to as the divine proportion and was said to come from God. It is produced by dividing a line AB into two parts so that the ratio of the whole line AB to the longer part AC is the same as the ratio of the longer part AC to the shorter part CB, both resulting in a ratio of 1.618:1.

$$\frac{AB}{AC} = \frac{AC}{CB} = 1.618:1$$

A. C. B.

Over the centuries artists from Leonardo da Vinci to Salvador Dali have been obsessed with the golden ratio, and musicians are also drawn to it, often unknowingly. In a musical composition something dramatic will often happen just after halfway, and the ratio of how far this moment is from the start and the end will often fit the golden ratio. The golden ratio can also be found in nature, in human proportions and in the growth patterns of animals and plants.

When this ratio of 1.618:1 is turned into a rectangle, it is universally known as the golden ratio rectangle. It is certainly not a recent discovery as rectangles with proportions of around 1.6:1 can be identified in the architecture of Stonehenge, dating from around 2000BC. It was also used by Greek and Renaissance artists and has been a continual presence in architecture right up to the present day.

◀ Fig. 3.5
A group of ordinary people were asked to choose their preferred ratio and as the results indicate, the majority chose the 5:8 ratio which is extremely close to 1:1.618, known as the golden section ratio.

1:1	4:5	7:10	5:8	1:2
square			golden section	double square
5%	**4%**	**9%**	**36%**	**9%**

Despite the undoubted popularity of the Hasselblad, the Rollei and other 6×6cm format film cameras, the square format Rolleiflex with its excellent Zeiss Planar lens was not completely satisfactory. Rarely did the viewfinder image look just right, and photographers spent much time mentally cropping it to produce a horizontal or vertical-format image. Why was this, and why are so few pictures in art galleries perfectly square? Could it be linked to the golden ratio rectangle? Photographic papers, such as the old postcard size, 5½×3½, have a ratio of 1.55:1, while the full-frame digital SLR (36×24mm) also come close at 1.5:1. Even the ubiquitous credit card, bus pass, club card or supermarket card all measure 35×53mm giving a ratio of 1.604:1.

Our attraction to this rectangular shape may be inherent in our nature or merely culturally acquired, but a ratio of around 1.6:1 seems to produce a very satisfactory rectangular shape. From a display of differently proportioned rectangles, a group of ordinary people were asked to select their preferred shape. The majority (56 per cent) chose the 5:8 ratio (that is, 1:1.6), which is nearly the golden ratio. But is this favoured rectangular shape culturally conditioned or genetically programmed? No one can say.

APPLYING THE RULE OF THIRDS

The obvious place for the subject is right in the centre of the frame where it will have immediate impact. Unfortunately this interest is usually short-lived, and eventually the image becomes rather boring. To avoid this try placing the subject towards the side of the frame in a position suggested by the rule of thirds.

How it works
Mentally divide the image area into thirds using two imaginary horizontal and two imaginary vertical lines. The best places to locate your subject are near any of the points of intersection known as the 'strong' points. The rule of thirds is probably inherent in the human psyche, being closely related to the golden section.

Placing the subject
Having located the animal, bird or person near one of the strong points, it is good practice to have it looking into the area of greatest space, because this tends to look right, providing space for the subject to move into.

If you really want to catch the attention of the viewer, the subject can very occasionally be moved to the other side of the frame facing the edge and right next to it; however this is generally not recommended.

◀ Fig. 3.6
The intersection-of-thirds strong points occur around the handler's eye and near to the body and eyes of the barn owl. 1/300 f7.1. ISO 200

◀ Fig. 3.7
Household pet exploring the snow. It is good practice to have an animal or bird placed towards one side of the image, providing space for it to move into. Locating it at an intersection of thirds is also worth the effort. 1/1000 f4.5. ISO 200

◀ Fig. 3.8
This image of a Great Horned Owl does not fit in very well with the rule of thirds; however the penetrating eyes and the bilateral symmetry make it a balanced and quite acceptable image. Flash f16. ISO 200

The Focal Point

The focal point of a picture is the area on which the eye alights first. It does not necessarily need to be the main subject, although it usually is. It may come as a surprise to inexperienced photographers that the focal point is most effectively positioned according to the rule of thirds. When the picture includes people, no matter how small or where they are placed in the frame, the eye will automatically focus on them, such is the eye-catching power of the human form.

After the eye has settled on the focal point it will then begin to wander over the picture taking in the rest of the detail, albeit in a fairly organized way. In western society we read from left to right and from top to bottom, resulting in a natural tendency to scan a picture from the top left, moving clockwise around the frame, before returning to the main point of interest. However this habit can be disturbed when the picture includes very strong eyelines such as curves, spirals or meanders. An effective picture should be composed so that the eye can scan it easily and naturally.

Framing the Image

What you include in the frame will determine the composition of the picture, and the easiest way to decide this is to use a 35mm or medium-format slide mount (or make one on black card) and hold it at varying distances from one eye. This works equally well for distant landscapes or close-ups. It will not only save cropping but is a useful way at arriving at a satisfactory composition prior to releasing the shutter.

▲ Fig. 3.10
The result of using the black frame shows a satisfactorily composed image of cultivated crab-apples taken indoors. 1/60sec f11. ISO 100

▼ Fig. 3.9
Framing the image carefully before making the exposure is the best way of producing a well-composed photograph, requiring little if any subsequent cropping. 1/60sec f11. ISO 100

COLOUR

We live in a world full of colour, and only when we are deprived of it do we realize its true power. While black and white film was developed first, as soon as colour film was unveiled, black and white faded away almost completely. The same applied to television. How many people today would be satisfied with a black and white television?

We do more than see colour; we feel it at an emotional level. The colour sensation is sometimes so strong it can move us to tears, and occasionally its power is beyond verbal description. It is interesting and revealing that we often use colour to describe a feeling or mood: feeling blue, purple with rage, in the pink, and green with envy; or in a slightly different vein we talk about someone with a yellow streak, or being yellow-bellied as having a tendency towards cowardice.

With a prism white light can be split into the colour spectrum – red, orange, yellow, green, blue, indigo and violet – with each colour produced at a

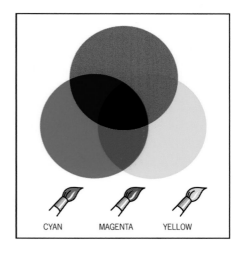

▲ Fig. 3.12
Subtractive colour synthesis. Mixing yellow, magenta and cyan inks or dyes in different proportions can produce a whole range of colours, and where the three overlap the result is black. This process is used in all colour printers.

▼ Fig. 3.13
The basic colour wheel, known as Rood's hue circle, contains the three primary colours red, blue and yellow and their secondaries – violet, green and orange.

▼ Fig. 3.11
Additive colour synthesis. Red, green and blue light each covering approximately one third of the spectrum. Projected at various strengths produces a whole range of colours, and when all three overlap completely the result is white.

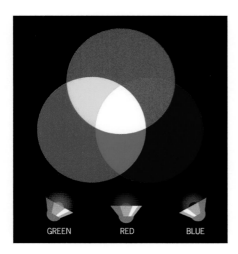

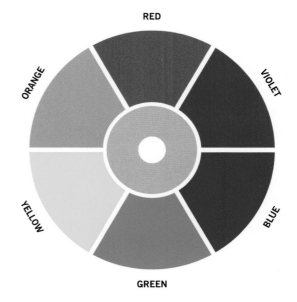

specific wavelength of light. One method of gener-
ating a range of colours is to partially overlap beams
of light from different parts of the spectrum. For
example, the three primaries – red, green and blue
– each cover one third of the spectrum, and where
all three overlap the result is pure white; this is called
additive colour synthesis.

The mixing of coloured paints, inks or dyes – for
example yellow, magenta and cyan (used in colour
printers) – as opposed to coloured lights, can
produce a full range of colours, and where all three
overlap the result is black; this is known as subtrac-
tive synthesis, and is used in most photographic
colour processes and all colour printing.

When the three primaries are mixed in pairs,
they produce secondary colours: orange (from red
and yellow), green (yellow and blue) and violet (red
and blue). If these secondary colours are mixed with
their adjacent primaries, another set of intermedi-
ate colours is produced – for example, yellow-
orange, red-orange, red-violet, blue-violet and so
on – giving a total of twelve colours. These can be
presented in sequence on a colour wheel known as
Rood's hue circle, where colour harmony, as well
as complementary and contrasting colours, is easy
to identify, as discussed a little later in this section.
This colour wheel is reasonably faithful to the colour
spectrum produced by a prism or in a rainbow.

Colour Temperature

The colour of daylight and artificial light is meas-
ured in degrees Kelvin (K) as colour temperature,
named after William Thomson Kelvin (1824–1907),
a British physicist. The scale begins at absolute zero
(–273°C), increasing in the same way as the Celsius
(commonly called Centigrade) scale, in that 0°C is
equivalent to –273°K while 100°C is 373K and 1000°C
is 3730K.

The colour temperature is related to the colour
produced by a black non-reflecting object (scientifi-
cally known as a black body) when it is heated. This
ranges from red at around 1000K, through yellow
(1500K), to white (5000K) and finally blue (around
8000K). This can be related to daylight which ranges
from red (1000–3000K) during a clear sunrise or
sunset to around 5400K at midday, the latter being
the colour temperature of most flash units. The
domestic lamp is around 2600k, while candlelight
registers a very low colour temperature of approxi-
mately 1500K (towards the red end of the scale).

If you are reading a book in bright daylight, the
pages will be to all intents and purposes white, but
in ordinary room lighting they will have a yellow
cast (that is, a lower colour temperature due to the
artificial lighting) although the brain quickly adjusts
and we see the page as white.

Photographers too young to have used a film
camera might be interested to know that films
were manufactured to produce an accurate colour
image in daylight and in electronic flash light (both

KELVIN COLOUR TEMPERATURE SCALE

Cloud sky	Fluorescent Light	Daylight	Halogen Bulb	Household Light Bulb	Candle
8,000	6,000	5,000	3,000	2,500	1,500

◀ Fig. 3.14
The colour of light which varies throughout the day is measured in degrees Kelvin, which relates to the colour of a black body when heated; it warms up from dull red to bright red and eventually through to white hot. Digital cameras can cope extremely well with variations in colour temperature when automatic white balance setting is used (AWB).

Fig. 3.15
A variety of chrysanthemum photographed in bright sunlight around mid-day with a colour temperature of approximately 5400K. Note the overall warmth of the petals compared to those in the adjacent photograph. 1/125sec f8.0. ISO 64

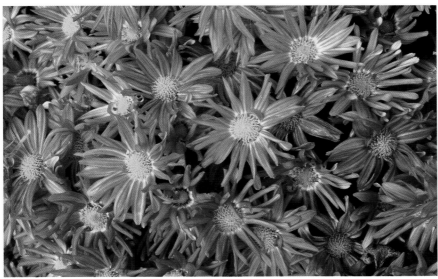

Fig. 3.16
The same pot of chrysanthemums was then photographed in the shade where a drop in colour temperature resulted in a cooler light producing a slightly different colour. 1/100sec f8.0. ISO 64

at 5400K). Photographs taken in artificial light had a strong, sickly yellow cast that could only be eliminated by attaching a quite strong blue conversion filter to the camera lens. Photographers working exclusively with artificial light could buy film designed to produce a natural-looking image in artificial studio lighting.

Colour print, colour slide and black and white film are available from Fuji, Kodak and Ilford. Colour film balanced for artificial light is no longer available, or indeed necessary, as studio portrait photographers use electronic flash (with a soft box or umbrella) to make the exposure. Film is still used by a not-so-small group of enthusiasts, including several well-known professional photographers.

To take account of the colour temperature of the scene being photographed digital cameras have an Auto White Balance (AWB) setting which due to the camera's sophisticated electronics will produce a pleasing image in almost any type of light. Alternatively you can select one of the various corrective settings, such as Cloudy (too blue), Fluorescent (too green) or Incandescent (too red) which usually produces very acceptable results, often similar to the Auto White setting.

Some digital SLR cameras come complete with the full colour temperature scale in Kelvins, allowing the user to select the appropriate setting for the prevailing conditions. This also allows the 'wrong' setting to be selected, putting a complete colour cast over the entire photograph, such as an exaggerated sunset or a very blue icy winter scene.

Colour Characteristics

When examining a colour photograph or a painting we can identify three different colour characteristics – hue, saturation and adulteration.

Hue

Hue is a colour's main quality and gives it its uniqueness and name. It is what first comes to mind when looking at or describing the colour of a plant, flower or animal. However, this colour is not fixed, even though the human eye gives the impression that it is, because the final colour will depend on the colour of the light falling upon it, (that is, its colour temperature K, as described in the previous section). In the natural world the colour of light varies throughout the day; it could be red at sunrise and sunset, brilliant blue-white at midday in summer, or bluish-grey on a dull, overcast day.

Saturation

Also referred to as brilliance, saturation is a term in common use amongst photographers. In photography an overexposed image results in paler and paler colours, while in an underexposed image the colour becomes more saturated and strong and eventually goes black. For example, red can darken to a deep pure red, but lighten to produce pink, while blue stays blue from a very pale blue to a very strong dark blue. Photographers who favour stronger colours often reduce the exposure by up to one stop to slightly underexpose the image, producing richer, more saturated colours. However, this treatment does not suit every subject, and on occasion the subject might be overexposed to lighten it slightly.

Adulteration

Colours become adulterated or corrupted when they are mixed with white, grey, black or their opposite colour on the colour wheel. A lot of natural land-scapes include adulterated colours such as greys, browns and dull greens, resulting in a sense of tranquillity and peace. The other side of the coin is that a small amount of strong unadulterated primary colour, for example a distant small bright red rowing boat, will often form the focal point of a photograph, turning an average picture into a more arresting one. At macro level a similar result is achieved by photographing, for example, a spotted red-bellied newt against a dark green aquatic background.

Complementing and Harmonizing Colours

An effective form of colour combination is to use colours more or less opposite each other on the colour wheel – for example yellow and purple, red and green, orange and violet. Classed as complementary colours, in addition to working well together on aesthetic grounds, there is a physiological explanation why these pairings seem to work. Apparently the eye, and ultimately the brain, finds satisfaction and balance in mid-grey or any colours which combine to produce a mid-grey after-image, hence the visual attractiveness of opposite colours on the colour wheel.

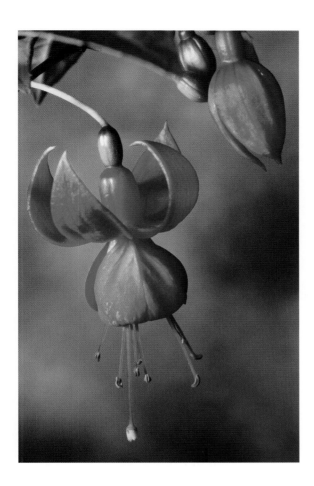

◀ Fig. 3.17
Complementary colours from opposite sides of the colour wheel work well together in this image of a fuchsia flower against a green background. 1/25sec f16. ISO 50

It has also been suggested that triple colours can work well together; these are produced by placing an equilateral triangle inside the colour wheel so that, for example, yellow, red and blue come together. In day-to-day living, colour combinations such as pink and orange, brown and blue or orange and purple seem to clash, although there appears to be little general agreement about it. However, these colour combinations do occur in the natural world – for example in a pink/orange sunset – and we readily accept it.

Harmonizing colours tend to have a lot in common, and are often next to each other on the colour wheel. Horse-chestnut leaves in autumn are often mahogany brown, slowly becoming a rich red and finally a brownish red, the latter being an adulterated colour. The small tree frog, *Hyla arborea*, is bright green and yellow, two colours next to each other on the colour wheel; the tree frog is also well camouflaged by living in a bright green leafy background.

◀ Fig. 3.18
Green and yellow are harmonizing colours next to each other on the colour wheel as seen in this image of the male pollen-bearing catkins of the goat or pussy willow, *Salix caprea*. 1/30sec f16 macro lens. ISO 100

◀ Fig. 3.19
Red is an advancing colour
which seems to jump out
of the frame. In this image
the bright red cotoneaster
berries are well supported by
the small dark green leaves
– complementary colours.
1/125sec f16. ISO 100

Emotional Responses to Colour

The experience of colour is much more subjective
and unquantifiable than we normally realize. We
all see colour and colour combinations slightly dif-
ferently, although there are many colours that elicit
specific and predictable responses, both aesthetically
and emotionally in most people. Strong, brilliant
colours are powerful and eye-catching, setting the
adrenalin flowing, while subtle, delicate colours
create quite a different feeling of tranquillity, peace
and restfulness.

Not only is the brilliance or subtlety of the colours
an important factor in eliciting a response from the
viewer, but the colours themselves carry particular
overtones. Images which are predominantly one
colour evoke a particular response often associated
with the natural world. For example, red seems to
jump out of the picture – it is an advancing colour.
Reds and yellows are associated with sunsets,
inducing a feeling of warmth or even intense heat,
as in red-hot; while blue, the colour of sky or water,
is a 'clean' but 'cool' colour implying peace and tran-
quillity. Blue-grey is cold and strikingly effective in
winter scenes, where it can create an atmosphere of
cold desolation. Green is a restful colour associated
with grass and trees, promoting feelings of space
and calm – hence the 'green room' in theatres and
broadcasting studios where actors or interviewees
relax before going on stage or on camera. Green is
also a receding colour, making it useful as a non-
distracting background in close-up work, both
outdoors and in the studio.

IMAGE BALANCE

Usually, but not always, a picture should feel bal-
anced in relation to the position, size and colour
of the main components. This can be visualized
as a see-saw with the balance point in the centre.
A weight on one side can be balance by an equal
weight at the same distance from the balance
point on the other side, or by using a larger weight
nearer to the balance point, or a smaller weight
further away. Of course, in a picture there are no
real weights, just areas of interest that have 'colour
weight'.

(a)

(b)

▲ Fig. 3.20
(a) Without colour, a large black object near to the pivot point will balance a smaller object placed at the other end, resulting in a stable image. (b) Using two colours, the small dense colour of a deep red apple will balance the large block of pale colour produced by the yellow melon.

Assuming the colours are similar, the components of the picture can be balanced on size alone by being located at different positions along an imaginary lever. It is also possible for two small objects to be balance by a larger one on the other side of the picture. If we introduce hue and colour saturation, a small strong saturated colour can be balanced by a much larger area of weaker, less saturated colour.

Finally, when we have a combination of different colours, it becomes rather tricky, as different hues have different colour weights. For example, dark green and red are visually quite weighty, whereas pale sky-blue and yellow have light colour weights; but a sense of balance can still be achieved if these are placed at different points on the lever.

However if the subject of the picture is placed at the intersection of thirds, then although it is located at a strong point in the frame, the picture may, theoretically at least, be unbalanced based on the discussion above. Yet it may feel complete and quite satisfactory. There is no 'one size fits all' and what works well for one subject may not be appropriate for another. Be aware of the possibilities and then decide on the most appropriate solution.

Background Considerations

Since the background colour has not been mentioned, it might be assumed that it plays little or no part in the colour balance. However it can have quite a strong bearing on the subject being photographed. Referring to the photographs in Fig. 3.21, when the background is a very pale yellow, the weighting of the small bunch of black grapes would be balanced by a large yellow melon; however, were the background to be switched to a deep blue, the yellow would gain in visual weight, while the smaller dark-red grapes would lose weight. A crimson-red background would cause the grapes to lose even more colour weight while the melon would remain unaffected.

For indoor still-life work paper rolls, spray-painted background boards or photographs of cloud and sky or out-of-focus grass are usually used, with complex subjects often benefiting from a plain or subtly mottled background. Black velvet works well, highlighting the main subject, but often appears rather artificial, while plain white rarely seems right, often leaving the picture looking incomplete.

When photographing outdoors it is often difficult to eliminate an unsatisfactory background despite changing the camera position. If the background is not an integral part of the picture, it can be thrown out of focus by using a large lens aperture or a long lens to reduce the depth of field. A suitable background board as mentioned above can be set up behind the specimen. However, if the background is an integral part of the picture – be it dramatic, aggressive, softly atmospheric or simply narrative – then it should be kept in sharp focus by stopping down the lens to a small aperture to produce a large depth of field.

◀ **Fig. 3.21**
Background colour can have a profound effect on the objects being photographed. (a) Against a pale background a small bunch of grapes is prominent, balanced by the large pale-coloured melon. (b) Switch the background to dark blue and the grapes begin to lose visual weight, and (c) with a crimson background the grapes lose more weight, while the melon continues to gain prominence. 1/25sec f11. ISO 100

▲ Fig. 3.22
Although a black background is quite dramatic it looks rather artificial, yet here it seems to work well with the clematis seedheads. The white feathery seeds are beautifully highlighted by quite powerful backlighting. 1/60sec f22. ISO 50 1 stop underexposure

LIGHTING

Negative Space

This is sometimes referred to as blank or dead space and is quite simply a fairly large area of the picture with nothing significant in it. Clear blue sky, a calm sea, a stretch of sand or snow or even a plain wall could all be examples of negative space. It should contain nothing that catches the viewer's attention, thus leaving the eye to concentrate on the main subject. It is not wasted space and should not necessarily be cropped out of the picture, even though it may leave the image slightly unbalanced, particularly if it is placed at one of the strong points at the intersection of thirds.

The atmosphere and general appeal of a picture is greatly influenced by the lighting, which at the extremes can be either hard and unyielding or soft and subtle, each having its own effect on how the subject is perceived. Harsh light emitted from a point source results in high contrast with dark sharp-edged shadows, as typified by the midday sun in a clear blue sky, or a flash unit, or the concentrated beam of a slide projector. This type of lighting is shunned by most photographers because the contrast is too high with blocked-up shadows and burnt-out highlights.

Flash lighting, which is used in most photo-graphic studios, is often softened, either by firing the flash into an umbrella as mentioned previously, or by using a soft box into which the flash is fired. This flexible fold-up box has a silver lining with a large diffuser at one end, producing an extensive area of soft diffused light. Sizes range from 50cm square to 120cm square.

The direction of the lighting is extremely important, having a fundamental effect on the character of the final image. Frontal lighting, whether harsh or diffused is 'safe' lighting because everything facing the camera will be clearly lit – hence the advice given to amateur photographers to keep the sun behind them. Unfortunately, frontal lighting tends to be very flat, producing no modelling or three-dimensional effects. When the main light is in the 45 per cent frontal position (that is, 45 per cent above and 45 per cent to one side), it creates good modelling, though you will probably require a small fill-in light or reflector to lighten the darker shadows. This form of flash lighting is often used when photographing, for example, frogs and newts swimming in an aquarium.

◄ **Fig. 3.23**
The eye is led by the leaves and the small puff-balls up towards the main puff-ball and the cloud of spores, resulting in a satisfactory composition. The lighting is a mixture of backlighting plus a little weak frontal, while the dark-coloured background fits in well with the colour of the subject. Multiple flash f22. ISO 100 −2/3 stop underexposure

Other useful types of lighting include grazing (or low oblique), which emphasizes surface texture and is employed extensively in both landscape and close-up photography. Backlighting (*contre jour*) is favoured by many nature photographers, where the main light is behind and usually above the subject and directed towards the camera. It works well in animals and plants fringed with delicate hairs or fine bristles, and when photographing pollen and spores being dispersed (Fig. 3.23) having the ability to transform an average subject into something quite special. As the light is shining almost directly into the camera lens, you will need to use an efficient light shield, such as a conventional lens hood or a piece of card (or your hand) held just out of the picture area but shading the lens from direct sunlight.

STUDY THE IMAGE

An artist may take weeks or even months to complete an oil painting, and at each stage he has full control of the various elements of the composition. A photograph can be taken in 1/100sec or less, a mere blink of an eye on the painter's timescale – and because photographs can be taken so quickly, there is a tendency to do just that.

The composition of an image should be planned in detail long before the shutter is released. This may require visiting a potential photographic site several times to study the direction of the light and to check the development of the shrubs, trees and wildlife. Also consider the choice of lens and whether a wide-angle view or the shortened perspective and larger image of a telephoto lens would best suit the purpose.

Close-up photographs of parts of animals and plants may require extra lighting, while some backgrounds should be rendered sharp to provide information about the habitat, and others thrown well out of focus so as not to be distracting. Study the image in the viewfinder or LCD screen of the handheld camera, moving it a few metres to either side and trying different camera heights before making the final decision. Then, with the camera firmly mounted on a tripod (or a monopod for in-flight bird photography), adjustments can be made to the height, lens aperture (depth of field) and overall exposure, before you finally release the shutter.

When taking close-ups indoors the same general principles apply, although setting up the material will require more time and patience than with outdoor shooting. If you want everything pin-sharp, the main plane of the specimen should be parallel to the camera back, with the lens stopped down to f16 to f22. Extra lighting can be provided by a video light or a small LED pocket torch, although for small living, moving organisms one main flash unit and a smaller fill-in flash is usually necessary. Lens focusing should always be manual, concentrating on the most important part of the image, which in animals and birds is the eyes. However, if you want your picture to be more abstract, with large areas of solid, out-of-focus colour, focus manually on the key point but leave the lens fairly open – for example f2.8 to f5.6 – and the shutter released either remotely or by using the timed delay. However, your time and patience should be rewarded with the production of an exciting, carefully composed image rather than a mere snapshot.

Chapter 4

Restless in Water

In this chapter we shall be considering a selection of aquatic plants and animals and how to photograph them. We begin with the flatwrack seaweed and the common barnacle, which are permanently fixed to the rock surface yet through movement during their reproductive process manage to maintain the species and even extend it to new territories. The next stage towards freedom of movement in water is exemplified by the common limpet, which moves only during the short period when it is covered by the tide. We then move on to a freshwater organism, hydra, which spends much of its life attached to vegetation by its basal foot; however, periodically it can detach itself and roam freely in the water. Finally, beginning with amoeba and ending with frogs, newts and terrapins, we will consider animals that can move about (usually swim), enjoying the freedom of their selected aquatic habitats (albeit in the frog and newt life-cycle for only a limited time).

MUSCLE: THE POWERHOUSE OF THE ANIMAL KINGDOM

First of all, however, we will look at movement itself, and how it is achieved. Although muscle is a key component in virtually all animals, microscopic organisms such as amoeba have no muscles and rely on changes in the properties of their protoplasm for movement (protoplasmic streaming). Other protozoans, including volvox, use their hair-like flagella to roll them through the water. In hydra, the body wall contains musculo-epithelial cells in which minute fibrils shorten and produce movement.

In the rest of the invertebrates and in all vertebrates muscle is present, and is used for both external movement and the movement of most internal systems. There are three main types of muscle: smooth (visceral, involuntary), cardiac (heart) and striated (skeletal, voluntary). As we are primarily interested in animal locomotion we will concentrate on striated or voluntary muscle, which produces the types of movement which we are exploring. Typically a muscle has a longish tendon at one end attached to a movable bone and a short band of fibrous tissue, the ligament, attached to bone at the other end. When the muscle contracts, the bone is moved, this movement being controlled by willpower, although with constant practice it soon becomes almost automatic.

◀ Fig. 4.0
A pair of living sea-horses. Flash f16. ISO 80

HOW A MUSCLE WORKS

A muscle consists of thousands of muscle fibres, 10–100 microns (1 micron =1/1,000mm) in diameter. Each muscle fibre is made up of many 1–2 micron diameter myofibrils which, when examined under the microscope, display a distinctive regularly repeating pattern of cross striations – hence the descriptive term 'striated muscle'. At molecular level each myofibril consists of many sliding filaments of the proteins actin and myosin. Energy required for muscular contraction comes from the breakdown of the chemical ATP (adenosine triphosphate) to ADP (adenosine diphosphate).

The muscle contractile process is very complex but consists basically of the formation of molecular cross bridges from the thick myosin filaments to the thinner actin filaments. When the cross bridges are established and contract, the actin filaments pull the myosin filaments along in a ratchet-like fashion and they begin to slide past and overlap each other. This results in a shortening of the myofibrils and contraction of the whole muscle.

Living tissues will not function for long without a good supply of oxygen, and the rate at which it can be supplied is often a limiting factor in muscle performance. Vigorous sustained exercise produces an oxygen debt which must be repaid by resting and prolonged heavy breathing after the exercise.

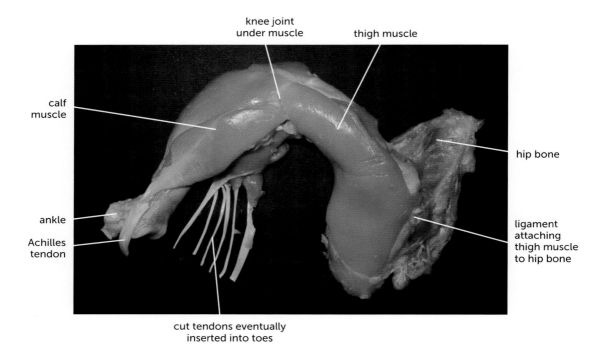

▲ Fig. 4.1
A chicken leg showing the attachment of the muscle to the bone. Photographed indoors in diffused daylight. 1/15sec f11. ISO 100

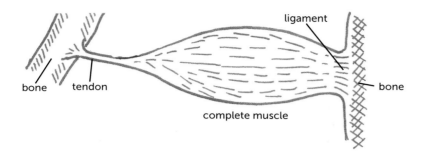

bone

tendon

complete muscle

ligament

bone

◀ Fig. 4.2
Structure of muscle (from
the top): whole muscle
with tendon and ligament;
isolated myofibril with Z lines
separating each sarcomere;
relationship between actin
and myosin filaments and
their molecular cross bridges
(after Cooke).

muscle fibre

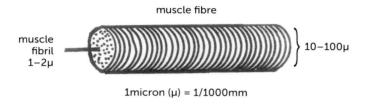

muscle
fibril
1–2μ

10–100μ

1micron (μ) = 1/1000mm

portions
of adjacent
myofibrils

single
myofibril

Z line

Z line

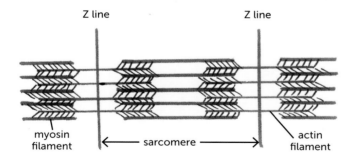

myosin
filament

◀——— sarcomere ———▶

actin
filament

FLATWRACK SEAWEED
(*FUCUS SPIRALIS*)

How does a plant such as flatwrack seaweed – which is permanently fixed to a rock surface by a strong holdfast and submerged twice a day – compete, survive and expand its territory?

Close examination of its life cycle reveals that in the spring, pimple-covered swellings (conceptacles) are visible on the tips of the frond. These are the male and female sex cells, consisting of oval oogonia, which on maturity divide into eggs (ova) which are released onto the surface of the frond at low tide. The male cells (antheridia) develop in similar conceptacles, which at maturity divide into biflagellate spermatozoids, imparting a yellow colouration to the conceptacles. At the next high tide the eggs are released into the water where they are fertilized by the actively swimming spermatozoids. The resulting zoospores are carried around the shore by tidal movement, eventually coming to rest on a suitable rock surface where they quickly grow a holdfast and develop in a new flatwrack seaweed plant. Although the adult is permanently fixed to the rock surface, the reproductive parts are very motile, spreading the seaweed around the immediate locality and beyond, to colonize new ground.

◄ Fig. 4.3
The swollen tips of the fucus fronds contain the male and female sex cells which are released onto the surface of the frond, where fertilization takes place. The resultant spores are carried by the tide, eventually coming to rest and growing into a new seaweed plant. 1/60sec f16 50mm macro lens. ISO 100

Photographing the Flatwrack

The tide was low when I arrived on the seashore, giving me plenty of time to photograph the barnacles, limpets and the flatwrack seaweed. The sun was hazy – bright but sufficiently strong, adding some contrast to what could have been a rather dull brown-green image. The tripod-mounted camera was aligned with the camera back more or less parallel to the seaweed conceptacles, and the shutter was released using a remote cord. A shot like this could be taken with any type of camera including a point-and-shoot compact set on Auto or Programme.

◄ Fig. 4.4
Laminaria digitata seaweeds, very firmly attached to a crowded rock surface, are well able to withstand severe wave action and tidal movements. 1/125sec f11 50mm macro lens. ISO 100

◄ Fig. 4.5
Even the small bushy seaweeds are securely attached to rock surfaces and able to withstand the twice daily tidal movements. Taken with a tripod-mounted camera with the camera back parallel to the rock surface to ensure sharpness across the entire image. 1/125sec f11. ISO 80

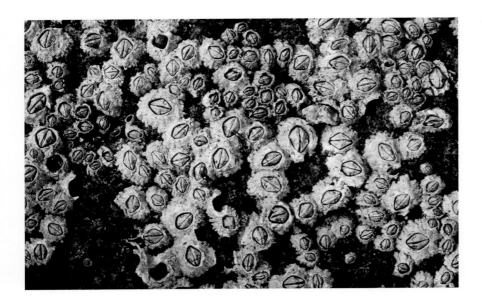

◄ **Fig. 4.6**
Barnacles measuring 5–7mm in diameter on a flat rock surface. Tripod-mounted camera set up with camera back parallel to the rock surface. 1/125sec f8 50mm macro lens. ISO 100

COMMON BARNACLE (*BALANUS BALANOIDES*)

The ubiquitous barnacle is a classic example of a marine animal which is fixed permanently to the rock surface. Once established it cannot be moved, although it does manage to feed by opening the hard, limy plates on the top of the shell, allowing the legs to emerge, rhythmically wafting in microscopic food particles. The common, or rock, barnacle was aptly described by the Swiss-U.S. naturalist Louis Agassiz as 'nothing more than a little shrimp-like animal, lying on its back in a limestone house and kicking food into its mouth'.

But how does it extend its territory? Barnacles are hermaphrodite, containing both male and female sex cells, which after fertilization within the barnacle's body, are liberated into the water as tiny microscopic larvae (the nauplius). They swim around, moulting several times before becoming cypris larvae, lying on their backs before finally becoming firmly cemented to the rock surface. Though completely immobile for most of its life, the inherently restless nature of the barnacle, exemplified by the free-swimming larval stages, enables it to increase in number and expand to new surroundings.

Photographing Barnacles on the Shore

Each time you walk along a rocky shore you tread on literally thousands of barnacles, probably unaware that these living animals are resting quietly until covered again by the rising tide.

Any type of camera, including a small digital compact, can be used to photograph barnacles on the seashore. The ideal conditions, which were present on my visit, would be little or no wind and more importantly, a hazy sun, which produced some light shadows on the barnacles emphasizing their three-dimensional structure. A bright sun from a cloudless sky would result in very contrasty lighting, leading to possible dark blocked shadows and washed-out highlights.

Having found a piece of flat rock covered with barnacles, and using a monopod for extra support, I held the camera with the back parallel to the barnacles to ensure sharpness across the entire image. Several exposures were made at varying distances from the barnacles, with an exposure of 1/125sec at f8 on ISO 100.

Photographing Barnacles Feeding

Photographing barnacles magnified up to 8×
requires working precision not possible on the
seashore. I found the easiest way to collect the
barnacles was not to try to remove them from the
rock but instead to find a few barnacle-covered
pebbles for removal. Several were collected with
some seawater, taken home and kept in a domestic
fridge (9°C, 48°F – about the same temperature
as the sea). To simulate tidal action, every twelve
hours or so I alternately exposed and submerged the
barnacles by tilting the container.

◀ Fig. 4.7
A complete barnacle
(approximately 3× life size)
showing the tiny waving
appendages. A reversed
50mm macro lens was used.

◀ Fig. 4.8
The delicate fringed legs
flick in and out very rapidly,
making the timing of the
shutter release and flash
quite tricky. To produce the
high magnification required
I used a 20mm macro lens,
mounted on a bellows unit,
but various reversed lenses
or extension tubes could be
tried. Flash f16 20mm macro
lens bellows unit. ISO 100

For the photo session the barnacle-covered pebbles were carefully placed in a small homemade aquarium (see Fig. 4.15), measuring 30×20×7cm, and allowed to settle down. Within minutes the hatches slowly opened and the barnacles started feeding.

The camera, bellows unit and the 80mm macro lens were assembled, using a powerful Metz 45 flash unit as a backlight (to highlight the delicate feeding legs) and a small piece of white card to reflect some light onto the front surfaces of the barnacles.

Although the 80mm lens is only a lens head, it does have some built-in fine focusing plus an automatic diaphragm, making it fairly easy to use with an automatic bellows unit. However, the 20mm macro lens used for the 8× close-ups has no built-in focusing and only a manual diaphragm, resulting in severe focusing problems due to the slight backlash in the rack-and-pinion mechanism of the bellows unit – sufficient to throw the image out of focus.

Using the lens stopped down to its minimum aperture of f16 on a longish bellows extension resulted in the viewfinder image being almost too dark to see. Using a powerful hand-held spotlight however enabled me to focus on the barnacle's waving legs and release the shutter and flash units just prior to the very quick withdrawal of the legs. While this eventually produced the desired effect,

almost a roll of film was used before I felt reasonably satisfied.

With a standard (or macro) lens in the reverse position the image will be larger than life-size and the lens will produce sharp images. Alternatively, a high quality 50mm enlarging lens reversed onto the bellows unit will deliver quite excellent results, but without built-in focusing or an automatic diaphragm the lens will be slightly more awkward to use.

If your digital compact camera has a close-up setting and will focus down to a few centimetres, you could use the built-in flash (on a reduced output) to trigger a remote flash unit positioned above and behind the feeding barnacles. It is certainly worth a try.

THE COMMON LIMPET (*PATELLA VULGATE*)

For anyone walking along any rocky shore it is impossible not to be aware of large numbers of limpets, many seemingly dead and immovable. Are they completely inactive or are we missing something?

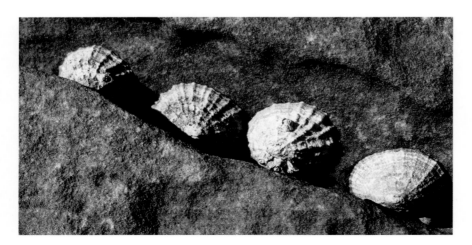

◀ Fig. 4.9
This photograph was taken on too sunny an afternoon, but it did highlight the surface texture of both the shells and the rock. A monopod-mounted camera was used with the camera back held parallel to the plane of the line of limpets to ensure a sharp overall image. 1/250sec f11 90mm macro lens. ISO 100

◀ **Fig. 4.10**
A limpet was placed on a piece of glass and when it was firmly attached, the glass was inverted and gently slid into the rock pool. Note the very large muscular foot, the head and open mouth and the pair of tentacles. The camera was supported over the rock pool using a tripod. 1/60sec f8 90mm macro lens. ISO 100

If tapped gently with your foot the limpet remains firmly attached to the rock surface, with subsequent heavier pushing having little effect as the limpet clings more tenaciously to the rock surface. This is exactly what happens in stormy weather, where the harder the sea pounds on the rocks, the firmer the limpet clings. Attachment to the rock surface is achieved using a large, flat, muscular foot that occupies most of the underside of the shell. The foot adheres to the rock surface using a combination of reduced air pressure and sticky mucous.

Movement is revealed however when the tide comes in and the situation changes, with the limpet loosening its grip on the rock surface and moving around, using its long, narrow, rasp-like tongue to scrape away small surface algae and lichens. The limpet has also a small head, a pair of tentacles, two rudimentary eyes and a small mouth, all visible in the photograph (Fig. 4.10) showing the underside of the limpet.

Researchers have shown that the limpet uses the foot muscles to lift part of the sole some 0.2mm clear of the rock surface, allowing part of the foot to be pushed forward. This is then re-attached to the rock surface permitting the rear section to be brought forward resulting in a very slow side to side movement of the animal's shell.

Limpet Homing Instinct

As part of a marine biology field course on the Yorkshire coast the students were asked to investigate whether limpets possessed any 'homing' instinct. Quick drying motor car touch-up cellulose paint was used to draw a line down the shell and onto the rock surface. When the paint was dry, the shell was given a sharp tap with the foot to release the limpet from the rock surface. Each of the ten colour-coded limpets was place a measured distance from its 'home', starting at ¼ metre and extending to a maximum of two metres.

The following day (and two high tides later) we returned to the shore to find out how many limpets had returned 'home'. Rather surprisingly, all those placed one metre or less from their home had returned safely; two at one and a half metres also returned home, but none at two metres. Even more surprising, each limpet having returned home moved about until it was perfectly aligned to the stripe on the rock surface. This moving about, which the students quickly called 'the limpet shuffle',

◀ **Fig. 4.11**
The limpet red-lined at the start of a homing experiment. 1/125sec f11 90mm macro lens. ISO 100

◀ **Fig. 4.12**
On returning home after feeding a limpet shuffles around, wearing a circular depression in the rock surface. This close association with the rock surface helps to prevent desiccation when the tide is out. Grazed lighting helped to highlight the depression worn in the rock surface. 1/125sec f11 50mm macro lens. ISO 100

caused the edges of the shell to grind into the soft rock surface until it became a perfect fit. The close contact with the rock resulted in a ring-shaped depression, which helped to prevent the limpet from becoming dehydrated while exposed to the drying atmosphere when the tide was out.

Extending its Territory

If a limpet's normal territory does not extend beyond a metre or so from its home, the reproductive process must therefore be the means by which it spreads and colonizes new ground. Limpets reproduce over the winter, mainly in January and February, with the eggs and sperm being liberated into the sea. They develop into free-swimming

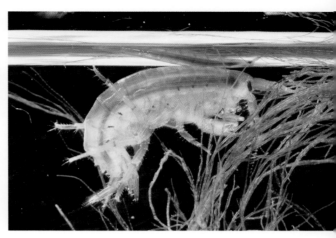

▲ Fig. 4.13
The set-up for photographing tiny marine creatures consisted of a 50mm macro lens reversed onto a bellows unit and supported on a tripod. A laboratory stand carried a small frontal flash (GN22 at ISO 100) and a larger flash (GN32) for backlighting. The tiny creatures were housed in a miniature aquarium consisting of two pieces of glass separated by a short length of rubber tubing and held together with elastic bands.

▲ Fig. 4.14
The sea louse Idotea, foraging for food. The camera back was set up parallel to the glass enclosure to ensure sharpness across the entire image. For some shots a piece of black velvet was held behind the rear flash unit. Flash f22 50mm macro lens reversed. ISO 100

larvae which are carried by the tides before settling on the shore. Growth is steady, resulting in a three-year-old limpet being on average just over 50mm (2in) long. And so the species is able to colonize new ground.

Photographing Limpets on the Seashore

The limpets on the rocks were photographed during the visit to photograph barnacles. The set-up and methods were exactly the same – hazy sun, with monopod and camera back parallel to the limpets.

HYDRA OLIGACTIS: THE AQUATIC ACROBAT

Moving along towards total freedom in the water we can now consider a tiny freshwater animal called hydra, which is free for some of the time, but attached for most of its day-to-day life. The hydra

is so named because if split partway through the mouth region it will form a two-headed polyp (in Greek mythology hydra was a water serpent with many heads, each of which, when cut off, generated two more, until it was destroyed by Hercules). If a living hydra loses a tentacle, not only will it grow a new one but the lost tentacle can regenerate into a new complete hydra.

There are four British species of hydra including a green and a brown, plus nine American species, all living in freshwater ponds and streams. The brown hydra, oligactis, featured here, has a body length of up to 10mm with tentacles of up to three times this length, and it is therefore just visible to the naked eye but is easily overlooked among the plant life. When disturbed a hydra will contract into a tiny ball, making it almost impossible to detect in the water. Hydra feeds by capturing tiny water fleas and other small creatures with its poisonous 'darts' (nemato-cysts), which are ejected from the tentacles when they touch the prey.

Locomotion

In its endless search for food and its innate drive to reproduce and colonize new ground, hydra displays several interesting methods of locomotion. In the water it is normally attached by its basal foot to objects and vegetation, or hanging from the surface film. It is able to twist about, performing movements for the capture of prey and to change its position.

Hydra can move in several ways, including 'walking' inverted, using its tentacles as legs, or simply gliding along the bottom of the pond on its basal foot. Hydra can 'climb' by attaching its long tentacles to a vertical object, releasing the foot, swinging up the body and re-attaching its foot higher up the vertical surface.

Perhaps the most interesting form of movement occurs when the body elongates, bends over, attaches the tentacles to the ground and releases the foot which moves forwards. The tentacles are disengaged and moved along to a new position, followed by the foot, similar to the looping action of a leech or inchworm caterpillar.

Reproduction

In their restless urge to maintain and spread the species, hydra can reproduce both asexually and sexually. In its asexual form, a bud grows on the side of the body, eventually breaking away to create a new individual.

Most species of hydra are single sexed, with the ovaries and testes developing on different individuals. A mature egg (ovum) grows on the side of the body and is fertilized by a sperm liberated from another hydra. The egg wall hardens, with the cyst breaking away from the female parent and sinking to the bottom of the pond. After ten to seventy days the cyst softens and a young hydra, complete with short tentacles, emerges to begin an independent life.

Photographing a Living Hydra

At the local pond I collected a handful of pondweed, which I knew would also contain a number of small pond animals. The pond weed and some pond water were placed in a large screw-topped jar for easy transport home. A large collecting net was also trailed through the water to catch larger pond animals such as water beetles and insect nymphs. A smaller net with the pointed end cut off and replaced by a plastic tube was trailed through the water to filter out any tiny creatures into the tube, allowing the bulk of the water to pass through the net back into the pond.

SETTING UP AN AQUARIUM

A small aquarium can be constructed, using thin picture frame glass for the front surface with heavier window glass for the remaining sides, back and base, and 'glued' together using silicone adhesive sealant.

For pond life photographs, the aquarium measured 20 × 14 × 6cm (8 × 6.5 × 2.5in). A layer of small washed pebbles was distributed along the bottom, and several pieces of fresh-looking pondweed were attached with cotton to one or two pebbles and buried discreetly among the other pebbles.

The aquarium was filled with filtered pond water and allowed to settle for twenty-four hours, as any fine suspended particles in the water would show up on the photograph, particularly when backlighting was used.

◀ Fig. 4.15
The small home-made aquarium used to photograph creatures such as hydra and newts. The large artificial light at the top left was used to focus on the organisms before the shutter was released and the flashes fired.

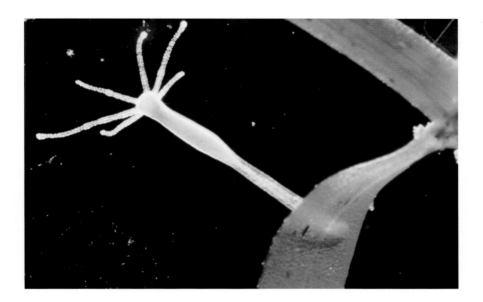

Taking photographs with the camera in front of an aquarium can result in unwanted reflections of the camera on the front glass of the aquarium; this can be prevented by attaching a piece of black card, with a hole cut in the centre, over the camera lens barrel. It is important also to check that the aquarium's front surface is absolutely free from greasy fingermarks.

The lighting consisted of two flash units, with the more powerful one positioned high and just behind the aquarium to provide fairly powerful backlighting (useful for lighting small, semi-transparent creatures). A smaller fill-in frontal flash unit was placed slightly to the left of the aquarium. The camera was mounted on a firm tripod set on aperture priority, with the 90mm macro lens stopped down to f16, but because a black velvet background was used I reduced the exposure by one stop.

Searching among the pondweed for any interesting creatures I noted a small featureless blob on one of the plant leaves. Ignoring it, I moved on, but some minutes later I noticed a slight movement as the spherical mass began to elongate. Finally it became fully extended with the tentacles moving slowly around in the water.

AMOEBA PROTEUS: A SIMPLE ONE-CELLED ORGANISM

Amoeba belongs to a group of microscopic animals called the Protozoa ('earliest animals'), which is usually described as the lowest and simplest division of the animal kingdom.

The description 'simple', as in 'uncomplicated', is often applied to amoeba, although in most respects it is anything but simple. This wandering shapeless piece of almost clear, colourless, jelly-like protoplasm can move about, take in food, digest it, breathe, excrete waste matter and, of course, reproduce. Quite an achievement for a tiny, inconspicuous blob of protoplasm!

Amoeba used to be taught in school biology lessons and although diagrams of it were popular and widely used, hardly anyone actually saw a live amoeba because it is so microscopically small (less than 0.5mm long) and unobtrusive, making it very difficult to find in pond water, which is its natural environment.

PHOTOGRAPHING UNDER THE MICROSCOPE

Begin by spreading a small piece of filamentous alga on a glass slide, protecting it with a cover slip, and proceed to examine the material methodically using low ×30 magnification (×3 objective and ×10 eyepiece). This provides a large field of view at low magnification but allows you to detect any moving organisms.

If the little creatures are still too tiny but warrant closer examination, rotate the microscope nosepiece bringing the ×10 objective lens into use, giving a total magnification of ×100. Very occasionally the ×40 objective lens can be used, but the ×400 magnification, wonderful though it is, is at the expense of an extremely small visual field and a very shallow depth of field. The latter can be increased by reducing the diameter of the iris diaphragm below the condenser lens, but eventually the definition suffers as diffraction becomes a significant factor.

Movement by Pseudopodia

Amoeba moves among submerged plant life by simply pushing out a blunt-ended false foot (pseudo-podium), allowing the rest of the protoplasm to flow into it. It has been suggested that some directional stimulus causes this movement to occur (not dissimilar to slow waves of muscle contraction) with the fluid endoplasm flowing forward along the line of 'forward' movement. Around the perimeter of the pseudo-podium the fluid endoplasm is converted into a gel-like ectoplasm, building up and extending the sides of the pseudopodium rather like a moving sleeve. At the 'posterior' end of the body the more solid ectoplasm is converted into liquid endoplasm which flows forward in the direction of the movement, thereby bringing up the rear. This can be observed in living material using a microscope to magnify the image.

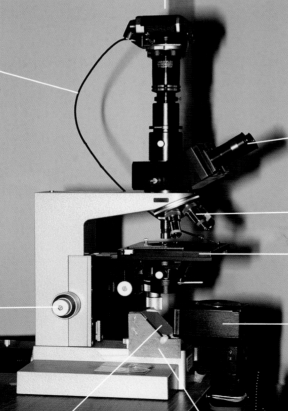

camera

TTL lead linking camera to flash

binocular eyepiece

objective lenses

slide stage

focusing knob

flash unit pointing horizontally

semi-silvered (translucent) mirror

light unit pointing vertically up the microscope

◀ Fig. 4.17
The key feature of this microscope set-up is the half-silvered (translucent) mirror below the substage condenser lens, which allows approximately half of the built-in continuous lighting to go up through the mirror and the microscope and into the eyepiece (or camera). When the flash is triggered half of the light is transmitted through and around the mirror and is wasted, while the rest is reflected up into the camera. The flash metering is used with exposure adjustments where required.

Reproduction

When the amoeba reaches a certain size, reproduction takes place with the nucleus dividing into two, as the body elongates, finally splitting into two parts (binary fission), each part carrying a nucleus. Under adverse conditions caused mainly by the drying up of the pond, the amoeba contracts into a small ball with a thick resistant coat (cyst). It remains in this dormant condition until it becomes covered with water again, when the cyst breaks open, the amoeba emerges, and once more takes up its free-living independent life.

Photographing Amoeba and Other Protozoa

Pond water is teeming with a rich variety of microscopic animals including single-celled protozoans such as amoeba, where, as mentioned earlier, all the bodily functions take place in one cell. A small jar filled with pond water and cottonwool-like green filamentous algae will provide sufficient material for many hours of microscopic work, which can be as exciting as it is time-consuming.

At a magnification of ×100 I discovered a small irregular blob of jelly-like material which at first I could not identify, but when it started to move I realized it might be an amoeba. The high power objective lens (×40) was swung into position, with careful observation over a few minutes confirming that this was indeed an amoeba.

Although the microscopic animals and plants were examined and focused using the microscope's inbuilt light source (projected up through the 45-degree half-silvered mirror), the photographs were taken using flash (pointing horizontally and reflecting some of its light off the half-silvered mirror, up through the microscope and eventually into the camera). I used a TTL lead to link the flash unit to the camera, but I had already done some bracketing on the last few frames of the previous film to establish the best exposure (+ 1.3 stops) for the brightfield illumination system.

VOLVOX AUREUS: THE ROLLING SPHERE

Continuing our examination of locomotion in micro-organisms we now consider another interesting type of movement involving whip-like hairs (flagella) as seen in volvox. This tiny pinhead-sized, hollow sphere, some 2mm in diameter, consists of between 500 and 15,000 individual cells embedded in the mucilaginous wall of the sphere, each bearing a pair of flagella directed outwards into the water. They are connected by various protoplasmic processes, resulting in an integrated beating of the flagella, causing the colony to rotate and roll through the water.

Whether volvox should be classified as a plant or an animal is a moot point. It has beating hair-like flagella and rolls gently through the water (animal characteristic) but it also contains green chlorophyll and manufactures its own food by photosynthesis (plant characteristic). As a result, both zoology and botany books usually include it in their list of contents!

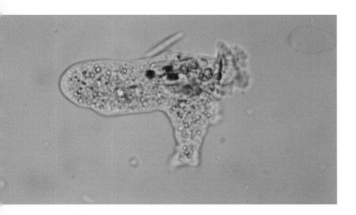

◀ Fig. 4.18
Amoeba is arguably the best known of all protozoans, and yet because it is so small and almost shapeless it is very difficult to spot when examining a drop of water under the microscope. It was moving when photographed and it contains some clearly visible dark food particles. flash magnification ×400. ISO 100

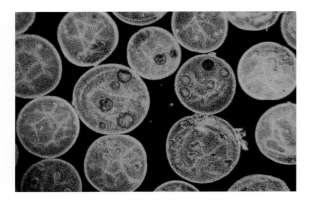

▲ Fig. 4.19
A prepared slide of volvox colonies, several of which are carrying daughter colonies. Photograph taken using the microscope and flash set-up described for Fig. 4.18. Flash magnification ×30. ISO 100

How do restless volvox colonies increase in number and colonize new territories? Some of the larger cells (mother cells) in the colony divide, forming a new colony inside the parent sphere, and are eventually released when the sphere breaks up. This is asexual reproduction.

Sexual reproduction involves both female egg cells and male spermatozoids, which are released into the water-filled cavity of the parent sphere. After fertilization each zygote becomes dark and thick walled, developing only after the breaking-up of the parent colony. The zygote is dormant throughout the winter but develops to form the first colonies the following spring.

Photographing Living Volvox Colonies

The presence of micro-life in any pond is quite unpredictable, no more so than volvox, which is notoriously erratic in its occurrence. Very occasionally it is so abundant it turns the pond water green, whereas in other years no trace of it can be found. In my professional life as a biologist only once have I witnessed this phenomenon, and what a spectacular sight it was, as the glass beaker of pond water shimmered green with thousands of volvox colonies.

To begin the search, I collected samples of water and pondweed, examining small amounts on a slide under the microscope, as described in the previous work on amoeba. As volvox is relatively large (in microscopic terms), low power magnification (×30) was sufficient to spot any colonies among the pond weed. The same lighting set-up was used as described for amoeba – continuous transmitted light from the base of the microscope, to search for and accurately focus on the volvox. The photographs were taken using through-the-lens flash (TTL). Again, + 1.3 stops overexposure proved to be the best setting.

SEA URCHIN: SPINY-SKINNED ANIMAL

Sea urchins are fairly common on many rocky shores, particularly down at low water. They are spherical and built on a five-part symmetry (like the five arms of the starfish) although this is not apparent to the casual observer. They can be found wedged between rocks or hidden under large seaweeds, and nearly always submerged in sea water.

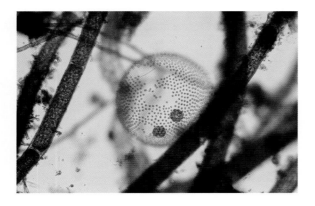

◄ Fig. 4.20
A volvox colony beginning to break up and liberate its daughter colonies. The image is marred by some dark out-of-focus filamentous green algae. Flash magnification ×30. ISO 100

▲ Fig. 4.21
A side view of a sea urchin in a rock pool; clusters of tube feet
are visible indicating that the urchin was moving very slowly. An
umbrella was used to block out reflections of the bright cloudy blue
sky. Tripod mounted camera with remote shutter release. 1/25sec f8
90mm macro lens. ISO 50

The sea urchin's Latin name, *Echinus esculentus*
comes from the Greek and Latin terms for hedgehog,
a group which also includes starfish, brittle stars, sea
cucumbers and sea lilies. Apart from the very obvious
spiny covering, its interesting features include a
mouth on the underside with five hard teeth, which
is part of a complicated structure called Aristotle's
lantern, a complex internal water system consist-
ing of a ring surrounding the mouth canal with five
radial canals extending around the inside of the shell.
Each sends out short side branches terminating in
pairs of tiny tube feet which project through holes in
the shell. Internal muscular contraction pumps water
into the tube feet which lengthen accordingly, but
this only occurs when the sea urchin is submerged
by the incoming tide or is marooned in a rock pool.

Movement

The restless nature of the sea urchin can be seen
by the way it moves around looking for food.
Numerous tube feet are extended in an organized
way, attaching their sucker ends to the rock surface,
helped by a light-sensitive spot on the end of each
tube foot. By their contraction the sea urchin is
pulled along. Despite the sucker power of each tube
foot being extremely small, because of their great
numbers the total effect can be quite substantial,
allowing the sea urchin to cling to rock surfaces in
the roughest weather.

Photographing the Sea Urchin

The weather was bright and sunny with virtually no
breeze to disturb the surface of the water. I arrived
on the rocky shore about an hour before low water
and made my way down to the water's edge. Using
a walking stick I searched among the seaweed in the
deep channels, and after about fifty minutes, just as
the tide was turning, a sea urchin was discovered
wedged in a crevice and covered with kelp. It was
carefully carried some thirty metres up the shore,
placed in a sheltered crevice, and left for a few
minutes to settle down and extend its tube feet.

ELIMINATING REFLECTIONS

Reflections of the sky and white clouds can cause
problems. On a previous visit I had discovered,
almost by chance, that a 25×20cm (10×8in) grey, 18
per cent reflectance card which I had used to check
the exposures would, if held above the specimen,
cut out completely all the surface reflections,
without affecting the sunlight on the water.

Unfortunately the shaded area did not quite fill
the frame. On this visit I had brought along a large
black umbrella and, by moving it around, the surface
reflections could be eliminated while the sun still
shone brightly on the sea urchin. (A polarizing filter
could be used but would absorb up to two stops
of light which was too large a penalty to pay, as I
was using slow film and needed a small aperture to
produce a good depth of field – and the urchin was
slowly moving!)

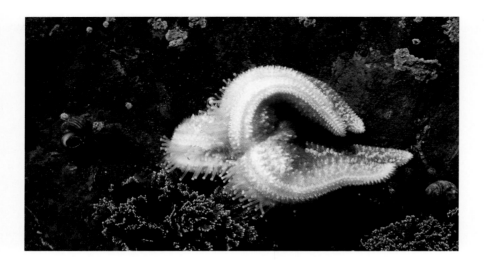

◀ Fig. 4.22
A starfish righting itself. Many tube feet are extended and the arms bent backwards. 1/60sec f8 90mm macro lens. ISO 50

THE COMMON STARFISH (*ASTERIAS RUBENS*)

Like the sea urchin the starfish is also built on a five-point symmetry pattern as indicated by the five arms. The internal structure is very similar to the sea urchin's, including the water ring system and tube feet. The arms and tube feet are used for movement but also play a significant role in feeding. The starfish often settles over a bivalve mollusc such as the common mussel, slowly prising apart the two shells. This is not achieved by brute force, however, but by a steady pulling action over an extended period of time.

Extending the Territory

Sea urchins and starfish spread throughout their territory by sexual reproduction involving the production of eggs and sperm from separate individuals. This usually takes place in spring or early summer with the young fertilized eggs developing into tiny, free-swimming larvae (echinopluteus), complete with five pairs of arms covered in ciliated bands. After several months the larvae sink to the bottom to complete their development, culminating in tiny adults only a few millimetres in diameter.

Photographing the Starfish

On my way back down the shore to return the urchin, I discovered a starfish awkwardly wedged in a deep crevice. After carefully freeing it, I placed it upside down in a shallow rock pool. After a minute or so, it pushed out its tube feet and very slowly began to right itself. A sequence of photographs was taken to illustrate the 'righting' process, again using the umbrella to cut out surface reflections on the water.

Exposures of 1/30sec or shorter were used as the tube feet were constantly swaying around in the water. The camera was handheld but supported on a monopod.

FISH

Fish are inherently restless creatures, always on the move looking for food and searching for somewhere to lay their eggs, thereby hopefully increasing their numbers and extending their territories.

The power to produce movement in a fish is located in three types of body muscle: the white muscle is used for short sprints (but tires quickly); while the dark muscle lying just beneath the skin

is used for continuous sustained, slow swimming; and the intermediate muscle which combines the properties of the other two is ideal for extended bouts of fairly rapid cruising. Fish, therefore, appear to possess three forward gears, each powered by its own engine.

Mechanism of Locomotion

The majority of fish swim by limited flexing of the body but with extensive movements of the tail area and tail fin. The eel and water snake exhibit this flexing movement in a more exaggerated form. The action of the tail and tail fin can be compared to a man sculling a boat with one oar at the stern, moving it from side to side.

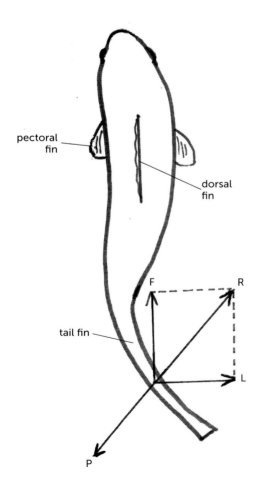

As the tail and tail fin push the water to one side (*see* Fig. 4.23) a reactive force is generated on the opposite side, which can be resolved into a sideways (lateral) force and a forward thrust. The result is forward movement with a slight yaw to one side. When muscles on the other side of the body contract, this produces a similar forward motion but with a slight yaw to the opposite side. The other fins are used mainly for balance and manoeuvrability, including slow forward and reverse motion, while the large stiff dorsal fin helps to keep the body upright in fast swimming.

Fish have evolved streamlined shapes ideal for efficient and rapid movement through water. However, they still experience some drag due to friction over the body surface. In a number of fish the skin is porous and beneath it lies a network of fine tubes filled with water. This system helps to iron out surface turbulence by adding or absorbing water into the under-skin network. The other, more obvious, anti-drag feature is the somewhat slimy nature of the fish's body, produced by mucous-secreting glands that help to provide a smooth surface and reduce surface friction.

Buoyancy at Depth

Fish can swim at different depths, controlled by a swim bladder usually located just below the backbone. Descending only a fraction of a metre increases the pressure on the fish's body compressing the swim bladder, making the fish less buoyant, and therefore tending to increase the rate of descent. The fish can counteract this by actively swimming at the new depth, allowing time for more gas to be secreted into the swim bladder until the pressures are equalized. The fish can now swim comfortably at the new depth.

◀ **Fig. 4.23**
The tail and tail fin push the water to one side, generating force (P), which produces a reactive force (R) on the other side. This can be resolved into a sideways (lateral) component (L), and a forward component (F), which pushes the fish forwards. Small movements of the main body assist lateral stability, aided by the stiff dorsal fin, which helps to keep the fish moving in a straight line.

▲ Fig. 4.24
The photograph of actively swimming Koi carp was not a mistake.
I wanted to produce a tranquil, ethereal effect so I lengthened the
exposure accordingly. Did it work? 1/15sec f4.5 50mm lens. ISO 400

▲ Fig. 4.25
The photograph of the two shubunkins required careful setting up
of the camera and flash units to avoid reflections in the front glass
of the aquarium. Capturing both fish in sharp focus and well-
positioned in the frame required great concentration and not a little
luck. Flash f16 50mm macro lens. ISO 100

Koi Carp (*Cyprios carpio*)

The Koi carp is an oriental strain that originated in
Japan and is now widespread throughout Europe
and Asia. It resembles a large goldfish (up to 40cm
long), being highly variable in both colour and
markings.

Photographing Koi carp

The photographs of the carp were taken indoors,
but in a very natural looking pool, surrounded by a
raised walkway. This allowed me to look down on
the carp and hold the monopod-mounted camera
with the camera back almost parallel to the surface
of the water.

Flash lighting was inappropriate as it would
reflect straight back from the surface of the water
and into the camera lens. As the indoor light level
was not high, the ISO setting was increased to
400, resulting in an exposure of 1/15sec at f4.5. The
bottom of the pool looked almost black, requiring
an underexposure of −1.3 stops to ensure the scene
would be recorded accurately. This was confirmed
on the camera's LED screen after several shots had
been taken.

Photographing Small Fish at Home

The equipment used was similar to that described
for Fig. 4.15, but with one or two modifications.
In addition to photographing the two Israeli
Shubunkins, I also intended to capture some images
of newts and frogs, and with this in mind I bought
a larger tank measuring 50×25×28cm (20×10×11in).
Washed pebbles and pondweed were arranged as
described previously, after which the aquarium was
filled with filtered pond water (tap water left standing
for twenty-four hours to dechlorinate would be an
alternative, with rain water even better).

Photographing fish through the front of the
aquarium is not difficult if you bear in mind that
the fish are moving in three dimensions. The main
problems are keeping them in focus and avoiding
unwanted reflections. To produce an acceptably
large image you need to work close to the subject,
and the depth of field will be very small. You will
therefore have to devise some means of keeping the
fish within the zone of sharp focus. I used a glass
sheet (or Perspex could be used), approximately the
same length and height as the aquarium, placed

in the water, about 7cm (2.8in) behind the front surface. This allowed the fish complete freedom of movement in two dimensions but limited them in the third dimension. I matched the spacing to the size of the fish; for tiny tropical fish about 4cm was sufficient. As the volume of water in front of the glass sheet was rather small, it would soon have become depleted of oxygen if several active fish were present, so I removed the glass sheet as soon as I had made the exposures.

Unwanted reflections on the front of the aquarium can arise from the immediate surroundings (windows and glass-panelled doors), the camera itself, and the source of the illumination. The window problem was solved by blacking out, and to eliminate reflections of the camera and photographer in the front glass of the aquarium a piece of black card was slipped onto the lens body as described earlier.

I positioned the key flash unit (GN 32 on ISO 100) above and slightly in front of the aquarium. This produced illumination similar to that found in the natural environment, and did not produce unwanted reflections. This simple overhead lighting was supplemented by a less powerful flash located just above and slightly behind the glass sheet, which helped to give the fish a more three-dimensional appearance.

I used electronic flash linked to the camera TTL leads, because the flash provides a high level of illumination and a very short exposure, which is important in this type of work. Finally a coloured (or black) card was positioned behind the tank to act as a background, with the colour selected to emphasize the mood of the photograph.

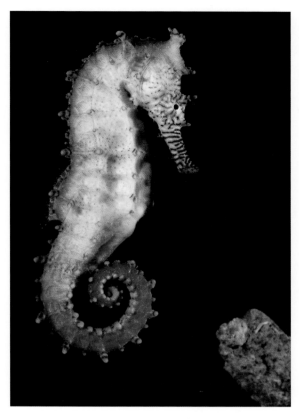

▲ Fig. 4.26
A sea-horse glides slowly in stately fashion through the seawater, propelled by the small vibrating dorsal fin just visible halfway down the left side of the body. Flash 1/60sec f8 −1 stop underexposure. ISO 100

The Sea-Horse (*Hippocampus guttalatus*)

An interesting and rather odd marine fish is the sea-horse with its long, grasping (prehensile) tail, horse-like head and a body covered in bony plates. It is also the mythical animal, half fish, half horse, ridden by Neptune and other sea gods. One of its most striking features is in swimming in the upright, vertical position using the dorsal fin as a vibrating fan as it silently moves through the water. Another interesting feature is that the male carries the eggs from the time they are laid by the female until they hatch as miniature sea-horses.

Territorial expansion

To maintain their number and colonize new territories, fish have adopted a number of strategies, the main one being the production of large numbers of eggs, in the hope that a small percentage will survive to maturity. Most fish lay eggs (oviparous), while a few produce living young (viviparous). The number of eggs shed varies from 200 to 1000 (minnows), up to 200,000 (perch), to over 6,000,000 (cod).

The eggs may float near the surface, sink to the bottom, or be attached to aquatic vegetation. For example, salmon deposit their eggs in shallow depressions in the river bed, sweeping sand over them to protect them from predators. The male stickleback constructs a globular nest from fine vegetable matter, later guarding the eggs and the developing small fry. Although a very large percentage of fish eggs do not survive, sufficient usually hatch and reach maturity, ensuring the species continues and may even expand to new areas.

AMPHIBIANS

Amphibians (Greek, 'double life') spend only a small part of their life cycle, usually the reproductive phase, in water, with the rest spent on land. This class includes the worm-like caecilians, salamanders, frogs, newts and toads. Here we are concentrating on movement in water, using the smooth newt (*Triturus vulgaris*) and the common frog (*Rana temporaria*) as examples of the class.

Newts and Frogs
Movement in water

Newts have a supple body and a long flexible tail which is employed to advantage in swimming. Newts swim rather like fish, using their tails to

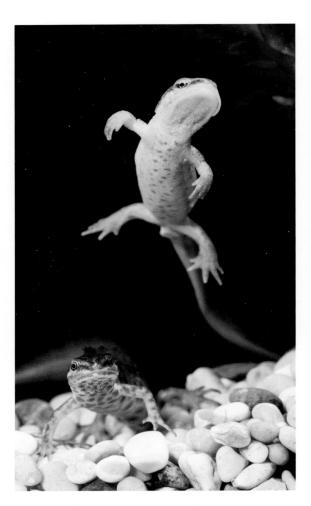

▲ Fig. 4.27
A newt swimming leisurely around the aquarium while the other appears to be looking at the camera! Flash 1/60sec f16 90mm macro lens. ISO 50

generate lift, drag and thrust, permitting them to swim rapidly over short distances. However, most of the time their movement is quite slow, with the long tail moving quite leisurely from side to side. The limbs play little part in normal swimming, being used mainly for grasping pieces of pondweed, and when the newt is swimming rapidly the legs are tucked into the sides of the body to reduce drag.

Frogs, as mentioned earlier, return to water only to mate and lay their eggs, but during this brief period they are capable of fairly rapid turns of speed. This is achieved by extending both hind legs simultaneously when the broad web between the toes pushes against the water, propelling the frog forwards. As the limbs are flexed the toes are brought together reducing the area of the web and therefore the drag, leaving the residual momentum to keep the frog moving. The forelimbs play little part in the swimming process.

Maintaining their numbers

Little needs to be said about how frogs maintain and increase their numbers, as almost every school-child has collected frogspawn and watched with excitement as the eggs hatch into tadpoles and finally into tiny frogs.

Newts return to the pond in spring where the male releases transparent capsules of sperm into the water. One of these will be collected by the female newt, as she swims repeatedly over them (her escape barred by the male) until one is taken up internally and the eggs are fertilized. Over a period of several days up to 300 fertilized eggs are deposited, singly, their sticky exterior adhering inside the crease of a folded-over leaf. (The female produces the crease by grasping the leaf edges with her hind feet.) These will soon hatch, developing through the tadpole stage and by late August the small newtlets leave the water to begin life on land. They hide under stones, logs and other moist cover by day, while seeking their prey at night. Despite their best efforts the newt population is in serious decline due to urbanization, agricultural changes, wetland drainage and habitat pollution.

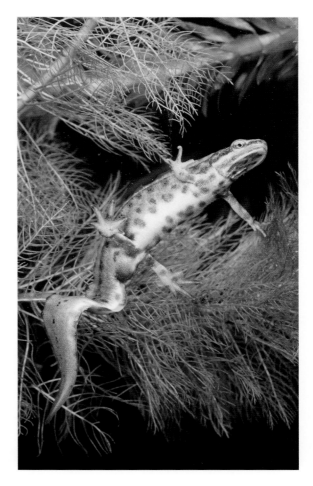

▲ Fig. 4.28
A male smooth newt using its large tail to swim up through the plant material. Flash 1/60sec f16 90mm macro lens. ISO 50

*Photographing the smooth newt
(Trituris vulgaris)*

As newts are now a rare species, I was fortunate to obtain four or five from a newt enthusiast who has several breeding ponds in his garden. In a good season he is able to release many small newts back into local ponds in an effort to re-establish them. The newts were collected with some pond water and kept outside overnight when the cool temperature settled them down. They can then be handled quite easily with cold hands (hold your hands under the cold tap for a minute or two).

The same set-up was used which had served so well for the small fish photograph (the small aquarium described above, but with the glass separator removed, two flash units and so on).

During the photo session I noticed one of the newts clasping some pond weed in preparation for egg laying. This was not difficult to photograph as the newt was too preoccupied with the business of laying the eggs to worry about me or the camera. Finally some action shots were taken by following the newts around the aquarium with the camera pre-focused and supported on a monopod. The latter not only provided some stability but also allowed me to rock the camera back and forth to keep the newt in sharp focus.

After the photography was completed the newts were released into a local pond, in the hope that they might breed and become established.

*Photographing the common frog
(Rana temporaria)*

As frogs are quite abundant in the early breeding season there was no difficulty finding a small local pond containing several very active frogs. Because they were moving I decided to use a monopod rather than a tripod to steady the camera. Note the large webbed feet, which are ideal for swimming during the mating season but of little use on dry land.

▼ Fig. 4.29
A frog showing its webbed feet, ideal for swimming. 1/125sec f16 90mm macro lens. ISO 50

REPTILES

The class Reptilia is represented by around 6,000 surviving species distributed throughout the world, with the majority living in the tropics. Their numbers decline the further north and south you travel from the equator. Europe is not particularly well represented by aquatic reptiles although some snakes do occasionally take to the water. Reptiles are more abundant in the Mediterranean countries, mainly due to favourable temperatures.

Movement using Hydrofoils

Aquatic reptiles such as turtles and terrapins move in the water by means of a hydrofoil – a wing that develops lift in the water in much the same way as an aircraft wing or bird wing develops lift in the air. A hydrofoil boat rises up in the water due to the lift developed by its wing-like structures, while its engine provides forward propulsion.

Turtles and terrapins use their front legs as hydrofoils rather than paddles. In cross section a turtle's front legs (flippers) resemble an aircraft wing, producing the same forces of lift, drag and forward motion. On the downstroke the leading edge of the flipper is tilted slightly upwards producing both lift and forward movement. On the upward recovery stroke the angle of attack and consequently the lift tends to become negative resulting in minimal residual forward motion.

The hind legs are quite powerful and well padded, functioning as paddles during gentle forward movement, but when swimming more quickly they function as a synchronized pair, in a similar manner to the back legs of a swimming frog.

PENGUIN

The wings of a penguin are not unlike the flippers of a sea-turtle and function in a similar way.

Photographing Penguins

The photographs of the penguins were taken at feeding time when the birds were very keen to swim rapidly towards food thrown in by the keeper. I worked from an elevated viewing area allowing me to look down on the pool, resulting in quite an extensive field of view. The camera was hand-held but supported by a monopod for extra stability. Using a 90mm lens set at f8, the exposure was 1/1250sec on the ISO 200 sensitivity setting.

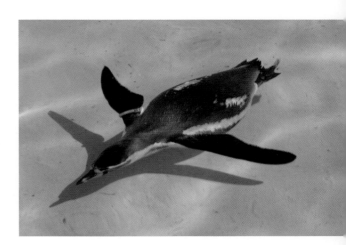

▲ Fig. 4.30
A swimming penguin uses its wings as hydrofoils, while the legs function as a synchronized pair. 1/1250sec f8 200mm lens. ISO 200

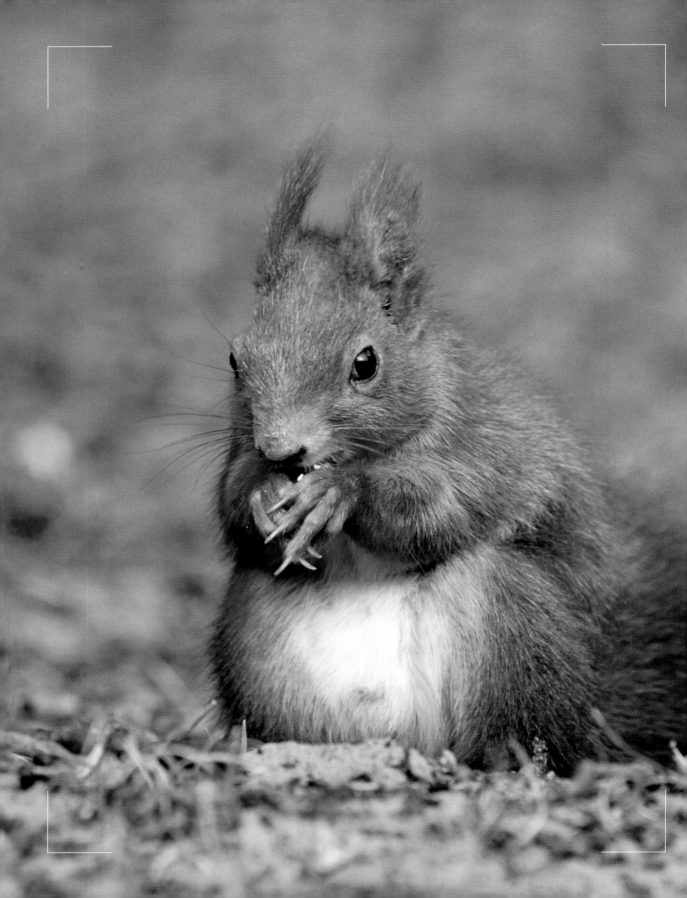

Chapter 5

Animals Restless on Land

There is a huge range of animals in this category, and just a few have been selected to illustrate how restlessness can lead to interesting forms of movement which are necessary if the animal is to obtain food, reproduce and maintain species numbers.

THE EARTHWORM

What better way to start this chapter than by considering the lowly earthworm which is widespread throughout most parts of the world including oceanic islands and subarctic regions. They are particularly numerous in fertile soils containing humus and abundant moisture, inhabiting burrows for protection against enemies and unfavourable climatic conditions. Burrows are almost vertical near the surface of the soil, but they wind and twist down to depths of up to two metres. In heavier soil

▼ Fig. 5.1
The cross-section of an earthworm showing the circular muscles which contract to make the worm long and thin, and the longitudinal muscles which contract to make it short and fat. Wriggling and general movement is helped by the four pairs of minute bristles gripping the ground (after Wheeler).

◄ Fig. 5.0
Red squirrel. 1/30sec f5.6. ISO 100

the worm excavates its burrows by eating its way through the soil, depositing small mounds of well ground-up soil and faeces on the surface as the familiar worm casts. This helps to turn over the soil, facilitating the entry of air and water, and according to Charles Darwin, on favourable sites as much as 18 tonnes per acre of soil can be brought to the surface in a single year – an amazing feat which is difficult to comprehend.

Movement

It is well known that an earthworm moves by wriggling, but this seemingly simple movement is actually a very complex process involving groups of muscles controlled by a well-developed nervous system. The body wall has circular muscles around the outside which on contraction squeeze the worm, which becomes long and thin. Underneath are the longitudinal muscles running the length of the body, and when they contract the worm becomes short and fat. On each segment, except the first and last, are four pairs of minute bristles (setae) which project slightly from the side and under surface of the body. They act as hold-fasts as the worm is moving over the ground or burrowing in the soil. Each body segment is a fluid-filled space separated from its neighbours by a vertical wall or septum.

But how does the worm actually move? The setae at the rear end are extended, holding down the rear, while the circular muscles ahead contract, elongating the worm's body and pushing it forward, being held in position by extended front end setae. The rear setae are then pulled in and the longitudinal muscles contract, pulling the rear end along, while the setae in the segments ahead are extended and hook into the burrow wall or into the surface soil. Once the rear end has been pulled forward the rear setae are extended, locking the rear end, while the circular muscles contract, pushing the body forward. This would appear to be a jerky stop-start movement but the continuous contraction and relaxation of the circular and longitudinal muscles result in a rhythmic wave which travels along the whole length of the body. However, to further complicate matters, this forward rhythm of contractile waves can be reversed (retrograde waves) but the worm still moves forward!

The movement described so far would allow the worm to travel only in a straight line, but if the muscles on one side contract while those on the opposite side relax, the result is the beginning of a wriggle – which only goes to show that there is much more to the earthworm's movement than the very simple wriggle we observe while digging the garden.

Maintaining the Population

Restlessness manifests itself in the worm's reproductive process, where each worm contains both male and female reproductive organs. When preparing to mate two worms come together parallel and head to tail with an overlap of around fifty segments, bound together by a band of mucus (clitellum) between segments thirty-one and thirty-seven. The worms exchange sperm, and after fertilization each worm deposits several cocoons, 5–7mm in diameter, containing several fertilized eggs of which only one develops. This takes several weeks, resulting in a small fully-formed earthworm. Adult earthworms have the ability to regenerate lost segments should they be accidentally cut in half by the blade of a spade.

▼ Fig. 5.2
An earthworm pushing its head through the moss into the soil. The worm was kept in sharp focus by holding the camera back parallel to the ground. Bright but hazy sun provided the lighting. 1/125sec f11. ISO 100

Photographing the Common Earthworm (*Lumbricus terrestris*)

Finding an earthworm for this assignment was straightforward because in wet weather they tend to come to the soil surface. Failing that, turning over a few spade depths of soil will usually unearth one or two. After finding a reasonably sized worm I gently sprayed it with a little water to wash off any soil particles. Holding the camera with the back parallel to the ground I took one or two photographs. The light was quite satisfactory with a bright but slightly hazy sun overhead.

THE SNAIL

The snail is a gastropod (Greek – *gaster* belly, *podos* foot), being widespread and common in gardens, woods and hedgerows in most areas of Britain and Ireland. Its two most conspicuous features are the large muscular foot and the marbled brown and black coiled shell. The soft fleshy head carries two pairs of retractile tentacles, with a pair of eyes on the ends of the larger tentacles, and a terminal mouth. When disturbed the softer parts are withdrawn into the shell using a large muscle extending internally to the spire at the top of the shell.

Movement

The foot, which plays a seminal role in movement, is infinitely more complex and interesting than appears at first sight. It contains a thick horizontal muscle layer from which oblique muscle fibres run down, forwards and backwards into the flattened sole. The foot is also quite spongy, containing many blood-filled tiny chambers (vesicles), which help to make more effective contact with the ground.

Highly viscous mucous secreted by a gland at the anterior end of the foot just below the mouth was originally thought to simply lubricate the sole as the snail moved over the ground. Recent work suggests that the sole does secrete mucous, but depending on the pressure from above this can be either an elastic semi-solid material that holds that part of the sole to the ground or an elastic liquid which helps in lubrication and movement of that particular section of the sole.

When movement occurs the muscles contract, lifting part of the sole very slightly from the ground, allowing the contracted region to move forward. In this way each section of the sole (and foot) is drawn forward and then reattached. When the sole of a snail crawling up a glass window pane is viewed through the glass, the waves of contraction can be seen as dark bands moving forward over the sole and leaving behind the familiar slime trail.

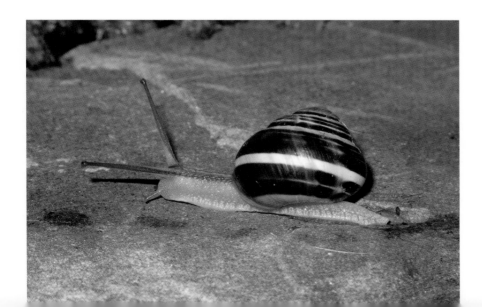

◀ **Fig. 5.3**
The brown lipped snail, taken indoors using the camera's built-in flash and a small supplementary flash placed to the side/behind the subject. A +2 close-up lens was also used. Flash 1/60sec f7.1 macro setting. ISO 80

◄ Fig. 5.4
The underside of the snail was photographed as it moved slowly down a 45° inclined pane of glass. Note the waves of contraction visible as slightly dark bands moving towards the snail's head. Flash 1/60sec f7.1 macro setting. ISO 80

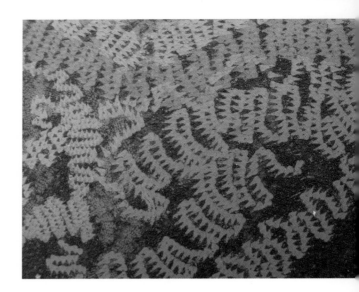

▲ Fig. 5.5
Can you identify this image? 1/125sec f11 macro setting. ISO 100

Reproduction

Each snail contains both male and female reproductive systems, and during mating the penis of each individual is inserted into the female opening of the other, transferring a spermatophore containing sperm. Internal fertilization then takes place with each snail depositing one or more batches of jelly-covered eggs in a damp place or a shallow burrow. Development is continuous over many days with the young emerging as minute snails. Maintaining the species has been achieved, and judging by the number of garden snails around, the reproductive process appears to be highly successful.

Photographing the Brown-Lipped Snail (*Capaea nemoralis*)

The small, attractive brown-lipped garden snail was photographed indoors using a piece of stone surrounded by mosses as a set-up, with a Canon PowerShot G10 bridge camera mounted on a tripod, using the aperture priority setting at f7.1. Diffused low-level daylight was enough to compose the image, but I also used two flash units, one built into the camera providing frontal lighting, and the other, a small Canon flash gun (*see* Chapter 2) positioned to the side/behind the snail to produce some modelling. The small flash unit was not linked to the camera and was triggered by the camera's flash.

With the camera lens on its maximum zoom setting (5×) and in the macro mode, the snail was too small (2.5cm/1in) to provide an acceptably large image, so I simply held a 58mm diameter +2 dioptre close-up lens in front of the camera lens, which enabled me to get closer and produce a larger but sharp image.

Photographing the underside of the snail

The image of the snail's foot and sole was taken as the snail moved down a 45-degree inclined pane of glass. I crouched down in front of the glass, lined up the image and fired the flash. To my complete surprise there were no reflections of me, the camera or the flash, and the image was almost perfect. I suspect the lack of reflections was because I was unintentionally not at right angles to the glass surface. The orange background was the kitchen wall. The image was successful because the waves of contraction, as described in the text, can be seen as slightly dark bands moving forward towards the head of the snail.

Mystery image

Can you identify Fig. 5.5? No-one I have asked could do so, but as it is in this section on snails, it might give you a clue. The background was part of the surface of a huge steel refuse container covered with a continuous uniform layer of minute green plant material. The snail rasped over the surface eating tiny pieces released by the back and movement of its tongue (radula). The snail moved from side to side producing a blue zig-zag pattern and exposing the original blue steel surface before it became covered with the uniform layer of microscopic green algae.

SPIDERS

Why do so many people think that spiders are insects? It is an easy assumption to make because spiders, like insects, are small creepy-crawlies with many legs, moving around in dark places. However, there are important differences. The body of a spider consists of a fused head and thorax and a separate abdomen (that is, two parts) whereas an insect has a three-part body. Spiders have four pairs of legs – insects only three. Spiders have up to eight fairly simple eyes whereas many insects have only two large compound eyes.

Catching Prey

On the underside of the spider's abdomen are the spinnerets producing a sticky fluid that hardens on exposure to the air to form a silky thread. The spider uses this thread to spin a web in which it rests, waiting for its prey to be trapped in the web. Fangs inject chemicals to subdue and digest the prey, after which the juices are sucked into the spider's body.

Spinning an Orb Web

Although the garden spider's orb web is a creation of great beauty and symmetry, it is its construction that is really fascinating. The garden spider's orb web is constructed by attaching silken threads to twigs, to form a Y-shaped frame. More threads are added like the spokes of a wheel, followed by a non-sticky thread spiral working out from the centre. On the return journey the spider eats the first spiral and simultaneously secretes the final sticky spiral thread. An oily substance on the spider's feet prevents it from becoming entangled in its own web. Quite an achievement! Contrary to popular belief, however, there are many spiders that do not spin webs.

Locomotion in Spiders

The walking pattern in spiders does not come from alternately straightening and bending the legs as might be expected, but from swinging them from side to side. The muscles that power these swings are located not in the coxa (the segment nearest to the body) but in the next segment, the trochanter. (The trochanter also houses special structures that allow the limb to be autotomized, letting a trapped or damaged end segment be cast off without causing any loss of blood. When the spider next casts its skin, a fresh leg segment emerges from the stump. The legs are also covered in fine hairs, sensitive to chemicals, touch and air currents.)

Although spiders lack extensor and retractor muscles near to the 'knee' joint, this does not seem to interfere with their movement. Male tarantulas, for example, cover considerable distances searching for a mate during their brief adult life. Researchers at Newcastle University, investigating how a large heavy tarantula can climb up a smooth vertical surface, discovered that the tarantula's feet secrete a sticky web-like substance which allows it to stick to the surface, and on moving, it leaves behind a web foot-print.

Jumping Spiders

Jumping spiders are hunters that move around in a jerky fashion; having found suitable prey, they jump onto the victim's back by quickly and forcibly extending their hind legs. Some of these spiders can jump more than twenty times their own length, but the leg extension is not powered by muscle contraction. Internally the body and legs are immersed in a blood-like fluid, and when the tough head-thorax unit contracts the hind legs are rapidly extended by a sudden peak in hydraulic pressure. It is a puzzle as to how this hydraulic pressure is prevented from ebbing away into the soft abdomen and nullifying its effects. Is there a very fast acting pressure-sensitive valve between the stiff cephalo-thorax and the soft abdomen? As yet we do not know.

Photographing Spiders

As spiders are very small creatures you either have to get very close and use the macro setting on the digital compact camera or, if you cannot get sufficiently close, you can use the zoom lens on your compact camera. An SLR camera without a macro setting on the lens could be used by adding a close-up supplementary lens, an extension tube or a 2× converter. A 90mm or 120mm macro lens producing a life-size image would, of course, be ideal. As for lighting, if photographing outdoors daylight is the obvious choice, supplemented by a little flash lighting if the spider is secreted away under a hedge. Shooting indoors would probably require flash or LED lighting.

Image stability is obviously important, and where possible the camera should be mounted on a substantial tripod. Another method of shortening the shutter speed is to keep turning up the ISO setting, while keeping in mind the noise problem.

▲ Fig. 5.6
This shot of a spider was taken one late autumn evening using room lighting. Note the symmetry of the spider's body and legs, with an imaginary vertical line dividing the spider into two halves, one being a mirror image of the other. Handheld camera. 1/40sec f4.5 macro setting. ISO 200

The house spider

On a late autumn evening a house spider was spotted crawling up the wall above the fireplace. I hastily got my Canon G10 bridge camera, quickly checked that the settings looked reasonable, but before approaching the spider I turned up the brightness level on the room up-light. Handholding the camera with the lens on the macro setting I closed in on the spider, taking a couple of shots before it scurried away. (The flash was turned off as I did not want to disturb the spider.)

▶ Fig. 5.7
The Mexican flame-knee tarantula photographed in a large glass enclosure. Handheld bridge camera. built-in flash aperture priority 1/60sec f5.6 macro setting. ISO 100

▲ Fig. 5.8
Garden spider in its orb web, taken early one autumn morning before the mist had lifted. Tripod-mounted camera set up with the back absolutely parallel to the plane of the web to ensure sharpness across the entire image. A handheld LED torch backlit the water droplets. 1/4sec f16 –1 stop underexposure. ISO 80

The Mexican flame-knee tarantula

The photograph of the tarantula (Fig. 5.7) was taken in a reptile house in Lake Garda, Italy, using my holiday camera – the Canon G10. The camera was handheld with the back parallel to the glass and with my finger keeping the lens from touching the glass and preventing any shutter vibration and noise being transmitted through the glass and possibly disturbing the spider. As the light level was quite low I used a small amount of flash to brighten up the image.

The garden spider and its orb web

The best time to photograph spiders' webs is on a misty or foggy autumn morning before the sun has broken through and while the web is still covered with minute water droplets.

A web tilted at about 15° to the vertical, allowed me to point the camera down slightly to include an acceptable background. A range of lighting was used including daylight, followed by flash to backlight the web. Finally a small video light was held at varying distances behind and above the web, again providing backlighting. Several exposures were made at f16 with the camera tripod-mounted and the shutter triggered using a remote release.

If the web is drying out, very fine water droplets can be sprayed on it, using a houseplant mist sprayer. Direct the mist well above the web, allowing the droplets to float down onto it; direct spraying will damage the web.

THE VERTEBRATE LIMB

It was assumed that once fish began to leave the water for brief periods, moving about in a similar way to a modern mudskipper, the two pairs of fins would be too delicate, lacking the strength and musculature necessary for life on land. However, research by the world renowned palaeontologist, Professor Jenny Clack, based on fossil evidence unearthed in Greenland, has indicated that during the Devonian Period, some 400 million years ago, some fish had clearly developed non-load-bearing legs complete with toes and fingers, which were used to push their way through aquatic plant material as they moved through the swampy water in search of food (see Fig. 7.11).

Slowly the vertebrate legs evolved in today's amphibians (and most reptiles). The bones in the arm and leg and nearest to the body (humerus and femur respectively) are horizontally positioned, while the rest of the limb (radius-ulna, tibia-fibula) is more or less vertical. The legs are not particularly strong or muscular, and movement is produced by sideways flexing of the body (not unlike fish movement) with the legs simply raised and put down in appropriate positions, making the movement slow and lumbering. As the body flexes, the fore and hind limbs on the inside of the curve almost touch, while the limbs on the other side are spaced well apart – a forerunner of movement in reptiles and mammals.

▲ Fig. 5.9
The slow ponderous sideways flexing of the newt's body (reminiscent of the fish ancestors) brings the limbs on the inside body curve almost in contact with each other, while those on the other side are spaced wide apart. Monopod-mounted camera. 1/30sec f8. ISO 100.

▲ Fig. 5.10
A crawling toad adopts much the same leg positions as the newt, but its bulkiness does not allow much flexing of the body. Hand-held camera. 1/60sec f11. ISO 100

SMOOTH NEWT (*TRITURUS VULGARIS*)

Newts spend most of their lives out of water, living in damp places among dead leaves and under stones, keeping their soft glandular skin moist. At night throughout the summer months they are out hunting for prey, while during the winter they hibernate. We have already considered the importance of the newt's tail in swimming, but on land the tail is really quite a hindrance, being dragged along like a spare part.

Photographing a Crawling Newt

I borrowed a couple of newts from a friend who has several hundred in his breeding ponds, carrying them home in a plastic box containing pond weeds and a little pond water. While I was there, as the bright sunlight was rather contrasty I photographed a newt in the shade just outside the back door. I would normally use a tripod to support the camera but as the newt was moving I had to make do with the camera mounted on a monopod, using a 90mm macro lens on the camera. The exposure was 1/30sec at f8 on the ISO 100 setting.

THE COMMON FROG (*RANA TEMPORARIA*)

Frogs, like newts, spend most of their life on land, looking for damp situations which help to prevent their moist skin from drying out. This is important because all amphibians can breathe through their moist skin (cutaneous respiration) and mouth cavity, which supplement respiration through their small thin-walled lungs.

However, evolution of the frog skeleton and movement has taken a rather different route from most other amphibians, in that the skeleton is semi-upright, and although the front legs are typically amphibian and similar to a newt or salamander legs, the back legs are rather different. The pelvic girdle is a stout, rigid V-shaped structure which connects the back legs to the backbone, transmitting the power of locomotion from the hind limbs to the body. The leg bones (femur and tibia/fibula) are extremely elongated, while the foot (tarsus and metatarsus) is greatly extended. Finally, the long webbed toes (phalanges), used so successfully in swimming, are of little advantage on dry land.

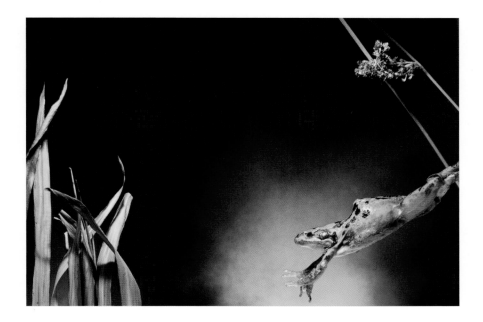

◀ Fig. 5.11
The leopard frog, which eventually leapt towards the maggots, breaking the infra-red beam and triggering the camera and flash unit. Tripod-mounted camera. Flash f16 90mm macro lens. ISO 100

A frog occasionally moves in an ungainly fashion by waddling along like a toad (*Bufo bufo*), although hopping is its main method of locomotion. When a hop increases in length and height it becomes a leap, and frogs are adept in making long leaps, either across the ground or into or out of water, usually to catch small insects, using their long sticky, frontally attached tongues. Leaping is second nature to the tree frog (*Hyla cinerea*) with its adhesive pads on the ends of its toes, which are used not only to climb trees but also to leap from branch to branch.

Newts and frogs are patently restless animals, and to increase their numbers and to colonize new ground they reproduce in relatively large numbers, providing at least some with a chance to become the next generation (*see* Chapter 3).

Photographing a Leaping Leopard Frog

In my work using the flight tunnel to photograph butterflies, moths, bees and the tree frog, the subjects are usually flying the length of the tunnel towards the camera. For the leopard frog I decided to try a side-view with the frog moving across the field-of-view of the camera (in normal photography this would be a panning shot).

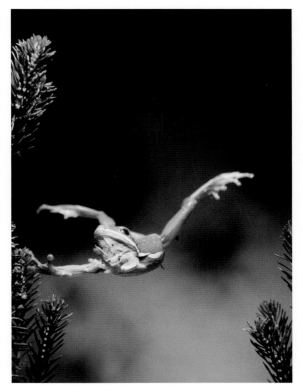

▲ Fig. 5.12
The little tree-frog in the flight tunnel, placed on a small platform quite high up at the far end of the tunnel with maggots supplied as food. Tripod-mounted camera. multiple flash f.16 50mm macro lens. ISO 100

The open set consisted of a board approximately 35×25cm (14×10in) with plant material at both ends. A blue, paint-sprayed background board was used to simulate the sky. The Jama infra-red triggering unit was located quite high on the side nearest the camera, beaming down to the receiver unit at ground level at the other side but below the image in the camera viewfinder (that is, well out of frame).

A powerful Metz 45 flash unit (GN 45 at ISO 100) was arranged to provide high 45-degree frontal lighting but not allowing any shadows of the frog to fall on the background board. The camera was mounted on a substantial tripod and manually focussed on an object, held in what I hoped would be the frog's flight path. With the macro lens set at f16 I was ready to go – but was the frog?

The main problem was not only getting the frog to leap, but to do so along the pre-determined flight path, resulting in a sharp, in-focus, in-frame image. I carefully placed the frog on a small platform about halfway up the right hand side of the set, with a small tray containing blowfly maggots at the left hand side towards ground level. The frog seemed mesmerized by the maggots, and after about ten minutes it made a sudden leap, which unfortunately did not break the beam and trigger the flash unit and camera shutter. Several more attempts were made but only four triggered the flash unit, of which only one was pin sharp. Unfortunately the webbed feet were out of frame, although the focus, lighting and general position were all satisfactory. The frog was then returned to the pond.

REPTILES

Reptiles (from the Latin *reptilis* – creeping) are more often referred to, not unnaturally, as belly crawlers, and the group includes snakes, lizards, geckos, crocodiles, turtles and tortoises.

In common with the amphibians, all reptiles are cold blooded (poikilothermic) requiring an external temperature of around 15°C before they emerge from their hiding place. Reptiles bask in the sun absorbing radiant heat until they become fully active at between 20°C and 40°C depending on the species.

Unlike amphibians, the reptilian life-cycle is completed on land, although sea turtles lay their eggs on land but after hatching the tiny turtles return immediately to the sea.

Locomotion

As the sun rises and air temperatures increase, reptiles become active, leaving their protected hiding places to find food and, in the breeding season, to mate.

The tailed reptiles such as lizards, geckos and chameleons move in a similar way to newts, using slow, fish-like movements. As the body flexes the legs on the inner side are brought fairly close together, while the legs on the opposite side are spaced well apart. For one of these animals to remain in equilibrium it must have three legs on the ground at any moment; otherwise it will, theoretically, topple over. Also, to stay upright, the centre of gravity must be located somewhere inside the triangle formed by the three legs. However, falling over is unlikely to occur in flat-bellied reptiles during normal day-to-day activity (these requirements do not apply to fast-moving, leaping mammals which will be discussed later).

A tortoise has a heavy, solid shell and as a consequence its movement is slow with uneven pitching, rolling and yawing, mainly because it lacks any quick-acting muscles to counteract changes in equilibrium. However, these slow-acting muscles are very energy efficient, which is a distinct advantage to any slow-moving animal having to spend time, and therefore energy, searching for food.

Snakes, on the other hand, are legless with no limb girdles or breastbone, but with a plentiful supply of ribs and connecting muscles extending the whole length of their bodies. The graceful, sinuous movement in snakes is initiated by backward pressure of the rear lateral ribs against irregularities in the surface of the ground. Once the rear end has been anchored, forward movement is produced by securing, section by section, the body and ventral scales to the ground and then releasing them in a smooth, rhythmic way, producing a straight line track.

The sidewinder or horned rattlesnake progresses by a curious looping of the body at right angles to its path of travel, leaving behind parallel lines almost at right angles to the direction of travel.

Photographing Reptiles

A convenient place to photograph exotic animals and plants from the hot regions of the world is in a purpose-built tropical house; these heated, humidified buildings are low on visitors during the winter, providing an ideal opportunity for the nature photographer to work undisturbed.

The tropical house does present a few difficulties, however. The first concerns the instant misting-up of the lenses, camera eyepiece, and even the camera, as you leave the cold winter air and enter the humid tropical house. This must be avoided at all costs. Keep all the equipment on the car floor next to the heater to warm it up, and then carry it quickly, in an insulated holdall, into the tropical house.

In temperate and cold regions most reptiles, with the exception of tortoises and terrapins, are kept behind glass. The next problem, therefore, is how to photograph them without including unwanted reflections from the glass surface. The best method is to keep the camera lens almost flat to the glass. The cleanliness (or otherwise) of the glass can compromise image quality, so always be prepared with a little window cleaning fluid.

For lighting I prefer to use a flash, allowing me to use the camera without a tripod. In this case, as I was working solo and needed both hands to hold and focus the camera, I had to attach the flash unit to the top of the camera, resulting in somewhat flat frontal lighting. The same would apply if I had been using the built-in flash unit. Although the camera lens must be flat to the glass, you should tilt the

◄ Fig. 5.13
For obvious reasons reptiles such as this water dragon are often referred to as belly crawlers. The upper part of each leg is horizontal, giving the reptile a large base for increased stability, although this is hardly necessary. Photographed through glass. Flash f16. ISO 100

flash unit down slightly to avoid a direct reflection from the back of the enclosure which, if shiny, will produce a hot spot on the image. If you are using a digital compact camera with a built-in flash, tilting the camera down very slightly will usually solve the problem.

Maintaining Species Numbers

All reptiles (except sea turtles) complete their life cycle on land without any intermediate aquatic stage. Fertilization is internal, with most reptiles depositing their fertilized eggs in natural cavities, vegetable debris or in earth or sand.

The eggs, which have a tough flexible shell, vary in number from around 400 in the sea turtle, to ten to twenty in small snakes and lizards, and a single egg in a house gecko. The development period varies from a few weeks to several months depending on the species. Prior to hatching, a hard egg-tooth grows on the tip of the upper jaw (as in birds) and is used to cut open the shell to liberate a minia-ture, fully-formed adult. Some lizards and snakes are viviparous, producing fully formed young.

▲ Fig. 5.15
The corn snake, widespread in the United States and Northern Mexico, photographed in a reptile house coiled around an old wooden wheel. Hand-held camera. Flash f6.3 90mm macro lens. ISO 100

▼ Fig. 5.16
The corn snake's flexible, ribbon-like tongue with its forked tip extended through a notch in the lower jaw even when the mouth is closed. It helps its sense of smell, bringing chemical stimuli to Jacobson's organ in the nasal cavity. flash f16 90mm macro lens. ISO 100

◄ Fig. 5.14
A tortoise making a slow laborious attempt to climb over another tortoise. The slow-acting but energy efficient muscles are useful in an animal that has to spend so much time, and therefore energy, searching for food. Hand-held camera in dull daylight. 1/60sec f5.6. ISO 400

MAMMALS AND MOVEMENT

Mammals have two very important advantages over reptiles: a high fixed body temperature (homoio-thermic) and internal development of the young. The controlled body temperature allows the body's chemical processes to proceed at a high rate all the year round (except in winter-hibernating mammals), making them efficient and active in cold conditions and allowing them to colonize areas of the globe which would be too cold for reptiles. The full development of the fertilized eggs inside the mother, with the young born fully formed, has replaced the wastage of external egg laying. During the early months after birth the young are fed on a balanced liquid food in the form of mother's milk, while being closely protected by the mother.

Movement is fundamental to animals finding food, avoiding predators and seeking a mate. Whereas in reptiles the legs, both back and front, extend almost horizontally from the sides of the body, merely acting as supports for the side-to-side flexing of the backbone and trunk, by contrast in

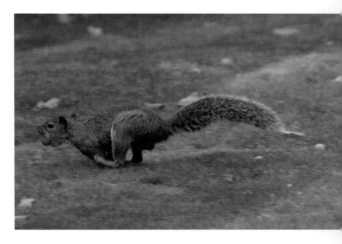

▲ Fig. 5.18
A grey squirrel moving swiftly with a stolen nut, eager to escape from possible rivals. 1/320sec f4.5. ISO 400

quadruped mammals the limbs hang vertically from under the body and in most cases raise the body well up from the ground. This highlights the problems of balance and stability, which are controlled by a highly evolved fast-acting balance system, preventing the animal from falling over. In a stationary four-legged mammal, three legs should be touching the ground at any one time, and the centre of gravity should be inside the triangle formed by the three legs.

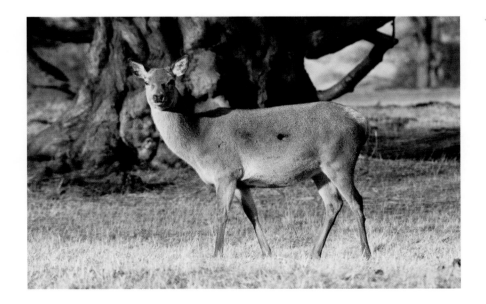

◀ Fig. 5.17
A roe deer, which has just paused momentarily to observe me, demonstrates the leg positions – the spread near ones and close-together far ones – as seen in amphibians and reptiles. 1/125sec f11. ISO 100

In normal walking and trotting the leg positions of mammals are quite similar to those seen in reptiles in that as the body flexes slightly, the legs on the inner side are brought close together, while those on the outer side are spaced well apart. As the animal moves forward the body flexes the other way as each leg takes a step forward. This is much easier to appreciate from the photographs.

Fast Running and Bounding Movement

When an animal is bounding along, the balance changes in a split second from stable to unstable equilibrium and back again, but the sheer forward momentum prevents the animal from falling to the ground at the point when all four legs are clear of the ground.

When a quadruped such as a dog or horse is leaping, the muscular back legs do practically all the work, raising and launching the body forward with the front legs outstretched and thrown ahead, clear of the ground. The rear legs are retracted and brought forward, almost touching the front legs as they make contact with the ground again. The rear legs are now ready to push the body and the whole process is repeated.

Factors that control the length of the stride, and therefore the speed, are the length of the legs and body and the degree of flexure in the spine. When the spine is flexed upward, the front and hind legs are not only brought close together but can actually overlap. A downward curvature of the spine allows maximum stretch between the front and hind legs resulting in longer leaps and faster movement. A gazelle has a long flexible spine and fast movement, while an eland, a large ox-like antelope has a heavy inflexible spine and a restricted, more stately gait.

As the feet touch the ground they function as shock absorbers, helping to soften the landing. Energy is absorbed as the tendons and ligaments are stretched, and is stored as elastic strain energy which is released as the foot recoils to begin its new cycle.

THE WORK OF EADWEARD MUYBRIDGE

Eadweard Muybridge, who was born in Kingston-upon-Thames in 1830 but spent most of his life in Philadelphia, USA, radically changed the way we understood animal and human movement. He set up a row of twelve (later twenty-four) cameras with each shutter mechanism attached to a string, and as the horse galloped past the string was broken and a photograph was taken. This method was unreliable and was replaced by an electro-magnet attached to the shutter. The photographs were taken against a time/distance background. He designed a very early focal plane shutter (exposures up to 1/2000sec) and the famous motion picture zoopraxiscope.

Photographing a Running Dog

These days to produce a series of photographs of horses or dogs running I used a digital SLR camera capable of exposing three frames per second. Ideally the best way to produce a photographic sequence of a running dog would be to stand in the centre of an imaginary circle and have the dog literally run circles round you, thereby keeping the dog equidistant from you and therefore the same size and in focus. An interesting idea but hardly realistic!

In the local park I spotted a lively dog and asked the owner if I might photograph it. Standing some thirty metres away I beckoned to the owner to throw the dog's ball, not towards me, but parallel to me some twenty metres away. I followed the running dog in the camera viewfinder and when it was almost opposite me (that is, sideways on) I released the shutter (set on continuous advance), taking a series of shots as the dog raced by.

The camera settings were the usual compromise between a small lens aperture for sharpness and depth of field and a short shutter speed to freeze the movements of the dog, particularly its legs and feet. I set the 210mm zoom lens almost wide open at f4.5, producing shutter speeds ranging from 1/2000sec to 1/1500sec (the sun kept going in and coming out) which were sufficient to freeze the movements of

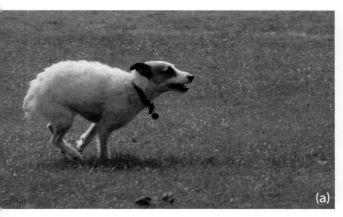
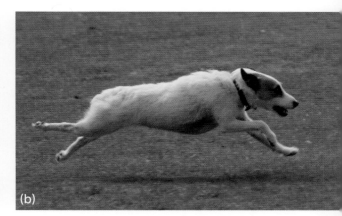
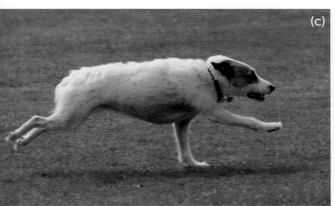
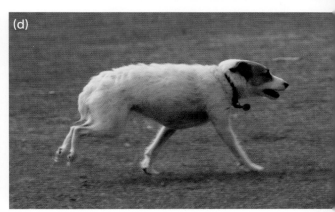

▲ Fig. 5.19a–d
These photographs were taken in a local park with images selected to illustrate the leaping process. (a) The dog's back legs provide the power to push the body forwards and upwards. (b) The front, back legs and body fully stretched as the dog moves through the air. (c) Returning to the ground, the front legs begin to take the body weight, while the back legs are still well clear of the ground. (d) The front legs are about to take the weight of the body, as the back is curved slightly upwards, while the powerful back legs are being brought forward ready to start the next leap. 1/1000–1/2000sec f4.5 210mm lens. ISO 200

the running dog. An ISO setting of 200 ensured a noise-free image and the camera was handheld. The photographs show the dog in various positions during its running cycle.

Red Fox at Night

Photographing a wild urban fox at night was never going to be easy. It started some weeks earlier when I noticed the occasional night-time passage of a fox across the bottom of the garden. Not one to miss an opportunity of observing and enjoying more wild-life, out went the food every evening at dusk. When the routine was fairly well established I decided to make a start on the photography.

The camera was set up in the garden shed at right angles to, and six metres from, an imaginary line three metres long, with a white marker (small plastic bottle) at either end. The camera was focused on a fox-sized box placed in the centre of the line, with the zoom lens adjusted so that the markers were just out of the frame.

Flash lighting was provided by two Metz 45s secured two metres up a flowering cherry tree, four metres from the centre of the line. Another pair of flash units providing some frontal lighting were

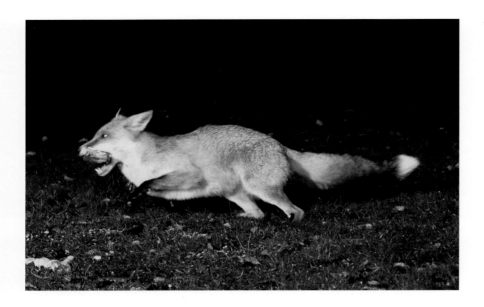

◄ Fig. 5.20
The fox moving swiftly across the garden, picking up the food and using its strong back legs launched itself across the garden. Multiple flash f8 −2 stop underexposure. ISO 200

attached to the side of the shed, two metres high and six metres from the line. Finally the food was placed in the centre of the line with the camera already pre-focused on it. (This was the final arrangement; earlier flash positions must have been too close to the food, as the fox was extremely cautious and would not come sufficiently close to snatch its evening meal.)

In the end, after several unsuccessful attempts, I wondered whether sitting in the shed with the door partially open was alarming the fox, so I removed myself completely, operating the camera and flash units from an upstairs bedroom some thirty metres away using a short range radio remote control unit (maximum range 40m, response time 0.2sec). It was very dark and I could hardly see the white markers. From this high vantage point and with the help of a pair of 7×50 binoculars (which provided a useful level of night vision), I could just about see when the fox was inside the markers and on the imaginary line and therefore, hopefully, in focus. It took a long time and a number of abortive sessions to produce a few good photographs.

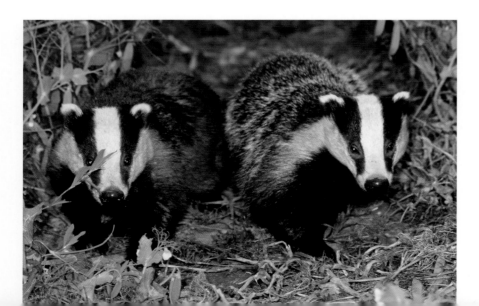

◄ Fig. 5.21
A pair of badgers trundling along a well-worn route into a field of peas. A twilight shot lit using a pair of Metz 45 flash units, triggered from a tripod-mounted camera. Multiple flash f8 150mm lens. ISO 200

▲ Fig. 5.22
The gerbil is looking for food; some of the leg muscles are in constant tension making this position difficult too maintain for more than a few seconds. The set-up was lit using a semi-backlight flash and a weaker frontal flash. Flash f11 −2/3 stop underexposure 90mm macro lens. ISO 100

▲ Fig. 5.23
A meerkat standing bolt upright on sentry duty; the centre of gravity runs down through its body to the extended feet, ankles and tail producing a triangle of stable support. 1/60sec f8. ISO 200

Crouching, Standing Upright and Climbing

The crouched stance of some small mammals such as mice, gerbils and hamsters is aided by the extended ankle and foot bones, which provide a proportionately larger base to support and balance the body. The leg muscles are in constant tension, which would be very expensive in energy requirements for large heavy animals because of their proportionately greater weight. However, the crouch does prepare these small rodents for speedy action by either running or jumping.

◀ Fig. 5.24
A young red squirrel climbing up a pine tree, its weight taken mainly on the strong hind legs and claws while the front legs and claws provide extra support, preventing the squirrel from losing contact with the tree trunk. 1/250sec f8 250mm lens. ISO 200

Small mammals such as meerkats when on sentry duty or grey squirrels when looking for food or enemies, stand upright, using their extended feet, ankles and tail to produce a triangle of stable support.

BIPEDAL MOVEMENT

Most primates, such as gorillas, chimpanzees and orang-utangs, are semi-erect and are chiefly tree dwellers, but evolution eventually produced the human species which habitually walks upright, using the hind limbs for locomotion and the fore-limbs (mainly the hands) for manipulation of tools, food and objects generally.

Does a person walking with the arms swinging bear any resemblance (albeit rotated to the upright position) to the way amphibians and reptiles move? I tried to investigate this theory by photographing someone walking, and analyzing the results. When we walk fairly briskly swinging our arms, the

right arm swings forward as the right leg moves backward, resulting in a large distance between the extremities of the arm and leg. At the same time the left arm swings backwards, closing in on and passing the almost stationary left leg. During normal walking the hips and shoulders swing from side to side and I can see some similarities to locomotion in amphibians and reptiles.

Disadvantages of Being Upright

There is no doubt that as man evolved he developed a wonderful brain with the capacity for reasoning, creativity and the power of speech. However, the bipedal upright posture brought with it many residual problems.

The weight of the body is carried vertically through the backbone, compressing (and occasionally displacing) the intervertebral discs and sometimes putting pressure on nearby nerves, causing back and leg pain. Similar pain can be caused when the lower back vertebrae are slightly displaced due to the immense pressure from above.

The weight of the organs and the rib cage located in front of the backbone tends to bend it forward, and as the posture muscles weaken with age, the upper part of the backbone begins to lean forward resulting in the familiar stoop in the elderly.

The blood system also suffered as its position moved from an efficient horizontal location in quadrapedal mammals to a vertical one, with the heart quite high up in the body. Blood returning from the lower regions including the legs has an uphill battle getting back to the heart. Valves in the veins prevent the blood from dropping back, but due to pressure from above, valves can leak or occasionally fail, and the walls of the veins stretch and bulge resulting in varicose veins. For the same reason the veins in the rectal and anal regions (where there are no valves) distend, producing haemorrhoids (piles).

▼ Fig. 5.25
When a human walks up a slope, the far arm and leg are spaced well apart, while the nearside ones are quite close together. The hips and shoulders swing from side to side – perhaps reminiscent of horizontal locomotion in amphibians and reptiles but turned upright. Handheld camera. 1/160sec f4.5. ISO 200

◀ Fig. 5.26
In humans the balance system is located in the three semi-circular canals, deep in the inner ear and linked to the balance centre at the base of the brain. The result is an extremely efficient, split second response system, as seen in this rugby match. 1/320sec f4.8. ISO 200

Balance: Staying Upright

Walking upright on two legs requires an extremely well-developed sense of balance. When standing still, in order to remain balanced, the centre of gravity should lie inside the small area outlined by the feet, although when walking the centre of gravity moves continuously through the space between and beyond the feet.

The balance system is located in the three semi-circular canals deep in the inner ear, which contain a fluid (endolymph). When the head moves the fluid presses on sensitive hair receptors which carry nerve signals to the balance centres located in the cerebellum at the base of the brain, just above the top of the spinal cord.

The system is extremely well developed; witness the incredible control of balance in gymnasts, acrobats and sportsmen. As an imbalance begins to develop, corrective action is immediate (milliseconds) and balance is restored. Occasionally the system can be caught literally off-balance – when, for example, someone accidentally bumps into you quite heavily from behind and knocks you off your feet before the system has had time to respond. Yet events like this are quite rare and for more than 99.9 per cent of the time the balance system works remarkably well.

Chapter 6

Plants Borne on the Wind

◀ Fig. 6.1
A mixed collection of moulds (micro-fungi) including the blue/green *Penicillium notatum*, easily cultured by placing some damp bread in a warm dark environment. 1/5sec f22 50mm macro lens on bellows unit. ISO 50

The effect of air currents and the wind on the dispersal of plant spores, pollen, fruits and seeds creates some of nature's most beautiful images.

In simple plants, such as moulds, puff balls and ferns, the spore is the main unit which allows the organism to increase in numbers and colonize new ground. As the plant kingdom becomes more complex we see that a two-part process must occur if the plant is to survive, reproduce and spread to new areas. Pollen (male units) must be produced and transferred to the stigma at the top of the pistil (female part). After successful pollination and fertilization, the fruits and seeds develop and are dispersed.

Here we will discuss the dispersal mechanism of the creeping thistle and ragwort, whose parachute seeds can be carried many kilometres on normal air currents; the seeds of the red campion, which are heavier, being flung out of the seed box by the wind, and may travel some distance; and the winged seeds of the sycamore and lime, which are quite heavy and spin to the ground but can be transported several metres on a windy day.

◀ Fig. 6.0
Silver birch dispersing pollen. Flash f16 −1 stop underexposure. ISO 100

SIMPLE PLANTS

Fungi, Moulds and Ferns

Fungi appeared very early in the evolution of the plant kingdom, making their appearance some 400 million years ago, yet many are still around today; witness the widespread distribution of moulds, mushrooms, toadstools and their relatives. Fungi differ from the rest of the plant kingdom in not possessing leaves or chlorophyll and in reproducing by means of spores. The group also includes mildews, yeasts, puffballs, and mushrooms and toadstools.

As fungi have no chlorophyll and therefore cannot make their own food, it must come from other sources. Fungi are either saprophytes living on dead organic matter or parasites, living on animals and plants. Some 50,000 different species have been identified and described, and although some are edible many are highly poisonous. Here we shall consider the blue-green *Penicillium notatum* and the common puffball, *Lycoperdon perlatum*.

*A common mould (*Penicillium notatum*)*

The spores of moulds float about in the air, settling on all surfaces and requiring only a suitable substrate, moisture, and a little warmth, to germinate and produce the moulds so familiar to us all.

Growing moulds

Moulds grow well on bread, and a useful technique to produce a variety of moulds is to moisten a cube of bread about 5cm (2in) square, wipe it across the kitchen table, place it on a saucer and after about a day cover it with a glass jar to retain the moisture. In a few days moulds, which came either from the surface of the table or from the air, will begin to appear, and after two or three weeks the bread will be completely covered. Bluish-green penicillium moulds also grow well on fruit, particularly oranges and melons, and on cheese.

PENICILLIUM NOTATUM: THE HISTORICAL PERSPECTIVE

In 1928 a Scottish bacteriologist, Alexander Fleming, discovered the anti-bacterial properties of *Penicillium notatum*, but failed to realize its true potential. Some years later Howard Florey an Australian pathologist, and the German biochemist Ernst Chain, both working in Oxford in 1940, isolated the active ingredient, penicillin. Large quantities were hastily produced, saving many lives during World War II. In 1945 all three were jointly awarded the Nobel Prize for Medicine. Since 1941 numerous other members of the penicillin family have been discovered, and it is still used today although the increasing resistance of pathogens to penicillin, plus allergic reactions in some patients, has slightly reduced its use.

Penicillin, which grows on damp bread, cheese and leather, consists of fine microscopic threads (hyphae) and under favourable conditions aerial hyphae grow up from the surface. A number of branches arise from each tip, giving the appearance of a microscopic sweeping brush or besom and from each branch chains of spores develop. These become detached and are carried away in the air, germinating when they come to rest on a suitable surface.

Growing and photographing penicillium is not difficult and you can, in a very simple way, retrace the footsteps of Fleming, Florey and Chain.

▼ Fig. 6.2
A tiny amount of mould was placed on a slide with a drop of water and a protective coverslip. After much searching I discovered some *Penicillium* (Latin – brush) surrounded by many spores, which would normally be carried on air currents. 1/2sec magnification x240. ISO 50

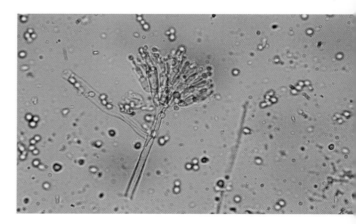

If you want to grow pure cultures of moulds, the method used by professional micro-biologists consists of using a food-enriched substrate called nutrient agar, and inoculating it with a little of the fungus to be cultured. There are many types of agar, each being designed to encourage the growth of a particular group of micro-organisms.

Photographing penicillium through the microscope

To photograph penicillium I used the microscope set-up described earlier (see Chapter 4). Remove a little of the blue-green mould from the growing surface (using a mounted needle or similar instrument), transfer it to a slide, adding a drop of water and cover it with a coverslip. The material can then be examined by normal transmitted illumination using the lowest power available.

When some interesting material has been discovered, switch to high power (in my case ×6 eyepiece and a ×40 objective lens = 240× magnification) and continue examining the material. With the camera body attached to the eyepiece of the microscope (via an adapter tube) an exposure can be made using the built-in transmitted illumination.

The Common Puff-Ball (*Lycoperdon perlatum*)

Like most fungi, the puff-ball consists of a network of underground threads (hyphae), and lacking any chlorophyll they absorb nutrients from the decaying plant material on which they live.

The puff-ball grows in pastures and grassy areas of woodland. The visible part above ground is the fruiting body containing millions of microscopic spores. At first off-white, but soon becoming brownish, the puff-ball has an inverted pear-shaped body up to 8cm (3in) tall and approximately 4cm (1½in) across. The young developing puff-ball body is covered with fragile spines, each surrounded by a ring of smaller warts. The spines soon fall off or are rubbed off leaving a network of small, warty projections.

▲ Fig. 6.3
The puff-ball was backlit using a quite powerful flash to the right. A gentle squeeze on the tapper released a cloud of spores and almost simultaneously the shutter was released. Flash f22 50mm macro lens −1 stop underexposure

The developed spores, numbering many millions, are dispersed as a fine brown powdery cloud through a pore which develops on the top of the fruiting body. Disturbance of the ripe puff-ball by wind or animals is sufficient to emit a cloud of spores which are carried away on air currents. On finding suitable ground they grow a network of fine hyphae, absorbing nutrients from the dead plant and animal material on which they have landed.

Photographing puff-balls

The puff-balls were discovered on the edge of a local wood one morning in early November. A cluster of three, plus the surrounding earth and leaf litter, was carefully dug up and transported home. It was arranged with the more powerful flash unit placed 30cm (12in) above and slightly behind the puff-balls (backlighting), with the less powerful flash positioned at subject level 60cm (24in) to the right and slightly in front. The background board was then placed some 60cm behind the puff-balls.

Spore dispersal can be initiated by tapping the puff-ball with a pencil or by setting up a mechanical tapper behind them. I opted for the tapper, using an off-the-shelf- pneumatic shutter release unit. The only modification was to attach a small button (or cardboard disc) approximately 5mm in diameter to the end of the narrow rod which normally triggers the camera shutter when the rubber ball is squeezed; the disc taps the puff-ball causing it to release a cloud of spores. Almost simultaneously the cable release was pressed, tripping the camera shutter and firing the flash units.

The 50mm macro lens was set at f22 for maximum depth of field and on aperture priority with the exposure reduced by 1 stop to ensure a well-exposed transparency. Kodak Ektachrome 64 film was set at ISO 80.

Photographing the spore cloud could be tackled using a digital compact camera. A small slave flash unit positioned slightly above and behind the puff-balls could be triggered by the camera's small, built-in flash. As the slave flash fires at full strength each time, it would have to be moved nearer or further away from the puff-ball to obtain a satisfactory balance of the lighting.

Great Scented Liverwort
(*Conocephalum conicum*)

Liverworts are small structurally simple plants with no highly developed system for transporting nutrients and water up and down the stems. In Britain there are approximately 280 species, which grow in damp, clean air regions away from towns.

Liverworts are members of the class Hepaticae (that is, belonging to the liver). The great scented liverwort has a ground-hugging leaf-like thallus, thought to resemble lobes of liver. (In early medicine, according to the Doctrine of Signatures, any plant resembling a human organ was often used to treat diseases of that organ.) The thallus is covered with raised pores clearly visible to the naked eye, and when the thallus is bruised or damaged it emits a very pleasant odour generated by oil-producing cells in the thallus.

▼ Fig. 6.4
The great scented liverwort growing in a damp spot on a river bank. The bright but slightly hazy sun nicely lit the plants, highlighting the slender stems. 1/125sec f4.5 50mm macro lens. ISO 100

Any detached fragment of the thallus can grow into a new plant if conditions are favourable. Sexual reproduction takes place in early spring with male and female organs on the same thallus. The presence of a thin film of surface moisture allows the microscopic male spermatozoids to swim to the female archegonia, fertilizing them. Each develops into a spore-producing organ (sporogonium) which grows a translucent stalk (seta) capped by a conical fruiting body (capsule) containing spores. The base of the capsule splits into sections (valves) liberating the spores, which are dispersed, eventually growing into new plants.

Photographing the great scented liverwort

The photograph of the great scented liverwort (Fig. 6.4) was taken on the edge of the river Wharfe near Bolton Abbey in North Yorkshire. The liverwort plants were growing on rocks a metre or so from the edge of the river leaving me little room to manoeuvre. It was quite a bright day with the hazy sun to the right and slightly behind the plants, allowing the translucent setae to be highlighted against the darker background. Working near ground level I set the 50mm macro lens aperture at a fairly wide f4.5 to throw out of focus the otherwise distracting background. The camera was handheld using an exposure of 1/125sec, f4.5, ISO 100.

Ferns

Ferns exhibit a wide variety of detailed structure, both at life size, and when examined in close-up. Most can be recognized by their characteristic leafy frond, as seen in the common bracken (*Pteridium aquilinum*), where the gentle curve of the frond is one of its most obvious and attractive features. There are one or two exceptions: the hart's tongue fern (*Asplenium scolopendrium*) has a simple undivided leaf, while some of the marsh ferns have clover-shaped leaves, and the water ferns are free-floating, quite unlike the bracken with which we are all familiar. The tree ferns of subtropical regions have well-developed stems maturing into sturdy trunks.

▲ Fig. 6.5
The curled head of the small bracken leads the eye up to the well-lit fronds of the taller plant. The dark shadowy background towards the top of the frame helps to highlight the backlit fronds. 1/125sec f11. ISO 64

Ferns, in common with all living organisms, are always trying to extend their territory and colonize new ground, through both asexual and sexual reproduction. The forerunner of a new frond develops behind the growing point towards the end of an underground rhizome. Once it appears above ground the frond gradually uncurls to produce the familiar fan-like fern frond. This is vegetative (asexual) reproduction and no sex cells are involved. On the underside of the frond reproductive spores begin to develop in spherical sacs, and in dry

weather the top of the sac (sporangium) ruptures liberating the spores, which are dispersed by air currents. This spore bearing plant is referred to as the sporophyte generation.

In damp conditions the spores develop into tiny heart-shaped structures (prothallus) with the reproductive organs forming on the underside. This is the gametophyte generation. The male sperm swim in the surface film of moisture, fusing with an egg cell to form a zygote which develops immediately, putting down roots and growing into a new fern plant. In the life cycle of the fern we have an alternation to the sporophyte and gametophyte generations.

The aggressive expansion of bracken is well illustrated on the North Yorkshire moors where the indigenous heather has been overtaken by the advancing bracken, which has to be burned off periodically to prevent the total collapse of the heather.

Photographing ferns

The photograph of the underside of the hart's tongue fern, *Asplenium scolopendrium* (Fig. 6.6), reveals recently exposed groups of damp sporangia which when dry, will split open liberating millions of microscopic spores.

The shot was taken in nearby woodland with the underside of the frond arranged to show the groups of sporangia. A bright hazy sun produced soft frontal lighting and although not highlighting the surface texture of the sporangia, it did penetrate into the spaces between and around them, eliminating any dark shadows.

The tripod-mounted camera was set up with the camera back parallel to the frond to ensure a sharp image across the entire frame. Exposure was 1/30sec at f8 on ISO 100.

The indoor shot of polypodium was taken in the autumn in the controlled environment of the kitchen. The frond was arranged obliquely with the tripod-mounted camera set parallel to the plane of the frond to ensure a sharp image along its entire

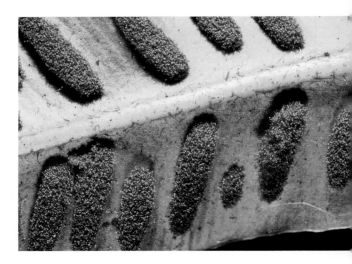

▲ Fig. 6.6
On the underside of the hart's tongue fern are groups of typical fern sporangia packed with tiny spores. Photographed indoors using grazed lighting to highlight the details in the sporangia. 1/25sec f16 50mm macro lens. ISO 100

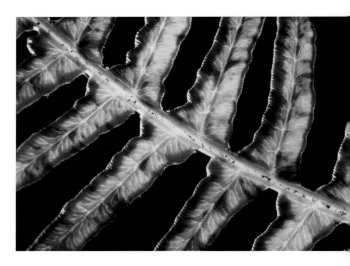

▲ Fig. 6.7
Polypodium fern frond photographed indoors with strong backlighting and weak, diffused frontal lighting. 1/2sec f16. ISO 64

length. A strong backlight highlighted the details of the edge-fringed pinnules, while weak daylight added some detail to the front surfaces. I used an 80mm macro lens set at f16 with ½sec exposure at ISO 64. The shutter was released remotely.

Any compact digital camera can be used but as we are working quite close to the specimen, manual focusing and aperture priority is recommended but not essential. Aperture priority will allow a small aperture to be used to increase the depth of field, which is quite shallow when working in close-up. A tripod is essential, and the camera shutter should be triggered either remotely or by using the inbuilt ten-second time delay. This will reduce any potential camera shake.

CONIFERS

Conifers belong to the group Gymnospermae (Greek – naked seeds), which includes the mountain pine and the larch. In gymnosperms the seeds are exposed (naked), as opposed to the structurally more advanced angiosperms (flowering plants) where they develop inside a protective ovary which ripens into the fruit. The angiosperms include the majority of flowers, shrubs, grasses and all trees except the conifers.

The Mountain Pine (*Pinus mugo*)

As the name suggests, the mountain pine thrives at high altitudes, although it is becoming quite widespread in parks and other recreational areas.

In addition to the long needle-like leaves, the other obvious feature is the two types of cone. The male cone is a scale-covered egg-shaped structure in which the microscopically small two-winged pollen grains (microspores) develop, facilitating wind dispersal. The female cone consists of spirally arranged scales, each carrying two ovules which after pollination and fertilization develop into seeds. The mature winged seeds are liberated from the female cone and in the third year of the female cone's life, assisted by wings, they are dispersed by wind.

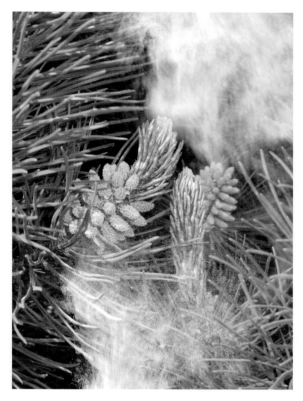

▲ Fig. 6.8
Walking through some nearby parkland I accidentally brushed against a mountain pine, liberating a cloud of pale yellow pollen. I decided to attempt something more striking indoors where I would be in control of the set-up, lighting and background. 1/125sec f6.3 −1 stop underexposure. ISO 200

In the restless struggle to survive the pine first disperses clouds of pollen which readily pollinates and fertilizes the ovules in the nearby female cones. The final stage in the production of a new pine tree is the efficient dispersal of the small winged seeds by the wind.

Photographing pollen release in the pine

There are quite a few shrubby mountain pine growing locally, and in early June I began checking the pollen levels by gently tapping one or two branches. When pollen production seemed to be reaching its peak, three small branches were very carefully removed and transported home in a plastic box (better than a plastic bag – no squashing). They were then stood in water and left for a day or two to fully ripen.

Two flash units (GN 32) were set up (one at either side), about 45 degrees behind and 45 degrees above the supported pine branch, each with a taped-on piece of card to prevent the flash light spilling into the camera lens. The tripod-mounted camera was linked to the flash units through TTL leads, and the shutter was tripped using a remote release. The technique was to tap the branch with a pencil and almost simultaneously trigger the shutter and flash units although unfortunately it was all too easy to tap the branch so forcefully as to move it partially out of frame and out of focus, or to tap it too gently, resulting in a beautifully framed and focused branch, but no pollen in sight.

A dark mottled green background was used, while for some of the shots I placed a white board in front of the branch to reflect a little light onto the male cone. Exposure was by flash with the lens aperture set at f16 and −1 stop underexposure at ISO 80.

The Larch (*Larix decidua*)
Seed dispersal

The European larch, *Larix decidua*, as the Latin name indicates, is a deciduous conifer which sheds its brown needle-like leaves in the autumn and winter, revealing knobbly twigs. In spring, small tufts of emerald-green leaves surround the base of the attractive pink-red female flowers, while the yellow-green male flowers are small and rather inconspicuous. The life cycle follows the same pattern as described for the mountain pine.

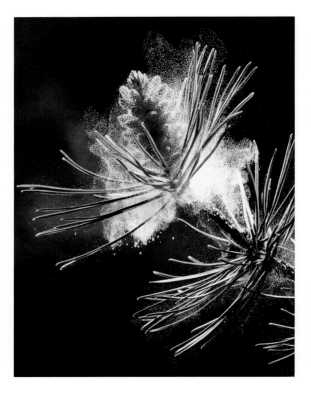

▲ Fig. 6.9
The male cone of the mountain pine was lit using a flash unit at either side, 45 degrees above and 45 degrees behind, with a white reflector in front to put a little light onto the front surface of the cone; a dark mottled green background completed the set-up. Tripod-mounted camera. Flash f16. ISO 80 −1 stop underexposure

▼ Fig. 6.10
The attractive female flowers of the European larch following overnight rain. Tripod-mounted camera set up next to the twig with a dark green background placed behind it. Fading daylight supplemented by a handheld LED torch as a semi-backlight. 1sec f22 80mm macro lens. ISO 50

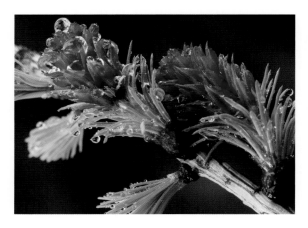

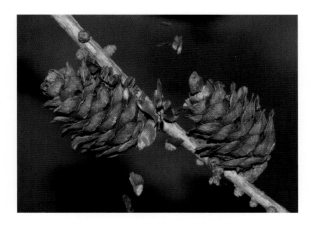

▲ Fig. 6.11
After pollination and fertilization winged seeds develop. When the cones were ready to disperse their seeds I tapped the twig and released the camera shutter and flash; this was the best result of several attempts. 1/125sec flash f13 50mm macro lens. ISO 200

Photographing the larch

To photograph the dispersal of the winged seeds, I collected several cone-covered twigs, keeping them indoors to dry out. The scales slowly opened exposing the winged seeds – two on each cone scale. I selected a pair of cones, checking that the seeds were sufficiently loose to be shaken out, finally topping up the cones with seeds from other cones.

With the twig set at the same angle as it was on the tree and with a dark mottled green-brown background board in place, I set up and aligned the tripod-mounted camera. The level of natural daylight was quite high, but I also switched on the camera's built-in flash unit (GN 11 at ISO 100).

As the twig was tapped with a pencil (replicating windy weather), I simultaneously fired the camera shutter and flash unit. Several attempts were made before an acceptable image was obtained. The exposure was 1/125sec at f13, flash, ISO 200.

FLOWERING PLANTS

Vegetative reproduction (also known as asexual reproduction) is quite widespread among flowering plants in their restless urge to reproduce and spread. The advantage lies in its simplicity, with no complex union of sex cells but with a quick spreading of the plant over the surface or underground. For example, a strawberry runner grows from the parent plant across the ground giving rise at intervals to new plants. A corm (crocus, cuckoo-pint, bulbous but-tercup) is a food-packed swollen stem, while a bulb (snowdrop, lily, tulip) is an underground bud packed with food. A rhizome (bracken, iris) is an under-ground stem which grows horizontally, producing a new aerial shoot each year. This form of growth produces new individuals but does not achieve a very wide spread, often resulting in overcrowding around the parent plant.

Flowering plants evolved over many millions of years (and are still evolving today) on a fit-for-pur-pose and survival-of –the-fittest basis, resulting in the huge range of complex and often very beautiful flowers we see today.

▼ Fig. 6.12
The tiger lily contains a very prominent pistil (female), surrounded by six stamens (male) with elongated orange anthers. Indoors with strong side lighting and fairly weak frontal lighting against an almost black background to highlight the stamens and pistil. 1/15sec f22 80mm macro lens. ISO 100

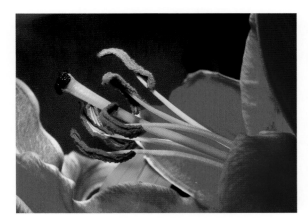

A typical flower consists of the sepals, petals, stamen and pistil. The sepals, collectively called the calyx, are usually small green leaves which protect the flower bud before it opens. The petals, which together form the corolla, are widely variable in shape, size, colour and number, but their prime function is to attract insects to pollinate the flower. Nectar, so important to bees in the manufacture of honey is usually, but not always, found at the base of the petals.

The two sexual parts of the flower are the male stamens and the female pistil. Each stamen consists of a stalk (filament) topped by the anther which holds the developing pollen. The female part of the flower is the pistil with a sticky stigma at the top of a long style, leading down to the ovary containing one or more ovules, which after fertilization develop into seeds. Again, there is much variation between different types of flower.

Pollination

The fundamental aim is that flowers will be cross-pollinated as a result of the pollen from one flower fertilizing the ovules of another flower of the same species. Why is cross-pollination so important when self-pollination would be much more straight-forward? It has been demonstrated by Charles Darwin no less, that cross-pollination produces stronger, healthier offspring. Darwin discovered that cabbages grown from the seeds of cross-pollinated flowers were larger, healthier and heavier than those produced through self-pollination.

Most flowers are designed to ensure that cross-pollination takes place with self-pollination being avoided in a number of ways. In some flowers (such as Canterbury bell) the stamens ripen first, while in others (for example, figwort) the stigma is the first to mature. In the yew and willow the sexes are on separate trees ensuring cross-pollination.

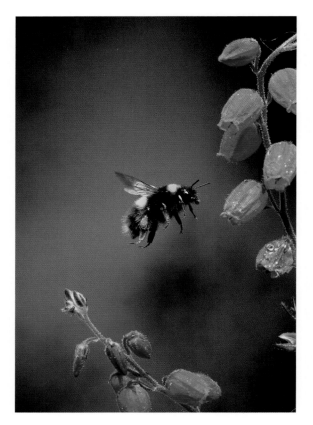

▲ Fig. 6.13
During pollen collection the bee accidentally transfers pollen from one flower to another, with some reaching the sticky stigma; the pollen basket on the bee's hind leg is clearly visible in the photograph. Flight tunnel. Multiple flash f16 50mm macro lens. ISO 100

Flowers are either wind or insect pollinated. Wind pollinators produce vast clouds of pollen with a very high wastage from flowers that are often relatively simple and often sombre coloured. Insect pollinated flowers are usually brightly coloured with nectaries at the base of the petals. The floral mechanism for ensuring cross-pollination by insects is often complex and varied. In legumes such as the sweet pea, a bee alights on the winged petal, pushing it down to expose the anthers and stigma. Pollen already on the bee is deposited on the stigma, while pollen from the flower is carried away by the bee, hopefully to pollinate a nearby flower of the same species.

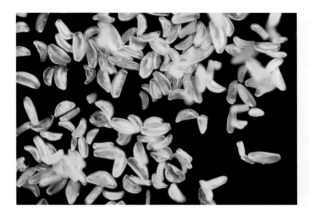

▲ Fig. 6.14
Pollen grains of an Alstroemeria hybrid, a summer flowering tuberous perennial. Overhead flash microscope preparation 60× magnification. ISO 100

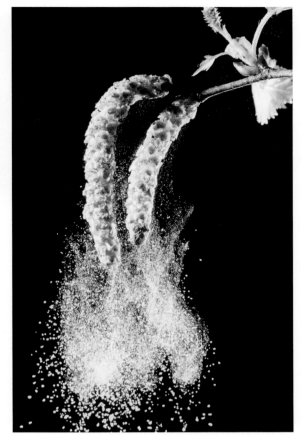

▲ Fig. 6.15
Three silver birch catkins arranged with a shielded flash unit at either side in a semi-backlit position with non-reflecting black velvet as background. The twig was tapped and as the cloud of pollen was released, the shutter and flash were triggered. Multiple flash f16 50mm macro lens -1 stop underexposure. ISO 100

Photographing silver birch catkins shedding pollen

For the tiny pollen cloud to be visible it would have to be backlit against a very dark or black background. As this would be virtually impossible in the natural environment, I decided to collect some catkins and photograph them indoors. The twigs were placed in a jar of water, covered with a bucket and after a couple of days a gently tapped twig confirmed an abundance of pollen.

The selected twig was arranged so that both catkins were parallel to the camera back to ensure overall sharpness of the images, while a piece of black velvet provided a black non-reflecting background. Two flash units (GN 32 at ISO 100) were set up, one at either side in a semi-backlit position, with a piece of card taped to each flash head to prevent spillage of light into the camera lens.

After the tripod-mounted camera was focused (manually) on the two catkins the twig was tapped with a pencil, and at the same time the shutter was released and the flash units fired. This was repeated several times until the pollen cloud was exhausted. The exposure was f16, −1 stop underexposure, flash, Velvia 100.

This work could also be done using a compact digital camera if the camera's built-in small flash is used to trigger a larger slave flash unit or possibly two, set up above and just behind the catkins. The slave units might have to be moved around until a satisfactory exposure is obtained, but this can easily be checked on the camera's LCD screen.

FRUIT AND
SEED DISPERSAL

After the flower has been pollinated each pollen grain on the sticky stigma produces a tube which grows down the inside of the style and fertilizes an ovule. This develops into a seed with the ovary wall forming the fruit, which can be either dry and tough (dandelion, hazel nut) or soft and succulent (plum, gooseberry).

We will now concentrate on examples of fruits and seeds which are dispersed either by being flung out of the seed box and blown by the wind, or even lighter seeds which, with the aid of a parachute can be carried many miles by a combination of rising warm air and a slight breeze.

Sycamore (*Acer pseudoplatanus*)

The sycamore was originally confined to mountain regions but has now been introduced to many parts of Europe and is widely naturalized. Dispersal of the winged seeds (they are actually hard-coated fruits) is reasonably effective in a strong wind, where they can spin some distance from the parent tree. The pairs of seeds often split apart giving each seed one wing. Due to the seedlings' rapid growth they are often referred to as tree weeds.

Photographing sycamore seed dispersal

This was one of the trickiest assignments for this book, with difficult-to-control variables such as the speed of rotation of the wings, the smoothness of the vertical panning, and having to pick the right moment to fire the flash.

The twin fruit and the dark brown background were front lit using a 60 watt daylight bulb. With the tripod-mounted camera set on manual and the shutter speed at one second the suggested aperture was f8, which I set at f11 (with −0.3 stop underexposed) to obtain a darker background. I rolled up a piece of black cartridge paper to produce a 25cm (10in) long snook and attached it to the flash unit (GN 32 at ISO 100). This would prevent any spillage of light onto the background. The flash unit was set at quarter strength on Manual and used at distances varying from 45 to 65cm.

The camera was focused on the sycamore fruit suspended on a length of black cotton thread and located in the upper quarter of the frame. The sycamore, previously wound up like a propeller, was released, and as it rotated and came face-on to the camera, the shutter was tripped. First the flash was fired, and then during a one-second exposure the camera was slowly and smoothly tilted upwards to a pre-set stopping point with the sycamore just out of frame. The flash produced a nice sharp, well-lit image of the sycamore fruit, while the slow tilt from the pan and tilt head on the tripod put a vortex-like swirl on the transparency. After processing, the transparency was turned upside down, showing the sycamore heavy-end down, slowly spinning to the ground.

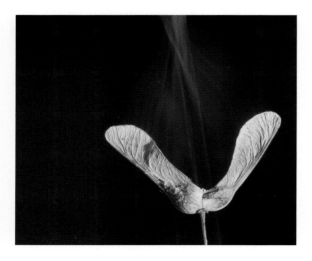

◀ Fig. 6.16
Spinning sycamore. For this rather tricky assignment, four elements were combined – a spinning sycamore fruit suspended on a black thread, a one-second exposure, moving the camera through a vertical arc, and finally a flash exposure. Flash 1sec f11. ISO 100

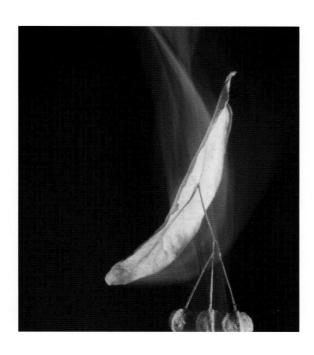

Red Campion (*Silene dioica*)

The red campion is common in Britain, except in northern Scotland and Ireland. It has hairy leaves borne in opposite pairs on a straight upright stem. The pinkish-red five-petalled flowers bloom from May to July. The fruit consists of a seed box (capsule) containing tiny seeds, and as the capsule dries and ripens the teeth around the top curl back exposing the seeds to the drying atmosphere. When shaken by the wind the seeds are scattered.

◀ Fig. 6.17
Quite often spinning lime fruits are carried over considerable distances by the wind. To produce this image the same set-up and techniques were used as for Fig. 6.16.

▼ Fig. 6.18
In anticipation of photographing red campion seed dispersal, I collected some flowers earlier in the season. The two-flower stem was photographed indoors against a very dark burgundy background, using a small handheld LED torch as a backlight to highlight the delicate hairs on the stem, leaves and the developing capsule. Tripod. 1/50sec f6.3 −2 stops underexposure. ISO 200

▼ Fig. 6.19
Campion seed dispersal. A two-capsule stem was attached to one side of the see-saw and lit using two flash units. Tapping one end of the sea-saw brought the capsules up into the frame, flinging out the seeds. The seeds' comet-like tails pointing in the wrong direction is due to the camera's first curtain flash synchronization. Flash f16 50mm macro lens. ISO 80

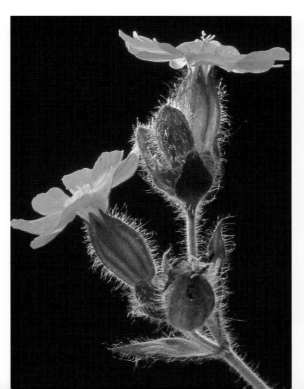

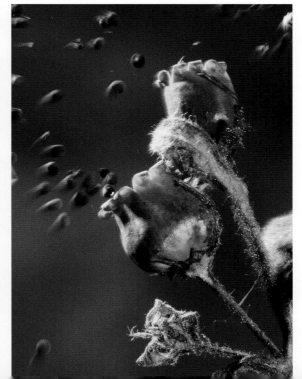

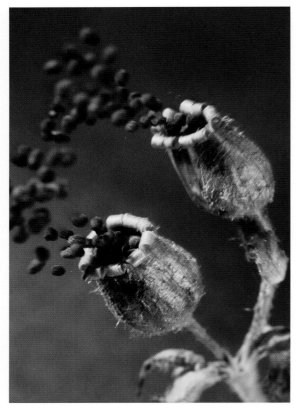

▲ **Fig. 6.20**
This image demonstrates the effect of halving the flash duration by opening up the lens by one stop. It freezes the spores completely, showing the sculptured surfaces on some of the seeds. Flash f11 50mm macro lens. ISO 80

Photographing red campion capsules

The selected specimen, consisting of two capsules, was carefully checked to ensure that the seeds were ripe and loose, ready for dispersal.

The capsules were lit using a flash unit (GN 32 at ISO 100) 22cm (9in) above and slightly behind, with a less powerful flash unit 30cm (12in) in front and to the right of the specimens, while a paint-sprayed background board was placed about 50cm (20in) behind.

My original method for taking the photograph was to tap the plant stem with a pencil, almost simultaneously pressing the cable release which tripped the shutter and fired the two flash units. This method was neither reliable nor predictable.

For my second attempt the campion was attached to one end of a small 15cm (6in) pivoted see-saw and pre-focused on the capsule, while the free end of the see-saw was held down. It was then returned to the resting position, and the capsules topped up with seeds. A sharp tap on the free end brought the campion capsules up into focus, throwing out some seeds. Firing the flash was as described previously.

◀ **Fig. 6.21**
Part of the set-up used to photograph the campion capsules dispersing their seeds. The pivoted see-saw is part of an old reading lamp with a solid metal base. The campion capsules were framed and focused. The sea-saw then returned to the resting position before being smartly tapped, bringing up the specimen and flinging out the seeds. 1/60sec f11. ISO 100

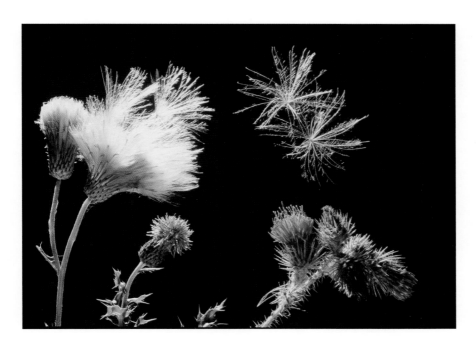

◄ Fig. 6.22
The thistle arrangement was backlit using a shielded flash unit, with crumpled kitchen foil in front of the thistles, providing some fill-in lighting. Rising warm air kept the seeds more or less suspended while the shot was taken. Flash f22 1.3 stops underexposure. ISO 100

The seed tails appear to be pointing in the wrong direction. This was a result of the camera's first curtain synchronization.

The tripod-mounted camera had its 50mm macro lens set at f16 with −2/3 stop underexposure, ISO 80.

Creeping Thistle (*Cirsium arvense*)

The creeping thistle is widespread and common on waste ground and on grassland. It is a perennial with upright unwinged stems. The pinkish-lilac flower heads are either solitary or in clusters of two or three at the ends of stems and branches.

The developing seed is surrounded by a thin fruit coat attached to a very delicate hairy pappus. In damp weather the pappus remains tightly folded, but in warm sunny weather the dead flower-head dries and splits, the hairy pappi expand like parachutes and are carried away on the wind.

Photographing thistle dispersal

I arranged some pieces of thistle to make a satisfactory composition and taped them to a piece of cardboard. A strong backlight was supplied by a Metz 45 flash unit positioned some 33cm (13in) above and behind the thistles with the flash carefully shielded to prevent any stray light falling on the camera lens. A piece of crumpled kitchen foil angled at around 45 degrees and placed 20cm (8in) in front of the thistles provided a little frontal fill-in lighting. As I wanted the very delicate parachute seeds to stand out against the background, I hung black velvet about 60cm (24in) behind the thistles.

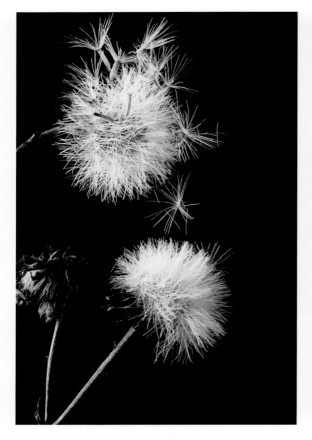

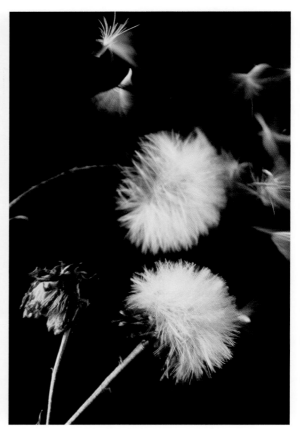

▲ Fig. 6.23
In this image the ragwort was lit using a spotlight resulting in an exposure of 1/125sec at f8.0, sufficient to freeze the dispersing seeds.

▲ Fig. 6.24
Exactly the same set-up was used, and again, the heads were very gently blown, but the exposure was changed to 1/30sec at f16. There is plenty of movement, but are the heads too blurred?

I had photographed the thistles before, but experienced great difficulty co-ordinating the blowing of the flower head to release the parachutes, with the tripping of the camera shutter and flash unit. Could I counterbalance their weight with an up-current of warm air, reasoning that if the two were about equal, the parachute seeds would be suspended almost motionless? The theory was that the holes in an upturned Chinese take-away tray would allow the warm air from a burning

candle to come through in a smooth laminar flow, which would help to keep the parachute seeds in one plane. The first ones shot upwards at great speed – too much hot air! Extinguishing the candle and waiting a few moments for the tray to cool down a little worked, and the parachutes hovered, allowing me to take a couple of shots. This was repeated several times, hoping that one frame would include a parachute seed well positioned and in sharp focus.

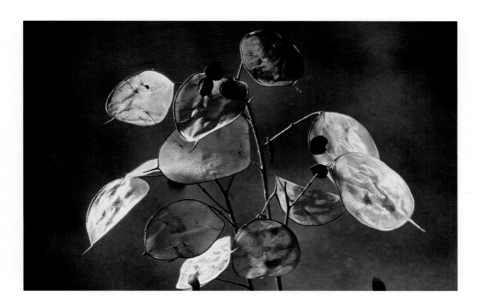

◀ **Fig. 6.25**
The honesty had only a few
seeds left to drop and a
gentle tap was all that was
required. Main flash unit was
positioned above and slightly
behind with a small frontal
flash as a fill-in. Flash f16.
ISO 64

Honesty (*Lunaria annua*)

Often an escapee from gardens, honesty is widely
distributed on waste ground, by the roadside and in
hedgerows. The pink four-petalled flowers, carried
on long stems, are pollinated by bees and moths.

The oval disc-shaped seedpods are green initially,
but as the seeds ripen the pods lose their colour,
becoming translucent. When completely dry the
outer membranes curl back and eventually drop
off, exposing the seeds, which fall from the central
septum to the ground as the plant is disturbed by the
wind or passing animals.

Photographing honesty dispersal

I collected the photography material in late
September and photographed indoors. The dis-
persal was captured by selecting honesty in which
some seeds were exposed and ready to drop,
tapping the specimen with a pencil, while almost
simultaneously triggering the camera shutter and
the flash units.

The more powerful flash unit (GN 32, ISO 100)
was positioned 25cm (10in) above, behind and
slightly to the left of the honesty, with the lower-
powered flash (GN 20, ISO 100) used to lighten the
background and to put a little detail onto the front
surface of the specimen, positioned approximately
46cm (18in) in front of the pod which was itself
50cm (20in) from the background board.

Different backgrounds were used with exposures
ranging from normal to −1 stop, all at f16. The Kodak
Elite 50 transparency film was set at ISO 64.

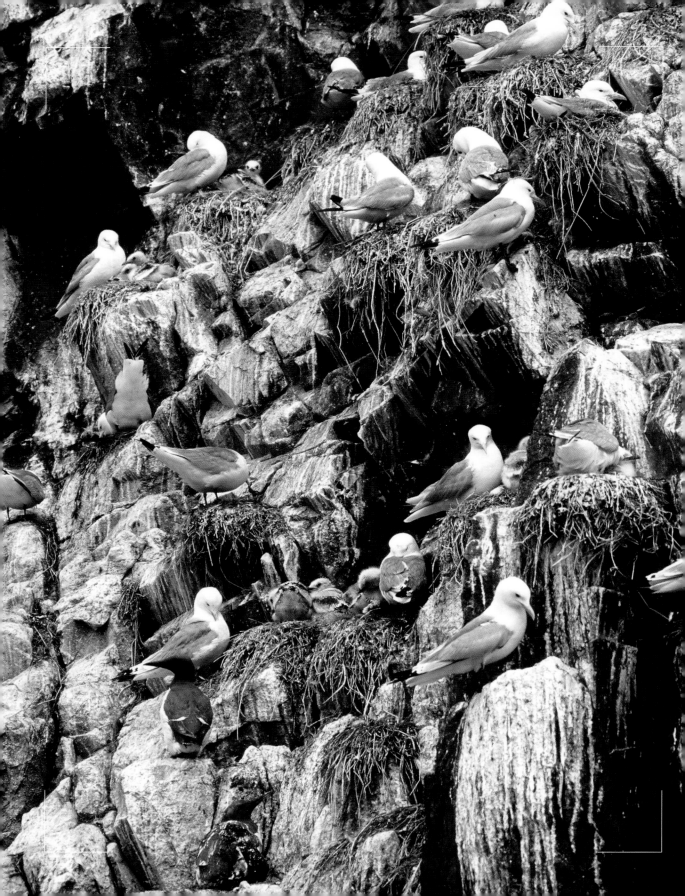

Chapter 7

Flight in Birds

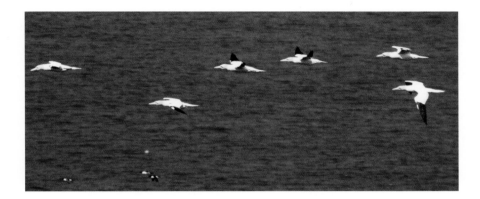

◄ Fig. 7.1
Gannets returning to their
nests on Bempton Cliffs on
the Yorkshire coast. 1/250sec
f8. ISO 100

▼ Fig. 7.2
Gannets tightly packed
on the nesting ledges on
Bempton Cliffs. 1/250sec
f5.6. ISO 100

As in all animals the innate drive and restlessness of birds is to reproduce, maintain their numbers and, where possible, to expand into new territories. To achieve this they must survive to adulthood, find a mate and locate the breeding ground. This is realized through the mechanism of flight, which has evolved over some 180 million years into the efficient, highly complex machine we see today. We now know much more about the dynamics of bird flight although there are still areas which we do not fully understand.

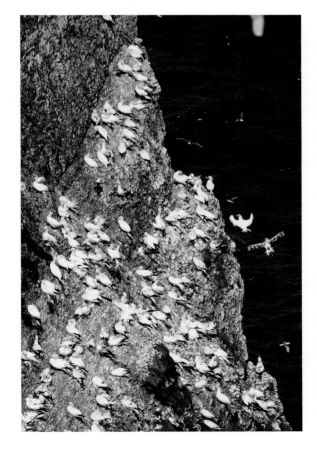

◄ Fig. 7.0
Kittiwakes on Bempton Cliffs, Yorkshire.

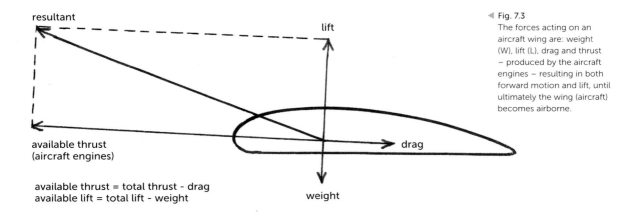

◀ Fig. 7.3
The forces acting on an
aircraft wing are: weight
(W), lift (L), drag and thrust
– produced by the aircraft
engines – resulting in both
forward motion and lift, until
ultimately the wing (aircraft)
becomes airborne.

resultant

lift

available thrust
(aircraft engines)

drag

available thrust = total thrust - drag
available lift = total lift - weight

weight

AEROFOILS

We begin by examining the airflow over the fixed wing of a modern aircraft before moving on to the complex aerodynamics of the bird wing, which not only can change its shape but can move during normal flight.

The airflow over an aircraft wing produces lift enabling it to become airborne. This was first discovered by the Swiss mathematician Daniel Bernouilli (1700–1782), who found that as the velocity of a fluid increased, the less pressure it exerted. This also applies to the movement of air. When an airstream passes over an aerofoil, the air moving over the curved upper surface has a greater velocity than the air flowing along the lower surface. According to the Bernouilli principle there will be less pressure on the upper surface compared to the lower, resulting in the aerofoil rising, thus producing lift. The other forces acting on the aerofoil are drag (resistance to the air while it is moving) and gravity, which tends to keep it on the ground.

The main forces acting on the wing are shown in Fig. 7.3, where the resultant of the lift and the drag would cause the wing to rise but move backwards. This backward movement is prevented by the forward thrust of the aeroplane's jet engines (or the wing muscle power in birds).

The upward tilt of the wing, known as the angle of attack, is between 2.5 and 3 degrees for a modern aircraft in level flight, generating the highest lift-to-drag ratio. As the angle of attack increases, the smooth laminar flow over the upper surface of the wing begins to break down causing turbulence and drag along the trailing edge. Should the angle of attack and the turbulence become so great that the drag exceeds the lift, then the wing would stall (fall to the ground).

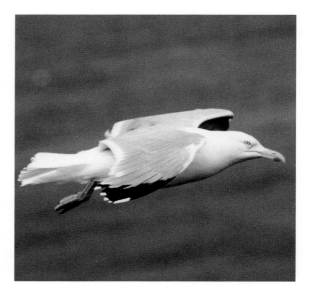

▲ Fig. 7.4
An airborne herring gull with the body weight and wing lift forces in equilibrium; it gains extra lift from the air currents rising up the cliff face. 1/125sec f11. ISO 100

Flaps and Slots

Flaps and slots play a very significant role in both aircraft and bird wing design. Flaps are located along the trailing edge of the aircraft wing; some can be extended, and all can be tilted downwards to extend the curvature of the wing. They increase both lift and drag and are therefore of enormous advantage in landing. Another type of flap is the airbrake, which opens up above and below the wings – again, a great aid to slowing down during landing.

◀ **Fig. 7.5**
This type of flap is an air-brake which is deployed to slow down the aircraft during landing. Birds adopt a similar strategy by rotating the wing to increase the drag just before touch down. 1/1000sec f8 200mm lens. ISO 100

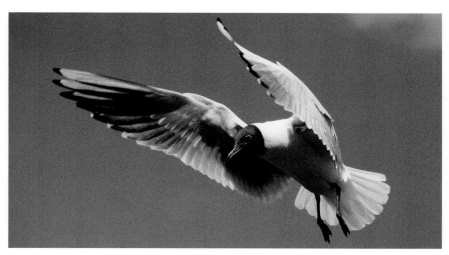

◀ **Fig. 7.6**
A black-headed gull with its wings rotated towards the vertical to increase the drag prior to landing, helped by the near vertical fanned tail and the extended legs. 1/500sec f8. ISO 200

◀ **Fig. 7.7**
The wing slot is the slender gap produced when a narrow section of the aircraft wing's leading edge moves forward. Air is directed more smoothly over the top surface of the wing, helping to reduce the likelihood of stalling. Birds have a similar device, which evolved many million years ago – the bastard wing, or alula, consisting of a group of feathers attached to the second finger. 1/600sec f5.6. ISO 100

A final device used on aircraft is the wing slot. This is a narrow gap along the wing's leading edge, produced when part of the leading edge (slat) moves forward from the wing. It then directs more air over the upper surface of the wing helping to smooth out any incipient turbulence and reducing the possibility of stalling. Apparently all these extra wing appendages can increase the stalling angle by up to 20 degrees and the lift by almost 50 per cent. Rather similar types of structure evolved in birds many million years ago.

FEATHERS

In bird flight the breakthrough came with the gradual evolution of the feather from the reptilian scale. This allowed the bare forelimb (arm) to increase dramatically in both area and shape with little increase in weight, resulting in the very efficient aerodynamic bird wing we see today.

Feathers provide a light-weight, flexible but mechanically resistant body covering with many dead air spaces providing vital insulation. Reptilian scales, bird feathers and mammalian hair are all composed of dead cells tightly packed to form a semi-rigid protein called keratin. There are basically three types of feather: flight, contour and down.

Flight Feathers

A typical wing feather consists of a flat vane supported by a central shaft which is an extension of the hollow quill attached to the skin follicle. Arising from the central shaft are hundreds of narrow parallel side branches (barbs), each with a row of tiny filaments (barbules) on either side. Minute inter-locking extensions on the barbules unite the barbs to form a continuous surface which can be broken by running the finger and thumb down the feather towards the quill. Sliding the finger and thumb in the opposite direction preens the feather, re-uniting the barbs.

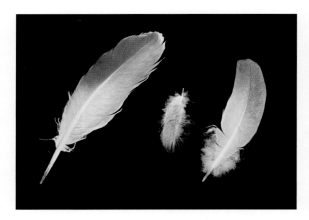

▲ Fig. 7.8
Feathers are strong, flexible and light. Flight feathers cover most of the wing, while contour feathers provide a smooth low-friction body covering and some insulation. Down feathers are next to the skin, providing excellent insulation which is so important in maintaining the bird's high body temperature of around 105–108°F, varying with the species. 1/5sec f16. ISO 50

▲ Fig. 7.9
A magnified image of part of a feather, slightly separated to show the structure of the interlocking barbules. 5sec f32 90mm macro lens + 2 close-up lenses. ISO 200

Contour and Down Feathers

Contour feathers provide a smooth low friction external covering, with each consisting of an outer vaned surface and an inner downy region which is concealed under the overlapping outer surface of the adjacent feather. Down feathers lie next to the skin, each consisting of a short quill, a reduced shaft and long flexible barbs with short non-interlocking barbules. Their function is to trap air next to the skin, providing excellent insulation against the cold.

Feathers can be ruffled by contraction of smooth muscles and elastic fibres in the skin, and ruffling is used in bathing and preening, in addition to providing extra insulation. Feathers grow only on certain areas of the skin (feather tracts) and are moulted and replaced either gradually (one from each wing in flight feathers) or completely, usually in late summer or autumn. Minute hair-like feathers (filoplumes) and bristles are found on some birds but play no part in flight.

Photographing Feathers

The photograph of the flight, contour and down feathers was taken indoors with the feathers neatly arranged on a piece of black velvet. The tripod-mounted camera was set up in the overhead position with the camera back parallel to the velvet. Diffused daylight provided almost shadowless lighting, and due to the large area of black velvet I reduced the exposure by one stop to ensure that the velvet would register as black rather than grey. The exposure was 1/5 sec at f16 on an ISO 50 setting.

The photograph of the eye of the peacock feather was taken under similar conditions, but as the feather was quite sturdy it was supported some 15cm (6in) above the black velvet to eliminate any possibility of unwanted shadows. The exposure was as above but with only minus 1/3 stop exposure compensation. In both photographs a 90mm macro lens was used.

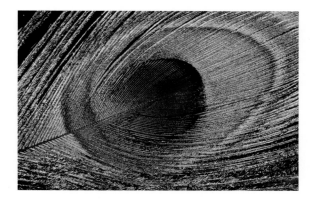

▲ Fig. 7.10
The eye of a peacock feather was photographed against a black background and positioned parallel to the camera back to ensure good definition across the entire image. 1/5sec f16 90mm macro lens. ISO 50

To photograph the details of the feather barbs and barbules I adopted a different strategy as the feather vanes were translucent. The feather was placed on a light box producing white light at a colour temperature of around 5000 Kelvin. The camera was set up over the light box with the camera back parallel to the top of the box. Ambient room lighting added a little warmth to the image. The 90mm macro lens with a two dioptre close-up lens attached was stopped down to f22 for maximum image sharpness producing an exposure of five seconds on an ISO 100 setting.

Wing Structure

The human arm contains exactly the same bones as the bird's wing, which is not too surprising as both evolved from early reptilian stock. The basic arm structure consists of the humerus (upper arm), radius and ulna (forearm), carpels (wrist), metacarpels (hand) and phalanges (fingers), although their shape, size and proportions do vary considerably as we move from bird to man, see Fig. 7.11.

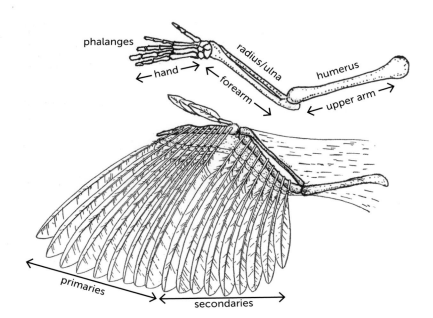

phalanges

hand →

← forearm

radius/ulna

← upper arm →

humerus

primaries

secondaries

◄ Fig. 7.11
The human arm is built on a similar plan to the bird's wing, almost bone for bone. One obvious difference that provides additional strength to the bird's wing is the fusion of the wrist bones; the second digit carries the feathers of the bastard wing.

The humerus with the tertiary feathers attached articulates with the radius and ulna with attachments for the secondary flight feathers. The primary flight feathers towards the tip of the wing are connected to fused digits 3 and 4, while digit 2 is quite separate with feathers attached to form the alula (bastard wing). Only two carpels (wrist) are evident, the other carpel bones being fused to the three metacarpals (hand) to form two elongated bones with primary feather attached. Two membranous extensions of skin near the fore and hind borders of the wing skeleton hold the quills of the flight feathers and control twisting during flight.

In humans the sternum (breast bone) is quite flat, whereas in birds it is extended to form a deep prominent keel for the attachment of the powerful flight muscles which can make up to 20 per cent of the bird's weight.

Other Flight Modifications

To save weight the bird skeleton is quite delicate with many hollow or porous bones, retaining material only in those areas where strength is essential. The skull is quite thin, with the original heavy reptilian teeth replaced by a light horny beak. Many individual bones (such as finger and wrist) are fused together to form lighter but stronger units.

Because of the heavy oxygen demands during flight birds have evolved an extremely efficient respiratory system, extracting about 90 per cent of the available oxygen from the air (mammals, including humans extract approximately 30 per cent). In addition to lungs, birds have a complex system of interconnected air sacs allowing one-way continuous airflow through the lungs. The system is even more efficient as blood and air flow in opposite directions (counter-current system) allowing even more oxygen to be extracted by the blood. These evolved improvements enable some migratory birds to fly at altitudes of 6,000 metres (19,000ft) where humans would experience breathing difficulties.

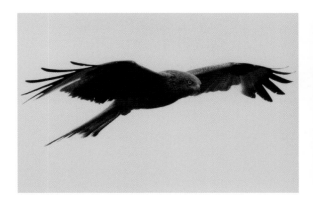

▲ Fig. 7.12
Red kite thermal soaring above the grounds of Harewood House, Yorkshire. Monopod. 1/840sec f5.6 400mm lens. ISO 200

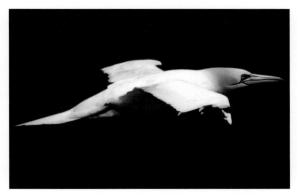

▲ Fig. 7.13
Gannet cliff-soaring using the air current rising up the cliff face. Underexposed to bring some detail into the white feathers. 1/2000sec f5.6 300mm lens −1.3 stops underexposure. ISO 200

MECHANISM OF FLIGHT

Gliding requires very little energy and is achieved by simply stretching out the wings, allowing the bird to glide in a similar manner to a man-made glider. Nevertheless, without some air movement and despite the lift generated by the aerofoil shaped wing, the bird would slowly descend to the ground. However air is rarely still and three examples will illustrate how gliding can become energy efficient and almost continuous.

Thermal Soaring

When the angle of attack of the wing is increased, the smooth air flow breaks into turbulence towards the trailing edge, reducing the lift until a point is reached when the wing stalls. This can be reduced by the slotting device mentioned earlier, which is used extensively in birds, particularly when landing.

Slow flying, soaring birds such as eagles, buzzards and kites make use of a similar principle, splitting up the outer sections of the broad wing by having deeply slotted primary feathers. These function as narrow aerofoils allowing the air to slip through the spaces, reducing drag even more and giving the wings added lift.

Thermal soaring allows birds such as the turkey vulture, red kite and buzzard to stay airborne for several hours. Uneven heating of land masses results in warm air expanding into huge rising columns which can reach heights of several hundred metres. The air at the top of the column cools down and slowly sinks back to earth. Birds locate the rising air in the centre of the column to gain height, and either stay circling in the thermal or glide away, slowly sinking until they find another thermal. A Ruppell's griffon vulture followed by a motorized glider over the Serengeti Plain covered 75 kilometres in 96 minutes using only five thermals.

Cliff Soaring

Many sea birds including herring gulls, kittiwakes and occasionally gannets enjoy the free lift offered when an on-shore wind hits the cliff face causing a strong up-current. This is beautifully illustrated at Bempton Cliffs in Yorkshire, the site of Britain's only mainland gannet nesting colony. However these cliff nesting birds have not evolved fully for gliding because they must also land safely on their tiny cliff edge nesting sites, which requires the wings to function at low stalling speeds to allow a controlled landing at a very precise spot.

Gradient Soaring

This method of soaring makes use of the fact that the wind blows more slowly close to the surface of the sea, than at thirty or so metres above it. This is mainly due to surface friction between the air and the sea and waves. The albatross fully exploits this phenomenon by flying hundreds of kilometres with very little flapping of its wings. After an upward climb on the wind to around thirty metres, it turns and glides earthwards, picking up speed on the way and covering considerable distances. Just above sea level it turns into the wind, gaining height again using the speed and momentum it has developed on the downward glide.

Ringed specimens indicate that albatrosses can circumnavigate the globe – some 6,000 kilometres at 40 degrees latitude in approximately eighty days by simply riding the wind. Oceanic birds owe their gliding skill to their slender streamlined bodies and their long narrow, lift-generating, aerofoil section wings.

Steering

This is a complex, highly evolved process involving the position and angle of the wings, the angle of the body and the use of the tail. In straight level flight, wing shape and movement must be equal on both sides of the body so that the aerodynamic forces are balanced. To turn left the bird banks to the left, deflecting the air flow to the right and generating more lift from the right wing. The tail, acting as a rudder is involved to a greater or lesser degree depending on the type of bird. The tail is also important in landing (as discussed later in this chapter).

PHOTOGRAPHING GLIDING BIRDS

An SLR (digital or film camera) would be the ideal camera for this type of work. It benefits from using interchangeable lenses, and the delay time after releasing the shutter is very short – many can shoot several frames per second. The quality should be first class.

Good work can also be done using a bridge camera such as the Canon Power Shot G 10. The image quality is excellent, although the drawbacks such as the limited 5× zoom can result in rather small images. A slower operating time is also an obvious drawback for this type of work. However, with practice at panning and holding the image steady on the LCD screen, useable images can be obtained.

Digital compact cameras suffer the same problems as bridge cameras only more so, but if your camera has a decent zoom range (at least 5×) then in-flight shots should be possible.

Selecting a telephoto lens of an appropriate focal length will depend on the size of the bird and its distance from the camera when the exposure is made. A useful guide would be a zoom lens of 200–400mm focal length or two fixed focal length equivalents. Unless you are going to produce very large pictures (A3 or larger) I would certainly recommend the versatility of the zoom lens, although many professional photographers still prefer to use fixed focal length telephoto lenses.

If your DSLR has a smaller sensor than the 35mm full frame (36×24mm) unit, such as the very popular APS-C sensor (23.6×15.8mm), then the zoom lens image would be cropped. The resulting image would be equivalent in size to that produced by a 300–600mm lens (that is, a crop factor of 1.5).

Exposure

Exposure is a balance between the lens aperture and the shutter speed. A small lens aperture will produce a very sharp image with a useful depth of field, while a shutter speed of around 1/500–1/1500sec may be necessary to freeze the image. I tend to use aperture priority, setting the lens at around f6.3–f8 and checking the shutter speed in the viewfinder. To achieve the above combination would probably require an ISO setting of 200–400. A useful guide is that the shutter speed should be no longer than the reciprocal of the focal length of the lens being used. For example, a 200mm lens would require an exposure of at least 1/200sec while a 600mm lens would need a 1/600sec or less.

Image stability (also called super steady shot) is now built into many cameras and lenses. This reduces the effects of camera shake by up to two stops (Exposure Values or EVs) in shutter speed allowing an exposure of, say, 1/250sec instead of the suggested 1/1000sec) with no visible camera shake. Exposure compensation of up to one stop under-exposure might be necessary should the image of the white sea birds prove to be rather washed out.

▲ Fig. 7.14
Photographing sea birds on Bempton Cliffs on the Yorkshire coast using a fully extended monopod for extra camera stability. 1/250sec f11. ISO 100

Focusing

Single shot autofocus is the default setting on most cameras and is quite satisfactory for many subjects, but for fast moving birds continuous autofocus will automatically track the subject, keeping it in sharp focus for each exposure. Predictive autofocus anticipates (predicts) the movement of the bird when the camera mirror is momentarily in the up position, keeping it in sharp focus. Rapid exposures of three or more per second are available on most DSLR cameras, and this setting is well worth using for this type of work.

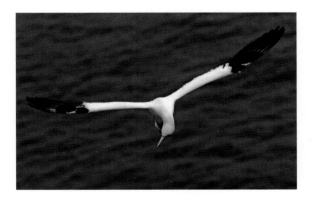

▲ Fig. 7.15
The gannet is Britain's largest sea bird, with a heavy body and long, quite narrow wings. During normal flight the wing movements are slow, deep and powerful. By comparison, the puffin Fig. 7.16) has a heavy body relative to its overall size and short wings, and it must beat its wings furiously to stay airborne. 1/1500sec f8 −1.3 stops underexposure. ISO 200

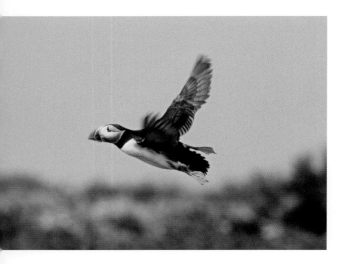

▲ Fig. 7.16
The puffin has just left its nesting hole in a grassy bank to fly out to sea in search of sand eels. Photographed on the Inner Farne Islands off the Northumberland coast. 1/1000sec f5.6. ISO 200

Camera Stability

A good solid tripod is my almost constant companion, but when photographing birds in flight the tripod is just too awkward to use. If the exposures are sufficiently short the camera can be hand held, although I prefer to use a monopod extended up to eye level. It allows sideways swings but stabilizes up and down movement. The ball and socket head should be very slightly loose, stabilizing the camera but still allowing plenty of controlled movement.

A recent accessory, which has replaced the old camera attached to a rifle butt, is a shoulder brace fixed to a monopod, resulting in even greater stability. Finally, it is worth mentioning the importance of the follow-through after swinging (panning) the camera; although it is quite natural to freeze the camera movement after the shutter has been released, it should be avoided, as this often results in a lost image or one disappearing out of the frame.

Red Kite (*Milvus milvus*)

In Medieval times the red kite was a common bird and was even found in central London, but due to wholesale shooting and egg collecting, it narrowly escaped extinction in Britain some 100 years ago. A conservation programme was started in 1989 in Buckinghamshire followed by several other programmes and now the British Isles has a thriving population approaching 1,000 pairs.

The red kite is one of Britain's largest birds of prey (only eagles and ospreys are larger) with a wing span of up to 1.7 metres. It soars effortlessly for long periods with virtually no wing movement and can be further identified by its large forked triangular tail and its attractive chestnut plumage.

Red kites are principally carrion feeders, with sheep carrion and road kills being particular favourites. Small live animals such as field mice and half-grown rabbits are sometimes taken, and they will occasionally pirate food from other birds.

▲ Fig. 7.17
For this shot of a red kite a 400mm telephoto lens was used on a fully extended monopod to stabilize the camera. The most successful shots were taken when the kite was some distance away because as it came overhead it was moving too quickly to maintain its position in the viewfinder. Monopod. 1/800sec f6.3 400mm lens. ISO 200

Photographing the red kite

In many parts of the country red kites can be seen soaring above houses and gardens. At Harewood House near Leeds, where several pairs were released in 1999, I set up my camera on a fully extended monopod, overlooking the lake. Using a 400mm telephoto lens, I picked up the image of a distant kite in the camera viewfinder, hoping it would soar gracefully in my direction. As the image became sufficiently large to be useful I released the shutter. Depending on the weather exposures varied from 1/1000sec down to 1/400sec with apertures ranging from f5.6 to f8, all at ISO 200. Photographing the attractive red kite was indeed time well spent.

▲ Fig. 7.18
The wings of the pigeon on the right are towards the end of their downstroke, generating both lift and forward momentum. The wings of the other bird are at the top of the upstroke, ready for the powerful downstroke. 1/300sec f4.5. ISO 200

FLAPPING FLIGHT

Instability

Although many sea birds and raptors have perfected gliding flight with little wing movement, for the vast majority of birds flapping flight is the norm and is necessary to produce forward momentum and lift. Despite our inability to fully understand all the details involved, we can still marvel that by using a combination of varying wing shape, angle and rotation, birds can accelerate, brake and change direction in a split second.

Birds have evolved the necessary sensory equipment (semi-circular canals in the inner ear) to detect and respond in milliseconds to incipient instability. By comparison, passenger aircraft are designed to be extremely stable in flight, with any departure from straight level flight being automatically corrected. (Military fighter aircraft are much more unstable and therefore very manoeuvrable). Whether the bird is catching prey, evading predators or simply performing aerobatics, this inherent instability allows split second corrective action, bringing with it enormous advantages.

Wing Movement

During flapping flight the wings can be extended like an outstretched hand and arm or bent back at the elbow and wrist. The wing tip moves typically in a flattened but changeable figure-of-eight, twisting about its long axis to present varying angles of attack and therefore different amounts of lift and drag.

The downstroke with the wings extended generates both lift and forward momentum, with the flight feathers bending back slightly indicating lift or flexing forward during forward movement. The flight feathers can overlap completely providing a continuous air-tight surface.

The upstroke is usually a recovery manoeuvre and plays a very important part in landing. The wings are pulled in slightly (at the elbow and wrist) to reduce air resistance and downward drag, and rotated at the shoulder joint to increase the tilt (angle of attack) and reduce the drag. As a further aid to cutting down air resistance on the upstroke, the primary flight feathers twist open rather like a Venetian blind, allowing air to pass between them.

Silent Flight

Owls are late evening and night predators, with their silent approach to their prey being a huge advantage. The leading edges of the owl's flight feathers have unhooked barbs (rather like down) producing loose fringes which deaden the sound of the wing beats. There is also some down on the upper surface of the wing feathers allowing them to move silently over one another, possibly helping to reduce incipient turbulence and therefore noise.

The silent approach to their prey also allows owls to make better use of their excellent hearing, so they can pick up sounds of their prey rustling about in the undergrowth. This, coupled to their superb night vision makes the owl a highly evolved, super efficient night predator.

Photographing Flapping Flight

The method described earlier of photographing gliding flight applies, with very little modification, to flapping flight. The main difference is that the wings will be moving quite rapidly with the greatest acceleration at the wing tips. To ensure a really sharp image by freezing the primary feathers, the shutter speeds should be shorter than those recommended for photographing gliding flight. Somewhere between 1/1000sec and 1/3000sec would be appropriate depending on the size of the bird and, by implication, the speed of the wing beat.

Lens apertures should be as small as possible (increased depth of field), commensurate with appropriately fast shutter speeds mentioned above. The suggested ISO setting of 200–400 would also be quite satisfactory, while panning and follow through is mandatory, with the camera supported on a monopod equipped with a partially slackened ball-and-socket head. Checking the image on the camera's LCD screen will decide whether exposure compensation is required for future shots

TAKING OFF AND LANDING

Take-off

The basic problem for a bird is developing sufficient lift to allow it to become airborne in as little time and space as possible.

Most birds take off from the ground by simply springing up into space followed immediately by very vigorous beating of the wing, with the powerful downstroke providing most of the lift, while the upstroke produces some forward momentum. This is extremely strenuous activity, with the bird returning to the normal cruising pattern as soon as possible. The familiar wing noise produced by pigeons becoming airborne is produced when the wings clap together at the top of the upstroke, followed by a violent fling on the down stroke – known as the clap-and-fling technique, which generates extra lift.

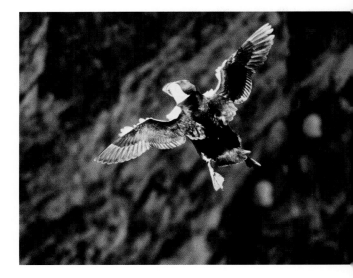

▲ Fig. 7.19
This puffin has just launched itself from the cliff top and is in free fall until it gains sufficient speed and momentum to begin to fly. The bird was well lit by the sun, while the cliff face remained in the shade. 1/1000sec f8.0. ISO 200

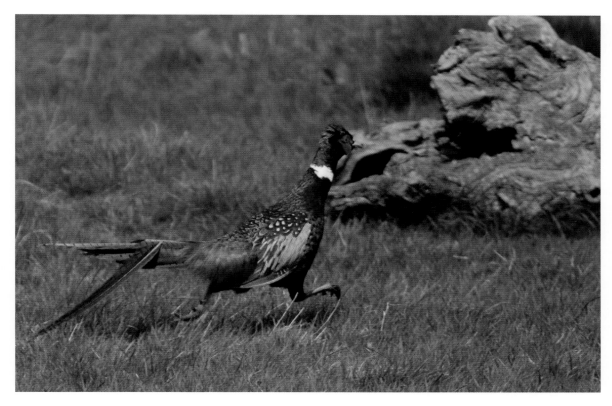

▲ Fig. 7.20
Pheasants normally take off directly from their moorland cover, but this startled male decided to run before eventually taking to the air. 1/2500sec f5.0. ISO 200

A second launch method, used by cliff-nesting birds such as guillemots, razorbills and puffins is to simply drop off the cliff edge into space, letting gravity do its work as the fall is converted into a controlled glide. Swallows and house martins adopt the same strategy by climbing out of their nests in the eaves of a house or barn and jumping into space.

A third method, which I call the runway method occurs when the bird uses the ground or the surface of a river or lake as an aircraft uses the runway. Large birds such as swans and geese, and smaller birds like ducks, moorhens and coots (the latter with large padded feet) simply turn into the wind and run along the surface of the water as they develop sufficient speed and lift to become airborne.

Landing

Whereas take-off demands energy and power, landing requires, in most cases, skill and judgement. Birds must land as slowly and lightly as possible to avoid damaging themselves, but must also be accurate if they are to arrive safely at, for example, the tiny area of a cliff face nest or a nest under the eaves of a barn.

To achieve a controlled landing most birds swing their bodies from the horizontal to the near vertical to increase air resistance, and twist their wings at the shoulder joint to meet the oncoming air and slow them down. Slotting their flight feathers lets the feathers function as narrow aerofoils, allowing the air to hug the feather surface and slip through the spaces, which gives added lift at a much reduced

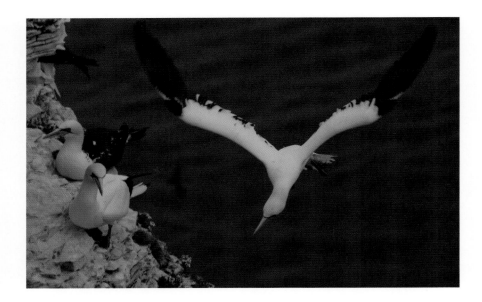

◀ Fig. 7.21
A gannet returning to its nest. The tail is turned down to increase drag and reduce speed, while the legs are lowered in anticipation of a safe landing on an area of rock little more than a foot square. 1/640sec f8.0 300mm lens. ISO 200

speed. Just before touch-down the wings are rotated beyond the stalling angle – flaring out, in hang glider terminology. The sudden loss of lift and greatly increased drag allows the bird to drop, quite harmlessly, the final centimetre or so onto solid ground. The tail is spread, acting as an air brake, while the legs and feet are thrust forward in preparation for a safe landing. The final impact is taken by the legs, which act as shock absorbers in a similar manner to an aircraft undercarriage. Birds'

legs, although quite delicate, have special elastic-like tendons that absorb the impact, preventing any possible damage.

When landing, water birds adopt a rather similar wing position to land birds, but they also use the water runway, often stretching out their legs and webbed feet which act as water brakes. Despite this, the landing is often rather clumsy with much sound and fury, and a definite loss of dignity. Trying to land on a frozen lake could best be described as comical.

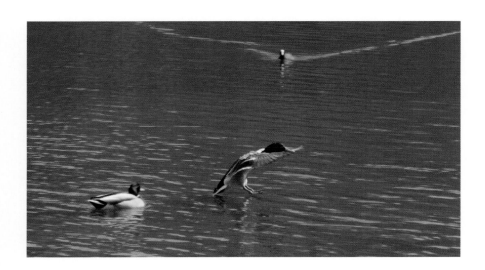

◀ Fig. 7.22
A male mallard preparing to land. The body and wings are tilted towards the vertical, while the legs are down with the webbed feet angled to act as water brakes. 1/640sec f5.6 300mm lens. ISO 200

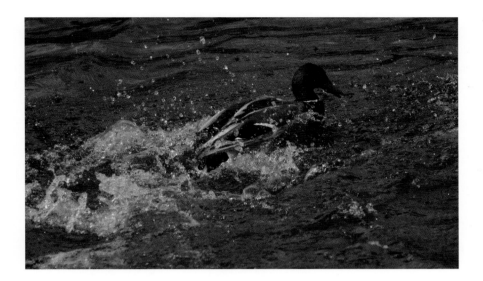

◀ **Fig. 7.23**
A male mallard drops
unceremoniously into the
water. Monopod. 1/1000sec
f5.6 300mm lens. ISO 200

◀ **Fig. 7.24**
A coot working extremely
hard, and almost running on
water (aided by its large lobed
toes) before finally becoming
airborne. 1/1000sec f5.6
300mm lens. ISO 200

Photographing take-off and landing
Photographing birds during take-off and landing
requires much the same equipment and set-up
described for photographing flapping flight. It
also involves spending many hours watching and
waiting for something to happen, interspersed by
bursts of hyper activity.

The shots of water birds were taken in a local
park, with the increase in activity during the mating
season providing many more opportunities. The
camera was mounted on an extended monopod
complete with ball-and-socket head. Exposures
ranged from 1/650sec to 1/2500sec depending on
the light level, with the lens aperture set around
f7.1–f8, while ISO 400 seemed appropriate.

Blue-tit landing

As part of a series of photographs of garden birds in winter I decided to try to capture a shot of a blue-tit as it alighted on a conifer branch set up in the garden.

Three flash units were used; two at 45 degrees to the right side and 45 degrees above the subject, and one to the left at subject level to act as a fill-in light. On this occasion I did not light the background, as the almost transparent flight feathers would show up more clearly against a black background. The flash leads trailed across the ground under the garage side-door to where the camera and tripod were located. The camera was focused on the conifer branch with the 300mm telephoto lens set at f22. Exposure compensation of −1 stop underexposure was based on previous experience of the same set-up.

Two holes drilled in the garage side-door allowed me to watch the action through the top hole while the camera was set up peeping through the bottom one. When a bird approached the conifer branch, I quickly switched my attention to the camera view-finder, checking the focus (usually on the bird's eyes) before releasing the shutter and flash units.

The same arrangement was employed on several occasions, but using an extra flash unit to add a little light to the background board. The results were much more predicable than those of the swallows nesting, with a fairly good proportion of sharp, well-composed images.

▲ Fig. 7.25
The blue tit had landed and a split second earlier the flash had just caught the outstretched wings before they were quickly folded away. The almost transparent primary and secondary flight feathers are highlighted by using a black background. Tripod-mounted camera. Flash f22 300mm lens. ISO 100

◀ Fig. 7.26
I do a lot of bird photography in the winter when we supply the birds with daily food and water. Multiple flash is used for modelling but it also allows me to select a small lens aperture and a short flash exposure, sufficient to freeze any movement. Multiple flash 1/60sec f8. ISO 100

NESTING

Photographing Nesting Swallows

The swallow returning to its nest in an old barn called for a radically different approach from the take-off and landing shots, as the light level was too low to work without fairly powerful flash, bearing in mind the rapid movement of the bird's wings. I set up the camera, complete with autowinder and two flash units (guide numbers 45 at ISO 100) on a fully extended tripod standing on a large wooden hopper. The flash units and camera were approximately 2 metres (6ft) from the nest allowing me to stop down the 70mm focal length lens to f16 to achieve a good depth of field.

The camera was pre-focused on the front edge of the nest and the shutter triggered via a long twin flex with a simple bell-push switch at the operating end. With the switch in my hand I retreated into a hide constructed from an old wooden door and several lengths of rotten timber. After several minutes watching the parent birds visiting and feeding their young, I finally chose my moment and released the shutter. Two hours later only half a roll of film had been exposed. With only a couple of acceptable images, it was still not a bad return for this type of work.

◀ Fig. 7.27
A swallow returning to its nest in an old barn, with food for its young. The body and wings are almost vertical to increase drag and reduce speed, while the outstretched legs are anticipating a safe and accurate landing on the edge of the nest. Tripod mounted camera. Multiple flash f16. ISO 100

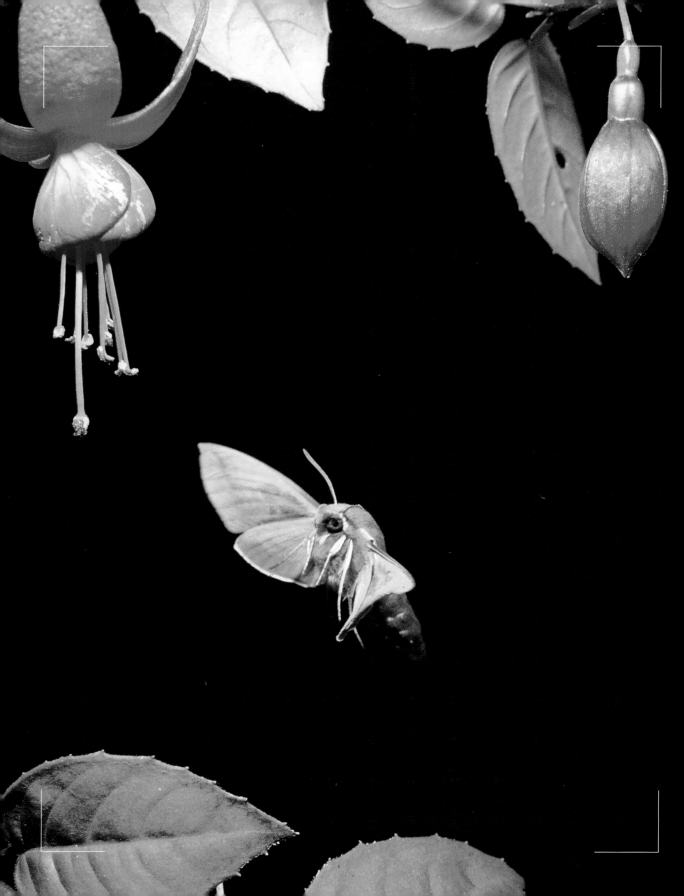

Chapter 8
Insect Flight

In common with most animals flying insects spend their time feeding, mating and producing offspring to keep their species in existence and, where possible, colonizing new territories. This is only made possible by their restless nature, which manifests itself in their ability to fly.

There are no fossil records of flying insects until about 300 million years ago during the Carboniferous period, and any theories about the origin of wings must be highly speculative. It has been suggested that flap-like extensions developed on the upper part of the thorax, probably acting as heat collectors and eventually becoming sufficiently large to keep the insect airborne as it jumped from branch to branch. Another theory is that small wing-like structures developed in aquatic insects, similar to mayfly nymphs, and were probably used as gills to extract oxygen from the water. When these aquatic insects eventually evolved into land dwellers, the possible forerunner of the wing was already present.

These are only theories, with no fossil evidence to back them up. Nevertheless, fossil remains do indicate that dragonflies with wingspans measuring over half a metre were well established around 300 million years ago. With no aerial competition flying insects evolved quite quickly (in geological time) until during the Cretaceous period, some 150 million years ago, when many flying insects including moths, flies, butterflies and bees had already evolved, taking full advantage of the newly developed pollen and nectar-containing flowering plants.

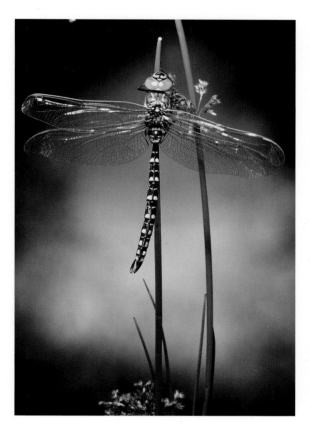

▲ Fig. 8.1
The golden-ringed dragonfly, photographed in a flight tunnel as part of a series on insect flight. Multiple flash f22. ISO 100

◀ Fig. 8.0
Elephant Hawkmoth. Flight tunnel. Multiple flash f16. ISO 80

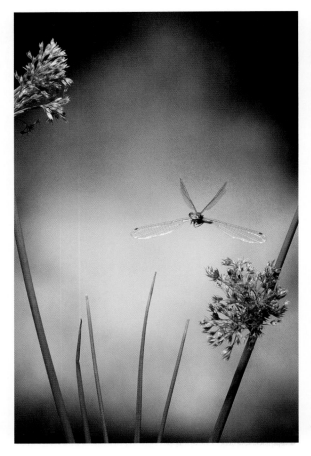

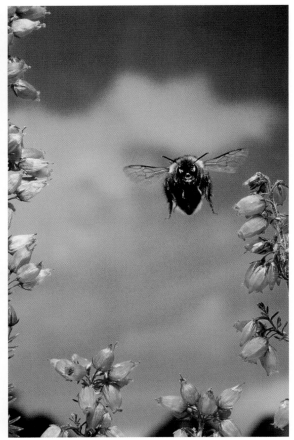

▲ Fig. 8.2
Dragonflies and damselflies – the only insect groups where the pairs of wings beat independently of each other, indicating early evolution. Flight tunnel. Multiple flash f22. ISO 100

▲ Fig. 8.3
Bumble bees, in common with most flying insects, can fly backwards, forwards, up and down and even upside down, with the ability to change direction in a split second. Flight tunnel. Multiple flash f22. ISO 100

Insects have evolved flight patterns and manoeuvres at which we can only marvel but cannot fully explain. They can fly backwards, forwards, up and down and even upside down, with the ability to change direction and speed in a split second. Try swatting a housefly in mid-flight – it can change direction and speed long before your newspaper is anywhere near it, no matter how quick your actions.

THE INSECT WING

Whereas bird wings are all built on the same skeletal pattern and are therefore fairly similar in basic shape, insect wings exhibit a wide variety of shape and size, ranging from the hair-fringed club-like extensions of minute thrips to the large scale-covered wings of butterflies and moths and the delicate transparent wings of damsel flies.

A typical insect wing is only two to six microns (1/1000mm) thick, consisting of two thin sheets of cuticle separated by a network of strengthening veins which are usually hollow, containing both blood vessels and fine air-tubes (trachea).

When the adult insect emerges from its pupal stage, the small tightly folded wings are inflated by blood pressure, reaching their final size and shape within minutes. The veins, useful in identification, support the wing, making it strong, flexible and very light. To the naked eye it looks quite smooth, but electron micrographs (images magnified many thousand times) indicate that the leading edge is often quite corrugated, providing additional strength to the wing, without causing any great problems to the airflow along the wing surface.

Wing Alignment

The standard arrangement for most flying insects is two pairs of wings attached to the second and third thoracic segments. In dragonflies and damselflies the pairs of wings function independently, but in most flying insects the fore and hind wings are linked together by slots, bristles or interlocking hairs to form a single functional unit.

The exception to this almost universal wing arrangement is in the Diptera or true flies, where the original second pair of wings has been reduced to peg-like halteres which are crucially important in manoeuvring, functioning as part of a complex gyroscopic system. Another group of insects, the Coleoptera or beetles, also use only one pair of wings for flying. The front pair (elytra) tend to be hard and tough and are held above the body at an angle of around 45 degrees, probably acting as aerofoils and generating some lift, while the rear wings do all the hard work.

Many insect wings are superficially quite smooth, whereas butterfly and moth wings are covered in tiny scales, arranged in a way similar to the roof tiles on a house. Each scale is attached by a short peg that fits into a tiny socket on the wing surface. The pigments in these scales produce the beautiful wing colours and patterns, although some metallic or iridescent colours are the result of light being refracted by the minute ridges on the surface of the scales. They may function as protective colouring or as heat exchange units, but whether they play any significant role in the flight process is debatable.

Photographing Insect Wings
Bee wings (Bombus terrestris)

Here we are dealing with extremely thin flat structures, making it very important to set up the wings absolutely parallel to the camera back to ensure satisfactory sharpness across the entire field. For the photograph diffused frontal lighting was used against a plain white background.

Note the obvious veins, particularly in the forewing, plus the additional strengthening along the leading edge. The fore and hind wings function as a single unit, coupled together by a complex system of hooks located towards the outer end of the leading edge of the hind wing, which engages with the forewing's trailing edge. This linkage is just visible in Fig. 8.4.

▲ Fig. 8.4
Bumble bee wings are extremely thin (2–6 microns thick) but quite stiff. The lighting was diffused frontal against a white background, with the veins clearly visible. 1/15sec f16 80mm macro lens +2 dioptre close-up lens

▲ Fig. 8.5
The lighting was oblique against a black background with the wing looking thick, pigmented and corrugated – quite different from Fig. 8.4. 1/15sec f16 80mm macro lens +2 dioptre close-up lens

Fig. 8.5 shows the same set-up but the lighting is now oblique and the background black, giving an impression of a quite thick, highly pigmented, corrugated wing, which appears to have little in common with the wing in the first photograph.

The camera was firmly mounted on a tripod and the 80mm macro lens was stopped down to f16 and supplemented by a +2 dioptre screw-in close-up lens. I used Velvia 50 film to record the fine detail and to ensure good colour contrast.

Peacock butterfly wing (Inachis io)

The two images show the scales of a peacock butterfly wing at different magnifications (×5 magnification in Fig. 8.6 and ×8 in Fig. 8.7). The peacock butterfly was found dead, trapped in a spider's web in a corner of a window in the garage. A forewing was removed and glued onto a piece of black cardboard which was then positioned vertically, using a pair of standard bench stands.

▼ Fig. 8.6
A section of a peacock butterfly wing magnified 5× and photographed with an 80mm macro lens stopped down to f.22 and mounted on a bellows unit, with the lens approximately six centimetres from the wing surface. Flash f22 80mm macro lens bellows unit. ISO 50

▼ Fig. 8.7
A 20mm macro lens was attached to the bellows unit allowing a magnification of 8×. The two flash units were obliquely positioned one at either side and the lens was stopped down to its smallest aperture. Flash f16 20mm macro lens bellows unit. ISO 50

Two flash units (guide number GN32 at ISO 100) were set up at about 45 degrees in front of and 45 degrees above the wing to highlight the texture of the wing surface. The 80mm macro lens, stopped down to f22 and mounted on a bellows unit, was positioned approximately 6cm from the wing.

For the higher magnification shot (Fig. 8.7) I switched to the 20mm macro lens and moved in even closer (3cm) after repositioning the flash units at a more grazing 30 degree angle to the wing. The smallest aperture available was f16; at smaller apertures the definition would fall off as diffraction set in. A powerful reading lamp was held close to the wing to provide sufficient light to focus the lens.

The camera, bellows and lens were operated as one unit rather than racking the bellows back and forth; although the 80mm lens did have a helicoid fine focus system the 20mm lens did not, and just to make life more difficult, it had to be stopped down manually.

This was a difficult assignment where image sharpness was all-important, but with a depth of field of less than 1mm, very accurate focusing was essential.

ENERGY REQUIREMENTS FOR FLIGHT

Wings beating at between 20 and 1,000 cycles per second must overcome their own inertia and drag, and this requires large amounts of muscle power and energy. A muscle contracts when stimulated by an electrical impulse from the controlling nerve, with a suggested upper frequency of approximately 100 nerve impulses per second, that is, 100 wing beats (Hertz) per second. This nerve impulse frequency is quite inadequate for bees and hoverflies (200/sec), mosquitoes (600/sec) or midges (up to 1000/sec). The explanation seems to lie in the extraordinary muscle tissue known as fibrillar

(or asynchronous) muscle, which can contract and relax much more rapidly than the rate of the nerve impulses stimulating it. This explains in part why a mosquito can beat its wings at 600 times per second.

The insect thorax and wing suspension system contains a very special energy-storing elastic tissue (resilin), a near perfect elastic material. It can store energy generated by the muscles and release it when required at 97 per cent efficiency.

Muscles require energy-rich food and oxygen, both being supplied direct to the muscles without the need for blood vessels. The almost clear haemoglobin-less blood circulates around the body organs, gently pushed by a long tubular heart and aorta located on the top side of the body.

Air containing oxygen is brought direct to the muscles through a system of tubes (trachea), which enter and exit the body through a row of small holes (spiracles). Contraction of the abdomen, plus the opening and closing of the spiracles, keeps the air circulating around the body organs and the muscles.

Flight Muscles

The earlier evolved dragonflies have relatively simple direct acting muscles with a pair for each wing (four pairs in total). Contraction of the outer group produces the wing's downward movement, while the inner set initiates the upward movement. The front pair of wings can move out of phase with the rear ones, this being readily observed in flash photographs of dragonflies and damselflies in flight.

However, most flying insects including bees, wasps, flies and butterflies have evolved an entirely different system based on a slight distortion of the thorax. The thorax can be likened to a slightly flexible shoe box complete with a lid which is attached to the box by flexible resilin. Some resilin is also present in the box itself and in the lid. The wings are inserted through the box at lid level. There are two sets of indirect flight muscles, one running vertically from the top to the bottom of the thorax, which

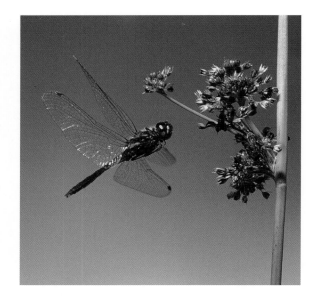

when contracted slightly flatten and bulge-out the sides of the thorax (see Fig. 8.9). This moves the wings upwards. The other muscles run the length of the thorax, and when they contract the thorax is squashed in the opposite direction, arching the roof upwards, causing the wings to move on their downward path. Because the flight muscles are fibrillar (asynchronous) they can contract extremely rapidly, producing the fast wing beat we see in bees and wasps.

▲ Fig. 8.8
The wing movements of the dragonfly are relatively slow, controlled by four pairs of muscles. Flight tunnel. Multiple flash f22. ISO 100

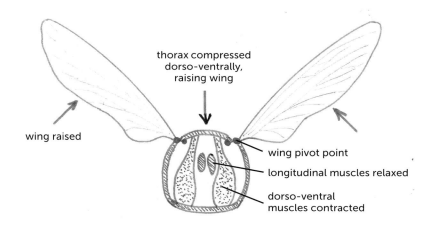

◄ Fig. 8.9
The wing movements are produced by slight distortion of the thorax which, when the dorso-ventral muscles contract, flatten the thorax very slightly, and as a result of the pivoting arrangement at the wing insertion points, the wings are raised. Contraction of the longitudinal muscles running the length of the thorax cause it to arch upwards and the wings to move down (after T.I. Storer).

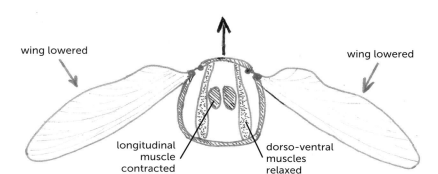

Temperature Control

All muscle tissue (including our own) works more efficiently when it is warm. Birds and mammals (including humans) have a high constant body temperature (homoiothermic) of 40°C and 37°C respectively; whereas the rest of the animal kingdom does not (poikilothermic). These animals are popularly referred to as cold blooded because their body temperature follows the cool environmental temperature (although in very hot climates they should be called hot blooded).

Insects depend on the heat from the sun to warm up their bodies and flight muscles to working temperature. This is around 30°C, which explains why flying insects are active when the sun is shining but disappear, remaining quiet and static, when the sun goes in and the temperature falls. When resting, butterflies always position themselves with their wings facing the sun to obtain maximum solar heat.

Some flying insects, particularly the large bodied ones, such as silk moths, hawkmoths and some beetles, raise their body temperature, especially the flight muscles, by shivering their wings before take-off. The ultimate example of real cunning must be the bumblebee, which disconnects its wings from

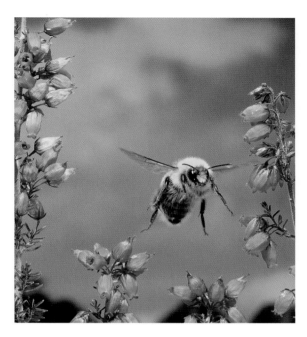

▲ Fig. 8.11
A buff-tailed bumblebee is now fully warmed up and well able to fly. Photographed in the flight tunnel using the infra-red triggering device and multiple flash. Flash f16. ISO 50

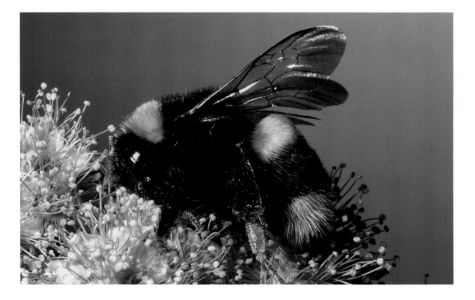

◀ Fig. 8.10
On cold mornings the bumble bee de-couples its wings and vibrates the flight muscles to generate heat (like an aircraft revving its engines before take-off, as insects can fly only when their body temperature reaches around 30°C. The wings are then re-coupled and the bee takes off, becoming one of the early visitors to the flowers to collect pollen. 1/125sec f16. ISO 100

the flight muscles, vibrating and warming up the muscles, before re-coupling the wings prior to take-off (like an aircraft warming up its engines at the end of the runway). This ability allows these early flyers to collect nectar and pollen long before other insects are sufficiently warm to fly. Finally, to prevent heat loss, the bodies of many flying insects have a dense covering of hairs or scales to provide insulation and help retain that all-important heat.

Photographing Bees and Butterflies
Feeding

Capturing the feeding bee or butterfly is best done outdoors in the natural environment, although natural looking photographs can be taken indoors when adverse weather conditions preclude outdoor photography. The obvious place to find both butterflies and bees is near flowering plants where pollen and nectar are readily available.

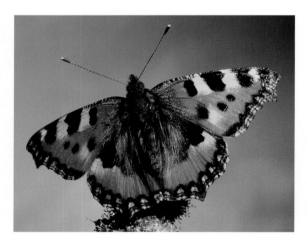

▲ Fig. 8.12
The tortoiseshell butterfly photographed against a blue sky. Keeping the plane of the wings parallel to the camera back ensures that the image is critically sharp revealing lots of fine detail. 1/60sec f22. ISO 100

Small tortoiseshells, *Aglais urticae*, are attracted to buddleia, nettles, and fallen apples in autumn, while the painted lady, *Cynthia cardui* is especially partial to thistle flowers. A butterfly becomes preoccupied as its long proboscis goes deep down to the bottom of the flower where the nectar is usually stored. This often takes a few seconds which is long enough to take a shot or two.

I suggest using a monopod for extra stability. Approach slowly and take your first photograph. Move in even closer, filling the frame with the image, while altering the camera angle until a satisfactory composition is achieved. If possible, align the camera back parallel to the wings to produce overall sharpness. I recommend using a medium focal length (90–120mm) macro lens to obtain a reasonably large image without getting too close and disturbing the butterfly.

A fairly small lens aperture of f11–f16 would render the background sufficiently sharp to show the local habitat. However, if you want to concentrate solely on the butterfly, a wider lens aperture would throw the background out of focus, or you could recompose the image using a more distant background. A camera ISO setting of 100–200 would be a good compromise between a smooth noise-free image but with sufficient ISO speed to help freeze any movement of the insect.

For bees you could follow much the same plan, but if overall body sharpness is required, the camera back should be parallel to the length of the bee's body. In dull cooler conditions photography becomes easier as the butterflies and bees slow down, although a touch of fill-in flash might be necessary to brighten the image a little.

Photographing Indoors

Bees and butterflies, plus the appropriate plant material, can be collected and photographed indoors.

Equipped with a large butterfly net and glass jar, I took a trip to the local park, hoping that the buddleia bush there would be a good place to start looking for red admirals and small tortoiseshell butterflies. I was not disappointed. With very little difficulty a couple of tortoiseshells were netted and carefully transferred to the wide-mouthed jar for safe transport home. Back in the study I carefully picked up a small tortoiseshell in my cupped hands and gently transferred it to a flower head; it was quite docile, being preoccupied with examining the flower head.

The camera could be handheld on a monopod, and I prefer to use manual focusing as it allows me to keep a particular area, usually the eyes, pin sharp. Due to the relatively low light level indoors, I used flash, which also freezes any slight movement in the insect.

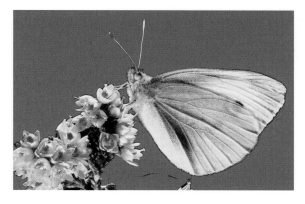

▲ Fig. 8.14
A cabbage-white butterfly at rest. Fine details on the underside of the wing are clearly visible due to the accuracy of the camera set-up and the side lighting. A green background was used to harmonize with the pale yellow of the wing. 1/60sec f16. ISO 100

▼ Fig. 8.13
A swallowtail butterfly resting on a fuchsia flower, photographed indoors against a paint-sprayed background. Keeping the flower and the swallowtail parallel to the camera back kept everything in sharp focus. 1/60sec f16. ISO 100

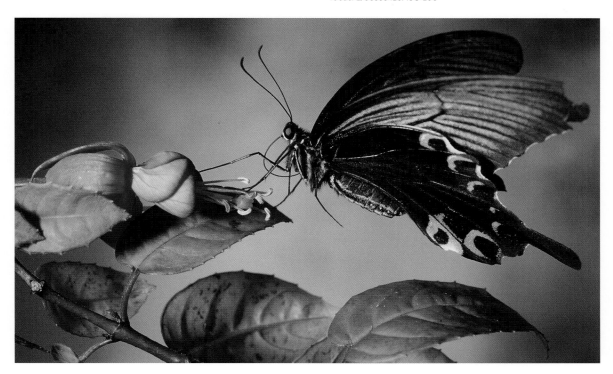

A suitable background could be a piece of black velvet for maximum impact, although the final result might appear a little too staged. Paint-sprayed background boards can be used with the overall colour being either bold or subtle to harmonize or contrast with the subject, depending upon what you are trying to achieve.

Some photographers collect and chill their specimens in a domestic fridge (around 5°C) for a few minutes to slow them down. This is not as hard-hearted as it might appear because during a clear late summer/autumn night, outside temperatures can easily fall to around 5°C or lower. The keen nature photographer will be up at dawn hoping to capture a well-composed image of a dormant butterfly or moth bedecked in jewel-like morning dew.

HEAD SHOT

If you are interested in taking a head-on photograph of a bee, butterfly or moth, the lens needs to be stopped well down (around f16–f22), as the depth of field when working so close would be only a millimetre or two. If you cannot get a sufficiently large image with your normal macro lens, a simple solution would be to screw a +2 dioptre supplementary lens onto the front of the camera lens or attach an extension tube or tele-converter between the lens and the camera body.

▲ Fig. 8.15
A tortoiseshell butterfly in side view showing the details of the head, the hairy body and underwing. 1/60sec f16. ISO 100

THE AERODYNAMICS OF FLIGHT

Gliding

Although flying insects have been around for some 350 million years, rather surprisingly, very few have perfected any form of gliding. The exceptions include dragonflies, which can glide for a few seconds, and some larger butterflies such as the monarchs and swallowtails, which can glide for short distances after gaining the necessary momentum and height from their normal flapping flight. Why more insects have not adopted this energy-saving method of flight is puzzling, but it might be due to the high-friction drag on the wings resulting in a poor lift-to-drag ratio.

▼ Fig. 8.16
Is this red admiral gliding or not? Normally only the larger butterflies and dragonflies are known to glide. Flight tunnel. Flash f16. ISO 100

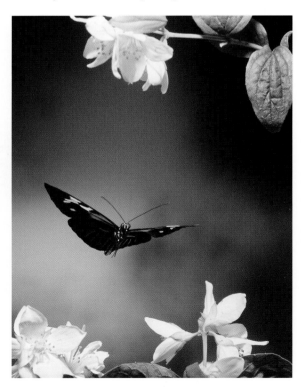

Flapping Flight

An insect wing performs like an aerofoil, twisting to produce varying angles of attack and therefore lift, at different points along the wing surface depending on the manoeuvre. Unlike an aircraft wing, the insect wing has to produce both lift and forward momentum, and during normal flight the wing tip describes a compressed figure-of-eight. This often becomes distorted in various ways depending on the flight characteristics at any particular moment in time.

▼ Fig. 8.17a–d
Images of wing movement during the flight of a red admiral butterfly. It is interesting to note that the wings are horizontal or above in most of the images, suggesting the possibility that the wing movement much below the horizontal is either very quick indeed or does not occur. Flight tunnel. Flash f16. ISO 100

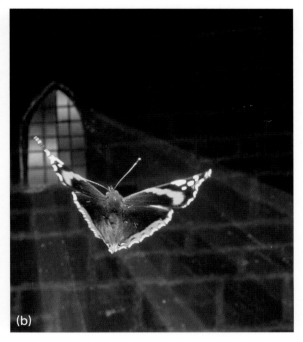
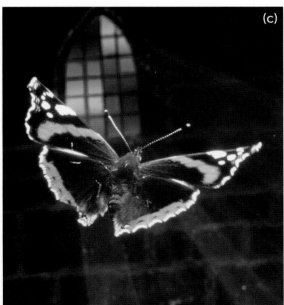
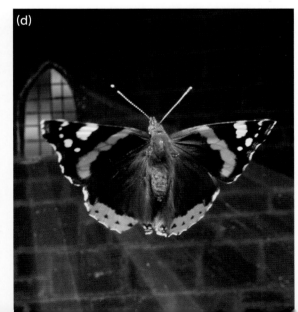

A normal wing cycle can be said to begin when the wing begins to move from the fully raised position, moving forwards and downwards generating both forward momentum and lift. When the wing is completely horizontal it produces maximum lift, but with little forward momentum. Once past the central point the wing slows down and begins to twist in the opposite direction, producing forward thrust. For a split second, at the bottom of the movement, the wing is motionless before it begins its upward sweep. As the upward sweep begins, the wing moves obliquely backwards and upwards but continues to rotate until the outer region of the trailing edge is facing down. Towards the end of the upstroke the wing rotates again increasing the angle of attack, producing both lift and forward movement.

The most surprising aspect of normal flight is the constant rotation (twisting) back and forth of the wing, presenting a large range of wing positions within the figure-of-eight cycle and an extensive range of angles of attack.

Different insects, although adopting this basic flight pattern, have added their own distinctive variations. For example, Torkel Weis-Fogh, working at Cambridge University on a small parasitic wasp, discovered that the wings clap together above the body and then fling themselves apart – known as the clap-and-fling mechanism, which can generate an extra 20–25 per cent lift. This has also been observed in the cabbage white butterfly and probably occurs in many other insects.

Recent research has discovered more details of the aerodynamic forces present in insects such as dragonflies, damselflies and large flies, these involving air movement over wing surfaces with the formation of vortices and delayed stall mechanisms resulting in a theory known as the party-streamer effect. Research on insect flight is ongoing, helping us to understand what a highly complex process flight is and to more fully appreciate some of the in-flight photographs.

PHOTOGRAPHING INSECT FLIGHT OUTDOORS

Someone commented favourably on one of my photographs of a bumblebee, *Bombus terrestris*, in flight, and without any irony asked if I had taken the snap at the bottom of the garden. I tried to explain the problems which make this naïve (but understandable) approach virtually impossible.

Speed of wingbeat
The wings of the bumblebee beat at around 200 cycles per second, each cycle including both the upstroke and the downstroke (400 wing strokes per second). During an exposure of 1/400sec each wing would make one complete stroke, leaving the wing image completely blurred or not visible at all. At an exposure of 1/4,000sec the wings would move through an arc of approximately 9 degrees (based on a 90-degree stroke), and again the wing image would be blurred.

Flash would be an obvious possibility but it would have to be extremely powerful, producing a flash of 1/10,000 to 1/15,000sec to freeze the wing movements. Bright ambient daylight might result in ghost images.

Flight Path
The second problem concerns the unpredictable flight path of the insect. Occasionally a bumblebee will fly directly to the flower, but more often its path can at best be described as random, leaving the photographer waving his camera around in sheer frustration.

Focusing
Finally, when trying to produce a reasonably large image of a bee or butterfly, extremely accurate focusing is critical, as the depth of field is measured in millimetres rather than centimetres.

These problems look almost insurmountable but they can be solved (almost!) by using a completely different approach plus some additional equipment – the flight tunnel.

Flight Tunnel Photography

Use of a flight tunnel belongs in a specialized branch of insect photography, calling for infinite patience and the ability to operate simple electronic equipment. The basic idea is that the insect flies along the flight tunnel, interrupting a white light or an infra-red beam, which triggers the camera shutter

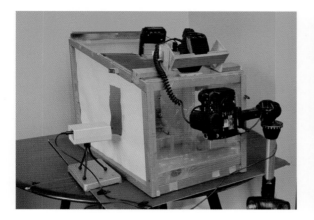

▲ Fig. 8.18
The flight tunnel consists of a wooden frame, cardboard-clad enclosure. The insect flies along the tunnel, triggering the infra-red switching unit which activates the flash units and the camera. Unfortunately the success rate is no greater than 10 per cent.

▲ Fig. 8.19
The flight tunnel and switching unit were tested and modified over several months. As I was using film at the time I had no means of checking the results until the film had been processed, thereby prolonging the task. The testing included using a butterfly-sized model suspended on a fine thread and released from the far end of the tunnel.

and fires the flash units. However, the success rate (that is, a pin-sharp image comfortably positioned within the frame) is no greater than around 10 per cent.

I designed my own flight tunnel using readily available materials and components coupled with some basic DIY skills. My flight tunnel is a wooden-framed cardboard-clad enclosure 60cm (24in) long, 30cm (12in) square at the front rising to 45cm (18in) high at the rear. A cardboard-framed sheet of perspex with a central hole for the camera lens is located at the front, and a selection of coloured background cards can be slot into the rear of the tunnel.

Early version

Several years ago, when I first thought of the flight tunnel, the solution was fairly basic. The light source was a 12 volt, 100 watt halogen lamp assembly, powered from a variable output power pack. Using a simple convex lens at the end of an 8cm length of domestic plastic piping focused on a pinhole at the other end of the piping, I managed to produce a pencil beam approximately 5mm in diameter over a distance of a metre.

The photoelectronic switch unit was provided by RS Components Ltd; with their light-activated switch LAS15. This is a combined photodiode and integrated circuit designed to operate over a range of 11–20V. The power to the circuit was supplied by two PP4 dry batteries linked in series to produce 18V. One of the many problems concerned the unpredictability of the insect flight path, and I used sugar solution and an additional light source to encourage the insect to fly along the tunnel towards the camera. I also increased the chances of a photograph being taken by a factor of three by introducing a small adjustable mirror at either side of the tunnel so that the very narrow beam of light zigzagged across the tunnel.

A sharp in-focus image of the insect was difficult to produce because after breaking the light beam and triggering the shutter it could take up to 1/30sec for the mirror to flip up and for the focal plane shutter to travel over the film, during which time the insect would have moved towards the camera and therefore would be out of focus. The ideal solution would have been to lock up the mirror and use a specially designed fast-acting leaf-blade shutter in front of the lens, leaving the focal plane shutter open (that is, set on Time). As I only had access to a standard camera with no mirror lock-up and with no fast-acting leaf-blade shutter available, I had to make allowances for the time delay. The camera was focused approximately 2.5cm in front of the light beam, the distance varying slightly, depending on the flight speed of different insects, and established by trial and error.

A number of trial exposures using a wooden model indicated that the underside of the insect would be underlit; this was corrected by placing a piece of kitchen foil-covered cardboard at an angle of 45 degrees placed on the floor just inside the tunnel to reflect some light upwards. Spray-painted background boards had been used previously, but on some occasions I also experimented with a photographic enlargement of an outside scene showing blue sky, clouds and out-of-focus purple heather in the lower part of the picture. Finally, some bell heather flowers were arranged just in front of the light beam and the tripod-mounted camera focused on them.

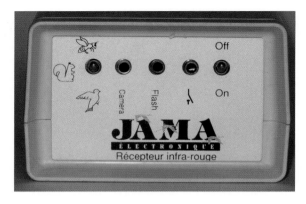

▲ Fig. 8.21
The back of the receiver unit shows various sockets including a switch with three settings – insects, animals and birds which alters the response time appropriate to the creature being photographed.

Infra-red switching

Today I still use the same basic set-up, but the white light beam equipment and the receiver unit have been replaced by a very easy to use, though pricey, infra-red beam switching device. It works on a single beam principle with the infra-red beam unit at one side of the tunnel and the receiver at the opposite side. It is extremely easy to set up and operate, being powered by two small 9-volt PP3 batteries, allowing it to be used outdoors.

The 50mm macro lens was set at f16, using aperture priority with –2/3 stop underexposure on Velvia 100 film. Using two quite powerful flash units (GN 32 at ISO 100) plus the reflected light in an enclosed white light-reflecting interior, the flash duration was estimated at around 1/10,000–1/15,000sec, which is sufficiently short to freeze the wings of most flying insects.

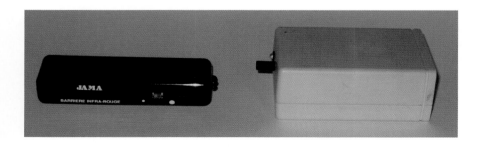

◀ Fig. 8.20
The Jama infra-red switch consists of an IR beam generator (black unit) which produces either a narrow or a broader beam and a receiver (white unit) which is connected by cable to the camera and flash units. When a flying insect breaks the beam it triggers the camera and flash units.

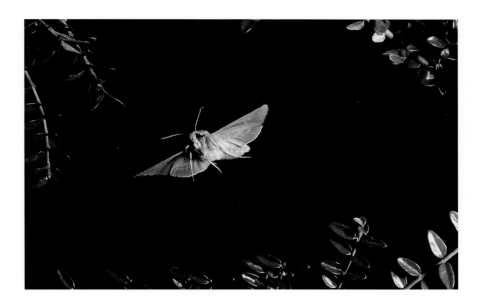

Fig. 8.22
An elephant hawkmoth flying along the flight tunnel. Non-intrusive dark green plant material and a black background were used to simulate night-time. The hawkmoth is perfectly positioned in the frame and very sharp – well set-up plus lots of luck. Flash f16 50mm macro lens. ISO 100

TAKE-OFF THEORY

Unlike aircraft and some birds, insects do not require a runway to gain sufficient speed and lift to become airborne. Most simply leap into the air. The importance of the wings in producing lift was discussed previously, but many insects also employ a tarsal (foot) reflex. When the feet and legs are pushed downwards prior to take-off, nerve impulses are transmitted up to the fibrillar muscles that run from the legs to the roof of the thorax, immediately stimulating the flight muscles. The wings are quickly positioned to produce maximum downdraught, allowing the insect to take off, not unlike a helicopter rising vertically from the ground.

Hovering
A helicopter sitting on the ground with the main horizontal rotor spinning will rise vertically as air is drawn from above by the rotating blades and pushed downwards, generating lift.

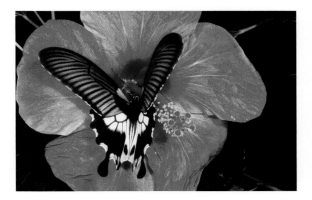

Fig. 8.23
Swallowtail butterfly hovering near the mouth of a hibiscus flower prior to landing. Flash f16. ISO 100

During hovering most insects use a near horizontal movement of the wings, although slight wing rotation through the insertion points in the thorax is necessary so that lift can be produced on both the near horizontal upstroke and downstroke. The wing tips describe a flattened figure of eight.

Photographing a Hovering Insect

I make frequent visits to a local tropical butterfly house, where the temperature is 35°C with the humidity approaching 100 per cent. When moving from a dry temperate outside environment into the hot atmosphere of the tropical house the camera body, lens and innards very quickly become covered in condensation, making the camera unusable. To prepare for these conditions I usually put my open camera bag in the car's passenger footwell and turn the heater full on. On arrival I close the bag and rush across the road into the tropical house. The camera is usually sufficiently warm, allowing it to be used without any condensation problems.

On one occasion I was hoping to obtain some close-ups of various types of butterfly as they rested on the vegetation. To obtain a reasonably large image I used an 80mm macro lens at a fairly small lens aperture, and used flash to freeze any movement in the insect. As I passed a brilliant pink/red hibiscus flower I noticed a swallowtail butterfly hovering around the entrance to the flower as it prepared to extend its long proboscis down the flower tube to the nectar at the bottom. I hastily checked the camera settings and made two exposures before the swallowtail finally settled on the flower and began to feed.

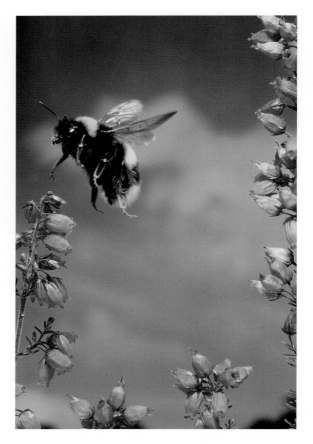

▲ Fig. 8.24
Bumble bee about to land on heather flower. Flash f16. ISO 100

Landing

More than 350 million years of evolution resulted in a landing technique second to none. Insects do not require a runway to land, as do aircraft and some birds, but can land within a few millimetres of their chosen target, and at considerable speed. This can be seen when a housefly lands very accurately on a few grains of sugar, or a bumblebee descends quickly and faultlessly on its chosen flower. Normally the legs are outstretched in anticipation of landing, and to prevent a heavy and potentially damaging touch-down, the legs function like very efficient shock absorbers in a similar way to an aircraft undercarriage.

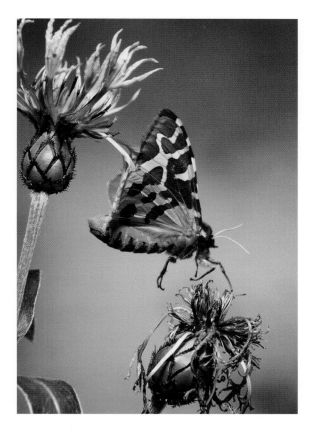

How does an insect such as a house fly land upside down on the ceiling? The possible mechanism had generated much debate among scientists and laymen, until Stephen Dalton solved the problem once and for all, using high speed sequential flash: 'Multiflash records show for the first time that the house-fly flies towards the ceiling at an angle of about 45°, stretching out all its legs. Using the front legs to touch down, the fly then deftly cartwheels over onto its other four feet to complete the landing.'

Astonishingly evolution has produced flying insects which can accelerate and decelerate, fly up, down and sideways, perform loops and rolls and even fly upside down, with each manoeuvre taking only a split second. Their methods and techniques still baffle our best scientific brains.

▲ Fig. 8.25
Tiger moth makes a clumsy attempt to land on a thistle. Flash f16. ISO 100

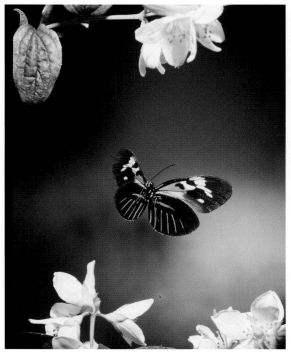

▶ Fig. 8.26
Zebra butterfly flying along the flight tunnel, approaching a flower. flash f16 50mm macro lens. ISO 100

Further Information

BIBLIOGRAPHY

Bebbington, J., *Insect Photography: Art and Techniques* (The Crowood Press, 2012)

Cooke, J., *The Restless Kingdom* (Blandford, 1991)

Dalton, S., *The Miracle of Flight* (Merrell Publishers, 2001)

Dalton, S., *Caught in Motion* (Weidenfeld & Nicholson, 1982)

Dalton, S., *Borne on the Wind* (Reader's Digest Press, 1975)

Davis, H., *Creative Close-Ups* (Wiley, 2010)

Elan, K., *Geometry of Design* (Princeton Architectural Press, 2011)

Morrison, P., *Mammals, Reptiles and Amphibians of Britain and Europe* (Macmillan, 1994)

Peterson, B., *Understanding Close-Up Photography* (Amphoto Books, 2009)

(If the book you are interested in is not available in the bookshops or from the publisher, new or secondhand copies can often be obtained on the internet.)

SUPPLIERS OF EQUIPMENT

Filters, close-up lenses, extension tubes
First Call, www.firstcall-photographic.co.uk.
Speed Graphic, www.speedgraphic.co.uk.

Microscopes – small handheld
Trekker T35:
GX Optical Microscopes, www.gxoptical.com.
GT Vision, www.gt-vision.com.

Standard microscopes
GT Vision, www.gt-vision.com.
Brunel Microscopes, www.brunelmicroscopes.co.uk.
(Brunel also supplies T adapters, slides, microscope kit and instruction booklets)

Jama infra-red switch unit
Wildlife Watching Supplies, www.wildlifewatching-supplies.com.

Infra-red beam break detector kit (MK 120)
Maplin, www.maplin.co.uk.

Index

Information Security Illuminated

Michael G. Solomon, Solomon Consulting, CISM, CISSP, TICSA
Mike Chapple, The Brand Institute, CISSP, MCP, MCSE, MCDBA, CCNA, and CCSA

JONES AND BARTLETT PUBLISHERS
Sudbury, Massachusetts
BOSTON TORONTO LONDON SINGAPORE

World Headquarters

Jones and Bartlett Publishers
40 Tall Pine Drive
Sudbury, MA 01776
978-443-5000
info@jbpub.com
www.jbpub.com

Jones and Bartlett Publishers
Canada
6339 Ormindale Way
Mississauga, ON L5CV 1J2
CANADA

Jones and Bartlett Publishers
International
Barb House, Barb Mews
London W6 7PA
UK

Jones and Bartlett's books and products are available through most bookstores and online booksellers. To contact Jones and Bartlett Publishers directly, call 800-832-0034, fax 978-443-8000, or visit our website at www.jbpub.com.

Substantial discounts on bulk quantities of Jones and Bartlett's publications are available to corporations, professional associations, and other qualified organizations. For details and specific discount information, contact the special sales department at Jones and Bartlett via the above contact information or send an email to specialsales@jbpub.com.

ISBN-13: 978-0-7637-2677-5
ISBN-10: 0-7637-2677-X

Cover image © Eyewire

Library of Congress Cataloging-in-Publication Data not available at time of printing

Acquisitions Editor: Stephen Solomon
Production Manager: Amy Rose
Production Assistant: Kate Hennessy
Marketing Manager: Matthew Payne
Editorial Assistant: Deborah Arrand
Manufacturing Buyer: Therese Bräuer
Cover Design: Kristin E. Ohlin
Text Design: Kristin E. Ohlin
Composition: Northeast Compositors
Technical Artist: George Nichols
Printing and Binding: Malloy, Inc.
Cover Printing: Malloy, Inc.

6048

Printed in the United States of America
11 10 09 08 07 10 9 8 7 6 5 4 3

Dedications

To God who has richly blessed me in so many ways – *Michael G. Solomon*

To my boys Matthew and Richard – *Mike Chapple*

Preface

Purpose of this Book

The study of information system security concepts and domains is an essential part of the education of computer science and information science students. A basic information security course should provide comprehensive coverage of each of the critical security domains, and guidance in implementing the topics discussed. Having worked in the information technology and security fields for over 15 years, the authors of this book have written from their extensive experience to present security topics using a no-nonsense approach. This text uses an easy-to-understand, practical format, making it not only more interesting to the student but easier for the instructor to explain. With pertinent lab exercises, strong real-world scenarios, and instruction on the use of common, popular tools and utilities, best practices, and recommended strategies and implementations, this book provides coverage of all necessary topics for individuals interested in developing information security literacy and competency.

Structure

Chapter 1, "Introducing Computer and Network Security," covers the basic elements of information security, such as network assets, vulnerabilities, and assessments. Chapter 2, "Access Control Methodologies," introduces

access control models and methods, identification and authentication, and related attacks. Chapter 3, "General Security Principles and Practices," defines commonly accepted principles of security, policies and practices, and general security checklists.

Chapter 4, "The Business of Security," focuses on protecting the needs of the organization, common best practices, and security-related laws and ethics issues. Chapter 5, "Cryptographic Technologies," explains encryption basics, encryption protocols, digital certificates, and selecting the right encryption technology. Chapter 6, "Securing TCP/IP," describes the industry-standard Transmission Control Protocol/Internet Protocol (TCP/IP), the OSI and TCP/IP Network reference models, IP packet flow, and secure IP protocols. Chapter 7, "Handling Security Incidents," discusses attacks, security incidents, malicious code, and procedures for reacting to incidents.

Chapter 8, "Firewall Security," covers network devices, traffic filtering, firewall architectures, basic firewall types, and implementing a firewall strategy. Chapter 9, "Operating System Security," explains general security concepts common to most operating systems, specific UNIX and Windows security issues, and techniques for assessing security risks. Chapter 10, "Securing Operating Systems," describes procedures for securing both UNIX and Windows operating systems, including operating system-specific security checklists, file systems, and account security issues.

Chapter 11, "Security Audit Principles and Practices," discusses common practices in conducting security audits, tools and techniques used in audits, and what to do after an audit. Chapter 12, "Network and Server Attacks and Penetration," steps the reader through the basics of recognizing attacks, identifying them, and establishing proper controls. Chapter 13, "Intrusion Detection Systems and Practices," covers methods of detecting intruders and attacks, intrusion detection system types, and choosing the right one for your needs. Chapter 14, "System Security Scanning and Discovery," describes techniques used in scanning systems for known vulnerabilities, common scanning tools, and common vulnerabilities. Finally, the appendices offer online security resources, a list of common security tools and software, a step-by-step guide to securing a Windows computer, and a glossary of terms used throughout the book.

Learning Features

The writing style is conversational. Each chapter begins with a statement of learning objectives. Step-by-step examples of information security concepts and procedures are presented throughout the text. Illustrations are used both to clarify the material and to vary the presentation. The text is sprinkled with Notes, Tips, and Warnings meant to alert the reader to additional and helpful information related to the subject being discussed. Challenge Exercises appear at the end of each chapter, with solutions provided in the Instructor's Guide, to provide students with hands-on experience with the material covered in the chapter. The Challenge Scenarios at the end of each chapter are an important part of the text, providing a real-world application of the material just presented.

Resources for student laboratory exercises are also available on the Web site. Chapter summaries are included in the text to provide a rapid review or preview of the material and to help students understand the relative importance of the concepts presented. The Instructor's Guide contains PowerPoint® presentations for each chapter, copies of figures, full statements of objectives for each chapter, alternative student projects, quizzes, chapter tests, comprehensive examinations for multiple chapters, and solutions to exercises.

Audience

The material is suitable for undergraduate or graduate computer science majors or information science majors, or students at a two-year technical college or community college, with a basic technical background. The book is intended to be used as a core information security textbook but could also be used for self study and in preparation for most basic security certifications.

About the Authors

Michael G. Solomon, CISM, CISSP, TICSA, is a full-time security speaker, consultant, and trainer, and a former college instructor who specializes in development and assessment security topics. As an IT professional and consultant since 1987, he has worked on projects or trained for more than 60 major companies and organizations, including EarthLink, Nike Corporation, Lucent Technologies, BellSouth, UPS, the U.S. Coast Guard, and Norrell.

From 1998 until 2001, Michael was an instructor in Kennesaw State University's Computer Science and Information Sciences (CSIS) department, where he taught courses on software project management, C++ programming, computer organization and architecture, and data communications. Michael has an M.S. in mathematics and computer science from Emory University (1998) and a B.S. in computer science from Kennesaw State University (1987).

Michael has also contributed to various security certification books for LANWrights/iLearning, including *TICSA Training Guide* and an accompanying Instructor Resource Kit (Que, 2002), *CISSP Study Guide* (Sybex, 2003), *Security+ Training Guide* (Que, 2003), *Security+ Lab Manual* (Que, 2005), and *Computer Forensics JumpStart* (Sybex, 2005). Michael also authored and provided the on-camera delivery of LearnKey's CISSP Prep e-Learning course.

Mike Chapple, CISSP, MCP, MCSE, MCDBA, CCNA, and CCSA, serves as Chief Information Officer of the Brand Institute, a brand identity consultancy based out of Miami, Florida. He previously served as a computer

security researcher with the U.S. National Security Agency, participating in the development of advanced network intrusion detection systems. Mike holds both B.S. and M.S. degrees in Computer Science and is a proud alum of the University of Notre Dame.

Mike has authored *The GSEC Prep Guide: Mastering SANS GIAC Security Essentials* (John Wiley & Sons, 2003) and co-authored several IT-related books, including *CISSP: Certified Information Systems Professional Study Guide*, 1st and 2nd editions, (Sybex, 2003 and 2004) and *TICSA Training Guide* (Que, 2002).

About the Technical Editor

Jeff T. Parker, MCSE, MCNE on NetWare 6, CCNA, and three SANS Institute certifications, is a senior software engineer with Hewlett-Packard, specializing in security, analysis of heterogeneous environments, and implementation of disaster-tolerant solutions. Recently, Jeff has been performing top-down security reviews in global environments, particularly those dealing with Information Technology Infrastructure Library (ITIL) standards. Jeff is an authorized GIAC Systems and Network Auditor (GSNA) grader for SANS Institute, helping SANS maintain its high standard of security training. Coming from a hardware background at Digital Equipment Corporation, Jeff served as the principal third-level support engineer for quad-processor and dual-processor Intel-based servers, allowing him to remain a significant contributor in solving interoperability and compatibility issues. In his spare time, Jeff is completing a M.A. in International Relations, working toward his MCSD (C# .NET), and traveling around the world with his beautiful Nova Scotian wife.

Acknowledgments

The authors would like to thank Jones and Bartlett for this opportunity to write a detailed and practical information security textbook. We appreciate the help of the Jones and Bartlett staff, especially Stephen Solomon, our Acquisitions Editor, and Deborah Arrand, Stephen's right-hand assistant. Amy Rose, our production editor, kept this project on track during the author review and page proofs phases and helped bring the project to a successful end.

The authors would also like to thank Jeff T. Parker, our technical reviewer, and the LANWrights/iLearning team—Ed Tittel and Kim Lindros. Ed led the book from proposal to project launch, was available throughout the project to offer assistance and guidance, and provided several of the appendices. Thanks to Kim for managing the project on our behalf, and reviewing and ferrying all the pieces that flowed between us and Jones and Bartlett.

Michael G. Solomon: My wife Stacey and my sons Noah and Isaac, who make everything I do possible and fun. I can never thank them enough. So, to my three best friends, thanks again.

Mike Chapple: Special thanks to the team at LANWrights/iLearning for their assistance on this book. Kim Lindros and Ed Tittel did an excellent job coordinating this book despite a number of challenges.

Contents

CHAPTER 1

Introducing Computer and Network Security

After reading this chapter, you will be able to:

- Explain the importance and applications of each element of computer security's CIA and DAD triads

- Identify the security complexities introduced when computers are used in a networked environment

- Understand the basic categories of threats to information systems

- Use risk analysis procedures to value assets, identify threat/vulnerability combinations that pose risks to those assets, and manage those risks

- Explain the tradeoffs inherent in the decision to implement any security policy or mechanism

Computers are everywhere; they impact almost every aspect of modern life to one degree or another. Our society has come to depend upon them to store and process most of the information we use on a daily basis, ranging in importance from a homemaker's grocery list to a cancer patient's treatment records. The act of placing this information in computerized systems is an act of trust. We trust that the information is secure—that it is protected from unauthorized access or modification and is available when we need to retrieve it. The stewards of this trust relationship are information security professionals—scientists, engineers, administrators, and managers—who have dedicated their careers to securing computing systems.

In this chapter, you'll learn some of the basic principles these professionals follow when designing security policies, procedures, and controls. In the remainder of this book, you'll be introduced to the specific technologies used to counter each type of security risk facing an organization.

1.1 Computer Security Basics

Before we can begin a discussion of computer security, we must come to a consensus regarding a definition of the term itself. What is computer security? Depending on the type of person you ask, you'll get different answers relevant to each person's interaction with computer security. For example, if you ask an end user to define computer security, you might hear "It's the password I use to log in to my system in the morning" or "It's the set of rules that mean I have to lock my screen when I step away from my desk." A network administrator might offer a much more technically complex answer, such as "It's the proper combination of firewall technologies with encryption systems and access controls used to ensure that data remains safe." A manager might give a higher-level answer that ignores some of the technical details, such as "It's keeping the bad guys out of my network."

In their book *Practical Unix and Internet Security*, Simson Garfinkel and Gene Spafford provide an extremely concise and practical definition of computer security: "A computer is secure if you can depend on it and its software to behave as you expect."

So, which one of these definitions is correct? In reality, they all are. Each focuses on the way computer security is viewed from a different standpoint. As a security professional, it's important that you keep all of these perspectives in mind. Not everyone in your organization will be as focused on security as you are. It's your responsibility to ensure that others are aware of the importance of information security to the organization and understand the potential ramifications of their actions.

1.1.1 CIA Triad

Within the security profession, practitioners tend to describe security as the sum of its component parts: confidentiality, integrity, and availability. These are the three requirements that users demand from information systems, and they are the cornerstones of any well-designed information secu-

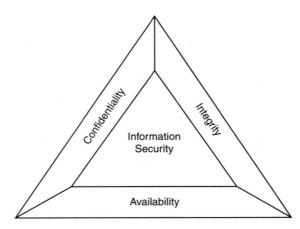

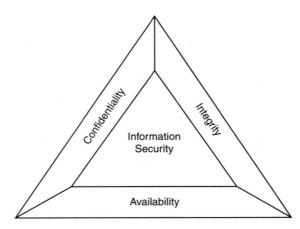

Figure 1.1
CIA triad

rity program. Together, these three attributes are known as the "CIA triad," as illustrated in Figure 1.1.

In the following sections, we review each of these goals in detail. While reviewing this material, you should consider them in the context of real-world scenarios that you're familiar with. Think about how each of these goals applies to your school, business, or other organization.

Confidentiality

Confidentiality is the most commonly cited goal of information security programs. Quite simply, we don't want our confidential information falling into the hands of unauthorized personnel. The security community invests a large amount of time and money in developing and implementing systems to ensure that the goal of confidentiality is maintained. In Chapter 2, you will learn how access controls protect the confidentiality of data by preventing unauthorized personnel from entering a system and preventing legitimate users from accessing information that they are not authorized to access. Chapter 5 introduces the concept of encryption systems—software implementations of mathematical algorithms designed to prevent a third party who intercepts a message from determining the contents of the communication. This type of technology facilitates the confidential exchange of information over an otherwise insecure communications channel, such as the Internet.

Integrity

Organizations also charge security practitioners with protecting the **integrity** of organizational data. The basic definition of integrity is ensuring that data may be modified only through an authorized mechanism. Integrity involves protecting data from the following types of unauthorized modification:

- Unauthorized users altering data (such as a hacker breaking into a database and altering records)

- Authorized users making unauthorized changes to data (such as a bank teller adding money to his personal account, rather than that of the customer)

- Data being altered through an inappropriate mechanism (such as a power surge causing database corruption)

Many of the mechanisms used to protect the confidentiality of data are also used to protect the integrity of data. For example, access control mechanisms help prevent the first two types of data modification in the preceding list. In Chapter 5, you learn how encryption systems use digital signature technology to prevent the modification of data by an unauthorized (either accidental or malicious) mechanism.

Availability

The third goal of information security programs is to guarantee the **availability** of information systems—the ability of authorized users to access data for legitimate purposes. After all, an organization's data is not useful if it isn't available for its intended use. A hacker who manages to prevent authorized access to a system may often be considered just as successful as one who manages to steal or manipulate the data stored within it.

We have dedicated a large portion of this book to helping you achieve the goal of availability within your organization. Chapter 6 provides you with an intimate understanding of how the TCP/IP protocol (the source of many vulnerabilities that lead to these attacks) operates. Chapter 7 describes some of the techniques hackers use to implement denial of service (DoS) attacks against an organization. In Chapters 9 and 10, you learn how to harden your operating systems to protect against these attacks.

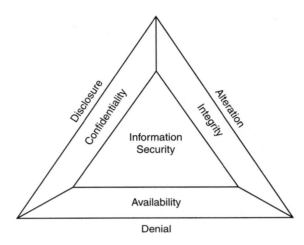

Figure 1.2
DAD triad

1.1.2 DAD Triad

In the previous section, you learned how security professionals use the CIA triad as a model for implementing security practices. Malicious individuals have a model of their own—the disclosure, alteration, and denial (DAD) triad, which outlines the three primary mechanisms used to defeat the security goals of an organization. An illustration of how the DAD triad complements the CIA triad is shown in Figure 1.2.

In the following sections, we examine each of the DAD triad components and look at how they relate to their CIA triad counterparts.

Disclosure

Disclosure occurs when unauthorized individuals gain access to confidential information. It occurs when security professionals fail, in one way or another, to achieve the CIA triad's goal of confidentiality. Examples of actions that constitute disclosure include:

- A hacker gaining access to your system and reading confidential information
- An insider disseminating confidential information to unauthorized third parties
- A programming failure that causes customers accessing your Web site to see the account information of other customers

This is not a complete list of possible causes of a disclosure of confidential information—such a list would be impossible to build. Take a few minutes to consider the confidential information that your organization maintains and the possible ways that it could fall into the wrong hands.

Alteration

Data **alteration** occurs when security mechanisms fail to ensure the integrity of data. As you learned during our discussion of integrity, there are a number of ways that this could occur. You should keep in mind that unauthorized alteration can be the result of either malicious or accidental activity. The following are a few examples:

- An administrative employee untrained in the use of a database may accidentally delete records while trying to retrieve a report for corporate executives if he or she is not properly trained.

- A janitor cleaning the floor may trip over a power cord and cause a critical system to lose power in the middle of writing data to disk, causing a portion of the disk to become corrupted and rendering the data stored on it unusable.

- A hacker might gain access to a computer containing data files with the personal identification number (PIN) codes for automated teller machine (ATM) users and change the PIN for a stolen ATM card, allowing the hacker to use the card at an ATM.

It's the responsibility of security professionals to ensure that these eventualities do not come to fruition. You can accomplish this through a combination of several mechanisms that you'll learn about in other chapters, including proper backups, protection against physical threats, training and education of employees, and implementation of proper access control systems.

Denial

Denial occurs when events take place that prevent authorized users from accessing a system for legitimate reasons. This includes actions as basic as a computer crashing, leaving users unable to access it until IT professionals restore it to proper working order or bring a backup system online. It also includes an entire class of malicious activity known as DoS attacks. Over the past few years, these attacks have become more prevalent and danger-ous as hackers harness the power of many computers worldwide to flood a

target system with traffic. (This technique is known as a distributed denial of service, or DDoS, attack.) You'll learn more about these attacks when you study security incidents in Chapter 7.

1.2 Introducing Networks

Until this point, we've focused on a general discussion of computer security as it applies to individual systems. In the early days of computing (and computer security), the main focus of protection was on the individual system. Individual users had desktop computers on which they stored files and processed their own data. Occasionally, you'd come across the rare user who used a device known as a modem to connect to other computers over the telephone lines. Over time, developers came up with the technology needed to interconnect computers in an organization, and the local area network (LAN) was born. Then, it no longer mattered where a user was located physically within the office. He or she could exchange files with other users electronically, without using floppy disks or magnetic tape. In recent years, the explosion of networking capability extended to the Internet, which interconnects almost every LAN in the world today. It's difficult to find a computer user anywhere who doesn't have some sort of Internet access. Indeed, most users now have broadband access to the Internet either at home, at work, or both, and the dial-up modem is slowly disappearing from general use.

This explosion of technology means an increasingly difficult job for the information security practitioner. In Chapter 6, you will learn about the security mechanisms used to protect the TCP/IP protocol, which powers communication over the Internet and many internal LANs. When you read Chapter 11, you'll learn about some of the security considerations unique to networked systems. Chapter 8 describes the use of firewalls to protect an organization's LAN from external attack, while Chapter 13 describes the use of intrusion detection systems to identify cases where other protection mechanisms have failed.

1.3 Threats to Security

At this point in the chapter, you might be a bit nervous about the threats and challenges facing security practitioners . . . good! Security professionals must have an acute sense of the threats facing them that borders on paranoia in order to effectively protect their environments. Of course, as you'll

learn later in this chapter, true professionals learn to balance this sense of impending doom with a healthy knowledge of the business goals of an organization and the computing requirements of the end users struggling to meet those business objectives.

Where do all of these threats originate? We can essentially narrow down the threats to three distinct classes of miscreants: hackers, malicious code objects, and organizational insiders gone astray.

1.3.1 Hackers

The term *hacker* has dual meanings. In contemporary culture, we usually refer to anyone who attempts to penetrate the security of an information system, regardless of their intent, as a hacker. Hackers are generally viewed as those who wreak havoc on innocent computer users. In the early days of computing, however, the term described anyone who was extremely proficient with the use of a computer. For example, an expert programmer or system administrator would have been proud to be branded a "hacker" by his or her peers.

In reality, the world of hacking has a wide range of followers, which can include the following:

- Corporate spies searching for trade secrets
- Peace activists wishing to deface an opposition Web site
- Intelligence agencies seeking military secrets
- Investors seeking "inside information"
- Teenagers seeking thrills

These are just a few examples of the types of people you might find seeking to undermine the security of a computer system or network of computer systems. Indeed, the world of hacking includes just about anyone who might wish to engage in the disclosure, alteration, or denial of another person's or organization's computing resources.

Hackers tend to travel in groups. A quick search on the Internet can easily uncover Web sites full of information and message boards that hackers of all types use to exchange information about techniques and boast about their latest attacks. These sites are both a hindrance and a help to security administrators. In one respect, the sites provide hackers with the ability to exchange information they can use against you and your systems. However,

you have the same access to this information and can use it to make sure that you're not the victim that the hacking community targets with these attacks.

1.3.2 Malicious Code Objects

Even the most novice computer user has some familiarity with **malicious code objects**, although perhaps not with the term specifically. Malicious code objects, such as viruses, worms, and Trojan horses, are computer programs that carry out malicious actions when run on a system. Some of these objects spread from system to system under their own power, whereas others require some sort of intervention by an unsuspecting computer user. They also vary greatly in their intent—each malicious code object carries some type of **payload**, the specific portion of the program that carries out the malicious act (as opposed to the parts of the malicious code object designed to fool the user or help the code spread from system to system). The payload may be as harmless as displaying an annoying message on the screen or as destructive as reformatting the computer's storage devices, destroying all data stored on the system.

In Chapter 7, you will learn more about the specific malicious code threats that face modern computing systems. Chapter 10 includes a discussion of antivirus software and some other simple measures that you can take to minimize the vulnerability of your system to malicious code objects.

1.3.3 The Malicious Insider

The final class of threats to your system that we examine is perhaps the most dangerous—the malicious insider. This is the most insidious of threats because it involves a betrayal of trust by a user that you've authorized to use your system. The insider threat is also one of the most difficult to prevent. The vast majority of security systems and policies in place today are designed to "keep the bad guys out." You face a much more difficult challenge—controlling the activities of someone who's already inside your perimeter of protection. In later chapters of this book, you will learn how you can use a combination of access control mechanisms and intrusion detection systems to help mitigate this threat.

A distinct subgroup of insiders exists that merits special protections—security professionals and system administrators. These individuals have

> **TIP**
>
> Attrition.org provides an interesting list of recent Web site defacement attacks. For details, visit *http://www.attrition.org/ security/commentary/*.

extremely powerful levels of access to your systems and, if they turn malicious, could have the most devastating impact on your organization. Keep this in mind when designing security controls and ensure that you never give one person too much unconstrained power.

1.4 Risk Analysis

To effectively identify and deal with the many threats facing their systems, security professionals must perform several distinct actions, as follows:

- Determine which of an organization's assets are most valuable.
- Identify any risks to those assets.
- Determine how likely each risk is to occur.
- Take some action to manage the risk.

Collectively, these actions are referred to as the risk analysis process. You actually perform these actions every day, whether you're conscious of it or not. Every time you get into your car, you perform a subconscious risk assessment. You realize that there is some danger involved in driving your vehicle, such as having an accident, getting lost, or becoming the victim of a carjacking. However, you take actions to minimize those risks—you purchase insurance, wear a seatbelt, and lock your doors. You then weigh the risk of driving your car against the benefits you receive and determine that the benefits outweigh the risks.

In this section, we take a more formal look at the risk analysis process and explain how security practitioners weigh the risks facing information systems on a daily basis.

1.4.1 Identifying and Valuing Assets

The first step in the risk analysis process is to identify the information assets in your organization (hardware, software, and data) and place values on them. You may choose from several valuation methods. Some of the more common techniques include the following:

- *Replacement cost valuation* puts a dollar value on an asset corresponding to the cost the organization would incur if the asset had to be replaced at market prices.

- *Original cost valuation* uses the original purchase price of an asset as that asset's value.

- *Depreciated valuation* techniques use the original cost less some allowance for the deterioration in value of the asset since the time it was purchased.

- *Qualitative valuation* techniques don't use dollar values but rather assign priorities to assets based upon their value to the organization.

The proper assignment of values to assets is a critical step in the risk analysis process, as it sets the foundation for critical decisions that will be made in the future. Risk management personnel decide whether particular protective measures are warranted by analyzing the cost/benefit ratio based upon the assigned asset value.

1.4.2 Identifying and Assessing Risks

After you identify and value your assets, the next step is to identify the risks facing those assets. First, let's clarify some key risk assessment terms:

- A *vulnerability* is a weakness in a system that may be exploited to degrade or bypass standard security mechanisms. For example, the fact that a system does not have antivirus software would constitute a vulnerability.

- A *threat* is a set of external circumstances that may allow a vulnerability to be exploited. For example, the existence of a particular virus represents a threat to a system.

- A *risk* occurs when a threat and a corresponding vulnerability both exist. For example, the threat of a particular virus combined with the vulnerability of a system without antivirus software combine to constitute a risk to that system.

The relationship between threats, risks, and vulnerabilities is illustrated by the Venn diagram in Figure 1.3.

There are two major classifications of risk assessment techniques: qualitative risk assessment and quantitative risk assessment. The following sections describe both types of assessments in detail.

Qualitative Risk Assessment

Qualitative risk assessment (like qualitative valuation) focuses on analyzing the intangible properties of an asset rather than focusing on monetary

Figure 1.3
Identifying risks

value. Qualitative risk assessment prioritizes risks based on the threats (tangible and intangible) that they pose to the organization. Risk managers can then prioritize the assignment of security resources to combating those risks based on the determined prioritizations.

Qualitative risk assessment has two major benefits. First, it is relatively easy to conduct. The assignment of priorities may be a relatively straightforward process arrived at through a discussion among senior security and business personnel. Second, it allows the risk assessment process to capture intangible attributes such as customer goodwill. For example, consider a financial institution that goes to great lengths to conceal evidence of information security breaches and refuses to support law enforcement efforts to press charges against the offenders. The reason for these actions is easy to understand: If the public perceived that a certain institution's information systems were vulnerable to intrusion, they might not want to keep their money there.

Quantitative Risk Assessment

Quantitative risk assessment, on the other hand, attempts to assign dollar values to each risk and then uses those dollar values to weigh the potential benefit achieved by implementing additional security measures. The key monetary measures used in quantitative risk assessment are:

- **Asset value (AV):** The value of the asset, as determined by one of the methods described in Section 1.4.1 of this chapter. For example, a computer might have an asset value of $1,000.

- **Exposure factor (EF):** The expected portion of an asset that would be destroyed by a given risk, expressed as a percentage of the asset. For example, if a power surge affected a computer, it might destroy the power supply. If the value of the power supply is 10% of the value of the computer, the exposure factor of the computer to a power surge is 10%.

- **Annualized rate of occurrence (ARO):** The number of times you expect a risk to occur each year. For example, you may expect a power surge to occur two times a year.

- **Single loss expectancy (SLE):** The amount of damage the asset would incur each time the risk occurs. It is computed as the product of the AV and EF. Continuing with the power surge example, this would be $1,000 times 10%, or $100.

- **Annualized loss expectancy (ALE):** The amount of damage the asset would incur each year from a given risk. It is computed as the product of the ARO and the SLE. In our example, this would be 2 times $100, or $200.

The process you use to analyze whether you should implement a security measure is relatively straightforward. For example, if you could purchase a surge suppressor that costs $25 to eliminate the risk to the power supply, it would be an easy decision to make—you'd recapture your investment almost immediately by saving $200 the first year on replacement power supplies. You can treat this process somewhat more rigorously by performing the following calculation:

$$\text{Benefit} = (\text{ALE} \times \text{life of measure}) - \text{cost of measure}$$

If the result is a positive number, you should implement the security measure. If it's a negative number, you may wish to pass.

> **NOTE**
> The discussion of cost/benefit analysis presented here is simplified. You should consult your organization's accounting staff to assist with these calculations, as you may wish to take into account factors such as depreciation and opportunity cost.

1.4.3 Managing Risks

After you determine the prioritization of your risks through a qualitative or quantitative risk analysis, you should take steps to manage the risks facing your organization. There are four choices that you may make when facing a specific risk—risk avoidance, risk mitigation, risk acceptance, or risk transference. The following sections cover each of these options.

Risk Avoidance

Risk avoidance is perhaps the simplest response. Risk analysts choose this option when the risk posed to an asset simply overwhelms the benefits gained by operating it. For example, an organization may decide that allowing employees to exchange e-mail with the outside world is an unacceptable risk, given that the employees may (accidentally or intentionally) e-mail confidential information outside of the corporate network. In this case, managers might choose to avoid the risk entirely by simply disallowing e-mail.

Risk Mitigation

Risk mitigation is the most common response to threats that pose a great risk to a system. In this risk management technique, administrators take preventative measures to reduce (or mitigate) the risk posed to an asset. For example, the risk of a hacker attack on a Web site is greatly mitigated by the presence of a firewall between the hacker and the system hosting the Web site.

Risk Acceptance

Managers may also choose to simply accept a particular risk as the cost of doing business, which is called **risk acceptance**. This is often the case when the chances of a risk occurring are extremely remote (such as a meteor hitting a data center) or when the potential damage the risk would cause is trivial (such as the cost of a floppy disk). When managers choose to accept a risk, they simply do nothing and continue to operate as if the risk did not exist.

Risk Transference

The final option for risk management is to simply transfer the risk to someone else, which is called **risk transference**. The most common example of risk transference is the purchase of an insurance policy. Consider the case of a homeowner who is concerned about the amount of damage that a fire might cause to his multimillion-dollar home. To protect himself against this risk, he purchases a homeowner's insurance policy for several thousands of dollars a year. In exchange for this premium, the insurance company agrees to accept the transfer of the risk. If the home burns down, the insurance company will pay to rebuild it. If the home doesn't burn down,

the insurance company keeps the premium and uses it to pay the claims of other policyholders while earning a profit.

Combination Approaches

In reality, the choice of a risk management option is rarely black and white. In many cases, especially for serious risks, managers choose to implement a combination of the above techniques. For example, a bank might choose to manage the risk of data manipulation by both implementing a firewall (risk mitigation) and purchasing an insurance policy (risk transference).

1.5 Considering Security Tradeoffs

In the preceding section, you learned how security is often looked at as a tradeoff between risks and benefits. Your choice of whether to implement a specific security mechanism is influenced by the cost of the mechanism itself and the amount of damage it may prevent.

One other major tradeoff must be considered when making security decisions—user convenience. Many security mechanisms are cumbersome from the perspective of the end user. For example, you could build a highly secure system at great expense by requiring users to enter a password, undergo a retinal scan, authenticate via voiceprint, and provide a DNA sample; however, two commonsense reasons prohibit this approach (besides the expense) in most cases. First, the security mechanisms may be so burdensome that users simply refuse to use the system and gain the productivity benefits of its use. Second, when you push users too far, they will seek methods to bypass your security mechanisms that may undermine the security of the entire system. Consider the example of passwords. If you force users to have a 15-character password with 3 numbers, 2 special characters, and a mix of uppercase and lowercase letters, their responses will be quite predictable. The users will write their complicated, hard-to-remember passwords on sticky notes and put them on the side of their monitors. Clearly, this is worse than having weak passwords, because anyone can walk by and gain unauthorized access to the system.

It's important that security practitioners keep these concerns in mind when designing a system. Weigh the tradeoffs of security, user convenience, business goals, and expenses before making any policy decisions.

1.6 Policy and Education

The fundamental cornerstone of any security effort lies in implementing proper policies and taking the appropriate steps to educate users about those policies. Your organization's information security policies should be comprehensive but flexible enough to accommodate changes in technology without requiring frequent rewrites. The policies should also be made available to all members of the organization and its affiliates.

You'll learn more about the development and implementation of proper security policies and education programs in Chapters 3 and 4.

1.7 Chapter Summary

- The CIA triad summarizes the three goals of security practitioners: confidentiality, integrity, and availability.

- The DAD triad summarizes the techniques that hackers use to defeat security measures: disclosure, alteration, and denial.

- The proliferation of networked computing greatly increases the number of risks facing an information security program. Practitioners must be aware of these risks and manage network connectivity to minimize their impact on an organization.

- The three main sources of threats to an information system are hackers, malicious code objects, and malicious insiders.

- The main steps of the risk analysis process are identifying and valuing assets, identifying and assessing risks, and managing risks.

- The four approaches to risk management are risk avoidance, risk acceptance, risk mitigation, and risk transference. Organizations often use a combination of these approaches.

- To build a strong information security program, you must implement a sound security policy and ensure that your employees are properly educated on their roles and responsibilities related to security.

1.8 Key Terms

alteration: The result of when security mechanisms fail to ensure the integrity of data, either accidentally or maliciously.

annualized loss expectancy (ALE): The amount of damage an asset would incur each year from a given risk. The ALE is the product of the ARO and the SLE.

annualized rate of occurrence (ARO): The number of times you expect a risk to occur each year.

asset value (AV): The value of an asset.

availability: The ability of authorized users to access an organization's data for legitimate purposes.

confidentiality: The assurance that unauthorized personnel do not obtain access to private information and that legitimate users don't access information they are not authorized to access.

denial: Occurs when events take place that prevent authorized users from accessing a system for legitimate reasons.

disclosure: The result of when unauthorized individuals gain access to confidential information.

exposure factor (EF): The expected portion of an asset that would be destroyed by a given risk, expressed as a percentage of the asset.

integrity: The assurance that data may be modified only through an authorized mechanism.

malicious code object: A computer program that carries out malicious actions when run on a system.

payload: The specific portion of a malicious code object that carries out the malicious action.

qualitative risk assessment: Attempts to assign dollar values to each risk and then use those dollar values to weigh the potential benefit achieved by implementing additional security measures.

quantitative risk assessment: Focuses on analyzing the intangible properties of an asset, rather than focusing on monetary value.

risk: Occurs when a threat and corresponding vulnerability both exist.

risk acceptance: A risk management technique in which a particular risk is accepted as the cost of doing business, often because the chances of a risk occurring are extremely remote or the potential damage the risk would cause is trivial.

risk avoidance: A risk management technique in which a potential risk is avoided entirely by disallowing a given activity. Risk analysts choose risk avoidance when a risk posed to an asset overwhelms the potential benefits.

risk mitigation: A risk management technique in which administrators take preventative measures to reduce (or mitigate) the risk posed to an asset.

risk transference: A risk management technique in which a risk is transferred to someone else.

single loss expectancy (SLE): The amount of damage an asset would incur each time a given risk occurs. The SLE is the product of the AV and the EF.

threat: A set of external circumstances that may allow a vulnerability to be exploited.

vulnerability: A weakness in a system that may be exploited to degrade or bypass standard security mechanisms.

1.9 Challenge Questions

1.1 Matthew's manager Renee recently informed him that she was concerned about the possibility of a hacker tapping into their corporate database and altering customer records. What security goal is Renee concerned about achieving?

 a. Confidentiality

 b. Alteration

 c. Integrity

 d. Availability

1.2 A janitor cleaning the floor of an organization's data center accidentally tripped over a power cord and cut the power to a critical file server. Users who depend on that data to complete their job functions are unable to access it and must take time off from work until IT personnel arrive and restore power to the computer. What security principle is most involved in this incident?

 a. Confidentiality

 b. Integrity

 c. Denial

 d. Alteration

1.3 Which one of the following DAD triad components is related to the CIA triad goal of integrity?

 a. Disclosure

 b. Denial

 c. Alteration

1.4 DDoS attacks are a manifestation of which component of the DAD triad model of malicious activity?

 a. Disclosure

 b. Denial

 c. Alteration

1.5 Which one of the following types of attacks is not normally considered a malicious code object?

 a. Virus

 b. DoS

 c. Worm

 d. Trojan horse

1.6 Which one of the following asset valuation techniques does not place dollar values on assets?

 a. Depreciated valuation

 b. Replacement cost valuation

 c. Original cost valuation

 d. Qualitative valuation

1.7 The failure of a security administrator to apply the most recent security patches to a system is an example of _____.

 a. threat

 b. risk

 c. vulnerability

 d. malicious code

 e. denial of service

1.8 Jim decides to purchase a business insurance policy to protect himself against liability from hacker attack. What risk management technique is Jim practicing?

a. Risk mitigation

b. Risk avoidance

c. Risk transference

d. Risk acceptance

1.9 Beth evaluated the potential risk of a hacker entering a specific system and decided that it did not justify the cost of purchasing an expensive intrusion detection system. What type of risk management is Beth practicing?

a. Risk mitigation

b. Risk avoidance

c. Risk transference

d. Risk acceptance

1.10 Richard is responsible for evaluating whether his company should develop and host a Web site on the corporate network. He decides that the risk posed to the site by hackers overwhelms the benefit that would be gained from having the site and decides not to develop the site. What risk management technique is Richard practicing?

a. Risk mitigation

b. Risk avoidance

c. Risk transference

d. Risk acceptance

1.11 Alex is the network administrator for an organization. He decides to implement a new firewall on the company's broadband Internet connection to prevent hackers from entering the network. What risk management technique is Alex practicing?

a. Risk mitigation

b. Risk avoidance

c. Risk transference

d. Risk acceptance

1.12 Which of the following terms describes the percentage of an asset that managers expect to be destroyed as the result of a given risk?

a. ALE

b. AV

c. SLE

d. EF

e. ARO

1.13 Which of the following terms describes the number of times per year that managers expect a risk to occur?

a. ALE

b. AV

c. SLE

d. EF

e. ARO

1.14 Which of the following terms describes the expected loss each time a given risk occurs?

a. ALE

b. AV

c. SLE

d. EF

e. ARO

1.15 Which of the following threats is commonly considered to be the most dangerous?

a. Hackers

b. Malicious code

c. Insiders

d. Natural disasters

1.10 Challenge Exercises

Challenge Exercise 1.1

In this exercise, you read a real-world security policy that's currently in use and answer several questions about it. You need a computer with a Web browser and access to the Internet.

1.1 Using your Web browser, visit the Web page that contains the computer security policy for your school or business. You should obtain the Web address from your instructor. If your organization doesn't have a formal policy accessible on the Internet, you may use the University of Georgia's policy instead. You can find it at *http://www.uga.edu/compsec/*.

1.2 Read the policy carefully.

1.3 Answer the following questions:

a. What is the stated goal of this computer security policy?

b. What specific individuals/groups are charged with computer security responsibilities in this policy?

c. What enforcement mechanisms does the policy contain?

d. Does the policy contain flexible provisions that enable it to be applied to new technologies as they come into existence?

e. Is there anything that you feel is an important security issue that is not addressed in the policy?

Challenge Exercise 1.2

In this exercise, you explore various Internet resources and learn about some common types of computer security incidents. You need a computer with a Web browser and access to the Internet.

1.1 Using your Web browser and favorite search engine, explore the Internet and find sites that contain descriptions of computer security threats. To get started, you may look at the following sites:

- *http://www.cert.org*

- *http://www.sans.org*

- *http://www.microsoft.com/security*

1.2 Describe one example of an attack that violates the confidentiality goal of computer security.

1.3 Describe one example of an attack that violates the integrity goal of computer security.

1.4 Describe one example of an attack that violates the availability goal of computer security.

Challenge Exercise 1.3

In this exercise, you perform Internet research on risk management practices and identify how organizations have managed risks in the past. You need a computer with a Web browser and Internet access.

1.1 Using your Web browser and favorite search engine, search the Internet for articles describing how various organizations have dealt with specific risks they've faced.

1.2 Find at least three such articles and summarize the risk the organizations faced and how they dealt with it in one paragraph per article. At least two of the three risks discussed should be related to information security. The third may be from any field.

1.11 Challenge Scenarios

Challenge Scenario 1.1

ABC Distributing is a wholesaler specializing in the distribution of canned fruits and vegetables. To facilitate their supply-chain management, they developed and implemented a Web site that allows customers and vendors to directly interact with the ABC ordering system. The Web site is hosted on a single computer in the ABC Distributing warehouse located in Miami,

Florida. When a customer or vendor changes information in the ordering system, those changes are immediately made permanently in the main ABC ordering database system.

Analyze this scenario and answer the following questions:

1.1 Based on the scenario, what are the main information assets held by ABC Distributing?

1.2 Place the assets you identified in Question 1.1 in a prioritized order, according to your evaluation of the scenario. Be sure to provide a reasoned justification for your prioritization.

1.3 Identify some of the risks that the assets, identified in Question 1.1, face.

Challenge Scenario 1.2

Milton's Magpies is conducting a risk assessment to determine what security measures should be put in place in their corporate infrastructure. The risk management team is currently analyzing the risk posed to their San Francisco data center from an earthquake. After consulting with several experts, they've determined that a magnitude 5 (or above) earthquake would cause 60% of the facility to be destroyed. They use the original value method to value assets, and the purchase price of the facility was $2,500,000. Seismic geologists predict that a quake of this magnitude will occur in the region once every 13 years.

Milton's Magpies has the option to harden their data center at a cost of $600,000. This hardening would last for 15 years and would then have to be repeated. If they choose to do the hardening, experts predict that earthquake damage to the facility would be negligible.

1.1 What is the asset value (AV) in this scenario?

1.2 What is the exposure factor (EF)?

1.3 Compute the single loss expectancy (SLE) for this scenario.

1.4 What is the annualized rate of occurrence (ARO)?

1.5 Compute the annualized loss expectancy (ALE) for this risk.

1.6 Should Milton's Magpies harden the data center? Justify your answer.

CHAPTER 2

Access Control Methodologies

After reading this chapter, you will be able to:

- Understand access control basics
- Discuss access control techniques
- Recognize and compare access control models
- Contrast various identification and authentication techniques
- Recognize common attacks and implement controls to prevent them

This chapter presents various methods and techniques for controlling users' access to system resources. You'll learn about different approaches to help ensure that only authorized users can access secured resources. This chapter also covers the basics of access control, general methods and techniques used to manage access to resources, and some common attacks that are launched against access control systems.

2.1 Basics of Access Control

Access control is a collection of methods and components used to protect information assets. Although some information is and should be accessible by everyone, you will most likely need to restrict access to other information. Access control supports both the confidentiality and the integrity properties of a secure system. The confidentiality property protects information from unauthorized disclosure. You use access control to ensure that only authorized users can view information. The integrity property protects information

from unauthorized modification. Access control gives you the ability to dictate what information a user can both view and modify.

Before you can implement a sound access control policy, you must first develop a plan. Here are a few questions you need to answer:

- How do I separate restricted information from unrestricted information?
- What methods should I use to identify users who request access to restricted information?
- What is the best way to permit only users I authorize to access restricted information?
- Where do I start?

2.1.1 Subjects and Objects

Access control is all about, well, controlling access. First, let's define a few terms. The entity that requests access to a resource is called the **subject** of the access. A subject is an active entity because it initiates the access request. The resource a subject attempts to access is called the **object** of the access. The object of an access is the passive part of the access because the subject takes action on the object. So, the goal of a sound access control policy is to allow only authorized subjects to access objects they are permitted to access. It is possible to be an authorized subject but not have access to a specific object.

2.1.2 Least Privilege

Organizations use several general philosophies to design access control rules. The least secure philosophy (read this as "most dangerous") is to give everyone access to all objects by default. Then, you restrict access to only the objects you define as being sensitive. Sounds simple, right? Well it is simple; simple to implement and simple to compromise. The main problem with this philosophy is that you must be absolutely sure you restrict all sensitive objects. This is harder than it sounds. A little sloppy administration can leave large security holes.

Another philosophy, which exists at the opposite end of the spectrum, is much safer and more secure. The philosophy of **least privilege** states that a

subject should be granted only the permissions necessary to accomplish required tasks and nothing more. This approach often requires more administrative maintenance, but it provides more security than more permissive strategies. Least privilege helps to avoid **authorization creep**, which is a condition in which a subject gets access to more objects than was originally intended. The most common causes of authorization creep are ineffective maintenance and poor security philosophy choices.

2.1.3 Controls

Once you decide on the most appropriate access control philosophy for your organization, you can begin to choose the best way to allow subjects to access objects. The mechanisms you put into place to allow or disallow object access are called **controls**. A control is any potential barrier that protects your information from unauthorized access. Controls safeguard your information from threats. There are many types of controls, often organized into several categories. Table 2.1 lists several common control categories.

TABLE 2.1 Common Control Categories

Control Category	Description	Example
Administrative	Policies and procedures designed to enforce security rules	▪ Hiring practices ▪ Usage monitoring and accounting ▪ Security awareness training
Logical (also called technical controls)	Object access restrictions implemented through the use of software or hardware	▪ User identification and authentication ▪ Encryption ▪ Segregated network architecture
Physical	Physical access to hardware limited	▪ Fences ▪ Walls ▪ Locked doors

Sound access control involves choosing the right controls for your organization that will protect and support your security policy.

2.2 Access Control Techniques

You should choose the access control technique that best fits your organization to provide the highest degree of security. Different techniques provide varying levels of security, depending on what the organization needs. In addition to the level of security each technique provides, carefully consider the impact to your users. A grand security scheme will fail if it is so difficult to work with that users commonly try to circumvent it. Consider the techniques covered in the following section, "Access Control Designs," and how each technique could be used in a specific environment. Consider the environmental impact of each technique. Adopt stringent strategies only when absolutely necessary. Remember, a security strategy that is so strict as to encourage users to search for loopholes actually degrades security instead of increasing it.

Each of the following techniques differs in the way objects and subjects are identified, and how decisions are made to approve or deny an access request. First, we look at several models of access control and some of the characteristics of each model. Then we consider and compare several common implementations.

2.2.1 Access Control Designs

An access control design defines rules for users accessing files or devices. We refer to a user, or any entity, that requests access as a subject. Each subject requests access to an entity called an object. An object can be any entity that contains data or resources a subject requests to complete a task. Objects can be files, printers, or other hardware or software entities. The access control type in use for a particular request has the responsibility of evaluating a subject's request to access a particular object and returning a meaningful response. Let's look at three common access control designs.

Mandatory Access Control

Mandatory access control assigns a **security label** to each subject and object. A security label is an assigned level of sensitivity. Some examples of sensitivity levels are public, sensitive, and secret. Tables 2.2 and 2.3 list com-

TABLE 2.2 Military Data Classifications, from Lowest Sensitivity to Highest

Classification	Description
Unclassified	Data that is not sensitive or classified
Sensitive but unclassified (SBU)	Data that could cause harm if disclosed
Confidential	Data for internal use that is exempt from the Freedom of Information Act
Secret	Data that could cause serious damage to national security
Top secret	Data that could cause grave damage to national security

TABLE 2.3 Commercial Data Classifications

Classification	Description
Public	Data not covered elsewhere
Sensitive	Information that could affect business and public confidence if improperly disclosed
Private	Personal information that could negatively affect personnel, if disclosed
Confidential	Corporate information that could negatively affect the organization, if disclosed

mon security labels for military and commercial uses. A subject's security label defines the security clearance, or category of object, that the subject is permitted to access. For example, a subject with a clearance of "secret" can only access objects with a security label of "secret." Some access control methods allow the same subject to access objects of a lower classification, whereas others do not.

One common implementation of mandatory access control is **rule-based access control**. In a rule-based access control system, all access rights are

granted by referencing the security clearance of the subject and the security label of the object. Then, a rule set determines whether an access request should be granted or denied. The rules in place depend on the organization's needs. In addition to matching subject security clearance to an object's security label, many systems require a subject to possess a **need to know**. The need to know property indicates that a subject requires access to an object to complete a task. Thus, access is granted based on both security labels and specific task requirements.

Discretionary Access Control

Discretionary access control uses the identity of the subject to decide whether to grant or reject an access request. The object's owner defines which subjects can access the object, so all access to the object is at the discretion of the object owner. This access control design is generally less secure than mandatory access control, but is the most common design in commercial operating systems. Although it tends to be less secure, it is easier to implement and more flexible for environments that do not require stringent object security. Most objects have permissions, or rights, that specify which users and groups can access the object. This method of granting rights is an example of discretionary access control.

Discretionary access control implementations include identity-based access control and access control lists. **Identity-based access control** makes object access decisions based on a user ID or a user's group membership. An object owner specifies what users or user groups can access each object. When a subject requests access to the object, the subject's credentials are presented and evaluated to grant or deny the request. Most operating systems allow the owners of files and other resources to specify the read, write, and execute permissions based on users and groups. To make the administration a little easier, **access control lists (ACLs)** allow groups of objects, or groups of subjects, to be controlled together. An access control list can grant a subject access to a group of objects or grant a group of subjects access to a specific object.

Nondiscretionary Access Control

The third common access control design is **nondiscretionary access control**. This design most commonly uses a subject's role, or a task assigned to the subject, to grant or deny object access. Because nondiscretionary access

control is generally based on roles or tasks, it is also called **role-based access control** or **task-based access control**. This type of access control works well in cases with high turnover or reassignments. When security is associated with a role or task, replacing the person who carries out the task makes security administration easier. At first glance, a role may look like a group, but there are several differences. Although users generally can be associated with multiple groups, users normally are assigned only to a single role. Groups can also represent several types of user associations, but a role represents general tasks a user must perform.

Lattice-based access control is a variation of the nondiscretionary access control design. Instead of associating access rules with specific roles or tasks, each relationship between a subject and an object has a set of access boundaries. These access boundaries define the rules and conditions that allow object access. In most cases, the access boundaries define upper and lower limits that correspond to security classifications and labels.

2.3 Access Control Administration

Once an organization chooses an access control design, the next step is to decide on the method of access control administration. Access control administration can be implemented in both centralized and decentralized modes. It is not uncommon to find hybrid environments where both approaches are used. The best choice of administration style depends on the needs of the organization and the sensitivity of information stored on the affected computer systems.

2.3.1 Centralized Access Control

Centralized access control administration requires that all access requests go through a central authority that grants or denies the request. This approach simplifies administration because objects must be maintained only in a single location. One drawback is that the central access control unit is a single point of failure. If the centralized access control unit fails, no access can be granted to objects, so all objects are effectively unavailable. In addition, the central point of access control can have a negative effect on performance if the system is unable to keep up with all access requests. You can choose from several common packages to implement centralized access control administration.

Remote Authentication Dial-In User Service (RADIUS) provides centralized access control for dial-in users. Users are validated against the user list on the RADIUS server. You can configure the server to hang up and then call the valid user back at a predefined telephone number. Another example of centralized access control for dial-in users is **Challenge Handshake Authentication Protocol (CHAP)**. CHAP presents a challenge when a user requests access. If the user responds to the challenge properly, the access request is granted. CHAP enhances overall security by using encryption during the message exchanges.

Centralized access control for networked applications can use **Terminal Access Controller Access Control System (TACACS)**. TACACS provides general centralized authentication and authorization services. EXtended TACACS (XTACACS) extends TACACS by separating the authentication, authorization, and accounting processes, and TACACS+ adds two-factor authentication.

2.3.2 Decentralized Access Control

Decentralized access control places the responsibility of access control administration closer to the object in question. This approach requires more administration than centralized access control because an object may need to be secured at several locations. It can, however, be more stable because no single point of failure or single point of access exists. Decentralized access control is most often implemented through the use of **security domains**. A security domain is a sphere of trust, or a collection of subjects and objects, with defined access rules or permissions. A subject must be included in the domain to be trusted. This approach makes it fairly easy to exclude an untrusted subject, but makes general administration more difficult due to the fine granularity of security rules.

2.4 Accountability

System auditing assists administrators by keeping logs of activity. These activity logs allow administrators to monitor who is using their systems and how the systems are being used. System logs that are gathered though monitoring can be used to:

- Identify unusual or suspicious activity
- Document usage patterns for possible subsequent action

- Use information to deter future improper actions
- Ensure that users abide by the current security policy

Proper use of the information collected through auditing ensures that each user is accountable for actions performed on or to an information system. Through extensive auditing, all events, whether good or bad, can potentially be traced back to an originating user. The major drawback to complete system auditing is that the process of auditing can have a negative impact on system performance. Administrators must also expend effort to ensure the confidentiality and integrity of sensitive logs.

Many system events can be audited, but prudence often dictates that administrators carefully choose which events to actually audit. One common method to limit the amount of data logged is to use **clipping levels**, which are thresholds for activity that cause no auditing unless exceeded. For example, you may set a clipping level for failed login attempts at 3. If a user fails to log on once or twice, no auditing information is recorded. When the third attempt fails, the third and subsequent failed attempts are logged. This allows administrators to more easily sift through volumes of data and see only the anomalies.

2.5 Access Control Models

Access control models are very useful when deciding what controls are necessary to support your security policy. An access control model provides a conceptual view of your security policy. It allows you to map goals and directives of your security policy to specific system events. This mapping process allows for the formal definition and specification of required security controls. In short, access control models make it possible to decompose complex policies into a series of manageable steps. Many different models have been developed over the years. We look at some of the more important models and discuss some of their unique characteristics in the following sections. Most sound security policy implementations employ a combination of the following access control models.

2.5.1 State Machine Model

A **state machine model** is a collection of defined instances, called states, and specific transitions that permit a modification to occur that changes an object from one state to another. State machines are often used to model

Simple state machine

real-life entities when specific states and the transitions from one state to another exist and are understood. Think of a state as being objects at a certain point in time. When a subject requests to read an object, there must be a defined transition that allows an object to change from a closed, unread object to an open object. Figure 2.1 shows a diagram of a simple state machine. States are represented with circles, and transitions are represented with arrows.

The following sections cover four important models: Bell-LaPadula, Biba, Clark-Wilson, and noninterference.

Bell-LaPadula Model

The **Bell-LaPadula model** was developed in the 1970s to help better understand and implement data confidentiality controls. The U.S. military was very interested in protecting classified data while allowing an increasing number of users access to the machines that stored the confidential data. Because the military is most interested in data confidentiality, this model works well in organizations that focus mainly on the confidentiality controls. The Bell-LaPadula model is a state machine model that employs access control lists and security labels to implement object security.

The model uses two basic properties to evaluate access requests. Table 2.4 shows the basic properties and their common names.

The properties may seem confusing at first, but think about what each property states. Remember that confidentiality is the focus. The simple security rule protects information from being disclosed to an unauthorized

TABLE 2.4 Bell-LaPadula Properties

Property	Common Name	Description
Simple security rule	No read up	A subject of a given security clearance cannot read data from a higher security level.
*-property (star property)	No write down	A subject of a given security clearance cannot write to an object at a lower security level.

subject. The *-property protects sensitive or secret data from being inserted into an object of a lower security level. If this were allowed, you could paste a paragraph from a top-secret document into a document that is classified as public. Such a write would disclose the top-secret information to anyone cleared to see public documents. This would clearly violate the confidentiality of the information that was pasted into the public document.

Biba Model

The **Biba model** was developed after the Bell-LaPadula model to address the issue of data integrity. The Biba model is also built on the state machine model and defines states and transitions that focus on the integrity of the data instead of the confidentiality. The Biba model quickly became popular with businesses because its main focus is to ensure that unauthorized subjects cannot change objects.

Similar to the Bell-LaPadula model, the Biba model uses two basic properties to evaluate access requests. Table 2.5 shows the basic Biba properties and their common names.

TABLE 2.5 Biba Properties

Property	Common Name	Description
Simple integrity property	No read down	A subject cannot read an object of a lower integrity level.
*-property (star property)	No write up	A subject cannot write to an object of a higher integrity level.

Clark-Wilson Model

The **Clark-Wilson model** was developed after the Biba model. Unlike the Bell-LaPadula and Biba models, the Clark-Wilson model is not based on the state machine model; it takes a different approach to ensure data integrity. Instead of granting access of a subject to an object, the Clark-Wilson model restricts all accesses to a small number of tightly controlled access programs. The model uses security labels to grant access to objects through the access programs. This approach works well in commercial applications where data integrity is often more important than overall data confidentiality.

The Clark-Wilson model defines several terms that are necessary to understand in order to follow the model's access path:

- **Constrained data item (CDI):** Any data item protected by the model
- **Unconstrained data item (UDI):** Data not protected by the model (for example, data input or output)
- **Integrity verification procedure (IVP):** Procedure that verifies the integrity of a data item
- **Transformation procedure (TP):** Any procedure that makes authorized changes to a data item

The Clark-Wilson model ensures all unconstrained data is validated by the IVP, and then submitted to the system by the TP. All subsequent modifications are first validated by the IVP, and then the modification takes place by the TP. Of course, the IVP and TP are not called until the subject has been properly authenticated and cleared to access the object in question.

Noninterference Model

The last access control model is often an addition to other models. The **noninterference model** ensures that changes at one security level do not "bleed over" into another security level and affect an object in another context. For example, what would happen if you saved a secret document that was embedded in a public document? The dangers in this case are obvious: You risk disclosing secret data when the information is copied to the public document. The basic premise of the noninterference model is that each security level is distinct and changes will not interfere across levels. This assurance reduces the scope of any change and reduces the possibility that a change will

have unintended side effects. By isolating modifications to a specific security level, this model can maintain both data integrity and confidentiality.

2.6 Identification and Authentication Methods

The first user interface element most subjects encounter when accessing an information system is the **identification** and **authentication** challenge. The identification phase allows a subject to claim to be a specific entity by presenting identifying credentials. These credentials could be as simple as a user ID or personal identification number (PIN), or more complex, such as a physical attribute. Once a subject has claimed an identity, the system validates that the user exists in the user database, and then authenticates that the subject really is who she claims to be. The authentication phase asks the subject to present additional information that matches stored information for that subject. These two phases, often called **two-factor authentication**, provide reasonable protection from unauthorized subjects accessing a system. After a subject has been authenticated, the access control system then evaluates the specific rights or permissions for the subject to grant or deny object access requests. This phase is called the authorization phase.

There are three general categories, or types, of authentication information. Best security practices generally dictate that the identification and authentication phases require input from at least two different types. Table 2.6 lists and describes the three common types of authentication data.

The most common and easiest type of authentication to implement is Type 1 authentication. All you have to do is ask the subject to make up a password, passphrase, or PIN. The alternative is to provide one for the user. The

TABLE 2.6 Authentication Types

Authentication Type	Description	Examples
Type 1	What you know	Password, passphrase, PIN, lock combination
Type 2	What you have	Smart card, token device
Type 3	What you are	Biometrics—fingerprint, palm print, retina/iris pattern, voice pattern

difficulty with Type 1 authentication is that you must encourage subjects to create challenge phrases that are very difficult for others to guess, but not so complex that they cannot be easily remembered. If your requirements are so stringent that passwords (or passphrases or PINs) cannot easily be remembered, you will start to see notes stuck to monitors and keyboards with passwords written on them. That negates any value of the password. The same result can occur when administrators require that passwords be changed so often users do not have time to memorize the new ones. Keep passwords safe and secret. The following rules are a good starting point for creating secure passwords:

- Passwords should be at least six characters in length.

- Passwords should contain at least one number or punctuation character.

- Do not use dictionary words or combinations of dictionary words.

- Do not use common personal data, such as birth date, social security number, family member or pet name, or favorite song or hobby.

- Never write down your password.

- Try to make your password easy to remember but hard to guess.

Type 2 authentication data solutions are more complex to administer because subjects are required to carry a device of some sort. The device generally is electronic in nature and either generates a time-sensitive value or generates a value in response to input data. Although Type 2 authentication is more complex, it is almost always more secure than Type 1 authentication.

The most sophisticated authentication type is Type 3, or **biometrics**. Biometrics describes the detection and classification of physical attributes. There are many different biometric techniques, including:

- Fingerprint/palm scan

- Hand geometry

- Retina/iris scan

- Voice print

- Signature/keyboard dynamics

Due to the complexity of biometrics, it is the most expensive authentication type to implement. It is also more difficult to maintain due to the

Figure 2.2
Biometrics errors

imperfect nature of biometrics analysis. You should be aware of several important issues regarding biometrics errors. First, a biometrics system could reject an authorized subject. The rate at which this failure occurs is called the **false rejection rate (FRR)**. On the other hand, the biometrics system could accept an invalid subject. The rate at which this failure occurs is called the **false acceptance rate (FAR)**. The problem is that when you adjust the sensitivity of the biometrics system to reduce the FRR, the FAR increases. The inverse is also true. So, what is the best setting? The best balance between the FRR and FAR occurs when the rates are equal. This occurs at the **crossover error rate (CER)**. Figure 2.2 shows the CER in relation to the FRR and FAR of a general biometrics device.

2.6.1 Single Sign-On

The more pieces of information, or factors, you request from a subject, the more assured you can be that the subject is who she claims to be. Thus, two-factor authentication is more secure than single-factor. The problem is that if a subject needs to access several resources on different systems, she may be required to provide identification and authentication information at each different system. This quickly becomes tedious. **Single sign-on (SSO)** systems avoid multiple logins by positively identifying a subject and allowing the authentication information to be used within a trusted system or group of systems. Users love SSO, but administrators have a lot of additional work to do. You must take extreme care to ensure the authentication credentials are not compromised or intercepted as they pass across the network.

Several good SSO systems are in use today. It is not important to understand the details of each one. The important concepts and difficulties are fairly common to all SSO products. We look at one product, Kerberos, to examine how these systems work.

2.6.2 Kerberos

The **Kerberos** system came from the Massachusetts Institute of Technology's (MIT's) project Athena. It is named after the three-headed dog from Greek mythology that guards the gates of the underworld. Kerberos provides both authentication and message protection. It uses symmetric key cryptography (both sides have the same key) to encrypt messages. The encryption feature provides end-to-end security, meaning the intermediate machines between the source and target machines cannot see the contents of messages. Kerberos is growing in popularity for use in distributed systems. Although it works well in distributed environments, Kerberos itself uses a centralized server to store the cryptographic keys.

Kerberos includes a data repository and authentication process. The **Key Distribution Center (KDC)** is at the heart of Kerberos. The KDC stores all of the cryptographic keys for subjects and objects. The KDC is responsible for maintaining and distributing these keys, as well as for providing authentication services. When the KDC receives a request for access to an object, it calls the **Authentication Service (AS)** to authenticate the subject and its request. If the subject's request is authenticated, the AS creates an access **ticket** that contains keys for the subject and the object. It then distributes the keys to both the subject and the object. Here are the basic steps in a Kerberos access request cycle:

1. The subject requests access to an object. The subject's Kerberos software prompts for a user ID, and sends the user ID along with the request to the KDC.

2. The KDC calls the AS to authenticate the subject and the object.

3. If authenticated, the KDC sends an encrypted session key to the subject and the object's machine.

4. The subject's Kerberos client software prompts the subject for a password and uses it, along with the subject's secret key, to decrypt the session key.

5. The subject then sends the access request with the session key to the object.

6. The object decrypts the session key it received from the KDC and compares it to the session key it received with the access request.

7. If the two session keys match, access is granted.

The centralized nature of the KDC exposes one of Kerberos' main weaknesses: The KDC is a single point of failure. KDC failure means object access failure. The KDC can also cause a performance bottleneck on heavily utilized machines. Also, there is a small window of time when the session key lives on the client machines. It is possible for an intruder to capture this key and gain unauthorized access to a resource. In spite of several weaknesses, Kerberos is a good example of SSO systems and has enjoyed widespread acceptance.

2.7 File and Data Ownership

Files and data may contain important and valuable information. This important information should be the focus of your security efforts. But who is responsible for ensuring the security of your organization's information? This question is answered by assigning different layers of responsibility to each piece of important information. Each file, or data element, should have at least three different responsible parties assigned. The three layers of responsibility represent different requirements and actions for each group. The most common layers are **data owner**, **data custodian**, and **data user**. Each layer has specific expectations to support the organization's security policy.

2.7.1 Data Owner

The data owner accepts the ultimate responsibility for the protection of the data. The data owner is generally a member of upper management and acts as the representative of the organization in this duty. It is the owner who sets the classification level of the data and delegates the day-to-day responsibility of maintenance to the data custodian. If a security violation occurs, it is the data owner who bears the brunt of any negligence issues.

2.7.2 Data Custodian

The data owner assigns the data custodian to enforce security policies according to the data classification set by the data owner. The custodian is often a member of the IT department and follows specific procedures to secure and protect assigned data. This includes implementing and maintaining appropriate controls, taking backups, and validating the integrity of the data.

2.7.3 Data User

Finally, the users of data are the ones who access the data on a day-to-day basis. They are charged with the responsibility of following the security policy as they access data. You would expect to see more formal procedures that address important data, and users are held accountable for their use of data and adherence to these procedures. In addition to a commitment to follow security procedures, users must be aware of how important security procedures are to the health of their organization. All too often, users use shortcuts to bypass weak security controls because they lack an understanding of the importance of the controls. An organization's security staff must continually keep data users aware of the need for security, as well as the specific security policy and procedures.

2.8 Related Methods of Attacks

The main purpose for implementing access controls is to block unauthorized access to sensitive objects. The primary purpose of attackers is to access these same objects. Several attack types are related to access controls. Most attacks directed toward access controls are designed to thwart, or bypass, the controls and allow access to unauthorized subjects. One of the best ways to decide which controls to put into place is to understand the nature of the attack you are trying to stop. Let's take a look at three of the most common access control attacks.

2.8.1 Brute Force Attack

Brute force attacks are fairly unsophisticated attacks that can be effective. The purpose of such an attack is to attempt every possible combination of characters to satisfy Type 1 authentication. Often called password guessing, a program submits many login attempts, each with a slightly different password. The hope is that the program will hit on the correct

password before anyone notices an attack is underway. One variation of the brute force attack is **war dialing**, in which a program dials a large group of telephone numbers and listens for a modem to answer. When the war dialing program finds a modem, the number is logged for later probing and attacks. These attacks are called brute force attacks because they attempt a very large number of possibilities to find the password or access number.

The best defense is a good offense. A great way to protect your system from a brute force attack is to run one yourself. It is a good idea to run a password cracking or war dialing program against your system periodically. Make sure you have written permission to execute the attack first. You could find that you are violating your security policy as you try to protect it. Once is not enough. Any time a user gets tired of a password or finds that getting access to the Internet is too hard, you will start seeing easily cracked passwords and unauthorized modems showing up. Run your brute force attacks periodically to find users who are taking shortcuts.

In addition to running your own attacks, set your monitoring system clipping levels to warn you when unusual activity occurs. It is also a good idea to set aggressive lockout levels so accounts are locked after a certain number of login failures. As frustrating as this is to honest users who have forgotten passwords, it provides a great defense against brute force attacks.

2.8.2 Dictionary Attack

A **dictionary attack** is actually a subset of a brute force attack. Instead of trying all password combinations, a dictionary attack attempts to satisfy a password prompt by trying commonly used passwords from a list, or dictionary. Many lists of commonly used user IDs and passwords exist and are easy to find. Although they make great input sources for dictionary attacks, they also provide examples of user IDs and passwords to avoid. In fact, one of the best deterrents to a dictionary attack is a strong password policy. A password policy tells users how to construct passwords and what types of passwords to avoid. You can avoid having nearly all of your passwords appear in a password dictionary by creating and enforcing a strong password policy. Once passwords are in place, run dictionary attacks periodically. These attacks are not as intensive as brute force attacks and give you a good idea who is abiding by your password policy. You can also avoid password disclosure by never sending passwords as clear text. Avoid using

HTTP or Telnet for that reason. When you need to send a password to a Web application, use another protocol, such as HTTP-S.

2.8.3 Spoofing Attack

Another interesting type of access control attack is **login spoofing**. An attacker can place a fake login program that prompts a user for a user ID and password. It probably looks just like the normal login screen, so the user likely provides the requested information. Instead of logging the user into the requested system, the bogus program stores or forwards the stolen credentials, then returns a notice that the login has failed. The user is then directed to the real login screen. The beauty of the approach is that few of us would ever think of a spoofing attack if we were presented with a failed login screen. Most of us would chalk it up to a typo.

The best defense against this type of attack is to create trusted paths between users and servers when at all possible. Attempt to minimize the opportunities for attackers to step in between users and servers. In environments where security is extremely important, users should carefully examine all failed login attempts and ensure the failure is properly recorded and reported. If, after being alerted your login has failed, you find that the system thinks the last login failure happened last week, you may have been spoofed. Security awareness goes a long way in preventing and detecting these types of attacks.

2.9 Chapter Summary

- Access control supports data confidentiality and data integrity.
- The least privilege philosophy states that a subject should be granted only the permissions necessary to accomplish required tasks and nothing more.
- A control is any potential barrier you put into place that protects your information.
- Mandatory access control, also called rule-based access control, uses security labels to grant or deny access requests.
- Commercial and military organizations have similar but distinct data classifications.
- Discretionary access control, also called identity-based access control, uses the subject's identity to grant or reject an access request.

- Nondiscretionary access control, also called role-based or task-based access control, uses roles or tasks, as opposed to a subject's identity, to grant or deny access requests.

- Access controls can be centralized, such as RADIUS, CHAP, and TACACS, or decentralized, as with security domains.

- All users of secured information systems are subject to monitoring to ensure they are accountable for all actions.

- Several theoretical access control models help visualize object access issues.

- The Bell-LaPadula model is a state machine model that supports data confidentiality.

- The Biba model is also a state machine model that supports data integrity.

- The Clark-Wilson model supports data integrity by limiting the procedures that can modify data items.

- The noninterference model ensures that changes at one security level have no effect on data at a different security level.

- Identification is a subject claiming to be a specific identity.

- Authentication is the process of validating that a subject is who she claims to be.

- Type 1 authentication is something you know, Type 2 authentication is something you have, and Type 3 authentication is something you are.

- Data owners, custodians, and users each have responsibilities to maintain the security of data.

2.10 Key Terms

access control list (ACL): 1. A list used to grant a subject access to a group of objects or to grant a group of subjects access to a specific object. 2. A list of resources and the users and groups allowed to access them. It is the primary storage mechanism of access permissions in a Windows system.

authentication: A subject provides verification that he is who he claims to be.

Authentication Service (AS): A process in the Kerberos KDC that authenticates a subject and its request.

authorization creep: A condition under which a subject gets access to more objects than was originally intended.

Bell-LaPadula model: An access control model developed in the 1970s to help better understand and implement data confidentiality controls.

Biba model: An access control model developed after the Bell-LaPadula model to address the issue of data integrity.

biometrics: The detection and classification of physical attributes.

brute force attack: An access control attack that attempts all possible password combinations.

centralized access control administration: All access requests go through a central authority that grants or denies the request.

Challenge Handshake Authentication Protocol (CHAP): A centralized access control system that provides centralized access control for dial-in users.

Clark-Wilson model: An access control model that addresses data integrity by restricting all object accesses to a small number of tightly controlled access programs.

clipping levels: Thresholds for activity that trigger auditing activity when exceeded.

constrained data item (CDI): Any data item protected by the Clark-Wilson model.

control: Any potential barrier that protects your information from unauthorized access.

crossover error rate (CER): The point where FRR = FAR.

data custodian: Generally, an IT person who is assigned by the data owner to enforce security policies according to the data classification set by the data owner.

data owner: A member of upper management who accepts the ultimate responsibility for the protection of the data.

data users: System users who access the data on a day-to-day basis.

decentralized access control: Places the responsibility of access control administration close to the object in question.

dictionary attack: An access control attack that attempts passwords from a dictionary of commonly used passwords.

discretionary access control: Object access decisions based on the identity of the subject requesting access.

false acceptance rate (FAR): The rate at which invalid subjects are accepted.

false rejection rate (FRR): The rate at which valid subjects are rejected.

identification: 1. The phase in which a subject claims to be a specific identity. 2. The act of verifying a subject's identity.

identity-based access control: Object access decisions based on a user ID or a user's group membership.

integrity verification procedure (IVP): A procedure that verifies the integrity of a data item.

Kerberos: A popular SSO system that provides both authentication and message protection.

Key Distribution Center (KDC): The network service and data repository that stores all the cryptographic keys for subjects and objects in a Kerberos system.

lattice-based access control: A variation of the nondiscretionary access control model that establishes each relationship between a subject and an object with a set of access boundaries.

least privilege: A philosophy in which a subject should be granted only the permissions needed to accomplish required tasks and nothing more.

login spoofing: An access control attack that replaces a valid login screen with one supplied by an attacker.

mandatory access control: A system-enforced access control mechanism that assigns a security label, which defines the security clearance, to each subject and object.

need to know: A condition when a subject requires access to an object to complete a task.

nondiscretionary access control: Uses a subject's role, or a task assigned to the subject, to grant or deny object access.

noninterference model: An access control model that ensures that changes at one security level do not "bleed over" into another security level and affect an object in another context.

object: The resource a subject attempts to access.

Remote Authentication Dial-In User Service (RADIUS): A centralized access control system that provides centralized access control for dial-in users.

role-based access control: A nondiscretionary access control method that uses a subject's role to grant or deny object access.

rule-based access control: All access rights are decided by referencing the security clearance of the subject and the security label of the object.

security domain: A sphere of trust, or a collection of subjects and objects with defined access rules or permissions.

security label: An assigned level of sensitivity.

single sign-on (SSO): A system that avoids multiple logins by positively identifying a subject and allowing the authentication information to be used within a trusted system or group of systems.

state machine model: A collection of defined instances, called states, and specific transitions that permit a modification to occur that changes an object from one state to another.

subject: The entity that requests access to a resource.

task-based access control: A nondiscretionary access control method that uses the task a subject is working on to grant or deny object access.

Terminal Access Controller Access Control System (TACACS): A centralized access control system that provides centralized access control for networked users.

ticket: A Kerberos authentication message that contains keys for the subject and the object.

transformation procedure (TP): Any procedure that makes authorized changes to a data item.

two-factor authentication: A process of providing two pieces of information to authenticate a claimed identity.

unconstrained data item (UDI): Any data not protected by the Clark-Wilson model.

war dialing: Automated dialing of many telephone numbers searching for a modem.

2.11 Challenge Questions

 2.1 What is the access control subject?

 a. The passive entity that is the target of an access request

 b. The active entity that initiates an access request

 c. A specific type of access requested

 d. The authentication service that processes the access request

2.2 Which statement best describes the principle of least privilege?

 a. Only allow the minimum number of defined users to access a system.

 b. An object should allow only data owners to access it.

 c. A subject should be granted only the permissions to accomplish a task and nothing more.

 d. An object should grant access only to subjects through one model and nothing more.

2.3 What is a control?

 a. Any potential barrier that protects your information from unauthorized access

 b. Any data source that contains sensitive data

 c. A user or program that attempts to access data on a secure system

 d. A device for setting the security clearance of data

2.4 Which of the following are logical controls? (Choose all that apply.)

 a. Hiring practices

 b. Encryption

 c. Walls

 d. User identification and authentication

2.5 What two terms mean access control defined by the security clearance of the subject and the security label of the object?

 a. Discretionary access control

 b. Mandatory access control

 c. Rule-based access control

 d. Role-based access control

2.6 What type of model is identity-based access control?

 a. Mandatory access control

 b. Discretionary access control

 c. Nondiscretionary access control

 d. Transitive-discretionary access control

2.7 What are two types of nondiscretionary access control?

 a. Role-based access control

 b. Identity-based access control

 c. Rule-based access control

 d. Task-based access control

2.8 Access and activity monitoring supports what security principle?

 a. Availability

 b. Least privilege

 c. Accountability

 d. Liability

2.9 Which access control models primarily support data integrity? (Choose all that apply.)

 a. Bell-LaPadula

 b. Biba

 c. Clark-Wilson

 d. State machine

2.10 What is the best definition for the term *authentication*?

 a. A subject presents credentials to claim an identity.

 b. The access control system looks up permissions assigned to a subject.

 c. The access control system searches a user database to see if the subject exists.

 d. A subject provides additional information that should match information the access control system stores for that subject.

2.11 What types of authentication do you use when you withdraw cash from an automated teller machine (ATM)?

 a. Type 1 and Type 2

 b. Type 1 and Type 3

 c. Type 1

 d. Type 2

2.12 What is the rate at which a biometric device rejects valid subjects?

 a. FAR

 b. FRR

 c. CER

 d. CDC

2.13 What is an SSO system?

 a. Single sign-on

 b. Single secure opening

 c. Secure signal operation

 d. Single secure operation

2.14 Who is ultimately responsible for the protection of data?

 a. Data user

 b. Data custodian

 c. Data owner

 d. Data security administrator

2.15 Which type of attack uses a list of common passwords?

 a. Brute force attack

 b. Spoofing attack

 c. Dictionary attack

 d. Smurf attack

2.12 Challenge Exercises

Challenge Exercise 2.1

This exercise directs you to a common repository of security-related reports. Because the security profession constantly changes, professionals must continuously strive to stay up to date. Reading rooms and peer reports offer a great way to keep current. In this exercise, you visit a popular online reading room and review a report submitted by a security professional. You need a computer with a Web browser and Internet access. The Web site you visit is the SANS (SysAdmin, Audit, Network, Security) Institute reading room. Security practitioners who pursue certification through SANS must submit at least one current and relevant report for publication. These reports offer excellent information to help you learn more about security.

2.1 In your Web browser, enter the following address: *http://www.sans.org/rr.*

2.2 From the SANS InfoSec Reading Room page, click the "Authentication" link in the Category section.

2.3 Select and read one or more reports and write a brief summary.

Challenge Exercise 2.2

This exercise examines a current security add-on for the Linux environment. It is not necessary for you to have any Linux experience to complete this exercise. The purpose is to look at a viable product and get a better understanding of how real operating systems implement access control. You need a computer with a Web browser and Internet access. The Web site you visit is the Rule Set Based Access Control (RSBAC) for Linux Web site. The RSBAC product implements discretionary access control for Linux systems.

2.1 In your Web browser, enter the following address: *http://www.rsbac.org.*

2.2 Visit both the "What is RSBAC?" and "Why you need RSBAC" pages.

2.3 Write a two- or three-paragraph summary of how RSBAC could increase the security of a commercial Linux system.

Challenge Exercise 2.3

This exercise examines an access control implementation for Microsoft Windows XP Professional. You do not need extensive Windows experience to complete this exercise. The purpose is to look at a viable product and get a better understanding of how real operating systems implement access control. You need a computer with a Web browser and Internet access. The Web site you will visit is the Microsoft Corporation Web site.

2.1 In your Web browser, enter the following address:
http://www.microsoft.com/windowsxp/pro/using/howto/security/accesscontrol.asp.

2.2 Read the description of Windows XP access control.

2.3 Write a two- or three-paragraph summary of how Windows XP implements access control.

2.4 Create a list of at least five new user groups you would need for a commercial system.

2.5 Assign privileges to your user groups and explain the purpose of each group.

2.13 Challenge Scenarios

Challenge Scenario 2.1

You are the new Chief Information Officer (CIO) for Spatula City, Inc., the leading wholesaler of spatulas of every shape and size. Because Spatula City provides many products to competing retailers, information security is important. (Imagine what could happen if details of a new spatula design leaked out!) Your job is to implement a security strategy that will satisfy Spatula City's security requirements.

The Spatula City system will contain a central database and be connected to the corporate intranet. In-house users will connect and need access to both sensitive and public resources. Additionally, outside sales representatives will need access through dial-up connections, and customers will access some product information through the company's Web site.

Select an access control design to use and explain how you plan to implement access control. Explain your choices and describe the authentication techniques that will provide the best security for your users.

Challenge Scenario 2.2

You are a security manager for Doorknobs-Are-Us, a manufacturer of custom doorknobs and miscellaneous door fixtures and hardware. Your company just landed a new contract to manufacture doorknobs and locks for a retrofit of military ships. The new locks contain sensitive technology, so all data that pertains to this project must be protected. Your engineers need to access pertinent data stored in the corporate database and document management system from various remote locations. You need to select an authentication technique that will ensure only authorized engineers can access this sensitive data.

Select appropriate authentication controls that will uniquely identify an engineer and explain your choices. As you consider alternatives, explain why you would rule out those solutions that you do not choose.

CHAPTER 3

General Security Principles and Practices

After reading this chapter, you will be able to:

- Explain the importance of and implement the principles of separation of privileges and least privilege

- Utilize the defense in depth strategy to design an effective perimeter protection methodology

- Understand the weaknesses in the "security through obscurity" approach to information security

- Write and implement general and specific information security policies for an organization

- Utilize common security administration tools, such as checklists and matrices, to facilitate compliance with security policies

- Understand the significance of integrating personnel and physical security measures with other technical controls

Information security professionals are charged with accomplishing a difficult and often thankless task—securing an organization's data. It's often difficult to judge when their efforts are successful, but failures are often placed in the spotlight. Designing an organization-specific security program that balances the needs for confidentiality, integrity, and availability with the legitimate business needs of end users can be a daunting task. Fortunately, a wealth of resources are available to security professionals, mostly in the form of a body of knowledge and best practices developed over the first few decades of our young profession. Many of these practices trace their roots back to the era before computers appeared on the scene. In this chapter, you'll discover some of the underlying principles that guide the efforts of information security practitioners around the world, in organizations as small as a home business with a Web site and as large as a national government. You'll learn about the types of policies these professionals use to achieve and maintain the security "edge" and the tools they use to comply with and monitor those policies. Finally, you'll gain an understanding that technical measures like firewalls, intrusion detection systems, and access controls are not a panacea for computer security. These technical controls must be supplemented with sound physical and personnel security practices to achieve a well-rounded organizational information security program.

3.1 Common Security Principles

Information security is nothing new. Although it's true that our field has attracted a great deal of attention over the past two decades, the ideas and policies behind information security programs have been around for hundreds of years. Before the era of computing, organizations of all types guarded their secrets from the competition. Generals didn't want the enemy to discover their battle plans. Investment professionals didn't want the public to gain advance knowledge of their trading activities. Consumer package goods companies didn't want their rivals to learn the secret ingredient or recipe that made their products distinctive in the marketplace. In all of these cases, the organization with information to protect adopted some type of security controls to limit access to information to authorized users working within the scope of their legitimate authority. The field of computer security began in the 1950s and 1960s, and was generally limited to government and military computer systems that stored and processed extremely sensitive defense information.

In this section, we'll look at four enduring principles that have guided security professionals through the centuries. The first three—separation of privileges, least privilege, and defense in depth—provide guidance on how to properly build an information security program. The fourth—security through obscurity—warns of the danger of falling victim to a common security vulnerability.

3.1.1 Separation of Privileges

Separation of privileges is one of the oldest security principles still in use today. Quite simply, it states that no single person should have enough authority to cause a critical event to take place. Some examples of this principle from security fields other than computer/information security include:

- In the Air Force, no single military officer can launch a nuclear missile on his or her own authority. Release of an Intercontinental Ballistic Missile (ICBM) requires that two officers turn their keys simultaneously. The keys are positioned far enough apart that it is impossible for one person to complete the task.

- Financial institutions and retail establishments that keep large quantities of cash on hand do not allow anyone to enter cash storage areas by themselves. The fact that another person is present in the area where cash is handled serves as a deterrent to theft—the two individuals must be in collusion for the theft to escape detection.

- When repairs are made to an aircraft or other mechanical system where safety is critical, two mechanics generally must sign off on the repair. Normally, one of the two mechanics must not have been involved in the repair process. This double-check ensures that the repair was made correctly.

Separation of privileges applies to information security programs as well. When designing access controls and other measures, you should take steps to ensure that no single individual possesses enough authority to impact your critical operations. The level of control that you need to provide will depend on your industry and the type(s) of information that you handle. Any determination should be made based on your organization's security policy. Some examples of how privilege separation might apply within the realm of information security include:

TIP

When designing a separation of privileges program for your organization, you'll need to weigh the security benefit gained by implementing this type of control against the additional manpower required to achieve it. For example, if you require two people to be present during certain types of repairs, the second person may simply be observing and not able to contribute. This is a drain on manpower and results in increased personnel costs for your organization.

- The right to create a new account and the right to assign administrative responsibilities to accounts can be divided between two individuals. This prevents one person from creating a new account and granting it administrative powers over the network.

- Access to physical locations containing critical servers should require the presence of two trusted individuals.

- Finalization of critical financial transactions (such as those exceeding a certain dollar threshold) should require the authorization of two separate users to deter fraud and ensure quality control.

3.1.2 Least Privilege

The principle of **least privilege** is an extension of the principle of separation of privileges. This principle states that an individual should have only the minimum level of access controls necessary to carry out his or her assigned job functions. This may seem like an obvious statement, but it is one of the most-often violated principles in the field of information security. Two main culprits cause violations of the principle of least privilege:

- **Administrator inattention:** Often causes users to be assigned privileges that they do not need. Often, users are classified into extremely broad groups with a wide range of powers, rather than assigned specific roles that limit the scope of their power. For example, you wouldn't want to create a single class of users for an organization's accounting department and assign them all the same privileges. You should instead create specific roles for the users responsible for billing, issuing checks, and authorizing payments.

- **Privilege creep:** Occurs when users change roles within an organization but never forfeit the access privileges associated with their prior positions. This can be a serious problem in organizations in which users frequently move from position to position. In order to combat this problem, any request for permission changes associated with a user's changing role within an organization should be accompanied by an audit of all of that user's privileges.

3.1.3 Defense in Depth

Military leaders have long recognized the significance of building a layered defense against the enemy. No general protecting a country's border would ever do so by creating a single line of troops stretching from one end to the other—this would create too easy an opportunity for the enemy to exploit. Opposing generals would simply concentrate their forces at one point and overrun the small group of soldiers in that area. Instead, generals create a complex line of defensive forces including soldiers, mechanized equipment, and air defenses.

Information security practitioners have learned to operate in a similar manner. Over the past few years, the concept of **defense in depth** has gained popularity among those responsible for designing the perimeter protection for computer networks. This approach involves creating layers of security beginning with the points of access to a network and continuing with cascading layers of security at various bottleneck points. An example of a defense in depth approach to computer security is shown in Figure 3.1.

Re-examine Figure 3.1 from the perspective of a potential intruder approaching the network from the outside. This individual will have to clear multiple hurdles before reaching any sensitive systems. He or she must first make it past the border router and then successfully penetrate the firewall and at least one more border router while simultaneously avoiding the notice of the several intrusion detection systems guarding the network. You'll learn more about the specific devices that make up a sound defense in depth posture in Chapters 8 and 13.

3.1.4 Security through Obscurity

In the early days of information security, administrators often depended on the fact that malicious individuals had no knowledge of the security mechanisms in place on a network to help bolster their security. This was the concept of **security through obscurity**. This approach was somewhat effective when computer security was generally restricted to the classified world of the national defense establishment. Government security programs prevented any one individual from gaining "too much" knowledge about the security measures put in place on a network and encouraged the

TIP

The ability to examine a computer security program through the eyes of an intruder is a critical skill for security professionals. It's all too easy to view the system through the myopic eyes of the designer. Learn to think outside of the box by asking yourself questions like, "How would I penetrate this system if I absolutely needed to?" Using this technique, you'll often discover new ways in which intruders might bypass your security controls. You can then use these discoveries to strengthen existing controls and implement new ones to help you improve the overall security of your protected network.

Figure 3.1
Example of defense in depth

"black box" approach, where practitioners were not to question how a security device worked, but only to accept that it did.

In today's modern age of open-source code and widely deployed security mechanisms, this old approach no longer stands the test of time. There is simply too much information out there about how different security techniques work to depend on the secrecy of their operational details to protect a network. Modern security devices must be inherently secure, such that intimate knowledge of their operation does not provide an attacker with the information necessary to bypass their controls. Even the developer of a particular security solution should not be able to bypass the device when it is placed on a production network.

Throughout this book, you'll see examples of how the transparency of operation of various security devices contributes to the overall security of the device. After all, public scrutiny by security experts is the best assurance that a device functions as advertised. One of the best examples of this type of transparency occurs with the design of modern cryptographic systems. The mathematicians responsible for the design of these systems strive to ensure that the algorithm itself doesn't contain any secret components. They design the system in such a manner that the secrecy of the communication depends solely on the use of one or more secret cryptographic keys. Only parties with access to those keys are able to decrypt messages that are encrypted using the cryptosystem. Knowledge of how the algorithm itself works provides no advantage to a hacker. Indeed, most mathematicians who design a new cryptosystem publish the inner workings of their algorithm in a scientific journal. Only after an algorithm has successfully withstood such public scrutiny is it accepted by the security community as a whole. You'll learn more about the design and use of cryptographic systems in Chapter 5.

AES Avoids Obscurity

In 2000, the National Institute of Standards and Technology (NIST) concluded a 3-year competition to choose a new cryptographic algorithm for use throughout the U.S. government. The algorithm for this new standard, known as the Advanced Encryption Standard (AES), underwent intense public scrutiny throughout the selection process and serves as an excellent example of avoiding security through obscurity with transparent security algorithm design. The stages of the competition systematically reduced the field of contenders from hundreds of entries down to 15 semifinalists, 5 finalists, and 1 accepted algorithm (the Rijndael algorithm). The creators of the algorithms wrote technical specifications detailing the inner workings of their algorithms, and these specifications were available to the public for review and comment. When NIST selected Rijndael as the new standard, it knew that although computer security professionals (and hackers) around the world had access to the complete details of its inner workings, the standard could still be considered secure from undesired compromise.

3.2 Security Policies

An effective information security program must have clearly defined objectives that are used both to design the specific controls put in place on a network and to inform users of the behaviors expected of them. This goal is accomplished through the development, promulgation, and enforcement

of a written information **security policy**. One of the most critical functions of this type of policy is to provide users with not only the "letter of the law," but also the "spirit of the law" to provide an official mechanism informing users that the discovery and exploitation of loopholes in security controls is not permissible.

It is critical that organizations of any size have a *written* information security policy. This document should be freely available to all users of organizational information systems—a goal that is often accomplished by placing the document on an intranet site. However, simply posting this type of document is not enough. Users must be trained in the proper interpretation of these policies, both when they first join an organization and on some type of recurring basis throughout their employment. In the following sections, you'll learn about the various types of information security policies that organizations put in place and the procedures used to implement those policies, ranging from development to training, enforcement, and maintenance.

3.2.1 Types of Security Policies

TIP

If you would like to view some example policies, the SANS Institute maintains an excellent site with descriptions of policies and templates that you can use to fashion your own policies. You'll find it at *http://www.sans.org/resources/policies/*.

You can choose from literally hundreds of different types of security policies for your organization. Some organizations with simple computing requirements will have a single multipage document that outlines the organization's desire to achieve a secure computing environment along with some specific rules and regulations to assist in achieving that goal. Larger organizations (or those with more complex security requirements) may have multiple volumes of security policies covering almost every possible contingency and providing specific guidance to administrators, managers, and users.

In the next few sections, we'll take a look at some of the more common types of security policies that you're likely to encounter during the day-to-day practice of security.

Acceptable Use Policy

Almost every organization has some form of **acceptable use policy (AUP)**. These policies spell out the allowable uses of an organization's information resources. Separate provisions may apply to individual groups, such as:

- Managers

- Line employees
- Vendors
- Partners
- Customers (think of the complexity of implementing AUPs for an Internet service provider)

The true challenge in developing an AUP is to make the policy specific enough to restrict user activity to those actions deemed acceptable by management, but general enough to cover unanticipated types of activity. For example, the recent development of peer-to-peer (P2P) networks like Napster and Kazaa required many organizations to revise their security policies to explicitly prohibit this type of activity. Other organizations had general statements in their policies (such as "Users shall not share files outside of the organization's network") that were flexible enough to cover these unforeseen developments in computing and Internet technology.

Your AUP should answer several key questions:

- What types of activities are acceptable?
- What types of activities are clearly unacceptable? (This should be a list fashioned after the "including, but not limited to" model.)
- Where should users turn for guidance if aspects of this policy are unclear?
- What procedures should be followed if a violation of the AUP is suspected by a manager or an end user?
- What are the consequences for violations of this policy?

Of course, the specific answers to these questions will depend on the culture within your organization. Some organizations may have liberal policies that permit personal use of the Internet during working hours, provided such activity does not interfere with job functions. Other organizations may have extremely strict policies that do not allow any personal use of computing resources under any circumstances.

Backup Policy

All too often, when we think of information security, we focus on the confidentiality aspect of security. Security professionals must remember that

there are three legs to the CIA triad, and incorporate integrity and availability concerns into their program. One key piece of this puzzle is the design and implementation of a sound **backup policy** to ensure that the organization's data is protected against corruption or loss (whether accidental or intentional). The backup policy should clearly outline the following items:

- What data should be backed up?
- How should it be backed up?
- Where should the backup media be stored?
- Who should have access to those media?
- How long should backups be retained?
- How many times can the same backup media be reused before they are discarded?

Each of these questions comprises a critical portion of an organization's overall security policy.

Confidentiality Policy

The organization's **confidentiality policy** outlines the procedures that will be used to safeguard sensitive information. At a minimum, the confidentiality policy should address the following data protection questions:

- What data should be considered confidential?
- How should confidential information be handled?
- What are the procedures for releasing confidential information outside of the organization?
- What procedures should be followed if confidential information is accidentally or intentionally released without authorization?

The confidentiality policy is one example of how information security policy should extend beyond the realm of computer and network security. For the confidentiality policy to be effective, it must cover all means of information dissemination, including telephone contact, printed copies of data, and verbal transmission. Like other security policies, the confidentiality policy should have high-level sign-off and spell out specific consequences for violations of the policy. Many organizations require new employees to sign nondisclosure agreements (NDAs) in which the employees acknowledge

their understanding of the policy and their individual responsibilities under it. NDAs also typically contain provisions that require employees to keep confidential information private even after they leave the organization, and provide legal recourse for the organization to take action against current and former employees if they later violate the policy.

Data Retention Policy

Data is the lifeblood of modern organizations; therefore, it's no surprise that organizations have complex policies regarding the retention of data. A written **data retention policy** should be a part of your information security program and should contain at least three basic elements:

- **Categories of data:** The data retention policy should provide broad categories of data that will be protected under the policy. Most likely, there will be several different categories of data that will have different retention requirements. Outlining these categories in advance helps simplify the content of the policy document.

- **Minimum retention time:** The policy should specify the minimum length of time each category of data should be retained. The primary objective of this information is to ensure that critical data is available for the amount of time required by law, regulation, business needs, or other requirements; for example, financial information related to taxes should be retained for seven years, as required by Internal Revenue Service regulations.

- **Maximum retention time:** The policy should also state the maximum amount of time that data from different categories should be retained. Often, organizations face legal or regulatory requirements that specify data must be destroyed after a certain period of time. This often occurs in areas that relate to personal privacy.

> **NOTE**
>
> Data categorization information may be duplicated by other information security policies, such as the confidentiality policy. If this is the case, it may be useful to describe the categories in a separate document and then reference that document in all other applicable policies.

The overall objective of the data retention policy is to ensure that the organization remains in compliance with applicable laws and regulations while keeping in mind business objectives and data storage requirements.

Wireless Device Policy

Wireless devices, such as mobile telephones, personal digital assistants (PDAs), palmtop computers, and the like are becoming increasingly prevalent in today's computing environment. Even if your organization doesn't

currently own mobile devices, you should consider implementing an enterprise-wide **wireless device policy** in the event users elect to bring personal devices into the workplace. (This is a practice that you may wish to prohibit in your policy, because the devices are outside of the control of your organization and may represent a risk for your proprietary information.)

The wireless device policy should clearly spell out the following pieces of information, at a minimum:

- Types of equipment that may be purchased by organization entities
- Types of personal equipment (if any) that may be brought into organization facilities
- Permissible activities with wireless devices (e.g., what type of data may be synchronized for offline use)
- Approval authorities for exceptions to the standard policy

Wireless computing devices represent a significant threat to the confidentiality of your corporate data. Be sure you put an appropriate level of thought into this policy and enforce it consistently throughout the organization.

3.2.2 Implementing Policy

One of the biggest challenges facing information security professionals charged with the development of security policies is the implementation of those policies. You can take specific steps throughout the implementation process to aid in policy development, acceptance, training, enforcement, and maintenance. Some of these activities may take place on a one-time basis, but many will be continuing efforts as your organization matures through the various stages of the security lifecycle.

Developing Policies

The development of a set of information security policies is best handled using a team approach. Depending on the size, structure, and nature of your organization, representatives from different functional elements should be included. Commonly, such committees include the following types of people:

- IT professionals
- Business unit representatives

TIP

The executive management representative will be one of the most critical members of your team. Although it may be difficult to secure a senior representative, it's well worth the effort. This high-level person may not significantly contribute to the "down and dirty" details of policy development, but he or she will serve two significant roles. First, the executive will provide a higher-level, business-oriented insight into policy development. Second, the fact that he or she is associated with the policy development effort will provide it with increased credibility in the eyes of other organization leaders.

- Physical security representatives
- Human resources representatives
- Financial representatives
- Executive management representatives

Once the policy development team is in place, it's time to begin developing the organization's security policy. One of the more common ways to approach this task is to first develop a high-level list of business objectives that should be achieved by the information security policy, and then put together a list of policy documents that must be written in order to achieve those objectives. The next step should be a rough outline of the contents of each policy document, followed by several rounds of draft document review and revision, until a final consensus is reached among the committee members.

Building Consensus

Once the information security policy committee has reached a mutual conclusion regarding the policy documents, it's time to spread that consensus within the organization. Take the time to explain the reasoning behind the security policy to key opinion leaders (both formal and informal) within the organization and ensure that they're "on board" with the policy. This portion of the process is where your committee's representative from senior management will play a significant role. One of the most effective ways to promote your policy is to announce it with an e-mail or a letter from a senior executive (the president or chief executive officer, if possible) requesting the cooperation of all personnel. During this phase, you'll need to wear your salesperson hat—you're *selling* the policy to others within the organization. If you succeed here, future implementation phases will be much easier. If you fail to build organizational consensus, your policy will most likely be bypassed by individuals who either seek out loopholes or simply ignore it altogether.

Education

The next phase of information security policy implementation is providing effective education and training programs for all affected individuals. Don't confuse this phase with the previous consensus-building phase. In that phase, you were simply "selling" the importance of the policy program

within the organization. During the education phase, you're providing users with details on the operational aspects of the policy and their specific responsibilities with regard to implementing and maintaining compliance with security policy.

A well-rounded education program should contain two different types of security policy training:

- **Initial training** should be provided to all employees on or before their first day of employment with the organization. This training should offer a comprehensive look at the individual's security responsibilities. If it's not possible to conduct this training on the first day of employment, it should at least be conducted prior to the employee's first use of a computing system and should be a required check box before the issuance of system login credentials. You may also wish to conduct more lengthy training (perhaps a full-day or multi-day seminar) for those employees with higher levels of security responsibility. Another popular option is to provide a short (one hour or so) live presentation stressing the goals and importance of the program and follow it up with a self-paced training program available online, by videotape, or through other appropriate media.

- **Refresher training** should take place at periodic intervals during an employee's tenure with the organization. It is common for this to take place on an annual basis. Refresher training should be relatively short and used to accomplish two goals. First, it should provide employees with a reminder of their security responsibilities from the initial training program. Second, it should be used as an opportunity to provide employees with updates that result from changes in security policy or the advent of new technologies that require interpretation under the security policy. The scope and format of refresher training will depend on your organization. If you regularly have training sessions for groups within your organization that cover a variety of topics, you may be able to schedule time at one of those sessions. In other organizations, you may be limited to the use of self-paced training programs for this type of periodic training.

The security training you provide to employees should be custom-tailored to their role within the organization. For example, a receptionist will require a much different type of training program than the one you provide

to new system administrators. Be sure that the training materials are appropriate for the individual's job function and educational/career background.

Enforcement

In order for an information security policy to be effective, it must be consistently enforced throughout the organization. The policy itself should contain enforcement provisions clearly spelling out responsibilities for reporting policy violations and the procedures to be followed when a violation occurs. A policy that is not enforced is not even worth the paper it is written on.

Maintenance

Security policies are living, dynamic documents and should be treated as such. When developing a policy, the security committee should strive to make the policies general enough to apply to unforeseen situations, but it is almost inevitable that changes will one day be necessary. The policy should contain provisions for its own modification through standardized maintenance procedures. It is common for organizations to require members of the security policy committee to review the document (either as a group or individually) on a periodic basis (quarterly or annually) to ensure that the policy meets the requirements of the organization's contemporary computing environment.

3.3 Security Administration Tools

Just like any group of professionals, security practitioners have standard tools of the trade. Some of these tools are technical measures (such as firewalls, intrusion detection systems, and vulnerability scanners) that will be discussed in later chapters. Others are management tools used to help with the consistent application and enforcement of the information security policy throughout the organization. This section looks at two such tools: security checklists and security matrices.

3.3.1 Security Checklists

Checklists are among the most useful administrative tools in information technology, and they're used in both large and small organizations. Security professionals can use checklists in two distinct manners. First, security professionals should take the opportunity to review any checklists that currently exist in the organization to ensure that the procedures outlined within them are consistent with the information security policies of

WARNING

Consistent enforcement is especially important with respect to the organization's confidentiality policy and other policies that may one day require legal action against an individual. The courts have previously disregarded the responsibility of an employee to follow policies that were not consistently enforced throughout the organization to prevent the unfair "singling out" of one or more employees.

TIP

Two great sources for security checklists are the SANS Institute (*http://www.sans. org*) and the Computer Emergency Response Team (CERT) (*http://www.cert. org/tech_tips/usc20_ full.html*).

	Confidentiality	Integrity	Availability
Critical Importance		X	X
Moderate Imporance			
Low Importance	X		

Figure 3.2

Sample security matrix

the organization. Adding, modifying, or deleting items from these check-lists offers an easy opportunity for security practitioners to quickly and effectively modify the behavior of the individuals using those checklists on a daily basis. Second, security practitioners may wish to develop checklists of their own for use in security-specific tasks. These checklists may be either developed from scratch or modeled after existing checklists promoted by organizations that develop "best practices" for the security community.

3.3.2 Security Matrices

A security matrix is a tool used both in the development of security policies and in the implementation of specific procedures. A sample of a security matrix is shown in Figure 3.2.

As you can see, the matrix lists the primary goals of the information security program (confidentiality, integrity, and availability) across the top and three levels of attention down the side. Administrators developing security procedures for a system or network may first complete a matrix for each case. The matrices may then be used to help guide effective utilization of security resources.

3.4 Physical Security

Another important aspect of security that sometimes is forgotten is physical security. Firms invest hundreds of thousands of dollars in technical measures designed to keep hackers from illegitimately obtaining access to information resources over the network. It's just as important to ensure

that safeguards are in place to prevent someone from simply walking in and gaining physical access to the facility where those resources are housed. Similarly, measures should be taken to protect assets from physical harm due to fire, flood, or other natural disaster.

Certainly, physical security is a discipline in and of itself. Many professionals have dedicated their careers to ensuring that physical facilities have appropriate access controls, and some of these professionals may exist within your organization. If they do, take advantage of their talents. It's your responsibility as an information security professional to ensure that the physical security specialists understand the critical nature of the assets under your care so that they may allocate their resources appropriately. On the other hand, if your organization does not have personnel dedicated to maintaining security of the physical plant, you may need to take this responsibility on yourself. In the next sections, we'll take a look at three of the major physical security issues facing information security professionals: perimeter protection, electronic emanations, and fire protection.

> **WARNING**
>
> Keep in mind that this material is presented to provide you with a brief overview of these topics and is not a comprehensive look at physical security.

3.4.1 Perimeter Protection/Access Controls

One of the first concepts that comes to mind when you think of physical security is perimeter protection. Just as you put a firewall in place to protect the perimeter of your network, you should build appropriate defenses to protect your physical facility from intrusion. On the perimeter of the facility, you may wish to include measures such as:

- Fences
- High-wattage lighting
- Motion detectors
- Guard dogs
- Patrols

Obviously, the level of protection you provide will vary greatly depending on your facility's purpose and location. A military installation may use armed patrols and guard dogs, but you'd be very unlikely to find this level of protection on a university campus!

The principle of defense in depth applies to the area of physical security just as it does to other realms of information security. It's appropriate to build several layers of perimeter protection that safeguard more and more

critical assets. For example, you may have a barbed wire fence with a single entry point surrounding your facility to control access to the building itself. People seeking entry may then need to pass a guard station and show identification to actually enter working areas of the building. Rooms containing sensitive data or equipment may have specialized access controls such as biometric devices (like fingerprint readers or retinal scanners) or combination locks.

3.4.2 Electronic Emanations

Every electronic device unintentionally emits electromagnetic radiation as a byproduct of its operation. To the end user, this is not terribly important—there are no documented health risks or other safety concerns arising from **electronic emanations**. However, they do pose a significant threat from an information security point of view, due to the fact that those emanations carry data. In fact, it is possible to actually re-create a monitor's display from hundreds of feet away using a few thousand dollars worth of equipment. The possibilities are scary—a nondescript van in a parking lot across the street from your office could be used to read the signals generated by monitors inside.

TIP

For a truly useful information source on the TEMPEST program, visit The Complete, Unofficial TEMPEST Information Page Web site at *http://www. eskimo.com/~joelm/ tempest.html*.

The U.S. government recognized the significance of this threat as early as the 1950s and developed the **Transient Electromagnetic Pulse Emanation Standard (TEMPEST)** program to help protect government computers from this threat through the use of shielding technologies. TEMPEST-certified equipment is extremely bulky (picture a computer with a heavy metal case) and expensive. Although the thought of an attack against your organization may be scary, the costs of implementing safeguards are so extreme that you're unlikely to find this type of equipment outside of the realm of highly classified government information processing programs.

3.4.3 Fire Protection

Fire is one of the most prevalent (and oldest) threats to physical facilities. To protect your computing facilities, you should have adequate fire detection and suppression systems in place. Building codes often dictate the use of sprinkler systems throughout a building, supplemented by handheld fire extinguishers and hoses.

There are four classes of fire extinguishers in use today, and each works on specific kinds of fires:

- Class A extinguishers are designed to put out fires for ordinary combustibles, such as wood, cardboard, and paper.

- Class B extinguishers are designed for fires burning flammable liquids such as grease, oil, and kerosene.

- Class C extinguishers are designed for fires that are of electrical origin.

- Class D extinguishers are used to fight fires involving combustible metals.

It's extremely common to find a single fire extinguisher rated "ABC" that handles the first three classes of fire and reduces the likelihood that someone will inadvertently use the wrong type of extinguisher on a fire and endanger themselves or exacerbate the situation.

Many computing centers have specialized fire suppression systems that reduce the potential for damaging electronic equipment inherent in other types of systems. Up until a few years ago, the prevalent system used a chemical known as Halon, which has fallen out of common use due to environmental concerns. Replacement systems use carbon dioxide, FM-200, and other chemical substances.

3.5 Personnel Security

No matter what security controls you put in place, people will always be the weakest link in any system. For this reason, it's vital to include personnel security provisions in your overall information security program. Some of the common measures that you should consider implementing are:

- Background investigations should be conducted for all employees prior to extending a final offer of employment. The scope of these investigations will vary depending on the nature of the position and organization, but may include criminal record checks, credit reports, driving histories, education/credential verification, and reference evaluations. For extremely sensitive positions, you may consider conducting background checks on a recurring basis.

- Monitoring of employee activity may also play a role in your information security program. This may include actions such as monitoring Internet usage for inappropriate activity, using surveillance cameras in sensitive areas, and recording telephone conversations.

> **WARNING**
>
> Many countries have privacy laws that restrict the types of background investigations you may perform and may require prior written consent from the job candidate before initiation. You should seek advice from an attorney before beginning any background investigations.

> **WARNING**
>
> Legal restrictions may exist that limit the extent of your monitoring activities. These regulations vary from country to country and state to state. Be sure to consult with legal counsel before implementing any such program.

- Mandatory vacations serve two purposes. They not only provide employees with well-deserved rest periods, but also provide you with an opportunity to detect fraudulent activity that the employee may be able to cover up while in the office.

- Exit procedures for employees who leave the company (voluntarily or involuntarily) should provide for a friendly departure, when possible. During the exit process, employees should be reminded of any continuing obligations that they may have under their nondisclosure agreement or other contractual relationships.

3.6 Chapter Summary

- The principle of separation of privilege ensures that the authority to perform actions that may impact critical events requires approval by two separate users.

- The principle of least privilege states that each user should have only the minimum level of access permissions necessary to perform his or her assigned job functions.

- The defense in depth strategy involves building a multilayered defensive posture against malicious activity.

- Security through obscurity is no longer considered an acceptable approach to information security; the details of security devices should be made available to those who use them.

- An organization's information security policy should describe the measures taken within the organization to protect the confidentiality, integrity, and availability of data. It should be developed using a multidisciplinary approach and maintained over time.

- Security checklists and matrices provide administrators with useful tools to help implement security policies within an organization.

- Providing proper physical security for a computing facility is just as critical as providing other information security controls.

- People can be the weakest link in any security program. Therefore, every organization should implement a solid personnel security program for all current and prospective employees.

3.7 Key Terms

acceptable use policy (AUP): Document that describes the allowable uses of an organization's information resources.

backup policy: Document that specifies what data must be backed up, approved methods, storage locations, who has access, retention schedule, and media rotation.

confidentiality policy: Document that outlines procedures to use to safeguard sensitive information.

data retention policy: Document that describes categories of data that must be protected, and minimum and maximum retention times.

defense in depth: Principle that states security administrators should build a layered defense against malicious activity.

electronic emanations: Unwanted electromagnetic signals that are generated by any electronic device and may be used by eavesdroppers to gain information about activity on a system.

initial training: Security training that takes place when an individual first enters an organization or assumes a new role that entails significantly different information security responsibilities.

least privilege: Principle that states a user should have the minimum set of computing privileges required to complete his or her assigned job function.

privilege creep: Situation that occurs when users change roles in an organization but retain access privileges associated with their former positions.

refresher training: Security training that takes place on a periodic basis for all organization employees.

security policy: Written documents that outline an organization's security requirements and expectations of users, administrators, security professionals, and managers.

security through obscurity: Outdated security principle that sought to maintain the integrity of information security devices by keeping the details of their operation a secret from device users.

separation of privileges: Principle that ensures that one user does not have the authority to perform actions that could impact critical events.

TEMPEST: Government program designed to limit the scope of unwanted electromagnetic emanations from electronic equipment.

wireless device policy: Document that describes permissible wireless equipment and its use within an organization.

3.8 Challenge Questions

3.1 Which general security principle dictates that no single user should have enough authority to commit a serious computer crime?

 a. Defense in depth

 b. Security through obscurity

 c. Least privilege

 d. Separation of privileges

3.2 The practice of layering multiple security mechanisms to achieve a comprehensive defensive posture is known as _____.

3.3 Which one of the following security principles explains a practice that security administrators should *not* follow when designing an information security program for their organization?

 a. Defense in depth

 b. Least privilege

 c. Security through obscurity

 d. Separation of privileges

3.4 The two main causes of violations of the principle of least privilege are _____ and _____.

3.5 Which part of a well-designed cryptographic system is responsible for maintaining the secrecy of communications?

 a. Identity of sender

 b. Algorithm

 c. Key

 d. Time of use

3.6 A properly developed security policy should provide users with an understanding of both the _____ and the _____ of the regulations contained within it.

3.7 What type of information security policy document should define the procedures users should follow if they suspect misuse of corporate computing resources by an employee or other affiliate?

 a. Backup policy

 b. Data retention policy

 c. Acceptable use policy

 d. Confidentiality policy

3.8 An organization's data retention policy should, at a minimum, cover which of the following topics? (Choose all that apply.)

 a. Minimum length of time data should be retained

 b. Maximum length of time data should be retained

 c. Types of data covered by the policy

 d. Data backup requirements

3.9 What types of organizations should consider implementing a wireless device security policy?

3.10 The two types of information security policy training that should be part of an education program are _____ and _____.

3.11 Which of the following types of individuals are normally included on the information security policy development committee? (Choose all that apply.)

 a. IT professionals

 b. Administrative support staff members

 c. Physical security representatives

 d. Senior management representatives

3.12 What type of security planning tool is often used to ensure the security of routine tasks like system configuration?

 a. Access control list

 b. Matrix

 c. Checklist

 d. Role-based review

3.13 Which one of the following physical security threats can be reduced through the use of shielding technologies?

a. Fire

b. Electronic emanations

c. Theft

d. Intrusion

3.14 What general security principle, when applied to information security, would suggest the use of biometric access controls to safeguard extremely sensitive areas within a larger physical facility?

a. Least privilege

b. Separation of privileges

c. Defense in depth

d. Security through obscurity

3.15 Which one of the following is not a key component of a thorough personnel security program?

a. Background investigations

b. Fire protection

c. Exit procedures

d. Monitoring

3.16 What type of fire extinguisher is specifically designed for use on fires with an electrical origin?

a. Class A

b. Class B

c. Class C

d. Class D

3.17 What chemical was commonly used for data processing facility fire suppression but is no longer as common due to environmental concerns?

a. Halon

b. Water

c. Carbon dioxide

d. FM-200

3.18 Finalization of critical financial transactions should require the authorization of _____ to deter fraud.

3.19 What term is used to describe the condition where users change roles within an organization but retain the access rights of their previous positions?

a. Access flow

b. Privilege creep

c. Unacceptable use

d. Permission refresh

3.20 What type of fire extinguisher should be used on fires involving flammable liquid sources?

a. Class A

b. Class B

c. Class C

d. Class D

3.9 Challenge Exercises

Challenge Exercise 3.1

In this exercise, you review the acceptable use policies of various organizations and determine common elements. You need a computer with a Web browser and Internet access.

3.1 Using your Web browser and a search engine, find an acceptable use policy from a government organization and review the policy.

3.2 Using your Web browser and a search engine, find an acceptable use policy from an educational institution and review the policy.

3.3 Using your Web browser and a search engine, find an acceptable use policy from a corporation and review the policy.

3.4 Using your Web browser and a search engine, find an acceptable use policy from an Internet service provider (ISP) and review the policy.

3.5 Write several paragraphs comparing and contrasting the policies you discovered during your searches. What elements are common to all of the policies? What specific considerations do you think were behind areas of difference in the acceptable use policies?

3.10 Challenge Scenarios

Challenge Scenario 3.1

Adams Communications is a mid-size manufacturer of custom signage for retail storefronts. The organization has a number of traveling salespeople who cover territories around the United States. Many of these employees work from their homes and use laptops with wireless Internet connections and mobile phones to communicate with the home office. They often retrieve confidential price lists from headquarters and need access to them while on the road. They also prepare customized proposals for each client and forward them to the home office for review prior to e-mailing or hand delivering them to the potential client.

You were recently hired by Adams Communications to help put together an information security policy. The organization is especially concerned about the need for maintaining the confidentiality of their pricing information (both on the price list and in proposals prepared for individual clients). You have been tasked with the responsibility of developing the first draft of a security policy document that governs the use of wireless devices by traveling salespeople. Your supervisor has explained to you that she recognizes organizations usually develop individual wireless device policies and confidentiality policies but stressed the importance of including all of this information in a single document. She also reminded you that the majority of the sales force is not technically proficient and they are not likely to read a document that exceeds one page in length.

Using the information from earlier in the chapter as a reference, prepare a security policy document that meets the requirements of Adams Communications in a clear, concise manner. While writing the document, keep in mind the business needs of the organization and the target audience for your writing.

Challenge Scenario 3.2

You are the chief security officer of FinTrade, a financial services firm that allows clients to trade stock on FinTrade's Internet Web site. Your organization is extremely concerned with security and you would like to develop a checklist to help enhance the physical security procedures at your primary data center.

The data center itself is a free-standing building that has a security station manned by a guard 24 hours a day. All employees are issued photo ID badges with a magnetic stripe. The facility has a card reading system that can analyze an ID and determine whether an employee is authorized to access the facility during specific time periods.

Your task is to develop a security checklist to help the guard deal with any exceptions to the policy that arise. Think carefully about the types of circumstances that could require the guard to make judgment calls and attempt to accommodate those situations in the checklist. As the primary security official within FinTrade, you have the authority to develop the procedures that will be used, but keep in mind the situation presented in this Challenge Scenario when preparing the checklist.

CHAPTER 4

The Business of Security

After reading this chapter, you will be able to:

- Build a solid business case to justify the dedication of resources to a computer security program

- Explain how business continuity planning is used to minimize the impact a disaster may have on an organization's operational continuity

- Describe how to implement a disaster recovery plan to facilitate the rapid restoration of services should they become interrupted by a disaster

- Implement a data classification program appropriate for various types of organizations and security environments

- Understand the ethical considerations that govern the activities of information security professionals

- Comprehend the legal requirements facing security professionals working in the United States and other jurisdictions

NOTE

Throughout this chapter, we'll assume that the environment being discussed is a business, for ease of reference. However, these principles apply equally to nonprofits, educational institutions, and other types of organizations. Although these organizations do not have profit as a primary objective, they still have specific "business" objectives that must be achieved through the use of various financial, manpower, and other resources.

Security is not the primary focus of the vast majority of organizations in existence today. If you work for an organization that is the exception to this statement, congratulations! If not, you must face the business realities imposed by your situation. Chances are, you must make do with limited resources (financial, manpower, and otherwise). Don't feel alone—you're in the same situation as the majority of security professionals worldwide. In this chapter, you'll learn about the various ways that security professionals build a business case for the dedication of appropriate resources to the information security effort and the ways they use security tools, techniques, and practices to help achieve the business goals of an organization.

4.1 Building a Business Case

Building a business case for an information security program is a relatively straightforward task that many security professionals find extremely challenging. In many businesses, there's often a dichotomy between the business people and the security people who "just don't understand how to run a business." This clearly doesn't need to be the case, but bridging that gap requires effort on the part of both groups.

As a security professional, you must strive to understand both sides of the issue. After all, the business exists to satisfy business objectives, and all other programs (including the security program) are there to support those efforts. The first step you should take is to gain a thorough understanding of the business's goals and objectives and determine how security can play a part in the organization's drive to meet those objectives. In a smaller company, you may need to speak to only a few people and read some of the company's sales literature to gain this understanding. In larger businesses, it may take more effort to build your corporate knowledge base. If you're responsible for security on an enterprise basis, you need to have a high-level understanding of how the entire corporation functions. If you're responsible for a specific business unit, on the other hand, you'll probably want to become familiar with the intimate details of that unit's operations.

Once you understand the business, you'll be able to describe security efforts in relation to the organization's mission. Indeed, if you're planning a security effort and *can't* trace it back to a specific business objective, you should probably re-examine the necessity of the expenditure.

Recall from Chapter 1 that there are two types of risk analysis—qualitative analysis and quantitative analysis. When you're building the business case for an information security program, you can use similar approaches. When managers contemplate business decisions, some are made in a purely quantitative manner (e.g., "This new spam filter will save us 1,000 man-hours per year. Each man-hour costs $15 on average; therefore, the total savings from the filter will be $15,000. The cost of the filter is only $5,000, so we should implement it."). Other business decisions are made using a qualitative approach (e.g., "This firewall will help prevent intruders from entering our network and stealing our trade secrets which, if disclosed to our competitors, would cause the failure of our entire business. Therefore, we must implement it at any cost."). When building the business case for a program, think about the potential ramifications that implementation (or lack thereof) will have on the business; this will help you select the appropriate strategy.

One last word on building a business case before we move on. We mentioned earlier that in most organizations a sharp divide exists between technical professionals and "business people." This does not need to be the case. In fact, someone who understands both sides of the equation can be one of the most valuable employees a business can have. Why not strive to be that individual? Take some courses in business issues. Learn about accounting and finance, organizational leadership, and strategic planning. These skills will carry you a long way toward understanding the overall functioning of a business and will help you further your career as you progress along either a technical or a managerial track. You'll also learn the buzzwords used by business administration professionals. As technical professionals are acutely aware, there's no better way to effectively communicate with someone than in their own profession's technical jargon.

4.2 Business Continuity Planning

Every organization faces risks. Fire, flood, burglary, war, and hundreds of other incidents threaten the continued operation of every business. Protecting the business's computing resources from these risks falls squarely upon the shoulders of its information security professionals. This practice is known as **business continuity planning**, and its focus is on the develop-

ment, implementation, and maintenance of an organization's business continuity plan (BCP).

In the following sections, we'll review some of the main considerations that go into building a business continuity plan. We'll talk about conducting the initial vulnerability assessment, implementing appropriate controls for serious vulnerabilities, and performing adequate BCP maintenance to ensure that the plan remains responsive to current business needs.

4.2.1 Vulnerability Assessment

Every business in existence faces an innumerable array of information security vulnerabilities. Some of these are technical risks, such as hackers, hardware failures, and operator error. Others pose more indirect threats to information security (but are just as real a danger), such as natural disasters and building collapses. To effectively manage risk, an organization must prioritize using procedures designed to ferret out and compensate for serious risks while minimizing the time spent on those less serious. After all, a company located in Massachusetts should not spend a significant amount of time (if any) preparing for the threat of a tsunami. Although theoretically possible, it's not likely to happen.

> **NOTE**
>
> If you've forgotten the differences between threats, vulnerabilities, and risks, you may wish to review Section 1.4.2, "Identifying and Assessing Risks," in Chapter 1.

The vulnerability assessment is the first phase of building an organization's BCP. This initial analysis seeks to ferret out vulnerabilities in an organization, determining which have corresponding threats and pose a significant risk. A formula often used to express the relationship between these concepts is:

$$\text{Risk} = \text{Threat} \times \text{Vulnerability}$$

Let's take a look at our tsunami example again in light of this equation. Our Massachusetts organization is located on the coastline and has not built a seawall. Therefore, the organization's vulnerability to a tsunami is extremely high. It's likely that if a tsunami were to occur, the entire building would be completely destroyed. Therefore, the vulnerability of the organization is high. However, the threat of a tsunami occurring in Massachusetts is *extremely* low. This mitigates the high vulnerability and, when multiplied, results in a relatively low risk to the organization. On the other hand, take the same building and look at this equation in the context of the threat of flood. The vulnerability of the building to a flood is probably similar to that of a tsunami (high). However, the risk of flood on the coast is probably

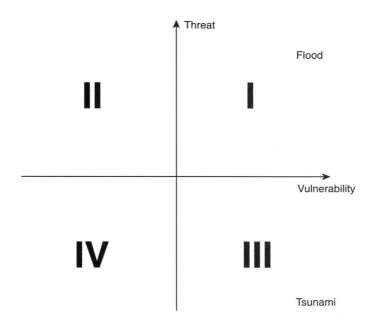

Figure 4.1
Vulnerability assessment
quadrant map

very high. Therefore, both portions of the equation are high and the resulting risk is high, meriting attention from business continuity planners.

Figure 4.1 shows a quadrant map that allows you to plot the results of your calculations and includes the tsunami and flood examples from the preceding paragraph. When you place risks on this map, those that fall in quadrant I require the most attention. The closer a risk falls to the upper-right corner, the more attention it requires. Risks in quadrants II and III should be analyzed and possibly controlled. Risks that fall in quadrant IV, although they should not be totally ignored, probably do not represent a serious risk to the organization.

4.2.2 Implementing Controls

Recall from Chapter 1 that four techniques are used to manage the risks that the vulnerability assessment identifies: risk avoidance, risk mitigation, risk acceptance, and risk transference (or a combination approach). During your risk analysis and vulnerability assessment, your team identified the appropriate strategy for handling each type of risk. The goal of the BCP is to take this strategy analysis and put it into concrete, actionable terms. The

BCP team should determine exactly *how* the organization will mitigate risks that pose a significant threat to the organization's livelihood. This chapter won't delve into the specific techniques used, because that is the focus of much of this book. Some of the technical risks that you face may best be mitigated through technical controls, such as access control systems, firewalls, and intrusion detection systems. Other risks may be better handled through the use of comprehensive education, training, and monitoring systems. On the other hand, some physical risks (such as that posed by flooding) need to be handled by professionals from other disciplines, such as engineers and architects. No matter what the type of risk, your BCP should be comprehensive enough to address all of the significant risks facing your information security program. Keep in mind that your data is subject to various risks, and not all of them can be handled through a technical approach.

4.2.3 Maintaining the Plan

Once you've committed your BCP to paper and developed appropriate controls to protect your organization, give yourself a nice pat on the back, sit back, and relax for a few minutes. Then get right back up again and start working on the BCP. The BCP is a living document. The risks facing your organization will change as your organization (and its operating environment) changes. It's best to convene periodic meetings of the team responsible for developing and implementing the BCP to ensure that changes in the organization and environment are properly accounted for and haven't significantly altered the business continuity control requirements. When these changes do occur, your BCP must be flexible enough to adapt and counter those emerging risks.

4.3 Disaster Recovery Planning

An organization uses **disaster recovery planning** to prepare for situations in which a disaster strikes and operations are temporarily interrupted. This process is described by a document known as the disaster recovery plan (DRP). The DRP has three primary goals:

- Facilitate the rapid establishment of an alternative processing facility should a disaster interrupt operations at the primary production site.

- Provide for the maintenance of operations at that alternate facility for an extended period of time.

- Enable the organization to efficiently transition production operations back to the primary facility after the disaster is resolved.

NOTE

Many students confuse the disciplines of business continuity planning and disaster recovery planning. Although the two fields are closely related, they cover different portions of the emergency response process. An easy way to keep the two straight is to remember that the goal of the BCP is to prevent an organization from feeling the impact of a disaster. The DRP kicks in when the BCP fails, and attempts to quickly restore the business to normal operations.

4.3.1 Selecting the Team

As with any security process, the most important part of developing a disaster recovery plan is the selection of a well-qualified and organizationally appropriate disaster recovery team. In smaller organizations, this team may consist of a handful of employees who share overall responsibility for both the development/maintenance of the plan and actual implementation should disaster strike. Larger organizations typically have two types of DRP team members. Several key representatives from each functional area of the business typically serve on a central council that bears overall responsibility for DRP development and maintenance. However, due to the size of the organization, it is not feasible to expect this small council to bear full responsibility for implementing the plan during an actual disaster. For this reason, the core team is supplemented with other employees who have specific DRP roles to assume when the core team activates the plan. These employees receive ongoing training and evaluation, but they are not typically involved in high-level discussions about the plan itself.

Always keep in mind the fact that DRP team members (with the possible exception of one or a handful of core team members) take on their DRP responsibilities as a secondary role within the organization. During normal operating periods, their other job functions have primary demands on their time.

4.3.2 Building the Plan

Once the core team is selected, it's time to put pencil to paper and begin designing the DRP itself. You should ensure that all mission-critical business units are represented on the core team that designs the plan. The DRP that you design should include a description of the processes that will take place when disaster strikes in order to transfer operations to a recovery facility in an orderly manner. It should describe the specific implementation responsibilities of members of the disaster recovery team, along with a list of the resources required to implement the plan. These resources include:

- **Financial resources:** Cash expenditures will likely be necessary to implement the plan.

- **Manpower resources:** Employees from throughout the organization will need to dedicate most or all of their time to the disaster recovery effort.

- **Hardware resources:** Information processing systems will be required at the disaster recovery site.

- **Software resources:** Software and data critical to the business's ongoing operation must be maintained at or transferred to the recovery facility.

Disaster Recovery Facilities

The selection of one or more disaster recovery facilities is one of the most significant challenges facing disaster recovery planners. The general rule that applies to site selection is that the greater the amount of capabilities you require from your site, the higher the cost you will incur. There are three major classifications of alternate processing facilities:

- **Hot sites:** Contain all of the hardware, software, and data necessary to assume primary processing responsibility. These sites are capable of taking over the production role at a moment's notice.

- **Warm sites:** Contain most (if not all) of the hardware and software required to run the business, but do not maintain live copies of the organization's data. In the event of a disaster, several hours or days may be required to load the data from backup and restore the organization to full processing load.

- **Cold sites:** Do not contain any of the hardware, software, or data necessary to run the business's operations. They do, however, maintain the necessary support systems (power, heating, ventilation, air conditioning, security, and so on) and telecommunications circuits necessary to transfer operations. Cold sites generally take a significant amount of time to activate (normally measured in weeks or months).

Creative Disaster Recovery

The preceding list of alternate processing facilities is by no means comprehensive. Only your imagination and resources limit the type(s) of facility incorporated in your DRP. Let's examine a few examples of nontraditional arrangements.

Organizations with a large number of facilities that are geographically dispersed sometimes choose to use mobile disaster recovery facilities. These may be located in trailers, mobile

homes, or air-transportable units. The primary advantage of these facilities lies in the fact that the organization may maintain a small inventory of facilities that are available for worldwide deployment, achieving significant savings over maintaining traditional facilities to provide disaster recovery support for individual locations. One word of caution—don't keep all of your mobile facilities in one place. What happens if a serious disaster (such as a fire) destroys them all at once?

Another nontraditional approach to disaster recovery involves the use of mutual assistance agreements. In this type of arrangement, organizations with similar data processing needs agree to support each other's operations in the event of a disaster. Obviously, this provides significant cost savings because neither organization is forced to maintain a freestanding recovery facility. However, you must choose your disaster recovery partner wisely to ensure that your confidential information is protected from disclosure and that its primary facilities would not likely be impacted by the same disaster.

4.3.3 Training and Testing

Once you've developed a DRP appropriate for your organization, it's essential that you build a training program that ensures all personnel with DRP roles are familiar with the responsibilities they have should the plan be activated. Most organizations implement DRP training using a combination of programs, including:

- **Initial training:** Takes place when an individual assumes a new disaster recovery role within the organization. This comprehensive training provides an overview of the DRP itself with a detailed discussion of each individual's specific security responsibilities.

- **Refresher training:** Occurs periodically throughout an employee's tenure with the business. This type of training is used to remind employees of their disaster recovery responsibilities and to ensure that they are ready to fill their role in the event disaster interrupts business operations.

This education program should sound similar to the general security policy training system outlined in Chapter 3. In fact, these general procedures are a good way to implement any type of security training program that is required for your organization. The length, frequency, and scope of DRP training programs should be custom-tailored to the level of responsibility each individual bears under the DRP.

In addition to the organization's formal DRP training program (which encourages education mainly on an individual basis), the organization should implement a system that allows the entire disaster recovery team to test portions of the DRP on a periodic basis. The next four sections outline some of the common DRP tests in use today: checklist reviews, tabletop exercises, soft tests, and hard tests.

Checklist Review

The **checklist review** is the simplest and least labor-intensive of the DRP tests. In Chapter 3, you learned how checklists serve as a critical component of information security programs. They are extremely common in DRP programs because they provide structured guidance to individuals charged with quickly changing hats from their common everyday role within the organization to their disaster response role. The circumstances of the disaster itself are often unsettling and place demands on the team members as well.

During the checklist review, each member of the disaster recovery team reviews the procedures on their individual disaster checklists with two main goals. The first is to refresh themselves on the details of their program involvement. The second is to verify that the plan meets the organization's current business needs. This may be as simple as realizing that the organization recently added new computing equipment that is critical to the organization's mission but is not adequately addressed by the plan.

Organizations approach checklist reviews in different manners. Some demand that the entire disaster recovery team gather in a centralized location to conduct the review together during a team meeting. Others assemble team members in smaller groups according to their DRP role or their alignment with various business units. In many cases, the checklist review is conducted on an individual basis, using an organized procedure for individuals to provide feedback on potential checklist revisions.

Tabletop Exercise

The next level of DRP test is the **tabletop exercise**. In this type of test, disaster recovery team members gather to verbally "walk through" a specific disaster scenario. Generally, the test facilitator will describe a hypothetical disaster and guide the participants through a discussion of the actions they would take in response to the disaster. These discussions are quite valuable because they provide team members with the opportunity to consider a number of specific scenarios and contemplate how they would impact the organization.

Test Scenarios

One of the major differences in how organizations conduct tabletop exercises lies in whether participants are provided with scenario details in advance. Some organizations choose to keep this information confidential until the exercise takes place. This approach provides management with a feel for how quickly disaster recovery team members are able to gather data and react to an emerging disaster. Other organizations choose to disseminate the scenario to team members in advance of the exercise. This option facilitates the learning process because it allows participants to fully think through the scenario and consider various response options. Advance exposure to the scenario is a particularly valuable component of DRP training programs for organizations that face a high risk of specific disasters (such as those located in areas of the world prone to earthquakes, hurricanes, volcanic eruptions, or other geographically dependent disasters).

The decision you make will depend heavily on your specific situation. You may wish to consider a mixed approach to this issue, such as alternating strategies. This allows you to achieve some of the benefits of both methodologies.

Soft Test

Soft tests, sometimes referred to as parallel tests, go one step beyond the tabletop exercise. In this type of evaluation, disaster recovery team members respond to the scenario using checklist procedures and actually activate the organization's disaster recovery facility(s). The flow of data to the facility is activated, but the site never assumes full operational responsibility for the organization. It merely operates in parallel with the production facilities for a designated period of time.

Soft tests provide a significant advantage over tabletop exercises in that they test the actual hardware and software resources that will be used in the event of a disaster and provide valuable feedback on how well the processes that the DRP outlines in theory operate when used in practice. However, this added benefit comes with additional cost. Soft tests require a much more significant investment of time and resources because employees are diverted from their normal job functions for an extended period of time.

Hard Test

Hard tests, sometimes referred to as full-interruption tests, have the most significant impact on the business and, therefore, are rarely used. In this

type of test, the disaster recovery team simulates a disaster by actually shutting down operations at the production facility and attempting to restore operations at the disaster recovery facility. At the conclusion of the test, the team transfers control back to the production facility, simulating the transition process that would take place at the conclusion of an actual disaster.

Although hard tests are extremely expensive in terms of manpower and resource utilization, as well as potential impact on the business's operations, they are sometimes used by organizations with a mission so critical that they must have absolute confidence in the ability of the disaster recovery team to successfully resume operations after disaster strikes.

4.3.4 Implementing the Plan

In the lifetime of any organization, there will come a time when it's necessary to implement the disaster recovery plan. This will undoubtedly be a chaotic moment during which the organization is thrown into significant turmoil. It's possible that employees may be questioning the continued viability of the organization itself, and their own lives or possessions may be at risk. The chaotic nature of these moments is the very reason that your DRP's implementation procedures must be straightforward and well thought-out.

The implementation plan should define the actions that the first responders to a disaster should take. Remember that this could be anyone within your organization. A programmer might be watching the news and see a breaking news item that a nearby volcano just erupted. The night watchman may be on duty when a flash flood wipes out a power facility. Everyone in your organization should know the procedures to follow if they feel that they are noticing the beginning of a potential disaster.

Remember also that implementation of the DRP can have a serious financial, operational, and emotional impact on the organization. Therefore, it's probably not wise to allow anyone in the organization to single-handedly declare a disaster. The authority to make these judgments is usually reserved for senior managers who are on call 24 hours a day, 7 days a week. Although you shouldn't be quick to rush to a disaster declaration, the process must be smooth enough that it can be done very quickly. Once a disaster is actually declared, the disaster recovery team should be rapidly assembled and the components of the plan should efficiently fall into place to restore operations as soon as possible.

4.3.5 Maintaining the Plan

Just as the business continuity planning process is a dynamic process that must evolve with the organization, the disaster recovery plan is also subject to change with the business. The disaster recovery team's membership, procedures, and tools will change over time, and the DRP should be flexible enough to allow for these changes.

As mentioned earlier in this section, the disaster recovery team should be set up to rely heavily upon checklists and organized procedures. This makes calm, efficient operation in the wake of a disaster feasible. However, it's critical that these checklists be maintained and kept current. If disaster recovery personnel are calmly and efficiently carrying out outdated procedures, the entire effort is at risk. The best way to maintain the plan is to continually test and evaluate it using some of the techniques you learned in this section. Take the time to conduct these tests and hold a *lessons learned* session to debrief team members about what went right and what went wrong during each test. Use the valuable feedback gained during these sessions to perform maintenance on the DRP.

4.4 Data Classification

The implementation and regimented use of a data classification program is a mark of a truly professional information security program. **Data classification** systems provide users with a way to stratify sensitive information and apply appropriate safeguards to data with varying levels of sensitivity in a consistent manner. The following sections examine the two prerequisites for access to classified information (security clearance and a need to know) and look at two different types of classification systems in common use today.

4.4.1 Security Clearances

In an organization using a data classification program, the fundamental requirement for anyone to be given access to classified information is that they must have a valid **security clearance**. In some organizations, determining security clearance is an extremely rigid process that requires completion of rigorous background investigations, polygraph tests, and the execution of secrecy agreements. In other organizations, security clearance may be granted automatically upon employment and acceptance of a standard nondisclosure agreement.

Security clearances are normally granted in various levels that specify the maximum sensitivity level of information that a user is authorized to access. They may also bestow special access to various "compartments" that house extremely sensitive data that is limited to a select subgroup of cleared individuals.

Security clearances should be granted only to those individuals who absolutely need them for the performance of their regularly assigned functions. Furthermore, the clearance status of organization affiliates should be reviewed on a regular basis. If an individual no longer requires access to classified data for his or her job, that access should be revoked until such time as it is needed again.

4.4.2 Need to Know

A security clearance is only one of the two requirements for access to classified information. The second is a valid *need to know* what classified information is needed to complete a designated job function. Whereas a security clearance offers access to broad categories of classified information (for example, all "secret" data), the need-to-know basis narrows the scope of that access down to specific data needed to complete tasks.

Normally, the process of enforcing security clearance requirements takes place at a centralized location (usually the security office) of an organization. That office is responsible for granting, maintaining, and revoking clearances. The need-to-know aspect, on the other hand, is normally enforced by specific individuals charged with the custody of specific pieces of classified data. When asked for access to that information, these custodians must ascertain the individual's identity and, after validating his or her clearance, determine whether that person has a valid need to know the information in question. If the need to know cannot be established, they must deny access until such time as it is established in the future.

4.4.3 Classification Systems

There are two main types of classification systems—those used by governments and government agencies and those used by private industry. In most (but certainly not all) cases, the world's governments use classification systems that are much more restrictive than those used by private industry. They also tend to have a good deal more bureaucracy and admin-

istrative overhead behind them. Let's take a look at each type of system and explore the benefits and drawbacks of each.

Government Classification System

The U.S. government uses what's known as a mandatory access control system (discussed in Chapter 2). Each piece of classified data is assigned a specific security level, and everyone who handles that information is responsible for treating it with the appropriate security safeguards. The five levels of classified information used by the U.S. government and their definitions are as follows:

- **Top Secret:** Information that, if it falls into the wrong hands, would cause "exceptionally grave damage" to the national security of the United States.

- **Secret:** Information that, if compromised, would cause "serious damage" to the national security of the United States.

- **Confidential:** Information that, if disclosed to unauthorized individuals, would cause "damage" to the national security of the United States.

- **Sensitive but Unclassified (SBU)**, also referred to as **For Official Use Only (FOUO):** Information for which disclosure would not necessarily cause damage to national security, but which the government has some obligation to protect. Examples of information that may fall into this category are personal tax records, proprietary corporate information disclosed to government regulators, and details of contract negotiations.

- **Unclassified:** Information that is not protected by any classification safeguards and may be freely distributed.

> **NOTE**
>
> Although this system is used only to protect government secrets, it is often found in private industry as well. Many businesses that contract with the federal government are required to submit to the same background checks and information protection safeguards (including the five-level classification system) used by the government.

Industry Classification Systems

Industry classification systems are often much less complicated than their government counterparts, but still have the same system of levels and access controls. Some of the data classifications commonly found in industry are:

- **Trade secret:** Information that consists of the crown jewels of many organizations. This data is normally not protected by formal intellectual property systems (such as patents and copyrights)

because the inventors do not wish to risk the public disclosure and eventual release into the public domain that these systems entail. Rather, they have decided to protect the data as a trade secret by using internal controls designed to prevent unauthorized disclosure.

- **Company confidential/proprietary:** Information that consists of data that the business does not wish to see released into the public domain but that is much less sensitive than trade secret information.

- **Unclassified:** Information that, like its government counterpart, the company deems does not require classification protections.

No matter which system you use, it's important that you apply it consistently and label information appropriately. This is critical in the event you must later take legal action to enforce your intellectual property rights. For example, if you consider a piece of information to be a trade secret, but don't explicitly label it as such, a former employee could disclose it to unauthorized individuals and then later claim that he or she did not know that it was a trade secret because it wasn't clearly labeled as such.

4.5 Security Ethics

Security professionals are trusted with the proverbial "keys to the kingdom." Due to the nature of their positions, they have access to data from all parts of the organization and are responsible for ensuring that all employees operate within the appropriate framework designed to protect that information.

Due to this high degree of trust, it is essential that security professionals exhibit the utmost degree of ethical standards in their behavior. The International Information Systems Security Certification Consortium ((ISC)²), one of the security field's preeminent professional organizations, has developed a simple four-rule Code of Ethics for information security professionals. The four canons of this code are:

- Protect society, the commonwealth, and the infrastructure.
- Act honorably, honestly, justly, responsibly, and legally.
- Provide diligent and competent service to principals.
- Advance and protect the profession.

These principles, although straightforward, provide an excellent framework for the practice of information security and, indeed, any other profession.

4.5.1 Monitoring

An old saying from the intelligence field goes "In God we trust. . . . All others we monitor." Monitoring of internal and external activity is an important part of many information security programs. As the monitors, information security professionals are trusted with a high degree of confidence. It is their ethical responsibility to ensure that they handle the information they gain during this monitoring with the utmost of professionalism.

4.6 Computer Security Law

A number of laws govern the practice of information security. Although this book is certainly not a law text and is by no means a substitute for competent legal counsel, it's important that you have at least a basic understanding of the laws and regulations governing the information security profession. Some of these laws govern privacy of information stored and processed in information systems; others provide details on the security safeguards required in various industries. Although these laws vary significantly from jurisdiction to jurisdiction and industry to industry, we'll examine some of the main regulations in the next few sections.

4.6.1 Electronic Communications Privacy Act (ECPA)

The Electronic Communications Privacy Act (ECPA) of 1986 is the basic law governing the interception and monitoring of electronic communications. It has been interpreted by the courts in some cases to apply to communications that take place over the Internet. The ECPA outlines the procedures that government agencies and law enforcement officials must follow in order to obtain legal wiretaps.

4.6.2 USA Patriot Act

Enacted in the wake of the September 11, 2001, terrorist attacks on the United States, the USA Patriot Act provides the government with additional

> **TIP**
>
> Another adage asks, "Who watches the watchers?" It's important that you have programs in place to ensure that the people conducting monitoring, especially internal monitoring of employee activity, handle information appropriately.

leeway in the use of electronic monitoring systems. It also grants government investigators access to certain types of electronic records without requiring a warrant or notification of the subject of those records. If you're in an industry that maintains sensitive personal records, it's essential that you contact an attorney and ensure that you are in compliance with this law.

4.6.3 Children's Online Privacy Protection Act (COPPA)

The U.S. Children's Online Privacy Protection Act (COPPA) provides safeguards for children under the age of 13 who access Internet sites. It requires that the operators of those sites obtain varying degrees of parental consent before collecting any personally identifying information from children.

4.6.4 Health Insurance Portability and Accountability Act (HIPAA)

The U.S. Health Insurance Portability and Accountability Act (HIPAA) was designed as a sweeping overhaul of the health insurance industry in the United States. It made a number of changes in health insurance law that were designed to protect the consumer. One of the major provisions of this law is enactment of privacy requirements for organizations that handle personal medical records. Those who violate the provisions of HIPAA may be held accountable in a court of law.

4.6.5 Gramm-Leach-Bliley Act

The Gramm-Leach-Bliley Act is another U.S. law containing privacy regulations that apply specifically to a single industry—in this case, the financial field. Firms that possess and manipulate private financial information must disclose their uses of that information to the subjects of the records. They are also required to implement a number of privacy safeguards to ensure that the information is handled appropriately while in their possession.

4.6.6 European Union Directive on Data Privacy

The European Union has some of the strictest regulations concerning privacy of personal information in use today. It greatly restricts the collection and use of this type of information and limits the transfer of it across international borders. If you are located in Europe or conduct operations there, you should consult with an attorney to determine whether you are subject to these regulations and what impact, if any, they may have on the continuing operations of your business.

4.7 Chapter Summary

- Security programs support the standard business activities of an organization. Security professionals must be able to build and support the business case for their activities.

- Business continuity planning focuses on ensuring the continued operations of a business in the event of a disaster. It consists of conducting a vulnerability assessment and then designing a business continuity plan that contains controls to limit potential impact.

- Disaster recovery plans kick in when business continuity plans fail. They describe the procedures that will be followed to restore a business to normal operations after it is interrupted by a disaster.

- The three main types of disaster recovery facilities are hot sites, warm sites, and cold sites.

- Organizations should train for disasters by using initial and refresher training in conjunction with tests. The four main types of DRP tests are checklist reviews, tabletop exercises, soft tests, and hard tests.

- Government data classification systems use five levels of classification: Top Secret, Secret, Confidential, Sensitive but Unclassified, and Unclassified.

- The levels of protection used by industry vary but often include trade secrets, company confidential/proprietary information, and unclassified data.

- Access to classified information should be granted only to individuals who possess a valid security clearance and who need to know the specific information.

- A number of laws and regulations govern computer security and the protection of personal information. These laws vary from jurisdiction to jurisdiction and industry to industry. Security professionals must remain current on applicable laws.

4.8 Key Terms

business continuity planning: The process of preparing an organization to continue operations uninterrupted in the face of a disaster.

checklist review: A DRP exercise in which all team members review their disaster recovery checklists for accuracy.

cold site: A site that does not contain any of the hardware, software, or data necessary to run the business's operations. It does, however, maintain the necessary support systems (power, heating, ventilation, air conditioning, security, etc.) and telecommunications circuits necessary to transfer operations.

data classification system: A system that provides a structured methodology for applying protection schemes to information of various sensitivities in a consistent manner.

disaster recovery planning: The process of preparing an organization to efficiently resume operations after a disaster impacts business continuity.

hard test: A DRP exercise in which team members activate the disaster recovery facility in production mode to simulate a disaster scenario.

hot site: A site that contains all of the hardware, software, and data necessary to assume primary processing responsibility.

security clearance: The official determination that an individual should be granted access to a certain level of classified information.

soft test: A DRP exercise in which team members actually activate the disaster recovery facility in parallel status to simulate a disaster scenario.

tabletop exercise: A DRP exercise in which team members gather and walk through a disaster scenario during an in-person meeting.

warm site: Contains most (if not all) of the hardware and software required to run the business, but does not maintain live copies of the organization's data.

4.9 Challenge Questions

4.1 What government security classification applies to materials that, if compromised, would cause serious damage to national security?

 a. Sensitive but Unclassified

 b. Secret

 c. Confidential

 d. Top Secret

4.2 Which one of the following disaster recovery plan tests may be conducted without requiring team members to gather in a centralized location?

a. Soft test

b. Tabletop exercise

c. Checklist review

d. Hard test

4.3 The _____ plan takes effect when the _____ plan fails and a disaster impacts the ongoing functioning of the business.

4.4 Which of the following is one of the primary goals of an organization's disaster recovery plan?

a. Minimize the impact of a disaster on the organization.

b. Allow for the transfer of operations to an alternate site.

c. Maintain operations at the alternate site for an extended period of time.

d. Provide for the efficient transition of operations back to the primary site when the disaster is resolved.

4.5 What type of alternate processing facility generally contains all of the hardware, software, and data necessary to assume primary data processing responsibility for the organization in the event of a disaster?

a. Hot site

b. Mobile site

c. Warm site

d. Cold site

4.6 What government information security classification involves data that may not directly impact national security if disclosed?

a. Sensitive but Unclassified

b. Secret

c. Confidential

d. Top Secret

4.7 Jan needs to build the business case for the implementation of a new firewall. She's confident that she can show that the new firewall

will require less attention from the security staff and will result in significant manpower savings. She does not expect that there will be any change (positive or negative) in the security posture of the organization based on this implementation. What type of approach is best suited to building the business case for this firewall?

a. Qualitative

b. Quantitative

c. Combination of qualitative and quantitative

4.8 Which one of the following security-related laws provides specific guidance that impacts firms in the financial industry?

a. Gramm-Leach-Bliley Act

b. Health Insurance Portability and Accountability Act

c. Children's Online Privacy Protection Act

d. Electronic Communications Privacy Act

4.9 Under the Children's Online Privacy Protection Act, what is the minimum age child that an organization may collect information from without requiring special privacy safeguards?

a. 9

b. 13

c. 15

d. 18

4.10 Using the quadrant map technique described in this chapter, the risks that fall in which quadrant represent the most serious risks facing an organization?

a. Lower left

b. Lower right

c. Upper left

d. Upper right

4.11 Which one of the following formulas best describes the relationship among the concepts of risk, threat, and vulnerability?

 a. Threat = Vulnerability + Risk

 b. Risk = Threat + Vulnerability

 c. Threat = Vulnerability × Risk

 d. Risk = Threat × Vulnerability

4.12 Under a data classification system, a user's access to data is determined by his or her _____ and _____.

4.13 What individuals in an organization should have the authority to declare a disaster and activate the DRP?

 a. All individuals

 b. Security personnel only

 c. Senior managers only

 d. Administrative staff only

4.14 What type of disaster recovery facility contains only the environmental support systems and telecommunications circuits necessary to establish an operational facility but none of the computing resources?

 a. Cold site

 b. Warm site

 c. Hot site

 d. Mobile site

4.15 What classification label is often applied to highly sensitive corporate secrets that the company does not want publicly disclosed?

 a. Company confidential

 b. Proprietary

 c. Trade secret

 d. Patent

4.10 Challenge Exercise

Challenge Exercise 4.1

In this exercise, you search the Internet for disaster recovery plans and templates and compare and contrast various options. You need a computer with a Web browser and Internet access.

4.1 Using your Web browser and a search engine, locate three examples of disaster recovery plans or templates being used by organizations.

4.2 Print copies of each plan and template that you locate.

4.3 Using a highlighter, identify the major areas of difference between each of the three plans.

4.4 Write a brief summary of each plan, highlighting the areas where each does a good job and the improvements you would suggest to each plan.

4.11 Challenge Scenarios

Challenge Scenario 4.1

You are the chief information security officer (CISO) for Ryan Health Services, a practice management firm for physicians. You strongly feel that the organization should adopt a new software package that will allow for the centralized management of the firm's routers and switches. The main reason for your support of this initiative is that it will help bolster the firm's overall posture against attack by allowing your small security staff to easily manage the security configuration settings of networking devices across the entire organization from a centralized location. Currently, the staff are not able to monitor each device because of the sheer number of devices, and you are certain that this results in security holes throughout the organization.

Based on conversations with technical professionals throughout the organization, you've also learned that this type of system will save a significant amount of time on behalf of network administrators performing routine maintenance. You estimate that they will save approximately 150 man-hours per year at an average cost of $23/hour. The total cost of the system will be $5,000/year.

You approached Ryan's Chief Information Officer (CIO) with your proposal and she replied that it's simply not in the budget for this year. How-

ever, there are additional funds available from a central business committee for projects that will have an immediate and direct impact on the organization. The CIO said that if you can build a solid business case for the new management system, she would present it to that committee.

Using a combination of quantitative and qualitative analysis, prepare a brief proposal (no more than one typewritten page) explaining why the new management system is a good idea and should be funded by the committee.

Challenge Scenario 4.2

You are the Disaster Recovery Coordinator for Jackson Aerospace. Jackson already has a comprehensive disaster recovery plan in place that outlines the response procedures for various disasters. The company operates one facility—an aircraft maintenance shop located in an airport hangar. The company conducts regular training and testing of the DRP. You have been tasked with designing a tabletop exercise that will be used for an upcoming test. Write a test plan that includes the disaster scenario and provides participants with enough information that they will know what to expect when the exercise takes place.

CHAPTER 5

Cryptographic Technologies

After reading this chapter, you will be able to:

- Describe the four fundamental goals of cryptographic systems: confidentiality, integrity, nonrepudiation, and authentication

- Explain how to use cryptographic systems to achieve each one of these goals

- Understand the difference between symmetric and asymmetric cryptographic algorithms and provide examples of each

- Implement and use digital signatures to achieve nonrepudiation and integrity

- Explain how digital certificates facilitate the exchange of keys in public key cryptosystems

Cryptographic technology is one of the most well-known products of the information security industry. The use of codes and ciphers to protect the secrecy of information dates back hundreds of years to the messenger corps of the world's earliest armies. In today's information-dependent society, the safeguarding of sensitive data is increasingly important. In this chapter, you'll learn how modern cryptography enhances security in the contemporary environment. You'll understand how this field combines advanced theories from the fields of mathematics and computer science to produce complex cryptosystems.

5.1 Goals of Cryptography

When most newcomers to the security field think of **cryptography**, they immediately think of cryptography's most common application—confidentiality. After all, everyone's familiar with spy movies, secret decoder rings, and other cultural icons that glorify the use of codes and ciphers to conceal the true meaning of a message from prying eyes. Confidentiality is perhaps the most common goal of those using cryptography, but it's joined by three other important objectives: integrity, nonrepudiation, and authentication. Many applications allow users to take advantage of multiple cryptographic benefits simultaneously; for example, many e-mail cryptography systems use algorithms that enforce confidentiality, integrity, and nonrepudiation.

5.1.1 Confidentiality

Cryptographic algorithms provide confidentiality by allowing the sender of a message to **encrypt** it using a cryptographic key. The message is then transformed into an unintelligible format suitable for transmission over insecure media such as the Internet. Anyone who intercepts the message along the way wouldn't be able to make heads or tails of it. When the message reaches its destination, the recipient uses a cryptographic key (depending on the algorithm, it may be the same key used by the sender or a different key) to **decrypt** the message, revealing the original text (also known as the **plaintext** message).

5.1.2 Integrity

Cryptography may also be used to verify the integrity of a communication—that is, to ensure that the message received by the recipient is the

same as the message sent by the originator. Integrity may be enforced independently or in conjunction with one or more of the other cryptographic goals. In order to achieve integrity, the sender of a message uses a hash function to create a unique **message digest** that is transmitted along with the message. A message digest is a string of characters created by the hash function that is unique to the message. If a proper hash function is used, no two messages should have the same message digest (a condition known as a *collision*). When the message arrives at the destination, the recipient uses the same hash function to generate a message digest from the received message and compares it to the digest sent by the originator. If the two digests match, the message was not altered while in transit.

As just described, the message digest provides protection against only unintentional alteration of the message (e.g., transmission errors and power surges). A malicious third party who wished to alter the message could simply create a new message digest using the same hash function to fool the recipient into thinking the message was authentic. For this reason, message digests are usually encrypted by the sender to create **digital signatures** (covered in Section 5.3, "Digital Signatures"). When the recipient verifies the digital signature, he or she can be assured that the message was not altered by a malicious third party (assuming that the third party did not have access to the cryptographic key).

5.1.3 Nonrepudiation

An added advantage to digital signatures is that they provide for nonrepudiation when used in conjunction with an asymmetric encryption algorithm (the technical details of asymmetric algorithms are covered in Section 5.2, "Cryptographic Algorithms"). Nonrepudiation ensures that the sender of a message cannot later claim that he or she did not actually send the message and that it was fabricated by the recipient. For example, if a customer places an order with you via e-mail, you want to be able to prove in the future that the customer actually placed the order and you didn't create the e-mail yourself. Nonrepudiation takes away the user's ability to deny responsibility for his or her messages.

5.1.4 Authentication

Cryptography may also be used to allow a user or a system to prove his or her identity to another user or system. This is accomplished through the

use of **digital certificates**, as described in Section 5.3. One common cryptographic authentication system is the Kerberos system, originally developed for use in UNIX environments but incorporated into recent releases of Microsoft Windows. Kerberos is also available in a free, open-source form.

5.2 Cryptographic Algorithms

The very heart of any cryptographic system is the mathematical algorithm that performs the underlying calculations required to implement the cryptographic goals. In this section, we'll examine the two major categories of cryptographic algorithms—symmetric algorithms and asymmetric algorithms—and look at specific examples of each.

The easiest way to understand the basic functionality of cryptographic algorithms is through the use of a pair of illustrations. Figure 5.1 shows the basic encryption operation performed by a cryptosystem. The user provides the software application (which implements the cryptographic algorithm) with a plaintext message and a cryptographic key. The application then produces the **ciphertext** message as output.

Decryption, on the other hand, involves the reverse process, as shown in Figure 5.2. The user provides the algorithm with the ciphertext message and the cryptographic key. The software application then returns the original plaintext message.

These two basic operations represent the complete functionality of a cryptographic algorithm. Depending on the mathematics involved, some algo-

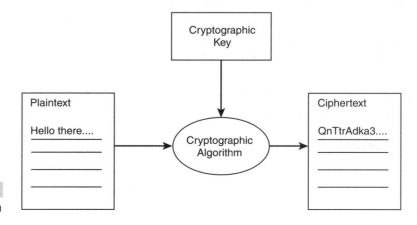

Figure 5.1

Basic encryption operation

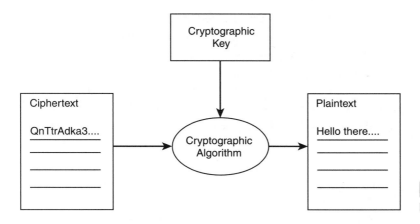

Figure 5.2
Basic decryption operation

rithms are capable of achieving different cryptographic goals than others. We'll explore that concept further in Section 5.2.3, "Symmetric Versus Asymmetric Cryptosystems."

In the early days of cryptography, the inner workings of cryptographic algorithms were closely guarded secrets. It was widely believed that the best way to achieve security was to ensure that nobody knew the details of how the cryptosystem's "black box" algorithm transformed plaintext into ciphertext and vice versa. The security community has since discarded this principle, known as "security through obscurity," in favor of open disclosure of the inner workings of cryptographic algorithms. It's widely believed that allowing the world's cryptanalysts (those individuals involved in the breaking of codes and ciphers) to closely analyze algorithms for flaws is the best way to provide security. After all, an algorithm that survives those rigorous checks is much less likely to contain vulnerabilities than one known to only a few individuals.

5.2.1 Symmetric Algorithms

The first major classification of cryptographic algorithms that we shall consider is the symmetric algorithms. These cryptosystems earned their name because of the symmetry that results from the sender and receiver both using the same cryptographic key, commonly referred to as the "shared secret key" or simply the "**secret key**." Along those same lines, you may also hear symmetric cryptosystems referred to as "secret key cryptosystems."

Symmetric algorithms are divided into two classes: stream ciphers and block ciphers. As the names imply, stream ciphers work on the message bit by bit (or byte by byte, in some cases) whereas block ciphers work on discrete chunks of text (commonly 64 or 128 bits each). Common stream ciphers include the Data Encryption Standard (DES), the Advanced Encryption Standard (AES), Blowfish, Twofish, Skipjack, and RC2. The most common stream cipher is an algorithm known as RC4.

Key Length

One of the most critical components of a cryptosystem's security is the length of the cryptographic key used to provide confidentiality, integrity, nonrepudiation, and authentication. In general, the longer the key, the greater the degree of protection afforded to the cryptosystem. A common attack used against cryptosystems is the "brute force attack," in which the attacker simply tries every possible cryptographic key in an attempt to read the contents of the message. Longer keys frustrate brute force attacks because they create an enormous number of possible combinations that must be tested by a brute force attacker.

Key length is usually measured in terms of the number of bits in the key. Each bit represents a binary value of 0 or 1. Therefore, a 1-bit key would have two possible combinations—0 and 1. A 2-bit key, on the other hand, has four possible combinations—00, 01, 10, and 11. If you're using a 3-bit key, there are eight possible combinations—000, 001, 010, 011, 100, 101, 110, and 111. The formula used to compute the number of possible keys of a given length is 2^n, where n is the key length in bits. Obviously, we would want to use a key significantly larger than the examples shown here. Table 5.1 shows the number of possible keys for a few more common key lengths.

TABLE 5.1 Possible Keys of a Given Length

Key Length	Approximate Number of Possible Keys
56 bits	72,057,594,037,927,936
128 bits	3.40×10^{38}
256 bits	1.16×10^{77}
512 bits	1.34×10^{154}
1,024 bits	1.80×10^{308}
2,048 bits	3.23×10^{616}

As you can see, that's certainly not a trivial number of keys! If the magnitude of the numbers shown in the table doesn't immediately strike you, try writing them out in decimal form. For example, to write out the number of possible keys for a 2,048-bit key length, you'd need to write down 323 and follow it with 614 zeros. That's a big number!

Data Encryption Standard (DES)

One of the most common symmetric cryptosystems is the Data Encryption Standard (DES), which was originally developed by the United States government for use in the protection of sensitive government information. This algorithm uses a 56-bit key and has four modes of operation:

- Electronic codebook (ECB) mode

- Ciphertext block chaining (CBC) mode

- Output feedback (OFB) mode

- Ciphtertext feedback (CFB) mode

The mathematical workings of DES are beyond the scope of this book, but make for quite fascinating reading if you're interested in what makes cryptosystems tick. They're published in Federal Information Processing Standard (FIPS) 46-2, which is readily available on the Internet at *http://www.itl.nist.gov/fipspubs/fip46-2.htm*.

DES is an extremely flexible set of cryptographic algorithms. The various modes lend themselves to different types of implementation—some are more suitable for implementation in extremely fast hardware-based cryptosystems, whereas others allow for the flexibility afforded by software implementation. However, DES has a fatal flaw—the 56-bit key chosen for the standard when it was designed in 1977 is no longer considered cryptographically strong enough to survive brute force attacks. To overcome this limitation, cryptographers have designed a work-around that involves using three separate iterations of DES encryption on a single message. This variation, known as Triple DES (or 3DES), provides an acceptably strong level of protection with limited additional computational overhead.

Triple DES provides longer effective key lengths by using either two or three cryptographic keys. For illustrative purposes, let's assume that we want to encrypt a plaintext message M using the keys K_1, K_2, and K_3. We'll

> **NOTE**
>
> Mathematicians have proven that two iterations of DES (Double DES [2DES]) provides limited additional protection over standard DES and, therefore, is not worth implementing. This is due to the algorithm's vulnerability to a "meet-in-the-middle" attack, where cryptanalysts simultaneously work on the plaintext and ciphertext messages to determine the secret key.

symbolize the act of encrypting message M with key K_1 as $E(M, K_1)$, and the act of decrypting the same message with the same key as $D(M, K_1)$. The first 3DES option is referred to as 3DES-EEE (for encrypt-encrypt-encrypt), and uses three keys for encryption as follows:

$$C = E(K_1, E(K_2, E(K_3, M)))$$

The second 3DES option is known as 3DES-EDE (for encrypt-decrypt-encrypt), and also uses three keys for encryption as follows:

$$C = E(K_1, D(K_2, E(K_3, M)))$$

There are three variants to 3DES-EDE that allow for the use of different numbers of keys:

- **$K_1 \neq K_2 \neq K_3$ (three independent keys):** This mode provides an effective key length of 168 bits.

- **$K_1 \neq K_2, K_1 = K_3$ (two independent keys):** This mode provides an effective key length of 112 bits.

- **$K_1 = K_2 = K_3$ (one independent key):** This mode provides an effective key length of 56 bits. It is exactly the same as using standard DES and is included to provide backward compatibility between 3DES and DES systems. Note that this variant should be avoided because there is no added security over standard DES.

Advanced Encryption Standard (AES)

When it became apparent that DES was becoming insufficient to protect sensitive information, the National Institute of Standards and Technology (NIST) announced a worldwide competition to help develop the next generation of government cryptography—the Advanced Encryption Standard (AES). Several candidate algorithms publicly disclosed their inner workings and were subjected to intense scrutiny by the world cryptographic community. This type of scrutiny by fellow information security practitioners is vital to the acceptance of an algorithm as "secure." Failure to allow public scrutiny often clouds an algorithm with the suspicion of backdoors inserted by the algorithm's developers. In February 2001, NIST announced that there was a winner—the Rijndael algorithm developed by two Belgian cryptographers, Joan Daemen and Vincent Rijmen (the name Rijndael is a

variation of their combined names). This algorithm became the standard for government cryptography on May 26, 2002.

AES allows the user to select one of three different key lengths: 128 bits, 192 bits, or 256 bits. Obviously, the longer the key, the greater the security and the more computational overhead required to complete encryption/decryption operations. AES is slowly gaining momentum, but the sheer quantity of DES hardware and software currently in place, combined with the strength of 3DES, is making conversion very slow.

5.2.2 Asymmetric Algorithms

Asymmetric cryptosystems differ from their symmetric counterparts in one major aspect—each participant in the communication uses different cryptographic keys. In fact, each user has his or her own pair of keys—a **public key** and a **private key**. These key pairs are mathematically related so that any message encrypted with one of the two may only be decrypted with the corresponding key from the same pair. Users may freely distribute their public key to anyone with whom they wish to communicate, without fear that it may compromise their communications. For this reason, asymmetric algorithms are commonly referred to as "public key cryptosystems."

Imagine two users, Renee and Michael, who wish to communicate with each other using a public key cryptosystem. First, they each generate a key-pair consisting of a public and a private key. They then exchange public keys with each other. At this point they each have the following keys (where $K_{Renee,pub}$ is Renee's public key and $K_{Michael,priv}$ is Michael's private key):

- Renee has $K_{Renee,pub}$, $K_{Renee,priv}$, $K_{Michael,pub}$
- Michael has $K_{Michael,pub}$, $K_{Michael,priv}$, $K_{Renee,pub}$

When Renee wants to send a message to Michael, she simply encrypts it with Michael's public key, $K_{Michael,pub}$. Once this operation is complete, no user other than Michael (not even Renee!) can decrypt the message. This is due to the fact that decryption requires the other key from the same pair used to encrypt the message. Because Michael's public key was used to encrypt the message, his private key must be used to decrypt it. When Michael generated his keypair, he kept his private key secret and only distributed his public key. Unless Michael's private key somehow

becomes known to another user, Renee can be sure that only Michael may read her message.

Rivest, Shamir, Adelman (RSA)

One of the most well-known public key cryptosystems is the Rivest, Shamir, Adelman (RSA) algorithm developed in the late 1970s by three Massachusetts Institute of Technology computer security researchers. This algorithm relies on the fact that it is extremely difficult to factor very large prime numbers to generate secure public/private keypairs. When users wish to encrypt or decrypt a message, they perform a simple modular arithmetic operation that involves the plaintext or ciphertext message and the appropriate cryptographic key, and provides the corresponding ciphertext or plaintext message as output.

Pretty Good Privacy (PGP)

The Pretty Good Privacy (PGP) application, developed by Phil Zimmerman, offers a cross-platform cryptographic solution. Although it's not a cryptographic algorithm in and of itself, it's a well-designed implementation of several other cryptographic algorithms including the RSA public key cryptosystem.

The major benefit of PGP is that it provides an easy way to manage a decentralized public key infrastructure. It facilitates key exchange by allowing the easy import and export of public keys, and provides functionality such as automatic verification of digital signatures. PGP allows for the encryption/decryption of both text and binary files and provides for the exporting of data into ASCII format for easy exchange via electronic mail.

> **NOTE**
>
> PGP is a proprietary program available for purchase. An alternative, GnuPG, has been released under the Free Software Foundation's Open License. For more information on this package, visit *http://www.gnupg.org*. You'll use this package to complete this chapter's four Challenge Exercises.

The Web of Trust

One of the greatest problems facing cryptosystems is that of key exchange—how do you get a shared secret key or a public key from one user to another in a secure fashion? Before PGP, it was necessary to exchange public keys via trusted offline media. Users would typically visit each other and exchange floppy disks containing public keys. PGP's "web of trust" model has made this obsolete. The web of trust allows users to rely on the judgment of others that they trust in evaluating whether a public key is authentic.

When you accept a user's public key, PGP allows you to assign that user one of four trust levels. The trust level that you select determines how qualified that person is to introduce you to other individuals' public keys. The four levels of trust are as follows:

- **Implicit trust:** This level of trust is reserved for keys that you own. If your key ring contains the private key that signed a public key, you automatically trust the public key.

- **Full trust:** You completely trust this user to provide other keys to you without additional verification. This is an extremely trusting posture and should be granted with discretion.

- **Marginal trust:** You do trust the user, but will require at least one other user that you marginally trust to vouch for any new public key before you will accept it into your key ring.

- **Untrusted:** You do not trust a user to introduce you to new keys. Any signatures from that user will be disregarded. This is the default setting for new PGP keys that you accept.

The web of trust model is ideally suited for communications over a vast network such as the Internet. It does, however, require the judicious use of the trust model by all participants. Before you assign someone a level of trust, be sure that you are confident in his or her reliability and understanding of the trust model.

5.2.3 Symmetric Versus Asymmetric Cryptosystems

The choice between a symmetric cryptosystem and an asymmetric cryptosystem can be a difficult one, depending upon the circumstances. Table 5.2 provides a detailed feature comparison between the two types of cryptosystems.

In general, the choice between asymmetric and symmetric cryptosystems boils down to the number of keys that must be generated. Symmetric cryptosystems simply don't scale well to large environments and are not practical for use when more than a few users are involved. However, they can provide extremely fast alternatives when the number of users is small. Symmetric algorithms also lend themselves well to hardware implementations when speed is a priority. They are excellent for securing either end of a communications circuit (such as a site-to-site virtual private network [VPN] connection) and are commonly used in that type of cryptographic environment.

TABLE 5.2 Comparison of Symmetric and Asymmetric Cryptosystems

Symmetric Cryptosystems	Asymmetric Cryptosystems
Provide confidentiality among all participants who share the same secret key	Provide confidentiality between individual users of a cryptosystem
Provide integrity against modification by individuals who do not possess the secret key	Provide integrity against modification by anyone other than the sender of the message
Provide for authentication between two individuals when they are the only ones who possess the secret key	Provide for authentication of any individual user of the cryptosystem
Do not provide for nonrepudiation	Provide for nonrepudiation
Require shorter keys than asymmetric algorithms to achieve the same level of security	Require longer keys than symmetric algorithms to achieve the same level of security
Operate faster than asymmetric algorithms	Operate slower than symmetric algorithms
Are not easily scalable	Scale well to environments with large numbers of users
Do not facilitate the use of digital certificates	Lend themselves well to digital certificate hierarchies
Make the exchange of cryptographic keys difficult (often requiring offline exchange)	Allow for the exchange of public keys over otherwise insecure transmission media

5.3 Digital Signatures

As mentioned earlier, digital signatures are used to add integrity and non-repudiation functionality to cryptosystems. It's important to note that full implementations of digital signature algorithms (with nonrepudiation enforced) are possible only when asymmetric cryptosystems are used. It is simply not possible to enforce nonrepudiation within the scope of a symmetric cryptosystem.

5.3.1 Signature Creation

Digital signatures are created by first generating a unique message digest from the plaintext message using a special mathematical function known as a **hash function**. Hash functions are designed such that there is a one-to-one mapping between messages and message digests; that is, no two messages would generate the same hash value. If the algorithm is not properly implemented or if the message digest is not long enough for the maximum

message length, the one-to-one mapping may fail and result in a condition known as a **collision**, where two messages have the same message digest.

The defining characteristics of a hash function are the length of the message digest produced and the length of the longest message that may be safely processed by the function. The higher these numbers, the less likely a user is to encounter a security failure in the form of a collision.

Four government-approved hash functions are mentioned in FIPS 180-2, put out by NIST. Each is a variation of the Secure Hash Algorithm (SHA) and differs in the length of the digest produced:

- **SHA-1** produces a 160-bit message digest for any input of less than 2^{64} bits.

- **SHA-256** produces a 256-bit message digest for any input of less than 2^{64} bits.

- **SHA-384** produces a 384-bit message digest for any input of less than 2^{128} bits.

- **SHA-512** produces a 512-bit message digest for any input of less than 2^{128} bits.

All of these algorithms replaced the original SHA as the officially approved U.S. government standards on February 1, 2003.

Another frequently used set of hash algorithms are the Message Digest (MD) algorithms developed by Ronald Rivest. There are three commonly seen MD algorithms:

- **MD2** generates a 128-bit message digest from a message of arbitrary length. It is optimized for use on 8-bit processors.

- **MD4** generates a 128-bit message digest from a message of arbitrary length. MD4 has known vulnerabilities to collisions. Therefore, *it is not considered secure and its use should be avoided.*

- **MD5** generates a 128-bit message digest from a message of arbitrary length. It is optimized for use on 32-bit processors. MD5 checksums are commonly used to verify the integrity of files downloaded from the Internet. This protects against both accidental and intentional tampering.

Once the message digest is generated, the sender of the message encrypts the message digest using his or her private key. Because the user is the only

one with knowledge of the private key, he or she is the only one who could possibly have generated that digital signature.

5.3.2 Signature Verification

When a cryptosystem receives a digitally signed message, it can verify the signature using the following process:

1. Decrypt the message (if it contains encryption in addition to the digital signature) and extract the plaintext message and digital signature.

2. Using the same hash function used by the sender, generate a message digest for the plaintext message.

3. Decrypt the digital signature by using the sender's public key.

4. Compare the message digest obtained in step 2 with the decrypted digital signature obtained in step 3.

If the two signatures match, you can be assured that the integrity of the communication was maintained. Furthermore, you are guaranteed nonrepudiation and can prove that the message originated from the sender (or someone with access to the sender's private key).

If the two signatures do not match, any one of a number of circumstances could have occurred. Some possibilities include:

- There was a transmission error between the sender and the recipient.

- A third party altered the message while it was in transit.

- The message is a forgery.

- A user on one end of the communication improperly used the cryptographic software.

5.4 Digital Certificates

As mentioned earlier, key exchange is one of the most significant problems facing cryptosystem users. One solution to the key exchange issue is the "web of trust" model implemented by PGP that allows users to sign each other's keys and to import keys from other users with varying degrees of trust. This works well in a peer-to-peer communication model, but is not particularly well-suited to applications like secure communications between a Web server and a client.

Digital certificate technology was developed to help bridge this gap. Digital certificates are essentially copies of a user's (or system's) public key that are digitally signed by a trusted third party. Anyone receiving the key that trusts the third party may accept the public key, despite the fact that he or she has no personal relationship with the public key's owner.

5.4.1 Certification Authorities

The trusted third parties that issue digital certificates are known as **certification authorities (CAs)**. Actually, anyone can set up shop as a CA—the technology is not complicated. Indeed, many organizations set up internal CAs for use on corporate intranets and other limited-use environments. The greatest asset of a CA is the level of trust that users have in its policies and procedures. If users perceive that a particular CA issues certificates without properly verifying the identity of a user, that CA will quickly be discredited and certificates issued by it will become worthless. Two of the dominant players in the CA field today are VeriSign and Thawte.

5.4.2 Certificate Generation

When a user or a server wishes to obtain a digital certificate, they first select a CA and then follow the standard certificate creation process laid out by that CA. The process typically begins with several technical operations performed by the client and used to generate the public key that will be signed (if that has not already been accomplished). The CA then will collect a fee from the certificate owner (typically several hundred U.S. dollars) and subject the certificate owner to an identity verification process. This typically involves credit checks and business records checks, and may possibly require that the certificate requestor appear in person before a notary or other official.

When the CA is satisfied as to the certificate requestor's identity, the CA creates a digital certificate following the X.509 standard. This certificate includes the following information:

- Version of X.509
- Certificate serial number
- Algorithm used to generate the signature
- Subject name (the owner of the certificate)

- Subject public key
- Issuer name (the CA)
- Start date
- Expiration date

After assembling this information, the CA digitally signs the certificate using the CA's private key.

5.4.3 Certificate Verification

Once the certificate owner receives the certificate, it can be used to securely transmit the owner's public key to any other entity. Anyone who receives the certificate first verifies the digital signature using the CA's public key (which is freely available). If the signature is valid and the recipient trusts the CA, they may then extract the public key and use it to initiate communications with the certificate owner.

5.5 Chapter Summary

- The four fundamental goals of cryptography are confidentiality, integrity, authentication, and nonrepudiation.

- Cryptographic algorithms use cryptographic keys to encrypt plaintext messages into ciphertext messages and to decrypt ciphertext messages into plaintext messages.

- Symmetric cryptosystems use the same shared secret key for both encryption and decryption. Common symmetric algorithms include DES and AES.

- Each user of an asymmetric algorithm has two individual keys: a public key that is freely shared with other users and a private key that is kept confidential. Common asymmetric systems include RSA and PGP.

- Symmetric algorithms operate much faster than asymmetric algorithms but are not scalable to large environments. They do work extremely well for link-to-link communications.

- Digital signatures are used to enforce integrity and nonrepudiation in cryptographic systems.

■ Digital certificates allow entities to securely share their public key with individuals with whom they have no established relationship. Digital certificates are copies of the entity's public key that are digitally signed by a CA.

5.6 Key Terms

asymmetric cryptography: A cryptosystem in which each user has his or her own pair of public and private keys (also known as public key cryptography).

certification authority (CA): A centralized authority that verifies the identity of users and then digitally signs their public keys to create digital certificates.

ciphertext: A message that has been encrypted to hide its contents from the eyes of those unable to decrypt it.

collision: A condition that occurs when two messages have identical message digests computed using the same hash function.

cryptanalysis: The science of studying codes and ciphers with the intent of defeating them.

cryptography: The science of developing new codes and ciphers and analyzing their security.

decrypt: The action of transforming a ciphertext message into its plaintext equivalent using a cryptographic algorithm.

digital certificate: A user's public key that has been digitally signed by a certificate authority.

digital signature: A message digest that has been encrypted with the sender's private key to provide for integrity and nonrepudiation.

encrypt: The action of transforming a plaintext message into its ciphertext equivalent using a cryptographic algorithm.

hash function: A mathematical function used to generate a unique message digest for a given message.

message digest: A unique value derived from a plaintext message through the use of a hash function.

plaintext: A message that has not been encrypted (or that has been decrypted following an encryption operation).

private key: The half of an asymmetric keypair that is kept secret by each cryptosystem user. A user's private key is used to decrypt messages sent to him or her and to create digital signatures.

public key: The half of an asymmetric keypair that is freely distributed among cryptosystem users. A user's public key is used to encrypt messages sent to him or her and verify the authenticity of messages digitally signed by that user.

secret key: The shared key used by all users of a symmetric cryptosystem for both the encryption and decryption of messages.

symmetric cryptography: A cryptosystem in which all users use the same shared secret key (also known as secret key cryptography).

5.7 Challenge Questions

5.1 Which goal of cryptography is concerned with ensuring that the contents of a message are not revealed to third parties?

 a. Integrity

 b. Confidentiality

 c. Nonrepudiation

 d. Authentication

5.2 Which cryptographic goal may not be achieved by symmetric cryptosystems?

 a. Integrity

 b. Confidentiality

 c. Nonrepudiation

 d. Authentication

5.3 Which of the following key lengths is not available in an AES cryptosystem?

 a. 128 bits

 b. 192 bits

 c. 256 bits

 d. 512 bits

5.4 Matthew would like to send a private message to Richard using an asymmetric cryptosystem. What key should Matthew use to encrypt the message?

 a. Matthew's public key

 b. Matthew's private key

 c. Richard's public key

 d. Richard's private key

 e. Shared secret key

5.5 Richard received a message from Matthew that was encrypted using an asymmetric cryptosystem. What key should Richard use to decrypt the message?

 a. Matthew's public key

 b. Matthew's private key

 c. Richard's public key

 d. Richard's private key

 e. Shared secret key

5.6 Matthew would like to send a private message to Richard using a symmetric cryptosystem. What key should Matthew use to encrypt the message?

 a. Matthew's public key

 b. Matthew's private key

 c. Richard's public key

 d. Richard's private key

 e. Shared secret key

5.7 Richard received a message from Matthew that was encrypted using a symmetric cryptosystem. What key should Richard use to decrypt the message?

 a. Matthew's public key

 b. Matthew's private key

 c. Richard's public key

 d. Richard's private key

 e. Shared secret key

5.8 Which of the following cryptographic concepts has been widely discredited among the information security community?

 a. Confidentiality

 b. Nonrepudiation

 c. Security through obscurity

 d. Integrity

 e. Authentication

5.9 _____ cryptographic algorithms operate faster than _____ cryptographic algorithms when using the same length key.

5.10 James recently received a secret message from Martha containing an order for custom services. He would like to be able to prove that Martha sent the message and that it could not be forged. What cryptographic goal is James attempting to achieve?

 a. Confidentiality

 b. Nonrepudiation

 c. Security through obscurity

 d. Integrity

 e. Authentication

5.11 What is the effective cryptographic key length used by the Data Encryption Standard algorithm?

 a. 56 bits

 b. 112 bits

 c. 128 bits

 d. 168 bits

5.12 What is the effective cryptographic key length provided by the Triple DES (3DES) algorithm when used with two independent keys?

a. 112 bits

b. 128 bits

c. 168 bits

d. 336 bits

5.13 Assume you have developed a new cryptosystem that uses 8-bit keys. How many possible keys exist in your cryptosystem?

a. 128

b. 256

c. 512

d. 1,024

5.14 What cryptographic algorithm was designed to replace the outdated Data Encryption Standard?

a. RSA

b. IDEA

c. PGP

d. AES

5.15 Which of the following situations would be the best environment for use of a symmetric cryptosystem?

a. Corporate e-mail system

b. Site-to-site VPN

c. Certificate authority

d. Web site certificates

5.16 Which of the following hash functions is optimized for use on systems with 8-bit processors?

a. SHA-256

b. SHA-512

c. MD2

d. MD4

5.17 Which of the following hash functions contains demonstrated collision vulnerabilities and is not considered secure?

 a. SHA-256

 b. SHA-512

 c. MD2

 d. MD4

5.18 Grace would like to send a message to Joe using digital signature technology. What portion of the message should she sign in order to obtain the digital signature?

 a. The plaintext message

 b. The ciphertext message

 c. The plaintext message digest

 d. The ciphertext message digest

5.19 Grace would like to send a message to Joe using digital signature technology. What cryptographic key should she use to create the digital signature?

 a. Grace's public key

 b. Grace's private key

 c. Joe's public key

 d. Joe's private key

5.20 Joe received a digitally signed message from Grace. What cryptographic key should he use to verify the digital signature?

 a. Grace's public key

 b. Grace's private key

 c. Joe's public key

 d. Joe's private key

5.8 Challenge Exercises

Challenge Exercise 5.1

In this exercise, you download and install the GNU Privacy Guard (GnuPG) cryptographic application and create a keypair for your use. This

NOTE

GnuPG is a command-line driven program. You must use a command-line environment, such as a DOS command tool or UNIX console session, to operate the software.

application is a free substitute for the PGP application that was released under the Free Software Foundation's General Public License. It is available for a wide variety of operating systems. You need a computer with a Web browser and Internet access to complete this exercise. You must be logged on with an account capable of installing software on the local system.

5.1 Using your Web browser, visit the GnuPG home page, located at *http://www.gnupg.org*.

5.2 Locate the area of the site that allows you to download the GnuPG software and download a version appropriate for your computer.

5.3 Follow the instructions included with GnuPG to install the software on your system.

Generate a keypair by issuing the **gpg --gen-key** command while in a command-line environment and follow the instructions provided. You may select the default options for key generation or choose your own settings.

Challenge Exercise 5.2

In this exercise, you exchange GnuPG public keys with another student in your class. Before completing this exercise, you must complete Challenge Exercise 5.1 and have access to the computer with GnuPG installed on it.

5.1 If you haven't done so already, open a command-line session and navigate to the directory where the GnuPG executable is stored.

5.2 Create an ASCII-readable version of your public key by issuing the command **gpg --export -a**. You should redirect the output to a text file with your name as the file name using the command appropriate for your operating system. Normally, this will be done using the following command:

```
gpg --export -a > your_name.txt
```

The file that you export should look similar to the one shown here:

```
—BEGIN PGP PUBLIC KEY BLOCK—
Version: GnuPG v1.2.2 (MingW32)
```

> **NOTE**
>
> The **gen-key** argument to the **gpg** command is preceded by *two* hyphens. Some arguments to **gpg** use one hyphen, whereas others use two. Be extremely careful when keying in the commands in this book that you're using the correct number of hyphens.

> **TIP**
>
> Formatting is extremely important when using GnuPG. If you're experiencing problems importing your partner's key, examine the file and make sure that it is formatted exactly as in the example just shown. The number of characters may differ, but the lines should break in the same manner. The inclusion of a blank line after the "Version" line is critical, as is the formatting of the last three lines of the file.

```
mQGiBD8G+5ARBADJsrs2cmkf/facNV1bnt/1Ew+KJ9IxJsOn1IkTzqJFc7Z+q+7/
4fFmunTtNDOGAfnpPbFdBvi8r1hbQIPjbhGJOtvrAPesPdU+qOBeEAJRXj4i3JgG
mbF2HiWRFWHD1mY6kmTA9iOCB53h3vd7U+NKFD/140bEIfaWVZZPICPdjwCgkS5u
NjO+8b4MgXCFphO8qCyoYmcEAJKpsfk1J/fLwrnuvvetwSFSP/foqozs+z7MBMtb
OnkAIUwsXzNMySRdwYfSrYFXZLkh3p1OFwp4UFgNbj57H6TxBR9HrSZmIw2obJ5u
LedDKU7hQw6VN+LyOJqrSWqEgotTpm1DxM1OuIgJcgjRTJAOOwNZnyiOwXB5Nbo1
YkfaBACZHvGDjt7+orCey/fIOh/b8QEpWhABcUM+1tMBODSK4MuuiIR3uHFTTbKR
6gFn3fZXTkv3mKvTBGqL8s+U8jg5wYQOjFHIK5q6kBCYUZCNHixr4ZS+11GRyz51
GxwDyh16sMSA+Dwm1Ri7OhBM1Lr3SW6EowojKwUkOm+Qco6QI7QsTW1rZSBDaGFw
cGx1IChJbnNOcnVjdG9yKSA8bW1rZUBjaGFwcGx1Lm9yZz6IWwQTEQIAGwUCPwb7
kAYLCQgHAwIDFQIDAxYCAQIeAQIXgAAKCRAdRn4xDuazM6jeAJ9Nxtd3ZEVo5TkE
z3Lj2qjZ5OtJtwCeJdrO1KIBCiq+I8n8xW1X8HUZxr65AQOEPwb7kRAEAMHLOA+w
YuTR6EzmTHR4MIrHXrIQ5JTwGcYbsxS9og8RPSVi9Hh7BuT2NuJ6GhQ/1W1DzY1+
OjuVB9bB7j1v5FvyRZYG8aMmI4ViAiFGXMQ54/Hi31SKcX7+66xXap+Vq4J2Jstx
SN9t7fdCdPyER56CupVPsR1WoOgppmY3ay1nAAMFBACRy59ru9GNORgGthdBGSRg
Vk4JhOdOp+Azg+XfZ8OKOEv4cbnBdUOn5AFjUqNLMOVCSPqmtXgenc8BmAJntvfZ
QLBrpCjOjrB7JvxJDS1EFN64IhwX9P/KggtEn4RBeqODn8JX1YQivtJKm1Ktvobu
nJ/5EN1PXqGOcbnxW3JKDYhGBBgRAgAGBQI/BvuRAAoJEB1GfjEO5rMzwLoAn2WH
oagjJ3HHMUg92vYSbySyKP2yAJ4sZ9q7VCLA8dVcSriuAYmFSiWbJA==
=61mS
—END PGP PUBLIC KEY BLOCK—
```

5.3 Give the resulting file to the student in your class that is your partner for this exercise. You may exchange keys via electronic mail, floppy disk, network share, or any other medium available to you.

5.4 When you receive the file from your partner, import it using the command **gpg --import** *partners_name*.**txt**

Challenge Exercise 5.3

In this exercise, you encrypt and digitally sign a message using the GnuPG software and send it to another student in your class. Before completing this exercise, you must complete Challenge Exercises 5.1 and 5.2 and have access to the computer with GnuPG installed on it.

5.1 Create a text file containing a message that you wish to send to your partner for this exercise. (Note: The partner should be the same individual that you worked with during Challenge Exercise 5.2.) Save the file on your hard drive as *your_last_name*.txt.

5.2 Encrypt and digitally sign the message using the following command:

```
gpg -r recipient_address --armor --sign --encrypt your_last_name.txt.
```

Make sure that you replace *recipient_address* with the e-mail address of the intended recipient. This request uses your private

key, so you will be prompted to enter your passphrase to verify your identity prior to the encryption actually taking place.

5.3 You should now have a file on your hard drive (in the current directory) named *your_last_name*.asc. Send this file to your partner using any means available to you.

Challenge Exercise 5.4

In this exercise, you decrypt the message received from another student in Challenge Exercise 5.3 and verify the digital signature on that message. Before completing this exercise, you must complete Challenge Exercises 5.1, 5.2, and 5.3 and have access to the computer with GnuPG installed on it.

5.1 Save the message you received from your partner as mymessage.txt in the same directory as the gpg executable.

5.2 Decrypt the message using the following command:

```
gpg --decrypt mymessage.txt
```

You will be prompted to enter your passphrase, because the decryption operation requires the use of your private key.

5.3 The GnuPG package will automatically verify the digital signature on the message (provided that you have imported your partner's public key). You should see a message similar to the following at the bottom of the decrypted message:

```
gpg: Signature made 07/27/03 11:21:31 using DSA key ID 0EE6B333
gpg: Good signature from "Mike Chapple (mike@chapple.org)"
```

5.9 Challenge Scenario

Challenge Scenario 5.1

You are the principal security architect for MindVision Software, a firm with three regional offices and 28 employees located around the world. The company has an aggressive growth plan and intends to hire at least 100 new employees over the next two years. The company also has a relatively high employee turnover rate, with 25% of the employees leaving the firm each year. Your management has tasked you with the responsibility of implementing a secure messaging facility that uses cryptographic technology to

protect information while in transit. The system must allow for private e-mail communication between any two users of the cryptosystem.

You are trying to decide whether you should use a symmetric cryptosystem or an asymmetric cryptosystem. Based on your knowledge of cryptography, answer the following questions:

5.1 How many keys will each user need if you choose a symmetric cryptosystem?

5.2 How many keys will the entire system contain if you choose a symmetric cryptosystem?

5.3 How many keys will each user need if you choose an asymmetric cryptosystem?

5.4 How many keys will the entire system contain if you choose an asymmetric cryptosystem?

5.5 Which system will require less time to add a new user to the cryptosystem?

5.6 Which system will require less time to remove a user from the cryptosystem?

5.7 Which system will allow for faster encryption and decryption of messages?

5.8 Which system would you select, and why?

CHAPTER 6

Securing TCP/IP

After reading this chapter, you will be able to:

- Explain the role that the Transmission Control Protocol (TCP) and the Internet Protocol (IP) play in computer networking

- Understand how security concepts integrate into the OSI networking models

- Identify the major components of the TCP/IP protocol suite and explain how each is used in networking

- Decipher the contents of a TCP/IP packet and describe the types of modifications involved in malformed packet attacks

- Describe the enhancements provided by adding IPSec security to a network

- Identify the various security protocols used to enhance Web communications and choose the protocol appropriate for a given situation

The vast majority of computer networks, including the Internet itself, are dependent upon a set of protocols known as the TCP/IP suite. The two core components of this suite, the Transmission Control Protocol (TCP) and the Internet Protocol (IP), control the formatting and routing of data as it flows from point to point across the network. Although a large number of other network protocols are in use today (such as Novell's Internetwork Packet Exchange/Sequenced Packet Exchange [IPX/SPX] and Apple's AppleTalk), the discussion in this book is limited to these popular protocols because they are the "language of the Internet" and the source of many security vulnerabilities.

6.1 Introduction to Transmission Control Protocol/ Internet Protocol (TCP/IP)

Although the TCP/IP suite has been modified and enhanced over the years, the core set of protocols date back to the earliest days of the Internet, when it was a private network interconnecting several large U.S. government research sites. These protocols completely describe the ways that devices communicate on TCP/IP networks, ranging all the way from the way individual chunks of data (known as **packets**) are formatted to the details of how those packets are routed through various networks to their final destinations.

In this section, we introduce the basic concepts behind the TCP/IP suite. You'll first learn about the four protocols that form the basic building blocks of TCP/IP. Next, you'll learn about how the Open Systems Interconnection (OSI) reference model governs the design of TCP/IP and other networking protocols. Finally, you'll learn how to examine the "guts" of a packet and actually interpret those electrical impulses as they transit a network.

6.1.1 TCP/IP Protocols

Four main protocols form the core of TCP/IP: the Internet Protocol (IP), the Transmission Control Protocol (TCP), the User Datagram Protocol (UDP), and the Internet Control Message Protocol (ICMP). These protocols are essential components that must be supported by every device that communicates on a TCP/IP network. Each serves a distinct purpose and is worthy of further discussion.

Internet Protocol

The **Internet Protocol (IP)** is a network protocol that provides essential routing functions for all packets transiting a TCP/IP network. By this point in your computer science education, you're probably familiar with the concept of how IP addresses uniquely identify network destinations. Each system connected to the Internet and available for public use is assigned an IP address that allows other systems to locate it on the global network. (There are some exceptions that you'll learn about later in this book. Sometimes multiple systems share a single IP address for security and/or efficiency reasons using a service known as Network Address Translation [NAT].)

The Internet Protocol provides networking devices (workstations, servers, routers, switches, and so on) with guidance on how to handle incoming packets. Each IP datagram bears a source IP address that identifies the sender and a destination IP address that identifies the recipient. When a device receives an IP datagram, it first checks to see whether the destination IP address is an IP address assigned to the local machine. If it is, it processes the datagram locally. If not, it determines the proper place to forward the packet (the "next hop") to help it along toward its ultimate destination. IP is responsible for ensuring that systems can identify the next hop in an efficient manner so that all network traffic eventually reaches its ultimate destination.

It's important to note that the IP protocol itself does not provide any reliability guarantees; that is, IP provides no assurance to users that a packet will reach its ultimate destination. This is the responsibility of other protocols within the TCP/IP suite.

Besides addressing, the other main responsibility of IP is datagram **fragmentation**. As a datagram travels from source to destination, it may pass through several intermediate networks with varying topologies. Each of those networks may specify a different maximum datagram size. Because the originating machine has no way of telling what networks a datagram will pass through, let alone the maximum datagram size on those networks, IP must accommodate those limits in a method transparent to the end users. This is where fragmentation comes into play. If a datagram reaching a network exceeds the maximum length permissible for that network, IP breaks the datagram up into two or more fragments, each of which complies with the maximum length for that network. Each fragment is labeled

> **NOTE**
>
> Throughout this section, you'll see individual units of data referred to as either IP datagrams or TCP packets. Many people use these terms interchangeably, but that is not technically correct. IP and UDP work with datagrams, whereas TCP processes packets (sometimes referred to as segments).

> **NOTE**
>
> The material on IP routing presented in this book is intended to be a brief refresher only. We have assumed that students have a familiarity with basic networking, routing, addressing, and network devices. If this is not the case, please take the time to review this material in a networking text.

Figure 6.1
Original datagram

Length=425, Offset=0

Length=425, Offset=0

Figure 6.2
Fragmented datagram

Len=100 Offset=0	Len=100 Offset=100	Len=100 Offset=200	Len=100 Offset=300	Len=25 Off=400

with a length and an offset (both specified in bytes). The length simply specifies the total number of bytes in the fragment. The offset specifies the location of the first byte of the fragment in the original datagram. Therefore, the first fragment always has an offset of 0.

When a host wishes to reassemble a fragmented datagram, it merely puts all the pieces together using the length and offset information. This process is best understood through the use of an example. Imagine a network where the maximum datagram length is 100 bytes. Assume that the network receives an inbound datagram that is 425 bytes in length, as shown in Figure 6.1.

> **TIP**
>
> A thorough understanding of IP fragmentation is essential to understanding several networking vulnerabilities presented later in this chapter. Take the time to ensure that you comprehend this material.

It would be impossible for that network to carry the original datagram, so IP breaks it up into five fragments, as shown in Figure 6.2.

Take a moment to ensure that you understand how IP derived the length and offset of each fragment. The first four fragments each contains 100 bytes of data, so they all have a length of 100. The final fragment contains the remaining 25 bytes of data, so it has a length of 25. The first fragment always has an offset of 0 and, therefore, occupies bytes 0–99 of the original datagram. The second fragment then occupies bytes 100–199, so it has an offset of 100, indicating that the first byte of the second fragment should be placed in the 100th byte of the reassembled datagram. The third, fourth, and fifth datagrams similarly receive offsets of 200, 300, and 400, respectively.

Transmission Control Protocol

The **Transmission Control Protocol (TCP)** provides networks with a reliable mechanism for process-to-process communication. TCP "rides" on top of the Internet Protocol. After a TCP packet is constructed, it is transformed into an IP datagram by adding appropriate addressing and fragmentation information. This process, known as **encapsulation**, is discussed later in this chapter. There are three critical features of TCP:

- TCP is a *reliable* protocol that guarantees delivery of individual packets from the source to the destination. This is accomplished through the use of an acknowledgement system where the receiving system informs the sender that it has received the packet successfully. TCP's reliability is sometimes compared to the reliability of sending a "return receipt requested" letter through the mail. The sender receives a confirmation notice when the recipient receives the original message.

- TCP provides *error-checking*. Each packet contains a checksum that the recipient uses to ensure that the data was not corrupted while in transit. If the checksum does not match the data, the receiver asks the sender to retransmit the packet. From a security perspective, it's important to note that TCP's error-checking functionality does not provide any security against malicious tampering; it merely ensures that the data was not corrupted accidentally while in transit.

- TCP is *connection-oriented*. It uses a session establishment and teardown algorithm that creates dedicated channels of communication between two processes.

Each TCP connection begins with the use of a three-way handshaking process that establishes a two-way communications channel between two processes. This handshaking process, shown in Figure 6.3, takes advantage of two binary fields—the SYN and ACK flags. When a process on one machine wishes to establish a connection with a process on another machine, it sends a single packet with the SYN flag set to signify a connection request. If the destination host wishes to establish the communication, it acknowledges the opening of a communications channel from the source to the destination by replying with a packet that has the ACK flag set. It uses this same packet to set up a communications channel from the original

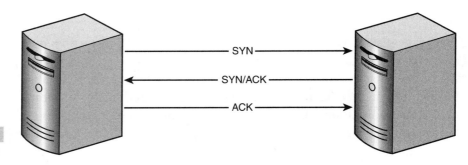

Figure 6.3
Three-way TCP handshake

source to the original destination by setting the SYN flag of that packet. When the original source receives the "SYN-ACK" packet, the first channel of communication is open. It then sends a third packet with the ACK flag set to complete the handshaking process by acknowledging the opening of the second channel of communications.

Throughout our discussion of TCP, we've referred to the fact that it is used to establish connections between *processes* on two systems. TCP allows the unique addressing of a process (such as a Web server or a mail transfer program) through the use of **ports**. Each port uniquely identifies a particular process on a system and, when combined with an IP address, uniquely identifies the combination of a system and process often referred to as a **socket**.

User Datagram Protocol

The **User Datagram Protocol (UDP)** is a companion to TCP. Like its counterpart, it is a transport protocol that rides on top of the Internet Protocol. Unlike TCP, UDP is a connectionless protocol that does not provide the reliability of guaranteed datagram delivery. It merely makes a best effort to deliver a packet from one process to another. It is up to higher level software to provide reliability, if desired.

The major advantage to UDP is the extremely low overhead involved in connectionless communications. UDP datagrams may be sent freely between hosts without the lengthy three-way handshaking process required by TCP. Additionally, UDP does not need to keep track of the sequencing and acknowledgement information that TCP uses to provide reliable packet delivery. UDP is often used for applications such as streaming media that do not depend on the guaranteed delivery of every packet. You may recall from our discussion of TCP that we compared TCP's reliability to sending a return receipt requested letter. UDP is analogous to putting on a first-class stamp, dropping the letter in a mailbox, and hoping for the best.

> **NOTE**
>
> It's important to note that although many ports are commonly associated with specific protocols (for example, Web servers ordinarily run on port 80 whereas SMTP servers run on port 25), these are not *required* associations. You can configure a Web server to run on port 8080, 800, 25 or any other port. Malicious individuals sometimes take advantage of this fact to hide the true nature of network traffic.

REQUEST FOR COMMENTS

The open nature of the Internet requires that every participant follow the same sets of standards when communicating with other hosts. If this were not the case, communicating systems would have no way of deciphering the bits and bytes sent and received across the network wire. Hardware and software developers, therefore, follow a common set of standards when creating systems that communicate using TCP/IP. These standards are written up in documents known as Requests for Comments (RFCs) and are published by the Internet Engineering Task Force (IETF).

These documents are full of detailed technical specifications, but are often written in a surprisingly clear manner. If you ever find yourself attempting to analyze packets at the bit level and become confused, you may wish to utilize one or more of these documents. You can find them at a large number of sites on the Internet, including the central IETF repository located at *http://www.ietf.org/rfc.html*. Each RFC document pertains to a specific protocol or application, and has a unique number for easy identification. For your quick reference, some commonly used RFCs include:

- **RFC 768:** User Datagram Protocol
- **RFC 791:** Internet Protocol
- **RFC 792:** Internet Control Message Protocol
- **RFC 793:** Transmission Control Protocol
- **RFC 2821:** Simple Mail Transfer Protocol

Internet Control Message Protocol

The final protocol we will examine, the **Internet Control Message Protocol (ICMP)** is the administrative workhorse of the TCP/IP suite. It is responsible for transmitting control messages between networked devices. Unlike TCP and UDP, ICMP does not use IP *per se* to provide datagram delivery; however, it does incorporate basic portions of the IP header so that it can use the same routing infrastructure as IP. Figure 6.4 illustrates the relationships among TCP, IP, UDP, and ICMP.

ICMP is used to deliver many different types of administrative control messages. Some examples are:

- Network/host/port unreachable
- Packet time to live expired

Figure 6.4
Relationships among protocols in the TCP/IP suite

- Source quench (used when a gateway is overloaded and wishes to pause incoming traffic)

- Redirect messages (used to reroute traffic)

- Echo request and echo reply messages (used to determine whether a host is active on the network; these messages are used by the **ping** command)

6.1.2 Open Systems Interconnection Model

The Open Systems Interconnection (OSI) reference model, shown in Figure 6.5, was developed by the International Organization for Standardization in the late 1970s in an effort to describe the basic functionality of networked data communications. The model consists of seven layers: Application layer, Presentation layer, Session layer, Transport layer, Network layer, Data Link layer, and Physical layer.

Application
Presentation
Session
Transport
Network
Data Link
Physical

Figure 6.5
OSI model

Figure 6.6
Encapsulation using the OSI model

The OSI model uses a process known as encapsulation to sequentially process data through the various model layers until it is ready for transmission across a network medium (e.g., a copper wire or fiber-optic cable). Each layer of the OSI model performs some transformation of the data, either by adding a header that encapsulates the data received from the previous layer or by converting the data into another form (such as from binary data into electrical impulses). When the remote device receives the packet, it also processes it through the layers of the OSI model, but in reverse order. At the conclusion of the process, the destination machine has the same data that was sent by the originating machine. The process of encapsulation is illustrated in Figure 6.6.

The beauty of the OSI model lies in the ability of system developers to take advantage of abstraction. A programmer writing software that works at the Application layer doesn't need to worry about the details of how the lower layers work. If the software communicates with other systems, the programmer may simply view it as communication between the systems at the Application layer. The encapsulation process ensures that the networking protocols take care of the other details. The OSI model is a fundamental principle of networking, and many texts devote entire chapters to fully exploring the model. Keeping with the focus of this text, we'll briefly describe each layer and provide information on its relevance to information security practitioners.

Application Layer

The Application layer is the highest layer encountered in the OSI model. It consists of the software that directly interacts with computer users and provides the standards that govern how those users manipulate the system. The Application layer is home to innumerable applications, including electronic mail software, Web browsers, office productivity suites, financial tools, and other packages.

The vast majority of security vulnerabilities inherent in computing systems occur at the Application layer of the OSI model. This layer includes almost all malicious code objects, such as viruses, worms, and Trojan horses. The exploits that take place at the Application layer are discussed in detail in Chapter 7.

Presentation Layer

The Presentation layer is responsible for taking data from the lower layers and converting it into a format usable by the Application layer. This layer is responsible for taking the formats (both proprietary and standardized) used by various applications and allowing the data within those applications to be shared. Common standards found at the Presentation layer include the ASCII, ANSI, and EBCDIC character sets.

The most important activity that takes place at the Presentation layer from a security perspective is encryption. This layer is responsible for making encryption and decryption of data transmitted over the network transparent to the end user. It handles these mathematical processes to ensure that the end user receives a secure and efficient computing experience.

Session Layer

The Session layer is responsible for the creation, teardown, and maintenance of network connections between processes that are used with connection-oriented protocols such as TCP. It is the location of the three-way handshaking process that takes place to establish TCP communications between two hosts.

A common exploit malicious individuals use to take advantage of security vulnerabilities at this layer is session hijacking. With most unencrypted application traffic, authentication takes place at the beginning of a communications sequence. Consider the case of a typical Telnet session—you ini-

tiate communications with a remote host and provide a username and password to prove your identity to the remote system. Once you've completed that process, you are never again required to authenticate yourself. A malicious individual may try to use a session hijacking attack to "take over" your session by disabling your computer in the midst of the communication and responding to the other system as if it were you.

Transport Layer

The Transport layer is responsible for managing the flow of data between two systems. It includes error recovery functionality, message acknowledgments, and flow control mechanisms. Two of the most common transport protocols that operate at this layer are TCP and UDP.

A large number of vulnerabilities are present at this layer of the OSI model. One attack found at the Transport layer is the SYN Flood attack, which takes advantage of weaknesses in the way some operating systems handle TCP's three-way handshaking process. This attack is described in further detail in the next chapter.

Other Transport-layer attacks exploit buffer overflow vulnerabilities in various components of the TCP/IP stack. Buffer overflows are the result of poor programming practices that allow a cleverly crafted series of actions to cause the overfilling of a memory space reserved for a certain task. The results of a buffer overflow range from the annoying (the system restarts) to the severe (the perpetrator of the attack gains complete administrative control of the targeted system).

Network Layer

In the TCP the Network layer IP model, consists of the Internet Protocol. This layer is responsible for ensuring that datagrams are properly routed across the network from their source to their ultimate destination. The mapping of physical to logical addresses and fragmentation of datagrams take place at this layer of the OSI model.

Several classes of attacks exploit weaknesses in the Network layer. Fragmentation attacks are one such class. Recall from earlier in the chapter that IP is capable of taking datagrams that are too large for a particular network and dividing them up into smaller fragments suitable for transmission. Malicious individuals can wreak havoc on unprepared systems by cleverly manipulating datagram fragments so that one of two conditions occurs:

Figure 6.7
Overlapping fragment attack

- **Two fragments overlap:** This takes place when the offset field for one fragment contains a value that places it within the space occupied by the previous fragment. An example of an overlapping fragment attack is shown in Figure 6.7.

- **Two adjacent fragments do not meet:** This occurs when one fragment contains an offset that causes a gap between it and the immediately preceding fragment. An example is shown in Figure 6.8.

Both of these attacks have been around for quite some time and are well known to security administrators and operating system developers. Most modern implementations of the TCP/IP stack are immune to these vulnerabilities, but many computers on the Internet running older operating systems may still be vulnerable, if appropriate security patches have not been applied.

Data Link Layer

The Data Link layer is responsible for the conversion between upper layer datagrams and the digital language of bits—the 1s and 0s capable of transmission across a computer network. The two sublayers of the Data Link layer—the Logical Link Control (LLC) sublayer and the Media Access Control (MAC) sublayer—each have distinct functions. The LLC sublayer is responsible for three functions:

- Error correction

Len=100 Offset=0		Len=100 Offset=150	Len=100 Offset=250

Figure 6.8

Nonadjacent fragment attack

- Flow control

- Frame synchronization

Most network administrators are more familiar with the MAC sublayer because it shares a name with the physical addressing scheme used by computer networks—the MAC addressing scheme. These low-level addresses are completely independent of the upper layers. In fact, they are actually assigned to each networking device at the factory and are normally never changed during the device's lifetime. The 48-bit (12-byte) address has two components: the first six hexadecimal characters identify the manufacturer of the networking device and are selected by the manufacturer from a range assigned to it by the Institute of Electrical and Electronics Engineers (IEEE). The last six hexadecimal characters uniquely identify the device and are normally assigned in a sequential manner by the manufacturer. Under normal circumstances, each MAC address should be globally unique; that is, no two devices anywhere in the world should share the same MAC address. Of course, this is dependent upon the ability of each manufacturer to correctly manage its assigned address space. Consider the MAC address 00:00:0C:45:12:A6. The first six characters (00:00:0C) identify the manufacturer (in this case, Cisco Systems) whereas the last six characters (45:12:A6) uniquely identify the device.

> **TIP**
>
> For a complete listing of IEEE-assigned manufacturer IDs, visit *http://standards.ieee.org/regauth/oui/oui.txt.*

During the conversion between the Network layer and the Data Link layer, networking devices make use of the Address Resolution Protocol (ARP). This protocol provides the capability of determining a remote device's physical address by polling a network using its IP address. A similar protocol, the Reverse Address Resolution Protocol (RARP), handles conversions between MAC addresses and IP addresses when necessary. Every time a packet reaches a new intermediate device, that device determines the appropriate "next hop" address using ARP or an internal MAC address cache, and changes the destination MAC address of the packet accordingly.

Physical Layer

The lowest layer of the OSI model is the Physical layer. This layer converts the Data Link layer's data bits into the actual impulses that are transmitted over the physical network. The type of impulse is dependent upon the type of media used on the network. For example, in a network that uses twisted-pair or coaxial cabling with copper conductors, the Physical layer will convert bits

into electrical impulses. On the other hand, the same bits will be converted into pulses of light on network segments utilizing fiber-optic cabling.

The Physical layer is subject to a new class of threats that does not affect the other layers: physical threats. If a hacker has access to a physical component of a computer network, such as a computer attached to that network or the cables themselves, he or she may be able to use a hardware or software packet sniffer to monitor traffic on that network. These devices simply monitor the network wire and capture the bits that pass, allowing the user to monitor all traffic on the network. If these packets are unencrypted, the hacker essentially has full access to view (and possibly modify) all network traffic, effectively invalidating most of the security controls put in place by administrators.

6.2 Anatomy of a Packet

In the last section, you learned how hackers might use a packet sniffer to monitor traffic on a computer network. These devices are also useful to administrators seeking to hunt down the source of malicious activity or troubleshoot networking issues. They allow the user to see details of each packet that are not normally displayed by a typical computer system.

> **TIP**
>
> Several free packet-sniffing utilities are available on the Internet. Consider evaluating programs such as tcpdump (for UNIX) or windump (for Windows). You can locate downloadable versions of these packages through an Internet search. More sophisticated packet sniffers (including hardware sniffers) are available from a number of commercial sources.

To effectively use these tools, it's important that you understand the components of a packet and their formatting and structure. Each packet has two main components: a payload and a header. The packet payload is the "meat" of the packet—it's the actual data that one system wishes to transmit to another. The header is all of the protocol and routing information necessary to facilitate the transmission of the packet over the network. As a packet travels down the OSI model during the encapsulation process, each layer adds information to the front of the packet header. As the packet traverses the network, each device processes as much of the packet header as is necessary to carry out its function. For example, a switch may need only to read and modify the Physical and Data Link layer headers to modify a packet's destination MAC address, whereas a router reaches down to the Network layer to read the IP address of the packet's final destination.

When you use a packet sniffer to analyze packets, you have the option of displaying the data in a number of different forms. The sniffer should be capable of displaying the actual binary (0/1) bits of the packet or converting it into a number of other forms, including hexadecimal, ASCII, and

0		1		2		3	

```
 0 1 2 3 4 5 6 7 8 9 0 1 2 3 4 5 6 7 8 9 0 1 2 3 4 5 6 7 8 9 0 1
```

Version	IHL	Type of Service		Total Length	
Identification			Flags	Fragment Offset	
Time to Live		Protocol		Header Checksum	
Source Address					
Destination Address					
Options				Padding	

Figure 6.9
IP header (source: RFC 791)

ANSI. You should use whatever method you find provides the easiest results for you to interpret.

6.2.1 Packet Header

As mentioned in the previous section, packet headers are built sequentially, with additional information added at each layer of the encapsulation process. Let's take some time to look at the header information added by three common protocols: IP, TCP, and UDP.

IP Header

The IP header, shown in Figure 6.9, contains all of the information needed by the Internet Protocol to carry out its routing functions. Figure 6.9 is taken directly from the IP specification found in RFC 791. Examine the header carefully and familiarize yourself with its contents. If you're unclear about any of the specific fields, you may wish to consult RFC 791 for further details. You should have at least a basic familiarity with the following:

- The *Total Length* and *Offset* fields are important in datagram fragmentation and reassembly.

- The *Protocol* field identifies the higher-level transport protocol being used by the datagram. Values commonly found here include 1 for ICMP, 6 for TCP, and 11 for UDP.

- The *Source Address* and *Destination Address* contain the IP addresses of the communicating hosts.

> **NOTE**
>
> Many students find analysis of packet headers a tedious and confusing process. Although it is clearly not the most exciting part of the information security profession, it is extremely important. A large number of security exploits (such as fragmentation attacks) are difficult, if not impossible, to detect through analysis at higher levels of processing and may only be identified through the use of packet analysis.

Figure 6.10

TCP header (source: RFC 793)

TCP Header

If the IP header information identifies the packet as a TCP packet, you may further dissect it by analyzing the TCP header. The header format, as specified by RFC 793, is shown in Figure 6.10.

You'll notice that all of the fields contained within the TCP header are directly related to the services provided by TCP. You won't find IP addresses or lower-level routing information here; those are handled by IP. You will find fields that assist with the error correction, sequencing, and connection creation/maintenance/tear-down process. Some important details you may wish to take note of include:

- The *Source Port* and *Destination Port* are used to uniquely identify the processes that are communicating with each other. Some values commonly found here are shown in Table 6.1.

- The *Sequence Number* and *Acknowledgement Number* are used by TCP to place packets in the proper order and ensure that they reach their final destination.

- The *SYN* and *ACK* flags are used in the three-way handshaking process described earlier in this chapter that is used to create a connection.

- The *RST* and *FIN* flags are used in a similar three-way handshaking process that tears down a connection. (The host wishing to close

TABLE 6.1 Well-Known Ports

Well-Known Port	Service
20/21	FTP
23	Telnet
25	SMTP
53	DNS
80	HTTP
110	POP
443	SSL

the connection sends a single RST packet to request closure of one side of the communication. The second host sends a packet with both the FIN and RST flags set that completes the first RST request and initiates the second. The initiating host then sends a FIN packet to complete the connection closure.)

- The *checksum* is used to ensure that the data received by the destination host is identical to the data that was sent by the sender. Note that this field provides error correction, not security. If an intermediate party intercepts an unencrypted TCP packet, he or she can alter both the packet payload and the checksum and defeat the error correction process.

UDP Header

As you would expect, the UDP protocol also adds header information to a packet when it is the transport protocol of choice. UDP is a connectionless protocol that provides fewer services than TCP, so the header is somewhat shorter (it only contains four fields). Figure 6.11 contains the UDP header specification found in RFC 768.

The fields of the UDP header are as follows:

- The *Source Port* and *Destination Port* are used to identify the communicating processes.

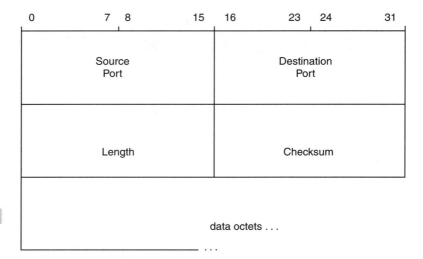

Figure 6.11
UDP header (source: RFC 768)

- The *Length* field contains the number of bytes in the datagram (including both the data payload and the datagram header).

- The *Checksum* field is used for error correction in the same manner as the TCP checksum.

6.2.2 Packet Payload

It's easy to get wrapped up in header analysis and forget the purpose of a packet: to carry data from one point on a network to another. The payload of the packet usually comprises the great majority of the data within the packet and contains the actual data that is being exchanged as part of the communication between the two systems. The packet payload can contain any type of data that can be expressed in binary form. Once you've analyzed a large number of packets, you may begin to notice telltale signs of packet payloads common on your network. For example, you may start to recognize the binary string that precedes a file formatted using an image type commonly found on your network.

6.3 Internet Protocol Security (IPSec)

As you no doubt have realized by this point in the chapter, TCP/IP is fraught with insecurities. This is inherent in its nature. Keep in mind that

the TCP/IP suite was designed to operate on a government network with a relatively small number of hosts who completely trusted each other. Security was simply not a concern to the designers of the Internet. Now that the network has expanded to global use and large numbers of people around the world are connected, security is paramount.

Security developers have engineered a number of solutions designed to add security to this inherently insecure infrastructure. One of the major developments of the past decade is the launch of **IPSec**, a security-enhanced version of the Internet Protocol. IPSec is designed to add several different layers of security to the communications process and work in a manner that is transparent to the end user. Support is optional in systems that implement IPv4, but IPSec support is required for systems that implement IPv6.

6.3.1 Protocols

IPSec makes use of three major protocols to provide security services to communicating systems:

- All IPSec communication is based on the establishment of security associations (SAs) between communicating systems. These SAs contain the identification and keying material used to create the secure session. The **Internet Security Association and Key Management Protocol (ISAKMP)** is responsible for the creation and maintenance of SAs in an IPSec environment.

- The **Authentication Header (AH)** adds information to the header of a packet to provide two critical cryptographic functions: integrity and authentication. When AH is used in an IPSec environment, systems making use of this service to communicate with each other can be assured that the communications they receive were actually sent by the purported sender and were not altered while in transit. It is important to note that the use of AH alone does *not* provide any confidentiality services.

- The **Encapsulating Security Payload (ESP)** adds guarantees of confidentiality. Like AH, it provides integrity and authentication, but it also adds data encryption to ensure that the contents of packets are kept safe from eavesdroppers. As you'll learn in the next

> **NOTE**
>
> There is a fourth protocol, the IP Payload Compression (IPcomp) protocol, which increases IPSec performance through the use of compression technology.

section, the degree of confidentiality provided by ESP depends on the mode in which IPSec is run.

6.3.2 Encryption Modes

IPSec's ESP supports two different modes of operation. Each mode provides different services, and its confidentiality guarantee covers different subsets of packet data. Each mode is suitable for different networking circumstances.

- **Transport mode** is used mainly for host-to-host communication over a network that may or may not support IPSec. When run in this mode, ESP provides confidentiality for the data contained within the payload. However, the packet header data must remain unencrypted so that intermediate hosts not participating in the IPSec security association can properly forward it. If the data were encrypted, intermediate hosts would not be able to read the addressing information and would be unable to determine the appropriate action to take with the packet.

- **Tunnel mode** creates virtual circuits between two networking devices and encrypts all of the data passed between them. Because virtual circuits are used, ESP in tunnel mode can also encrypt the packet header. This added security prevents traffic analysis attacks, where a malicious individual monitors a network and, despite the fact that he or she cannot read the encrypted packet payloads, may glean useful information simply from determining which hosts are communicating with each other and the frequency at which they communicate. Tunnel mode is often found in gateway-to-gateway communications, such as two firewalls communicating with each other. When packets reach the destination gateway, they are decrypted and processed appropriately.

6.4 Web Security

The World Wide Web comprises a large portion of the traffic on today's Internet, second only to electronic mail. In Chapter 5, you learned how security may be added to email communications through the use of cryp-

tographic technologies. In this section, we examine two common technologies used to add security to Web communications: SSL and HTTP-S.

6.4.1 Secure Sockets Layer (SSL)

Netscape developed the **Secure Sockets Layer (SSL)** to provide confidentiality, integrity, and authentication to any Application-layer protocol that supports SSL. However, its use is mainly seen in the securing of communications between Web browser clients and Web servers. When used in this scenario, it is known as HTTP over SSL, and is abbreviated as "https." This is how the common secure Web site prefix https:// is derived. SSL is evolving into the new Transport Layer Security (TLS) standard. More information on TLS is available in RFC 2246 (online at *http://www.ietf.org/rfc/rfc2246.txt*).

SSL works by facilitating the exchange of digital certificates between systems. A required element of SSL is that the server must send a digital certificate to the client to provide a public key and verify its identity. After the client is satisfied as to the authenticity of the certificate (through an automated process conducted by the browser software), the two hosts may begin communicating using encrypted communications. Optionally, SSL allows the client to provide a digital certificate to the user in order to prove the client's identity. However, this optional component of SSL is rarely used, because very few individuals have their own SSL certificates.

6.4.2 Secure-HTTP (HTTP-S)

Secure-HTTP (HTTP-S) offers an alternative to SSL for those seeking to secure Web connections. Like SSL, HTTP-S provides confidentiality, integrity, and authentication services. However, there are several key differences:

- SSL is a connection-oriented protocol (designed to support sessions), whereas HTTP-S is a connectionless protocol (designed to facilitate the transmission of individual messages).

- SSL is embedded in most popular Web browsers, whereas HTTP-S is found only in a few less common browsers.

- SSL functions between the Session and Transport layers, whereas HTTP-S functions at the Application layer.

> **WARNING**
>
> The terminology used to describe secure Web protocols is confusing. The Secure Sockets Layer (SSL) is often referred to as HTTP over SSL and abbreviated "https." The Secure-HTTP protocol, on the other hand, is often abbreviated "HTTP-S." Be sure you understand the difference!

6.5 Chapter Summary

- The Internet Protocol is responsible for providing essential routing functions for all traffic on a TCP/IP network.

- The Transmission Control Protocol and User Datagram Protocol are the most commonly used transport protocols on TCP/IP networks. TCP provides connection-oriented communication, whereas UDP provides connectionless communications.

- TCP connections are initiated and terminated with a three-way handshaking process.

- The Internet Control Message Protocol provides administrative services to TCP/IP networks.

- The seven-layer OSI model provides a general framework for the transmission of data across a network. The layers (from highest to lowest) are Application, Presentation, Session, Transport, Network, Data Link, and Physical.

- Packets consist of a header and a payload. The header is created as a result of the encapsulation process and contains specific information for each protocol used in the communication. The payload contains the actual data being transmitted between hosts.

- IPSec provides security enhancements for the TCP/IP suite. The major IPSec protocols are the Authentication Header, Encapsulating Security Payload, and Internet Security Association and Key Management Protocol.

- AH provides only integrity and authentication; ESP provides confidentiality, integrity, and authentication.

- IPSec may be run in tunnel mode (mainly for gateway-to-gateway connections) or in transport mode (mainly for host-to-host communications).

- The SSL protocol provides connection-oriented secure Web communications; the Secure-HTTP protocol provides connectionless secure Web communications.

6.6 Key Terms

Authentication Header (AH): An IPSec protocol designed to provide only integrity and authentication for packets transiting a network.

Encapsulating Security Payload (ESP): An IPSec protocol designed to provide confidentiality, integrity, and authentication for packets transiting a network.

encapsulation: The process used by layers of the OSI model to add layer-specific data to a packet header.

fragmentation: The process used by the Internet Protocol to divide packets into manageable fragments for transmission across varying networks.

Internet Control Message Protocol (ICMP): An administrative protocol used to transmit control messages between hosts.

Internet Protocol (IP): A Network-layer protocol used to route network traffic across the Internet and internal networks.

Internet Protocol Security (IPSec): A suite of security enhancements used to provide confidentiality, integrity, and/or authentication to the TCP/IP suite.

Internet Security Association and Key Management Protocol (ISAKMP): An IPSec protocol responsible for the creation and maintenance of security associations.

packet: A basic unit of data carried across a network by the TCP protocol.

port: An integer value that uniquely identifies a process running on a system and is used to establish interprocess communications.

Secure HTTP (HTTP-S): A secure Web communications protocol used to establish connectionless communications.

Secure Sockets Layer (SSL): A secure Web communications protocol used to establish connection-oriented communications.

socket: A combination of an IP address and a port used to uniquely identify process/system pairings.

Transmission Control Protocol (TCP): A Transport-layer protocol that runs on top of IP to provide connection-oriented communications.

transport mode: An IPSec mode that encrypts only the packet payload, facilitating host-to-host transmission over a non-IPSec network.

tunnel mode: An IPSec mode that encrypts entire packets for link-to-link communications security.

User Datagram Protocol (UDP): A Transport-layer protocol that runs on top of IP to provide connectionless communications with low overhead.

6.7 Challenge Questions

6.1 Which organization is responsible for maintaining the Request for Comments (RFC) documents that define Internet protocol standards?

a. DOD

b. IANA

c. InterNIC

d. IETF

6.2 What protocol is responsible for fragmenting datagrams that exceed the maximum length permissible on a network?

a. TCP

b. UDP

c. ICMP

d. IP

6.3 Network X receives a datagram consisting of 3,429 bytes of data. The maximum datagram length for Network X is 1,024 bytes. What will be the offset value of the last fragment?

a. 0

b. 1023

c. 1024

d. 3095

e. 3096

6.4 How many packets are used in the typical handshaking process that establishes a TCP connection?

a. 1

b. 2

c. 3

d. 4

6.5 Which two flags are used in the three-way handshaking process that establishes a TCP connection?

a. SYN

b. RST

c. FIN

d. ACK

6.6 Which one of the following terms is not normally used to describe the Transmission Control Protocol (TCP)?

a. Reliable

b. Connectionless

c. Error-checking

d. Guaranteed delivery

6.7 Which protocol is utilized by the **ping** command to determine whether a host is active on a network?

a. UDP

b. ICMP

c. FTP

d. IP

6.8 What layer of the OSI model includes the encryption and decryption of data transmitted over the network?

a. Application

b. Presentation

c. Transport

d. Data Link

6.9 What type of malicious activity involves carefully constructing a series of actions to interfere with the way memory is allocated in a system?

a. SYN flood

b. Session hijacking

c. Buffer overflow

d. Spoofing

6.10 Which layer of the OSI model may contain vulnerabilities that make a system susceptible to fragmentation attacks?

a. Session

b. Transport

c. Network

d. Data Link

6.11 If two computers are configured identically and attached to networks that differ only in the fact that one network utilizes twisted-pair cabling and the other uses fiber-optic cabling, which layer(s) of the OSI model are different between the two systems? (Choose all that apply.)

a. Network

b. Physical

c. Data Link

d. Transport

6.12 When moving a computer from one network to another, which of the following characteristics may change? (Choose all that apply.)

a. Computer name

b. IP address

c. Physical location

d. MAC address

6.13 Jim suspects that a fragmentation attack may be taking place on his network and wishes to conduct packet analysis to diagnose the

problem. What specific headers will provide him with information useful in detecting a fragmentation attack? (Choose all that apply.)

a. Fragment number

b. Total length

c. Offset

d. Type of service

6.14 Which two flags are used in the three-way handshaking process used to terminate a TCP connection?

a. SYN

b. RST

c. FIN

d. ACK

6.15 What IPSec protocol is responsible for the creation and maintenance of security associations between communicating devices?

a. ESP

b. IPcomp

c. AH

d. ISAKMP

6.16 Beth is considering implementing IPSec on her network. Her primary concern is to protect the contents of packets on the network from prying eyes. Which one of the following IPSec protocols is directly responsible for providing this type of service?

a. ESP

b. IPcomp

c. AH

d. ISAKMP

6.17 IPSec's ESP protocol may be run in two different modes. _____ mode is commonly used for host-to-host

communication across a network that may not necessarily support IPSec, whereas _____ mode is used for gateway-to-gateway communications, such as between two firewalls.

6.18 Richard suspects that a denial of service attack is taking place on his network that utilizes a large amount of SSL communications. He wishes to monitor network activity using a packet sniffer to determine whether this traffic is present on his network. What destination port should he look for in the packet sniffer output to confirm the presence of this traffic?

a. 80

b. 110

c. 443

d. 8088

6.19 Which one of the following Web security solutions is supported by most popular Web browsers?

a. SSL

b. SET

c. S-HTTP

d. SAM

6.20 Which one of the following Web security solutions is designed to function in a connectionless manner?

a. SSL

b. SET

c. S-HTTP

d. SAM

6.8 Challenge Exercises

Challenge Exercise 6.1

In this exercise, you use network sniffing software to capture and analyze packets on a real computer network. You need a computer running packet sniffing software (such as Ethereal or WildPackets EtherPeek) that is attached to a network. The installation of this software normally requires

administrator access to the computer and should be completed by your instructor.

6.1 Following the instructions provided with your packet sniffing software, capture three individual packets. When capturing these packets, do not capture them consecutively; rather, capture three packets individually at random times. This will increase the likelihood that you capture a variety of packets.

6.2 View each of these packets in their binary form and analyze their content.

6.3 Describe the contents of each packet in general terms, answering the following questions:

a. What type of packet is it?

b. What is the source of the packet?

c. What is the packet's destination?

d. What type of activity likely generated this packet?

> **TIP**
>
> Remember to convert from binary to decimal in a manner appropriate for each type of header that you analyze. In order to complete this analysis, you should reference the appropriate RFC document(s) for each packet type that you analyze. See the "Request for Comments" sidebar earlier in this chapter for more information.

Challenge Exercise 6.2

In this exercise, you examine the contents of a digital certificate used for SSL communication with a Web site. You need a computer with a Web browser and Internet access. The following instructions describe the sequence of steps required if you are using Microsoft Internet Explorer 6.0. If you are using a different browser, you will still be able to complete this exercise, but the process may vary slightly.

6.1 Open your Web browser and access a secure Web site (i.e., one that begins with the https:// prefix). For example, go to *https://secure.safaribooksonline.com/promo.asp2.code=ITT03&port al=informit.*

6.2 If you are required to enter a username and password, please do so. Accept any security messages issued by your browser.

6.3 Once you have reached the secure Web page, pull down the File menu of your browser and select the Properties option.

6.4 Click the Certificates button in the lower-right corner of the resulting pop-up window.

6.5 Spend some time reading the information presented in the General tab and use it to answer the following questions:

 a. Who issued this certificate?

 b. To whom was the certificate issued?

 c. What is the purpose of this certificate?

6.6 Select the Details tab of the certificate Properties window. Read the information presented and use it to answer the following questions:

 a. What is the validity period of the certificate?

 b. What algorithm was used to sign the certificate?

 c. What algorithm was used to create the thumbprint (another term for message digest)?

 d. What is the length of the key used to sign the certificate?

6.7 Close your Web browser.

6.9 Challenge Scenario

Challenge Scenario 6.1

You are the security administrator for SoftWear, a maker of T-shirts with witty computer slogans on them. SoftWear currently has four offices: a corporate headquarters in New York, a manufacturing plant in Hong Kong, and sales offices in Los Angeles and London. These offices currently communicate with each other using unsecured IP communication over the Internet. You have been given the responsibility of adding security to these communications and have selected IPSec as the appropriate methodology to achieve that.

Currently, each office has a firewall sitting on the perimeter of its network that serves as the gateway to the Internet. These firewalls support IPSec communications. It is important to you that you provide confidentiality, integrity, and authentication across the interoffice links. Additionally, you wish to provide integrity and authentication to communications that take place between systems within an office.

Describe an IPSec implementation that meets the listed business objectives and technical requirements.

CHAPTER 7

Handling Security Incidents

After reading this chapter, you will be able to:

- Recognize and react to an attack on your system
- Understand incidents and how they relate to your security policy
- Plan for a proper response to security incidents
- Develop and maintain an incident response team
- Identify and understand common types of system attacks

The basic goal of information system security is to protect your data. You also want to protect the infrastructure that surrounds and supports your data, but the real asset is the data. To provide the highest level of assurance that your data is protected, you need to understand what threats exist. The most active threat to an information system is a malicious attack. Although other events, such as a natural disaster, can cause data loss, much of your security efforts will be targeted toward minimizing loss from a malicious attack. It is important to understand how to recognize and react to an attack.

This chapter introduces several common types of attacks and discusses how you can identify and react to an attack when it does occur. Knowing that an attack has occurred, or is in process, is only the first part of a security policy. You must have a plan in place that instructs all affected personnel on how to handle an attack. A sound security policy must provide detailed steps to take to react to, and recover from, any number of malicious attacks. Let's start from the beginning and look at what an attack is and what to do when it happens to your system.

7.1 Attack Terms and Concepts

An **attack** is any attempt to gain unauthorized access to a system or to deny authorized users from accessing the system. That covers a lot of activity. Notice that an attack is an attempt, not necessarily a successful breach. The purpose of an attack is to violate one or more of the three basic properties of security, ensuring confidentiality, integrity, and availability of data. The purpose of an attack is to bring about data disclosure, alteration, or destruction. An **attacker** is an individual, or group of individuals, who strives to violate a system's overall security. When an attacker launches an attack on a system, it can come in many different flavors and from different origins. Some attacks result in laws or regulations being broken. When an attacker breaks a law or regulation, a **computer crime** occurs. Note that not all attacks are crimes.

7.1.1 Types of Attacks

Most attacks directed at computer systems fall into several broad categories. The list of categories discussed in this chapter is not exhaustive, but serves to illustrate the major types of attacks you are likely to see. Recogniz-

ing the type of attack helps you to contain the damage, react, recover from
the attack, and may even lead you toward the attacker.

Military and Intelligence Attacks

Military and intelligence attacks are almost always attempts to acquire
secret information from military or law enforcement agencies. These agen-
cies routinely maintain data that could cause great harm if disclosed. Such
data could include defense strategies and sealed legal proceedings. Once
acquired, an attacker could sell or disclose the data to render it useless to
the owner agency. In addition to the data being useless after being dis-
closed, it could cause serious damage and possibly result in great expense to
change and reformulate plans to replace the data's original function. For
example, if an attacker acquired and disclosed the location of the U.S. sub-
marine fleet, it could endanger the crews of the submarines and force the
Navy to redeploy its forces to new locations. Any existing plans that relied
on the secret locations of any submarines would also need to be modified.

Business and Financial Attacks

A **business attack** is similar to a military or intelligence attack in that its
purpose is to access sensitive data. The primary difference is in the target,
which for a business attack is a commercial organization. The desired data,
if disclosed, could cause harm to the owner organization in several ways.
Sensitive data disclosure could violate many laws and regulations and cause
a loss of standing or position in the market. What would happen if the for-
mula for your favorite soft drink was suddenly available on the Internet? If
you could make your own soda, why buy it? Sales would definitely suffer.
Or think of the negative press that would occur if everyone found out that
the leading "all natural" ice cream actually contained pesticides.

A **financial attack** also generally targets commercial organizations, but for
a different purpose. A financial attack is designed to improperly acquire
goods, services, or money. Any attack that results in "something for noth-
ing" would fall into this category. One popular financial attack is **phone
phreaking**—the practice of obtaining free long-distance telephone service.
One of the more novel ways this was carried out in the 1980s was through
the use of a cereal box whistle. A children's cereal gave away a free whistle in
every box that happened to produce the right frequency to fool a telephone

into thinking it was a touchtone key. Used at the right time, it could bypass telephone system security controls. Needless to say, that vulnerability has long since been fixed.

Terrorist Attacks

Tragically, a **terrorist attack** takes little explanation. An attacker launching a terrorist attack would most likely coordinate his or her efforts to coincide with a physical attack. By attacking communication and infrastructure control systems, an attacker could dramatically affect the ability of agencies to react to a simultaneous physical attack. How could law enforcement personnel or fire fighters react to a physical attack if there was no way to call for help?

Grudge Attacks

A **grudge attack** really describes the motivation behind an attack as much as it describes the likely methods. An attacker who wishes to inflict damage or "get back at" an organization will often launch such an attack. There is often little reward to the attacker beyond the feeling of vengeance. This type of attack could destroy data, disclose damaging data, or result in some other damage to a person or organization. Whenever the media refers to a suspect as a "disgruntled" employee or customer, think of a grudge attack.

Former employees comprise a large number of attackers from this group. Your security policy should clearly specify how terminated employees are to be handled. Make sure you remove all system access immediately. An employee who has been fired often has a strong urge to retaliate. Your job is to make it hard for any former employee to do any real damage.

Fun Attacks

A **fun attack** has no real purpose other than to provide a rush to the attacker. Fun attacks are all about ego and bragging rights. The underground hacker community associates prestige with successfully compromising very secure systems. Many hackers launch these attacks just to maintain their status in their community. These attackers can be among the toughest to track down. Because they are not motivated by greed or hatred, the most skilled hackers tend to leave few pieces of evidence behind.

7.2 Understanding Security Incidents

So what is the difference between an attack and an **incident**? An incident is defined as any violation of your security policy. Every attack is an incident, but every incident is not an attack. For example, your security policy should contain an acceptable use policy and a password policy. If your policy states that accessing Internet auction sites is not allowed, then surfing to *www.auctions-r-us.com* would be considered a security incident. Let's say your password policy states that passwords should not be dictionary words. If anyone uses a dictionary word for a password, they have created another security incident. Not all incidents are catastrophic.

The most important factor in reacting to a security incident is recognizing when an incident occurs. Most incidents are never noticed because no one looks closely enough to recognize it. Incident recognition starts with education. Make sure your security policy clearly states what incidents are. If an action violates your policy, it is a security incident. The people who are closest to the systems need to understand the security policy well enough to know when it has been violated. Think of it this way: If you do not know the speed limit for the road you are driving on, how do you know if you are speeding? You must ensure that all system users understand when an incident occurs. Then they need to know what to do about it.

7.3 Handling Security Incidents

The first step in handling a security incident is recognizing an incident has occurred. Many incidents go unresolved because they are unnoticed. Your security policy should clearly state actions that constitute a security incident. Once you know what an incident is, you are ready to go look for one. Some incidents are discovered after their occurrence through log analysis or system audit. One such example would be unauthorized access to secure files. The most common way to uncover such access is to scan an access log and see who has touched a file or group of files. If the access controls failed and allowed unauthorized users to access files, the actions would be recorded in a log file for later discovery. In real life, an attacker would probably gain access to a user account that possesses the level of desired permissions to access target files. Assuming the attacker did not hijack another user account, the log files would point to the culprit. Some incidents can be

identified and examined in real time, as they are happening. Many **denial of service (DoS)** attacks can be analyzed as they are in progress. A DoS attack renders a system unavailable for its intended use. Loss of critical business functionality is often the first indication that such an attack is underway.

7.3.1 Types of Incidents

There are four general types of incidents. It is important to understand these four basic types of incidents, how to detect them, and how to protect a system from such attacks. Each type presents its own challenges in detection and avoidance.

Scanning

Scanning a system is the systematic probing of ports to see which ones are open. Ports that are found to be open are interrogated to see what type of return data is useful. Scanning a system is not, in and of itself, an attack. It is a way of collecting information about a system that could be useful for a later attack. It is similar to a burglar "casing" a neighborhood, looking for the easiest targets. When a scanner finds an open port, it will query the port to see what any software monitoring it will send back. To make connecting machines easier, most network software will respond with the program name, version, and other information when queried. This information paints a pretty good picture of what a computer is running.

Compromise

A system **compromise** is any unauthorized access to the system. A compromise generally involves defeating or bypassing security controls. It is the same as trespassing. The general purpose of a compromise is to gain unauthorized access to some system resource. After an attacker gains the necessary access, he can disclose, alter, or destroy data at will. These types of incidents are generally difficult to detect. A successful system compromise is one that leaves no traces. The best way to detect a compromise is to pay close attention to what your "normal" system looks like. Anything that is just not right could be a subtle hint that a compromise has occurred.

Malicious Code

The term **malicious code** refers to any program, procedure, or other executable file that makes unauthorized modifications or triggers unautho-

rized actions. The most publicized type of malicious code is the software **virus**, which is a piece of malicious code that modifies an existing executable file in such a way that the newly "infected" file performs some unauthorized action. A software **worm** is similar to a virus, except a worm is a standalone program. A worm does not need a host to infect; it can run own its own. Another type of malicious code is the **Trojan horse**, which is a program that appears to do something useful, but actually exists for another purpose. The seemingly useful nature tricks the user into loading it into a system and executing it. Then, the real purpose comes to life. The Trojan horse could make unauthorized modifications to a system, send out copies of itself, or just perform some silly function that alerts the user that a compromise has occurred.

Denial of Service (DoS)

A DoS attack violates the third security property, availability. An information system must be available to prospective users when they need access to it in order to be useful. By denying authorized users access to the system, a DoS attack can render a system unusable. For organizations that rely on system access, such an attack can have a devastating effect. Think of your favorite online book retailer. What would happen of you wanted to order a book online and found that the Web site was down? You would probably go to the competitor. So would many others who found the Web site unreachable. The success of a DoS attack is a measure of the level of disruption the attack generates.

7.4 Incident Management Methods and Tools

Once you know an incident has occurred, you must put your incident handling plan into action. Look at your security policy. The section that describes how to handle an incident should generally follow this flow:

1. Detect that an incident has occurred.

2. Contain the damage caused by the incident.

3. Assess the damage and report the incident to the proper authorities.

4. Investigate the origin of the incident.

5. Analyze findings.

6. Take action to avoid another occurrence.

This process is often too expansive for only one person. It is generally helpful to create a standing **incident response team** consisting of members from different departments who work together to ensure an incident is handled efficiently and that as much information is collected as possible to promote any changes that will reduce the likelihood of a reoccurrence. The incident response team will perform most of the action items listed by using tools and formal methods to contain the damage and investigate the nature of the incident.

Each type of incident requires different actions to contain the damage. For a DoS attack, denying the attacker's IP address at the firewall can stop the attack cold—for now. Always remember that if your computer was interesting enough to attack once, it is probably interesting enough to attack again. You need to review the controls you had in place at the time of the attack and understand why they did not prevent the attack. Implementing good controls will not make your system attacker-proof. Your goal is to make your system hard enough to compromise that attackers will go after easier targets. Carefully plan a defense for each type of incident.

During the response to an incident, the incident response team will need to collect information for analysis and possible legal action. The investigation phase of the incident response is mainly concerned with the collection of **evidence**. Evidence is any hardware, software, or data that can be used to verify the identity or activity of an attacker. The analysis of a system with the purpose of finding evidence of specific activity is called system **forensics**. Investigators have many different tools for collecting evidence, including log file analyzers, disk search and scanning tools, and network activity tracing tools. The system investigators use as many tools as necessary to identify, acquire, and analyze evidence that helps to make the system more secure and catch attackers.

One of the first decisions that an incident response team must make after an incident is identified is whether to alert law enforcement. If an incident involves violating a law or regulation, you have no choice. The problem is that some incidents look innocent enough at the beginning, but as the investigation continues you find evidence of a crime. Most people would say to call in law enforcement at that point. The problem is that by the time you realize an incident involves a crime, the evidence may no longer be admissible in a court of law. You still have to call the police, but you may have compromised any potential lawsuits by not alerting the police earlier.

So, the rule of thumb is to call the appropriate law enforcement officials if you think there is any chance a violation of law has occurred. The law enforcement officials are experts at collecting and handling evidence. If you need to take legal action as a result of an incident, you definitely want to have evidence you can use in court.

7.5 Maintaining Incident Preparedness

Your security policy should outline how to respond to and handle incidents. As mentioned earlier, each organization should have a group of individuals assigned to an incident response team. This team mobilizes when an incident is reported and manages all activities related to the incident. The incident response team is directed by the security policy, so careful and complete planning has to occur first. The security policy development group must consider all viable incidents and plan accordingly for the appropriate response to each. Several excellent resources are available on the Internet that provide additional information and guidelines on how incident response teams operate. Look at the resources listed in Table 7.1 for more information.

Once you have developed a documented response to potential incidents, it is imperative that you train the incident response team to follow the procedures. Ensure that each team member understands his or her role and is comfortable with handling an incident when it occurs. It is also a good practice to cross-train members of the team in other roles, so they can

TABLE 7.1 Incident Response Team Resources

Resource	Address
Handbook for Computer Security Incident Response Teams	http://www.sei.cmu.edu/pub/documents/98.reports/pdf/98hb001.pdf
Computer Security Incident Response Team	http://www.cert.org/csirts/
Responding to Intrusions	http://www.cert.org/security-improvement/modules/m06.html
Forming an Incident Response Team	http://www.auscert.org.au/render.html?it=2252&cid=1920
SANS IESEC Reading Room: Incident Handling	http://www.sans.org/rr/catindex.php?cat_id=27
FIRST: Forum of Incident Response and Security Teams	http://www.first.org

operate smoothly with a key member of the team missing. Take the time to train end users as well. All system users should have some training on incidents. The training can be basic. Users at least need to know how to recognize common incidents and what to do if they notice one. You could easily inform users to "stay away from the suspected machine and call the incident hotline." That may be all the training that is necessary, but it is enough.

Most important, the first call to your local law enforcement agency should not be after you think a crime has been committed. Take the time to establish a working relationship with a representative from your local law enforcement agency. Know whom to call before you need to place the call. Take care of the background work so an officer can be mobilized and briefed faster should the need arise. After you establish relationships with law enforcement, do the same with utility companies and critical suppliers. You want to already know a name to call on when you need help. A time of crisis is not the time for introductions. Of course, document your contacts and make the call list easy to find.

7.6 Using Standard Incident Handling Procedures

When and if an incident does occur, it is time to mobilize the incident response team. The team follows the prescribed procedures. One team member assesses the extent of the damage while another notifies management and contacts critical suppliers for help. A team member who is specially trained in legal issues evaluates the situation and decides whether to call the police to help with the investigation. All team members use standard incident response forms that document each action a team member takes with the person's name, the action, and the date and time. These standard forms are the basis of the incident report.

Make sure each team member follows a prescribed sequence of steps, and that the team handles the incident in a professional manner and maintains a complete document trail throughout. This is the way an incident should be handled. The opposite end of the spectrum is when the next step to take is always a guess—it just happens to be the action that seems to make sense at the time. Incidents that are handled in this way are seldom documented and often happen again. Make sure you take the time to plan your incident response activities so you respond with order instead of chaos.

Use your local law enforcement contacts when developing standard incident handling procedures. They will very likely have their own

requirements when an incident response involves their officers and investigators. Including their requirements in your policy makes for a smoother transition should you ever need to escalate to a criminal investigation.

7.7 Postmortem: Learn from Experience

After the incident has been detected, contained, investigated, and resolved, it is time to complete the documentation and review the process. Collect all of the incident reports and compile them into a chronological diary of the incident. Fill in any missing information and highlight the information you had to collect after the initial reports were submitted. Finally, meet with the entire incident response team to review the incident report. It is important that this meeting occur as soon after the incident as possible—memory fades as time passes.

The main purpose for the team meeting is to review the incident and the performance of the team. Each major incident should be followed up with a team meeting and review. The first item should be to assess the success of the response. Ask as many pertinent questions of the team as possible. The main questions should include the following:

- What did we do well?
- Was our response timely and appropriate?
- What can we improve upon?
- What modifications can we make to the standard incident reporting forms to reduce postmortem research?
- Did the actions of the incident response team increase the overall security of our system? Why or why not?
- Can we identify any controls that would reduce the likelihood of this incident occurring again?

Use these questions to request input and suggestions that will improve the quality of the team and its actions. Reinforce what you did well and take steps to change what did not go as well. Over time, the team should develop skills and experience that allow incidents to be handled efficiently and professionally. Make sure the meeting is productive, and not just a time to complain about any difficulties you encountered. Value all of the input and agree as a group what changes, if any, you will adopt for the next incident.

Above all, encourage all team members to research what other organizations have published on the topic of incident response. The cheapest way to learn is by using the experiences of others. Find out what other incident response teams did well and what they did not do well at all. As much as is possible, learn from other people's mistakes.

7.8 About Malicious Code

We briefly introduced several types of malicious code earlier in this chapter. Let's take a closer look at different types of malicious code and how to protect a system from its effects. Recall that malicious code is any set of instructions that exceeds the intended authorization to perform unauthorized actions. The best defense against malicious code is a good offense. Use a good virus shield software package that scans all files, especially executable files that are introduced into a system. This introduction most often comes from a network, but could also be easily brought into a system from removable media. Any data entry point into a system is a potential point of entry for malicious code. In addition to floppy disks, consider all data ports (serial, parallel, and USB), any removable storage devices, and your IR port, just to name a few.

It is possible for malicious code to elude controls and find its way into a system, but there are ways to detect and eradicate it. One technique is to look for executable files whose size or access time-date stamp has changed. Another technique compares executable files with bit patterns of known viruses. This is called a signature scan, and is how most virus scanners work.

7.8.1 Viruses

A virus is the most commonly recognized type of malicious code. A virus is simply a program that seeks out other programs and "infects" a file by embedding a copy of itself inside the program. The infected program is often called the virus host. When the host procedure runs, the virus code runs as well and performs whatever instructions it was intended to perform. Different types of viruses act differently, but the general profile is the same. A virus needs a host to infect. Without a host, the virus cannot replicate.

7.8.2 Worms

A worm is different from a virus in that it is a standalone program. A worm does not need a host program; it stands on it own. Once a worm executes, it behaves much like a virus by performing unauthorized data access.

7.8.3 Logic Bombs

A **logic bomb** is a type of malicious code that executes a sequence of instructions when a specific event occurs. Events that trigger logic bombs can be virtually any system event. A logic bomb can execute based on a date and time, or when you shut down your machine for the 33rd time. Any event works.

7.8.4 Trojan Horses

A Trojan horse is a type of malicious code that is similar to a worm. It is a standalone program that appears to perform some helpful or neutral purpose, but is actually performing a malicious act while the user watches the program appear to do something else.

7.8.5 Active Content Issues

One of the most common entry points for malicious code is through the Internet. Today's Web browsers and other network applications rely on downloadable executables to provide a wide range of sophisticated functionality. These "plug-ins" make it easy to keep your system current and able to support many types of new files. These downloadable programs, or active content files, also make it fairly easy for someone to send malicious code to your machine. Due to the enormous number of machines on the Internet, this is an ongoing threat to system security. You must ensure that your virus scanner and shield software protect your system from corrupt or malicious active content objects.

7.9 Common Types of Attacks

Remember the first step in responding to an incident? Before you can respond to an incident, you must detect that an incident has occurred. Outright attacks can cause serious security violations and potentially represent criminal activity. Let's briefly discuss some common attacks you may encounter.

7.9.1 Back Doors

A **back door** is a special access path to higher authorization that software developers often put into programs they write. The basic philosophy states that the developer should not be locked out of his or her own programs. One problem with back doors is that an unscrupulous programmer could

use the back door to gain unauthorized access to data without being detected. Another problem is that a back door works just as well for an attacker as it does for the developer who put it there. Once discovered, a back door is a huge hole in your access controls. The best ways to prevent back doors are through strict development control and security-related testing to ensure back doors do not exist. Once you install a program on your system that has a back door, your options are limited. You have to know your system well enough to recognize unusual behavior.

7.9.2 Brute Force

A brute force attack attempts to guess a password by systematically attempting all character combinations. This attack can be executed by submitting many passwords to an access control system, searching for a successful combination. Another method is to compare encoded strings to a known encoded password to find a match. The second approach requires the attacker to obtain an encoded version of the password he or she is trying to crack. The best defense against this type of attack is to carefully secure your stored passwords and allow only a small number of failed login attempts before the account is automatically locked. If you allow an attacker to try all possible password combinations, he or she will eventually win. Make sure you also audit login attempts. The audit logs can be used later in an investigation.

7.9.3 Buffer Overflows

A **buffer overflow** is a preventable attack that is always due to careless development practices. Basically, a buffer overflow occurs when you copy a string that is longer than the target buffer; for example, you copy 20 bytes into a buffer that is only 10 bytes long. The easy way to stop such an attack is to simply check the size of data before copying it to the target buffer. It is an extra step many programmers skip.

A successful buffer overflow generally creates an exception and crashes the program. If you copy 20 bytes into a 10-byte buffer, where do the extra 10 bytes go? They go in the next 10 memory locations at the end of the buffer. Overwriting memory in this manner can easily cause the program to fail. So, what if you are running a program that is operating in a state with increased security when you crash it? You may crash at a point that leaves you with free updated authority to wreak havoc in the system. This type of attack is very popular because there are so many programs on live systems with this vulnerability that the targets are plentiful. Remember our discus-

sion of a scanning attack? An attacker scans a system to see what is running, along with versions of most software. With that information, the attacker can look up any known vulnerabilities for each piece of software he finds running on the machine. A common vulnerabilities database on the Web is located at *www.securityfocus.com*. If the attacker finds a vulnerable piece of software, he or she can mark it as a potential attack target.

7.9.4 Denial of Service

A DoS attack is any attack designed to disrupt the ability of authorized users to access data. This is most often accomplished by keeping the system so busy it does not have the capacity to service legitimate requests. There are many types of DoS attacks, and new ones surface at very frequent intervals. The majority of the DoS attacks send a network packet to a target computer that asks for a reply. The attack may be in the sheer dnumber of packets sent or in the type of packets sent. They all share the same purpose: to deny access.

7.9.5 Man-in-the-Middle

In a **man-in-the-middle attack**, an attacker listens for network traffic from a spot between an authorized user and a resource he or she is accessing. The attacker intercepts the data traveling back and forth and uses it to either crack a password for later use or extract data intended for the user. The purpose of this type of attack is to intercept data.

7.9.6 Social Engineering

Social engineering is a term that describes any attempt to convince an authorized user to disclose secure data or allow unauthorized access. An attacker generally tricks a user into giving up a password or running a Trojan horse on a secure system. These types of attacks can be hard to detect because the user who actually takes the action is an authorized user. The best defense against this type of attack is security awareness training. Make sure your users know to never share their passwords with anyone. Any person who tries to access a secure machine should be reported. These simple rules can thwart many social engineering attacks.

7.9.7 System Bugs

Although a **system bug** is not technically an attack, it can offer an attacker a vulnerability he or she can exploit. Use software configuration and quality assurance techniques to minimize the amount of buggy code you write.

For software you did not develop, make sure you have applied the latest patches to fix as many bugs as possible.

7.10 Unauthorized Access to Sensitive Information

One of the final goals of many attacks is to access sensitive information. An attacker may just want to see or disclose the data. It may be data that will embarrass an organization or individual. It could be information that could be valuable, such as an unreleased report that is so favorable for a company as to cause certain stock prices to rise. Such information could have substantial financial value. Alternatively, the attacker may want to modify the data. Let's say your classmate, Tom, received a "C" in Computer Organization and Architecture. If he was unscrupulous and wanted to change his grade, he might launch an attack to access the database with his grades. He does not want to view the data; he wants to change it.

Either way, unauthorized access to sensitive data can cause serious damage, whether the data is disclosed or modified. Protect your data. Use the appropriate controls and be prepared to handle an attack if one occurs.

7.11 Chapter Summary

- An attack is any attempt to gain unauthorized access to a system or to deny authorized users from accessing the system.

- The purpose of an attack is to bring about data disclosure, alteration, or destruction.

- Military and intelligence attacks are generally attempts to acquire secret information from military or law enforcement agencies.

- Business attacks are directed at commercial organizations to acquire access to sensitive data.

- Financial attacks are designed to improperly acquire goods, services, or money.

- Terrorist attacks are attacks to disrupt daily life patterns.

- Grudge attacks are designed to "get back at" an organization or individual.

- "Fun" attacks are launched for the thrill of the experience.

- An incident is defined as any violation of your security policy.

- The first step in handling a security incident is recognizing an incident has occurred.

- Scanning a system is the systematic probing of ports to see which ones are open.

- A system compromise is any unauthorized access to the system.

- The term *malicious code* refers to any program, procedure, or other executable file that makes unauthorized modifications or triggers unauthorized actions.

- An incident response team consists of members from different departments who work together to ensure an incident is handled efficiently.

- Evidence is any hardware, software, or data that can be used to verify the identity or activity of an attacker.

- The analysis of a system with the purpose of finding evidence of specific activity is called system forensics.

- Review incidents when they are over to evaluate performance and make changes to your plan.

- A virus is a program that seeks out other programs and "infects" a file by embedding a copy of itself inside the program.

- A worm is a piece of malicious code that does not need a host program. It stands on its own and runs as a separate program.

- A logic bomb is a type of malicious code that executes a sequence of instructions when a specific event occurs.

- A Trojan horse is a type of malicious code that appears to perform some helpful or neutral purpose, but is actually performing a malicious act while the user watches the program appear to do something else.

- A back door is a special access path to higher authorization that software developers often put into programs they write.

- A brute force attack tries to guess a password by systematically attempting all character combinations.

- A buffer overflow occurs when you copy a string that is longer than the target buffer into that target buffer.

- A denial of service (DoS) attack is any attack designed to disrupt the ability of authorized users to access data.

- In a man-in-the-middle attack, an attacker listens for network traffic from a spot between an authorized user and a resource the user is accessing.

- Social engineering is a term that describes any attempt to convince an authorized user to disclose secure data or allow unauthorized access.

7.12 Key Terms

attack: Any attempt to gain unauthorized access to a system or to deny authorized users from accessing the system.

attacker: An individual, or group of individuals, who strives to violate a system's overall security.

back door: A special access path to higher authorization that software developers often put into programs they write.

buffer overflow: An error that occurs when you copy a string that is longer than the target buffer.

business attack: An attack to acquire access to sensitive data from a commercial organization.

compromise: Any unauthorized access to the system.

computer crime: An attack that results in breaking a law or regulation.

denial of service (DoS) attack: An attack that renders a system unavailable for its intended use.

evidence: Any hardware, software, or data that can be used to verify the identity or activity of an attacker.

financial attack: An attack designed to improperly acquire goods, services, or money.

forensics: The analysis of a system with the purpose of finding evidence of specific activity.

fun attack: An attack that has no real purpose other than to provide a rush to the attacker.

grudge attack: An attack designed to "get back at" an organization or an individual.

incident: Any violation of your security policy.

incident response team: Individuals from different departments who work together to ensure that an incident is handled efficiently.

logic bomb: A type of malicious code that executes a sequence of instructions when a specific event occurs.

malicious code: Any program, procedure, or other executable file that makes unauthorized modifications or triggers unauthorized actions.

man-in-the-middle attack: An attacker listens for network traffic from a spot between an authorized user and a resource the user is accessing.

military and intelligence attack: An attack to acquire secret information from military or law enforcement agencies.

phone phreaking: The practice of obtaining free long-distance telephone service.

scanning: Systematic probing of ports to see which ones are open.

social engineering: Any attempt to convince an authorized user to disclose secure data or allow unauthorized access.

system bug: An unwanted piece of code in a software program that can result in a vulnerability.

terrorist attack: An attack designed to disrupt everyday life.

Trojan horse: A program that appears to do something useful, but actually exists for another purpose.

virus: A piece of malicious code that modifies an existing executable file in such a way that the newly "infected" file performs some unauthorized action.

worm: Malicious code that is a standalone program and does not need a host to infect.

7.13 Challenge Questions

7.1 What is an attack?

a. An attempt to damage information system hardware

b. An attempt to gain unauthorized access to a system or to deny authorized users from accessing the system

c. An attempt to gain authorized access to an information system

 d. An attempt to violate the disclosure property of a secure system

7.2 What are the main goals of an attacker?

 a. To bring about data confidentiality, integrity, and availability

 b. To bring about data disclosure, integrity, or destruction

 c. To bring about data confidentiality, alteration, or destruction

 d. To bring about data disclosure, alteration, or destruction

7.3 What is a computer crime?

 a. Any violation of the security policy

 b. Any attack that results in losses exceeding $5,000

 c. Any attack that involves a violation of a law or regulation

 d. Any attack on a public information system

7.4 Which of the following are common types of attacks? (Choose all that apply.)

 a. Fun attacks

 b. Financial attacks

 c. Iterative attacks

 d. Nonlinear attacks

7.5 What is the main difference between a military attack and a business attack?

 a. A military attack focuses on data disclosure whereas a business attack focuses on getting free services.

 b. A military attack focuses on changing secret data whereas a business attack focuses on disclosing confidential data.

 c. There are no real differences.

 d. A military attack seeks to access secure data on a government machine whereas a business attack seeks to access sensitive data on a commercial machine.

7.6 What is an incident?

 a. Any violation of the security policy

b. Any violation of a law or regulation that involves a computer

c. Any attack that results in damage to data

d. Any attack that can be associated with an individual

7.7 What is a scanning incident?

a. Systematically searching a computer system for installed software

b. Systematically dialing telephone numbers to find a modem that answers

c. Systematically searching a system of ports to see which ones are open

d. Systematically searching all executable files for embedded viruses

7.8 What is a system compromise?

a. Any unauthorized access to a system

b. Unauthorized access to a system that results in data modification

c. Unauthorized access to a system that results in data disclosure

d. Any unauthorized access to a system that results in data loss

7.9 What is malicious code?

a. Executable code that contains hidden entry points for developers to use to bypass access controls

b. Any program, procedure, or other executable file that makes authorized modifications or triggers authorized actions

c. Any executable file that contains bugs

d. Any program, procedure, or other executable file that makes unauthorized modifications or triggers unauthorized actions

7.10 What is evidence?

a. Any hardware, software, or data that can be used to verify the identity or activity of an attacker

b. Any hardware, software, or data that is admissible in a court of law and used to verify the identity or activity of an attacker

c. Only hardware, software, or data collected by a law enforcement officer that can be used to verify the identity or activity of an attacker

d. Any hardware, software, or data that was collected during an incident investigation

7.11 Which is the best description of information system forensics?

a. The analysis of a system with the purpose of finding evidence of criminal activity

b. The analysis of a system with the purpose of finding evidence of specific activity

c. The analysis of a system with the purpose of finding evidence of any activity

d. The analysis of a system with the purpose of finding evidence of inactivity

7.12 What is the main difference between a virus and a worm?

a. A virus can do more damage than a worm.

b. Worms work only in background mode.

c. A virus is a standalone program, whereas a worm requires a host program to infect.

d. A virus requires a host program to infect, whereas a worm is a standalone program.

7.13 What characteristic makes a logic bomb different from a worm?

a. A logic bomb contains at least one virus, whereas a worm is a standalone program.

b. A logic bomb activates when a specific event occurs, whereas a worm executes whenever it is run.

c. A worm can contain dangerous code, whereas a logic bomb can only appear to be dangerous.

d. They are essentially the same.

7.14 Which type of attack tries every possible combination of characters to guess a password?

a. DoS

b. Brute force

c. Scanning

d. Man-in-the-middle

7.15 Which type of attack involves an attempt to convince an authorized user to disclose secure data or allow unauthorized access?

a. Man-in-the-middle

b. Scanning

c. Social engineering

d. DoS

7.14 Challenge Exercises

Challenge Exercise 7.1

A security professional must commit to keeping skills current. The most pervasive and dangerous attacks change by the hour. It is imperative that you keep an eye on the most popular attacks that are in play at any particular time. In this exercise, you visit a Web site that keeps statistics on the most current attacks. From this Web site, you will choose a current attack and research the topic, providing an opportunity to learn how to track down suspicious activity and find out if it is part of a larger attack. You need a computer with a Web browser and Internet access. The Web site you will visit is the Internet Storm Center, a common resource many security professionals use to find out what is happening worldwide with respect to network attacks.

7.1 In your Web browser, enter the following address: *http://www.incidents.org.*

7.2 From the main page, scroll down and choose any port or service under the heading "Top Attacked Ports." Each of these links directs you to a page that contains a port attack report.

7.3 Use the information on this page to write a brief summary of this attack. Explain how the frequency of attacks has changed over the last 10 days and what services are registered to your chosen port.

Challenge Exercise 7.2

A computer incident response team makes responding to an incident more manageable and predictable. But where do you start? In this exercise, you visit a Web site that has information and suggestions for forming your own computer incident response team. You need a computer with a Web browser and Internet access. The Web site you will visit is the Computer Security Incident Response Team (CSIRT) Coordination and Development Center of Carnegie Mellon University, which contains a wealth of suggestions on how to organize and maintain a CSIRT.

7.1 In your Web browser, enter the following address: *http://www.cert.org/csirts/*.

7.2 Browse the information on this page. There is more information than you can absorb in one visit.

7.3 On the main page under the heading "CSIRT Resources," click the "Creating a Computer Security Incident Response Team: A Process for Getting Started" link. This link takes you to a set of guidelines for forming a CSIRT.

7.4 Using the information on this page, write a simple outline for organizing a CSIRT. Include at least five questions you must answer before you form the CSIRT.

Challenge Exercise 7.3

One step you should take in securing your system is to detect and repair all known vulnerabilities. To help security personnel keep track of software vulnerabilities, SecurityFocus maintains a comprehensive database of virtually every known software vulnerability. In this exercise, you visit the SecurityFocus Web site to search the vulnerabilities database for information on system problems. You need a computer with a Web browser and Internet access.

7.1 In your Web browser, enter the following address: *http://www.securityfocus.com/bid/*.

7.2 Notice that from this page you can search for vulnerabilities by vendor, software title, keyword, or other identification. Select the "By Title" tab.

7.3 From the "Title" drop-down list, select "Outlook Express" and click the Submit button. You will see a list of known vulnerabilities for the Outlook Express product.

7.4 Select any vulnerability and read the discussion section. Using the information from this page, write a brief overview of at least three vulnerabilities in Outlook Express.

7.15 Challenge Scenarios

Challenge Scenario 7.1

You are the CIO of a small engine manufacturing company. Your company has developed a quieter engine than the ones your competition sells. Ever since your company announced the new, quieter engine, you have noticed a dramatic increase in port scanning and attack attempts. The number of incidents you and your staff handles is increasing weekly. You realize each person in your group handles incidents a little differently and you want to standardize the response. You need to form a computer security incident response team.

Develop an outline that lists the basic responsibilities and actions of your CSIRT. Briefly state the goal of the CSIRT and list the standard steps your team will take when responding to an incident. You should list at least 15 separate tasks your team should accomplish.

Challenge Scenario 7.2

You have successfully formed your CSIRT and are awaiting your first call. The phone rings, and a user reports that a dramatic increase in activity is being observed on port 137 of several of your machines. Explain what your CSIRT team should do to try to hunt down this problem. Where should they go to find out what port 137 does? How pervasive is this problem? What should they do next?

Develop a simple plan of action for your team to respond to this incident.

CHAPTER 8

Firewall Security

After reading this chapter, you will be able to:

- Explain the role of routers, proxies, and firewalls in providing perimeter protection for a computer network

- Describe the three major types of firewall topologies (bastion hosts, screened subnets, and dual firewalls), and understand the appropriate topology for various sets of circumstances

- Design a firewall rulebase that complies with an organization's business needs and security requirements

- Explain the significance of the cleanup rule and the stealth rule in developing a firewall rulebase

Security professionals from all disciplines—computer security, physical security, data security, and so on—understand the significance of securing a perimeter. If you were charged with securing a physical building, chances are that your first move would be to put a lock on the door and erect a fence. If you're a general planning the defense of a territory, you're likely to deploy your troops in a manner that secures the territory's perimeter. Similarly, one of the primary responsibilities of network security specialists is securing the perimeter of the network from malicious activity.

In all of these cases, security professionals recognized the importance of keeping intruders outside the perimeter for overall security. After all, if you can keep the bad guys on the outside, it's much less likely that they'll be able to do significant damage to your assets. If they manage to defeat your perimeter protections and gain insider access, you're facing an uphill battle to protect your resources.

This chapter is dedicated to the application of perimeter security techniques to network security. You'll learn how information security professionals use devices like routers, proxy servers, and firewalls to build a comprehensive defense against malicious activity. You'll also discover how technologies like virtual private networking can be used to let down those defenses just enough to permit authorized use of network resources by users physically located outside of the protected perimeter.

8.1 Perimeter Security Devices

Networking devices form the core of a perimeter security posture. Most information security practitioners use a combination of devices including routers, proxy servers, and firewalls to achieve the highest level of protection possible within the limitations of business requirements, financial resources, technical resources, and available manpower to build, maintain, and monitor the perimeter.

Keep in mind while you're building a perimeter that you must build a manageable defense. As the old adage goes, quality is much better than quantity. If you only have the manpower necessary to effectively manage and monitor one or two security devices, you're better off going with a limited setup that you can keep tabs on than a larger-scale perimeter that you can't maintain control of. Indeed, a poorly configured network security device may

represent a threat to the network and actually *degrade*, rather than strengthen, the overall security of the network.

In this section, we'll look at the three primary security devices used in perimeter protection. It's important to note that these devices are used to enforce access control and keep malicious activity off of the network. Another important component of protecting the network is the judicious use of intrusion detection systems to detect successful (as well as attempted) penetrations of the network perimeter.

8.1.1 Routers

Every network administrator is familiar with the use of **routers** to interconnect networks and appropriately route traffic bound for distant locations. In Chapter 3, you learned how these devices play a critical role in networking infrastructure. They can also be critically important in securing a network perimeter. In most cases, a router is the first physical networking device encountered as one enters a network from the Internet. As such, it should be configured in a manner that enhances network security by limiting the traffic allowed to enter the protected network.

Routers do contain some security functionality. For example, Cisco routers allow you to configure relatively sophisticated packet filtering through the use of access control lists (ACLs) that are customized for different transport and networking protocols. Routers may also be configured to protect other perimeter security devices from denial of service attacks by reducing the load on those machines. For example, a malicious individual seeking to compromise a firewall may try to overwhelm the firewall with networking traffic or send carefully crafted packets designed to compromise the firewall. In most cases, there is a router sitting between the Internet and the firewall. If security administrators are able to configure the firewall to reject the type of attack aimed at the firewall (or even any traffic aimed directly at the firewall), the attack may be stopped.

Routers may also be used in efforts to prevent spoofing attacks on a network. In these types of attacks, malicious individuals attempt to disguise themselves as insiders to gain unauthorized access to a network. One of the most common ways they try to do this is by changing their IP address so that it appears to be an address inside the target network. Routers can easily screen out this type of traffic by checking the headers of packets coming

> **TIP**
>
> It's not possible to overemphasize the importance of perimeter security to network protection efforts. If you only have the resources to focus your security efforts on one area, this is it!

Figure 8.1
Routing scenario

into a network and determining whether they make sense. For example, consider the scenario shown in Figure 8.1. In this case, the router is protecting the New York network, which has exclusive use of the 129.76.0.0 IP address range. It connects that network to the Chicago network (which exclusively uses the 129.77.0.0 IP address range) via a dedicated connection. It also maintains a connection between the New York office and the public Internet.

An administrator seeking to prevent spoofing attacks would want to take care of two situations. First, it would be wise to ensure that traffic bearing an IP address in the 129.76.0.0 range doesn't enter the protected network from either external connection. Any such packets are almost certainly signs of either malicious activity or a misconfigured system. Second, the administrator should configure the router to reject any packets coming from the Internet connection with a source address from the 129.77.0.0 network. Any legitimate traffic from the Chicago network should be routed over the dedicated network connection. If traffic bearing a Chicago IP address appears on the Internet interface of the router, this is also likely the result of a misconfigured network or malicious activity.

It's also important that you be a good citizen on the Internet. Besides protecting your network from spoofing attacks, you should also take steps to ensure that your network is not used as the launching point for a spoofing

attack. This is accomplished through the use of a process known as **egress filtering**. When performing egress filtering, you configure your router to examine traffic *leaving* your network in addition to traffic entering your network. You should ensure that all of the traffic leaving your network bears a valid source IP address from your network. In the scenario shown in Figure 8.1, any traffic leaving the New York network through the router should have a source IP address in the 129.76 range. If this is not the case, a hacker may be using your network to launch an attack on external systems. This type of activity may also alert you to unauthorized or misconfigured systems appearing on your network.

8.1.2 Proxies

If you've taken classes in government, business, or law, you may be familiar with the concept of a **proxy**. In those situations, a proxy is a person or organization authorized to act on behalf of another. Proxy servers operate in a similar manner on computer networks. One of the most dangerous situations in computing occurs when a client on a protected network attempts to access resources located on an untrusted system. In this scenario, the untrusted system has the opportunity to commit a number of unwanted acts, such as:

- Transferring malicious code to the client system and surreptitiously causing its execution

- Determining the true IP address of the client system

- Identifying the types of software running on the client and determining any potential vulnerabilities in that software

This typical client/server interaction is shown in Figure 8.2.

Desktop Request Response Web Server

Figure 8.2
Normal client/server interaction

When a proxy server exists on the network, clients are normally prevented from directly accessing Internet hosts. Instead, their requests are redirected to the proxy server, which then analyzes the request and determines whether it is permissible. If the request is authorized, the proxy server then fulfills the request using the following sequence of steps:

1. The proxy server first checks its cache of data to determine whether it has previously answered the same request for a client.

2. If the information exists in the cache, the proxy server determines whether the information is recent enough to use to answer the client query. This is done by comparing the timestamp on the data to a configurable threshold. If the data is recent enough, the proxy server answers the client request using the cached data and the process ends.

3. If the cached data is too old or the requested information doesn't exist in the cache, the proxy server then initiates a request to the remote Web server on behalf of the client. The Web server is not aware of the presence of the proxy server; it simply believes that the proxy server is a client like any other. It then returns the requested data to the proxy server.

4. When the proxy server receives the information from the Web server, it processes the response (which may include checking for malicious content) and then responds to the client with the requested data.

5. If the proxy server is configured to use caching, it then stores a copy of the requested information in its cache to facilitate the answering of future requests from network clients.

The process of client/proxy/server interaction is shown in Figure 8.3.

The benefits of a proxy server are therefore twofold. From a security perspective, proxy servers mask the identity of clients on a network and limit the usefulness of network sniffing as a reconnaissance technique. They also provide filtering capabilities that allow security administrators to enforce acceptable use policies (by limiting the type of content that users may request) and to screen incoming data for malicious content. From a performance perspective, proxy servers allow administrators to optimize bandwidth utilization by supplying frequently requested data directly from

Figure 8.3

Client/server interaction using a proxy server

the proxy server's cache, rather than initiating a new Internet communication for each request.

8.1.3 Firewalls

Firewalls are often seen as the "silver bullets" of network security. Indeed, they do provide significant benefits and are capable of single-handedly improving the security posture of an unprotected network. However, they are not a network security panacea, and their benefits must be taken in context. Firewalls play an important role in network security, but they are only one link in the complex perimeter protection chain.

Firewalls are responsible for screening traffic entering and/or leaving a computer network. The firewall's engine determines whether each packet received may be passed along to its destination by comparing it to the security rules contained within its rulebase (discussed later in the chapter). The next several sections of this chapter focus on the various types of firewalls, firewall topologies, and the design and maintenance of a firewall rulebase.

8.2 Types of Firewalls

Firewalls have been a part of the computer security scene for quite some time. Over the past several years, as corporate Internet connections became ubiquitous and the attention of administrators shifted to security issues, firewall technology evolved. A diverse range of firewall solutions and technologies are available on the market today. In this section, we'll look at the differences between hardware and software firewalls as well as the two most common types of filtering technology: packet filtering and stateful inspection.

8.2.1 Hardware Versus Software Firewalls

When choosing a firewall solution, you typically have two choices of platform—a hardware-based firewall or a software-based firewall. Hardware-based firewalls (often referred to as "appliances") are integrated solutions that contain all of the hardware and software needed to implement the firewall. They are stand-alone devices that offer administrators a dedicated approach to firewall security. From the administrator's point of view, they look and feel similar to a software-based approach, using the same graphical user interfaces, logging/audit capabilities, and remote configuration capabilities. However, as dedicated appliances, they are often capable of processing data much more quickly than a software-based approach, and thus are suitable for organizations operating in a high-bandwidth environment. Of course, this added performance comes with a correspondingly stiff price tag. You'll likely find it somewhat more expensive to purchase a firewall appliance than to build and configure a dedicated firewall yourself from separate components.

Software-based firewalls, on the other hand, are usually relatively inexpensive. When you purchase a firewall software license agreement, you're provided with the media needed to install and configure a firewall solution on any supported platforms. Most commercial firewalls are available in Windows, Linux, and Unix versions. If you purchase your system from a value-added reseller, the purchase price will typically include design of a firewall rulebase (see Section 8.4, "Firewall Rulebases," later in this chapter), configuration of the system, and ongoing maintenance and support. Although the installation and configuration of a firewall is not tremendously complicated, it's wise to have this kind of support unless you have personnel within your organization with hands-on firewall experience. A slight misconfiguration during this phase of the process could negate all of the security benefits you intend to achieve with the firewall implementation.

8.2.2 Packet Filtering

The earliest firewalls used a screening methodology known as packet filtering to vet traffic passing through a network. In this approach, each inbound (and/or outbound) packet is treated in an isolated manner. The firewall reads the packet header (for more on packet headers, see Chapter 3) and analyzes the routing and protocol information contained within. Most

packet filtering firewalls provide you with tremendous flexibility with respect to the fields that may be analyzed, but the most common ones are:

- Source address

- Destination address

- Destination port (service)

- Transport protocol

Many packet filtering solutions allow you to incorporate additional factors into the decision, such as the day of the week or the time of day. For example, you may wish to allow certain types of noncritical traffic to pass through the firewall only during nonbusiness hours, when utilization is low. These capabilities allow you to use your firewall as a performance-enhancing device in addition to a perimeter security solution.

8.2.3 Stateful Inspection

The next-generation firewall technology, stateful inspection, overcomes one of the major limitations of packet filtering firewalls—the fact that packet filters analyze each packet individually and are not capable of maintaining connection state information. Stateful inspection firewalls maintain data about open connections to ensure that packets are part of a legitimate connection initiated by an authorized user.

The easiest way to understand stateful inspection is through the use of an example. Consider the process that two computers follow when a client requests a Web page from a remote server:

1. The client sends a request from a random high-numbered port (let's say 1423 for the sake of example) to port 80 on the destination server.

2. The destination server accepts the connection request and responds to port 1423 on the client from a randomly selected high-numbered port (let's say 2901).

3. The client and server then communicate using port 1423 on the client and 2901 on the server.

This elaborate process is designed to keep the well-known ports (port 80 in this case) available to service connection requests. However, it creates a

dilemma for firewall administrators. If you're using simple packet filtering, you must leave the high-numbered ports open to accommodate this scenario. Unfortunately, this has the adverse consequence of allowing remote systems to attempt to initiate communications with protected systems using those high-numbered ports.

Stateful inspection firewalls contain advanced technology that allows them to track the status of connections. When a client sends out an allowable connection request (as determined by the firewall rulebase), the firewall actively listens for the response and makes note of the two ports being used by the client and server. Traffic on those ports is then authorized to pass through the firewall for the duration of the connection. When the firewall observes the signature FIN-FIN/ACK-ACK handshaking characteristic of a connection teardown (see Chapter 6 for information on this process), it removes the temporary authorization, and traffic between those sockets is again blocked. This same action may also occur when a connection times out according to a preconfigured threshold value.

8.3 Firewall Topologies

In order to be effective, firewalls must be properly placed on a network. They should be placed in a manner that positions them between the protected network and all potential avenues of entry to that network from the outside. In addition, many organizations choose to use internal firewalls to segment their protected network into further protected subnets on a geographic or functional basis.

Lines of Communication

It's not possible to overemphasize the importance to information security professionals of maintaining an accurate and current knowledge of all lines of communication into and out of a network. It's not sufficient simply to protect the major data circuits, such as T-1 lines or other broadband connections. You must ensure that every single point of entry into your network is safeguarded. Hackers can and will find the least common point of entry and probe it for exploitable weaknesses.

One of the most commonly overlooked access points is the connection of dial-up modems to the telephone network. If it's possible to dial the computer's telephone number from an outside line, this is a dire threat. Hackers often use tools called war dialers to randomly dial tele-

phone numbers, searching for the telltale squeal of a data modem. Unfortunately, most PCs ship from the factory with modems installed, and it's all too easy for an end user to connect a simple telephone cable that could undermine the security of your entire enterprise. For that reason, it's strongly recommended that you remove modems from all PCs unless a specific business justification for their use exists.

We'll discuss three commonly used firewall topologies in this chapter. Please note that these solutions are used to protect individual networks in their entirety from external attack. There are many possible topologies that mix and match from these basic building blocks to create more complex security perimeters designed to provide layers of internal protection. We'll explore each of the three types—bastion hosts, screened subnets, and dual firewalls—in further detail.

8.3.1 Bastion Host

The **bastion host** topology, shown in Figure 8.4, places the firewall at the perimeter of the network as the sole link between the protected network and the outside world. All traffic flowing into or out of the network must pass through the firewall. This topology is the easiest to implement and the most inexpensive. However, it also poses a significant security risk if services are to be offered to the outside world.

Suppose, for example, that your network contains a Web server designed to offer services to Internet users. In order to provide this service, the bastion host firewall must be configured to allow traffic to pass from any Internet host to port 80 on the Web server. Now suppose a malicious individual comes along and launches an attack against your Web server that passes through the firewall because it uses port 80. If that individual succeeds in compromising your Web server, he or she now has unrestricted access to

Figure 8.4

Bastion host

Figure 8.5

Screened subnet

the internal network. The remaining two firewall topologies (screened subnets and dual firewalls) make provisions that minimize the risk of this type of total compromise.

8.3.2 Screened Subnet

The **screened subnet** (also known as the **demilitarized zone** or **DMZ**) firewall topology still uses a single firewall, but with three network interface cards. As with the bastion host, one interface card is connected to the Internet (or other external network) and another is attached to the protected network. With the screened subnet, however, a third network card connects the firewall to the screened subnet, as shown in Figure 8.5.

The purpose of the screened subnet is to provide a middle ground that serves as neutral territory between the Internet and the internal network (hence the nickname DMZ). Administrators place systems on this network that provide services to external users, such as Web servers, SMTP servers, and the like. This way, even if a malicious individual is able to compromise a server that offers services to the public, that individual has only limited access to the rest of the network. They may be able to gain access to other systems on the DMZ, but chances are slim that they will gain access to the protected internal network (assuming the firewall and rulebase are configured properly!).

Figure 8.6
Dual firewalls

8.3.3 Dual Firewalls

The final firewall topology, shown in Figure 8.6, is the **dual firewall** scenario. Like the screened subnet topology, the dual firewall topology provides a DMZ network that may be used to house public services. However, instead of using a single firewall with three network cards to achieve this goal, the dual firewall topology uses two firewalls with two network cards each to create a middle ground.

The dual firewall approach offers the same security benefits as the basic screened subnet approach, but with an added twist. The use of two separate firewalls minimizes the possibility that a malicious individual could compromise the firewall itself. A powerful variation on this topology is to use two firewalls that are substantially different from each other in the implementation. There are several scenarios you might wish to use to achieve this differentiation:

- Use a hardware firewall for one system and a software firewall for the other system.
- Use firewalls from two different vendors.
- Use firewalls with different security certification levels.

The main benefit achieved by this differentiation is the fact that two different firewalls are not likely to have the same inherent security vulnerability. It's important to keep in mind that firewalls are based on the same types of hardware and software that other computing systems are based on. Therefore, they're also bound to have undocumented security flaws. Granted, firewall vendors are often quick to release security patches when these vulnerabilities are discovered, but who wants to be the one to discover the vulnerability? The use of two firewalls provides an additional layer of

> **WARNING**
>
> Watch the terminology here! Bastion hosts are commonly referred to as *dual-homed firewalls* (referring to the fact that they have two network interface cards). These should not be confused with a *dual firewall* scenario, which utilizes two dual-homed firewalls.

protection that just may be the barrier stopping an attacker from successfully penetrating your internal network.

8.4 Firewall Rulebases

As you've probably gathered by this point in the chapter, a firewall's **rulebase** is one of the most critical components in your perimeter security architecture. This rulebase provides the firewall with a definition of what traffic should be allowed onto the network and what traffic should be blocked. Firewall administrators spend the majority of their time designing, configuring, maintaining, and troubleshooting issues related to the firewall rulebase.

Each firewall solution uses a different syntax for rule specification, and most offer a graphical user interface that makes input of the rules a breeze. However, the basic functionality is consistent from platform to platform. Most rules you'll encounter are of the form:

```
<action> <protocol> from <source_address> <source_port> to
<destination_address> <destination_port>
```

These fields have at least the following values:

- <**action**> may be either **deny** or **allow**.
- <**protocol**> may be **tcp**, **udp**, or **icmp**.
- <**source_address**> and <**destination_address**> may be an IP address (including network addresses), an IP address range, or the keyword **"any"**.
- <**source_port**> and <**destination_port**> may be a port number or the keyword **"any"**.

As mentioned previously, this is only the basic functionality that all firewalls support. Most systems implement some advanced functionality that allows administrators to customize actions to the organization's business requirements. Some examples of the type of functionality you may find include:

- The ability to drop (as opposed to block) inbound traffic. Dropped traffic is simply ignored, whereas the originator is notified when traffic is blocked.
- The ability to integrate with the firewall's own (or an external) authentication system to apply different security restrictions to different classes of users.

- Integration with virtual private network solutions.

- Provisions for Quality of Service (QoS) rules that prioritize certain types of network traffic.

When designing a firewall rulebase, the best place to start is with a list of business requirements that must be supported by the network, then work forward to a list of services that must be enabled to meet those business requirements, and finally create a list of firewall rules that enable those specific services. One of the common missteps made by security administrators is to begin with a list of supported rules and work backwards to the business justifications. This can result in two problems. First, business requirements may be overlooked through this process, requiring frequent re-engineering of the rulebase. Second, this type of approach may lead to a scenario in which administrators stretch the definition of business requirements to justify services that are presently allowed.

8.4.1 Special Rules

Two special rules should be present in every firewall rulebase: the cleanup rule and the stealth rule. These rules are basic security principles that are consistent from organization to organization.

Cleanup Rule

The **cleanup rule** enforces the fundamental precept of firewall engineering: "Deny everything that is not explicitly allowed." In the syntax introduced in this chapter, it would be written as:

```
deny any from any any to any any
```

Because of this simple syntax, the cleanup rule is often referred to as the "deny any" rule. It should be the very last rule in every firewall rulebase. If you find that it's necessary to remove this rule to achieve a security goal, your firewall rulebase is not well engineered and needs to be redesigned.

Stealth Rule

The **stealth rule** is designed to protect the firewall itself from external (or internal) attack. It prevents anyone from directly connecting to the firewall over the network, limiting access to those with physical access to the system. In firewall parlance, this rule is written as:

```
deny any from any any to firewall any
```

where **firewall** is the IP address of the firewall itself.

> **NOTE**
>
> In reality, it's not necessary to explicitly state the cleanup rule on most firewall platforms because the firewall software implicitly includes it at the end of the rulebase. However, it's still good practice to include the rule as a written part of the rulebase to remind administrators of its presence.

> **WARNING**
>
> Unlike the cleanup rule, the stealth rule is not a standard part of most firewall rulebases. It must be explicitly stated.

The stealth rule should be the first rule in any firewall rulebase. However, in some cases you may wish to allow limited network connections to the firewall. In this situation, the first rule should explicitly allow those particular connections and should be immediately followed by the stealth rule.

8.5 Chapter Summary

- Perimeter security solutions are the electronic fence that protects networks from external attack. They are usually composed of a number of devices including border routers, proxy servers, and firewalls.

- Routers are primarily intended to efficiently route traffic between networks. They also have the capability to serve as security devices in a limited capacity by acting as packet filters.

- Proxy servers make requests to Internet servers on behalf of internal clients, which provides two benefits: They enhance network performance and mask the identity of the requestor.

- Firewalls are security devices responsible for screening traffic entering and/or leaving a computer network. They consist of an engine that makes decisions based upon a firewall rulebase.

- Hardware firewalls perform more efficiently (but at greater cost) than software-based firewalls.

- Packet filtering firewalls analyze information found in packet headers to make security decisions. Stateful inspection firewalls are capable of monitoring connection status and incorporating that information into the decision-making process.

- Bastion host firewalls operate at the perimeter of the network and sit between the Internet and the protected network. The screened subnet topology adds a third network card to implement a neutral DMZ. The dual firewall topology uses two firewall systems to implement the DMZ.

- Firewall rulebases normally contain two special rules. The cleanup rule denies any traffic that is not explicitly permitted. The stealth rule prevents direct connections to the firewall itself.

8.6 Key Terms

bastion host: A firewall that uses two network cards to connect an external network to a protected network.

cleanup rule: A firewall rule that denies any traffic that is not explicitly permitted by previous rules.

demilitarized zone (DMZ): The screened subnet that hosts publicly accessible servers in a screened subnet or dual firewall topology.

dual firewalls: The use of two firewall systems containing two network cards each along with an intermediate DMZ to protect an internal network from an external network.

egress filtering: The use of a security device to filter traffic leaving a network.

firewall: A network security device (hardware or software) responsible for screening traffic entering or leaving a computer network.

proxy: A network security device that interacts with Internet servers on behalf of internal clients, hiding the true identity of the client and providing performance benefits.

router: A networking device that ensures traffic is passed efficiently from network to network and also provides limited security capabilities.

rulebase: The component of a firewall that contains the customized decision-making rules used to determine whether traffic is permitted or denied.

screened subnet: A firewall that uses three network cards to connect an external network, a protected network, and a DMZ.

stealth rule: A firewall rule that prevents direct connections to the firewall itself from external hosts.

8.7 Challenge Questions

8.1 What is the minimum total number of network interface cards used in a dual firewall topology?

 a. 2

 b. 3

 c. 4

 d. 6

8.2 Which one of the following is *not* commonly used to prevent malicious activity from entering a network?

 a. Router

 b. Intrusion detection system

 c. Firewall

 d. Proxy server

8.3 Which of the following security activities may be carried out by a router? (Choose all that apply.)

 a. Packet filtering

 b. Stateful inspection

 c. Anti-spoofing

 d. Intrusion detection

8.4 John is the security administrator for a network that has exclusive use of the 129.83.0.0 IP address range. The network is connected to a trusted network in another city that uses the 129.84.0.0 address range. He would like to configure egress filtering on his network. Which one of the following rules achieves that goal?

 a. Block inbound traffic from any source with a 129.83.x.x address.

 b. Block inbound traffic from the Internet with a 129.84.x.x address.

 c. Block outbound traffic to the Internet with a 129.83.x.x address.

 d. Block outbound traffic to the Internet without a 129.83.x.x address.

8.5 Which of the following benefits are achieved by a proxy server? (Choose all that apply.)

 a. Optimizes use of network bandwidth

 b. Prevents denial of service attacks against the firewall

 c. Eliminates the need for a Web browser

 d. Hides the IP address of the true client

8.6 Angie is the network administrator for a small e-commerce business. Her organization uses a screened subnet firewall approach. She's installing a Web server that contains information that should be accessible to external users. Where should she place the server?

 a. On the Internet segment

 b. On the intranet segment

 c. On the DMZ segment

d. On the segment between the two firewalls

8.7 Which of the following statements are true?

a. Only hardware firewalls are capable of performing stateful inspection.

b. Only software firewalls are capable of performing stateful inspection.

c. Software firewalls are typically faster-performing than hardware firewalls.

d. Hardware firewalls are typically more expensive than software firewalls.

8.8 In a typical client/server communication, where the client requests a Web page from a server, how many different ports are involved?

a. 1

b. 2

c. 3

d. 4

8.9 What type of firewall always monitors a connection for the three-way handshaking process?

a. Hardware firewall

b. Packet filtering firewall

c. Software firewall

d. Stateful inspection firewall

8.10 Which of the following firewall topologies may be implemented with the use of only one firewall system? (Choose all that apply.)

a. Dual firewall

b. Screened subnet

c. Bastion host

d. Parameterized network

8.11 Which one of the following ports is likely to be the source port of a client request to view a Web page?

a. 25

b. 80

c. 110

d. 2194

8.12 How many connections should exist between a screened subnet and the protected internal network?

a. 0

b. 1

c. 2

d. 3 or more

8.13 Which one of the following firewall actions results in an error message being returned to the originator of a packet?

a. Deny

b. Ignore

c. Log

d. Allow

8.14 Which one of the following rules enforces the "Deny everything that is not explicitly allowed" policy?

a. Stealth rule

b. Denial rule

c. Cleanup rule

d. Firewall rule

8.15 Which one of the following rules protects the firewall itself from external attack?

a. Stealth rule

b. Denial rule

c. Cleanup rule

d. Firewall rule

8.8 Challenge Exercises

Challenge Exercise 8.1

In this exercise, you will research various commercially available firewall products and compare them to the open-source firewalls netfilter and iptables. You will need a computer with access to the Internet.

8.1 Using your Web browser, research at least four different firewall products available from commercial vendors. You should include at least one hardware firewall and at least one software firewall in your research. Some of the systems you might want to research include:

- Cisco PIX 500 Series Firewalls:
 http://www.cisco.com/warp/public/cc/pd/fw/sqfw500/index.shtml

- Checkpoint Firewall-1:
 http://www.checkpoint.com/products/firewall-1/

- Juniper Networks NetScreen:
 http://www.juniper.net/products/glance/

- Microsoft ISA Server: *http://www.microsoft.com/isaserver/*

If you can't find information on these products, consider another product from the same manufacturer or any of the other products on the market. Product reviews can be found at: *http://www.pcmag.com* and *http://www.zdnet.com*.

8.2 Perform similar research on the open-source netfilter and iptables firewall packages available for Linux systems. Information on netfilter and iptables can be found at:

- *http://www.netfilter.org/*

- *http://linuxgazette.net/103/odonovan.html*

8.3 Compare and contrast the firewall options that you researched. Answer at least the following questions in your comparison:

a. How much does each solution cost?

b. What type of filtering does each firewall perform?

c. How do you apply updates to the firewall?

 d. What are the differences among the packages in the amount of maintenance time required on behalf of the administrator?

 c. What other differences exist among the firewalls you studied?

Challenge Exercise 8.2

In this exercise, you will design a simple firewall rulebase. This is a pencil-and-paper exercise, so you won't need to use a computer or the Internet.

Each firewall application uses its own syntax and procedures for entering rules, so we'll work with a pseudocode-style rulebase for the purposes of this exercise. When designing rules, please use the following format:

```
<action> <protocol> from <source_address> <source_port> to
<destination_address> <destination_port>
```

These fields should be completed as follows:

- <**action**> may be either **deny** or **allow**.

- <**protocol**> may be **tcp**, **udp**, or **icmp**.

- <**source_address**> and <**destination_address**> may be an IP address (including network addresses), an IP address range, or the keyword **"any"**.

- <**source_port**> and <**destination_port**> may be a port number or the keyword **"any"**.

For this exercise, complete the following steps. Unless otherwise mentioned, you should assume that all services are configured in a standard manner. Your protected network includes all hosts in the 129.71.0.0 class B network. The subnet 129.71.12.0 is configured as a screened subnet. The stateful inspection firewall's IP address is 129.71.0.1.

 8.1 Write a firewall rulebase that fulfills the following security requirements:

 a. Allow anyone to access a Web site on a server located at 129.71.12.8.

 b. Allow internal users to access their mailboxes via POP3 on the mail server located at 129.71.12.12.

 c. Allow internal users to send mail via SMTP on the mail server located at 129.71.12.12.

d. Allow internal users to access any Web sites they wish except for that of a competitor located at 12.7.6.15.

e. Allow anyone to send mail into the network via SMTP to the mail server located at 129.71.12.15.

8.2 Ensure that your rulebase contains any "best practice" firewall rules that may not be explicitly stated here, but that are normally used in firewall rulebase design.

8.3 Recall that firewalls process rulebases in a top-down manner. Ensure that your rulebase is ordered in the proper manner.

8.9 Challenge Scenario

Challenge Scenario 8.1

You were recently hired to serve as the security administrator for a new business that will be starting operations in several months. The corporate network must connect offices located in three different buildings in the same city. Due to budgetary constraints, it is not possible to purchase dedicated circuits, and all of these offices must communicate with each other over the public Internet.

The company has four departments:

- Administration
- Operations
- Sales
- Accounting

These departments are distributed among the buildings as follows:

- Building 1: Administration and Accounting
- Building 2: Administration, Operations, and Sales
- Building 3: Operations and Sales

The departments are set up on separate subnets within each building. For example, within Building 1, the Administration department is on a separate subnet from the Accounting department, both physically and logically.

Members of each department should be able to share information with each other seamlessly, without regard to the building they are in. Members of other departments should not be able to access their data.

The organization does not offer any public services to Internet users.

Using the technologies described in this chapter, design a perimeter security solution that meets all of the requirements outlined above.

CHAPTER 9

Operating System Security

After reading this chapter, you will be able to:

- Understand operating system security features and benefits
- Explore basic Windows and UNIX security design
- Recognize and handle Windows and UNIX common risks
- Appreciate the importance and danger of system backups
- Identify risks to data and analyze the cost to control each one
- Prioritize risks by the impact to your system

An operating system is a layer of software between the hardware and user programs. It exists to support all operations and interactions with the system. The operating system is the central entity users and programs encounter when accessing computing resources. It is the operating system that provides the services and paths for access to data and other resources. If the operating system is not secure, there can be no guarantees that any resource managed by the operating system is secure.

In order to implement any security controls, you first need to understand how operating systems ensure the security of their own resources. Then you can start creating secure infrastructures on which you can build a more secure computing platform. Without knowledge of how your operating system approaches security, you will have a difficult time implementing any security controls. This chapter introduces basic operating system security and discusses how to identify common vulnerabilities.

9.1 Operating System Security Terms and Concepts

The primary purpose of an operating system is to provide user programs with controlled access to hardware components. These components include **primary storage**, **secondary storage**, **processors**, **input/output devices**, and **network components**. Table 9.1 lists and defines the major system resources an operating system manages.

Another important function of an operating system is to ensure the security of all resources and the data they contain or process. Older operating systems focused their security efforts at ensuring data confidentiality. The largest concern was making sure only authorized users could see sensitive data. As operating systems and networking matured, many more security issues required consideration. Current operating systems must do far more than just impose strict access control. In addition to confidentiality, the operating system must ensure data integrity and availability. Data integrity ensures that no unauthorized changes occur to protected data. Data availability ensures that all mechanisms are in place and working properly to allow access to desired data whenever it is needed.

An operating system must perform four basic security functions to support the confidentiality, integrity, and availability of data: positively identify a user, restrict access to authorized resources, record user activity, and ensure proper communications with other computers and devices. The last function is

TABLE 9.1 Major Operating System Resources

Resource	Example	Description
Primary storage	Random Access Memory (RAM)	Physical memory that resides in the computer and is easily accessible by the processing unit. Primary storage is volatile and the contents are lost when power is removed.
Secondary storage	Disk drives, floppy disk drives, CD-ROM drives, magnetic tape drives	Nonvolatile storage for data. Includes both fixed and removable random access and sequential storage.
Processor(s)	Central processing unit (CPU)	The component(s) where instructions are executed. There may be several CPUs, as well as other special-purpose processors.
Input/output devices	Keyboard, monitor, printer, mouse, scanner	Any device used either to collect data from the outside world or to present data to the world.
Network components	Network interface card (NIC)	Hardware device that connects the computer bus to an external network using either cables or wireless connections.

overly simplified. An operating system not only must ensure that data is secure when it resides on the system, but also must provide a way to securely send the data to another system. These four functions make up the core of the operating system's responsibilities, at least with respect to security. We will discuss how these functions are implemented in the following sections.

9.2 Organizing System Security

If you look at each of the basic four security functions, you see how an operating system approaches protecting data security. First, the system identifies a user. This can be accomplished through various means, as we discussed in Chapter 2. Regardless of the identification methods the system uses, we can assume that the access controls positively identify a user. The

next step is to authenticate the user. The authentication generally requires users to provide some additional information to prove they are who they say they are.

The third step, after we have identified and authenticated a user, is to authorize the user for a specific access. This decision is based on rules, which can be based on the user's identification, role, or some criteria involving the security label of the object. (Remember that the subject is the user, or entity, that requests access. The object is the entity the subject is attempting to access.) It is on this process of authorizing a subject that we focus most of our attention in this chapter. It is the responsibility of the operating system not only to restrict object accesses to authorized users, but also to record accesses for later auditing. At the same time, the operating system security controls must discard invalid requests in such a way that the system allows valid requests to be processed in a timely manner. In other words, the operating system security control software has its work cut out for it!

As with most computer science topics, the security functionality of operating systems is generally layered. The software sits between the user request and the drivers that access the resources. The layer that intercepts all requests is called the **reference monitor**, which is the collection of methods, or functions, that actually perform the authorization of each object request. The reference monitor is part of the **security kernel**, which is the part of the operating system that handles all security issues. The security kernel handles authorization, as well as outcome conditions (positive and negative) and auditing. Although much of the security kernel is part of the core operating system, it can incorporate external components that extend its capabilities.

After the security kernel initially authorizes a resource request, the request passes to a target operating system layer. Current operating systems employ at least two distinct layers—the user layer and the kernel layer. The user layer is the part of an operating system at which application programs operate. Instructions carried out in the user layer operate at a restricted CPU level. User-layer programs generally cannot execute many potentially dangerous instructions. Kernel-layer programs are generally utilities and drivers that can execute privileged CPU instructions. Kernel-layer programs need a higher level of privilege to carry out many operations that directly affect hardware devices and memory. Due to the potential danger

of allowing programs to run in kernel mode, this type of program is generally reserved for the crucial operating system functions only.

9.3 Built-in Security Subsystems and Mechanisms

Every modern operating system comes with basic security mechanisms out of the box. In fact, current operating systems ship with fairly sophisticated security capabilities. To make installation and general use easier, most operating systems default to low security. It requires a little work to increase the level of security of a new operating system. The process of increasing the level of security is often called **hardening**. This process identifies known vulnerabilities and tries to minimize or mitigate them.

The most common built-in security subsystem is the identification and authentication system. With few exceptions, the first user interaction with an information system is the login prompt. Although workstations may not require logins, it is very common for networked computers and servers to require each user to provide a user name. After the user provides the user name, the operating system prompts for a password. These two items are validated in the stored user database and the user is either accepted or denied. This simple process is common across nearly every current operating system.

The alternatives are plentiful. Instead of providing a user name, you may provide input from a smart card or biometric device. The general idea is the same. You provide credentials and the operating system validates those credentials. The operating system matches your identification and authentication input to stored credentials and decides what to do with you. In most cases, the operating system will either authenticate you at a predefined level of authority or deny your access request. In some cases, such as after recognizing repeated access failures, the operating system may lock the account in question and require additional administration to resolve the problem. As operating systems mature, more and more frontend functionality is being shipped as standard behavior. In addition to the basic user name and password capability, many newer operating systems also come with single sign-on and remote authentication solutions. For example, Kerberos is a network authentication protocol that is available for most UNIX variants and ships with current Microsoft Windows products.

Each operating system boasts unique built-in security features, but generic identification and authentication protocols are common in all current

operating systems. After you get past the authentication controls, the differences start to become more evident. Before you ever start to harden a system, make sure you are comfortable with the security services your operating system provides. Proper operating system security implementation will always be more secure and more efficient than security layers added on to hide poor planning. Although you can download and implement many third-party security strategies, first make sure your own operating system cannot do what you want.

9.4 System Security Principles and Practices

A secure operating system is always a result of solid planning. Security planning starts with an understanding of your security risks. We will cover risk assessment techniques later in this chapter. For now, just consider risk assessment as a way of identifying and ranking all of the risks to your data. You will need to evaluate and analyze each risk to identify one or more techniques to handle it. As we will see in the risk assessment section, there are several alternatives to handling risks. Let's assume we are going to use a control to handle each risk. A control is any mechanism that limits access to an object. It can be a software control or some other type of control, such as a locked door (a physical control).

After you have identified all of the risks and methods of handling those risks, you can start implementing the controls that will mitigate identified risks. The process of implementing controls increases the overall security of a system and makes it more difficult to penetrate. This process should take place only after careful study of the risks to your organization. Do not blindly follow the "Hardening Your Computer in 10 Easy Steps" checklist (although such a checklist is better than doing nothing). The steps included on such a checklist are probably the most common vulnerabilities, but you need to know what risks affect your specific organization before implementing controls. If you would like to see the top 20 security vulnerabilities for both UNIX and Microsoft Windows operating systems, go to the SysAdmin, Audit, Network, and Security Institute (SANS) and Federal Bureau of Investigation (FBI) Twenty Most Critical Internet Security Vulnerabilities page at *http://www.sans.org/top20/*.

After hardening your operating system, it is time to test the results. Remember that additional controls restrict access to objects, so it is possi-

ble that you have restricted access to such a degree that your system does not operate properly. Fully test all system access operations after you implement or modify any security controls. After testing the security controls, the next phase is security training and general system operation. Always provide training for any changes to the system.

These principles are generic for all operating systems. Identify risks and then select the best control to handle each risk. After you have completed the implementation phase, evaluate each control to make sure that it not only performs properly, but also handles the risk it was selected to resolve.

9.5 Windows Security Design

Our discussion up to this point has been generic and is applicable to any operating system. Now, let's take a closer look at Microsoft Windows security design. The Windows security model differs among the various Windows products. You will find the biggest differences between the workstation and server products. This difference makes sense because each class of computers exists for different purposes. Workstation computers often act as access subjects, whereas server computers are the objects. Because we are most concerned with data stored on the server platforms, we'll look at the Windows server security design.

Windows server security is built on the concept of the **Active Directory**. Windows Active Directory is a structure that allows easy addressing and accessing of objects across a network. Active Directory is not the only directory service. Other vendors such as Netscape iPlanet and Novell NDS products also provide similar services to Active Directory. An administrator creates a logical group of network resources called a **domain**, which forms the basic grouping of systems in the Active Directory structure. Network resources can be computers, printers, users, or even other directory objects. Domains can be grouped together into trees and forests, which are hierarchical groupings of systems. Active Directory also allows domains to form direct trust relationships with other domains, regardless of their location in a forest.

The purpose of the logical groupings of systems is to ease administrative burdens by allowing administrators to apply group attributes to several objects. Each file, folder, share, and printer is an Active Directory object. Each object has an associated **discretionary access control list (DACL)** that specifies which subjects can access the object. The subjects can be

listed as users, groups, or computers. The DACL can restrict access at the object class, object, or object attribute level. Because subjects and objects each have multiple levels (e.g., user, group, computer), the access controls are very flexible and can be detailed and tedious. You may also note that the possibility exists for conflicting entries. What if Mary is granted permission to modify ReadMe.doc, but the programmer group is not? If Mary is a member of the programmer group, which rule wins? Because Active Directory uses inheritance to "build" access rules, the more specific rule would win. In this case, Mary would retain her right to write, because the user is more specific than the group. However, the rule changes slightly if the programmer group has been specifically denied access to the ReadMe.doc file. Although most rules do build hierarchically, the Deny rule takes precedence. If the programmer group was specifically denied access to the ReadMe.doc file, Mary would not be able to access the file as long as she remains a member of the group.

Inheritance allows rules to be specified at the domain level and implemented with a minimum amount of administrator maintenance. All an administrator should have to maintain are the exceptions to the generic access permissions. Each object can specify rights for subjects, after the initial access has been granted. Active Directory provides the framework for specifying, storing, addressing, and querying object access information in a networked environment. The actual object information is stored in a database that can be distributed, so access to the authentication information creates no bottlenecks or single points of failure.

For local security, Windows uses locally stored security objects. For either local or domain security, the administrator maintains individual security object attributes through the Microsoft Management Console (MMC) snap-in. The MMC is the primary interface for defining and maintaining **Group Policy** objects, which define the security settings for a specific system event, by user group. Figure 9.1 shows the Local Security Policy object for shutting down the system.

When any resource request that requires authorization occurs, Windows evaluates the currently logged on user and the group membership to allow or deny the action. In a networked environment, these settings would be inherited in object settings from the domain. Higher-level security settings

Figure 9.1
Windows XP Local Security Policy setting

are maintained in a similar fashion through the MMC on domain controller computers.

9.6 UNIX and Linux Security Design

Unlike Windows systems, which associate security with events and groups, UNIX and Linux systems construct basic security around the file. In fact, in a UNIX system, everything is a file. (For simplicity, we will refer to both UNIX and Linux variants as UNIX.) In UNIX, files are files, devices are files, directories are files, and even running processes are files (at least the presentation makes it look that way). This simplifies many administrative tasks in UNIX. It also makes understanding file permissions crucial to successful system administration. The vast majority of all UNIX administration difficulties are related to file permissions. So, let's take a look at UNIX files and the permissions associated with them.

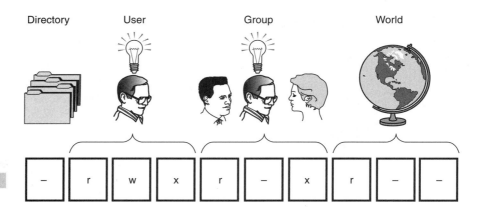

Figure 9.2
UNIX file permissions

Figure 9.3
UNIX file listing with mode fields

Each file in a UNIX file system has a permission setting, or **mode field**, associated with it. The mode field consists of 10 characters that specify the security access and other special characteristics for a file. Figure 9.2 shows what each mode field means. In this example, the object is a file. (There is no "d" in the first field.) The permissions allow the file's owner to read, write, and execute the file. The permissions allow users who belong to the file's group to read and execute the file. All other users have only the read permission.

TABLE 9.2 UNIX File Mode Field Components

Position	Values	Description
1	- —Regular file d—Directory l—Symbolic link b—Block special file c—Character special file	The first character of the file mode field indicates the type of the file. These are just some of the various valid file types. There are a few other advanced types. The file type can affect how the permissions are implemented.
2 to 4	r—Read permission w—Write permission x—Execute permission - —No permission	Access permissions for the file's owner. Permissions can be combined; for example, *rwx* indicates the file's owner can read, write, and execute the file. The permission *r--* would allow the user only to read the file.
5 to 7	r—Read permission w—Write permission x—Execute permission - —No permission	Access permissions for users that belong to the group the file is assigned to.
8 to 10	r—Read permission w—Write permission x—Execute permission - —No permission	Access permissions for users who are neither owners of the file nor members of the file's group.

You can see the mode field for a file with the listing command ls -l *filename*. Figure 9.3 shows a typical listing with file mode fields.

The mode field consists of four parts that specify the special characteristics of the file and access permissions for the file's owner, group, and the rest of the world. Table 9.2 describes each part of the mode field.

UNIX puts all the characters together to form a mode field for each file. For example, consider the following line from the **ls** command:

```
-rwxrw-r-- 2 michael gstud 7394 Sep 15 14.45 signals.sh
```

This output gives information about the signals.sh file. This file is owned by the user *michael* and the group *gstud*. The file is 7,394 bytes in size and was last modified on September 15, at 2:45 P.M. For this discussion, the

most important information is the mode field. The mode field, "-rwxrw-r--", shows that the file's owner can read, write, and execute the file (rwx). A user who is a member of the *gstud* group can read or write this file (rw-). Any other user can only read the file (r--).

Remember that all file access is governed by the user's identity and group membership. UNIX uses identity-based access control for basic resource protection. Although you can add other layers of controls to a UNIX system, you will go a long way toward understanding the basic security design by really studying file permissions.

9.7 System Backups

Any discussion of operating system security would be incomplete without a discussion of **system backups**. A backup of the system is a partial or complete copy of the system, typically stored on removable media. The purpose of a backup is to provide a secondary copy of your entire system to use in case of the loss of your primary copy. There are many reasons why you could lose your primary system copy. Your server could suffer a disaster that renders it useless, a malicious attack could destroy critical data, or the hardware could just fail. In any case, the ability to recover depends on the existence of a secondary copy.

A system backup can be your best insurance and your worst vulnerability. The insurance part is easy to understand. When you lose your primary copy of any data, the first place to turn is to your most recent backup. There are other options, though. For example, redundant systems can provide the same coverage as a backup. The cost can be much higher for such systems, but the recovery time will generally be much shorter. Even for systems that contain redundant components, the tried and true system backup provides a stable secondary copy of your system.

So, how can it be your worst vulnerability? The key to system backups is that they are universally created on removable media. This is done to allow the media to be physically transported to a remote location. If a fire or tornado destroys the data center, the backup will survive. The problem is that you have created a portable copy of your data. Unless you maintain strict physical controls on the transportation and storage of your backups, they could fall into the wrong hands. If you wanted to steal sensitive data, do you think it would be harder to get to the data in the data center or to pick up a system backup?

Even if confidentiality is not your primary concern, a full system backup contains enough information to possibly assist an attacker in launching an attack on your live system. The moral of the story is to protect your backups!

When you do create backups, you should never consider the process complete until you verify the media. All too often, backups are created day after day on bad media. No one takes the time to verify the media, so there really is no backup at all! Make sure the backup utility you use allows you to verify the contents of the media after the backup completes. The worst time to find out your backups are bad is the one time you need them. Plan your backup schedule, regularly introduce new media, label the media, and store the backups in a secure location. A good backup is an integral part of a recovery plan. Take steps to ensure your backups are complete and secure.

9.8 Typical System Security Threats

The overall goal of system security is to protect data from threats. There are many threats to the data stored in an information system, and all center around one of two themes. A threat either allows a subject to exceed authorization levels and perform unauthorized acts or denies authorized subjects from authorized resource access. Some threats are intentional, whereas others are unintentional. This section presents three common security threats that will allow someone to perform unauthorized acts.

9.8.1 Bugs

The first type of threat is the **software bug**. A software bug is any flaw that causes unexpected behavior. Bugs may cause software to return unexpected results, halt processing, or even crash. In general, software bugs are caused by sloppy programming techniques. Software developers are responsible for producing code that runs correctly for all input and processing conditions. This may seem like a straightforward endeavor, but it can be quite complex. However, it is possible. Developers who learn to program well can create far more stable code than those who just program haphazardly.

The term *computer bug* is attributed to Grace Hopper and the Mark II computer in 1945. A system malfunction was traced to a moth stuck in an electrical relay. When the bug was removed, the system worked fine. Thus, the term *debugging* was born. The actual bug and the logbook page to which it is glued are in the Smithsonian Museum of American History.

Bugs pose a security threat because of the opportunities they provide for attackers. A bug that crashes a program may leave the user running the program at a shell with higher authorization than normal. If the program crashes while executing privileged instructions, the bug could allow an attacker to bypass all access controls. The attacker could use the elevated authority to compromise data and other trusted systems.

Because bugs can pose such a large security risk, the best way to handle them is to prohibit their introduction. You can severely limit the number of bugs in software by training programmers to write solid code, following formal software development methods, and completely testing all software before it is released. These steps are extensive and time-consuming; however, the payback is that far fewer resources are required to isolate and fix bugs in released code.

9.8.2 Back Doors

Another type of common threat is the back door. A back door is a direct entry point into software that bypasses some, or all, of the security controls. The purpose of the back door may be innocent. Many software developers include back doors to avoid having to deal with security controls during development and testing. The back door may have been left in by accident. It may also have been left in as a "secret" entry point after implementation. Even if the purpose of the back door is not malicious, it is a large security threat. The back door may be used by its originator for unethical purposes, or it may be discovered by an attacker and used. Either way, it poses a security threat that must be contained. Formal testing should find most back doors. When you find them, you must remove them. Giving an attacker a way to bypass security controls is a very bad practice.

9.8.3 Impersonation or Identity Threat

The last of the three common threats is **impersonating** or hijacking a user's identity. By far the easiest way to realize this threat is to compromise someone's password. Walk through any office and you will likely see several passwords written on Post-it notes and attached to computer monitors, desktops, or bulletin boards. They are there for the taking. After you know someone's user name and password, you can "become" that user. There are many ways to compromise a user's identity, including "asking for it," uncovering it from a written note, and "cracking" it using one of several techniques to figure out the password. We will discuss another covert method of compromising a password, called keystroke logging, in the next section.

In addition to the obvious problems with identity theft, there is also the problem of monitoring and the ability to audit a user's activity. If an attacker is using Fred's user name, all audit logs will contain activity that represents Fred's activity as well as the attacker's. It becomes difficult to separate the two. Make sure you aggressively protect all user names and passwords. Teach your users about the importance of password security. The best way to handle impersonation is to take steps to avoid accidental disclosure of any personal information.

9.9 Keystroke Logging

As mentioned in the previous section, **keystroke logging** is a collection of methods of intercepting keys a user has typed. You can install software and hardware keystroke monitors on a computer to intercept and store all keystrokes a user enters on a computer. You can also use a video camera focused on the user's keyboard, although this method is less precise. The software keystroke monitors act as drivers and require privileged access to the operating system to install. Hardware devices simply plug into the keyboard port on the computer itself. The hardware devices are by far the easiest to install if someone has physical access to the computer. Regardless of the type, their purpose is to track and store each keystroke in a log file for later analysis.

There are generally three reasons a keystroke monitor would be used on a system:

- **Testing and quality assurance:** When testing software, it is desirable to perform the same tasks repeatedly. Saving the end user inputs and replaying them multiple times is less tedious, more precise, and removes many human errors that manual typing can introduce into the testing process. This use of keystroke monitoring is common.

- **Evidence collection:** When a user is suspected of illegal or inappropriate activity, it may be necessary to collect evidence for legal or disciplinary action. One method investigators use to collect evidence is the keystroke monitor.

- **Malicious attacker:** An attacker can monitor all user keystrokes and use the resulting log to extract passwords, credit card numbers, and many other types of personal information. The keystroke monitor requires the attacker to first compromise the computer by installing the device or software, and then to compromise the system again to retrieve the information. Two-factor authentication minimizes the

success of this type of attack. Proper physical security and access controls can reduce the risks of keystroke monitoring. In addition, you have to train all users on security risks and ensure they understand their part in the overall security of the system.

9.10 Well-Known Windows Risks

Security risks exist for all operating systems and are not new. In fact, several resources maintain up-to-date lists of the most common risks for specific operating systems. It is important to know what the most common risks for your operating system are because attackers know. In fact, most attackers identify victim computers by scanning a large number of systems for the most common vulnerabilities. The rationale is that it is easier to pick the "low hanging fruit" first.

The SANS Institute and the FBI joined forces to create the SANS/FBI Twenty Most Critical Internet Security Vulnerabilities list. The list combines the most frequently realized threats for Windows and UNIX systems. You can find the most current list (and vulnerability details) at *http://www.sans.org/top20/*. The following is a brief recap of the most common vulnerabilities for computers running a Windows operating system, listed in decreasing order of severity:

1. **Internet Information Services (IIS):** IIS, Microsoft's Web server, is prone to several different vulnerabilities, including poor behavior when handling unexpected requests and buffer overflows. It is also very common for administrators to leave sample users and applications unprotected after installing IIS. With the exception of Windows Server 2003, IIS is installed by default on Windows server operating systems. This default installation often causes administrators to overlook configuration details.

2. **Microsoft Data Access Components (MDAC)—Remote Data Services:** Older versions of MDAC contain a vulnerability that allows attackers to run commands locally with administrator privileges. Your databases could be vulnerable to attacks that target this vulnerability.

3. **Microsoft SQL Server:** MSQL has several commonly known vulnerabilities that allow attackers to access database contents. The vulnerabilities include issues with open ports and insecure default users and sample applications. Several types of malicious code target MSQL vulnerabilities.

4. **NetBIOS—Unprotected Windows Networking Shares:** Windows provides an easy method of allowing remote computers to access, or share, local resources. This feature is most commonly used with shared folders and printers. The sharing mechanism, if improperly configured, can allow a remote attacker to take full control of the host file system.

5. **Anonymous Logins—Null Sessions:** Windows uses logins with no associated user IDs to gather information about a computer and perform some connection services. These logins are called null sessions. Because null sessions allow access to valuable information such as user and group accounts and shares, they provide an attractive entry point for attackers.

6. **LAN Manager Authentication—Weak LM Hashing:** Windows includes support for legacy LAN Manager authentication, even though few systems really need it. The weaker passwords associated with LAN Manager make cracking any stored passwords fairly easy with current computers. A cracked password could be used to gain access through this legacy system.

7. **General Windows Authentication—Accounts with No Passwords or Weak Passwords:** Amazingly, many systems have accounts with no passwords at all! Other accounts have passwords that are easy to compromise. Although well understood, this vulnerability just will not go away.

8. **Internet Explorer:** The World Wide Web's popularity makes Web-related attacks extremely popular. Because Internet Explorer is the most popular user interface to the Web, it is a very common target of Web attacks. The product has several security vulnerabilities of different types, mainly due to its advanced functionality and scripting capabilities.

9. **Remote Registry Access:** The central configuration database for computers running a Windows operating system machines is the registry. Any changes to the registry can dramatically change the way a system works. Improper security settings can allow remote users to modify critical registry settings.

10. **Windows Scripting Host (WSH):** The Windows Scripting Host allows computers running a Windows operating system to execute

any text file with an extension of .vbs. Such files are intended to be Visual Basic scripts. Older versions of Windows can be susceptible to attacks by Visual Basic scripts run through the WSH. Many malicious code attacks use this vulnerability, including the famous "Love Bug" worm.

It is important that you understand the most common vulnerabilities for your system, and the appropriate protection measures you must take. Ignorance is no protection at all. In fact, if attackers know more about your system than you do, there is a good chance your system will be the victim of an attack sooner, rather than later.

9.11 Well-Known UNIX Risks

The SANS/FBI Twenty Most Critical Internet Security Vulnerabilities list also includes the top vulnerabilities for UNIX systems. You can find the most current list at *http://www.sans.org/top20/*. The following is a brief recap of the most common vulnerabilities for UNIX computers:

1. **Remote Procedure Calls (RPC):** RPCs allow a user on one computer to run a command on another computer. The protocol often ends up running the command on the target computer with *root* privileges. This can allow an attacker to compromise older RPC software and gain root privileges and run any desired software.

2. **Apache Web Server:** Although most security professionals consider the Apache Web Server to be more secure than IIS, it still has vulnerabilities and can be configured to be insecure. In fact, the perception of its superior security often lulls administrators into a false sense of security and encourages them to ignore basic security configuration.

3. **Secure Shell (SSH):** To avoid the many security vulnerabilities associated with other remote access software, most administrators have turned to SSH. Although SSH is far more secure than its alternatives, it still contains some software vulnerabilities. As with Apache vulnerabilities, attackers know that the perceived higher security makes some administrators lazy.

4. **Simple Network Management Protocol (SNMP):** SNMP is used throughout networks to monitor remote network devices. Several

vulnerabilities in older SNMP implementations open the door for different types of network attacks.

5. **File Transfer Protocol (FTP):** FTP is the most common method used to transfer files. Vulnerabilities exist both in the authentication process and in the file transfer process. FTP sends password in clear text to the server. A sniffer utility that picks up network packets can read passwords. Authentication issues can divulge user credentials, and software vulnerabilities can allow attackers to gain root privileges.

6. **R-Services—Trust Relationships:** Older systems commonly used several "R-services" to access services on remote computers. These include remote shell (rsh), remote copy (rcp), remote login (rlogin), and remote execute (rexec). These services allow trust relationships to negate the demand for authentication each time a command is issued. The trust allows attackers to impersonate a trusted computer and gain higher authority with no authentication.

7. **Line Printer Daemon (LPD):** This daemon allows remote users to connect and submit print jobs. Buffer overflows exist that allow attackers to gain root privileges.

8. **Sendmail:** The popularity of the sendmail program makes it a common target. Attackers can target older versions of the program to create buffer overflows or use other vulnerabilities to launch e-mail attacks.

9. **BIND/DNS:** Similar to the sendmail vulnerabilities, older versions of BIND/DNS can allow attackers to launch various types of attacks due to vulnerabilities in the software.

10. **General UNIX Authentication—Accounts with No Passwords or Weak Passwords:** Amazingly, many systems have accounts with no passwords at all! Other accounts have passwords that are easy to compromise. Although well understood, this vulnerability just will not go away.

As with Windows vulnerabilities, it is important that you understand the most common vulnerabilities for your UNIX system, and the appropriate protection measures you must take. Regardless of your operating system, vulnerabilities exist and must be addressed. Learn what steps you can take and make every effort to implement and maintain the appropriate countermeasures.

9.12 System Forensics: Scanning and Footprinting

At different times in the life of a computer system, it becomes necessary to assess its current status. This may be for purely preventative purposes or as part of an investigation. From time to time, it becomes necessary to locate and analyze data that provides status information. The process of identifying, extracting, and documenting data, searching for evidence of some specific activity, is called **computer forensics**. The process includes extracting the contents of log files and file systems to see what exists on a system and what users have been doing.

One purpose of such an analysis is to document the current status of a computer. This information can be used for later comparison and is useful for detecting unusual activity or changes in system performance. Extracting and documenting the state of a system is called **system footprinting** or baselining. A system footprint is a collection of data that realistically represents the state of a computer at a certain point in time. A good time to collect a system footprint is right after a system is fully configured, tested, and up and running. Later footprints can be collected and compared to the original to document any changes in state or use.

When inappropriate or illegal activity is suspected, one of the first steps you should take is to begin an investigation. One crucial component of the investigation involves extracting log files and other data that document a user's activities. There are few actions you can perform on a computer without creating multiple log file entries. These activity files provide a wealth of information for investigators with the appropriate tools and knowledge. System forensics is a growing discipline and is used in many investigations to collect evidence of suspected behavior.

9.13 The Security Auditor's Role

Although it is the responsibility of security administrators to implement security controls, some type of entity must validate the effectiveness of controls and the level of compliance with the controls. That is the role of the **security auditor**. In all but the smallest organizations, it is best for the security auditor and the security administrator to be separate people.

The security auditor is not the "bad guy." This crucial role assesses how effective your security controls are. An ineffective security control is a waste

of time and organization resources. Without ongoing security auditing, an organization has no way of knowing whether a control is doing its job. If a control does not provide the necessary amount of protection, it needs to be evaluated. The problem could be compliance or the control could just be inappropriate. Auditors collect the information necessary to determine why a control is not doing its job.

Another crucial role the security auditor provides is that of satisfying legal requirements. Depending on the organization, there may be many statutory and regulatory requirements to provide assurance of data security. Even if the organization is not compelled by law or regulation to provide proof of data security compliance, most courts of law will look at auditing activity during legal proceedings. Your organization may one day become a party to a lawsuit involving information security issues. Any prior security auditing can demonstrate the importance your organization places on security issues. Just the existence of formal auditing can make a difference. Organizations that do not make a formal attempt to address security issues may be found guilty of negligence if any damages result from their lack of controls. The security auditor provides a layer of protection and assurance.

9.14 Assessing Security Risks

Before any organization can implement appropriate controls, it must decide what risks are the most likely to cause damage to its systems. Although it would be nice to protect your organization from every known risk, time and budgetary constraints make that endeavor impossible. You have to hit the ones that will hurt you most. The process of identifying and ranking security risks is called risk assessment. Risk assessment starts with identifying all potential threats that could cause a loss of data, including natural disasters, malicious activity, man-made threats, and external threats. There are many threat lists you can use as a starting point, but the final product will be specific to your organization.

Even before listing all the threats, you must list the assets you wish to protect. This list comes from an analysis of your business process and a determination of what is important. Decide what assets are critical to the operation of your organization and put these at the top of the necessary assets list.

The specific threat list should contain any event that could result in data loss, even temporarily. Try to cover all threats, regardless of likelihood or

severity. You will rank the threats later. When developing your threat list, make sure you have the input of every operational unit in your organization, as well as all levels of management. This is not the time to be exclusive. Collect as much information as you can before you move to the analysis phase.

Remember that risk assessment is a time-consuming task and will require substantial resources when it comes time to implement any chosen controls. Including upper management in the planning team is the only way to ensure you will have the resources you need. Excluding upper management can delay or derail your planning efforts. Carefully consider your planning team and include everyone who has business knowledge to contribute. Although you will end up with a longer list, the effort can make your system more secure by handling more risks.

After you have a list of the risks to your data, you have to determine which ones to address. It is very unlikely that you will be able to address all of the risks on your list, so you need a method to compare the risks and form priorities. Two basic techniques are used to analyze risk: quantitative risk analysis and qualitative risk analysis, which were discussed in Chapter 1. Each type of analysis has its strengths and weaknesses and should be used in the appropriate situations. To conduct a complete risk analysis, you should include both types of analyses.

9.15 Chapter Summary

- The primary purpose of an operating system is to provide user programs with controlled access to hardware components.

- It is the responsibility of the operating system not only to restrict object accesses to authorized users, but also to record accesses for later auditing.

- The most common built-in security subsystem is the identification and authentication system.

- A secure operating system is always a result of solid planning.

- Windows Active Directory is a structure that allows easy addressing and accessing of objects across a network.

- Each file, folder, share, and printer is an Active Directory object. Each object has an associated Discretionary Access Control List (DACL) that specifies which subjects can access the object.

- UNIX and Linux systems construct basic security around the file.

- A system backup can be your best insurance and your worst vulnerability.

- Never consider the backup process complete until you verify the media.

- Typical operating system security threats include bugs, back doors, and impersonation.

- Keystroke monitoring can be used by attackers, as well as by administrators, to monitor a user's activity.

- The SANS Institute maintains a list of the top 20 most common risks for UNIX and Windows systems.

- Most operating system vulnerabilities are due to insufficient administration.

- Quantitative risk analysis is very computation intensive and provides dollar values for losses due to threats and the cost of implementing safeguards.

- Qualitative risk analysis is more concerned with the tangible and intangible impact of a realized threat to an organization, ranked by severity.

9.16 Key Terms

Active Directory: A structure in Windows that allows easy addressing and accessing of objects across a network.

computer forensics: The process of identifying, extracting, and documenting data, searching for evidence of some specific activity.

discretionary access control list (DACL): A security structure that specifies which subjects can access the object.

domain: A logical group of computers, created by an administrator, that forms the basic grouping of systems in the Active Directory structure.

Group Policy: An object that defines the security settings for a specific system event, by user group.

hardening: The process of identifying known vulnerabilities and attempting to minimize or mitigate them.

impersonation: The act of pretending to be someone you are not.

input/output devices: Any device used either to collect data from the outside world or to present data to the world.

keystroke logging: A collection of methods of intercepting keys a user has typed.

mode field: A field of a file that consists of 10 characters that specify security access and other special characteristics.

network component: A hardware device that connects the computer bus to an external network, using either cables or wireless connections.

primary storage: Volatile physical memory that resides in the computer and is easily accessible by the processing unit.

processor: The component(s) where instructions are executed. There may be several CPUs, as well as other special-purpose processors.

reference monitor: The collection of methods, or functions, that actually performs the authorization of each object request.

secondary storage: A nonvolatile storage location for data that includes both fixed and removable drives and devices.

security auditor: A trained and trusted entity that validates the effectiveness of controls and the level of compliance with the controls.

security kernel: Handles authorization, as well as outcome conditions (positive and negative) and auditing.

software bug: Any flaw in software that causes unexpected behavior.

system backup: A partial or complete copy of your system, typically stored on removable media.

system footprinting: The process of extracting and documenting the state of a computer system. Also called baselining.

9.17　Challenge Questions

9.1　What resources do operating systems manage?

　　a.　Encryption keys, storage devices, and network software

　　b.　Primary and secondary storage, software configuration, processors, and communication standards

 c. Primary and secondary storage, processors, input/output devices, and networking components

 d. Input/output devices, firewalls, and network sniffers

9.2 What was the first area of security that many older operating systems addressed?

 a. Confidentiality

 b. Integrity

 c. Availability

 d. Encryption

9.3 What layer of software intercepts all resource access requests to perform authorization of the request?

 a. Control

 b. Security object service

 c. Reference monitor

 d. Security monitor

9.4 What is the common term for increasing the security level of a system by addressing all known vulnerabilities?

 a. Securing

 b. Hardening

 c. Anchoring

 d. Auditing

9.5 What is a control?

 a. A physical device that authenticates users

 b. Any software that limits access to an object

 c. A policy that provides information on how to secure a system

 d. Any mechanism that limits access to an object

9.6 Windows security design is based on what basic concept?

 a. Large market share

 b. Active Directory

 c. File permissions

 d. Access control lists

9.7 UNIX security design is based on what basic concept?

 a. Large market share

 b. Active Directory

 c. File permissions

 d. Access control lists

9.8 What is a Windows domain?

 a. Trusted computers with exclusive user lists

 b. A logical grouping of directory objects that can share security information

 c. Closed networks that do not allow remote connections

 d. Open networks with little security that allow anonymous connections

9.9 What structure does UNIX use to store file access permissions?

 a. Mode field

 b. Group Policy object

 c. Domain

 d. Trusted hosts file

10. Which of the following describe a system backup? (Choose all that apply.)

 a. The only way to recover from data loss

 b. Possibly your best insurance

 c. A potentially serious vulnerability

 d. Nearly failure-proof

11. Which common operating system threat is nearly always due to sloppy programming practices?

 a. Impersonation

 b. Malicious code

c. Back doors

d. Bugs

12. Which of the following are valid uses for keystroke monitoring? (Choose all that apply.)

a. Surveillance of a user suspected of inappropriate activity

b. Testing and quality assurance

c. Information gathering

d. Routine activity monitoring

13. What common threat is pervasive in UNIX and Windows and most often overlooked, but should be easy to fix?

a. IIS Web server vulnerabilities

b. RPC vulnerabilities

c. General authentication—accounts with no passwords or weak passwords

d. Internet Explorer weaknesses

14. If your main goal in risk assessment is to find out the top five most critical risks to your organization, which method would you most likely choose?

a. Quantitative risk assessment

b. Solomon-Chapple ranking system

c. P-ranking assessment method

d. Qualitative risk assessment

15. What type of assessments should you perform when assessing your company's security risks? (Choose all that apply.)

a. Qualitative

b. Quality assurance

c. Quantitative

d. Quality of Service

9.18 Challenge Exercises

Challenge Exercise 9.1

The first step to securing your operating system is understanding its security features. After you understand how your operating system provides resource security, you need to make yourself aware of the current risks for your environment. Unless you are a single-vendor shop, you will likely encounter multiple operating systems in your organization.

In this exercise, you explore some security vulnerabilities in the Windows operating system. You need a computer with a Web browser and Internet access. You will visit the SANS Web site, where you can find many resources that will help you develop your security skills and keep them current. Specifically, you will go to the SANS/FBI Twenty Most Critical Internet Security Vulnerabilities list. This list changes over time, so you might want to bookmark it for later research.

9.1 In your Web browser, enter the following address: *http://www.sans.org/top20/*.

9.2 Scroll down to the "Top 20 List Version *X* Update Log" heading. Briefly review what vulnerabilities have been updated recently. This will give you a feel for what the current security environment is.

9.3 Scroll further down to the "Top Vulnerabilities to Windows Systems." (We will cover UNIX vulnerabilities in Challenge Exercise 9.2.) Read through each of the vulnerabilities to get a general overview of what attackers are looking for. Keep in mind that these vulnerabilities are common on many Windows computers. Think about how you could protect your own computer.

9.4 Choose one vulnerability and read its description thoroughly.

9.5 Write a one-page description of the vulnerability, its potential impact, and countermeasure recommendations to mitigate the risk. Include information from *at least* one additional information source (the vulnerability descriptions provide additional resources).

Challenge Exercise 9.2

This exercise is nearly identical to Challenge Exercise 9.1, except that we focus on the UNIX operating system vulnerabilities. You need a com-

puter with a Web browser and Internet access. You will visit the SANS Web site, returning to the SANS/FBI Twenty Most Critical Internet Security Vulnerabilities list and continuing your research into operating system vulnerabilities.

9.1 In your Web browser, enter the following address: *http://www.sans.org/top20/*.

9.2 Scroll down to the "Top Vulnerabilities to Unix Systems." Read through each of the vulnerabilities to get a general overview of what attackers are looking for. Keep in mind that these vulnerabilities are common on many UNIX computers. Think about how you could protect your own computer.

9.3 Choose one vulnerability that is substantially different from your choice for Challenge Exercise 9.1 and read its description thoroughly.

9.4 Write a one-page description of the vulnerability, its potential impact, and countermeasure recommendations to mitigate the risk. Include information from *at least* one additional information source (the vulnerability descriptions provide additional resources).

Challenge Exercise 9.3

There is no way around it: If you want to properly plan for your system's security, you have to assess the risks to your system. This exercise will take some work. You will perform a quantitative risk assessment for a fictitious organization; however, you can use a real organization if you would like. You have three basic assets you want to protect in this exercise: a database, a server, and a data center. You will evaluate risks to these assets and suggest some controls to mitigate the risks. Be creative, but be realistic. You need paper and a pencil. You can optionally use a spreadsheet to organize your data.

9.1 List each asset (database, server, and data center) and at least three risks to each asset. Use a six-column table with the assets and risks in the leftmost column.

9.2 In the next column, assign a value to each asset.

9.3 In the third column, decide on an EF value for each asset and risk pair. For example, if a fire destroys your building, how much of the building is lost? The answer depends on the severity of the

fire. You may end up (in a real risk assessment) specifying several different types of fire. Do not do that here. Each risk in this exercise should be unique.

9.4 In the next columns, calculate the SLE, ARO, and ALE.

9.5 After you have a completed the asset/risk table, create a new table of controls and their associated costs for each risk you have identified. Create at least two controls for each risk (choices are always good). You only need two columns: Control Description and Annual Cost.

9.6 From your two tables, compare the control cost with the ALE of each risk and make a recommendation for the "best" control for each risk.

9.19 Challenge Scenarios

Challenge Scenario 9.1

You are the security manager of a trucking firm. Your organization wants to expand its scheduling application to allow remote entry and querying via the Internet. Your organization currently uses desktop computers running Microsoft Windows and a combination of Microsoft Windows and UNIX servers for data center operations. Management is concerned about the security of the new system function. It has heard alarming stories about Web server attacks. You have two senior administrators—one a Windows expert and the other a UNIX expert. Needless to say, they have provided you with conflicting recommendations.

Your job is to cut through the marketing hype and figure out whether a Windows or a UNIX system would be best for your new Web server platform. Go to the Internet, do some research, and put a document together that illustrates the pros and cons of UNIX and Windows. Summarize your document with a recommendation on which operating system would best meet your organization's needs.

Challenge Scenario 9.2

Your first task as the new security manager of a trucking firm was to select the best operating system for your Web server. The Web server will support a new Web application that allows scheduling from anywhere on the Internet. Now, you must decide what controls to implement to ensure a secure system. You need to find out what vulnerabilities are common to Web

applications and which ones are the most important for you to control. Your company is concerned about its image and is aware that customer confidence is extremely important to gain repeat business. If a customer has difficulty accessing your Web site, they might go to the competition's site and your organization will lose business.

You have been given the task of assessing risks to the new Web application and ranking them in order of importance. Remember that the intangible costs may be more important than hard costs. You must pay attention to any risk that could result in lost business. Prepare an ordered list of risks and their associated controls (one Internet resource you may find helpful is *www.owasp.org*). Also, present a discussion of your list, explaining why you placed the risks in their final order. Try to include at least 10 risks and suggested controls. You can suggest several controls for a single risk, but include at least five unique risks. In your discussion, point out any areas in which the operating system choice could help alleviate a particular risk.

CHAPTER 10

Securing Operating Systems

After reading this chapter, you will be able to:

- Understand the concepts behind hardening an operating system
- Implement essential elements of a secure operating system
- Recognize the importance of a security checklist
- Implement operating system–specific security features
- Understand basic file system security

Analysis of many systems that have been attacked has produced results that indicate how vulnerable systems can be. The same data points out that simple, but solid, security practices can be extremely effective in stopping or preventing devastating attacks. These findings have resulted in some simple, basic rules that help to keep systems safe. By applying good, solid security practices, you can reduce many of the security risks that can lead to personal or business losses.

An effective security professional must understand the most common security threats and review the security policy to make sure it addresses these threats. This chapter discusses the steps necessary to secure an operating system. We will cover basic strategies to make any operating system secure, and formalize these strategies into checklists that are appropriate for the two most common operating system families—Windows and UNIX.

10.1 Security Maintenance Practices and Principles

The first step toward a secure system is creating a security policy; however, a solid security policy is only a starting point. A security policy mandates actions to implement security controls. You must follow through with the policy-suggested actions and make sure your controls are appropriate and effective. This takes an investment of time and resources. It's not easy to stay current on the latest releases of software and make sure all known security holes are closed. In fact, it can be challenging to just keep up with knowing what the most serious vulnerabilities are. You need to set up a specific strategy for reviewing and updating your software, hardware, and policies; assign tasks to specific people; and set the schedule. It's surprising how many security violations can be prevented by basic proactive security.

Your overall goal is to **harden** your system, which refers to the steps taken to make it more secure. Operating system hardening includes many tasks, such as keeping a sensitive server in a locked computer room, instituting an aggressive password policy, and monitoring network logons. The process of hardening a system is iterative and ever changing. It takes patience and persistence. The payoff is a system that resists attacks and protects the data it contains. To get there, you must evaluate the current level of security, make any necessary adjustments, and test the changes. Then, you do it again.

Where do you start? The same place you started developing your original security policy. You should have started by identifying the threats to your

system and selecting appropriate security controls. After you have been through the process once, reviewing the policy for completeness and effectiveness should be a simpler task. Don't skimp, though. It's important that you maintain a current security policy for it to be effective. Once the policy becomes stale, it loses its ability to ensure a secure system.

10.2 Maintaining the Operating System: Patches, Fixes, and Revisions

Keeping systems secure is a game with very high stakes. You must constantly stay ahead of **crackers** who attempt to compromise your system. A cracker is any person who attempts to access a computer system without authorization. Crackers often have malicious intent when accessing systems. Many people use the term **hacker** to refer to a *cracker*. True **hackers** generally do not have malicious intent and simply enjoy learning minute details of programming and systems in general. However, the terms cracker and hacker are often used interchangeably. Your goal is to avoid becoming an attractive victim. Many dedicated crackers routinely uncover and share **exploits** with fellow crackers. An exploit is a specific procedure that takes advantage of a vulnerability that can be used to compromise one or more security controls to gain unauthorized access to a system. Once crackers take advantage of a newly uncovered vulnerability, the pattern shows up in forensics reports. The game is on. Information about a new exploit becomes mainstreamed, and, after a short period of time (hopefully), the software or hardware manufacturer releases a patch or fix to eliminate the problem. After the vulnerability has been identified and a patch is released, attackers begin to see a diminishing pool of potential victims.

> **NOTE**
>
> Although hardening your system might dissuade some attackers, anyone who has targeted your system for a specific reason will not generally be put off by security controls. An attacker with a grudge against you or your organization can be very persistent.

The most likely time for your system to be attacked is shortly after a new vulnerability is uncovered. It is imperative that you keep current on newly emerging exploits and their countermeasures. Although you cannot make your systems impenetrable, you can make them unattractive enough to discourage many attackers. Because many systems are poorly maintained, an attacker is likely to pass your secure system over for an easier target.

The most basic step in keeping up with emerging threats is to ensure your operating system and software are up-to-date. Consult the Web site of your operating system vendor and the providers of all your critical software to

learn how to remain current. Most vendors offer notification services that inform you when a patch has been released.

Although the sheer number of patches can become overwhelming, make sure you understand what a patch does before installing it. Also make sure you have a valid system backup before installing any new software. Your authors have installed more than one software patch that has rendered their systems unusable. In those situations, a direct recovery path is crucial, which involves access to a current backup. Catalog the software you have installed on your system and keep it up to date. When an attacker scans your system and sees currently patched software, you may be left alone.

10.3 Antivirus Software

The next area of concern is the introduction and proliferation of malicious code, which includes viruses, Trojans, and worms. Of the different types of malicious code (see Chapter 7), the software virus is the most notorious. A basic security policy must implement controls that protect the system from software viruses. **Antivirus software** protects a system from malicious code by identifying and handling files that contain known malicious code. After you install antivirus software on your system, you take three basic steps to ensure it provides the most protection.

First, you examine files for known malicious code. Nearly every antivirus software package has a scanning mode that automatically examines a large number of files. You can scan all files for the most complete examination or just choose to scan the most common types of files that host viruses. Always take the time to scan *all* files. The examination process looks at each file for the existence of known **virus signatures**. A virus can be identified by either the specific instructions it carries out or by the data it uses. Both unique identifiers are called a virus's signature. Antivirus software packages consult a database of all known virus signatures when scanning a system's files. If a file's contents match a known virus, it is flagged as a probable infected file. After you have identified any existing infected files, you need to dispose of them. At this point, you will have a clean system.

The next step is to enable a **virus shield**, which is software that scans all incoming files for known viruses. Files are generally transferred to your system through removable storage devices and network connections. Virus shield software blocks incoming viruses by scanning any files before they

can be stored on your system. After you have scanned a system, the virus shield should keep the system clean.

For the virus scanner and virus shield to be effective, the virus **signature database** must be up to date. A virus signature database is a collection of virus signatures that antivirus scanning software uses as a reference while it scans. If the scanner finds a file that contains a signature that matches an entry in the signature database, the scanner reports a virus. As of this writing, there are more than 57,000 different known viruses. More are discovered each week. If your virus scanner or virus shield uses an outdated signature database, it will not detect the latest viruses. Make sure you keep the signature database current. Most antivirus packages have an option to automatically update the database as new viruses are discovered. After each database update, you need to perform a full system scan to uncover any files infected with new viruses. Of course, scanning only detects malicious code that is already on your system. A virus shield provides real-time scanning that protects your system from becoming infected by inspecting all data entering or exiting your system.

By aggressively scanning your system with a current antivirus product and using a strong virus shield, you will drastically reduce the likelihood your system will fall prey to a malicious code attack. To make your system even more resistant to these types of attacks, train your end users to understand the basics of malicious code attacks and let them know what to look out for. Make sure they know how to recognize suspicious files and how to report them to you. You may have to deal with several false alarms, but you will have a more secure system.

10.4 Applying a Post-Install Security Checklist

One of the best ways to ensure you have done everything you can to harden a system is to develop and use a security checklist. It is nearly impossible to remember ever step necessary to close all of the security holes in a system. A checklist keeps your activities on track and prevents you from forgetting crucial checks and modifications. Always use checklists when you are working on an important task. Just as pilots use checklists for nearly every phase of operations, both ground and air, checklists will simplify important security-related tasks for you.

The real power of a checklist comes from the way it is developed. A good checklist is based on the experiences and perspectives of many professionals.

It should be the summary of past attempts to secure computers and include action items of things to do and things not to do. When security is at a critical point, you can follow a checklist that was developed and tested in a safer environment. The pressure to perform in intense and menacing situations, such as when responding to security incidents (a.k.a *incident handling*), can lead to mistakes that you may not normally make, so a checklist can help you keep things straight. As you accomplish each step, take the time to document your progress and make any appropriate notes. Constantly update your checklists to reflect the latest information and experiences. Just as systems and software are constantly changing, the steps required to secure information will need frequent updates to remain current.

Each operating system has different action items for its security checklists, although many of the concepts are the same. You may find that you need different checklists for different system functions as well. The specific steps you take to secure a Web server computer will likely be different than those for a database server. Although the operating system may be the same, you will probably have different software and access requirements for the two different types of computers. Create and maintain the different checklists you need, but be careful not to create too many. A good checklist is one that continually matures; having too many checklists available makes proper system maintenance difficult.

The first step to creating a security checklist is to start with a standard list. Go to the operating system vendor's Web site and search for "security checklist." Visit other Web sites that provide system administration tips for your operating system as well. Searching for "Windows security checklist" or "UNIX security checklist" using an Internet search engine will return many useful sites. Use the standard checklists as a starting point, and then customize them to fit your environment. To get you started, the following two sections list some basic action items for the Windows and UNIX operating systems. Remember that they are just starting points. You will likely need to add your own custom items to the lists.

10.4.1 Windows Checklist Elements

Securing any computer involves a collection of tasks that result in disallowing any action that could result in harm to the system or the data it supports. That's a broad statement. If you use multiple operating systems in your organization, you need to focus on the specific needs of each operat-

> **TIP**
>
> When using security checklists, you are leveraging OPM (Other Peoples' Mistakes). The best mistakes to learn from are those that others have made. Although you tend to remember the mistakes you make more vividly, learning from the mistakes of others is a lot less painful.

ing system separately. We cover checklist elements for the Windows operating system first. Let's break the tasks down into four basic areas:

- **Hardening the Windows registry:** This is the central database of control information for Windows. There are plenty of settings in the registry to keep you busy.

- **Removing unneeded services:** Always disable any services you do not actually use. You will save valuable CPU time and memory while closing many security holes.

- **Securing networking protocols and services:** Because most attacks come from a network connection, pay special attention to hardening all possible entry points.

- **Securing miscellaneous services, settings, and files:** Address any other configuration settings or programs that could provide an attacker a weak spot to compromise a system.

Windows Registry

The Windows registry is the central repository of system information on Windows operating systems. It is a database of values the operating system uses to do everything from authenticate resource access to track Web addresses you type in. The registry is organized as a collection of values in a tree hierarchy. The values are stored in **registry keys**. To modify keys, choose Start, Run from the Windows desktop, type "regedit.exe" or "regedt32.exe" in the Open text box, and click OK. The Windows Registry Editor opens. There are also several third-party applications that specialize in editing the registry. Use the tool you prefer.

> **WARNING**
>
> Editing the Windows registry can also be categorized as one of the easiest ways to trash a Windows system. Be careful, and always create a registry backup before changing anything.

For more registry information, look at the Registry Guide for Windows at *http://www.winguides.com/registry/* on the Microsoft Web site.

Table 10.1 lists some Windows registry keys you should consider when securing a Windows machine. Note, however, many more registry keys exist that you need to consider as a security administrator. Table 10.1 covers the basic security-related keys.

Explore the registry keys listed in Table 10.1 and decide on the most appropriate values for your organization. Also consult the Microsoft Web site and other Windows-related sites for more in-depth discussions of the Windows registry. In addition, in Windows XP, you can assign 11 permissions to each

TABLE 10.1 Windows Registry Keys That Affect Security

Description	Key Value Names
Prevent access to the content of selected drives	NoViewOnDrive
Restrict applications users can run	RestrictRun
Disable registry editing tools	DisableRegistryTools
Disable the shutdown command	NoClose
Disable the Windows hotkeys	NoWinKeys
Restrict access to the Windows Update feature	NoWindowsUpdate
Manage system policy updates	UpdateMode, NetworkPath, Verbose, Load Balance
Restrict changes to user folder locations	DisablePersonalDirChange, DisableMy PicturesDirChange, DisableMyMusicDirChange, DisableFavoritesDirChange
Implement a user-based custom shell	Shell

registry key. Right-click the mouse on any key and select Permissions. You can specify the permissions for each key that will allow or deny key creation, subkey creation, key deletion, and eight other permissions. Consider using the specific key permissions for keys you want to protect from unauthorized changes.

Removing Unneeded Services

The next part of a solid Windows security checklist is the suppression of unneeded services. A default Windows installation enables services that will attempt to provide the most elaborate functionality—all at a cost. All of these extra services running consume valuable CPU cycles and provide additional opportunities for attackers to compromise your system. In short, extra services provide more system entry points. Make sure you disable all services that you do not need. Table 10.2 lists some common services that may be optional for your system.

TABLE 10.2 Windows Services That May Be Unneeded

Service	Description	Comment
File Sharing	Allows remote users to access local drives and files	Disable this service.
Printer Sharing	Allows remote users to print to a local printer	Disable this service.
Internet Information Services (IIS)	Microsoft's Web server	Unless you are hosting a Web site, do not install this service.
NetMeeting Remote Desktop Sharing	Allows others to share your desktop	Unless you need it, disable this service.
Remote Desktop Help Session Manager	Allows remote support	Unless you need to perform or support remote support, disable this service.
Remote Registry	Allows remote users to modify and maintain the registry	If you do not plan to manage the registry remotely, disable this service.
Routing and Remote Access	Allows for remote access to your system	Unless you need to dial in to your system, disable this service.
SSDP Discovery Service	Supports the Universal PnP Service	Disable this service; closes port 5000.
Universal Plug and Play Device Host	Allows your system to connect to network-enabled appliances	Because there are no practical applications for this service yet, disable this service.
Telnet	Allows remote users to log in to your system	Because all information, including passwords, is transmitted in the clear, disable this service. Use ssh instead.

Securing Networking Protocols and Services

For the remaining services that you did not disable in the previous section, try to limit access as much as possible. This can be accomplished with several checklist elements. The following are a few areas you need to address:

- Use a firewall. You can use either a hardware or a software firewall. Hardware firewalls protect you at all times. A software firewall protects you only when the software is running; therefore, make sure you understand when the software firewall loads. If your system is connected to the Internet, make sure you are using a firewall. Also, make

sure the firewall is properly configured. Aggressively block all unsolicited network traffic and know what you allow through the firewall.

- Disable any networking protocol that you do not need. If you don't use it, disable it.

- Review all services related to remote access and networking to see if you really need each service. Consult the Microsoft Web site for additional information on any service you do not recognize. Before you change anything, create a baseline. (Baselines are discussed in Chapter 11, "Security Audit Principles and Practices.") You always have the option of rolling back to a baseline if you make changes that cause undesirable effects.

Windows Security Miscellany

In addition to the previously listed items, the following are some elements that you cannot ignore:

- Secure the physical computer. Keep unauthorized people away from your computers, especially the servers.

- Keep the Windows operating system patched to the latest release. Microsoft provides update notification through e-mail or direct system messaging. Visit the Microsoft Windows Update Web site at *http://windowsupdate.microsoft.com* for more information.

- Use the Microsoft Baseline Security Analyzer (MBSA) to assess your system's security. Go to *http://www.microsoft.com* and search for HFNetChk. Download, install, and run the application. You will likely be prompted to download and install additional patches.

- Do not set up the Administrator account for daily usage. Create separate user accounts for each user who will access the system.

- Disable the Guest account.

- Ensure all users have passwords and that the passwords adhere to a strong password policy. One way to enforce strong passwords is to run a password-cracking program on your user accounts periodically.

- Install an antivirus software package. Perform a full system virus scan and enable complete virus shield functionality. Make sure the

software and signature database are updated to the latest release. Perform a full system scan immediately after any update.

- Make sure all backup media are protected from damage and theft. A stolen backup tape is as good as getting your hands on the server.
- Enable the Encrypting File System (EFS) for Windows XP.
- Enable system auditing.
- Disable the CD-ROM auto-run feature.

UNIX Checklist Elements

Elements to consider when securing UNIX systems are similar to many of the items covered in the Windows discussion. Although the philosophy is the same, substantial differences exist between UNIX and Windows, so a separate discussion for each environment is required. We won't restate all the basic issues here because many good security practices are consistent across operating systems. In this section, we look at a few of the areas you need to address when hardening a UNIX system.

Removing Unneeded UNIX Protocols and Services

As with any operating system, you should disable any unneeded protocols and services. Unused running programs provide too many opportunities to degrade the overall security of your system. Table 10.3 lists common UNIX services and **daemons** you may choose to turn off. For the most secure system, turn every service off and re-enable only the ones you really need. This approach takes some time to stabilize, but you will identify the services you actually need. For the services started by the inet.d daemon, edit the /etc/inet.d file. Place a pound sign (#) character at the beginning of each line. This turns each line into a comment and stops the service it describes from starting when the system boots. Then, remove the # character from each service description you do want to enable.

Working with TCPWrapper

The most common protocol used by attackers to communicate with a target system is Transmission Control Protocol (TCP). Unfortunately, it is also the most popular protocol for everyone else, too. Disabling all TCP communication would make a system safer, but also render it unable to communicate

TIP

For additional Windows security information, visit the following Web sites:

- Microsoft Security Tools: *http://www. microsoft.com/ technet/security/tools/ default.mspx*
- Microsoft Security Checklists and Resource Guides: *http://www.microsoft. com/technet/security/c hklist/default.mspx*
- LabMice.net Windows XP Security Checklist: *http://www.labmice. net/articles/winxp securitychecklist.htm*
- University of Wisconsin at Milwaukee Windows 2000/XP security Web page: *http://www. uwm.edu/IMT/ purchase/itpsfaqs/ security101.html*

TABLE 10.3 UNIX Services and Daemons That May Be Unneeded

Service	Description	Comment
Telnetd	Allows remote user access	Disable this Telnet daemon. Use ssh instead.
Fingerd	Provides information about users on your system	Disable this daemon unless it is considered essential.
R-commands (rlogin, rsh, rcp, …)	Allow remote users to interact with your system	Disable the commands to reduce password and other data disclosure.
Cron	Executes commands at specified times	Consider disallowing cron for regular users.
RPC	Remote Procedure Call	Disable this service if not needed.
Ftpd	Transfers files using the File Transfer Protocol (FTP) daemon	Disable it if you don't need to provide FTP access.
Trivial ftp (TFTP)	Transfers files using a simpler version of FTP	Disable this program.
UNIX to UNIX copy (UUCP)	Transfers files (older method)	Disable this service.
Sendmail	Sends and forwards e-mail	Disable this service unless your computer processes e-mail. If you need e-mail processing, consider alternatives (qmail or postfix).
NFS, SAMBA, AFS, DFS	Provide network access to files and volumes	Use these only if absolutely necessary. Use with care.

in many cases. There is a way you can have better TCP security without having to give up functionality. First, a good firewall should filter out some traffic before it ever reaches your system. But you still need to examine the packets that get through the firewall. The **TCPWrapper** package gives you the ability to further filter traffic and log any suspicious activity.

TCPWrapper is the more common name of the tcpd daemon that intercepts and examines all TCP traffic and decides whether to accept or deny each request. It does a double-reverse lookup on the sender's IP address to uncover a spoofed address. If the DNS entry and the IP address in the request don't agree, the request is denied and is logged as a failed connect request. If the addresses agree, TCPWrapper compares the source host-

name and requested service with an access control list to see if the request is allowed. If all is OK up to this point, the request is logged, an optional program may be run, and the request is passed to the "real" daemon. The "real" daemon is the target of the original request.

TCPWrapper provides the ability to intercept all TCP traffic and decide on a course of action before it is passed on to another daemon. If the request is suspicious for any reason, the daemon can be configured to drop the request, log the violation, and possibly run a program to notify an administrator and archive the request for later investigation. Keep in mind that any filtering mechanism will result in some false positives. Carefully consider whether you should allow a notification to be sent for every suspicious request. A better way to manage such requests is to frequently review the log files that TCPWrapper produces.

UNIX Security Miscellany

In addition to the previously listed items, make sure you perform the following tasks:

- Secure the physical computer. Keep unauthorized people away from your computers, especially the servers.

- Keep your operating system patched to the latest release. Your operating system vendor's Web site will have information on keeping current.

- Protect your super user IDs and use them only when you must. Create separate user accounts for each user who will access the system. Disable any accounts that are unused.

- Ensure that all users have passwords and that the passwords adhere to a strong password policy. Run a password-cracking program on your user accounts periodically.

- Install an antivirus software package, perform a full system virus scan, and enable complete virus shield functionality. Make sure the software and signature database are updated to the latest release. Perform a full system scan immediately after any update. Software viruses are generally less of a danger in UNIX system than in Windows, but they are still a threat.

- Make sure all backup media are protected from damage and theft.

> **WARNING**
>
> Before you run *any* password-cracking software on a system, make sure you have the permission and authority to do so. Get it in writing. (This warning is important enough to repeat.)

> **TIP**
>
> For additional UNIX security information, visit the following Web sites:
> - UNIX Computer Security Checklist: *http://www.unixtools.com/securecheck.html*
> - Washington University UNIX System Security Checklist: *http://staff.washington.edu/dittrich/R870/security-checklist.html*
> - Astalavista Group: *http://www.astalavista.com/library/hardening/unix/*

- Enable system auditing. Review all audit logs periodically.
- Run vulnerability scanners against your system.

10.5 Understanding File System Security Issues

One of the most important areas of your operating system that you must secure is the **file system**, which is the collection of programs that manages and stores data, or files, on secondary storage devices. The file system software allows us to store data on hard disks and then get that data back later. To make it easy to find files, the file system presents a tree structure of directories and/or folders. Of course, storage devices are not limited just to hard disks, but we'll stick with the simple definition right now. Because the file system processes file access requests, it is responsible for access control and visibility.

> **NOTE**
>
> If you are new to UNIX, a mount point is a directory that is used as the root directory for a file system. For example, common mount points may be: /, /home, and /usr. Each of these directories would reference the root directory of a different device. These directories would be represented as three different drive letters in a Windows system.

Both UNIX and Windows file systems use tree-like architectures to organize files. The entry point to the tree is called the **root directory**. A computer may have several disks, and those disks can each be divided into multiple sections, called **partitions**. Each disk partition generally has a separate file system and its own root directory. In Windows, each file system has its own drive letter (A–Z); UNIX file systems each have their own **mount points**.

From a security standpoint, it is crucial that you understand how your operating system handles file system security. Each directory and file can have separate permissions that govern which users can view and modify parts of the file system. The next three sections cover file system issues that are file system dependent.

10.5.1 Securing NT File System (NTFS)

The preferred file system for Windows servers is NT File System (NTFS). It is newer and far more secure than its predecessor, the File Allocation Table (FAT) file system. NTFS was introduced with Windows NT and has been enhanced for Windows 2000 and newer versions of the Windows operating system. The FAT file system provided minimal services for systems that were largely standalone computers with only one user. When the need arose for multiple users to access a system and networks became popular, the FAT file system was not able to provide sufficient security. NTFS was designed to provide more protection of files and folders in a multi-user environment.

TABLE 10.4 NTFS Permissions in Windows NT/2000/XP

Permission	File Permission Granted	Folder Permission Granted
Read (R)	Read a file's contents	Read a folder's contents
Write (W)	Modify a file's contents	Modify a folder's contents
Execute (X)	Execute a program file	Traverse a folder or subfolder
Delete (D)	Delete a file	Delete a folder
Change Permission (P)	Change a file's permission setting	Change a folder's permission setting
Take Ownership (O)	Take file ownership	Take folder ownership

The core of NTFS security is the access control list (ACL). There are actually two ACLs associated with each file or folder object, but we'll keep it simple here. In Windows NT, Windows 2000 and Windows XP, six permissions are associated with each file or folder object. Table 10.4 lists the basic NTFS permissions that can be accessed in Windows NT/2000/XP.

Windows 2000 and newer Windows operating systems allow an administrator to have more control over files and folders—you can access 13 different permission types. The read, write, and execute permissions can be set for a file or folder, as well as for attributes and extended attributes. Each permission setting is stored in an **access control entry** (ACE). There is a separate ACE for each user or group that is authorized to access a file or folder object. In fact, one object can have several user and group ACEs that contain permission information. When a user requests access to a file or folder object, the user ID and group memberships are compared to the ACEs for the requested object. The operating system either grants or revokes the request based on the permissions stored for that particular object as defined for that particular user. NTFS gives administrators the ability to provide very specific access rules for every file and folder on a system.

10.5.2 Windows Share Security

Windows operating systems allow folders and printers to be **shared**, or available to remote users. To use this feature, File and Printer Sharing must be enabled in your system settings. (Windows 95, Windows 98, Windows Me, Windows 2000, and Windows XP has File and Printer Sharing enabled

by default). You can specify one of three different levels of security for each share—global level, share level, and user level. Global level means anyone can access the share, share level means the user must enter a password to access the share, and user level allows you to restrict access to specific users. When using user-level security, you build simple access control lists to store access permissions for each user and file. Remember that once you share a printer or folder, it can be accessed by remote users. Make sure you understand the risks.

10.5.3 Securing UNIX File Systems

UNIX file systems use a permission architecture that is similar to the NTFS approach in some ways. Actually, it is more correct to say that the NTFS approach is similar to the UNIX permissions in some ways because UNIX predated Windows by a number of years. We introduced the file mode settings in Chapter 9. UNIX stores the read, write, and execute permissions for each file in the File Mode field. This field retains the appropriate permissions for the file's owner, group member, and the rest of the world. The approach is somewhat flexible, but does not support the same degree of permission inheritance as the NTFS model.

In UNIX, all permissions are specific to a system. Remote users must identify themselves as local users to have credentials to present for resource access. This differs from the concept of domains that is often implemented in Windows networks. Although file-based permissions are native to UNIX file systems, it is possible to extend the UNIX file system security model and implement far more mature security models. But before you attempt to harden your file system with additional layers of software, take the time to really understand UNIX file security. It will be time well spent.

10.6 Understanding User Accounts and Passwords

The primary access requirement for most modern operating systems is through a user account. A prospective user will present credentials to allow the target system to identify and authenticate him. Once authenticated, some level of access will be granted based on rules stored in the user's account data. The nature and format of these rules can vary widely, but the concepts are the same. A user logs into a system and is granted some rights.

In any operating system, the most common vulnerability with respect to user account access is a weak password. Although we have mentioned it

> **NOTE**
>
> Because share-level security can leave a system wide open if you are not careful, it is not even an option in Windows 2000 and later Windows operating systems. Your only security choice (if you really have to use shares) is to use user-level security.

before, it definitely bears repeating: Do not allow weak passwords! Establish a strong password policy and enforce it. You must constantly educate and remind users of their responsibilities to system security. Explain to your users how important good password rules really are. Once you have users creating strong passwords, run a password-cracking program periodically to test their strength. You might be surprised how many passwords can be guessed.

So, what is a strong password and how do you teach users to create them? Here are a few simple rules to get your users started:

- Make passwords hard to guess. Never use dictionary words or common phrases.

- Never use personal information, such as your birth date, social security number, or a family member's personal information.

- Use a different password for each account (do not reuse passwords).

- Never write you passwords down; memorize them.

- Change your password periodically.

- Use letters, digits, and punctuation in your password. Use a mix of uppercase and lowercase letters as well.

Now that you know some of the ways to create stronger passwords, let's look at a few Windows and UNIX account security specifics.

10.6.1 Windows Account Security Mechanisms

Although you can create local users in Windows, the most common security strategy is to create users at the domain level. If you are running Windows NT, Windows 2000, or a newer version of Windows server operating systems, the domain controller security model allows all security permissions to be centralized. As a user, you can log on to any computer in the domain and "carry" your authorizations with you. The process of defining a user is simple—you go to the domain controller computer and add the user there. You must have administrative privileges to create users. Once you have created one or more users, you can create security groups and associate a user with one or more groups. By allocating permissions by group, you can ease the permission administration process. It is a lot easier to give the write permission for the database folder to the DBA group than to give the same permission to six or 60 individual users.

Plan your account strategy before you start implementing user accounts. Advance thought given to the required users, groups, and permissions for each will save a lot of time in the long run.

10.6.2 UNIX Account Security Mechanisms

UNIX accounts are typically local to a computer. There are two levels of account security, like in Windows—the user and the group. Account management is a little different for each flavor of UNIX, but the basics are pretty much the same. When you create a user, you generally specify the default group a user belongs to. You can add the user to additional groups as well. When a user requests access to a file, the file's permissions are examined to see if the user's ID or group ID allows the requested access.

Substantial differences exist between Windows and UNIX security mechanisms, but the overall concepts are similar. As in all aspects of security, know your environment. It is your responsibility to acquire specific knowledge about your operating system and its specific security capabilities.

10.7 Checksums Catch Unauthorized Changes

What if you do everything you are supposed to and you want to know you are safe? Although there is no foolproof method to ensure you are completely safe, you can take steps to increase your security level and determine if anything has changed. You can use **checksums** to detect unauthorized changes to instantly identify suspicious behavior. A checksum is a mathematically generated number that is derived from a sequence of values. In other words, if you feed a file (a sequence of bytes) through a checksum algorithm, you will get a number. If you make any change to the file and retry the same algorithm, you will get another number. A checksum represents a snapshot of a file and can help you determine if the file has changed.

If you have a collection of files that should not be changed, you can run a checksum calculation on each file and save the results. At a later time, rerun the same calculation on the same files. If the checksums are the same, the files have not been modified. Any checksum difference shows that the source file was changed since the first checksum was calculated.

One common example for using checksums is in collecting forensic evidence. When you conduct an investigation of a security incident, you will likely collect evidence of computer activity. When the incident may have

involved a crime, you must make sure the evidence will hold up in court. The best first step when collecting electronic evidence is to calculate one or more checksum values for the evidence. With this information in hand, you can testify as to whether the information has changed since you collected it.

A security administrator should identify all files that should remain unchanged and calculate checksums for them. Several checksum algorithms are in use today, and most operating systems implement utilities to calculate checksums for files. For example, the md5sum utility calculates an MD5 checksum (actually, a hash value) for one or more files. Consult your operating system documentation for specific commands to calculate these checksums.

10.8 Using System Logging Utilities

In addition to creating and comparing checksum values to detect when files change, an administrator needs to monitor system use and resource access. This is accomplished through system logging. Current operating systems allow many events to be logged for later inspection. In fact, some system logs provide the primary data source for the detection and identification of suspicious activity. So, should you log everything? Well, probably not. Although logging provides a wealth of information, it also requires extra system resources. It takes more CPU power to log all events and more disk space to store the log files. Also, someone has to manage and review all those log files at some point.

A more efficient logging method is to carefully choose what events you want to log. System events fall into many categories. You can record login attempts, authorization changes, resource accesses, print job activity, application and utility activity, and performance metrics, among other activities. You can use these logs to research both system problems and suspicious activity. The logs can provide the information you need to track down what someone is doing on your system.

As with other security topics, the key to proper logging is to know your operating system and make the best choices for your environment. A new system or one that requires strict security should log more events than an established system with lower security requirements. A system that is at higher risk of being compromised should have more events logged. Balance the logging requirements with the performance and maintenance requirements to decide which events to log.

10.9 Chapter Summary

- Solid security maintenance practices help to keep a secure system secure.

- Keep your operating system and all software patched to the latest release.

- Antivirus software will not keep your system totally safe, but it will drastically decrease the likelihood of incurring damage from a malicious code attack.

- Make sure your antivirus software's signature database is up to date.

- Use a security checklist to harden your systems.

- Windows and UNIX checklists are numerous and should be constantly updated. Always refer to the latest list to harden your system against the latest exploits.

- In all operating systems, disable any unneeded services.

- Implement an aggressive password policy, and enforce it.

- Know your own operating system's file system security capabilities.

- File system security controls access to files and folders.

- File and folder access is generally controlled by user and group permissions.

- UNIX and Windows implement user and groups differently, with different scopes.

- Using checksums can help you easily identify files that have changed.

- Use system logging to track system events for detecting suspicious activity.

10.10 Key Terms

access control entry (ACE): In Windows, a database entry that stores permission settings for each user or group that is authorized to access a file or folder object. Multiple ACEs constitute an ACL.

antivirus software: Software that protects a system from malicious code by identifying and handling files that contain known malicious code.

checksum: A mathematically generated number that is derived from a sequence of values.

cracker: An individual who attempts to compromise security controls for malicious purposes.

daemon: A program that runs in the background, usually providing a service to users or other programs.

exploit: A vulnerability that can be used to compromise one or more security controls to gain unauthorized access to a system.

File Allocation Table (FAT): The common file system for older Windows and DOS systems.

file system: The way data, or files, are stored on the secondary storage devices.

hacker: Person who writes programs and enjoys learning minute details of programming and systems in general without malicious intent. Often used synonymously with *cracker*, which is a person who attempts to access a computer system without authorization. Crackers often have malicious intent when accessing systems.

harden: Taking steps to make a system more secure by minimizing known threats.

mount point: Each disk partition generally has a separate file system and its own root directory. UNIX systems attach each partition to a separate directory, called a mount point.

NT File System (NTFS): The preferred file system for Windows servers.

partition: The division of a hard disk; each hard disk can be divided into multiple partitions.

registry key: A collection of values organized in a tree hierarchy in the Windows registry.

root directory: The entry point to the tree hierarchy.

share: A computer resource, such as a disk drive, a folder or a printer, that can be accessed from other computers on a network.

signature database: A collection of all known virus signatures used by antivirus software packages when scanning a system's files.

TCPWrapper: The tcpd daemon that filters traffic and logs any suspicious activity.

virus shield: A layer of software that scans all incoming files for known viruses.

virus signature: Part of the virus code that uniquely identifies the virus. Antivirus software packages consult a database of all known virus signatures when scanning a system's files.

10.11 Challenge Questions

10.1 Which statement best describes the process of hardening a system?

 a. Identifying the most important threats to a system

 b. Minimizing known threats to make a system more secure

 c. Making a system harder to scan within a network

 d. Addressing physical security limitations in a system's environment

10.2 What is the best method to avoid being a victim of a newly discovered operating system exploit?

 a. Keep your operating system patched to the latest level.

 b. Review all system logs daily.

 c. Install a firewall between your system and the Internet.

 d. Enforce a strong password policy.

10.3 What does antivirus software do? (Choose all that apply.)

 a. Stops all known viruses from infecting your system.

 b. Helps prevent new virus infections of known viruses.

 c. Helps prevent new virus infections of all viruses.

 d. Identifies many known viruses already on your system.

10.4 What is a virus signature?

 a. The result of virus activity that is unique to each virus type

 b. The footprint a virus leaves in memory after it executes

 c. Part of the virus code or data that uniquely identifies the virus type

 d. The footprint of a virus while it is executing in memory

10.5 Which of the following practices are always important to hardening a system? (Choose all that apply.)

 a. Secure all communication channels with encryption.

 b. Remove Telnet, FTP, and Web server software from the system.

 c. Ensure all accounts have strong passwords.

 d. Disable all unneeded services.

10.6 What is the central repository of system information on Windows operating systems?

 a. Security database

 b. System catalog

 c. Registry

 d. System Main Table

10.7 Which of the following services are good candidates to disable on a Windows system? (Choose all that apply.)

 a. File and Printer Sharing

 b. System Logger

 c. Secure Storage

 d. Telnet

10.8 What is the first step in securing network protocols?

 a. Enable network packet logging.

 b. Disable your Web server, if possible.

 c. Enable encryption.

 d. Use a firewall.

10.9 Which of the following services are good candidates to disable on a UNIX system? (Choose all that apply.)

 a. Secure Shell daemon (sshd)

 b. Telnet daemon (telnetd)

 c. Sendmail

 d. Web Server (httpd)

10.10 What software provides the ability to filter specific traffic and log suspicious activity?

a. TCPWrapper

b. TCPSecure

c. IPSecure

d. TCPLog

10.11. Which of the following help ensure strong passwords? (Choose all that apply.)

a. Very long password requirements

b. Running password-cracking programs

c. End-user training on password policy

d. Mandatory frequent password changes

10.12. What is a file system?

a. The organization of data, or files, on the secondary storage devices

b. The organization of data in main memory

c. The disk controllers that allow the operating system to access disk drives

d. The operating system file caching mechanisms

10.13. Which Windows file system provides the most security?

a. EXT3

b. FAT

c. FAT32

d. NTFS

10.14. Where are UNIX file system permissions stored?

a. Registry

b. File mode field

c. Domain security database

d. Domain ACE

10.15. What is the benefit of using checksums?

 a. They provide error correction for files.

 b. They preserve the confidentiality of data.

 c. They provide the ability to detect if a file has changed.

 d. They help detect unauthorized data disclosure.

10.12 Challenge Exercises

Challenge Exercise 10.1

One of the first steps in hardening an operating system is to address the most pressing security threats. The best way to do this is to start with one of the several available system security checklists for your operating system. In this exercise, you assemble a security checklist from various sources and present the most important modifications that will increase your Windows system's overall security. Visit at least three sites that advertise Windows system security checklists. Compile a list of at least 10 serious threats and accompanying checkpoint action items that will minimize each threat. This exercise is more than just cut and paste. Explain why you included each point on the checklist. You need a computer with a Web browser and Internet access. You will start this exercise the same way many security professionals start their research—with a search engine.

 10.1 In your Web browser, use your favorite search engine to search for "Windows Security Checklist" or other similar terms.

 10.2 Find at least three sites that present Windows security checklists.

 10.3 Use the information from the Web sites you found to compile your own security checklist consisting of at least 10 items.

 10.4 Along with each threat and checklist action item to minimize the threat, explain why it was important enough to include. What could happen if you did not address this item?

 10.5 Make sure you provide references to the Web sites or other resources you used for this exercise.

Challenge Exercise 10.2

This exercise is identical to Challenge Exercise 10.1, except that the focus is on the UNIX operating system. In this exercise, you assemble a security

checklist from various sources and present the most important modifications that will increase your UNIX system's overall security. Visit at least three sites that advertise UNIX system security checklists. Compile a list of at least 10 serious threats and accompanying checkpoint action items that will minimize each threat. Explain why you included each point on the checklist. You need a computer with a Web browser and Internet access.

10.1 In your Web browser, use your favorite search engine to search for "UNIX Security Checklist" or other similar terms. You may also use the URLs mentioned in the "UNIX Security Miscellany" section earlier in this chapter.

10.2 Find at least three sites that present UNIX security checklists.

10.3 Use the information from the Web sites you found to compile your own security checklist consisting of at least 10 items. (Do not just duplicate the same list from Challenge Exercise 10.1.)

10.4 Along with each threat and checklist action item to minimize the threat, explain why it was important enough to include. What could happen if you did not address this item?

10.5 Make sure you provide references to the Web sites or other resources you used for this exercise.

Challenge Exercise 10.3

As stated in this chapter, file system security in Windows 2000 and Windows XP provides more low-level control over file and folder objects than Windows NT. The capability for this control has always existed in the NTFS file system, but it was not until Windows 2000 that the additional permissions were accessible. There are six basic permissions available for use in Windows NT and 13 in Windows 2000/XP.

In this exercise, you explore the file permission capabilities contained in Windows 2000/XP. You need a computer running Windows 2000/XP.

10.1 On the Windows desktop, double-click **My Computer**.

10.2 Double-click the **C** drive.

10.3 In the menu bar, click **File**, click **New**, and then click **Folder**. Name the folder **Test**.

10.4 Right-click the **Test** folder and select **Properties**.

10.5 In the Test Properties dialog box, click the **Security** tab.

10.6 Notice that you can change six permissions for each user and group name. Select several groups or users, one at a time, and notice how the permissions shown for that group or user changes. (You can see the permissions in the lower portion of the Test Properties dialog box.)

10.7 Choose your user name and select the **Deny** check box next to List Folder Contents. This action removes the List Folder Contents permission for your user. Click **OK**.

10.8 Double-click the **Test** folder to try to open it. You should not be able to access the folder because you removed the List Folder Contents permission.

10.9 To change the permissions back, open the Test Properties dialog box, click the **Security** tab, and clear the **Deny** check box for your user.

Try this exercise on a file. Choose any file or create a test file in the Test directory. What happens when you remove read permission? (You should not be able to open the file.)

10.13 Challenge Scenarios

Challenge Scenario 10.1

You are the security administrator for a cooking supply retailer. Your CIO has tasked you with hardening the company's Windows 2000 server. Your job is to develop a security plan that uses a checklist to address all of the "Top 20 Vulnerabilities" for Windows systems, as presented on the SANS Web site (*http://www.sans.org*). You can address the problem any way you like, but your report has to address each of the Windows vulnerabilities.

Challenge Scenario 10.2

After successfully hardening the cooking supply retailer's Windows 2000 server, you are offered a job at an auto parts distributor. This company

uses a UNIX server. You are now responsible for hardening the company's UNIX system. Your job is to develop a security plan that uses a checklist to address all of the "Top 20 Vulnerabilities" for UNIX systems, as presented on the SANS Web site (*http://www.sans.org*). You can address the problem any way you like, but your report has to address each of the UNIX vulnerabilities.

CHAPTER 11

Security Audit Principles and Practices

After reading this chapter, you will be able to:

- Determine the appropriate system events to log in a variety of circumstances and environments

- Identify significant events that should trigger immediate alerts to security administrators

- Explain the logging mechanisms used by common Windows and UNIX operating systems

- Analyze log data for anomalous events and determine whether those events represent attempted or successful intrusions

- Conduct a basic network/system security audit using common audit tools and techniques

- Respond appropriately to the results of a network/system security audit by addressing any identified deficiencies and implementing an ongoing audit program

Let's face it. Logging and auditing are two of the most unpleasant chores facing information security professionals. They are tedious, time-consuming, and relatively boring. Now, with that pep talk, you're probably chomping at the bit to get out there and start! No? Well, despite their bad reputation, these activities are two of the most essential tasks undertaken by security professionals around the world. Unfortunately, because they're not sexy or glamorous, they're also the most often neglected duties on the plate of a busy administrator. In this chapter, we'll explore a number of techniques that take some of the unpleasantness out of these tasks and allow you to utilize these procedures to dramatically enhance the security posture of your organization.

We'll first examine the art of **logging**—the recording of system events in special files maintained for a predetermined duration—and the analysis of system logs. We'll then move on to explore the mechanics of the **security audit**, which is a periodic review of a system or network's security posture.

11.1 Configuring Logging

Before you can get started with a logging program, you'll need to configure logging for your system(s). This involves answering a few critical questions that will shape the future of your logging routine:

- What activities/events should be logged?

- How long should those logs be maintained?

- What events are so serious that they should trigger immediate notifications to security administrators?

In this section, we help you determine the answers to those questions and look at the logging mechanisms available in the two most common operating systems in use today—Microsoft Windows and UNIX.

11.1.1 Determining What Should Be Logged

To log or not to log? That is the question. Many novice security administrators use a simple rule—log everything. At first glance, this may seem a prudent approach to logging. You won't miss anything if you log every single event that takes place on your system. There are, however, several critical

flaws to this approach that may serve to actually undermine the effective-
ness of your logging program:

- **Someone must review the logs.** Anyone who suggests the "log
 everything" approach has obviously never spent any significant
 amount of time analyzing log files. It's exactly this type of approach
 that makes log review tedious and leads to eventual neglect. If you
 try to log everything, you will, without a doubt, overwork the per-
 sonnel reviewing the log files and effectively eliminate any proac-
 tive log review activity that may take place on your network.

- **Overlogging has a serious effect on system performance.** Logging
 consumes system resources. Each time a logged event occurs, the sys-
 tem must take the time to process the event, write it to the log file, and
 trigger any alert(s) associated with the event. Under normal circum-
 stances, this doesn't take a significant amount of time. However, if
 you perform excessive logging, the resource consumption necessary
 to process the log file can quickly overwhelm the system and result in
 dramatically decreased performance for normal user activity.

- **Critical events may be prematurely overwritten.** Many organiza-
 tions choose to rotate their log files based on the amount of storage
 consumed by the log. When the log reaches a certain size, it may be
 stored to an archive or completely overwritten. If too many trivial
 events are stored in the log file, it reduces the amount of chrono-
 logical time covered by the file. If a security incident occurs that
 escapes immediate attention, administrators may find that the log-
 ging of subsequent trivial events overwrote critical evidence that
 should have been contained within the log file.

As you now know, it's easy to overdo it when determining the events that
your systems should log. On the other hand, it's also easy to miss the mark
and fail to log critical information. Striking the appropriate balance is a
tricky task that requires knowledge and experience. There's no simple
answer to the question "What should be logged?" You must rely on train-
ing, instinct, and experience to reach a conclusion appropriate for your
specific technical and organizational environments.

To illustrate the importance of taking environmental factors into account,
consider the case of two security administrators: Mike and Renee. Mike is

the administrator for a government intelligence agency and is responsible for protecting a network that processes highly sensitive classified information. Renee performs similar duties to Mike but works for a popular news Web site. Mike must be extremely cautious when implementing security for his network. He's concerned with all three legs of the CIA triad—confidentiality (if critical data were released to unauthorized individuals, it could damage national security), integrity (the data used by intelligence analysts must be accurate or their assessments may be inaccurate), and availability (government decision makers need uninterrupted access to intelligence information). Therefore, his logging posture should be designed to alert administrators to the potential violation of any of the three legs of the CIA triad. For example, he'd want to log every access to files that contain the identity of undercover agents. If an agent's identity was later disclosed, he could consult the log to determine who had access to that information.

Renee has different security concerns. As the security administrator for a public news portal, she's not very concerned about confidentiality. After all, the information on her site is designed for public dissemination. However, the other two legs of the CIA triad do concern her. If the integrity of data is violated, users might receive inaccurate news, undermining the credibility of her organization. If the Web site is not continuously available, users might decide to use more reliable resources on a regular basis, resulting in lost revenue to her employer. Renee should be no less concerned with security logging than Mike, but she should have different priorities. She should not log individual file access attempts, as this would produce a large amount of extraneous data. She *wants* people to access information on her site. She should, however, design a logging program that monitors for any unauthorized modifications to the site or any attempts to conduct denial of service attacks.

11.1.2 Determining How Long Logs Must Be Maintained

Most operating systems allow you to automatically overwrite log files based on either time or storage space. The factor you select will depend on your security priorities. If you're concerned about the resources consumed by stored log files, you should ensure that the operating system overwrites log files when they reach a certain size. This prevents them from consuming

excess disk space. On the other hand, if your priority is preserving log files for a certain chronological period, you should use time-based overwriting.

Another factor you need to consider is the archiving of old log files. If you need to maintain a permanent record of system activity, you should back up old log files to archival media before destroying them. The best way to achieve this is to actually create two separate log files. When the system fills up the first log file, it switches to the second. At the same time, the backup process should automatically store an archival copy of the first log file. When the second log file fills up, the system should switch back to the first file, overwriting the data stored in it (which has already been archived) and perform a backup of the second log file. This process may repeat indefinitely, creating a permanent log of all system activity. The logging policy should then dictate how long the archive media should be maintained and the storage requirements for that media.

11.1.3 Configuring Alerts

Modern operating systems also allow you to configure alerts that proactively inform administrators when certain critical system events occur. For example, you wouldn't want to wait for a log analysis to tell you that a particular system's hard drive is completely full—you'd want to be informed of this when (if not before) it takes place so that you may repair the problem.

The options for alerting vary from operating system to operating system, but you can generally use a combination of the following alerting mechanisms:

- Electronic mail messages
- Pagers
- Short Message Service (SMS) text messages
- Instant messaging
- Pop-up windows
- Cell phone calls

Generally speaking, you can configure the alerting mechanism to report events via different mechanisms based upon the event severity and the time of day. For example, if an intrusion detection system reports a successful system penetration, you might want to alert all administrators immediately via cellular phone regardless of the day or hour. On the other hand, a less

critical event, such as a virus infection on a workstation, might not merit a telephone call at 3:00 A.M. Use discretion when establishing these policies. It only takes a few late night wake-ups before administrators start turning off their phones or having unexplained "problems" with their pagers.

11.1.4 Windows Logging

The primary logging mechanism used by the Microsoft Windows family of operating systems is **Event Viewer**. This flexible tool is found in the Windows Administrative Tools and allows you to record various system events as they occur. All Windows systems have three basic log files:

- **Security log:** This log contains records of security-related events that occur on the system. System administrators control the type of information recorded in the security log. Typically, this log contains information on failed logon attempts, attempts to exceed security privileges, and similar system events.

- **Application log:** This log stores events triggered by software running on the system. Each software package determines what it writes to this log file. Despite the name, this log file may also contain critical security information related to specific applications. For example, a failed attempt to delete information from a database might be recorded in the application log. Depending on the application involved, system administrators typically have some control over the type of application events stored in this Event Viewer log.

- **System log:** This log contains events recorded by the operating system, such as hardware/software problems and other system issues. The types of events stored in this log are predetermined by the operating system and may not be altered by system administrators. Figure 11.1 shows an example of a Windows XP Professional System log.

In addition to these basic logs, a number of other specialized logs are available when systems perform specific roles. These include:

- **Directory service log:** This log is found on Windows domain controllers and contains events related to the Windows directory service.

- **File replication service log:** This log is also found on domain controllers and contains details of events that occur when the server is attempting to replicate data using the File Replication Service.

Figure 11.1
Windows XP Professional System log

- **DNS server log:** Systems configured as DNS servers implement this log, which contains events related to the domain name service.

There are four types of events normally stored in the Event Viewer log:

- **Error events:** Created when a serious problem occurs on a system. From a security point of view, errors indicate a possible violation of one of the pillars of the CIA triad. For example, corruption of a file system that renders a file unusable would trigger an error event.

- **Warning events:** Alert administrators to potential problems on the horizon. For example, a hard disk may trigger a warning event when it nears capacity.

- **Information events:** Contain details that the administrator wishes to log but that do not necessarily represent a problem or potential problem. For example, the successful starting or stopping of a service may trigger an information event.

- **Success/failure auditing events:** Occur when administrator-defined auditable events take place. The administrator may decide that specific uses of privileges be recorded in Event Viewer when they are successfully used, unsuccessfully used, or both. For example, the administrator may wish to audit all attempts (successful

and unsuccessful) to create a new domain user, but may only wish to log unsuccessful logon attempts.

11.1.5 UNIX Logging

UNIX systems log system events using the **syslog** facility, which provides a vast degree of flexibility. Syslog is capable of writing to local log files, alerting users of events via e-mail, or, most importantly, logging to a centralized host. Many security administrators choose to use one or more dedicated syslog servers to track all activity on a network, facilitating the efficient and secure logging of security events.

Like Windows Event Viewer, syslog allows the operating system and other processes to assign specific priorities to each event, providing a mechanism for the flexible alerting/logging of the event. Syslog implements eight different priorities. They are listed in priority order from highest to lowest, as follows:

1. LOG_EMERG events are used in the event of an absolute emergency that requires the immediate notification of all system users.

2. LOG_ALERT events require immediate intervention by system administrators to restore the system to proper working order.

3. LOG_CRIT events are critical system events.

4. LOG_ERR events are error conditions that occur on the system.

5. LOG_WARNING events are similar to Windows Event Viewer Warning events. They provide information that the administrator needs to know in order to circumvent a potential error condition.

6. LOG_NOTICE events also provide information that the administrator needs to know, but are not the result or cause of error states.

7. LOG_INFO events provide information normally logged for future use.

8. LOG_DEBUG events are created when developers execute a program in debug mode, and provide detailed information on the execution of the application that is useful in determining the cause of software errors.

In addition to providing the priority level of each event, syslog also stores the *facility* that caused the event. This normally corresponds to the common name of the process that sent the event to the syslog facility.

11.2 Analyzing Log Data

So, you've designed and implemented a logging program that satisfies your organization's security requirements. What's next? It's time to start using that data to monitor your environment. You'll want to perform two main activities during your analysis: profiling normal behavior and detecting anomalies.

11.2.1 Profiling Normal Behavior

The first step in analyzing log files is to develop a profile of normal behavior, otherwise known as a **baseline**. You may wish to develop baselines at the network, system, user, and/or process level. These baselines should detail the normal consumption of various system resources during different time periods and will be used to later detect anomalous activity. Note that your baselines may vary significantly during different time periods, sometimes measured in chronological time and sometimes corresponding with specific events. For example, consider a business that operates entirely during normal business hours. The baselines developed for that business' networks would be markedly different during the week than on the weekends. On the other hand, the home page of a college football team would have 12 huge peaks each year during the time leading up to game days.

As the administrator, it's your responsibility to determine the baseline periods and subjects appropriate for your organization. You'll do this through a period of trial and error while you're attempting to figure out the best profiles for your organization. After you've developed a fairly stable baseline, monitor it closely and remember that normal activity changes over time as an organization evolves in size and scope. When anomalies become the norm, it's time to revisit the baselines, determine what changes have taken place in your monitored environment, and attempt to develop new profiles of normal activity.

11.2.2 Detecting Anomalies

After you've developed baselines, you need to put them into practice by monitoring your systems for anomalous behavior. You define anomalies based on a number of threshold values by answering the following questions:

- **How much of a deviation from the norm represents an anomaly?** Go back to the data gathered during the baseline process to help answer this question. Imagine two systems that each have an average CPU utilization of 45%. One system might remain fairly stable

around that value, usually ranging between 10 and 60%. The other might fluctuate wildly from 5–90% but never stay high for a long period of time. You may decide that 65% CPU utilization is the threshold value for the first system, but set the second system's threshold at 95%.

- **How long must the deviation occur before registering an anomaly?** As you may know, CPU utilization often spikes during periods of high activity. Returning to our two systems from the previous example, we might decide that the first system should report an anomaly when it exceeds the threshold value of 65% for two minutes. On the other hand, the system that never stays high for a long period of time might have a 30-second alert trigger associated with the 95% threshold value.

- **What anomalies should trigger immediate alerts?** Some anomalies are more significant than others. Those that represent major and threatening departures from normal activity should trigger the immediate alerting of a security administrator. For example, if the hard disk that holds a critical corporate database suddenly surges from its baseline utilization of 40% of capacity to 99% utilization, this situation requires immediate administrator intervention and should result in an immediate alert. Other, less serious anomalies may simply be logged and investigated at a convenient time.

In this section, you learned how security professionals analyze system logs for anomalous behavior based upon deviations from established baselines. This is a critical responsibility for security professionals, as well as system/network administrators, because it provides an early indication that something is amiss and warrants further investigation. In Chapter 13, you'll learn how this principle forms the basis of anomaly-based intrusion detection systems, which develop baselines of individual user behavior and then analyze real-time activity for deviations from those norms. These systems allow you to detect situations such as a secretary who uses her computer exclusively during business hours suddenly logging on during the middle of the night and downloading sensitive files over a modem connection. When analyzed at the system or network level, this scenario might not raise any red flags—the modem/disk utilization might be typical activity for that hour of the day. However, when analyzed at the user level, the activity clearly represents a deviation from standard behavior and requires the immediate attention of security administrators.

11.2.3 Data Reduction

As discussed earlier in this chapter, one of the most common failures of logging programs is the gathering of more data than can be analyzed. As a general rule, it's best to limit the scope of logging activities to reduce consumption of storage resources and analysis time. However, in some environments, this is simply not possible. Occasionally, security or bureaucratic requirements mandate aggressive logging of system/network activity. When this scenario is unavoidable, security analysts often use data reduction tools to limit the scope of their analysis to potentially malicious activity while still creating detailed log files on disk.

These data reduction tools are often built into the security tools that create log files. For example, CheckPoint's Firewall-1 perimeter protection application has a detailed logging capability along with a custom log viewing tool. When you first open the viewer, it presents you with all of the data logged by that system since the last time the log was purged. Obviously, this can be an overwhelming amount of data to analyze and interpret. Therefore, CheckPoint provides filtering technology that allows administrators to quickly reduce the amount of data presented by the tool, extracting only data relevant to the issue at hand. For example, if you want to isolate the traffic responsible for a mail spoofing attack on your SMTP server that occurred last Tuesday, you could quickly establish two filters: one restricting the log to inbound TCP traffic on port 25 and the other filtering out all traffic that occurred on days other than Tuesday. Although the resulting log may still be quite large, these filters make a previously insurmountable task somewhat manageable.

Log Analysis Tools

In addition to the data reduction facilities available through many logging applications, a number of log analysis tools are available on the commercial and open-source markets. These tools vary widely in their capabilities and coverage. Some are dedicated to the analysis of data generated by specific logging applications, whereas others are able to consolidate data from a number of disparate sources.

These tools, although sometimes costly, provide quite an effective weapon in the arsenal of any security administrator. They often handle much of the baselining/anomaly detection functionality described earlier in this chapter and can greatly reduce the burden that log analysis places on administrative personnel.

11.3 Maintaining Secure Logs

Logs are only as good as the security of the system on which they're stored. After all, if an intruder is able to gain administrative access to a particular system, he or she may be able to erase his or her footprints by simply deleting the relevant items from the system security log. Security professionals use several common techniques to help reduce the potential of an intruder successfully escaping detection, as follows:

- **Remote logging:** Uses a centralized storage location for logs generated from around the network. This storage location must have added security to protect itself from intruders who might have compromised other systems on the network. For this reason, centralized logging facilities often provide a secure write-only logging functionality that allows other systems to write log entries (and sometimes review them) but not to alter/delete existing entries. Console access to the logging facility or direct access to its storage resources often requires stricter authentication than other network resources and may even require physical presence at the console to complete a biometric authentication sequence.

- **Printer logging:** Often used in high-security environments to establish an unalterable paper trail. In this scenario, printers immediately create a hard-copy record of logged activity for future inspection. Administrators may then examine those hard copies if they have reason to believe their electronic counterparts are tainted. Organizations using printer logging commonly use inkjet or older dot-matrix printers that are capable of "line-at-a-time" printing to avoid the buffering issues involved with laser or other "page-at-a-time" printing technologies.

- **Cryptographic technology:** Often used to authenticate log files. After a log file is finalized, the system digitally signs the log file. When an administrator wishes to subsequently review the log, he or she first verifies the digital signature to determine the log's authenticity. If the signature is not authentic, the administrator knows that the log file has been altered (but not, unfortunately, *how* it was altered). The major limitation to the use of digital signatures in log files is that the files are not normally signed until after they are finalized, permitting the interim modification of the file.

TIP

Printer logging is dependent on the physical security of the location where the printer is stored. If an intruder is able to simply steal the hard copy output, you're just as bad off as if the printer log were never created in the first place!

As you've learned in this section, it's critical that you develop a well-rounded security posture that takes into account all of the various elements of security—data security, hardware security, physical security, and personnel security. A failure in any one of those areas can lead to log security issues.

11.4 Conducting a Security Audit

Security auditing is an important component of the security professional's responsibilities. When conducting an audit, professionals analyze the security posture of individual systems, applications, and/or the entire network; identify any deficiencies in that posture; and then develop an action plan to correct those issues.

11.4.1 Audit Team

One of the most important components of a successful information security audit is the selection of a well-trained and motivated audit team. The individuals assigned to this effort should be among the best and brightest security professionals in your organization. After all, hackers are very clever people—you certainly wouldn't want your audit team to have any less talent than those they're defending your network against!

Some organizations choose to have a multidisciplinary audit team. In addition to the technical professionals you'd expect to find on the team (network administrator, operating system experts, information security professionals, etc.) you may also find accountants trained in traditional audit techniques, general managers to provide business oversight, and administrators to assist with the team's compliance paperwork. The exact nature of the team you select will depend upon the complexity of your organization and its specific information security audit requirements.

11.4.2 Audit Tools

The team conducting an information security audit should make use of a number of different tools designed to assist with the audit process. These range from simple checklists of tasks that should occur during the audit to complex vulnerability assessment tools designed to ferret out flaws in systems and networks. In the following sections, we look at each of the major classes of audit tools and discuss specific examples of tools used by information security professionals on a daily basis.

Checklists

Checklists are an information technology professional's best friend. They provide a simple way to standardize repetitive tasks throughout an organization, providing a consistent approach to systems management. Security professionals make use of checklists in a number of ways during an audit:

- **Audit checklists:** Provide high-level guidance on the proper way to conduct a security audit. **Audit checklists** normally come in several forms: one that provides a high-level overview of the process of conducting an audit for the entire network and others that provide the stepwise process used to audit different classes of systems (e.g., user desktop workstations, laptops, file servers, Web servers, mail servers)

- **Configuration checklists:** Offer detailed information on the configuration of networked systems. **Configuration checklists** normally contain specific configuration settings required by the organization's security policy as well as the different software applications that should be installed on systems that perform various roles.

- **Vulnerability checklists:** Contain lists of critical vulnerabilities that auditors should check for when conducting security audits. **Vulnerability checklists** are normally created for each version of each operating system in use on a network and may also be created for specific versions of software applications with well-known vulnerabilities.

Each of these categories of checklists plays an essential role in the audit process. Don't take the development of these checklists lightly—if you design them well, they'll be used by information security auditors for years to come and will play a significant role in defining the security posture of your entire organization.

IP/Port Scanners

IP and port scanners are two of the frontline tools used by malicious individuals seeking a system to compromise. These tools use a brute-force approach to identify potential targets for exploitation. They probe IP addresses to detect systems running on a network and then further probe those systems for services running on open ports that may contain vulnerabilities. Hackers then use this data to help focus their malicious efforts.

TIP

Many hardware/software vendors and independent security organizations provide the public with baseline checklists designed to assist with the auditing process. It's a good idea to obtain several of these checklists and read through them before developing your own. Try checking with the creators of products that you use and performing an Internet search for "security checklist" to locate some potential starting points. One great resource for users of Microsoft products is the company's Security Checklists and Resource Guides Web site, located at *http://www.microsoft.com/technet/security/chklist/default.mspx.*

These same scanners can also serve as powerful tools in the hands of security administrators by allowing them to detect "rogue" systems and services running on a network without permission. These vigilante systems/services are often set up by legitimate users with good intentions—usually the cutting of red tape to quickly achieve a business objective. However, they're also the least likely systems to have proper security measures in place. Security auditors often use IP/port scanners to detect these systems on a network and then either remove them from the network or bring them under the control of information security professionals.

Vulnerability Scanners

Vulnerability scanners analyze systems and/or networks for signatures of well-known vulnerabilities and provide auditors with a detailed report of any detected deficiencies, often with suggestions on potential remedies.

The first vulnerability scanner to reach widespread distribution was the Security Administrator's Tool for Analyzing Networks (SATAN). Released in the early 1990s, this tool created quite a stir on the Internet. It's capable of quickly scanning a network for hosts that exhibit signs of any of a number of well-known vulnerabilities and provides information to the user running the report on those systems that might be susceptible to compromise. Many security administrators were extremely upset when this tool was released, arguing that it provided hackers with an easy way to quickly identify and exploit vulnerable systems. The creators of SATAN responded to this assertion in an Internet posting in March 1995, stating:

> We have done some limited research with SATAN. Our finding is that on networks with more than a few dozen systems, SATAN will inevitably find problems . . . (the vulnerabilities identified by SATAN) are well-known problems. They have been the subject of CERT, CIAC, or other advisories, or are described extensively in practical security handbooks. The intruder community has exploited the problems for a long time.
>
> We realize that SATAN is a two-edged sword—like many tools, it can be used for good and for evil purposes. We also realize that intruders (including wannabes) have much more capable (read intrusive) tools than offered with SATAN. We have those tools, too, but giving them away to the world at large is not the goal of the SATAN project.

SATAN is no longer commonly used because its vulnerability signature file was not maintained. Although many of the vulnerabilities detected by SATAN over a decade ago still persist on the Internet today (a sorry state of affairs!), there are more advanced tools that detect the same vulnerabilities in addition to the thousands of other vulnerabilities identified more recently.

One of these newer tools is Security Auditor's Research Assistant (SARA). SARA is a direct descendant of SATAN that provides added functionality. SARA's main advantage is its integration of a database that stores the results of security audits for further analysis. For those who seek a commercially supported solution, the Security Administrator's Integrated Network Tool (SAINT) vulnerability scanner (a clever wordplay on SATAN) offers a four-step approach to vulnerability detection:

1. Identify all networked systems.

2. Scan open ports on those systems to identify any services running on the host.

3. Analyze those services for potential vulnerabilities.

4. Provide a detailed report to the auditor including recommendations for patching security holes.

A fourth common vulnerability scanner is the Nessus platform, an open-source alternative that provides remarkably complex vulnerability scanning. Nessus implements an advanced scripting language—the Nessus Attack Scripting Language (NASL)—which enables administrators around the world to easily write (and share) security tests designed to ferret out specific vulnerabilities. (See Chapter 14 for more information about Nessus.)

All four of these scanners share a common trait—they're designed to run on systems running UNIX operating systems. (Many do, however, detect flaws on Microsoft Windows systems in addition to UNIX systems.) There are also a number of tools available for systems running Windows. One of the most popular is a free tool from Microsoft known as the Microsoft Baseline Security Analyzer (MBSA). When run, MBSA downloads the most recent vulnerability database directly from Microsoft and analyzes the target system against Microsoft's current security recommendations. It then provides a detailed listing of steps that administrators must take to bring

the system into compliance with Microsoft's security standards. MBSA, as well as a number of other Windows security tools, are available for free download from the Microsoft site at *http://www.microsoft.com/security/ default.mspt*.

Integrity Checking

Another class of tools commonly used by security auditors are file integrity checkers. These tools provide assurances of integrity by maintaining cryptographic signatures of each protected file on the system. They then periodically scan those files, recompute the signature, and compare it to the value stored in their signature database. If the signatures don't match, they alert the administrator to the situation for further investigation. Some alerts may be the result of legitimate changes, whereas others may be signs of malicious activity.

Tripwire is the most well-known file integrity assurance tool available today. It performs the tasks described in the previous paragraph in a highly automated manner. Tools like Tripwire are commonly used to protect static Web sites and other systems that store data that is both critical and infrequently modified.

Penetration Testing

Up until this point, all of the tools we've discussed have been passive in nature; that is, they don't affect the operation of a system in any manner, they merely seek to identify vulnerabilities and report on them. Security auditors who seek to take a more active approach to their audits often conduct **penetration testing**, a systematic attempt to penetrate the security of a system in order to test current security measures.

> **WARNING**
>
> Never conduct penetration testing on a system or network unless you have clear, written permission to conduct the test. Failure to obtain this permission can have serious legal consequences.

The individuals who conduct penetration testing are often among the most well-trained information security professionals in an organization. Many security teams even bring in an outside panel of experts to test the security of their networks on either a periodic basis or in response to specific changes in the organization's security posture. The teams that conduct these tests are often referred to as "white hat" hackers. Malicious hackers, on the other hand, go by the moniker "black hat" hackers.

11.4.3 Audit Results

After the audit is complete, the job is far from done. It's time to take a step back and review the results of the various techniques used to analyze the network. A common post-audit action plan includes the following steps:

1. Report on the results of the audit, including a detailed list of any deficiencies detected by the team.

2. Prioritize the deficiencies based on the threat they pose to the organization as a whole.

3. Develop action plans to address each of the deficiencies.

4. Implement the action plans in order of descending priority, addressing the most critical item first. (If there are "quick fix" items with lower priorities, you may wish to fix some of those items before tackling more complex items that bear higher priorities.)

5. Conduct ongoing monitoring to assess the effectiveness of the action plan and ensure that the lessons learned during the audit are applied in daily practice throughout the organization.

6. Repeat the audit on a periodic basis to identify any new or re-emerging security deficiencies.

11.5 Chapter Summary

- When developing a logging program, you must answer three basic questions: What activities/events should be logged? How long should those logs be maintained? What events are so serious that they should trigger immediate notifications to security administrators?

- Overaggressive logging can result in a failure of administrators to review logs, degraded system performance, and the premature loss of critical log data.

- Logs should be periodically refreshed to avoid excessive consumption of storage resources. Log refreshing may be done by rotating log files based on size or time. Backups of the archive files may be created if a permanent record is desired.

- Windows Event Viewer contains three standard logs: the system log, application log, and security log. Systems serving in special roles (e.g., domain controller or DNS server) may also contain supplemental logs.

- The four types of events normally stored in Event Viewer logs are error events, warning events, information events, and auditing events.

- UNIX logging is performed by the syslog facility, which is capable of logging events to the local system, alerting administrators, and logging to the syslog facility on a centralized server.

- Log analysis involves building baseline profiles of normal behavior and then analyzing logs for deviations (anomalies) from that norm.

- Many logging utilities provide filters and other mechanisms designed to reduce the amount of data that must be analyzed to answer particular questions.

- Some of the technologies used to facilitate secure logging include remote logging, printer logging, and cryptography.

- Checklists are commonly used in audits to provide a systematic, consistent approach. The commonly used types of checklists are audit checklists, configuration checklists, and vulnerability checklists.

- Vulnerability scanners probe systems and/or networks for known vulnerabilities and provide detailed reports to administrators. Some common vulnerability scanners include SATAN, SAINT, SARA, Nessus, and MBSA.

- File-integrity checking tools, such as Tripwire, use cryptographic technology to identify unauthorized modifications to data stored on a system.

- Security audit teams should include professionals from all appropriate technical backgrounds. Nontechnical professionals, such as accountants, managers, and administrators, should be asked to join the team as needed.

- At the conclusion of an audit, all deficiencies identified during the audit should be prioritized and an action plan developed to address them in priority order.

11.6 Key Terms

audit checklist: Provides high-level guidance on the proper way to conduct a security audit.

baseline: A profile of normal behavior gathered at the network, system, user, and/or process level and later used to help identify anomalous activity.

configuration checklist: Offers detailed information on the configuration of networked systems.

Event Viewer: Logging utility in Microsoft Windows operating systems.

logging: The recording of system events in special files maintained for a predetermined duration.

penetration testing: A systematic attempt to penetrate the security of a system in order to test current security measures.

security audit: Periodic review of a system or network's security posture.

syslog: UNIX event logging facility.

vulnerability checklist: Contains lists of critical vulnerabilities that auditors should check for when conducting security audits.

11.7 Challenge Questions

11.1 _____ provide an easy way to standardize procedures for the performance of routine tasks (such as configuring a system) throughout an organization.

11.2 Which of the following are major reasons that extraneous events should not be logged? (Choose all that apply.)

 a. Overlogging can degrade system performance.

 b. Someone must spend a lot of time reading the logs.

 c. Critical events might not be logged.

 d. Critical events might be overwritten.

11.3 Which of the following are commonly used criteria to determine when log files should be overwritten? (Choose all that apply.)

 a. Chronological time

 b. Occurrence of a critical event

 c. Size of log file

 d. Availability of backup media

11.4 Which of the following Event Viewer log files are found on all systems running the Windows operating system? (Choose all that apply.)

 a. Directory service log

 b. System log

c. Security log

d. Application log

e. File replication service log

f. DNS server log

11.5 Which one of the following events may be triggered by an unsuccessful Windows logon attempt?

a. Information event

b. Auditing event

c. Error event

d. Warning event

11.6 Which of the following would be used to log the successful starting of a Windows service in Event Viewer?

a. Information event

b. Auditing event

c. Error event

d. Warning event

11.7 Which of the following are critical questions that must be addressed when developing a log analysis policy? (Choose all that apply.)

a. What anomalies should trigger immediate alerts?

b. How long must the deviation occur before registering an anomaly?

c. How much of a deviation from the norm represents an anomaly?

d. What is the impact of the logging on system performance?

11.8 _____ are commonly used to create an unalterable hard copy of system log files.

11.9 Which of the following log security technologies is prone to unauthorized interim modification of the log files?

a. Printer logging

b. Remote logging

c. Secure logging

d. Digitally signed logging

11.10. What type of UNIX syslog event normally requires the immediate notification of all system users?

a. LOG_CRIT

b. LOG_ALERT

c. LOG_EMERG

d. LOG_WARN

e. LOG_DEBUG

11.11. What type of UNIX syslog event is primarily of interest to software developers troubleshooting applications?

a. LOG_CRIT

b. LOG_ALERT

c. LOG_EMERG

d. LOG_WARN

e. LOG_DEBUG

11.12. What type of checklist provides detailed information on the software that should be installed on different types of systems?

a. Audit checklist

b. Debug checklist

c. Configuration checklist

d. Vulnerability checklist

e. Database checklist

11.13. What type of checklist provides high-level guidance on the conduct of a security audit for specific classes of systems?

a. Audit checklist

b. Debug checklist

c. Configuration checklist

d. Vulnerability checklist

e. Database checklist

11.14. Which one of the following vulnerability scanning tools uses an open-source scripting language that allows administrators around the world to easily write vulnerability tests and share them with other security professionals?

 a. Nmap

 b. SATAN

 c. SAINT

 d. Nessus

 e. MBSA

11.15. Which one of the following vulnerability scanning tools is specifically designed to detect security deficiencies in systems running the Windows operating system?

 a. Nmap

 b. SATAN

 c. SAINT

 d. Nessus

 e. MBSA

11.16. What information security tool is designed specifically to detect services running on networked systems and has the capability to "fingerprint" those systems and services?

 a. Nmap

 b. SATAN

 c. SAINT

 d. Nessus

 e. MBSA

11.17. What is the main purpose of the Tripwire security tool?

 a. Integrity assurance

 b. Intrusion detection

 c. Perimeter protection

 d. Vulnerability scanning

 e. Network mapping

11.18. What is the best source for obtaining vulnerability checklists for a particular operating system?

 a. Friends and family

 b. The operating system manufacturer

 c. Unknown Internet sites

 d. Books and periodicals

 e. Cracker/hacker Web sites

11.19. Which of the following activities does SAINT perform when conducting a security assessment? (Choose all that apply.)

 a. Scan for active hosts.

 b. Identify services running on those hosts.

 c. Check for known vulnerabilities.

 d. Alert the administrator about altered files.

 e. Report scan results to the auditor.

11.20. Alan is a security administrator responsible for the protection of his company's Web site. He's particularly worried about the potential that malicious individuals might conduct a defacement attack and replace text somewhere on his site with information that might damage his company's reputation. What tool can best assist Alan in the detection of defacement attacks?

 a. Nessus

 b. SAINT

 c. SARA

 d. Nmap

 e. Tripwire

11.8 Challenge Exercise

Challenge Exercise 11.1

In this exercise, you conduct a security audit on a computer system. You need a computer with Internet access and a Web browser. You will down-

load, install, and run several security audit tools appropriate for your operating system, environment, and administrative privileges. You also need permission to conduct the audit from the system's owner.

11.1 Create a baseline profile of the system, including details of the hardware, operating system, software, and processes running on the system. To create a baseline, use your operating system's configuration tools (such as the System utility in Windows Control Panel) to access this information and store the relevant details in a file. This will come in handy in the future when attempting to determine whether your system configuration was altered. Be sure to keep a hard copy in case an attacker accesses your baseline file. Provide your instructor with a copy of this file.

11.2 Using checklists appropriate for your operating system and server role (if applicable), perform a security audit of the system, noting any deficiencies by comparing each item on the checklist to the actual configuration of your system. If you're having trouble locating an appropriate checklist, try searching the Web sites of the operating system vendor or recognized security resources, such as the Computer Emergency Response Team (*http://www.cert.org*) or the Microsoft Security Checklists and Resource Guides site (*http://www.microsoft.com/technet/security/chklist/default.mspx*). Provide your instructor with a copy of the completed checklists.

11.3 From the Internet, gather as many of the scanners and assessment tools discussed in this chapter as possible. Install the security audit tools. Provide a list of the checklists to your instructor.

11.4 Perform a vulnerability assessment on the system using the various scanners and assessment tools. For example, you might use MBSA, available for download at *http://www.microsoft.com/technet/security/tools/mbsahome.mspx*, to scan for common vulnerabilities on a Windows system. Simply download the program, install it, open MBSA, and select **Scan a computer** in the left pane. Use the default settings and click **Start scan**. MBSA retrieves current vulnerability information over the Internet, scans your system, and provides output such as that shown in Figure 11.2. Provide the output of this scan to your instructor.

Figure 11.2
MBSA output

11.5 If you are working in a closed laboratory environment, you may wish to attempt a penetration test of the test system using some of the attacks discussed in Chapters 2 and 7 of this book. *Only conduct this step with the permission of your instructor.*

11.6 Develop an action plan to remedy any deficiencies noted during the system audit. Provide specific responses that address each of the issues raised.

11.9 Challenge Scenarios

Challenge Scenario 11.1

Atlas Airlines is a passenger airline that serves several major cities in the southeastern United States. The airline maintains a public Web site that provides the public with general information about the airline and allows them to make travel reservations online using their credit card. Therefore, the Web site necessarily contains sensitive personal financial and travel information that must be kept private.

The Web site is hosted on a dedicated server running Microsoft Internet Information Services (IIS). It is supported by another dedicated system that hosts the backend databases using Microsoft SQL Server.

Design a logging policy appropriate for this Web site. While doing so, consider the elements of the CIA triad and recall the two examples cited in this chapter. Your logging policy, as a minimum, should answer the following three questions:

11.1 What type of information should be logged?

11.2 What events should trigger immediate alerts to security administrators?

11.3 How long should the logs be maintained?

Challenge Scenario 11.2

You are the new information security manager for Giant Widgets, an e-commerce company dedicated to the sale of large items over the Internet. As your first official act, you decide to review the previous information security audits conducted on the Giant Widgets network and discover, to your horror, that nobody has ever conducted an audit! You then set out to develop an audit program from scratch.

Giant Widgets runs a mix of operating systems. User workstations primarily run Windows XP Professional Edition, Windows 2000 Professional, and Windows XP Home Edition. Most of the servers are Linux systems, with the exception of three servers that act as domain controllers and file servers for internal users. All public services (Web, e-mail, etc.) are hosted on the Linux systems.

Your task is to develop an audit procedure for the Giant Widgets network. Describe a plan that will meet the key audit requirements discussed in this chapter in an efficient and effective manner.

CHAPTER 12

Network and Server Attacks and Penetration

After reading this chapter, you will be able to:

- Explain the importance of retaining security control of a system
- Understand the five phases of security control and the methods an attacker might use to achieve each phase
- Describe common points of attack against networks and individual servers
- Explain how an attacker might wage a multifront attack against a targeted server or network
- Use auditing and logging data to recognize and prevent attacks against a server or network

In previous chapters of this book, you learned a number of the techniques that malicious individuals might use to gain illegitimate access to a computer system. In this chapter, we'll take a look at the big picture—how attackers might combine multiple attacks and techniques to gain partial or complete control of an inadequately protected network. This information is absolutely critical to understanding the mind of an attacker and protecting your network against this type of activity.

12.1 Security Control

The basic responsibility of an information security practitioner is to maintain **security control** of the networks and systems under his or her authority. What exactly does this mean? Administrators are responsible for ensuring that their security mechanisms enforce three basic requirements, known as the CIA triad. We covered the CIA triad in Chapter 1; however, the components of the triad are summarized here for review:

- **Confidentiality:** All data on the secured system/network must be protected from unauthorized disclosure. Measures must be in place to prevent unauthorized individuals from accessing information, either by outsiders gaining illegitimate access to the system or insiders exceeding their legitimate authority.

- **Integrity:** All data on the secured system/network must be protected against unauthorized modification. If an attacker manages to modify sensitive data without being detected, the consequences could be worse than if the data was merely disclosed to an unauthorized individual, as organization insiders may then unsuspectingly act upon this erroneous information.

- **Availability:** The systems themselves must be protected in such a manner as they are available to authorized users during their normal operating hours. If an attacker is able to successfully deny an authorized user access to critical information, the attack may be just as successful as if he or she were able to steal or modify that same information.

These fundamental building blocks of information security are interdependent. If one of these elements is violated, you lose security control of the system or network in question.

Attackers have their own corresponding triad designed to defeat system security. It's known as the DAD triad (also covered in Chapter 1). Each element of the DAD triad is designed to directly counter an element of the CIA triad. To refresh your memory, the DAD triad elements are summarized as follows:

- **Disclosure:** The unauthorized transfer of information to individuals without the appropriate security clearance and/or need-to-know. Disclosure is the opposite of confidentiality.

- **Alteration:** The unauthorized modification of data stored on a system or network. Alteration is the opposite of integrity.

- **Destruction:** The unauthorized deletion of data or prevention of authorized users from accessing system/network resources or information. Destruction is the opposite of availability.

These three elements are the adversaries of information security practitioners around the world. Our tools and techniques are designed to prevent disclosure, alteration, and destruction through the enforcement of confidentiality, integrity and availability.

12.1.1 Phases of Control

When an attacker attempts to gain control of a network, he or she normally progresses through a series of five sequential phases. Depending upon the techniques used, some phases may be skipped in some attacks, but the general principle is that the attacker wishes to move from the initial state of no access at Phase 1 to the final state of total control at Phase 5.

We examine each of the control phases in the following sections.

Phase 1: No Access

In the most basic phase, a user has absolutely no access to a network. Phase 1 control is normally implemented through the use of strict perimeter protection techniques, such as the use of a firewall that completely blocks unauthorized traffic from entering the network. It is not possible for an intruder to abuse Phase 1 access because there isn't any access to exploit.

Phase 2: External Application Access

In some cases, a user might require limited access to a network to use certain applications designed for external use. The most common scenario in

> **WARNING**
>
> As discussed in Chapter 8, it is absolutely critical that you use a firewall and implement a demilitarized zone (DMZ) strategy if you plan to grant outside users Phase 2 control of your network. Failure to do so may result in the successful penetration and exploitation of other systems on your network.

which network administrators permit Phase 2 access is where a network hosts a public Web server. External users must be granted limited access through the firewall to access this resource, normally without undergoing any sort of authentication process. The main difference between Phase 1 and Phase 2 control of a network is that there is some expected interaction between the network and user that results in the consumption of resources. The main abuse of Phase 2 control is the illegitimate consumption of resources, resulting in a denial of service (DoS) attack, such as those discussed later in this chapter.

Phase 3: User Access

User-level access is the most commonly assigned access right on a network. It grants the basic ability to log on to a system and use it for routine purposes, such as running office productivity applications, accessing e-mail and the Internet, and the like. This access level is normally granted to all nonadministrative users of an organization's network. User-level access is not normally granted to those outside of an organization. Abuse of Phase 3 access is more severe than that of earlier phases. Attackers who gain user-level access may be able to pose as employees of your organization in communications with other employees and the outside world. Attackers also have the ability to consume larger amounts of your computing resources.

Phase 4: Superuser Access

Superuser access is a privileged level of system access that allows a user complete control of the system in question. This level of access is extremely sensitive and must be reserved for a select group of administrative personnel trained in the use of these special privileges. Access to systems using this type of account must be strictly audited to detect unauthorized logons and actions that exceed the legitimate authority of a superuser. Remember, just because a user has the technical ability to perform an operation doesn't mean that he or she has the *authority* to perform the action. For example, consider the case of reformatting a hard disk. Superusers undoubtedly have the technical ability to perform this action because it is required by their job in some instances. However, reformatting the hard drive of an operational server with the goal of crashing that server would certainly be an unauthorized use of that person's powers.

> **TIP**
>
> Users with administrative powers should be assigned two accounts: one with superuser privileges and one with normal user privileges. They should use the superuser account only when those access rights are necessary. This greatly reduces the likelihood that an unauthorized individual will come across an unattended system with an active superuser connection.

The terminology used to describe the superuser account varies from operating system to operating system. On UNIX systems, this account is sometimes described as the root account. Windows systems refer to this account as the Administrator account.

Under no circumstances should you allow more than one administrator to access the system using the same account. If your operating system comes with a default administrative account (such as Administrator) and you have multiple administrators, your first course of action should be to create individual accounts for all administrators and then disable the generic account. This provides individual accountability for the use of these special privileges, avoiding the "I didn't do it, somebody else did" syndrome by providing logged evidence of who performed particular administrative actions.

Phase 5: Total Control

Many network operating systems differentiate between administrative accounts local to a particular system and those that have control over an entire network. When a domain controller (or similar security device) authenticates a superuser account, that account often gains administrative powers over the network. This represents a much higher level of control, as it allows the user to modify attributes of the network itself. Users who achieve network administrator powers may have the capability of adding new systems and users to the network and altering intersystem access control lists.

Information security practitioners charged with protecting their network must ensure that all users remain at the appropriate phase of control, given their legitimate authority and computing needs. The administrators themselves should always be at Phase 5, exercising total control over the network. Unauthorized users should always remain at Phase 1 on a network that offers no public services and possibly at Phase 2 on networks that offer public services. Authorized users of a network should reside somewhere in between Phase 2 and Phase 5, depending upon the organization's business requirements.

12.1.2 Methods of Taking Control

When an attacker wishes to gain access to a network, he or she generally begins with either Phase 1 or Phase 2 access to that network. From that

> **NOTE**
>
> The goal of a cracker is not always to gain total security control of a network. In some cases, the cracker might simply be looking for a place to store pirated software files, launch an attack against a third-party system, or engage in some other type of activity that might only require user or superuser access to an individual system. Therefore, you should develop your security monitoring posture in such a manner that you're able to detect *any* unauthorized escalation of security privileges, not merely a jump to Phase 5 control of an entire networked environment.

Web Server

Intranet

Firewall

Internet

Figure 12.1
Network security scenario

point, the goal is often to achieve total security control (or Phase 5 control) of the target network. In this section, we'll take a look at the sequence of events a cracker might undertake when attempting to achieve this goal including a look at several common cracker tools. The discussion in this section will refer to some of the attack techniques you learned in Chapters 7 and 9 of this book.

Let's imagine a simple network security scenario, such as that shown in Figure 12.1. We have a simple firewall installation, which segregates an intranet from the Internet and provides a secure DMZ for the operation of a Web site. We'll assume that the Web site is open to the public and has no special security measures.

A cracker seeking to penetrate this network would most likely look first at the Web server in the less secure DMZ network segment. As we know from our scenario, this system offers services to the general public, so there is at least some accessibility to it through the firewall. Because of this fact, the cracker already has Phase 2 (external application access) control of the server. His next step is to reach Phase 3 (user-level access), the most difficult step in the process of taking control. He can use several techniques to gain user-level access:

- Use a tool such as nmap to determine the version of the operating system and any publicly available applications running on the

server and then exploit a known vulnerability in one of those applications.

- Run a password-cracking algorithm (such as *crack*) on the server's password file (obtained by exploiting another vulnerability).

- Locate a CGI (or other language) script running on the server that's in the public domain and analyze the source code to find a vulnerability that can be exploited.

- Locate a custom-written script running on the server and attempt a number of common techniques, such as buffer overflow exploits, to attempt to crash the server or compromise its security.

After the cracker has user-level access to the system, his or her next step is to exploit a vulnerability in the system and attempt to gain superuser access. A cracker can use two primary techniques to achieve this goal (although other techniques can also be used to achieve the same goal):

- Use a password-cracking algorithm such as crack to obtain the password for an account with superuser privileges.

- Use a **rootkit** program. Rootkits are suites of tools specially designed to exploit known vulnerabilities and achieve superuser access on a system. The main danger of these tools is their ubiquitous nature—almost anyone resourceful enough to use Google can locate, download, and execute one of these programs. This underscores the importance of maintaining the patch levels of your systems!

After successfully using one of these two techniques, the cracker now has superuser access to the Web server. The rest of the attack depends upon the specific system configuration. If the administrators weren't too security savvy, they might have used the same password for the Web server's administrative accounts and the firewall's administrative accounts. If so, the cracker merely needs to access the firewall with one of these administrative accounts and alter the rules to allow himself unrestricted access to the internal network. If this is not the case, the attacker might use the Web server as a partially trusted platform from which to launch a similar series of attacks on the firewall.

In any event, after the cracker compromises the firewall itself (in combination with the previous accomplishments), he or she has most likely gained

Phase 5 total security control of the network and may proceed to conduct whatever nefarious activity he or she has planned.

The ease with which our fictional cracker gained control of this network underscores the importance of developing a layered perimeter protection approach. The network security perimeter should have multiple security devices, perhaps even redundant firewalls from different manufacturers, to limit the likelihood of a successful penetration. These preventative devices should be backed up by reactive mechanisms such as intrusion detection systems (discussed in Chapter 13) and proactive mechanisms such as vulnerability scanners (discussed in Chapter 14) to form a well-rounded perimeter protection.

12.2 Recognizing Attacks

One of the most difficult challenges facing information security practitioners is recognizing when you're the victim of an electronic attack. Sometimes it's an easy task. If all of the computers in your organization start one morning with a message on the screen stating "You've been slammed" and critical files are gone, it's a safe bet that you've been attacked. Similarly, an unexpected flood of mysterious e-mails from internal sources is probably a symptom of a macro virus infestation. Unfortunately for us, most attacks aren't anywhere near as obvious. Consider the case of a slow-performing Web server. For most administrators, there's a simple diagnosis for this problem—the Web site is getting more traffic and needs a server upgrade. However, these same symptoms could also be the manifestation of a low-level DoS attack. In that case, you'd clearly want to eliminate the illegitimate traffic rather than investing in additional infrastructure.

In this section, we take a look at some of the tools and techniques at your disposal to help you recognize malicious activity on your networks. We examine some of the more common points of attack on a network and look at a scenario in which your systems are under siege from multiple directions.

12.2.1 Common Points of Attack

One of the best techniques for recognizing attacks is to focus on the most commonly attacked points on a network and monitor them for the key indicators that suggest an attack is in progress. Although certainly not a

foolproof panacea, this technique will help you detect and respond to the vast majority of attacks that can take place on your network.

Web Server

Organizations that host Web servers accessible over the Internet face a classic catch-22 situation. In many cases, these servers are the most often attacked and most vulnerable points on a network. On the other hand, for many businesses, they're an invaluable tool for electronic commerce, information dissemination, and collaboration. Therefore, management charges security professionals with the task of running them in a secure manner and balancing business needs with information security requirements.

Because of their inherent vulnerability, Web servers should be closely monitored by security personnel. One of the most common signs of attack is unexplained server load, especially during off-peak hours. If you notice that your Web site is experiencing a steadily increasing load or brief periods of extraordinary activity, investigate the matter. Sometimes, there's a rational explanation for this type of activity; for example, the administrators of online news sites experienced greatly increased Web site traffic the afternoon of September 11, 2001. Other times, the load is due to a server misconfiguration, operating system flaw, or programming error. In some cases, it's the result of malicious activity. Whatever the cause, it's your responsibility as a security professional to get to the bottom of the matter and ensure that appropriate controls are in place on the server.

DNS Server

DNS servers are fraught with vulnerabilities. A search through the vulnerability databases of a computer emergency response team will likely yield hundreds of reported flaws in various versions of BIND (the Berkeley Internet Name Daemon—one of the most common DNS packages in use on UNIX systems).

The most important thing you can do to protect your DNS server is keep it patched. New versions of BIND and other DNS packages are released constantly. Take the time to monitor a trusted source for updates and observe your DNS server for unusual activity. Something as simple as a sudden disappearance of requests for information on a domain you host could be a sign that you've been the victim of a DNS hijacking attack.

Mail Server

Like Web servers and DNS servers, mail servers must, by their nature, have some sort of exposure to the Internet. Some Simple Mail Transfer Protocol (SMTP) servers are configured in the DMZ, whereas other mail systems use SMTP relay agents to forward traffic through the firewall to the mail server itself. Whatever technology is in place, the fact remains that the server must have some connectivity to the public Internet if communication with third parties is required. This leaves the mail server open to attack.

As with the other server types discussed, you must monitor your mail servers for signs of unusual activity. If you're suddenly bombarded with inbound traffic, you might be the victim of a DoS attack. If unusually large amounts of SMTP traffic are leaving your network, you might have been compromised by spammers using your network as a tool of their trade. You should also periodically check to ensure that your SMTP server is configured to relay traffic only from authenticated users in your organization. If your server is accidentally configured to relay *all* mail (a situation known as an "open relay"), you might unwittingly become a way station for spammers seeking to disguise their true identities by sending all of their spam messages through your open relay.

Firewall

Your firewall is the most critical perimeter protection device on your network. As you learned in Chapter 8, it serves as the barrier between your protected network, the semipublic DMZ, and the wilds of the public Internet. You should continually monitor your firewall for any signs of malicious activity.

Many organizations have the resources to purchase and maintain only a single firewall device, so the firewall can quickly become a bottleneck critical point that all traffic must flow through. This makes it an especially tempting target for an intruder seeking to disrupt your business activities. One common strategy employed by these individuals is to simply flood a firewall with innocuous-looking traffic (such as a request for your organization's home page) until the firewall simply becomes overloaded and can't process legitimate network traffic. This type of situation can be extremely difficult to detect, especially if the attacker uses a distributed denial of service (DDoS) attack, which

comes from multiple directions. The best tool against this type of attack is common sense; when unexpected activity occurs at your firewall (or at any point in your network, for that matter), take a few minutes to think about it. Is there a reasonable explanation for the fact that your Web traffic jumped 2000% in the past two hours? If you just ran your first national television ad, that might actually be legitimate activity. If it's 3 A.M. and your entire market is asleep, you might be the victim of an attack.

Test/Development Systems

Most information technology professionals are aware of the danger of exposing an unhardened system to the wild Internet. If you don't understand the magnitude of the threat, perform a simple experiment. Take a brand-new system (one that doesn't contain any confidential data or links to other systems), configure it with a public IP address, and attach it directly to the Internet without applying any security patches or other controls. Then, observe how long it takes someone to compromise your system. It's guaranteed that if you perform this experiment, you'll never attach an unprotected system to the Internet again, even for a moment!

> **NOTE**
>
> If you'd like to give this experiment a try, see the details and warnings in Challenge Exercise 12.1 before attempting it.

Unfortunately, administrators around the world make this exact mistake on a daily basis. Sometimes it's the result of ignorance, sometimes the result of needing a "quick fix" to a networking issue. In any event, it's a serious vulnerability and has the potential to compromise your entire perimeter protection strategy. In case it's not already abundantly clear: *Never attach an unprotected system to the Internet, for any reason!*

12.2.2 Multifront Attacks

Crackers can be extremely clever individuals. They will try absolutely every trick to gain access to or disrupt your network. In some cases, they'll try them all at once and launch simultaneous attacks against many components of your network/security infrastructure. As an information security professional, you must be vigilant in your monitoring for this type of activity and take swift action. If a cracker tries hundreds of different attacks against your network, there's a good chance that at least one of those attacks will be successful. However, the reality is that hackers often go after the *low-hanging fruit*—systems that are poorly configured and contain substantial security vulnerabilities. A little prevention goes a long way.

Intrusion detection systems can play a critical role in detecting multifront attacks. If you suspect that a particular location on the Internet is waging war against you, it might be prudent (depending upon your business requirements) to simply block access from that location at the router level until you're able to resolve the situation. Although this may seem to be a drastic response, it might help you avoid bigger problems in the future.

12.3 Auditing to Recognize Attacks

> **NOTE**
>
> The auditing information presented in this chapter is designed to help you detect specific types of attacks when analyzing an audit trail. Detailed information on auditing and logging is presented in Chapter 11.

As you know, intrusion detection systems can help you detect attacks against your protected infrastructure in real time so that you may respond appropriately. In addition to this real-time detection capability, you should also configure and monitor the audit trails generated by operating systems and critical applications running on your network. This retrospective look won't stop an attack, but it might provide you with diagnostic information useful in reconstructing a previous successful attack and implementing countermeasures to prevent its recurrence. If you don't monitor these logs, you run the risk of being unaware that your network was even attacked in the first place!

In this section, we'll take a look at a few common attack methodologies and point out some ways you might be able to detect this type of activity in system/application audit trails.

12.3.1 Malicious Code

Malicious code objects, such as the viruses, worms, and Trojan horses discussed in Chapter 7, represent one of the most prolific threats against networks today. Fortunately, a large number of software packages are available that are specifically designed to detect and eradicate malicious code. These antivirus packages scan file systems, inbound/outbound electronic mail, Web content, and other network traffic for signs of malicious code and either quarantine or block suspect programs from entering the protected network.

It's critical that you analyze the audit trails generated by these packages on a regular basis. Even if they're functioning properly and blocking/quarantining traffic, you need to be aware of the level of this activity that's taking place on your network. For example, if a macro virus infects a user's system and causes it to generate large quantities of e-mail, an antivirus package that blocks those messages from infecting other systems is only half of the

solution. You must also locate and disinfect the afflicted machine to prevent a de facto DoS attack against your mail server.

12.3.2 System Bugs and Vulnerabilities

Every operating system and major application in existence has well-known and documented security flaws. Your responsibility as an administrator is twofold. First and foremost, as has been repeated throughout this book, you absolutely must ensure that all systems on your network have appropriate security patches to minimize the impact of these vulnerabilities on your network operations. Second, you should analyze system audit trails to monitor for any suspected attempts to exploit these vulnerabilities, in the event an unpatched system exists somewhere on your network.

Typical signs of these exploits may include unexplained crashes/reboots of systems, unusual network traffic that doesn't meet standard protocol specifications, or repeated ping traffic between systems on your network or any of a host of other anomalies. Basically, the same rule applies here that we've used elsewhere in this book: If it's unusual, check it out. It's a good practice to develop a security baseline and then use it as a point of reference to detect anomalous activity. This is discussed in Chapter 11.

12.3.3 DoS Attacks

DoS attacks threaten the availability of your resources to legitimate users. Some of them are easy to detect—a critical resource simply becomes unavailable, prompting a flood of phone calls and help desk tickets from concerned users. Others are less obvious, resulting in the gradual slowing of response times, intermittent unavailability of resources, or other signs that are common symptoms of overloaded resources and may be written off by users and administrators alike as growing pains on a busy network.

Detecting these less obvious DoS attacks requires vigilance on the part of administrators. You must pay attention to changing patterns in network activity and attempt to correlate each to legitimate changes in the activities of authorized users. The anomaly-based intrusion detection systems discussed in Chapter 13 can lend a much-needed helping hand for this unpleasant chore.

12.3.4 Illicit Nodes

Network jacks are becoming more and more prolific in modern architecture. One can even find jacks in the cafeterias and restrooms of newer

buildings. Combined with the explosive growth of wireless networking, this trend greatly increases the threat to networks from illicit nodes. Your network should be configured to reject internal traffic from unrecognized systems. These may be the result of innocuous attempts by employees to connect personal computers to the corporate network. On the other hand, they might also be attempts to penetrate your network from the inside, bypassing the majority of your perimeter protection systems.

War Driving

Crackers have taken notice of the rapid growth of wireless networking within organizations and evolved a new technique designed to detect and penetrate these often insecure networks. Called *war driving* (after the popular random-digit dialing modem hacking technique of the early 1980s known as *war dialing*), crackers simply sit in a car with a laptop configured for wireless access and slowly drive city streets searching for insecure wireless networks. When they locate such a network, they can quickly gain access as an insider, bypassing most common perimeter defenses and then use the techniques discussed in this chapter to escalate their privileges until they gain total control of the network. This is why it's a good idea to have separate networks for wireless users and segment them with a firewall that protects hard-wired resources from rouge wireless users.

The moral of the story is to be sure that you fully understand the risks of wireless networking and have adequate safeguards in place before going "on the air" for the first time, even if only for a few minutes.

NOTE

For an in-depth discussion of MAC addressing, see Chapter 6.

The best way to monitor networks for malicious nodes (either wired or wireless) is to monitor the MAC addresses of nodes on your network. These hardcoded addresses uniquely identify every network interface on the planet. If new addresses suddenly appear on your network, investigate them immediately. If they're not the result of legitimate hardware additions, take steps to block any traffic to or from that particular network node until you're able to locate it. At the same time, determine how that node gained access to your network and block the path so that other machines can't follow a similar route in the future.

12.3.5 Unwanted Control

This chapter discusses a variety of techniques that crackers might use to gain control of your network. Rootkits, malicious code, and exploitation of

well-known vulnerabilities are but a few of the more common techniques. Hopefully, you've put a comprehensive security plan in place designed to reduce the risk that these activities pose to your network. The final piece of the puzzle is to monitor your audit trails for signs of any successful attempts to gain control.

You clearly should audit all administrative activity that takes place on your network. If you see suspicious administrative sessions (either strange users exercising administrative powers or normal administrators exercising their powers in an unusual fashion), investigate it. Always err on the side of caution. The damage caused by a cracker who has gained total control of your network can be irreversible.

12.4 Chapter Summary

- The three main goals of information security are to maintain the confidentiality, integrity, and availability of protected resources. These goals are commonly referred to as the CIA triad.

- Crackers use the techniques that comprise the DAD triad—disclosure, alteration, and destruction—to counter attempts to enforce the CIA triad.

- Malicious individuals can quickly exploit even the smallest foothold on a system—application access or user-level access—and leverage it to gain total control of the affected network.

- Crackers often use specially designed tools, such as password-cracking algorithms, rootkits, and similar methods, to gain superuser access to a system.

- Administrators should pay careful attention to the most common points of attack on a network: Web servers, mail servers, DNS servers, firewalls, and testing/development systems.

- Never attach an unprotected system directly to the Internet at any time, for any reason.

- Auditing techniques should be used as a backstop against other security devices. Administrators should monitor the logs generated by these techniques to detect any successful security exploits and prevent their future recurrence.

- The growth of wireless networking has greatly increased the risk of illicit network nodes. Crackers use war driving techniques to locate

and penetrate vulnerable networks located in cities and towns around the country.

12.5 Key Terms

destruction: The unauthorized deletion of data or prevention of authorized users from accessing system/network resources or information.

rootkit: A set of hacking tools designed to take a user from Phase 3 (user-level access) to Phase 4 (superuser access) on a system.

security control: Maintaining the confidentiality, integrity, and availability of protected systems and networks.

superuser: A privileged account that has administrative powers over a system. Also known as the root account on UNIX systems or the Administrator account on Windows systems.

12.6 Challenge Questions

12.1 An elementary school in Ohio recently fell victim to a young cracker who penetrated the school's file server and attempted to change his grade in a course from a C to an A. What element of the CIA triad did this attacker attempt to defeat?

a. Confidentiality

b. Integrity

c. Availability

d. Authorization

12.2 Several electronic commerce sites were recently flooded with traffic by a group of malicious individuals. This traffic overwhelmed the servers and prevented customers from placing orders. What element of the CIA triad did these attackers defeat?

a. Confidentiality

b. Integrity

c. Availability

d. Authorization

12.3 A cracker broke into a database used by a major electronic commerce site and stole a list of customer credit card numbers. What element of the CIA triad did this attacker defeat?

 a. Confidentiality

 b. Integrity

 c. Availability

 d. Authorization

12.4 What level of control should security administrators have over their protected networks?

 a. No access

 b. Application access

 c. User access

 d. Superuser access

 e. Total control

12.5 What is the highest control phase that an unauthorized user should be able to reach on a network that hosts a public Web site?

 a. No access

 b. Application access

 c. User access

 d. Superuser access

 e. Total control

12.6 What is the highest control phase that a nonadministrative user should be able to reach on an organization's network?

 a. No access

 b. Application access

 c. User access

 d. Superuser access

 e. Total control

12.7 Which of the following terms are used to describe accounts with special privileges on various operating systems? (Choose all that apply.)

a. User account

b. Superuser account

c. Megauser account

d. Root account

e. Administrator account

12.8 On a system where many users have administrative powers, it is acceptable to have each user log on using their individual _____ accounts for normal activity and then use a shared _____ account for those times when they need to utilize superuser privileges.

12.9 It is absolutely critical that you put a _____ device in place on your network using a _____ strategy if you plan to allow outside users to access applications on your network.

12.10. On a system with multiple administrators, how many accounts should each administrator have?

a. 0

b. 1

c. 2

d. 3

e. 4

12.11. Which principle of the DAD triad corresponds to the CIA triad's principle of confidentiality?

a. Disclosure

b. Alteration

c. Assumption

d. Destruction

12.12. Which principle of the DAD triad corresponds to the CIA triad's principle of integrity?

a. Disclosure

b. Alteration

c. Assumption

d. Destruction

12.13. What type of program is specially designed to help a regular user achieve superuser status by exploiting known vulnerabilities?

a. Virus

b. Crack

c. Rootkit

d. Trojan horse

e. Trinoo

12.14. Of the following systems, which is the most likely first target of a cracker seeking to penetrate a network?

a. Public Web server

b. Firewall

c. Domain controller

d. Intrusion detection system

e. Individual workstation

12.15. Which one of the following programs contains software code designed to retrieve passwords from an encrypted password file?

a. Virus

b. Crack

c. Rootkit

d. Trojan horse

e. Trinoo

12.16. Which one of the following attack types, when conducted at a low level, could easily be misconstrued as increased demand on a Web server?

a. Denial of service

b. DNS spoofing

c. ARP poisoning

d. Port scanning

e. Network sniffing

12.17. Why is it unacceptable to connect an unprotected system to the Internet for short periods of time?

12.18. Which of the following software packages is a common DNS server that is the frequent subject of vulnerability reports?

 a. Sendmail

 b. Inetd

 c. RARP

 d. Gopher

 e. BIND

12.19. Analysis of _____ can help you review previously successful attacks and implement appropriate countermeasures to prevent their recurrence.

12.20. Which of the following techniques is commonly used by malicious individuals seeking unprotected wireless networks?

 a. War dialing

 b. Speed dialing

 c. War driving

 d. Speed driving

 e. Speed scanning

12.7 Challenge Exercise

Challenge Exercise 12.1

In this exercise, you observe the perils of attaching a test system to the Internet. You need a computer system that contains no data and has a freshly installed operating system, a static public IP address, and a direct connection to the Internet.

12.1 If you haven't done so already, delete all data from the system and install the operating system of your choice. Do not apply any updates or security patches to the operating system.

12.2 Install the security monitoring tools (e.g., antivirus software, personal firewall, intrusion detection system, etc.) of your choice. Configure the tools to log any attempted attacks, whether successful or not. You may use any tools available to you. If you're on a limited

> **WARNING**
>
> This experiment should be conducted only if you have appropriate permission to do so. It is critical that the system be a standalone system with no links to other systems, no accounts/passwords in common with other systems, and no confidential data. Furthermore, the system should be *completely* rebuilt after the experiment is complete. If you have any doubt about whether your system meets the above criteria or there is any question about your authority to conduct this experiment, *don't do it.*

budget, there are a number of free tools available, such as the F-Prot virus scanners (*http://www.f-prot.com/products/home_use/*), the ZoneAlarm personal firewall (*http://www.zonelabs.com*), and Microsoft Internet Connection Firewall.

12.3 Configure the system with a static public IP address.

12.4 Connect the system to the Internet and observe any malicious activity (successful or failed) that appears in the logs. Report on your results.

12.8 Challenge Scenarios

Challenge Scenario 12.1

Golden Sprockets manufactures high-quality widgets for use in upscale automobiles. Many of the company's management employees spend much of their time walking around manufacturing floors supervising the activities of production line employees. As part of a quality improvement initiative, each of these managers recently received a WiFi-enabled personal digital assistant (PDA). Management asked the IT director to investigate implementing a wireless network to boost the productivity of these managers.

As the company information security specialist, the director approached you and asked you to perform a risk assessment and action plan for the secure implementation of wireless networking. He has requested the following two deliverables:

12.1 A description of the various risks posed by wireless networking and the implications a successful exploitation of these risks would have on the company's network.

12.2 An action plan for the secure operation of the wireless network, minimizing the risk to the company's resources while still allowing managers fairly flexible wireless access.

Develop written responses to each of these requests.

Challenge Scenario 12.2

Challenge Scenario 12.2 builds upon Challenge Scenario 12.1, but requires you to approach the situation from the opposite point of view.

You are a cracker, employed by Evil Widgets, a direct competitor of Golden Sprockets. Evil Widgets hired you to penetrate the Golden Sprockets wireless network and steal the plans for their new Heavenly Widget. As a malicious cracker, you have no scruples and will use any technique, legal or illegal, at your disposal to achieve this goal.

Furthermore, you have an added advantage. A disgruntled former employee of Golden Sprockets stole a copy of the organization's wireless security plan and provided it to you. Your mission is to find the weaknesses in this plan and outline a possible attack against the Golden Sprockets wireless network.

CHAPTER 13

Intrusion Detection Systems and Practices

After reading this chapter, you will be able to:

- Understand intrusions and intrusion detection
- Identify two different types of intrusion detection systems
- Explain common errors intrusion detection systems produce
- List the main types of intrusions
- Understand different intrusion detection system placement locations

At this point, you should have a pretty good idea of what it takes to create a secure environment for your data. Although you may have strong security controls in place, you will still need a method to monitor your systems to detect any attacks that do occur. It's also nice to be aware of any attack attempts that fail. Without an aggressive policy that addresses the detection of attacks and how to handle them, you will have difficulty responding to any successful attacks.

This chapter covers the topic of **intrusion detection**. Intrusion detection is, well, the practice of detecting intrusions. Let's start with the basics of what intrusions are and how you can recognize them. Then we'll move on to a discussion of choosing, implementing, and monitoring intrusion detection systems.

13.1 Intrusion Detection Terms and Concepts

An **intrusion** is any use, or attempted use, of a system that exceeds authentication limits. Simply put, an intrusion is anyone or any program that accesses more than it should. You define what actions constitute an intrusion in your security policy. Intrusions are very similar to incidents. The basic difference between an incident and an intrusion is that an intrusion actively involves a system or network device, whereas an incident can be as simple as writing your password on a sticky note. It is important to understand what an intrusion is and how to detect it. Through continuous monitoring of a system's activity, you can both evaluate the effectiveness of your existing controls and identify any needs for new controls.

An **intrusion detection system (IDS)** is software and/or hardware that continuously monitors activity, looking for something suspicious. When it detects suspicious activity, it takes some action. The action could be alerting an administrator or simply recording the activity in another log file. In most cases, you decide what action the IDS takes. Some newer IDSs have the ability to automatically respond to certain attacks. You don't want the IDS to e-mail your cell phone every three minutes, but you don't want it to ignore an important event, either. You must carefully choose the right IDS and take the time to configure it for your organization.

Regardless of the type and brand of IDS, the configuration decisions you will make start with your security policy. In general, policies tend to be

either **prohibitive** or **permissive**. The terms *prohibitive* and *permissive* refer to the default access assumption when there are no specific rules for a particular object. A prohibitive policy begins by denying access to all objects. Access to every object is prohibited unless specifically granted. This type of policy supports the concept of least privilege and works well in an environment that contains many sensitive data objects. On the other hand, a permissive policy allows subjects to access all objects unless the access to a specific object is explicitly denied. A permissive policy might work better in an environment with a small number of sensitive data objects. The basic nature of your security policy will have a direct impact on the selection and configuration of an IDS.

No IDS is perfect, so you will have to set its sensitivity so that you get the best response. The "best" response is subjective, and depends on your particular organization. However, all IDSs require you to understand how to configure their many settings, and to do so properly. Many IDSs do not perform the tasks for which they were installed because an administrator did not understand how the IDS works or did not have time to configure it properly.

For example, a system that stores national defense secrets should have several IDSs that sound an alarm when any suspected intrusion occurs. Commercial systems that store few sensitive files should trip an alarm only when detected activity is almost definitely an intrusion. Another type of product that goes further than an IDS is an **intrusion prevention system (IPS)**. An IPS not only detects an intrusion but takes actions to block the intrusion. IPSs are generally logical extensions to classic IDS functionality. In any case, an IDS or IPS will generate some erroneous alerts. Although an IDS that is properly configured will be right most of the time, it will make false reports due to errors.

There are three basic types of IDS/IPS errors. A **false positive** error reports normal activity as being suspicious. When the number of false positive errors gets excessive, the "boy who cried wolf" syndrome causes further IDS/IPS alerts to be ignored. A **false negative** error is worse. False negative errors occur when an intrusion is missed. The IDS/IPS treats the intrusion activity as normal operation. Because the IDS/IPS fails to detect the intrusion, there is no immediate notification of what is happening. Lastly, a **subversion error** occurs when an intruder changes the way the IDS/IPS works to overlook current intrusion activity. Similar to the Jedi mind trick, the

intruder tells the IDS/IPS that all is well. An example of a subversion error is when your IDS/IPS is monitoring for a specific type of packet once per minute for five minutes. If a sophisticated intruder sent such a packet only once every three minutes, the attack would not be identified. Although such a packet would normally occur only once per week, the frequency is just below the IDS/IPS threshold and would be missed. A subversion error is extremely problematic because it stops the IDS/IPS from doing its job, and it means that you have a sophisticated intruder in your midst.

13.2 Dealing with Intruders

> **NOTE**
>
> The media generally refers to malicious attackers as "hackers." Although the proper term for this type of individual is "cracker," most people use the two terms interchangeably.

Before we discuss how to deal with intruders, let's look at the two basic types of intruders. Your system can fall prey to **external intruders** or **internal intruders**. The difference between the two is their access to the systems and the launch site of attacks. An external intruder is anyone who is outside of your organization. External intruders are actually the smaller of the two groups, but they are the ones that tend to get the most attention. All of us have heard of high-profile "crackers" who have broken into large corporate or government systems. External intruders generally start with a very limited amount of knowledge about a system and use progressively more intrusive measures to collect information. Knowing how these types of intruders operate is important to understanding how to detect their actions leading up to an attack.

Internal intruders make up the larger, and more dangerous, group of potential attackers. According to FBI studies, over 80% of all intrusions originate from within an organization. Internal intruders generally know quite a bit more about the systems and the value of the data they contain. By launching an attack from the inside, an intruder can bypass many common obstacles, such as perimeter network defenses, that an external intruder must deal with. The internal intruder also probably knows many of the security controls that are in place. Protecting a system from this kind of intruder can be very difficult. Not only can the security measures that protect a system from internal attacks be difficult to select and implement, but the detection of an internal intruder's activities also provides additional challenges. You have to secure data from both kinds of intruders.

The first step in the intrusion detection process is detection. We will cover how to get to that point in the next sections. But what do you do once you

have detected an intrusion? As with all security answers, consult the security policy. Your security policy should spell out what steps are necessary to handle an intrusion. There are three basic choices when dealing with intruders: You can block and ignore, block and investigate, or try to catch the intruder red-handed.

The first choice, block and ignore, is the simplest of the three, although blocking an intruder requires manual intervention. When you identify an intrusion, block the intruder and address the vulnerability that allowed the intrusion to take place. You do not take any further action with respect to the intruder. This course of action provides the most immediate protection for the system. When a general intrusion does not stand out as a targeted danger, the block and ignore strategy works well. It is a tactical move that stops an intruder from repeating a specific attack from a specific location. Many external intruders launch automated attacks against multiple potential victims. When you turn away an attack, the intruder will probably ignore your system and focus on less-protected victims. However, simply blocking an intruder does not stop him or her from launching additional attacks, perhaps from different locations.

The second course of action, block and investigate, also begins with blocking the intruder and modifying controls to stop a future attack of the same type. The difference is that after you contain the intrusion, you begin to collect evidence of the attack to uncover the intruder's identity and actions. This approach blends the tactical action of blocking the known attack to prevent further damage with the strategic action of seeking out the intruder. Although not all investigations yield the intruder's identity, it is possible to learn enough about the attack method to uncover previously unknown system vulnerabilities. The basic idea is to better protect your system by understanding the intruder's methods. The best result is to trace the attack all the way back to the source. This information could provide enough information to lead to legal action. Although stopping the "bad guys" is a noble cause, such investigations are very time-consuming, and may not provide a real benefit to the organization.

The third course of action is the most dangerous. Instead of immediately blocking an intruder, you actually allow him in! The idea is to create a deliberately insecure part of your network you use to attract a potential intruder. A deliberately insecure system or application that is exposed to the outside world as bait is called a **honeypot**. A honeypot attracts the

attention of an intruder long enough for the actions to be recorded and traced back to the point of origin. A successful honeypot incursion is one where the intruder hangs around in the honeypot long enough to be caught red-handed. This approach is very dangerous for two main reasons. In order for a honeypot to work, it must be partially insecure. You are putting an insecure computer on your network and allowing attackers to see it, exposing the computer to attack. Additionally, you run the real risk of making your system a bigger target by using a honeypot. Once the word gets out that your system hosts a honeypot, more crackers will start to look for the real data you are trying to protect. If you choose to use a honeypot, carefully monitor its configuration and use.

13.3 Detecting Intruders

An IDS examines activity on a specific machine or network segment and decides whether the activity is normal or suspicious. It can either compare current activity to known attack patterns or simply raise an alarm condition when specific measurements exceed preset values. In either case, the IDS determines that a user or process is attempting to do something that looks suspicious. When the IDS has identified suspicious behavior it takes some action. It is a specific action that alerts someone, or some other process, that it has detected an intruder. As far as the intrusion detection goes, that's it. It is up to the response process to carry on from here.

The response process is a combination of automated and manual steps that validate a detected intrusion and select an appropriate response. In a simple system, the IDS sends an alert to a person or process monitoring the system. It could be an e-mail message, a cell phone call, an audible alert, or any number of other mechanisms. The particular choice of communication method depends on the sensitivity of the system. For more sensitive systems, you may want to use a communication method that does not rely on the system you are monitoring to deliver a message. For example, a compromised system might not properly send an e-mail alert when required. In such cases, you should examine alternate communication methods, also known as out-of-band channels. An example of an out-of-band channel is a call to a cell phone. The message delivery is controlled by an unrelated system in an out-of-band communication model. After the IDS sends out the alert, it returns to its role of monitoring the system for additional intrusions. The recipient of the alert has the responsibility of

evaluating the seriousness of the activity and deciding on a further course of action.

Most IDSs do their job by monitoring multiple log files. Modern operating systems provide a method to record the majority of system events as they occur. Most events are simple log file entries that record the user, the time and date of the event, and any other relevant information. These log files are used for suspicious activity monitoring and to develop a picture of "normal" system behavior. It is difficult to determine if observing 100 running processes on a system is bad. It all depends on that system's normal load. A quick look at system logs will reveal the system's average load. From this information you can determine whether 100 processes is a high number, a low number, or just about right.

Regardless of the specific method an IDS uses to detect suspicious behavior, the system must compare current activity to either baseline (normal) or other suspicious activity. That means an IDS has to maintain a database of activity. We will cover what types of information different IDSs store in the database in later sections. But for now, we will characterize an IDS cycle as a three-step process. First, the IDS samples current activity. This can be by reading a log file or examining network packets as they travel around a network. The IDS then compares the activity sample to database entries. Depending on the type of the IDS, it could be looking for unusual activity or it could be just validating that the activity is normal.

The final step in the process is to make a determination based on the most recent comparison. Simply put, the IDS decides whether the sampled activity is normal or abnormal, and decides what to do next. If the activity is normal, the IDS does nothing. If the activity is abnormal or suspicious, the IDS initiates the alert process. An IDS repeats this sample-compare-decide cycle continuously to detect any activity that is abnormal. Figure 13.1 shows the continuous IDS cycle.

> **NOTE**
>
> Although these two approaches may sound the same, they are radically different. One type of IDS can recognize only normal activity, whereas the other main type can recognize only unusual activity. An activity they do not recognize is classified as "the other type" of activity. For example, if an IDS can recognize only unusual activity, any unrecognized activity is considered "normal."

13.4 Principles of Intrusion Detection Systems

Although there are many different types of IDSs from different vendors, they share a common goal. The purpose of an IDS is to detect intrusions. In order to perform this task in a meaningful way, an IDS must support several basic principles. Use these principles as a guideline when choosing an IDS for your organization.

Sample
current
activity

Compare
activity to
database

Decide
what to do

Figure 13.1

Standard sample-compare-decide IDS cycle

- A good IDS must run unattended for extended periods of time after it's been installed and properly configured. The requirements of an IDS to monitor ongoing system activity are tedious and repetitious. An administrator should not have to "babysit" an IDS. If an IDS does not run quietly and relatively problem-free without human intervention, find out why. You may need to spend additional time configuring the IDS to be more appropriate for your organization.

- The IDS must stay active and secure. The IDS must have a mechanism to resist failures. It must be fault tolerant to some degree. If an intruder can crash the IDS, any subsequent attack events will probably go unnoticed. The IDS must also resist any attempts by an intruder to change the IDS configuration. The easiest way for an intruder to get around an IDS is to reconfigure it; therefore, make sure your IDS is protected.

- The IDS must be able to recognize unusual activity. Without this capability, the IDS is worthless. Every IDS misses some activity and generates alerts for normal activity, but a good IDS that is properly configured minimizes these errors.

- The IDS must operate as much as possible without affecting the system's activity. If the IDS puts such a load on the system or network that availability becomes an issue, it is actually *degrading* the

system's security. The point of an IDS is to *increase* security. Make sure your IDS puts a minimal load on the system.

- The IDS must be configurable. You have to tweak the IDS to work well for your organization. You will create rules, set activity threshold levels, set baselines, and tailor the IDS for your system. Your IDS should be easy to configure and maintain so you can adapt it as your system and network change.

These five basic principles, or general characteristics, of an IDS will help when it is time to decide on which one to implement. Make sure your IDS does what you need and is flexible enough to change when you need it to. Let's take a look at some specific issues that pertain to IDS selection and setup.

13.4.1 The IDS Taxonomy

When you decide to implement an IDS, one of the first questions to ask is: Which kind do I need? Before we can discuss the different types of IDS, let's first cover different types of intrusions. The two basic types are **misuse intrusion** and **anomaly intrusion**. A misuse intrusion is a deliberate attack against a known system vulnerability. The intrusion is fairly easy to detect because the actions required to exploit a specific vulnerability are also known. The actions required to exploit a vulnerability are collectively known as the **attack signature**. The IDS simply compares current system activity to stored attack signatures. When the IDS finds a match, it triggers an intrusion alert.

The second type of intrusion, the anomaly intrusion, is more difficult to recognize. The intrusion itself generates some level of activity that is abnormal; however, there are no specific rules that govern anomalies. This type of intrusion generally represents a sophisticated attack that is different from the run-of-the-mill intrusion. The only way to detect such an intrusion is to compare current activity to normal activity. Any activity that is substantially outside normal deviations from standard behavior is considered to be suspicious. The common difficulty in detecting anomaly intrusions is defining normal and abnormal behavior.

To detect both types of intrusions there are two basic types of IDS: **signature-based** and **knowledge-based**. Most IDSs in use today are signature-based. A signature-based IDS examines current system activity and

compares it to a database of attack signatures. The degree to which a signature-based IDS can detect an intrusion depends on the quality of the signature database. You must ensure your signature database contains all known attack signatures as soon as they are available. This type of IDS generally produces a low false positive error rate and is fairly straightforward to configure.

The other basic type of IDS is the knowledge-based IDS. This type of IDS can detect anomaly intrusions. It is a more difficult type of IDS to configure and maintain. Because knowledge-based IDSs tend to require more administration, they are not as popular or numerous as signature-based IDSs. As it runs and examines activity, the knowledge-based IDS builds a profile over time of normal activity. The longer the IDS monitors a system, the better it can decide between normal and abnormal activity. It doesn't do its job alone, though. The configuration phases during IDS setup involve setting many values the IDS uses when deciding if activity is normal or worthy of an alert. The profile of normal activity and the individual activity settings give the IDS the input it uses to decide whether observed activity is acceptable or a possible intrusion. The knowledge-based IDS produces more false positive errors than the signature-based IDS, but it has the benefit that it can detect new and unknown types of attacks. The advantage of a knowledge-based IDS is that it does not require an administrator to tell the IDS to look for a particular attack. It can detect some attacks before the administrator even knows about them.

13.4.2 Using Rules and Setting Thresholds for Detection

The IDS uses either a signature database or a normal performance profile to discern when activity is suspicious. But how does it know what to do then? When you set up the IDS, you set up **rules** and **thresholds** that tell the IDS when to create alerts and how to communicate the current system status. A rule tells the IDS what packets to examine and what action to take if a packet looks suspicious. A threshold is a value that represents normal activity. Exceeding a threshold is grounds for an alert.

An IDS rule is similar to a firewall rule. Without getting into a lot of details, think about a simple firewall rule. It tells the firewall which packets to examine. Most firewall rules provide source and destination addresses and ports, along with protocol information. The firewall examines the header of a packet to see if the address, port, and protocol match a rule. If there is

a match, the rule states what action should be taken. IDS rules are constructed in a similar fashion.

Let's look at a sample IDS rule. (Don't be concerned with the specific format right now.) This particular rule is for a Snort IDS, and it gives you an idea of what IDS rules look like. Snort is a freely available signature-based IDS that has a growing user base. We will cover more Snort specifics in the next section. For now, consider this Snort IDS rule:

```
alert tcp any any -> 192.168.1.0/24 111 (content:"|00 01 86 a5|";
msg:"mountd access";)
```

The rule starts with an action. If the IDS finds a packet that matches the rule's criteria, it examines the packet's contents and compares it to the signature database. If the packet signature matches a known attack, the IDS takes the stated action. In this case, Snort generates an *alert*. Rules keep an IDS from examining all network traffic by restricting, or filtering, the packets it considers. The next tokens tell Snort to consider *TCP* packets originating from *any* source and traveling to *any* destination in the *192.168.1* subnet. The last token before the parenthesis tells Snort to apply this rule only to packets destined for port *111*. So, if Snort finds a packet that matches this rule, it creates an alert using the information in the parentheses. In our example, the *content* token tells Snort to examine the packet payload for the string "00 01 86 a5". If it finds a packet that matches the pattern, it generates the alert message with the supplied message text.

Another way to provide instructions to an IDS is by setting thresholds. A knowledge-based IDS uses thresholds to detect activity that exceeds normal usage. A simple example is login failure attempts. If the login threshold is set at 3, the IDS takes some action after the third failed login. In this case, the action might be to lock the account and send a notice to an administrator. Other thresholds could be set to watch file I/O, network activity, administrator logins and actions, and many other system activities. The main difference between thresholds and rules is that thresholds use specific values for guidelines to define what normal activity looks like. Intrusion detection requires that the IDS determines that activity departs from normal activity by a predetermined amount. Rules define specific conditions that constitute an intrusion.

13.4.3 Exploring a Typical IDS

Let's take a closer look at a common open source IDS, Snort. Snort has several qualities that make it an ideal IDS to demonstrate basic intrusion detection concepts. First, it is free. Go to *http://www.snort.org* to download the software and access product documentation. Snort was originally written for UNIX systems, but there is now a Snort port for Windows operating systems as well. Second, Snort is relatively easy to learn and work with. Although Snort is described by its creator as a "lightweight IDS," it really has plenty of horsepower. It is flexible and functional. Snort's rule construction is easy to learn and powerful enough to use on a demanding production system.

Snort is basically a highly configurable **packet sniffer** (that's where the name Snort came from). A packet sniffer is a program that intercepts, or sniffs, network packets as they pass by. Of course, the sniffer has to be connected to the network you want to analyze. Calling Snort a packet sniffer is telling only half the story. Although it started out as just a packet sniffer, Snort has become an effective IDS. Whereas some IDSs scan log files for intrusion activity, Snort analyzes network traffic in real time. The packet-sniffing capability sets the stage for the analysis of each packet. It is the ability to analyze packets for intrusion signatures that gives Snort its power, and allows administrators to react to incidents faster than waiting to analyze log files.

After a packet is sniffed from the network, the preprocessor, or part of the program that looks at the packet header, decides whether to look in the packet payload or ignore it. The first section of a Snort rule tells the preprocessor which packets to keep. Any packets that match the addresses and ports of at least one rule are passed to the detection engine. The detection engine compares patterns from Snort rules to the packet payload. If it finds a match, it generates the requested output.

The easiest way to start Snort is in packet sniffing mode. In this mode, all Snort does is sniff packets and output them. It also keeps some statistics to show you what is passing through your network. To start Snort in this mode, use the command:

```
$ snort -dev
```

The **-d** option tells Snort to include all Network layer headers (TCP, UDP, and ICMP), the **-e** option tells Snort to include the Data Link layer headers,

```
┌ ▄ ─                                              _ □ ×
═══════════════════════════════════════════════════════════
Snort analyzed 764 out of 764 packets, dropping 0(0.000%) packets

Breakdown by protocol:                  Action Stats:
    TCP: 730      (95.550%)              ALERTS: 0
    UDP: 34       (4.450%)              LOGGED: 0
   ICMP: 0        (0.000%)              PASSED: 0
    ARP: 0        (0.000%)
  EAPOL: 0        (0.000%)
   IPv6: 0        (0.000%)
    IPX: 0        (0.000%)
  OTHER: 0        (0.000%)
DISCARD: 0        (0.000%)
═══════════════════════════════════════════════════════════
Wireless Stats:
Breakdown by type:
   Management Packets: 0       (0.000%)
   Control Packets:    0       (0.000%)
   Data Packets:       0       (0.000%)
═══════════════════════════════════════════════════════════
Fragmentation Stats:
Fragmented IP Packets: 0       (0.000%)
   Fragment Trackers: 0
   Rebuilt IP Packets: 0
   Frag elements used: 0
Discarded(incomplete): 0
```

Figure 13.2
Sample Snort packet sniffing summary

and the **-v** option actually starts the packet sniffing mode. Figure 13.2 shows a sample summary output from a Snort run.

Snort can also log packet activity. The **-l** (that's the letter *l*, not the digit 1) option tells Snort what directory to use for storing logs. Use this syntax to enable packet logging:

```
$ snort -dev -l {log directory}
```

This command enables packet logging in text mode. All output is regular ASCII text. If you want binary output, Snort can generate a TCPDump formatted file. The TCPDump format is common among several IDSs. Binary data logging is faster than ASCII because the IDS does not have to translate packet payloads into text data. Snort uses the **-b** option to enable binary logging and the **-L** option to specify the location of the binary log file. Here is an example Snort command that uses binary packet logging:

```
$ snort -dev -b -L {log file}
```

The next mode for Snort is actual IDS mode. The only real difference between packet logging and IDS mode is the set of rules. As a packet logger, Snort grabs and logs all the packets it sees. When you add rules, Snort gets more picky about what it logs. The rules are generally stored in separate files, organized by rule type or context. For example, the Snort package comes

Figure 13.3
Contents of the
mysql.rules file

with two rules that attempt to detect mySQL attacks. The rules are stored in a file named mysql.rules. Figure 13.3 shows the contents of this file.

Each rule examines packets originating from any machine, traveling to a machine defined as a SQL server machine, and directed at port 3306. Snort examines each of the matching packets to see if the payload contains content that matches the pattern in the rules. If Snort finds a match, it creates an alert with the specified message.

Because there can be many different types of rules, it is common to create several separate rules files and pull them together with a session configuration file. The default configuration file is snort.conf. The configuration file serves many purposes and defines many variables and settings for a Snort session such as specifying which networks can be considered safe and which ones are potentially hostile. One service it provides is to reference each of the active rules files. It references these files by *including* the files in the Snort session. Including a file just opens the rules file and reads the rules into the active rules database. Figure 13.4 shows a partial listing of the snort.conf file. This section of the file shows some of the rules files that are included in the Snort session.

To start Snort in IDS mode, we use a command similar to packet logging mode and add the configuration file. The configuration file provides the entry point for the Snort rules. Here is an example command:

```
$ snort -dev -l /var/adm/snort/logs -c /usr/local/snort/snort.conf
```

Figure 13.4
Partial contents of snort.conf file

In this mode, Snort examines any packets you consider important and takes a specified action if the packet looks suspicious. This is just a peek at what Snort can do, but it gives some insight into the way a typical IDS operates. The details will differ from one product to another, but the core concepts are generally similar.

13.5 Network-Based Versus Host-Based IDS

IDSs can be classified not only by the methods they use to detect intrusions, but also by their intended locations. There are two types of IDSs, based on where they are placed and what data they inspect:

- A **network-based IDS** monitors all traffic on a particular network segment. The IDS consists of a network interface card in **promiscuous mode** and the software to sniff packets as they cross the network segment. A card in promiscuous mode reads all packets it sees, regardless of the packet's destination, and passes them to a waiting program (the packet sniffer).

- A **host-based IDS** is a software package that can examine all network activity intended for a particular machine. The IDS can examine network packets as they are received, system activity log files, or a combination of the two.

> **NOTE**
>
> For more information on Snort, go to the Snort home page at *http://www.snort.org*. If you want more general IDS information, go to the SANS reading room at *http://www.sans.org/rr/*.

Figure 13.5
A network-based IDS

Network-based IDSs are beneficial for detecting intrusions that cross a particular network segment. They can be used to detect attacks on multiple systems and can provide an "early warning system" for an entire subnet. Another use of a network-based IDS is to place one outside your organization's main Internet firewall and another inside the firewall. The external IDS keeps track of all intrusions attempted on your organization's firewall, and the internal IDS can detect any attacks that pass through the firewall. This information can help evaluate the effectiveness of your firewall configuration and point out any weaknesses. Figure 13.5 shows a simple network-based IDS. Notice that the IDS sees all traffic passing between the Internet and the LAN. However, due to the IDS placement, it does not see any packets that pass between LAN computers.

Host-based IDSs are useful to detect intrusions involving a particular system. Because the IDS runs on the system it is protecting, it can examine all input and output. Unlike the network-based IDS, the host-based IDS can consider network packets from all sources from multiple networks and contact points. The host-based IDS can also examine system log files for evidence of intrusion activity. Host-based IDSs require more administration than network-based IDSs because each system you want to protect has an IDS running on it.

Both network-based IDSs and host-based IDSs have advantages and disadvantages. The best choice is to use both. As long as you have the resources to configure and maintain both types of IDS, having one network-based IDS for each subnet and a host-based IDS on each machine with sensitive data will give you multiple layers of intrusion detection. In fact, you may already have IDS functionality available to your system right now. Many firewalls provide some IDS functionality. Check your firewall documentation for the features that are available to you.

13.6 Choosing an Appropriate IDS

With all the IDS choices, how do you decide which one is right for your organization? Before you can make an informed decision, you need to know what your organization's needs are. You should not be to the point of selecting an IDS without having a basic idea of your security needs, so take time to ensure you know what your security goals are. Make sure you know how much security you need, and where you need it. Know what your network looks like and where sensitive data is stored. Make sure you have a clear understanding of each access path to the systems that house sensitive information.

Once you are comfortable with your security needs, you can start becoming familiar with the different IDSs available today. Start surveying from the ground up. Use several Internet search engines to find current IDS products. IDS product offerings change very frequently. It is always a good idea to ensure you have the latest information available. Even though you may have an affinity toward a specific product line, make a complete survey of the IDS products available.

For medium- to large-sized organizations, it is common to implement several network-based and host-based IDSs in a blended environment. Make sure you have the appropriate expertise to configure and maintain the IDS you select. You also have to consider your budget. As much as we would like to have unlimited funds, that never happens. Consider any training costs necessary when implementing a new product. If budget and personnel are limited, look at add-on products to your firewalls instead of brand-new products. If you have the expertise but very little budget, look more closely at open source products. There are many options available. Chances are you will be able to find one that fits your needs.

The overall key is to know your needs. Acquire a product that you and your staff are comfortable with that covers your needs. You will be getting to know your IDS very well as you set it up and maintain it. As much as you can, try to get one you like. But more important, get a product you have confidence in. If you doubt your IDS, you will end up duplicating work just to validate that the IDS is doing its job. Get an IDS you trust and you will reduce your overall workload.

13.7 Security Auditing with an IDS

Every organization should undergo a periodic security audit. It's kind of like your annual physical exam. It may not be a lot of fun, but it sure beats the alternative of having a nasty surprise sneak up on you. A security audit is a systematic assessment of the security level of a system and the effectiveness of controls. Some security audits are required by laws or regulations. Others are required by investors or others with a material interest in your organization. All security audits should be regarded as opportunities to increase your security posture. There are many parts to a security audit, and an IDS cannot address every part, but a good IDS can contribute to a complete audit and make the auditor's job easier.

Perhaps the most useful IDS component is log file analysis. Many host-based IDS will scan system log files for intrusion activity. An auditor can modify the sensitivity of such an IDS and run it for existing log files. The amount of information stored in various log files can be enormous, so having a utility to filter out only the interesting entries saves a lot of time. A port-sniffing IDS can also assist with an audit. Port sniffers do a great job of profiling network activity. A good practice is to archive IDS output files for future reference. By researching IDS output over a period of time, an auditor can get a pretty accurate picture of system activity. The more IDS reports you maintain, the clearer the picture.

Remember that an IDS is a tool, not a complete solution. Solid security depends on intelligent layering. You always want to put as many obstacles between an intruder and protected data as you can. At the same time, you want a clear path between authorized users and the data they are seeking. Balancing the two requirements can be difficult. A collection of the right IDS products can help you reach a good compromise. Choose well, set up wisely, and maintain your IDS diligently. Your efforts will pay off.

13.8 Chapter Summary

- An intrusion is any use, or attempted use, of your system or network that exceeds authentication limits. An intrusion detection system (IDS) is software and/or hardware that continuously monitors activity, looking for something suspicious.

- A prohibitive policy begins by denying access to all objects. A permissive policy begins by granting access to all objects.

- A false positive error reports normal activity as being suspicious. A false negative error occurs when an intrusion fails to create an alert. A subversion error occurs when an intruder changes the way the IDS works so that it overlooks current intrusion activity.

- A system can be attacked by both internal and external intruders.

- A honeypot is a deliberately insecure part of your system that attracts the attention of an intruder long enough for the actions to be recorded. An IDS will examine system activity to detect possible intrusions.

- A misuse intrusion is a deliberate attack against a known system vulnerability. An anomaly intrusion generates some level of abnormal activity, but does not exhibit standard behavior.

- A signature-based IDS examines current system activity and compares it to a database of attack signatures. A knowledge-based IDS can detect anomaly intrusions by comparing current system activity with a normal profile.

- A network-based IDS monitors all traffic on a particular network segment. A host-based IDS examines all network activity intended for and coming from a particular machine.

- An IDS can provide valuable information for a security auditor.

13.9 Key Terms

anomaly intrusion: An intrusion that is not based on predictable activity that generates some level of activity that is abnormal.

attack signature: The collective actions required to exploit a vulnerability.

external intruder: An intruder who attacks a system from outside your organization.

false negative: An error that occurs when an IDS decides a true intrusion is just normal activity.

false positive: An error that occurs when an IDS reports normal activity as being suspicious.

honeypot: A deliberately insecure system or application that is exposed to the outside world to attract a potential intruder.

host-based IDS: A software package or hardware device that examines all network activity intended for a particular computer. The IDS can examine network packets as they are received, system activity log files, or a combination of the two.

internal intruder: An intruder who attacks a system from within an organization.

intrusion: Any use, or attempted use, of your system that exceeds authentication limits.

intrusion detection: The process of analyzing system activity to identify any suspicious actions.

intrusion detection system (IDS): Software and/or hardware that continuously monitors activity, looking for something suspicious.

knowledge-based IDS: An IDS that compares activity to known normal system behavior to attempt to detect abnormal behavior.

misuse intrusion: A deliberate attack against a known system vulnerability. A misuse intrusion generates predictable activity.

network-based IDS: A software or hardware device that monitors all traffic on a particular network segment.

packet sniffer: A program the intercepts, or sniffs, network packets as they pass by.

permissive policy: A policy that allows subjects to access all objects unless the access to a specific object is explicitly denied.

prohibitive policy: A policy that denies access to all objects by default. Access to every object is prohibited unless specifically granted.

promiscuous mode: A network interface card that reads all packets it sees, regardless of each packet's destination.

rule: Tells the IDS what packets to examine and what action to take if a packet looks suspicious.

signature-based IDS: An IDS that compares activity to a stored list of known attack signatures.

subversion error: An error that occurs when an intruder changes the way the IDS works to make it overlook current intrusion activity.

threshold: A system activity limit, such as the number of failed login attempts, that an IDS will note if exceeded.

13.10 Challenge Questions

13.1 What is the best description of an intrusion?

 a. It is the same as an incident.

 b. Any use, or attempted use, of a system that exceeds authentication limits.

 c. Any violation, or attempted violation, of your security policy.

 d. Any use, or attempted use, of a system for criminal purposes.

13.2 Which type of security policy best supports the concept of least privilege?

 a. Permissive

 b. Strict

 c. Prohibitive

 d. Lenient

13.3 If your IDS reports suspicious activity that is actually normal, what kind of error would that be?

 a. False positive

 b. False negative

 c. Crossover error

 d. Subversion

13.4 What type of IDS error occurs when an attacker is able to modify the way an IDS operates to ignore intrusion activity?

a. False positive

b. False negative

c. Crossover error

d. Subversion error

13.5 Which type of intruder is the most dangerous, and why?

a. External intruders, because they generally acquire a lot of pre-attack information through scanning

b. Internal intruders, because they generally possess more detailed system knowledge

c. External intruders, because there are more of them out there

d. Internal intruders, because most external intruders are amateurs

13.6 What term describes a deliberately insecure system, or portion of a system, that attracts an attacker?

a. Man trap

b. Entrapment portal

c. Golden idol

d. Honeypot

13.7 Which type of intrusion is easier to recognize because it generates a predictable activity pattern?

a. Misuse intrusion

b. Anomaly intrusion

c. Malicious intrusion

d. External intrusion

13.8 Which type of intrusion is more difficult to recognize because it does not generate a predictable activity pattern (activity may appear to be random)?

a. Misuse intrusion

b. Anomaly intrusion

c. Malicious intrusion

d. External intrusion

13.9 What is the purpose of an IDS rule?

 a. It tells the IDS which network interface adapters to monitor.

 b. It provides activity limits that, when exceeded, generate an alarm.

 c. It tells the IDS which packets to examine and what to look for in the payload.

 d. It tells the firewall what packets to allow through to the IDS.

13.10 What type of program reads network packets as they travel in a network?

 a. Signature database

 b. Packet sniffer

 c. Packet analysis engine

 d. Network scanner

13.11 Which type of IDS is a software package that can examine all network activity intended for a particular machine?

 a. Network-based IDS

 b. Knowledge-based IDS

 c. Signature-based IDS

 d. Host-based IDS

13.12 Which type of IDS monitors all traffic on a particular network segment?

 a. Network-based IDS

 b. Knowledge-based IDS

 c. Signature-based IDS

 d. Host-based IDS

13.13 What is a collection of actions required to exploit a vulnerability?

 a. System footprint

 b. Attack signature

 c. Normal activity profile

 d. Anomaly profile

13.14 Which type of IDS could you use to identify attempted attacks on your system from the outside world?

 a. A host-based IDS placed on a machine in the DMZ

 b. A network-based IDS placed between your firewall and your internal network

 c. A network-based IDS placed between the Internet and your firewall

 d. A network-based IDS placed anywhere in the DMZ

13.15 What issues should you consider when choosing an IDS? [Choose all that apply.]

 a. IDS cost

 b. Expertise required for configuration and maintenance

 c. Type of connection to the Internet

 d. Security needs of your organization

13.11 Challenge Exercises

Challenge Exercise 13.1

This exercise directs you to a common repository of security-related reports. The security profession is constantly changing, so professionals must continuously strive to stay up to date. Reading rooms and peer reports offer a great way to keep current. In this exercise, you visit a popular reading room and review reports submitted by security professionals. You will need Internet access and a Web browser. The Web site you will visit is the SANS (SysAdmin, Audit, Network, Security) Institute reading room. Security practitioners who pursue certification through SANS must submit at least one current and relevant report for publication. These reports are a great way to learn more about security.

1. In your Web browser, enter the following address: *http://www.sans.org/rr/*.

2. From the reading room page, select the **Intrusion Detection** link under "Categories."

3. Select and read one of the following reports:

 "Enforcing Policy at the Perimeter"

"IDS Burglar Alarms: A How-To Guide"

"Wanted Dead or Alive: Snort Intrusion Detection System"

"The Human Factor—Adding Intelligence and Action to Intrusion Detection"

For each report, write a brief summary of what you found to be the most relevant and interesting points. In your summaries, explain how you could use the information to improve the security of an organization.

Challenge Exercise 13.2

This exercise examines the Snort intrusion detection system. We discussed some of its features in the chapter, and now you will learn more about its operation and capabilities. The purpose is to look at a viable product and get a better understanding of how a real IDS works. You need Internet access and a Web browser. The Web site you will visit is the Snort Web site (although you can visit additional Web sites as well).

1. In your Web browser, enter the following address: *http://www.snort.org*.

2. Visit the documentation page, click the **Documentation** link, and then use the Snort Users Manual, SNORT FAQ, Snort Setup Guide (for your operating system), and How To Guide: Intrusion Detection Systems to answer the following questions:

 a. List the three modes in which Snort operates.

 b. Explain the difference between rule headers and rule options.

 c. Is Snort a network-based IDS or a host-based IDS? Explain your answer.

Challenge Exercise 13.3

This exercise is similar to Challenge Exercise 13.2, except you choose an IDS to examine. The purpose is to look at another viable product and get a better understanding of how it works. You need Internet access and a Web browser. You can visit several Web sites to collect the information you will need. You start at a generic IDS listing page.

1. In your Web browser, enter the following address:
 http://www.cerias.purdue.edu/about/history/coast_resources/intrusion_detection/

2. Look at the list of IDSs and choose one that looks interesting.

3. Give a brief overview of the IDS you chose and why it looked interesting.

4. Is your chosen IDS a network-based IDS or a host-based IDS? Explain your answer.

5. Is your chosen IDS a knowledge-based IDS or a signature-based IDS? Explain your answer.

6. Where would this IDS be a good fit? Should you place it on a network or on a specific host? Explain your answer.

13.12 Challenge Scenarios

Challenge Scenario 13.1

You are a new security administrator for Hook-U-Up-Cheap, a low-cost Internet service provider. Your supervisor has given you the responsibility to suggest two IDS products for your clients. One product is a simple host-based IDS that runs on client PCs. Most of your clients run a Windows operating system, so you only need to support that system. Your organization wants to sell this simple IDS to customers to protect their home and office PCs. The second product is a network-based IDS for your larger customers to use on their networks. You want to offer both Windows and UNIX versions of this IDS. Low cost and simplicity are important features.

With this information in hand, find the two products that will best fit your organization's needs. Examine at least three products in each category. Explain why you chose the products you did, and explain why you ruled out the other products.

Challenge Scenario 13.2

As in the previous scenario, you are a new security administrator for Hook-U-Up-Cheap. Your supervisor has chosen to implement Snort on your internal network. He is concerned that Snort is not totally secure itself. You have been asked to summarize any known Snort vulnerabilities and suggest actions to ensure Snort is as secure as possible. Your job is to research Snort

vulnerabilities, find ways to address the vulnerabilities, and document any Snort best practices.

This job requires that you revisit several sites you visited in other exercises and scenarios in this book. The SANS Reading Room (*http://www.sans.org/rr*) and SecurityFocus (*http://www.securityfocus.com*). These two Web sites should get you started. After you locate the information you are looking for, write a short report on your findings. Include at least five vulnerabilities.

CHAPTER 14

System Security Scanning and Discovery

After reading this chapter, you will be able to:

- Understand system security scanning
- Fingerprint an operating system and TCP/IP stack
- Identify system vulnerabilities
- Use discovery tools
- Plan a system assessment

By this time in your study of information systems security, you should have a good understanding of the risks to your data and the ways you can manage those risks. You have learned how to devise a solid security policy and how to address various vulnerabilities. We have discussed strategies for selecting and implementing the controls you will need to protect your data. We have even talked about how to proactively monitor your systems to detect intrusions.

Now it is time to build trust in your security strategy. How do you know to what degree you can trust that your system is secure? You have planned well and implemented the necessary controls. You have even audited your system's security. Will attackers find a hole you missed? Have you addressed all the vulnerabilities? In this chapter, we'll cover techniques for assessing your system just like an attacker would. Although we covered some of the basic techniques in earlier chapters, we will treat security assessment as a separate topic here. Let's look at how you can act like an attacker to make your system safer.

14.1 Understanding Security Scanning

Security scanning is the process of methodically assessing a system to find any known vulnerability. Attackers scan systems to plan attacks. You'll need to scan your system to find any holes before an attacker does. The overall process is fairly simple, as follows:

1. Create a list of all known vulnerabilities for your operating system. (Many resources are available to help you perform this step.)

2. Check whether each vulnerability exists on your system. (Many tools are available to help you perform this step as well.)

3. Document all vulnerabilities you find.

4. Rank all vulnerabilities by severity and cost to address.

5. Take corrective action as necessary.

The steps are more involved when you start actually scanning a system for vulnerabilities. We discuss pointers to resources to help you create a list of vulnerabilities and to select a security scanner in the following sections.

14.1.1 Creating a List of Vulnerabilities

The first step in the security process is to create a current list of known vulnerabilities. Several excellent resources are available on the Internet to help

TABLE 14.1 Web Sites with Common Security Vulnerability Lists

Organization	Web Address	Description
SANS	http://www.sans.org/top20	The SANS/FBI Top 20 vulnerability list
SecurityFocus	http://www.securityfocus.com/bid	The de facto standard for finding any vulnerability for any software
Common Vulnerabilities and Exposures	http://www.cve.mitre.org	A list of standardized names for vulnerabilities and other security exposures
CERT Coordination Center	http://www.cert.org/nav/index_red.html	CERT vulnerabilities, incidents, and fixes
Securia	http://securia.com	Vulnerability lists and security advisories

with this step. Table 14.1 lists a few Web sites that maintain up-to-date vulnerability lists. An informed security administrator will take the time to visit these resources frequently.

14.1.2 Selecting a Security Scanner Tool

After you have a list of all vulnerabilities that could affect your system, the next step is to test for each one. This is the most difficult step to accomplish without some help. However, many resources are available to you. You can hire a firm that provides assessment services, or you can acquire one or more automated tools to do most of the tedious work for you.

The advantage of hiring a third party to perform this assessment is that you do not have to do it yourself. Much of the tedious work in choosing the right tool set and creating the vulnerability report is handled by the firm you hire. You also can claim more impartiality if a firm outside your organization performs the assessment. In fact, some situations, such as litigation, industry regulation, or investor requirements, require an external assessment.

The drawback to hiring an outside firm is that you have little control over how the assessment is accomplished. You also lose the ability to assess your system on demand. You could have an outside firm perform the assessment multiple times, but it can get expensive and may not be as flexible as you would like.

TABLE 14.2 **Web Sites for Security Scanners**

Organization	Web Address	Product Name	Cost
Nessus	http://www.nessus.org	Nessus Security Scanner	Free
Microsoft Corporation	http://www.microsoft.com/technet/ security/tools/mbsahome.mspx	Microsoft Baseline Security Analyzer	Free
Foundstone	http://www.foundstone.com	Foundstone Professional	$12,000 per year
Insecure.org	http://www.insecure.org	Nmap	Free
GFi	http://www.gfi.com	GFi LanGuard	$499
The Center for Internet Security	http://www.cisecurity.org	CIS Security Benchmarks and Scoring Tools	Free

NOTE

Most of the scanners listed in Table 14.2 focus on scanning systems from an external point of view. In other words, they scan a target system by launching software on another system and looking at the target system from the outside. The last entry, CIS Security Benchmarks and Scoring Tools, looks at the system from an internal perspective. Make sure you investigate both types of security assessment tools.

Whether you do it yourself or hire someone, the general approach is the same. Your goal is to find all of the vulnerabilities you can and then minimize or eliminate the important ones. Not every vulnerability is important enough to address. Always consider the likelihood and impact of an exploit when considering which vulnerabilities to address. For the purpose of our discussion, let's assume you want to scan your own systems for security vulnerabilities. You can choose from many toolsets, both free and for a fee, that provide an easy way to scan for vulnerabilities. Table 14.2 lists several Web sites where you can acquire security scanners. (This is only a partial list. Many more scanners are available.) We will use the Nessus scanner for discussions throughout the remainder of this chapter.

Take time to search out the different products that support your operating system and learn what each can do. Start with the vendor's documentation and look for any Web-based resources and tips for using your chosen product. Check for published books as well. Publishers have taken note that security topics are high on IT "buy" lists, so the number of security titles on this subject continually grows. Regardless of where you collect your information, get to know the scanners you will use. Then, you are ready to start scanning. In the next several sections, we look at the specifics of how to find system vulnerabilities through system scanning.

14.2 Fingerprinting Utilities

The first task in actively scanning a system is to find out what operating system the computer is running. The process of detecting the operating system of a remote computer is called **operating system (OS) fingerprinting**. Most attacks are specific to an operating system, or even a certain operating system version. To an attacker, knowing the target operating system narrows down the possibilities for launching an attack. After you fingerprint a system and discover the operating system it is running, you can test for vulnerabilities. The vulnerability test begins with cross-referencing the fingerprint information with a list of known vulnerabilities for that operating system. Most scanner tools listed in Section 14.1.2, "Selecting a Security Scanner Tool," refer to a database of known vulnerabilities to create a list of further actions. It is important that you keep the vulnerability database up to date. Just like virus signature databases, the effectiveness of the overall assessment depends on how current the database is.

An operating system fingerprinting session scan can be as simple or as comprehensive as you want. Most tools provide options and configurations that provide much more information than simple operating system identification. If you only need an operating system fingerprint, you can use several tools. Table 14.3 lists three common utilities you can use to fingerprint operating systems.

Each tool uses different techniques to guess the operating system, but they all use the knowledge of how systems establish and maintain communications to make their guess. Each operating system handles network communication a little differently than other operating systems. Noticeable

TABLE 14.3 Popular Operating System Fingerprint Utilities

Organization	Web Address	Product Name
Insecure.org	http://www.insecure.org	Nmap
Safemode.org	http://www.safemode.org/sprint/	Sprint
Sys-Security Group	http://www.sys-security.com/html/projects/X.html	Xprobe2

differences exist even between versions of a single operating system. Operating system fingerprinting utilities generally send specially created packets to the target computer and examine the responses. If the responses match the signature of an operating system in the signature database, the utility reports a match.

We cover the specific techniques each of these tools use in Section 14.4 "Fingerprinting IP Stacks." For now, be aware that multiple tools exist that help determine the operating system type and version a target system is running. That knowledge is the first crucial piece of information you need. After you have that, you are ready to start looking for security holes.

14.3 Network- and Server-Discovery Tools

> **NOTE**
>
> Per the responses shown in Figures 14.1 and 14.2, it's obvious that we have a Web server and an FTP server running on our computer. Do we really need them? The computer we used to execute the Telnet commands is a laptop used for writing. It is a mobile office. In this particular case, we do not need to have a Web server and an FTP server running. To disable these and other services, see Appendix C, "Securing Windows, Step by Step." Section 14.7, "TCP/IP Service Vulnerabilities," discusses how services can be disabled using security scanners.

After you know the operating system of the target computer, you can start determining what software is running on the computer. You can accomplish this type of discovery by querying open ports (remember that you probably scanned to find open ports during OS fingerprinting) and analyzing responses received. This is where another database comes into play. A response from a port can be very informative. Try this: Use Telnet to connect to any open port on a system. We used the following command to connect to port 80 (the port most Web servers listen to) on a local computer (127.0.0.1), also commonly called local host:

```
$ telnet 127.0.0.1 80
```

Press the Enter key a few times. You might get an interesting response. Figure 14.1 shows the response we received when we entered the preceding Telnet command on a computer running Windows XP.

Many programs proudly announce a lot of information if you just ask. If you connect to a port and send a carriage return or two, the program monitoring the port will often generate a welcome message for the unknown input. This welcome notice is called a **banner**. Banners are great for making systems talk to one another, but not so good when you want to secure a system. Remember, an attacker will use any and all information you give him against you. You should consult your Web server's documentation to find out how to suppress or change the banner to avoid giving out free information to any attackers. Let's try connecting to another port. This time we used the following command to connect to port 21 (the port most FTP servers listen to), again on a local computer (127.0.0.1):

Figure 14.1
Results of using Telnet to attach to port 80

Figure 14.2
Results of using Telnet to attach to port 21

```
$ telnet 127.0.0.1 21
```

We received a banner message as soon as a connection was made. We then pressed the Enter key once, typed quit, and pressed the Enter key again. Figure 14.2 shows the response received when we entered the preceding Telnet command on a computer running Windows XP.

Scanning programs use the free information banners provided to detect programs and versions running on a computer. This information is then used to look up any associated software vulnerabilities in the vulnerability database. Once again, a current vulnerability database will result in more accurate scan results.

14.4 Fingerprinting IP Stacks

Fingerprinting Internet Protocol (IP) stacks is the primary mechanism utilities use to perform OS fingerprinting. Recall that each operating system, and each version of a single operating system, handles communication in subtly different ways. Careful analysis of network packets can accurately identify the networking stack that generated the packets. The idea is to send specially constructed network packets to a target computer and analyze any responses received. When you identify a particular IP implementation, you have identified the underlying operating system. The additional IP fingerprint is then used to identify any vulnerability that is specifically related to network protocols.

Let's look at some of the details of how the tools listed in the OS fingerprinting section make an educated guess at the operating system. Remember, the tool analyzes the IP packets and fingerprints the IP stack version.

The Nmap tool sends both normal and malformed Transmission Control Protocol (TCP) and User Datagram Protocol (UDP) packets to the target computer in nine separate tests to three ports (one open TCP port, one closed TCP port, and one closed UDP port). The tests create and send a number of packets to a target computer. Each packet is carefully constructed with flags set that cause specific responses to be sent back. When all responses have been received, the packets are analyzed and compared to responses from known IP stack versions. An exact match means the utility can report what IP stack and operating system is running on the target. Using this fingerprinting method, Nmap can identify more than 870 operating system fingerprints.

The Sprint tool is another tool that creates an IP and OS fingerprint. It can be run in active or passive mode. In active mode, Sprint establishes a connection with the target computer and exchanges various packets. It analyzes the SYN/ACK flags of received packets in order to make an OS guess. In passive mode, Sprint simply listens for any packets from the target computer and performs the same SYN/ACK flag analysis. In addition to OS guessing, Sprint also provides basic uptime information. This information can give some basic information on how the target computer is used. Sprint also provides an option to perform fairly sophisticated banner grabbing to uncover more system information.

The final fingerprinting utility on our list is the Xprobe2 utility. Xprobe2 sends specific ICMP packets to a target computer and analyzes the responses. The utility also sends a single TCP packet, but the majority of all traffic consists of ICMP packets. Xprobe2 does not need to first scan the target system's ports. The absence of a port scan and the use of Internet Control Message Protocol (ICMP) packets cause a smaller disturbance on the target computer than Nmap or Sprint running in active mode. Xprobe2 also uses a fingerprint matrix approach instead of a linear approach. The utility can result in a "near match" by using the fingerprint matrix. This provides a positive response when another utility may return a detection failure.

14.4.1 Share Scans

Another important area to consider when scanning systems for vulnerabilities is that of shared network resources. The Windows operating system allows users to share resources such as folders and printers with other network users. In Windows, these shared resources are simply known as **shares**. To make access easy for remote users, many shared resources have minimal or no protection. To make matters worse, most Windows users have become accustomed to accessing shared network resources and tend to resist any attempt to restrict their access. Although it is possible to secure shared resources, it generally creates some end user difficulties.

Windows uses the **Server Message Block (SMB)** protocol to provide access to shared network resources. For UNIX systems, the **Samba** software provides the same resource-sharing abilities. In fact, Samba running on a UNIX computer allows Windows users to access resources on a UNIX computer and allows the UNIX users to access Windows network resources. It is not uncommon to see a UNIX server with shared printers and folders that are exclusively used by Windows clients on the same LAN.

So, where's the weakness? There are three main security weaknesses with Windows shared resources. First, sharing a resource with anyone else increases the likelihood that an unauthorized user will gain access to the resource. As soon as you share a resource, you have to consider access control. If your folder can be accessed by everyone on the local area network (LAN), an attacker can compromise any computer on your LAN and have access to your resource. The "weakest link" theory plays a strong role in any security situation. Always look for the weakest link in your systems.

Second, because SMB implementations and Samba are both software packages, they can contain flaws. Several Windows shared resources have software flaws that are documented on popular vulnerability Web sites. Make sure you keep current with emerging vulnerabilities and keep all software updated with all relevant security patches.

> **TIP**
>
> Make sure each Samba shared folder is frequently and fully scanned for malicious code. For folders that are actually stored on a UNIX computer, you must run the scan from an attached Windows client to scan for Windows-based malicious code.

The last weakness inherent to shared network resources is that compromising a group of computers can be as easy as compromising only one. What if an attacker gained access to a single computer on your network? He or she could introduce malicious code to a shared folder and subsequently affect the entire network. What's worse, the problem could go unnoticed for quite a while unless each shared resource is thoroughly scanned for the presence of malicious code. Unfortunately, many antivirus packages are configured to ignore shared folders and mapped drives, by default, when scanning because of the negative performance impact of scanning code across a network. If the shared folder is actually a Samba share on a UNIX computer, a Windows antivirus scanner might never scan it.

Because so many potential issues exist with Windows shared network resources, it is recommended to use them sparingly. If you must share resources, know where they are and ensure that each one is secure. Prior to Windows Server 2003, all shares received Everyone–Full Control permissions by default. That means that if you create a share and do not restrict access to it, anyone can read from and write to the share. You can view all of the local system shares on a Windows computer by typing *net share* at a command prompt. A shared resource scanner, sometimes called a **share scanner**, sends SMB packets to query your network for any active shares. They are easy to find, both for you and an attacker. As with all security issues, make sure you know more than the attacker by limiting the amount of information you freely give away. Scan your network for shares frequently and secure any resources you must use. As with other types of scans, several tools are available that scan a network for active shared network resources. Figure 14.3 shows the results of the Nessus scanner that pertain to shared resources found on a network.

14.5 Telnet Inquiries

We have already introduced the telnet command as a discovery tool. Most people believe two things about Telnet. First, it uses port 23 to communicate. Second, Telnet security is poor. Both of the previous statements are

Vulnerability found on port unknown (32768/udp)

;The remote statd service could be brought down;with a format string attack - it now needs to;be restarted manually.;;This means that an attacker may execute arbitrary;code thanks to a bug in this daemon.;;Solution : upgrade to the latest version of rpc.statd;Risk factor : High
CVE : CVE-2000-0666
Nessus ID : 10544

[back to the list of ports]

Warning found on port unknown (32768/udp)

;The statd RPC service is running. ;This service has a long history of ;security holes, so you should really;know what you are doing if you decide;to let it run.;;* NO SECURITY HOLE REGARDING THIS; PROGRAM HAVE BEEN TESTED, SO; THIS MIGHT BE A FALSE POSITIVE *;;We suggest you to disable this;service.;;;Risk factor : High
CVE : CVE-1999-0018
Nessus ID : 10235

[back to the list of ports]

Information found on port general/udp

For your information, here is the traceroute to 192.168.0.1 :
192.168.0.1Nessus ID : 10287

[back to the list of ports]

Figure 14.3
Results of a Nessus scan for Windows shared network resources

partially untrue. Telnet does use port 23 by default. If you issue a regular telnet command, such as the following, it will connect to the remote host and communicate on port 23:

```
$ telnet 192.168.1.1
```

However, we have already seen that you can simply add the desired port number to the end of the telnet command and the Telnet program will use the desired port to communicate. Look at this command:

```
$ telnet 192.168.1.1 80
```

This telnet command attempts to connect to the IP address 192.168.1.1 using port 80 instead of the default port 23. One of the nice things about Telnet is that it doesn't really care what it's doing. It just does what you ask it to do. Many services that listen to TCP ports will send some response when you attach to them that identifies the listening program or service. This makes it possible for a client to decide whether it has attached to the correct service before attempting to send data. This also makes it easy to scan a computer and find out what services are running.

The other piece of information about Telnet is that it is widely regarded as being insecure. First, everything you type into Telnet is sent across the network **in the clear**. That means that all text sent through Telnet can be intercepted and read by anyone. So, if you use Telnet to log in to a remote system (the classic use for Telnet), you are sending your password in the clear. Also, anything you type is free game for someone to intercept. That is the reason

we recommend you never use Telnet to communicate in an insecure environment. Use an alternative such as Secure Shell (ssh) instead. Ssh uses encryption to reduce the likelihood your session will be compromised by sniffing. (See Chapter 9 for more information about ssh.)

However, the basic functionality of Telnet is great for network analysis. It allows you to interact directly with a remote service. Using Telnet to connect directly to sendmail, for example, attackers have learned how easy it is to send spoofed e-mail messages. We won't cover the details of e-mail spoofing, but it is not hard to reproduce. Learn how to use Telnet. It will help you scan and analyze many network vulnerabilities.

14.6 SNMP Vulnerabilities

The **Simple Network Management Protocol (SNMP)** has been in use for many years as a way to monitor and manage network devices. The protocol provides an easy standard method to communicate with all network hardware and software devices. In recent years, attackers discovered several vulnerabilities with SNMP that could lead to privilege escalation, denial of service, and unstable network devices. The power to be able to perform administration tasks from a remote computer made these vulnerabilities possible. These vulnerabilities had existed for several years, but no one had exploited them. This finding sent a wake-up call not only to network device vendors and administrators, but also to the security profession at large. It reminded us all that new vulnerabilities might not always be found in new software. It is very important that we all remain aware that security is a process, not a final state.

> **NOTE**
>
> For more information on the SNMP vulnerability findings, go to the CERT advisory Web page at *http://www.cert.org/advisories/CA-2002-03.html*. This Web page contains a complete description of the SNMP issues introduced in this section.

As you scan systems for vulnerabilities, do not focus on just servers and workstations. Be sure to include all network devices in your analysis. A vulnerable router or firewall can make your system just as exposed as a vulnerable server. Scan every system and device. Likewise, do not rely on one scanner to find every vulnerability. Each scanner was originally written for a purpose that was not fulfilled by existing products. Using several scanners to scan all network devices and systems will produce a more complete picture of the vulnerabilities that exist on your network.

14.7 TCP/IP Service Vulnerabilities

One of the most fertile areas for an attacker to exploit is unneeded and out-of-date network services. Most network services in use today use the TCP/IP protocols to provide a standard "plug" for dissimilar systems to

communicate. Although standards allow far more flexibility than proprietary protocols, the standards also leave the door open for exploitation. As has been mentioned previously, you should disable any unneeded network services. Here's why:

- Unneeded services provide additional entry points into your system for attackers.

- Unneeded services use system resources and can slow down a system.

- Unneeded services are probably not aggressively patched to the latest software version, which makes them even more susceptible to attacks.

- If a service is unneeded, chances are that activity associated with the service is not perpetually monitored. This makes detecting an exploit using this service more difficult. It also makes an attacker's job easier by allowing him to "fly under the radar" more easily.

For these reasons, you should identify all unneeded services and disable or remove them. That is yet another use for a good security scanner. One of the scans you should execute is for all services that are active on a system. Scanners use several methods to scan for active services. The simplest method is to simply detect whether or not a port is open. Nmap scans for open ports and then looks up the common port service in a local text file. If a target computer is running a nonstandard service on a common port, Nmap may report the service incorrectly. The next level of scanning is to connect to a port and examine any banner information that the target computer sends back. Figure 14.4 shows a sample Nessus scan report. This particular scan employed the option that scans and identifies network services running on the target computer.

Many TCP/IP services have vulnerabilities, and the list is always changing. Before you launch a system scan, make sure your scanner software and its vulnerability database are up to date. In the case of the Nessus scanner, keeping the product up to date is easy. The Nessus vulnerability scanner is written to be modular. All actions Nessus takes are defined by supplemental programs, or **plugins**. To keep Nessus current, you simply need to keep each plugin up to date. The Nessus software includes a command to do this automatically. The following command accesses the Nessus Web site (*http://www.nessus.org*) and downloads any updated plugins:

```
$ nessus-update-plugins
```

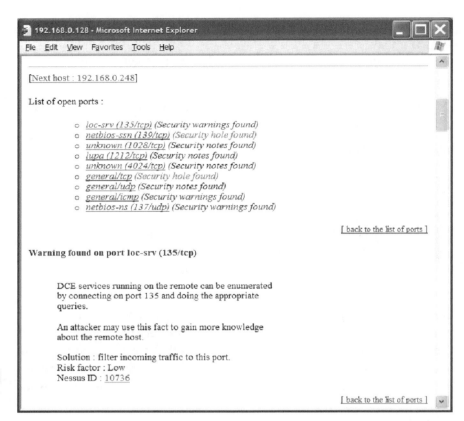

Figure 14.4
Results of a Nessus scan for running network services

Pretty simple, isn't it? But the automatic nature of plugin updates does not relieve you of the need to keep up to date yourself. Subscribe to one of the several security update mailing lists available or frequently check security Web sites for current information. Table 14.4 lists some security vulnerability mailing list and newsletter subscription pages. (Additional resources are listed in Appendix A, "Online Resources and Information.")

14.8 Simple TCP/IP Services

Network services work by passing messages between at least two computers. The most common strategy for implementing this, especially when using the TCP/IP protocol suite, is through the use of ports. Ports allow many services to run on a single computer and provide different services and layers of functionality. All a remote client needs to know to access a network service is the host name where the service is running and the port

TABLE 14.4 Security Vulnerability Mailing Lists and Newsletters

Organization	Web Address	Description
Security Focus	*http://www.securityfocus.com/subscribe?listname=1*	Configurable mailing list of new and significant vulnerabilities
SANS Institute	*http://www.sans.org/newsletters/*	SANS newsletters and mailing list digest subscriptions
Sintelli	*http://www.sintelli.com*	SINTRAQ Security Vulnerability mailing list

TABLE 14.5 Location of Services File in Windows and UNIX

Operating System	Services File Location
Windows	%windir%\System32\Drivers\Etc\Services
UNIX	/etc/services

number the server is listening to. Of course, once the client establishes a connection, it needs to know the protocol to communicate with the service running on the host.

Standard TCP/IP implementations allow ports in the range 1 to 65534. A specific range of ports, 0 to 1023, are used for standard services. These ports are called **well-known ports**, and software developers agree to steer clear of these special ports. These ports correspond to basic network services that exist in most common environments. Each operating system maintains a list of these ports in a file, along with any custom port assignments you define for your system. This file is commonly named *services*. Table 14.5 lists the location of the services file in both Windows and UNIX systems.

There are many entries in a generic services file. Figure 14.5 shows a portion of a services file from a Red Hat Linux computer. The basic purpose of the services file is to associate a name, such as FTP, with a port and protocol. In the case of FTP, the services file defines the port as 21 and the protocol as TCP. This file serves as both a source for services to define ports and a place to document port assignments. You should be aware of the common TCP/IP network services that most systems support. This information will help your overall system knowledge, as well as help you identify which

> **NOTE**
>
> For more information about well-known ports and port number assignments, go to *http://www.iana.org/assignments/port-numbers*.

Figure 14.5

Portion of the services file on Red Hat Linux

services are likely to be targets for attackers. Knowing where attackers are likely to strike can help you establish a sound security strategy.

The Windows operating system defines five particular services as **Simple TCP/IP Services**. These five services are typically used by UNIX systems. Actually, the services were designed for testing purposes. If you do not need these services, you can turn them off. By doing so, you reduce the number of services that may have vulnerabilities an attacker can exploit. If you decide to disable these services in Windows XP, the following link will tell you how: *http://www.lokbox.net/SecureXP/simpleTCPIP.asp*. For Windows 2000 users, try this link: *http://www.lokbox.net/SecureWin2k/simpleTCPIP.asp*. Disabling services for UNIX systems differ by vendor. Consult your system administration documentation for steps required to disable any unneeded services.

Table 14.6 lists the five services the Windows operating systems define as Simple TCP/IP Services.

14.9 Understanding Social Engineering

Most of us fall into the trap of thinking of attackers as people who use software tools to scan our networks looking for vulnerabilities to exploit. We tend to think of network security in terms of securing access to our systems. That is only part of the issue, though. There is another attack path that many of us do not want to acknowledge. It is possible for a fairly savvy

TABLE 14.6 Location of Simple TCP/IP Services

Service	Port	Description
CHARGEN (Character Generator) Service	19	Listens to port 19, waits for a connection, and then dumps characters across the connection
Daytime Server	13	Provides the system date and time to anyone who asks
Discard Server	9	Discards everything it receives
Echo Server	7	Echoes everything it receives
Quote of the Day	17	When prompted, returns a quote for the current day

person to convince an honest computer user to divulge secure information and bypass all of the access controls you have put into place. An attack that depends on convincing an authorized user to perform an unauthorized action is called **social engineering**. Social engineering attacks can cripple a system without the attacker ever having access to the victim's system.

Social engineering works well because people generally do not challenge anyone who acts like they know what they are doing, and most people respond positively to another person in need. Think about all of the delivery and service personnel who routinely move about in your office environment. Have you ever thought to challenge any of them and ask to see their credentials? There are many sad stories of workers sitting idly by while a person who is pretending to be a service technician walks away with valuable equipment.

There are other attack scenarios as well. Many people will divulge their passwords when asked to do so in an e-mail message or telephone call by a "system administrator." Unless your organization is fairly small, chances are you do not personally know all security and administration personnel. It is common to interact with IT people you do not know. This comfort with IT strangers provides the opportunity for a social engineering intrusion.

Let's look at a few real scenarios. A security consultant, Fred, was performing a penetration test for a client. Fred called the CEO's secretary, posed as a network administrator, and told her he had received a notice that her PC was infected with a virus. He instructed her to go to the company FTP site and download the fix program. She did as she was instructed. What she did

not know was that Fred had found that the company's FTP site had an upload directory anyone could write to. He uploaded a keystroke-logging program, calling the program *fixvirus.exe*. Once the program was in place, he had the CEO's secretary run the program that installed the keystroke logger on her computer. Within two days, he had her password and the CEO's password. Score one for social engineering.

For another example, a security consultant, Michael, was performing a security audit for a large Internet service provider (ISP). On the first day he arrived, Michael found that he had to call the security desk to be let in from the parking garage. Michael was instructed to proceed straight to the security desk. He entered the elevator and rode to the 1st floor. When the door opened, two employees entered the elevator and swiped their cards. Instead of exiting the elevator, Michael selected the 5th floor and rode up. To get through the next secure door, he tied his shoe a couple times until another employee swiped their card to open the door. Michael followed him in. By that time, Michael had passed three "secure" doors without being challenged. He did that for a week without a security badge.

The only way to deter social engineering attacks is through security awareness training. Make sure each person in your organization is cognizant of the security implications of not maintaining security. Publish simple guidelines on matters such as physical access control and care of passwords. Show employees how easy it is to take advantage of trusting people. Don't try to turn everyone into a super sleuth, but do try to raise their awareness. When your employees have a directive saying "administrators will never ask you to divulge your password," they should think it odd when a caller asks for a password. Define normal requests and abnormal requests. When your end users know what to look for, you have a fighting chance to minimize the damage caused by social engineering attacks.

14.10 Obtaining Security-Related Information Fraudulently

We have spent a lot of time in this chapter covering ways of acquiring information about a selected target computer. There is one important issue you must address before scanning a system—never scan a system for any information until you have written permission to do so from the system's owner.

It is very likely that you will uncover some sensitive information as you scan a system for vulnerabilities. You must ensure you have the legal authority to perform such discovery before you start.

Security practitioners possess the tools and knowledge to extract a large volume of information from a system. Some of the information that is readily available could be considered confidential or sensitive. It is important that each security practitioner adhere to a high standard of professional behavior. Without standards or codes of ethics, it is likely more information would "leak" out of insecure systems. Each major security certification requires the applicant to sign and adhere to a specific code of ethics. One common tenet of such codes of ethics is that a security practitioner will not use any tools, knowledge, or special access in an unethical manner. That includes disclosing or modifying any data, except within the specific scope of work set forth in an employee agreement or contactor engagement agreement. Any use of confidential or sensitive data that is outside the scope set forth in a scoping document is fraudulent and could result in legal action. Whatever you do, make sure you only touch what you are allowed to touch.

14.11 The Footprinting and Fingerprinting Drill (System Profiling)

OK, so now let's put it all together. To effectively scan a system, you need the five Ps:

- Purpose
- Permission
- Process
- Patience
- Persistence

First, you must have a defined purpose for scanning a system. You are going to end up spending a fair amount of time on this project, so you want to spend your time wisely. Know exactly why you are scanning the system in the first place. Your purpose will help direct you in the choice of tools and

the manner in which you manage the project. If you do not properly define your purpose, there is a good chance you will do more work in the long run.

Second, you must acquire permission to scan and assess each system you will involve in your assessment. As was stated in the earlier section, you can get into trouble if you fail to obtain prior permission.

After you know the purpose for scanning and have gained permission to proceed, decide on the process you will use. Don't just start scanning—think about what you want to scan. You can dramatically speed up the process by reducing the scope of your scans. You also need to decide how noisy or intrusive your scans should be. Is your assessment passive or active? Are you planning to be noisy or do you want your assessment to go unnoticed? Are you planning to launch attacks that could crash the target? These questions, and many others, must be answered as you plan the process of your scanning activities. Take the time to develop a plan. The time you invest on the front end will help ensure you do not miss a crucial component.

The last two necessary features are related. You must have the patience to fully evaluate your target. Some tests are repetitive and painfully slow. If the test is necessary, that's OK. Plan well and patiently implement your plan. Also, do not stop until you are finished. Many times, a scanning session is time or state sensitive. A scan performed one week may not correspond to a similar scan performed the following week. Plan to perform all needed assessments as close together as possible. Be persistent. Stick with the process until you are done.

We recommend using the Nessus vulnerability scanner. Visit the Nessus Web site at *http://www.nessus.org*. This Web site provides the program as well as documentation and a simple tutorial. Start with your own system. Download the program and run a basic vulnerability scan on your local system. Then use the documentation to learn about some of the advanced options. Work with the product until you are comfortable enough to use it for your assessment purposes.

Regardless of what tools you use, acquire the tools you need and learn how to use them. Then, follow the five Ps and you will execute effective system scans. You will have the information at hand to greatly increase the security of your system.

14.12 Chapter Summary

- Security scanning is the process of methodically assessing a system to find any known vulnerability. You can perform the scans yourself, or hire an outside firm to perform the scans. Nessus is a freely available, full-featured vulnerability scanner.

- Most attacks are specific to an operating system, or even a certain operating system version.

- Querying open ports and analyzing any responses received can detect what software a computer is running and whether there are any vulnerabilities that can be exploited.

- You can use the telnet command to collect information on what services are listening to TCP ports.

- Many services return informative welcome banners after a connection has been established.

- IP stack behavior is specific to an operating system, and even specific to a particular version of an operating system. Nmap, Sprint, and Xprobe2 are all popular IP stack fingerprinting utilities.

- Windows shares (and UNIX Samba resources) can be vulnerable to attack.

- Use SNMP sparingly, and ensure all known vulnerabilities have been addressed.

- Many TCP/IP services are unneeded and should be disabled. Windows makes it easy to disable vulnerable Simple TCP/IP Services.

- Social engineering attacks can be very successful because they are built upon standard human nature.

- Always secure permission before starting to scan a system. Follow the five Ps for a successful scanning project: Purpose, Permission, Process, Patience, and Persistence.

14.13 Key Terms

banner: An informational message generated by a program that is monitoring a port.

in the clear: All text is sent in a plain format that can be intercepted and read by anyone.

operating system (OS) fingerprinting: The process of detecting the operating system of a remote computer.

plugin: A supplemental program that defines all actions within Nessus.

Samba: Software for UNIX systems that provides the same resource-sharing abilities as Windows shares, using SMB.

security scanning: The process of methodically assessing a system to find any known vulnerability.

Server Message Block (SMB): A protocol to provide access to any shared network resource.

share scanner: Software that sends SMB packets to query your network for any active shares.

shares: Shared network resources, such as folders and printers.

Simple Network Management Protocol (SNMP): A protocol used to monitor and manage network devices.

Simple TCP/IP Services: Five generally unneeded services that can be easily disabled.

social engineering: An attack that depends on convincing an authorized user to perform an unauthorized action.

well-known ports: Ports that correspond to basic network services that exist in most common environments. Each operating system maintains a list of these ports, along with any custom port assignments you define for your system.

14.14 Challenge Questions

14.1 What is system security scanning?

 a. The process of methodically detecting all systems in a particular subnet

b. The process of methodically assessing a system to find any known vulnerability

c. Periodically scanning vulnerabilities databases for new or updated threats

d. Examining each file stored on a file system for virus signatures

14.2 What is the process of detecting the operating system of a remote computer called?

a. OS detection

b. OS scanning

c. OS fingerprinting

d. OS assessment

14.3 What are the common techniques for determining a remote computer's operating system? [Choose all that apply.]

a. Send specially crafted network packets and examine the responses.

b. Send a message asking what the operating system is.

c. Send a network packet, ignore the responses, and then evaluate the way the target handles retransmitted packets.

d. Read all packets sent by the target computer until an informative packet is found.

14.4 What generic tool can connect to any port and display banners that an attached service generates?

a. SNMP

b. Samba

c. Netstat

d. Telnet

14.5 How many network packets does Nmap have to send to create a remote system IP stack fingerprint?

a. 1

b. 15

 c. 150

 d. 1500

14.6 What protocol is used to provide the functionality for Windows shared network resources (shares)?

 a. PPP

 b. SMTP

 c. SMB

 d. SNMP

14.7 What is the default port Telnet uses?

 a. 20

 b. 21

 c. 23

 d. 80

14.8 Why is Telnet considered to be insecure?

 a. Everything it transmits is in the clear.

 b. It uses an insecure port by default.

 c. Persistent vulnerabilities in the Telnet program have not been fixed.

 d. Telnet is a secure program.

14.9 What is SNMP used for?

 a. To forward e-mail from one computer to another

 b. To pass data packets from network devices to servers

 c. To establish network connections between clients and servers

 d. To monitor and manage network devices

14.10 Which common operating system file contains a list of ports and the programs that use them?

 a. Protocols

 b. Services

 c. Netw.conf

 d. Hosts

14.11 Which of the following services are Simple TCP/IP Services? [Choose all that apply.]

 a. FTP Server

 b. Daytime Server

 c. Echo Server

 d. Telnet Server

14.12 What is social engineering?

 a. An attack that depends on the interaction of a group of people

 b. An attack that depends on convincing an authorized user to perform an unauthorized action

 c. A study of how to change the behavior of a group of people

 d. Using subliminal messages to encourage sensitive data disclosure

14.13 What is the most effective countermeasure to social engineering?

 a. Security awareness training

 b. Access controls

 c. Physical access control

 d. Least privilege

14.14 Which of the following are part of the five Ps? [Choose all that apply.]

 a. Purpose

 b. Persistence

 c. Probe

 d. Process

14.15 What must you acquire before you start scanning a system?

 a. Plan

 b. Permission

 c. Tools

 d. Time to complete the process

14.15 Challenge Exercises

Challenge Exercise 14.1

This exercise directs you to a Web site that performs free assessments of your system's security. If you have never used assessment and scanning software before, this site is a great introduction to what these tools can find out about a system. You need Internet access and a Web browser. The Web site you will visit is the AuditMyPC site. This is just one of many sites that will perform online simple security assessments.

1. In your Web browser, enter the following address: *http://www.auditmypc.com*.

2. From the main page, click the **Start Check** link.

3. On the resulting page, click the **Firewall Test** link.

4. On the resulting page, read the I Agree statement at the bottom of the page. Click the **I Agree** check box, and then click the **Firewall Test 1** button at the top of the page. The scanner scans your computer's firewall and reports the results. (If a report dialog box opens, read the contents and then close the box.) Read the report and then click the **Back** button in your Web browser.

5. Click the **Firewall Test 2** button. Follow the prompts on the resulting page to scan your system again.

6. Go to *http://www.auditmypc.com/freescan/prefcan.asp* and click the **Spyware Remover** link. When the scan is complete, read the results and then click the **Back** button in your Web browser.

7. Click the **Popup Blocking** link. On the Popup Blocking page, click the **popup blocking** link near the bottom of the page. On the resulting page, click the **Start** link at the bottom of the page. When the scan is complete, read the results.

8. Write a short commentary on the quick assessment. Did these scans find more about your computer than you thought they would? How could this information help make your computer more secure? Are you likely to use these assessment on another computer? Why or why not?

Challenge Exercise 14.2

This exercise directs you to perform a simple manual assessment of several aspects of your own system. You should try this assessment on at least three separate computers to see if the results differ. You need access to Telnet (from a Windows command prompt or a UNIX shell). You will use the telnet command to connect to various ports and analyze any responses you receive.

1. Open a command window (in Windows, click **Start**, click **Run**, type **cmd**, and press **Enter**) or access your login shell (UNIX).

2. Use Telnet to connect to the common ports for the following services. (Hint: Look at the services file if you do not know the port numbers. On a UNIX/Linux computer, the services file in located in /etc/services. On a computer running Windows, the services file is located in C:\WINDOWS\SYSTESM32\DRIVERS\ETC\ SERVICES, assuming C:\WINDOWS is your Windows installation directory. You can launch the telnet command from a shell prompt in UNIX/Linux or a command prompt in Windows.)

 a. FTP

 b. HTTP

 c. HTTPS

 d. SMTP

 e. POP3

3. Document your findings for each of the services.

4. Repeat this assessment on at least two other computers.

5. Document your findings for all computers you tested and compare the results.

6. If you found any differences, explain your findings.

14.16 Challenge Scenarios

Challenge Scenario 14.1

As stated in Chapter 13, you are a new security administrator for Hook-U-Up-Cheap, a low-cost Internet service provider. Your supervisor was so pleased with the work you did with the IDS project that he has assigned the

vulnerability assessment project to you. The board of directors has required that a nonbiased annual security vulnerability assessment be performed.

Write a simple executive summary (i.e., high level and short) to the board of directors, outlining your plan for fulfilling their requirement. Explain briefly what you will provide (a vulnerability report) and how you will acquire the information for the report.

Challenge Scenario 14.2

As the security administrator for Hook-U-Up-Cheap, you have decided it would be in the company's best interest if your department performed an internal security audit quarterly. All work will be done by you and your staff. Prepare a summary report that lists each step you will take and the tools you will use. Do some real research on the Internet and choose at least one commercial product that you think will fit into your organization's structure to augment the free tools we covered in the text. Keep your report high level, but informative.

APPENDIX A

Online Resources and Information

This appendix represents a variety of organizations, resources, and so forth that we have found useful for anyone in the security industry. The following URLs provide both detailed security information and jumping points to other great caches of information you should explore.

A.1 General Security Resources

- CERT Coordination Center: *http://www.cert.org*
- International Information Systems Security Certification Consortium, Inc. (ISC)[2]: *https://www.isc2.org/cgi-bin/index.cgi*
- Internet Engineering Task Force (IETF) Request for Comments (RFC) repository: *http://www.ietf.org/rfc.html*
- Microsoft Security Web site: *http://www.microsoft.com/ security*
- SANS (SysAdmin, Audit, Network, Security): *http://www.sans.org*
- SANS InfoSec Reading Room: *http://www.sans.org/rr*
- SecurityFocus: *http://www.securityfocus.com*
- Security World Wide Web Sites: *http://www.alw.nih.gov/Security/ security-www.html*
- TruSecure: *http://www.trusecure.com*

A.2 Access Control Methodologies

- Microsoft Windows XP access control: *http://www.microsoft.com/windowsxp/using/security/learnmore/accesscontrol.mspx*
- National Institute of Standards and Technology role-based access control for the Web: *http://csrc.nist.gov/rbac/cals-paper.html*
- Rule Set Based Access Control (RSBAC): *http://www.rsbac.org*

A.3 General Security Principles, Practices, and Policies

- The SANS Security Policy Project: *http://www.sans.org/resources/policies*
- University of Georgia's computer security policy: *http://www.uga.edu/compsec/*

A.4 Business Continuity Plans, Disaster Recovery Plans, Auditing, and Checklists

- MIT Business Continuity Plan: *http://web.mit.edu/security/www/pubplan.htm*
- The Business Continuity Planning & Disaster Recovery Planning Directory: *http://www.disasterrecoveryworld.com*
- FEMA Purpose of Standard Checklist Criteria for Business Recovery: *http://www.fema.gov/ofm/bc.htm*
- SANS Institute Information Security Management Audit Checklist: *http://www.sans.org/score/checklists/ISO_17799_checklist.pdf*
- Computer Emergency Response Team (CERT) UNIX Security Checklist v2.0: *http://www.cert.org/tech_tips/unix_security_checklist2.0.html*
- Microsoft Security Checklists and Resource Guides: *http://www.microsoft.com/technet/Security/chklist/default.mspx*
- LabMice.net Windows XP Security Checklist: *http://www.labmice.net/articles/winxpsecuritychecklist.htm*

- UNIX Computer Security Checklist: *http://www.unixtools.com/ securecheck.html*

- Washington University UNIX System Security Checklist: *http:// staff.washington.edu/dittrich/R870/security-checklist.html*

A.5 Encryption, Identification, and Authentication Technologies

- Federal Information Processing Standards (FIPS) Pub 46-2 Data Encryption Standard (DES): *http://www.itl.nist.gov/fipspubs/ fip46-2.htm*

- International Biometric Group: *http://www.biometricgroup.com*

- International Biometric Industry Association (IBIA): *http://www. ibia.org*

- Microsoft Description of Digital Certificates: *http://support. microsoft.com/default.aspx?scid=kb;en-us;195724*

- Microsoft Kerberos V5 Authentication Protocol: *http://www. microsoft.com/resources/documentation/Windows/XP/all/reskit/ en-us/Default.asp?url=/resources/documentation/windows/xp/all/ reskit/en-us/prdp_log_ovqw.asp*

- MIT Media Laboratory Vision and Modeling Group, "Face Recognition Demo Page": *http://vismod.media.mit.edu/vismod/demos/ facerec*

- National Institute of Standards and Technology (NIST) Computer Security Resource Center (CSRC) Advanced Encryption Standard (AES): *http://csrc.nist.gov/CryptoToolkit/aes/*

- Pretty Good Privacy (PGP): *http://www.pgp.com*

- The Biometric Consortium: *http://www.biometrics.org*

- Unofficial TEMPEST Information page: *http://www.eskimo.com/ ~joelm/tempest.html*

- What Is a Digital Signature?: *http://www.youdzone.com/signature. html*

A.6 Security Models

- CISSP Open Study Guides Web Site, "Handbook of Information Security Management": *http://www.cccure.org/Documents/HISM/ewtoc.html*

- RFC 1457: Security Label Framework for the Internet (includes Bell-LaPadula model and Biba model): *http://www.cis.ohio-state.edu/cs/Services/rfc/rfc-text/rfc1457.txt*

- Rule Set Based Access Control (RSBAC) for Linux—Models: *http://www.rsbac.org/models.htm*

- The State Machine Model: *http://www.nfra.nl/~olnon/jive/peter_docs/summaries/state_mach.html*

A.7 TCP/IP, Firewall, and Operating System Security

- Astalavista Group: *http://www.astalavista.com/library/hardening/ unix*

- C. Matthew Curtin's Firewalls FAQ: *http://www.faqs.org/faqs/firewalls-faq*

- Computer Forensics: Introduction to Incident Response and Investigation of Windows NT/2000: *http://rr.sans.org/incident/comp_forensics3.php*

- Linux DistroWatch: *http://www.distrowatch.com*

- Linux Online!: *http://www.linux.org*

- Microsoft Baseline Security Analyzer (MBSA): *http://www.microsoft.com/technet/Security/tools/mbsahome.mpsx*

- Microsoft Registry Guide for Windows: *http://www.winguides.com/registry*

- Microsoft Windows Update Web site: *http://windowsupdate.microsoft.com*

- Network Associates: *http://www.nai.com/us/index.asp*

- Purdue University, The Coast Project, "Internet Firewalls": *http://www.cerias.purdue.edu/coast/firewalls*

- SANS Intrusion Detection FAQ: *http://www.sans.org/resources/idfaq/index.php*

- SecurityDogs.com: *http://www.securitydogs.com*

- Simple TCP/IP Services, instructions for disabling in Windows 2000: *http://www.lokbox.net/SecureWin2k/simpleTCPIP.asp*

- Simple TCP/IP Services, instructions for disabling in Windows XP: *http://www.lokbox.net/SecureXP/simpleTCPIP.asp*

- Symantec: *http://www.symantec.com*

- University of Wisconsin at Milwaukee Windows 2000/XP security Web page: *http://www.uwm.edu/IMT/purchase/itpsfaqs/security101.html*

- What You Don't See on Your Hard Drive by Brian Kupper (SANS): *http://www.sans.org/rr/papers/index.php?id=653*

A.8 Attacks and Incident Management

- Attrition.org: *http://www.attrition.org/security/commentary*

- Computer Security Incident Response Team (CSIRT) Coordination and Development Center of Carnegie Mellon University: *http://www.cert.org/csirts*

- Computer Security Incident Response Team: *http://www.cert.org/csirts*

- FIRST: Forum of Incident Response and Security Teams: *http://www.first.org*

- Forming an Incident Response Team: *http://www.auscert.org.au/render.html?it=2252&cid=1920*

- Handbook for Computer Security Incident Response Teams: *http://www.sei.cmu.edu/pub/documents/98.reports/pdf/98hb001.pdf*

- How Computer Viruses Work: *http://www.howstuffworks.com/virus.htm*

- Internet Storm Center: *http://www.incidents.org*

- Responding to Intrusions: *http://www.cert.org/security-improvement/modules/m06.html*

- SANS Reading Room, "Incident Handling": *http://www.sans.org/ rr/catindex.php?cat_id=27*
- The Hack FAQ: *http://nmrc.org/pub/faq/hackfaq/index.html*
- Vulnerabilities database: *www.securityfocus.com*

A.9 System Security Scanning and Discovery

- CERT SNMP vulnerability findings: *http://www.cert.org/advisories/ CA-2002-03.html*
- CERT Vulnerabilities, Incidents & Fixes: *http://www.cert.org/nav/ index_red.html*
- Everything You Wanted to Know about Social Engineering—but Were Afraid to Ask: *http://www.happyhacker.org/uberhacker/ se.shtml*
- Intrusion Detection FAQ: TCP/IP Stack Fingerprinting Principles: *http://www.sans.org/resources/idfaq/tcp_fingerprinting.php*
- Nessus Security Scanner: *http://www.nessus.org*

 For more information on Nissus and other security scanners, see Appendix B, "Security Tools and Software."

- Port Scanning: It's Not Just an Offensive Tool Anymore: *http:// www.garykessler.net/library/is_tools_scan.html*
- Russian PaSsWord Crackers (free password-cracking software): *http://www.password-crackers.com/crack.html*
- SANS Institute newsletters and mailing list: *http://www.sans. org/newsletters/*
- SANS/FBI Top 20 vulnerability list: *http://www.sans.org/top20*
- SecurityFocus mailing list: *http://www.securityfocus.com/subscribe? listname=1*
- SecurityFocus, the de facto standard for finding any vulnerability for any software: *http://www.securityfocus.com/bid*
- SINTRAQ Security Vulnerability: *http://www.sintelli.com*
- The TCP/IP INS Vulnerability: *http://www.unixreview.com/ documents/s=1236/urm0104f/0104f.htm*

APPENDIX B

Security Tools and Software

This appendix includes a compendium of security-related tools, utilities, and software, all of which would be a valuable part of your security toolkit. Many of the tools were discussed in detail throughout the chapters in this book.

B.1 Antivirus Software and Spam Filters

Antivirus software programs offer always-on virus protection, e-mail scanning, automatic signature file updates, and scheduled system scanning. Several packages offer other features such as instant message scanning and spyware detection. Spam filters come in a variety of flavors—subscription services, plugins to e-mail clients, or stand-alone packages—all of which classify e-mail messages and sort out those considered to be junk mail. The following sections list some of the most popular antivirus software packages and spam filters currently available.

B.1.1 Antivirus Software

- F-Prot Antivirus: *http://www.f-prot.com*
- F-Secure Anti-Virus: *http://www.f-secure.com*
- McAfee VirusScan: *http://us.mcafee.com/root/package.asp?pkgid=100&cid=9052*
- Symantec Norton Antivirus: *http://www.symantec.com*

B.1.2 Spam Filters

- Death2Spam: *http://death2spam.net*
- IHateSpam: *http://www.sunbelt-software.com/product.cfm?id=930*
- McAfee SpamKiller: *http://us.mcafee.com/root/package.asp?pkgid=156*
- POPFile: *http://popfile.sourceforge.net*
- SpamBayes: *http://spambayes.sourceforge.net*
- SpamSieve: *http://www.c-command.com/spamsieve*

B.2 Biometrics

Biometrics involves the identification of a person for security purposes, which can include fingerprints, hand geometry, retinal patterns, voice response, and handwritten signatures. The following are a few of the companies that offer biometrics solutions:

- Imagis Technologies: *http://www.imagistechnologies.com*
- Virtual Service Inc.: *http://www.virtualservice.net/products.html*

B.3 Cryptography

Cryptography is the process of converting plaintext data into ciphertext for transmission over a public network. The ciphertext is decrypted by the receiver. Two of the most popular data encryption programs available are:

- GNU Privacy Guard (GnuPG): *http://www.gnupg.org*
- Pretty Good Privacy (PGP): *http://www.pgp.com*

B.4 Firewalls

Firewalls screen incoming and outgoing traffic on a single computer or an entire network, determining whether each packet received may be passed along to its destination. The following sections list both hardware- and software-based firewalls.

B.4.1 Hardware

- Cisco routers: *http://www.cisco.com*
- D-Link routers: *http://www.dlink.com*
- Linksys firewall router: *http://www.linksys.com*
- NetGear: *http://www.netgear.com*

B.4.2 Software

- BlackICE: *http://blackice.iss.net/product_pc_protection.php*
- McAfee Personal Firewall Plus: *http://us.mcafee.com/root/package. asp?pkgid=103*
- Microsoft Internet Connection Firewall: *http://www.microsoft.com/ WindowsXP/home/using/howto/homenet/icf.asp*
- Symantec Norton Internet Security: *http://www.symantec.com/ product/*
- Tiny Personal Firewall: *http://www.tinysoftware.com/home/tiny2? la=EN*
- ZoneAlarm: *http://www.zonelabs.com*

B.5 Intrusion Detection Systems

An intrusion detection system (IDS) monitors packets (data traffic) on a single computer or a network to discover if an attacker is trying to break into a system. The following list includes IDSs for users from SOHO to enterprise level:

- BlackICE (includes an IDS and firewall): *http://blackice.iss.net/ product_pc_protection.php*
- Cisco Intrusion Detection System: *http://www.cisco.com/en/US/ products/sw/secursw/ps2113/index.html*
- McAfee Entercept: *http://www.networkassociates.com/us/products/ mcafee/host_ips/category.htm*
- Snort: *http://www.snort.org*

- Symantec Host IDS: *http://enterprisesecurity.symantec.com/products/products.cfm?ProductID=48&EID=0*

- Symantec Intruder Alert: *http://enterprisesecurity.symantec.com/products/products.cfm?ProductID=171&EID=0*

- Tripwire (includes a server product and a network device product): *http://www.tripwire.com*

B.6 IP/Port Scanners

IP/port scanners detect rogue systems and services running on a network without permission. As a network administrator responsible for security, you should use an IP/port scanner to detect and, if possible, remove these systems from your network. Some of the many IP/port scanners available are as follows:

- AATools Port Scanner: *http://www.glocksoft.com/trojan_port.htm*

- Knocker: *http://knocker.sourceforge.net*

B.7 OS Fingerprint Utilities

Fingerprint utilities determine the operating system of a remote computer, which a network or systems administrator can then use to test for vulnerabilities. Check out the following fingerprint utilities:

- Insecure.org Nmap: *http://www.insecure.org*

- Safemode.org Sprint: *http://www.safemode.org/sprint*

- Sys-Security Group Xprobe2: *http://www.sys-security.com/html/projects/X.html*

B.8 Security Scanners

You use security scanners to test your systems for vulnerabilities, and then minimize or eliminate the important ones. The following tools are some of the most popular security scanners on the market, but represent only a short list of the many scanners available.

- Center for Internet Security (CIS) Security Benchmarks and Scoring Tools: *http://www.cisecurity.org*

- Foundstone Professional: *http://www.foundstone.com*

- GFi LanGuard: *http://www.gfi.com*

- Insecure.org Nmap: *http://www.insecure.org*

- Nessus Security Scanner: *http://www.nessus.org*

B.9 Vulnerability Scanners

Vulnerability scanners perform comprehensive scans of systems and/or networks for signatures of known vulnerabilities and provide a detailed report of detected deficiencies. Most of the following scanners run on UNIX/Linux platforms; however, the Microsoft Baseline Security Analyzer is designed for Windows platforms.

- Microsoft Baseline Security Analyzer (MBSA): *http://www.microsoft.com/technet/security/tools/mbsahome.mpsx*

- Nessus: *http://www.nessus.com*

- NetIQ Security Analyzer: *http://www.netiq.com*

- SAINT: *http://www.saintcorporation.com*

- Security Auditor's Research Assistant (SARA): *http://www-arc.com/sara*

APPENDIX C

Securing Windows, Step-by-Step

By this point, you should have a firm grasp of security concepts. Throughout this book, we have discussed both conceptual and practical aspects of implementing good security. You know the reasons we need security and the different areas of a computer system that must be secured. You know many of the pieces, but how do you actually do it? This appendix takes a step-by-step approach to securing a computer running the Windows operating system.

Before we continue, let's define what we mean by "the Windows operating system." Although many similarities exist within the Microsoft Windows product line, there are also vast differences among products. In an effort to maintain clarity and reduce confusion, we will cover a single version of Windows—Windows XP. However, most of the topics we will discuss in this section apply to more that just Windows XP. In fact, if you are running Windows 2000, you will find most of the tips throughout this appendix are nearly identical to those for your operating system.

C.1 Step 1: Ensuring Physical Security

The absolute first step in securing any computer is to physically secure the hardware. You'd be surprised how many systems simply "disappear." It's not all that difficult to pretend to be a computer repair technician and walk away with a computer. However, if you use rack-mounted servers, the level

of difficulty in such an attack rises substantially. Regardless of the type of hardware you use, restricting physical access to it increases the overall security. Before you spend any time *at* the computer, spend some time *around* the computer. Ensure that physical access to hardware is limited to authorized personnel only.

C.1.1 Access to the Computer

Start by ensuring only authorized personnel have the ability to physically approach the computer. You can do this by placing any sensitive hardware in a restricted access room. Simply put, place your servers and network devices in a room with a locking door. You need to provide access to authorized personnel only and block access for unauthorized personnel. You can do this through physical and administrative controls. Physical controls are the doors and locks, administrative controls are the policies covering access rights to the server room.

C.1.2 Computer Visibility

Even though it may be difficult to access a computer that contains sensitive data, ensure that unauthorized users cannot see data on the monitor screen. If data confidentiality is a concern in your organization, you need to place monitors so data cannot be read by anyone who is not authorized to see it. This is often a placement issue and generally only a concern when the server room contains windows. The practice of "shoulder-surfing" is not limited to the server room. You must consider the placement of any monitor that will display sensitive data. Modern office cubicles can make it difficult to effectively place monitors securely, but you must reduce sensitive data visibility to increase security.

C.1.3 Removable Storage Access

Removable storage devices can pose security risks as well. A floppy disk, Zip disk, tape, or CD can make it easy to copy data from a system onto portable media. Physically remove all nonessential devices from secure computers. Any devices that must be in place should be secured through physical and logical methods. Make such removable media devices difficult for unauthorized users to access using locking cabinets and gates. Once such a device is physically accessed, only authorized users should be given write permissions for the device. This layered approach avoids a single point of failure.

> **WARNING**
> Make sure you provide adequate ventilation, temperature, and humidity control in your limited access server room. Without special care given to the environment, server rooms can quickly exceed operating limits and cause equipment failures. (You do have a disaster recovery plan for equipment failures, right?)

> **WARNING**
> Don't forget about the actual media. You must store and transport removable media with security in mind as well. A carelessly controlled system backup tape can provide an easy-to-carry copy of your sensitive data.

C.2 Step 2: Changing the Administrator Password

Regardless of what password you originally used for the Administrator account when you installed Windows, you should change it during the hardening process. Choose a strong password, and consider changing it periodically. To change the Administrator password, follow these steps:

1. Click **Start**, right-click **My Computer**, and select **Manage**. The Computer Management tool opens.

2. Open the Local Users and Groups folder by clicking the + sign to the left.

3. Select the **Users** folder.

See Figure C.1 for an example of local users in the Computer Management tool.

4. In the right pane, right-click **Administrator** and select **Set Password**.

5. You are presented with a warning dialog box. Read the warning and then click **Proceed**. The Set Password for Administrator dialog box opens, as shown in Figure C.2.

> **WARNING**
>
> Make sure you understand the implications of changing a password using computer maintenance. The warning is there for a reason.

Figure C.1

Local users in Computer Management

Figure C.2

Set Password for Administrator dialog box

6. Enter the new password twice and click **OK**. Click **OK** in the resulting dialog box.

7. Close all open windows.

C.3 Step 3: Turning Off Simple File Sharing

One of the most common requests for networked computers is the ability to share files. And, most users want the file-sharing capability to be transparent. Microsoft satisfied these requests. As Microsoft operating systems become more advanced, they tend to want to share more. That's great from a functionality standpoint, but can be troublesome for security. Previous versions of Microsoft operating systems allowed folders and printers to be shared by granting rights to users individually. Setting up access rights quickly became an administrative chore, so administrators often just allowed everyone to connect and use shared resources as the Guest account. The problem is that the Guest account tended to allow far more access than was intended.

With Windows XP, simple file sharing provides a solution. With simple file sharing enabled, all accesses to a shared resource are treated as Guest account access. The operating system applies the appropriate permissions (i.e., read-only or read-write) based on the resource. So, you get easy access to selected resources. This works great for closed networks or networks with strong firewalls. However, it opens the door for attackers. To make

Figure C.3
Folder Options, General tab

your computers more secure, turn off simple file sharing and force each remote user to provide a user ID and password to access a shared resource. It means more administrative work, but it's safer.

Here's how to disable simple file sharing:

1. Click **Start** and then click **My Computer**.

2. From the Tools menu, select **Folder Options**. The Folder Options dialog box opens with the General tab displayed (see Figure C.3).

3. Click the **View** tab.

4. Scroll down to the bottom of the list, as shown in Figure C.4.

5. Deselect the **Use simple file sharing** (**Recommended**) check box.

6. Click **Apply**, and then click **OK**.

7. Close all open windows.

Figure C.4
Folder Options, View tab

C.4 Step 4: Changing/Creating Group Policy

Another step to secure a local computer is to create or modify a group policy. A group policy is an access control object that restricts access to a specific resource. Most access control objects are stored in the context of the domain controller, but you can create local group policies for stand-alone computers or to function when disconnected from the primary network. You can define access restrictions for a long list of resources. We will address only a few resources in this section. The method is essentially the same for securing any resource.

Here is how you use a group policy to define access restrictions:

1. Click **Start** and then click **Run**. The Run dialog box opens, as shown in Figure C.5.

2. In the Open text box, type **gpedit.msc** and then click **OK**. The Group Policy Editor opens, as shown in Figure C.6.

Figure C.5
Run dialog box

Figure C.6
Group Policy Editor

3. In the left pane of the Group Policy window, under Computer Configuration, expand the Windows Settings, Security Settings, and Local Policies folders. Click **User Rights Assignment**. The window should look similar to Figure C.7.

4. In the right pane, right-click **Access this computer from the network** and select **Properties**. The Access this computer from the network Properties dialog box opens, as shown in Figure C.8.

5. Remove Backup Operators, Everyone, Power Users, and Users from the list. (To do so, click the **Backup Operators** entry and then click the **Remove** button. Repeat this step for Everyone, Power Users, and Users.) This stops users who belong to these groups from accessing your computer from a remote location.

6. Click **Apply** and then click **OK**.

Figure C.7
User Rights Assignment

Figure C.8

Access this computer from the network Properties dialog box

Figure C.9
Security Options

7. In the right pane of the Group Policy window, right-click **Allow logon through Terminal Services** and select **Properties**.

8. Remove Remote Desktop Users from the list.

9. Click **Apply** and then click **OK**.

10. In the right pane of the Group Policy window, scroll down to locate Log on locally and right-click it. Select **Properties**.

11. Remove Backup Operators, Guest, and Users from the list.

12. Click **Apply** and then click **OK**.

13. In the left pane of the Group Policy window, click **Security Options** (see Figure C.9).

14. In the right pane, scroll down to find Interactive logon: Do not display last user name and right-click it. Select **Properties**. The Interactive logon: Do not display last user name Properties dialog box opens, as shown in Figure C.10.

15. Select the **Enabled** option, click **Apply**, and then click **OK**.

16. Change the Interactive logon: Number of previous logons to cache properties from 10 to **3**.

Figure C.10

Interactive logon: Do not display last user name Properties dialog box

17. In the left pane, open the Local Computer Policy, Computer Configuration, Administrative Templates, System folder and select **Scripts**.

18. In the right pane, change the Run startup scripts visible properties to **Enabled** (see Figure C.11).

19. In the right pane, change the Run shutdown scripts visible properties to **Enabled**.

20. Close all open windows.

The previous steps give you an idea of the many properties you can change using a group policy. Although we did not cover many of the properties, the ones we did change will make your computer much safer from external attacks.

C.5 Step 5: Disabling Unneeded or Unnecessary Services

Computer users have come to expect a high level of functionality from hardware and software. Operating systems are no exception. Unless you are meticulous when you installed your operating system, you probably ended up with many helpful, but not necessarily secure, services installed and initialized. To make your system secure, you need to disable or remove any services you do not need. A service is simply a program that monitors and controls an access path to and from a resource on your computer. If you do not need to maintain a particular access point for your computer, close the access path.

Figure C.11
Run startup scripts visible Properties dialog box

For example, you should not allow a Web server and an FTP server to run on a computer that does not require such services. You are only opening an additional attack path. Be assured that attackers routinely check for these often overlooked services when profiling a system. Your job is to remove as many of the easy targets as possible.

To disable a service, follow these steps:

1. Click **Start**, click **Control Panel**, click **Performance and Maintenance**, and then click **Administrative Tools**. The Administrative Tools window opens.

2. Double-click **Services** (see Figure C.12).

3. In the right pane, choose a service by double-clicking it. (We used the AdminService for our Progress database. It is currently running and is started automatically.)

4. To stop a service, click the **Stop Service** button.

Figure C.12

Services

5. To stop the service from starting automatically at startup, change the Startup type to either Manual or Disabled in the Properties dialog box (see Figure C.13).

6. Click **Apply** and then click **OK**.

7. Close all open windows.

Figure C.13

Changing a service Startup type

You need to evaluate the needs for each service to decide which ones to disable. Table C.1 lists common services that you should leave enabled. Consider disabling any other services. Of course, understand what each service does before you arbitrarily disable it.

Table C.2 lists services that are common for a domain controller computer.

TABLE C.1 Common Services for Most Computers

Service	Necessary for Basic System Operation?
DNS Client	Yes
Event Log	Yes
IPSec Policy Agent	No
Logical Disk Manager	Yes
Network Connections Manager	No
Plug & Play	Yes
Protected Storage	Yes
Remote Procedure Call	No
Remote Registry Service	No
RunAs Service	No
Security Accounts Manager	Yes

TABLE C.2 Common Services for Domain Controllers

Service	Necessary for Basic System Operation?
DNS Server	No
File Replication Service	No
Kerberos Key Distribution Center	No
Net Logon	No
NT LM Service Provider	No
RPC Locator	No
Windows Time	No

TABLE C.3 Additional Services Needed When Sharing Resources or Using Microsoft Networking Tools

Service	Necessary for Basic System Operation?
Server	No
Workstation	No

Table C.3 lists additional services you will need on any computer that participates in sharing resources or supports Microsoft Networking tools. The service you need depends on the role of the computer (server or client).

These lists should get you started looking at services to disable. Carefully consider your environment and the purpose of the computer in question. Disable any service that you do not need. It may make the computer a little more difficult to use, but it will be far more secure.

C.6 Step 6: Filtering TCP/IP Connections (Firewall)

One of the most important controls you can implement to secure a computer is a firewall. A firewall examines incoming and outgoing packets and decides which ones are acceptable. It passes acceptable packets along their way and either drops or rejects any unacceptable packets. You can use Microsoft's firewall that comes with Windows XP, Internet Connection Firewall (ICF), or you may choose to implement a third-party firewall. Additionally, you may have a hardware-based firewall. There are many hardware options to choose from. Just make sure you understand how to set up and maintain any rules for your chosen hardware.

If you choose to implement a third-party firewall, the following are a few common choices:

- BlackICE Defender: *http://www.iss.net*
- Zone Alarm: *http://www.zonelabs.com*
- Symantec Firewall: *http://www.symantec.com*

Fully configuring ICF is beyond the scope of this guide, but basic configuration is fairly straightforward. For more information, consult online doc-

umentation or guides specifically oriented toward firewall configuration. To set up ICF, follow these steps:

1. Click **Start**, click **Control Panel**, click **Network and Internet Connections**, and then click **Network Connections**.

2. Right-click the icon that represents your connection to the Internet, and then select **Properties**. The Properties dialog box for the network connection opens. Your dialog box should look similar to Figure C.14.

3. Click the **Advanced** tab and then select the **Protect my computer and network** check box, as shown in Figure C.15.

4. Click the **Settings** button to enable individual services for external clients. The Advanced Settings dialog box opens. By default, all services are disabled, as shown in Figure C.16.

Figure C.14

Properties dialog box for the network connection, General tab

Figure C.15
Network Connection
Properties—Advanced

Figure C.16
Advanced Settings dialog
box

For more information on setting up Microsoft's Internet Connection Firewall, go to *http://www.microsoft.com/windowsxp/using/networking/learnmore/icf. mspx.*

5. When you are finished, click **OK** and then click **OK** again to save your settings, and then close all open windows.

C.7 Step 7: Installing Antivirus Software

Even though you have protected access to your computer and restricted network traffic in and out of it, there is still a strong possibility you are vulnerable to malicious code attacks. You must install adequate antivirus software to protect from such attacks. There are several options you may consider. Compare the various options and install the solution that appears to be best suited to your environment. Regardless of which option you select, you must maintain the software. Antivirus software is not a fire-and-forget solution. You must:

1. Keep the virus database signature up to date. Either configure the software to automatically refresh the virus signature database or set a schedule to manually update it periodically. Do this at least weekly.

2. Scan your entire system for malicious code frequently. Daily scanning is not too much. It is possible for malicious code to sneak into your system before the virus signature database is current enough to catch it. Only a system scan may find the code at that point.

The following are a short list of available antivirus solutions:

- Norton AntiVirus: *http://www.symantec.com*

- McAfee VirusScan: *http://www.mcafee.com*

- AVG Anti-Virus: *http://www.grisoft.com*

- F-Prot Antivirus: *http://www.f-prot.com*

- NOD32 Antivirus: *http://www.nod32.com*

- BitDefender: *http://www.bitdefender.com*

C.8 Step 8: Updating the Operating System

After your system is secure, you're done, right? Wrong! System security degrades over time. You must be diligent to keep up with emerging threats. One of the easiest ways to keep up is to ensure your operating system has all of the latest security patches applied. Microsoft makes that part easy. Here is how to keep your operating system automatically updated to the latest patch:

1. Click **Start**, click **Control Panel**, click **Performance and Maintenance**, and then click **System**. The System window opens.

2. Click the **Automatic Updates** tab, as shown in Figure C.17.

3. Select the **Keep my computer up to date** check box.

4. You can modify the settings to reflect your particular system requirements. Be sure to click **Apply** and then **OK** to save your settings.

5. Close all open windows.

Figure C.17
Automatic Updates tab

Alternatively, you can use the on-demand Windows Update feature to keep your operating system up to date. Any time you want to check for available updates you can click **Start**, click **Control Panel**, and then click **Windows Update** (in the left pane).

C.9 Summary

Follow these steps and your system will be far more secure than when you started. But, securing your system is an ongoing endeavor. Always keep your system and software up to date and be on the lookout for new vulnerabilities. This list will get you started. Stay on top of emerging vulnerabilities and you will be positioned to keep your system as secure as possible.

APPENDIX D

Glossary

A

acceptable use policy (AUP): Document that describes the allowable uses of an organization's information resources.

access control entry (ACE): In Windows, a database entry that stores permission settings for each user or group that is authorized to access a file or folder object. Multiple ACEs constitute an ACL.

access control list (ACL): 1. A list used to grant a subject access to a group of objects or a group of subjects to a specific object. 2. A list of resources and the users and groups allowed to access them. It is the primary storage mechanism of access permissions in a Windows system.

Active Directory: A structure in Windows that allows easy addressing and accessing of objects across a network.

alteration: The result of when security mechanisms fail to ensure the integrity of data, either accidentally or maliciously.

annualized loss expectancy (ALE): The amount of damage an asset would incur each year from a given risk. The ALE is the product of the ARO and the SLE.

annualized rate of occurrence (ARO): The number of times you expect a risk to occur each year.

anomaly intrusion: An intrusion that is not based on predictable activity that generates some level of activity that is abnormal.

antivirus software: Software that protects a system from malicious code by identifying and handling files that contain known malicious code.

asset value (AV): The value of an asset.

asymmetric cryptography: A cryptosystem in which each user has his or her own pair of public and private keys. (Also known as public key cryptography.)

attack signature: The collective actions required to exploit a vulnerability.

attack: Any attempt to gain unauthorized access to a system or to deny authorized users from accessing the system.

attacker: An individual, or group of individuals, who strives to violate a system's overall security.

audit checklist: A tool that provides high-level guidance on the proper way to conduct a security audit.

Authentication Header (AH): An IPSec protocol designed to provide only integrity and authentication for packets transiting a network.

Authentication Service (AS): A process in the Kerberos KDC that authenticates a subject and its request.

authentication: The process of subject providing verification that he is who he claims to be.

authorization creep: A condition under which a subject gets access to more objects than was originally intended.

availability: The ability of authorized users to access an organization's data for legitimate purposes.

B

back door: A special access path to higher authorization that software developers often put into programs they write.

backup policy: A document that specifies what data must be backed up, approved methods, storage locations, who has access, retention schedule, and media rotation.

banner: An informational message generated by a program that is monitoring a port.

baseline: A profile of normal behavior gathered at the network, system, user, and/or process level and later used to help identify anomalous activity.

bastion host: A firewall that uses two network cards to connect an external network to a protected network.

Bell-LaPadula model: An access control model developed in the 1970s to help better understand and implement data confidentiality controls.

Biba model: An access control model developed after the Bell-LaPadula model to address the issue of data integrity.

biometrics: The detection and classification of physical attributes.

brute force attack: An access control attack that attempts all possible password combinations.

buffer overflow: An error that occurs when you copy a string that is longer than the target buffer.

business attack: An attack to acquire access to sensitive data from a commercial organization.

business continuity planning (BCP): The process of preparing an organization to continue operations uninterrupted in the face of a disaster.

C

centralized access control administration: All access requests go through a central authority that grants or denies the request.

certification authority (CA): A centralized authority that verifies the identity of users and then digitally signs their public keys to create digital certificates.

Challenge Handshake Authentication Protocol (CHAP): A centralized access control systems that provides centralized access control for dial-in users.

checklist review: A DRP exercise in which all team members review their disaster recovery checklists for accuracy.

checksum: A mathematically generated number that is derived from a sequence of values.

ciphertext: A message that has been encrypted to hide its contents from the eyes of those unable to decrypt it.

Clark-Wilson model: An access control model that addresses data integrity by restricting all object accesses to a small number of tightly controlled access programs.

cleanup rule: A firewall rule that denies any traffic that is not explicitly permitted by previous rules.

clipping levels: Thresholds for activity that triggers auditing activity when exceeded.

cold site: A site that does not contain any of the hardware, software, or data necessary to run the business's operations. It does, however, maintain the necessary support systems (power, heating, ventilation, air conditioning, security, etc.) and telecommunications circuits necessary to transfer operations.

collision: A condition that occurs when two messages have identical message digests computed using the same hash function.

compromise: Any unauthorized access to the system.

computer crime: An attack that results in breaking a law or regulation.

computer forensics: The process of identifying, extracting, and documenting data, searching for evidence of some specific activity.

confidentiality: The assurance that unauthorized personnel do not obtain access to private information and that legitimate users don't access information they are not authorized to access.

confidentiality policy: Document that outlines procedures to use to safeguard sensitive information.

configuration checklist: Offers detailed information on the configuration of networked systems.

constrained data item (CDI): Any data item protected by the Clark-Wilson model.

control: Any potential barrier that protects your information from unauthorized access.

cracker: An individual who attempts to compromise security controls for malicious purposes.

crossover error rate (CER): The point where FRR = FAR.

cryptanalysis: The science of studying codes and ciphers with the intent of defeating them.

cryptography: The science of developing new codes and ciphers and analyzing their security.

D

daemon: A program that runs in the background, usually providing a service to users or other programs.

data classification system: A system that provides a structured methodology for applying protection schemes to information of various sensitivities in a consistent manner.

data custodian: Generally, an IT person who is assigned by the data owner to enforce security policies according to the data classification set by the data owner.

data owner: A member of upper management who accepts the ultimate responsibility for the protection of the data.

data retention policy: Document that describes categories of data that must be protected, and minimum and maximum retention times.

data users: System users who access the data on a day-to-day basis.

decentralized access control: Places the responsibility of access control administration close to the object in question.

decrypt: The action of transforming a ciphertext message into its plaintext equivalent using a cryptographic algorithm.

defense in depth: Principle that states security administrators should build a layered defense against malicious activity.

demilitarized zone (DMZ): The screened subnet that hosts publicly accessible servers in a screened subnet or dual firewall topology.

denial of service (DoS) attack: An attack that renders a system unavailable for its intended use.

denial: Occurs when events take place that prevent authorized users from accessing a system for legitimate reasons.

destruction: The unauthorized deletion of data or prevention of authorized users from accessing system/network resources or information.

dictionary attack: An access control attack that attempts passwords from a dictionary of commonly used passwords.

digital certificate: A user's public key that has been digitally signed by a certificate authority.

digital signature: A message digest that has been encrypted with the sender's private key to provide for integrity and nonrepudiation.

disaster recovery planning (DRP): The process of preparing an organization to efficiently resume operations after a disaster impacts business continuity.

disclosure: The result of when unauthorized individuals gain access to confidential information.

discretionary access control: Object access decisions based on the identity of the subject requesting access.

discretionary access control list (DACL): A security structure that specifies which subjects can access the object.

domain: A logical group of computers, created by an administrator, that forms the basic grouping of systems in the Active Directory structure.

dual firewalls: The use of two firewall systems containing two network cards each along with an intermediate DMZ to protect an internal network from an external network.

E

egress filtering: The use of a security device to filter traffic leaving a network.

electronic emanations: Unwanted electromagnetic signals that are generated by any electronic device and may be used by eavesdroppers to gain information about activity on a system.

Encapsulating Security Payload (ESP): An IPSec protocol designed to provide confidentiality, integrity, and authentication for packets transiting a network.

encapsulation: The process used by layers of the OSI model to add layer-specific data to a packet header.

encrypt: The action of transforming a plaintext message into its ciphertext equivalent using a cryptographic algorithm.

Event Viewer: Logging utility in Microsoft Windows operating systems.

evidence: Any hardware, software, or data that can be used to verify the identity or activity of an attacker.

exploit: A vulnerability that can be used to compromise one or more security controls to gain unauthorized access to a system.

exposure factor (EF): The expected portion of an asset that would be destroyed by a given risk, expressed as a percentage of the asset.

external intruder: An intruder who attacks a system from outside your organization.

F

false acceptance rate (FAR): The rate at which invalid subjects are accepted.

false negative: An error that occurs when an IDS decides a true intrusion is just normal activity.

false positive: An error that occurs when an IDS reports normal activity as being suspicious.

false rejection rate (FRR): The rate at which valid subjects are rejected.

File Allocation Table (FAT): The common file system for older Windows and DOS systems.

file system: A collection of programs that manage and store data, or files, on secondary storage devices.

financial attack: An attack designed to improperly acquire goods, services, or money.

firewall: A network security device (hardware or software) responsible for screening traffic entering or leaving a computer network.

forensics: The analysis of a system with the purpose of finding evidence of specific activity.

fragmentation: The process used by the Internet Protocol to divide packets into manageable fragments for transmission across varying networks.

fun attack: An attack that has no real purpose other than to provide a rush to the attacker.

G

group policy: An object that defines the security settings for a specific system event, by user group.

grudge attack: An attack designed to "get back at" an organization or an individual.

H

hacker: Person who writes programs and enjoys learning minute details of programming and systems in general without malicious intent. Often used synonymously with *cracker*, which is a person who attempts to access a computer system without authorization. Crackers often have malicious intent when accessing systems.

hard test: A DRP exercise in which team members activate the disaster recovery facility in production mode to simulate a disaster scenario.

harden: Refers to taking steps to make a system more secure by minimizing known threats.

hardening: The process of identifying known vulnerabilities and attempting to minimize or mitigate them.

hash function: A mathematical function used to generate a unique message digest for a given message.

honeypot: A deliberately insecure system or application that is exposed to the outside world to attract a potential intruder.

host-based IDS: A software package or hardware device that examines all network activity intended for a particular computer. The IDS can examine network packets as they are received, system activity log files, or a combination of the two.

hot site: A site that contains all of the hardware, software, and data necessary to assume primary processing responsibility.

I

identification: 1. The phase in which a subject claims to be a specific identity. 2. The act of verifying a subject's identity.

identity-based access control: Object access decisions based on a User ID or a user's group membership.

impersonation: The act of pretending to be someone whom you are not.

in the clear: All text is sent in a plain format that can be intercepted and read by anyone.

incident: Any violation of your security policy.

incident response team: Individuals from different departments who work together to ensure that an incident is handled efficiently.

initial training: Security training that takes place when an individual first enters an organization or assumes a new role that entails significantly different information security responsibilities.

input/output devices: Any device used either to collect data from the outside world or to present data to the world.

integrity: The assurance that data may be modified only through an authorized mechanism.

integrity verification procedure (IVP): A procedure that verifies the integrity of a data item.

internal intruder: An intruder who attacks a system from within an organization.

Internet Control Message Protocol (ICMP): An administrative protocol used to transmit control messages between hosts.

Internet Protocol (IP): A Network layer protocol used to route network traffic across the Internet and internal networks.

Internet Protocol Security (IPSec): A suite of security enhancements used to provide confidentiality, integrity, and/or authentication to the TCP/IP suite.

Internet Security Association and Key Management Protocol (ISAKMP): An IPSec protocol responsible for the creation and maintenance of security associations.

intrusion: Any use, or attempted use, of your system that exceeds authentication limits.

intrusion detection: The process of analyzing system activity to identify any suspicious actions.

intrusion detection system (IDS): Software and/or hardware that continuously monitors activity, looking for something suspicious.

K

Kerberos: A popular SSO system that provides both authentication and message protection.

Key Distribution Center (KDC): The network service and data depository that stores all the cryptographic keys for subjects and objects in a Kerberos system.

keystroke logging: A collection of methods of intercepting keys a user has typed.

knowledge-based IDS: An IDS that compares activity to known normal system behavior to attempt to detect abnormal behavior.

L

lattice-based access control: A variation of the non-discretionary access control model that establishes each relationship between a subject and an object with a set of access boundaries.

least privilege: A philosophy in which a subject should be granted only the permissions to accomplish required tasks and nothing more.

logging: The recording of system events in special files maintained for a predetermined duration.

logic bomb: A type of malicious code that executes a sequence of instructions when a specific event occurs.

login spoofing: An access control attack is that replaces a valid login screen with one supplied by an attacker.

M

malicious code: Any program, procedure, or other executable file that makes unauthorized modifications or triggers unauthorized actions.

malicious code object: A computer program that carries out malicious actions when run on a system.

mandatory access control: A system-enforced access control mechanism that assigns a security label, which defines the security clearance, to each subject and object.

man-in-the-middle attack: An attacker listens for network traffic from a spot between an authorized user and a resource the user is accessing.

message digest: A unique value derived from a plaintext message through the use of a hash function.

military and intelligence attack: An attack to acquire secret information from military or law enforcement agencies.

misuse intrusion: A deliberate attack against a known system vulnerability. A misuse intrusion generates predictable activity.

mode field: A field of a file that consists of 10 characters that specify security access and other special characteristics.

mount point: Each disk partition generally has a separate file system and its own root directory. UNIX systems attach each partition to a separate directory, called a mount point.

N

need to know: A condition when a subject requires access to an object to complete a task.

network-based IDS: Software device that monitors all traffic on a particular network segment.

network component: A hardware device that connects the computer bus to an external network, using either cables or wireless connections.

non-discretionary access control: Uses a subject's role, or a task assigned to the subject, to grant or deny object access.

non-interference model: An access control model that ensures that changes at one security level do not "bleed over" into another security level and affect an object in another context.

NT File System (NTFS): The preferred file system for Windows servers is NTFS.

O

object: The resource a subject attempts to access.

operating system (OS) fingerprinting: The process of detecting the operating system of a remote computer.

P

packet: A basic unit of data carried across a network by the TCP protocol.

packet sniffer: A program the intercepts, or sniffs, network packets as they pass by.

partition: A division of a hard disk or memory.

payload: The specific portion of a malicious code object that carries out the malicious action.

penetration testing: A systematic attempt to penetrate the security of a system in order to test current security measures.

permissive policy: A policy that allows subjects to access all objects unless the access to a specific object is explicitly denied.

phone phreaking: The practice of obtaining free long-distance telephone service.

plaintext: A message that has not been encrypted (or that has been decrypted following an encryption operation).

plugin: A supplemental program that defines all actions within Nessus.

port: An integer value that uniquely identifies a process running on a system and is used to establish interprocess communications.

primary storage: Volatile physical memory that resides in a computer and that is easily accessible by the processing unit.

private key: The half of an asymmetric keypair that is kept secret by each cryptosystem user. A user's private key is used to decrypt messages sent to him or her and to create digital signatures.

privilege creep: A situation that occurs when users change roles in an organization but retain access privileges associated with their former positions.

processor: The component(s) where instructions are executed. There may be several CPUs, as well as other special-purpose processors.

prohibitive policy: A policy that denies access to all objects by default. Access to every object is prohibited unless specifically granted.

promiscuous mode: A network interface card that reads all packets it sees, regardless of each packet's destination.

proxy: A network security device that interacts with Internet servers on behalf of internal clients, hiding the true identity of the client and providing performance benefits.

public key: The half of an asymmetric keypair that is freely distributed among cryptosystem users. A user's public key is used to encrypt messages sent to him or her and verify the authenticity of messages digitally signed by that user.

Q

qualitative risk assessment: Attempts to assign dollar values to each risk and then use those dollar values to weigh the potential benefit achieved by implementing additional security measures.

quantitative risk assessment: Focuses on analyzing the intangible properties of an asset, rather than focusing on monetary value.

R

reference monitor: The collection of methods, or functions, that actually performs the authorization of each object request.

refresher training: Security training that takes place on a periodic basis for all organization employees.

registry key: A collection of values organized in a tree hierarchy in the Windows Registry.

Remote Authentication Dial-In User Service (RADIUS): Centralized access control systems that provide centralized access control for dial-in users.

risk: Occurs when a threat and corresponding vulnerability both exist.

risk acceptance: A risk management technique in which a particular risk is accepted as the cost of doing business, often because the chances of a risk occurring are extremely remote or the potential damage the risk would cause is trivial.

risk avoidance: A risk management technique in which a potential risk is avoided entirely by disallowing a given activity. Risk analysts choose risk avoidance when a risk posed to an asset overwhelms the potential benefits.

risk mitigation: A risk management technique in which administrators take preventative measures to reduce (or mitigate) the risk posed to an asset.

risk transference: A risk management technique in which a risk is transferred to someone else.

role-based access control: A non-discretionary access control method that uses a subject's role to grant or deny object access.

root directory: The entry point to the tree is called the root directory.

rootkit: A set of hacking tools designed to take a user from Phase 3 (user-level access) to Phase 4 (superuser access) on a system.

router: A networking device that ensures traffic is passed efficiently from network to network and also provides limited security capabilities.

rule: Tells the IDS what packets to examine and what action to take if a packet looks suspicious.

rulebase: The component of a firewall that contains the customized decision-making rules used to determine whether traffic is permitted or denied.

rule-based access control: All access rights are decided by referencing the security clearance of the subject and the security label of the object.

S

Samba: Software for UNIX systems that provides the same resource sharing abilities as Windows shares, using SMB.

scanning: Systematic probing of ports to see which ones are open.

screened subnet: A firewall that uses three network cards to connect an external network, a protected network, and a DMZ.

secondary storage: A nonvolatile storage location for data that includes both fixed and removable drives and devices.

secret key: The shared key used by all users of a symmetric cryptosystem for both the encryption and decryption of messages.

Secure HTTP (HTTP-S): A secure Web communications protocol used to establish connectionless communications.

Secure Sockets Layer (SSL): A secure Web communications protocol used to establish connection-oriented communications.

security audit: Periodic review of a system or network's security posture.

security auditor: A trained and trusted entity that validates the effectiveness of controls and the level of compliance with the controls.

security clearance: The official determination that an individual should be granted access to a certain level of classified information.

security control: Maintaining the confidentiality, integrity, and availability of protected systems and networks.

security domain: A sphere of trust, or a collection of subjects and objects with defined access rules or permissions.

security kernel: Handles authorization, as well as outcome conditions (positive and negative) and auditing.

security label: An assigned level of sensitivity.

security policy: Written documents that outline an organization's security requirements and expectations of users, administrators, security professionals, and managers.

security scanning: The process of methodically assessing a system to find any known vulnerability.

security through obscurity: An outdated security principle that sought to maintain the integrity of information security devices by keeping the details of their operation a secret from device users.

separation of privileges: A principle that ensures that one user does not have the authority to perform actions that could impact critical events.

Server Message Block (SMB): A protocol to provide access to any shared network resource.

share: A computer resource, such as a disk drive, a folder, or a printer, that can be accessed from other computers on a network.

share scanner: Software that sends SMB packets to query your network for any active shares.

shares: Share network resources, such as folders and printers.

signature database: A collection of all known virus signatures used by antivirus software packages when scanning a system's files.

signature-based IDS: An IDS that compares activity to a stored list of known attack signatures.

Simple Network Management Protocol (SNMP): A protocol used to monitor and manage network devices.

Simple TCP/IP Services: Five generally unneeded services that can be easily disabled.

single loss expectancy (SLE): The amount of damage an asset would incur each time a given risk occurs. The SLE is the product of the AV and EF.

single Sign-On (SSO): A system that avoids multiple logins by positively identifying a subject and allowing the authentication information to be used within a trusted system or group of systems.

social engineering: Any attempt to convince an authorized user to disclose secure data or allow unauthorized access.

socket: A combination of an IP address and a port used to uniquely identify process/system pairings.

soft test: A DRP exercise in which team members actually activate the disaster recovery facility in parallel status to simulate a disaster scenario.

software bug: Any flaw in software that causes unexpected behavior.

state machine model: A collection of defined instances, called states, and specific transitions that permit a modification to occur that changes an object from one state to another.

stealth rule: A firewall rule that prevents direct connections to the firewall itself from external hosts.

subject: The entity that requests access to a resource.

subversion error: An error that occurs when an intruder changes the way the IDS works to make it overlook current intrusion activity.

superuser: A privileged account that has administrative powers over a system. Also known as the root account on UNIX systems or the Administrator account on Windows systems.

symmetric cryptography: A cryptosystem in which all users use the same shared secret key. (Also known as secret key cryptography.)

syslog: UNIX event logging facility.

system backup: A partial or complete copy of your system, typically stored on removable media.

system bug: An unwanted piece of code in a software program that can result in a vulnerability.

system footprinting: The process of extracting and documenting the state of a computer system. Also called baselining.

T

tabletop exercise: A DRP exercise in which team members gather and walk through a disaster scenario during an in-person meeting.

task-based access control: A non-discretionary access control method that uses the task a subject is working on to grant or deny object access.

TCPWrapper: The tcpd daemon that filters traffic and logs any suspicious activity.

TEMPEST: A government program designed to limit the scope of unwanted electromagnetic emanations from electronic equipment.

Terminal Access Controller Access Control System (TACACS): A centralized access control systems that provide centralized access control for networked users.

terrorist attack: An attack designed to disrupt everyday life.

threat: A set of external circumstances that may allow a vulnerability to be exploited.

threshold: A system activity limit, such as the number of failed login attempts, that an IDS will note if exceeded.

ticket: A Kerberos authentication message that contains keys for the subject and object.

transformation procedure (TP): Any procedure that makes authorized changes to a data item.

Transmission Control Protocol (TCP): A Transport layer protocol that runs on top of IP to provide connection-oriented communications.

transport mode: An IPSec mode that encrypts only the packet payload, facilitating host-to-host transmission over a non-IPSec network.

Trojan horse: A program that appears to do something useful, but actually exists for another purpose.

tunnel mode: An IPSec mode that encrypts entire packets for link-to-link communications security.

two-factor authentication: A process of providing two pieces of information to authenticate a claimed identity.

U

unconstrained data item (UDI): Any data not protected by the Clark-Wilson model.

User Datagram Protocol (UDP): A Transport layer protocol that runs on top of IP to provide connectionless communications with low overhead.

V

virus: A piece of malicious code that modifies an existing executable file in such a way that the newly "infected" file performs some unauthorized action.

virus shield: A layer of software that scans all incoming files for known viruses.

virus signature: Part of the virus code that uniquely identifies the virus. Antivirus software packages consult a database of all known virus signatures when scanning a system's files.

vulnerability: A weakness in a system that may be exploited to degrade or bypass standard security mechanisms.

vulnerability checklist: Contains lists of critical vulnerabilities that auditors should check for when conducting security audits.

W

war dialing: Automated dialing of many telephone numbers searching for a modem.

warm site: Contains most (if not all) of the hardware and software required to run the business, but does not maintain live copies of the organization's data.

well-known ports: Ports that correspond to basic network services that exist in most common environments. Each operating system maintains a

list of these ports, along with any custom port assignments you define for your system.

wireless device policy: A document that describes permissible wireless equipment and its use within an organization.

worm: Malicious code that is a standalone program and does not need a host to infect.

Index